Dictionary of
BRITISH CARTOONISTS
AND
CARICATURISTS
1730–1980

Dictionary of
BRITISH CARTOONISTS
AND
CARICATURISTS
1730–1980

Compiled by
MARK BRYANT and SIMON HENEAGE

Published by
SCOLAR PRESS
Gower House
Croft Road
Aldershot
Hants GU11 3HR
England

Ashgate Publishing Company
Old Post Road
Brookfield
Vermont 05036
USA

British Library Cataloguing in Publication Data

Dictionary of British Cartoonists and Caricaturists
I. Bryant, Mark II. Heneage, Simon
741.5941

Library of Congress Cataloging-in-Publication Data

Bryant, Mark
 Dictionary of British cartoonists and caricaturists / compiled by Mark Bryant and Simon Heneage.
 p. cm.
 ISBN 0–85967–976–4
 1. Cartoonists—Great Britain—Biography—Dictionaries.
I. Heneage, Simon. II. Title.
NC1470.B78 1994
741.5'092'241—dc20
[B] 93–21363
 CIP

ISBN 0 85967 976 4

Typeset in 8 point Sabon by Photoprint, Torquay, Devon and printed in Great Britain at the University Press, Cambridge

Contents

Preface vii

Acknowledgements xi

List of Abbreviations xiii

A–Z Dictionary 1

Bibliography 248

Preface

'Take them away,' said Charles I when he was shown some caricatures, 'I do not understand these madde designes.' Another early commentator called caricaturists 'a nest of waspish scoundrels'. Caricature used to be despised because it violated the rules of art and appealed to the baser instincts. Either it was considered a trivial pursuit, practised by modish amateurs as a cure for the vapours, or it was the province of hired hacks taking unscrupulous advantage of the libelling laws.

Hogarth, by insisting on the difference between 'characters' and 'caricaturas', tried to distance himself from the amateurs and by his integrity, his artistry and his adoption of a moral standpoint, did much to elevate the art. But he had no successors; by the end of the century Sayers and Gillray were in the pay of the government and Rowlandson was dabbling in pornography. And so it went on in the nineteenth century – George Cruikshank accepted bribes and Marks resorted to blackmail – until the men of *Punch*, acutely concerned with their social status, called a halt. John Doyle had shown how caricature could be separated from scurrility and in the mid-century Thackeray proclaimed 'we have washed, combed and taught the rogue good manners'. The profession had indeed become less disreputable – even the occasional knighthood started to come its way – but it was far from tamed; Max Beerbohm showed how one sort of rudeness could still thrive whilst Donald McGill exploited another. In our own times the excoriations of Scarfe and Steadman have been condemned as often as they have been admired and Steve Bell's *Maggie's Farm* was denounced in the House of Lords as 'an almost obscene series of caricatures'. So the old derision is very much alive and with it the old sense of inferiority. Nicholas Garland wrote recently, 'English comic artists traditionally exist in relation to fine artists as buskers do to opera stars.'

Not much is known about buskers. Our first problem in compiling this dictionary was the paucity of information about the early caricaturists. Because of the risk of reprisal in some form, many of the early prints are anonymous or pseudonymous and contemporary chroniclers recorded little about the identified artists unless they were also fine artists like Reynolds and the Dances or distinguished in other spheres like Townsend and Bunbury. Despite the international pre-eminence of English caricature in the 'Golden Age' (1780–1830) and

the fact that in 1806 a German journalist could describe Gillray, our leading caricaturist, as 'the foremost living artist in the whole of Europe', we know little enough about his life and character. Caricatures were enormously popular but public appeal went hand in hand with personal obscurity. Doubly surprising, perhaps, is the fact that the same is also true of some twentieth-century cartoonists – especially those working in the 1930s and 40s. A case in point is that of Edward Hynes, who drew the cover of *Men Only* for nearly 20 years – succeeding Eric Fraser and being in turn succeeded by R. S. Sherriffs (both well documented). Very few cartoonists of this century have merited obituaries or appeared in biographical works and tracking down information about them has involved considerable detective work. As a result, details about the lives and works of a large proportion of the twentieth-century artists, living or dead, appear in print here for the first time.

The second problem was definition. Before 1843 it was relatively easy; the word 'caricature' described all humorous or satirical drawings and prints whether their purpose was social, political, personal or just amusing. In that year John Leech drew a social satire for *Punch* which, because it related to the rough designs (or cartoons) for wall paintings on exhibition at the House of Lords, was super-scribed 'Cartoon No 1'. From that moment the word 'cartoon' began to acquire its modern meaning of 'funny picture' and 'caricature' came to stand for distorted portraiture, emphasizing characteristic traits. Except that political cartoons are often humourless – 'Do they suppose there is anything funny about me?' asked Sir John Tenniel. Except that in wartime some cartoonists abandon humour for grotesque vilification. Except that strip cartoons are more often concerned with adventure than humour. So one also has to be constantly reminded that, in Sir Ernst Gombrich's words, 'Humour is not a necessary weapon in the cartoonist's armoury.'

Beyond that, the word 'cartoon' has come to have a number of different meanings and connotations. Comic magazines, TV and film animation, multi-frame newspaper jokes, continuity strips, graphic novels, humorous advertising, humorous illustration in books and magazines, and satirical puppetry have all been classified as varieties of cartoon art. For the purpose of this dictionary we escaped from the maze by taking the pragmatic approach of Sir Arthur Quiller-Couch who, when asked to define poetry, responded 'Poetry is the stuff that poets write.' We define as 'caricaturist' all artists producing satirical prints or drawings before c.1840; after that time we define as 'cartoonist' or 'caricaturist' comic artists whose work appeared regularly in national newspapers and magazines. With a few exceptions, we have excluded artists who were primarily strip cartoonists, animators and book illustrators as belonging to a different genre. The term 'British' has been stretched to embrace foreign-born artists who worked extensively for British publications.

The third problem was selection. Limiting ourselves to approximately 500 entries, we chose the caricaturists and cartoonists (by our definition) whose reputations had been established by 1980. Under Publications ('PUB') and

Literature ('LIT') we have listed a representative, not a definitive, selection of their work. Inevitably there were border-line cases and inevitably we shall be found to have landed, especially amongst contemporary cartoonists, on the wrong side. We can only apologize and say that we utterly repudiate the view of another compiler that 'among the most enjoyable of an anthologist's decisions is who to leave out'.

In choosing illustrations our aim was to preserve a balance between the familiar and the lesser known and to represent a variety of styles. We were also concerned to choose examples that were typical and reproduced to best advantage. Some of the drawings were published in national newspapers and familiar magazines such as *Punch*, *Private Eye* and the *Spectator* but we also took care to find illustrations from dimly remembered or forgotten journals like *Judy*, *Fun*, *Pick-Me-Up*, *Night & Day*, *Lilliput*, *Men Only*, and *London Opinion* that also published excellent cartoon art.

It was tempting, but on the whole futile, to make generalizations about the nature of British cartoon art and the sort of men and women who have practised it. If, in *Punch*, which set standards of humour for the second half of the nineteenth century and much of this, the social cartoons reflected Fougasse's title 'the good-humoured pencil', the pre-*Punch* caricaturists were anything but good-humoured and the expression would be scorned by many of our contemporaries. In the same way, whilst cartoonists are popularly supposed to be cynics and misanthropes with tendencies to drink and manic-depression, many have been good-natured people with quite ordinary habits. What has distinguished the best of them has been individuality of outlook allied to originality of style and it is this individuality which defeats any attempts to establish a British 'tradition'. The only apparent tradition is in subject matter: a perennial addiction to class, clothes, foreigners, clerics, boozing, seduction and lavatories. And we shouldn't forget the British tradition of comic absurdity, pretty well invented by Edward Lear.

This is the first book to encompass the entire field – from *c*.1730 when Hogarth published the first of his 'modern moral pictures' to the present day. Considering the enduring public appetite for cartoons and caricatures in Britain it is perhaps surprising that no attempt at a biographical dictionary has been made before.

It is hoped that this volume, long overdue, will improve matters and help to demonstrate the important contribution of cartoonists and caricaturists to Britain's artistic heritage.

Simon Heneage and Mark Bryant
Somerset and London, 1994

Acknowledgements

In helping with the preparation of this book thanks must go in the first instance to all the many cartoonists and caricaturists, and relatives and friends of deceased artists, who have spared the time to provide biographical information and to discuss details of their work and publications. Grateful acknowledgement is also made to all those whose publications appear in the Bibliography and in particular to those individuals whose scholarship and pioneering work in this field have proved invaluable, notably: Dorothy George, Simon Houfe, M. H. Spielmann, R. G. G. Price, William Feaver, B. Peppin and L. Micklethwaite, Keith Mackenzie and Maurice Horn.

Thanks too to the helpful staff of the Advertising Association Library, British Cartoonists' Association, British Film Institute, British Library, British Museum Prints & Drawings Department, British Newspaper Library, Cartoon Art Trust, Cartoon Gallery, Cartoonists' Club of Great Britain, Illustrated London News Library, Imperial War Museum Library and Department of Art, Punch Library, St Bride Printing Library, University of Kent Centre for the Study of Cartoons & Caricature, University of London Senate House Library and the Victoria & Albert Museum Department of Prints & Drawings.

In addition, the publishers and compilers of this dictionary would like to thank the following for their kind permission in allowing illustrations to be reproduced: *The Cartoonist, Daily Express, Daily Mail, Daily Mirror, Daily Telegraph, Evening Standard, Guardian, Independent, Oldie, Playboy, Private Eye, Punch,* Solo Syndication, *Spectator, Squib,* Tessa Sayle Agency and *The Times.*

Particular thanks must also go to the late Mel Calman, Jane Newton, Dr Paul Goldman, Paul Gravett, Bill Hewison, Pat Huntley, David Linton, Alan Mumford, Bryan Reading, John Rae-Smith, Professor Colin Seymour-Ure, Ian Scott, Dougal Wood and Jenny Wood for invaluable information about cartoonists, and in some cases for allowing access to their personal libraries and archives. Finally, thanks to all at Scolar Press, especially Nigel Farrow for having confidence in the project and to Ellen Keeling and Rachel Lynch for producing such a handsome volume.

While every effort has been made to make this dictionary as authoritative as possible and to trace all artists, relatives and copyright holders, the compilers would welcome further information, which will be added to future editions.

Abbreviations

A	Ashmolean Museum, Oxford
AA	Architectural Association
AB	Aberdeen Art Gallery
AC	Arts Council of Great Britain
AG	Abbey Gallery
AI	Association of Illustrators' Gallery
AIA	Artists' International Association
AR	Arnolfini Gallery, Bristol

B	Birmingham City Museum & Art Gallery
BAG	Bluecoat Art Gallery, Liverpool
BAR	Barber Institute, Birmingham
BC	Barbican Centre
BCO	British Council
BED	Cecil Higgins Gallery, Bedford
BEL	Belfast Museum & Art Gallery
BFI	British Film Institute
BG	Baillie Gallery
BGM	Bethnal Green Museum
BI	British Institution
BIB	Bibliothèque Nationale, Paris
BL	British Library
BM	British Museum
BN	Royal Pavilion Art Gallery & Museum, Brighton
BOD	Bodleian Library, Oxford
BR	City of Bristol Museum & Art Gallery
BRU	Bruton Galleries
BSG	Brook Street Gallery
BUR	Burlington Gallery

C	Courtauld Institute
CA	National Museum of Wales, Cardiff
CAC	Camden Arts Centre

CAS	Contemporary Arts Society
CAT	Cartoon Art Trust
CB	CEMA Gallery, Belfast
CBG	Chris Beetles Gallery
CCGB	Cartoonists' Club of Great Britain
CG	Cartoon Gallery (formerly The Workshop)
CHG	Chenil/New Chenil Galleries
CHR	Christie's
CI	Commonwealth Institute
COO	Cooling Gallery
CP	British Communist Party Library
CS	Charterhouse School
D	Derby City Art Gallery
DG	Dudley Gallery
DOW	Dowdeswell Galleries
DUL	Dulwich College
DUN	Dundee Museum & Art Gallery
E	Scottish National Gallery of Modern Art, Edinburgh
EU	Essex University
F	Fitzwilliam Museum, Cambridge
FAS	Fine Art Society
FR	Frost & Reed
FS	Folio Society
G	Glasgow Art Gallery
GC	Garrick Club
GG	Grosvenor Galleries
GI	Glasgow Institute of Fine Arts
GM	Geffrye Museum
GOU	Goupil Gallery
H	Hastings Art Gallery
HAM	Hamilton Galleries
HC	Hampton Court
HCL	House of Commons Library
HLL	House of Lords Library
HU	Hull University
HUN	Hunterian Museum, Glasgow
ICA	Institute of Contemporary Arts
IWM	Imperial War Museum

KH	Kenwood House, Hampstead
KN	Knokke-Heist Museum, Belgium
L	Walker Art Gallery, Liverpool
LAN	Langton Gallery
LC	Library of Congress, USA
LE	Leeds City Art Gallery
LEG	Leger Gallery
LEI	Leicestershire Museums & Art Galleries
LG	Leicester Galleries
LH	Leighton House
LM	Museum of London
LON	London Group
LTM	London Transport Museum
M	Manchester City Art Gallery
MAD	Musée des Arts Décoratifs, Paris
MAM	Musée d'Art Moderne, Paris
MAN	Manchester Gallery of Modern Art
MCO	Merton College, Oxford
MET	Metropolitan Museum of Modern Art, New York
MG	Mayor Gallery
MIN	Minories, Colchester
MOCA	Museum of Cartoon Art, New York
MOMA	Museum of Modern Art, Oxford
MOMI	Museum of the Moving Image
MT	Mermaid Theatre
N	Nottingham Castle Museum
NAD	National Academy of Design, New York
NBL	National Book League
NEAC	New English Art Club
NEC	National Exhibition Centre, Birmingham
NG	National Gallery
NGG	New Grafton Gallery
NGI	National Gallery of Ireland, Dublin
NGS	National Gallery of Scotland, Edinburgh
NIG	Nigel Greenwood Gallery
NLI	National Library of Ireland
NOR	Norwich Art Gallery
NPG	National Portrait Gallery
NPGS	National Portrait Gallery of Scotland
NT	National Theatre

NWS	New Watercolour Society
NYPL	New York Public Library
OHG	Orleans House Gallery, Twickenham
OWS	Old Watercolour Society
PAG	Patersons Gallery
PG	Piccadilly Gallery
RA	Royal Academy
RAF	RAF Museum
RAH	Royal Albert Hall
RAM	Royal Albert Museum, Exeter
RBA	Royal Society of British Artists
RCA	Royal College of Art
RE	Royal Society of Etchers & Engravers
RFH	Royal Festival Hall
RG	Redfern Gallery
RHA	Royal Hibernian Academy
RI	Royal Institute of Painters in Watercolour
RIBA	Royal Institute of British Architects
RL	Royal Library, Windsor
RMS	Royal Miniature Society
ROH	Royal Opera House
ROI	Royal Institute of Oil Painters
RP	Royal Society of Portrait Painters
RSA	Royal Scottish Academy
RSAB	Royal Society of Artists, Birmingham
RSMA	Royal Society of Marine Artists
RSW	Royal Scottish Society of Painters in Watercolour
RWA	Royal West of England Academy
RWS	Royal Society of Painters in Watercolour
S	Sheffield City Art Galleries
SA	Society of Artists
SAM	Sammlung Karikaturen & Cartoons, Basel
SBA	Society of British Artists
SBC	South Bank Centre
SC	Savage Club
SGG	St George's Gallery
SI	Smithsonian Institute, USA
SIM	Simavi Foundation Cartoon Museum, Istanbul
SM	Science Museum
SWA	Society of Women Artists

T	Tate Gallery
TG	The Gallery
TM	Theatre Museum
TOW	Towner Art Gallery, Eastbourne
TRY	Tryon Gallery
UAA	Ulster Academy of Arts
UKCC	University of Kent Cartoon Centre
UM	Ulster Museum
US	University of Surrey
UW	University of Wales
V&A	Victoria & Albert Museum
W	Whitechapel Art Gallery
WA	Wakefield Art Gallery & Museum, Yorkshire
WAC	Welsh Arts Council
WAD	Waddington Galleries
WAG	Whitworth Art Galleries, Manchester
WBM	Wilhelm Busch Museum, Hanover
WD	William Drummond Gallery
WG	Walker's Gallery
Y	York City Art Gallery
Z	Zwemmer's Gallery

A

ABRAHAM, Abu (b. 1924). Political cartoonist, journalist and politician. Born on 11 June 1924 in Tiruvalla, Kerala, India, Abu studied French, Mathematics and English at the Travancore University, Kerala, where he was also tennis champion. He graduated in 1945 and was a reporter on the *Bombay Chronicle* (1946–9), drawing cartoons in his spare time. He then moved to the New Delhi satirical journal, *Shankar's Weekly*, in 1951 as staff cartoonist. Abu came to the UK in 1953 and contributed to *Punch, Everybody's, London Opinion* etc before becoming the *Observer's* first ever staff political cartoonist in 1956. After ten years he moved to the *Guardian* and drew a regular pocket cartoon there for three years until 1969. He then returned to India and worked for *Indian Express* (1969–81), serving as a member of the Rajya Sabha or Upper House of the Indian parliament (1972–8). Described by the *Guardian* as 'the conscience of the Left and the pea under the princess's mattress', he also drew (as 'Abraham') for *Tribune*, and received a Special Award from the BFI for his animated political film, *No Arks*.
PUB: (ed.) *Verdicts on Vietnam* (1968), *Abu on Bangladesh* (1972), *Games of Emergency* (1977), *Arrivals and Departures* (1983), (ed.) *Penguin Book of Indian Cartoons* (1988)
ILL: R. Thapar, *Indian Tales* (1991) MB

ABU – see Abraham, Abu

ACANTHUS – see Hoar, Harold Frank

ADAMSON, George Worsley RE MCSD (b. 1913). Freelance designer, illustrator and humorist. George Adamson was born in New York City on 7 February 1913. He studied art at Wigan Art School under L. T. Howells ARCA and then at Liverpool City Art School under Geoffrey Wedgwood RE, where he specialized in aquatint and drypoint. Between 1940 and 1946 he served in the RAFVR as a navigator in 210 Coastal Command, flying Catalinas and Liberators, and was for a short while Official War Artist to Coastal Command. He was a lecturer in engraving and illustration at Exeter School of Art (1946–53) before turning freelance. Since then he has contributed 180 cartoons to the *Daily Telegraph's* 'Peterborough' column and supplied drawings and decorations as well as 34

covers for *Punch* (1939–92), commencing under FOUGASSE's editorship. Other freelance work has been for *Nursing Times, Countryman, New Scientist, Young Elizabethan, Country Fair, Time & Tide, Illustrated London News, Listener, Sketch, Tatler, Radio Times* and *Private Eye*. A Member of the Chartered Society of Designers since 1954, he was elected a Fellow of the Royal Society of Painter–Printmakers in 1987. Influenced by classical artists such as Velázquez, Rembrandt, Goya and Hokusai, he works on paper, gesso surfaces and scraperboard, and uses ink, wash, charcoal, chalk and other media.
PUB: *A Finding Alphabet* (1965), *Widdecombe Fair* (1966), *Finding 1 to 10* (1968), *Rome Done Lightly* (1969)
ILL: 84 books including *Faber Book of Nursery Verse* (1958); T. Hughes, *Meet My Folks!* (1961), *Iron Man* (1968); R. Carpenter, *Catweazle* (1970); N. Hunter's 'Professor Brainstawm' books (1966–77); F. Waters, *The Day the Village Blushed* (1977); first five volumes of *Private Eye's* 'Dear Bill' books (1980–4); P. G. Wodehouse, *Short Stories* (1983)
EXHIB: RAM; RA, L
COLL: [drawings/prints] RAM; IWM; UM; [prints] BM; V&A; RE Gallery; NYPL; Wigan Library; RAM; RAF MB

ALBERT – see Rusling, Albert

ALDIN, Cecil Charles Windsor RBA (1870–1935). Cartoonist, illustrator and painter. Born on 28 April 1870 in Slough, Berkshire, the son of a builder, Cecil Aldin was educated at Eastbourne College and Solihull Grammar School. He studied anatomy at the South Kensington Schools and animal painting under Frank W. Calderon. His first drawing was published in the *Graphic* in 1891 and he was a major contributor to *Illustrated London News* (1892–1911) and *English Illustrated Magazine* (1893–7). He also illustrated Kipling's 'Jungle Stories' for *Pall Mall Budget* and contributed to *Sporting & Dramatic News, Punch, Sketch, Pick-Me-Up* and others. A specialist in dogs, horses, hunting and coaching scenes and historic buildings, he was elected a member of the RBA (1898), and was a co-founder (with PHIL MAY, TOM BROWNE and DUDLEY HARDY) of the London Sketch Club (1898), becoming its President in 1905. Master

1

of the South Berkshire Foxhounds (1914), his bull-terrier 'Cracker' became so famous through his portraits that his death nearly three years after Aldin's was announced on BBC radio and led to an obituary in *The Times*. Influenced by LEECH and CALDECOTT, Aldin also designed posters (e.g. for Cadbury's Cocoa and Colman's Mustard) and worked in pen, ink, watercolour and crayon. He retired to Mallorca in 1930 and died on 6 January 1935.

PUB: Many books including [with J. Hassall] *The Happy Annual* (1907), *The Black Puppy Book* (1909), *Old Inns* (1921), *Old Manor Houses* (1923), *Cathedral and Abbey Churches of England* (1924), *Ratcatcher to Scarlet* (1926), *Dogs of Character* (1927), *The Romance of the Road* (1928), *An Artist's Models* (1930), *Mrs Tickler's Caravan* (1931), *Scarlet to MFH* (1933), [with J. B. Morton] *Who's Who at the Zoo* (1933), *Just Among Friends* (1934), *Exmoor* (1935), *How to Draw Dogs* (1935), *Hunting Scenes* (1936)

ILL: Many books including W. M. Praed, *Everyday Characters* (1896); W. Emanuel, *A Dog Day, or the Angel in the House* (1902); W. Irving, *Christmas Day*; C. Dickens, *Pickwick Papers* (1910); R. S. Surtees, *Handley Cross* (1911); N. Heiberg, *White Ear and Peter* (1912); A. Sewell, *Black Beauty* (1912); J. Masefield, *Right Royal* (1922)

EXHIB: FAS; BUR; L; RA; RBA; RMS; AG
COLL: IWM, V&A
LIT: [autobiography] *Time I Was Dead* (1934); R. Heron, *Cecil Aldin: The Story of a Sporting Artist* (1981), *The Sporting Art of Cecil Aldin* (1990) MB

ALKEN, Henry Thomas (1785–1851). Painter and etcher of sporting, predominantly hunting or racing subjects, comic artist. Henry Alken was born in London into a family of sporting artists of Danish origin. He was taught drawing by his father Samuel and by the miniaturist, J. T. Barber Beaumont, and exhibited two portrait miniatures at the RA (1801–2). His earliest sporting prints were signed 'Ben Tally Ho' but in 1816 he published under his own name *The Beauties and Defects in the Figure of the Horse comparatively delineated*. Of the humorous works, the best known are *Symptoms of Being Amused* (1822) of which 30,000 copies were printed and *Illustrations to Popular Songs* (1823), both containing 42 soft ground etchings coloured by hand, each plate with several figures. The humour in these is rather pun-bound but the drawing is lively

enough. Alken's work declined in the 1830s and he died in poverty. Many of his pictures were copied by his son, also called Henry, making for confusion. Following the lead of BUNBURY, GILLRAY and ROWLANDSON, Alken developed the accidental humour of sporting art and paved the way for JOHN LEECH on whom he was a strong influence.

PUB: More than 20 books including *Specimens of Riding near London* (1821), *The National Sports of Great Britain* (1821), *A Cockney's Shooting Season in Suffolk* (1822), *A Touch at the Fine Arts* (1824), *Alken's Sporting Scrap Book* (1824), *Shakespeare's Seven Ages of Man* (1824), *Analysis of the Hunting Field* (1846), *The Art and Practice of Etching* (1849)

ILL: Anon, *Real Life in Ireland* (1821); Anon, *Real Life in London* (1821–2); C. S. Apperley ('Nimrod'), *The Chace, the Turf and the Road* (1837), *Memoirs of the Late John Mytton* (1837), *The Life of a Sportsman* (1842); R. S. Surtees, *Jorrocks' Jaunts and Jollities* (1843)

COLL: BM; V&A; F; LE; LEI
LIT: W. Shaw Sparrow, *Henry Alken* (1927)
SH

ALPHA – see Fitton, James

ANDERSON, Martin 'Cynicus' (1854–1932). Cartoonist, designer and publisher of satirical postcards. Cynicus was born in Leuchars near Dundee and educated locally and at Madras College, St Andrews. He was apprenticed to a designer in Glasgow and attended Glasgow School of Art. After a spell as a staff artist on the *Dundee Advertiser* he moved to London (1891) and established a studio in an erstwhile fish shop in Drury Lane from which he issued his hand-coloured caricatures in sheet, postcard and book form under the pseudonym 'Cynicus'. In 1902 he established the Cynicus Publishing Company at Tayport, Fife. To begin with his cards sold well but demand was affected by the outbreak of war and the company was wound up in 1916. Cynicus attacked political and social abuses in an impersonal way. His crude images (softened by hand colouring) were captioned with spirited rhyming couplets. LOW called his work 'a reminder that satire is not mere pleasantry'.

PUB: *The Humours of Cynicus* (1891), *Symbols and Metaphors* (1892), *The Satires of Cynicus* (1893), *Cartoons Social and Political* (1893), *Selections from Cynicus* (1909)

EXHIB: RSA SH

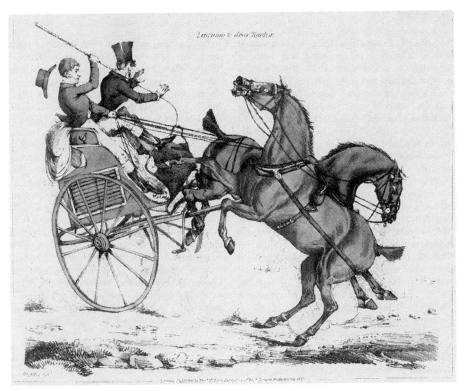

Learning to drive Tandem
Henry Alken, 1823

Cynicus (Martin Anderson), *The Humours of Cynicus* (1891)

3

ANGRAVE, Bruce FSIA (1912–83). Cartoonist and illustrator. Bruce Angrave was born in Leicester on 6 December 1912, the son of a graphic designer and photographer. He attended the Chiswick, Ealing and Central Schools of Art and then worked as art director of a London advertising agency. During a trip to the World's Fair in New York in 1939 he saw paper sculptures for the first time in the Polish Pavilion and on his return began producing paper-sculpture caricatures for advertisements, exhibitions and a film. During World War II he produced propaganda illustrations on waste, the blackout etc. for the Ministry of Information, wrote and illustrated two children's books telling moral tales about 'the essential logic of machinery' and made models for the 'Britain at War' Exhibition in Chicago. He also produced paper sculptures for the Festival of Britain (1951), Expo '70 in Japan and Ideal Home Exhibition (1971), and for advertising campaigns for London Transport, *Financial Times*, Pathé Pictures, Letraset, Trumans Beer, Marley Tiles and Mappin & Webb. As a cartoonist he contributed regularly to *Lilliput, London Opinion* (including covers), *Radio Times, Time & Tide, Woman's Realm, Aeronautics, Woman* (a weekly cartoon for 35 years) and *Punch* (often signing 'BA'). In addition he designed for TV (BAFTA Award, 1953), produced posters and fashion and advertising drawings. His work was influenced by R. Taylor of the *New Yorker* and poster designers Eckersley, Lewitt-Him and Games. Bruce Angrave died on 8 July 1983.
PUB: *Lord Dragline the Dragon* (1944), *The New English Fictionary* (1953), *The Mechanical Emperor* (1954), *Sculpture in Paper* (1957), *CATalogue* (1976), *MagnifiCAT* (1977), *TripliCAT* (1978), *Angrave's Amazing Autos* (1980), *Paper Into Sculpture* (1981)
ILL: J. K. Cross, *The Other Passenger* (1944); S. MacFarlane, *Lucy Maroon* (1944); A. Huxley, *Caught in the Act* (1953); C. Munnion, *Pineapple in Candyland* (1957)
EXHIB: [paper sculpture] Reed House, Piccadilly

MB

ANTHONY – see Hutchings, Anthony

ANTON – see Thompson, Harold Underwood & Yeoman, Beryl Antonia

APE – see Pellegrini, Carlo

APICELLA, Enzo (b. 1922). Cartoonist, illustrator, designer and painter. Enzo Apicella was born in Naples, Italy, on 26 June 1922, the son of a local councillor. He served in the Italian Air Force in World War II and briefly studied at the film school in Rome (1947). Then followed freelance design work, illustration and print journalism before he co-founded *Melodramma*, an opera magazine, in Venice (1953). When this folded he came to England (1954) and began designing posters for Schweppes and sets for TV, as well as producing cartoon films. Self-taught, his cartoons have been published in *Observer, Guardian, Punch, Economist, Private Eye* and *Harpers & Queen*. He has also worked as an interior designer for more than 65 restaurants, notably for the Pizza Express chain and has produced murals. In addition he has been a co-founder of the Arethusa club and Meridiana restaurant in London and is co-owner of Condotti restaurant in Mayfair. 'One of the creators of the Swinging Sixties in London' (Bevis Hillier, *Vogue*) Apicella draws with a fine line and a subtle use of colour. He is particularly at home with sophisticated captionless jokes about the world of food, restaurants and chefs.
PUB: *Non Parlare Baciami* (1967), *Memorie di Uno Smemorato* (1983), *Don't Talk, Kiss* (1988), *Mouthfool* (1993)
ILL: *The Pizza Express Cookbook* (1976); F. Lagattolla, *The Recipes That Made a Million* (1978); J. Routh, *The Good Loo Guide* (1985); *The Harpers & Queen Guide to Restaurants* (1987); R. Pazzaglia, *Il Guarracino* (1992)
EXHIB: Zarach Gallery; D. M. Gallery; Galeria 'Zapiecek' Desa, Warsaw (1976); Galeria 'Zapiecek' Desa, Cracow (1977); CG; D. Studio

MB

APP – see Appleby, Barry

APPLEBY, Barry Ernest (b. 1909). Cartoonist and strip cartoonist. Born in Birmingham on 30 August 1909, Barry Appleby studied art at Epsom Art School (1934), Heatherley's (1935), Central School of Art (1936) and the Royal Academy Schools (1936), and cartooning through the PERCY BRADSHAW Press Art School. He began work as a journalist and later as a motoring cartoonist under the name 'App' and also contributed to *Star, Sketch* and other publications (his first *Punch* cartoon appeared in 1937) but is best known for the internationally syndicated strip 'The Gambols', produced in association with his wife Dobs. Originally gamblers (horseracing), George and Gaye Gambol first appeared on the sports page of the

Daily Express on 16 March 1950 as a single panel, turning into a strip on 4 June 1951 and by 1956 were featured in the *Sunday Express* as well. The series has now been running for 43 years and is syndicated to 47 countries.
PUB: More than 40 'Gambols' annuals (from 1952) MB

ARDIZZONE, Edward Jeffrey Irving CBE RA (1900–79). Painter of humorous genre, illustrator, author, printmaker and commercial artist. Edward Ardizzone was born in Haiphong, French Indo-China, on 16 October 1900, of a Scottish mother and an Italian father who had become a naturalized Frenchman. Coming to England in 1905, he was educated at Clayesmore School (1913–18) then worked as a clerk in the City (1919–26) attending night classes at the Westminster School of Art under Bernard Meninsky who, with Doré, Daumier and CALDECOTT, influenced his style. In 1927 he became a full-time artist, in 1929 the first book with his illustrations was published, and in 1930 he had his first solo exhibition. He started a long association as an illustrator for *Radio Times* in 1932. The first of his own books illustrated with coloured lithographs, *Little Tim and the Brave Sea Captain*, was published in 1936. In 1940 he was appointed an Official War Artist. After the war he taught at the Camberwell School of Art and the RCA (1953–61). In 1955 he was awarded the Carnegie Medal and in 1956 the Hans Christian Andersen Medal and the Kate Greenaway Award for book illustration. He was elected ARA (1962) and RA (1970), awarded the CBE in 1971 and appointed a Royal Designer for Industry in 1974. He died on 8 November 1979. Never an actual cartoonist, much of Ardizzone's work is impregnated with a simple and kindly humour. It is perhaps most pronounced in advertisements, especially those he drew for the drink trade, and in his coloured cover designs for *Radio Times*, *Strand Magazine* (1946–7) and *Punch*. His style is comfortable, curvaceous, intensely personal and instantly recognizable. He once said 'one paints for artists and simpletons only'.
PUB: *Lucy Brown and Mr Grimes* (1937), *Tim and Lucy go to Sea* (1938), *Baggage to the Enemy* (1941), *Tim to the Rescue* (1949), *Tim and Charlotte* (1951), *Tim in Danger* (1953), *Tim All Alone* (1956), *Tim's Friend Towzer* (1962), *Tim and Ginger* (1965), *Tim to the Lighthouse* (1968), *The Young Ardizzone* (1970),

Tim's Last Voyage (1972), *Diary of a War Artist* (1974), *Indian Diary* (1984)
ILL: More than 170 books including J. S. Le Fanu, *In a Glass Darkly* (1929); H. E. Bates, *My Uncle Silas* (1939); W. de la Mare, *Peacock Pie* (1946); W. Shakespeare, *Hey Nonny Yes* (1947); M. Gorham, *Back to the Local* (1949); J. Reeves, *The Blackbird in the Lilac* (1952); G. W. Stonier, *Pictures on the Pavement* (1955); J. Kenward, *The Suburban Child* (1955); T. H. White, *The Godstone and the Blackymor* (1959); C. Ray, *Merry England* (1960); J. Betjeman, *A Ring of Bells* (1962); F. P. Nichols, *The Milldale Riot* (1965)
EXHIB: LEG; LG; MG; NGG; V&A (Retrospective 1973–4)
COLL: T; V&A; IWM; BN; E; LE; M; N; S; W; BM
LIT: B. Alderson, *Edward Ardizzone. A Preliminary Hand-List of his Illustrated Books* (1972); G. White, *Edward Ardizzone* (1979)
 SH

ARMENGOL, Mario Hubert (b. 1909). Designer, painter, sculptor and political cartoonist. Born in San Juan de Abadesas, Catalonia, Spain, on 17 December 1909, Mario Armengol studied in Terrassa, Barcelona, Madrid and Paris before arriving in the UK via Narvik in 1940. During World War II he was a political cartoonist and graphic designer attached to the Ministry of Information, producing advisory booklets and pamphlets, and contributing cartoons to *Message* (a Belgian review), *France* (Free French) as well as propaganda cartoons for neutral countries. These cartoons he drew on large Whatman paper using a brush, ink and lithographic pencil. He also worked as 'Mario', producing smaller drawings in pen and ink only with no tone. After the war he designed posters for British Rail and spent 20 years as a designer for ICI. In addition he contributed work to the Festival of Britain in 1952–3 and produced murals for Westminster Hall and the Science Museum, London. His design of the Industrial Pavilion at Expo Brussels was awarded a Gold Medal (1958) and he won joint first prize in an International Furniture Competition in 1968. He also designed a section of the British pavilion at Expo 67 in Montreal, featuring his own 20-foot-high sculptures. An admirer of Picasso and the cartoons of DAVID LOW he is now retired but recent work has included 3D paper animal sculptures, oil painting and collage.

PUB: *Those Three* (1942), *According to Plan* (1943)
ILL: *Spanish Fairy Stories* (*c.* 1944) MB

ARMITAGE, Joshua Charles 'Ionicus' (b. 1913). Painter and illustrator. J. C. Armitage was born on 26 September 1913 in Hoylake, Cheshire, the son of a fisherman. He studied at Liverpool City School of Art (1929–35) and later taught art (1936–50). During World War II he served in the Royal Navy. His first published work appeared in *Punch* in 1944, an association that lasted 44 years. He has also contributed to *Lilliput*, *Medical News*, *Financial Times*, *Countryman*, *Dalesman*, *Amateur Gardening* and *Tatler* amongst others. A full-time book and magazine illustrator since 1950 (with particularly long associations with publishers Chatto & Windus and William Kimber), he has also worked as a painter (oils and watercolour). Geipel has described his work as 'meticulously executed drawings incised with pellucid linearity'.
ILL: Many books including several titles by P. G. Wodehouse; R. G. G. Price, *How to Become Headmaster* (1960), *Survive With Me* (1962); O. Nash, *A Boy and His Room* (1964), *The Untold Adventures of Santa Claus* (1965); E. Blishen, *Town Story* (1964); C. Collodi, *The Adventures of Pinocchio* (1960); A. Lawrence, *The Good Little Devil* (1978), *Tom Ass* (1972); D. Kossoff, *Sweet Nutcracker* (1985);
COLL: BM; V&A MB

ARMOUR, George Denholm OBE (1864 –1949). Sporting cartoonist, illustrator and painter. G. D. Armour was born in Waterside, Lanarkshire, on 30 January 1864, the son of a cotton broker, and was educated at Glasgow Academy and Madras College, St Andrews. He studied art at the Edinburgh School of Art and the Royal Scottish Academy (*c.* 1880–8) – where he was encouraged by Robert Alexander RSA – later moving to London to work as a painter and illustrator (sharing a studio with PHIL MAY). In World War I he commanded a cavalry remount squadron, eventually reaching the rank of lieutenant-colonel with the British Salonika Force (1917). He was awarded an OBE in 1919. His first drawings were published in the *Graphic* (1890) and as well as producing some 1500 sporting drawings for *Punch (1896–1941) he* contributed to Pick-Me-Up, *Windsor Magazine, Judge, Field, Sporting & Dramatic News, Country Life* (from 1912), *Humorist, London Opinion, Sketch, Tatler* and others specializing in sporting subjects. For his

illustration work he used mostly pen, brush, ink and watercolour. He also painted equestrian portraits of the Dowager Duchess of Beaufort and other society figures. G. D. Armour died on 17 February 1949.
PUB: *The Humours of Sport* (1904), *Pastime With Good Company* (1914), *Humour in the Hunting Field* (1928), *A Hunting Alphabet* (1929), *Sport and There's the Humour of It* (1935)
ILL: R. S. Surtees (six titles, 1908–29); I. Bell, *Foxiana* (1929); J. Masefield, *Reynard the Fox* (1921); 'B. B', *The Sportsman's Bedside Book* (1937) and others
EXHIB: FAS; LG; RSA; RWA; GI; L; RSAB; RP; RA; RSW; New Gallery
COLL: V&A
LIT: [autobiography] *Bridle and Brush* (1937) MB

ARTZ, Sally (b. 1935). Cartoonist, strip cartoonist and illustrator. Born in London on 14 March 1935, Sally Artz studied graphic design at St Martin's School of Art (1951–2). She worked as a commercial artist and with Halas & Batchelor animation studios before selling her first cartoon to *Weekend Mail* in 1955. Since then she has produced strips for *Sunday People* ('Libby – the Adventures of a Liberated Wife', 1971–81; 'Cath's Caff', 1988-91), *Tit-Bits* ('Our Gran', 1978–81) and *Chat* ('The Wright Shower' since 1985), produced a widely syndicated cartoon feature 'Why . . .' (1981–5) for the *Daily Mirror* and has drawn regularly for the paper's business page since 1990. She has also contributed cartoons to *Reader's Digest*, *Penthouse* (USA), *Weekend*, *Oui*, *Chat*, *Bella*, *Private Eye* and *Punch*, designed greetings cards for Camden Graphics and produced illustrations for educational publishers such as Heinemann and Cambridge University Press. Winner of the Humor Gag section at the International Salon of Cartoons in Montreal (1981), she has been Vice-President (with PETER MADDOCKS) of the British Cartoonists' Association (1991–3). Influenced by Disney, NICOLAS BENTLEY and the American 'funnies', Sally Artz uses a Rotring Art pen and sketches in 3B pencil, using Wiggins Teape Hi-Speed card. For colour work she uses Ecoline inks.
PUB: *Why, Oh Why. . . ?* (1989)
COLL: MOCA MB

ATCHISON, Michael (b. 1933). Cartoonist, strip cartoonist and caricaturist. Michael Atchison was born in Victoria, Australia, in 1933 and

came to England in 1960, contributing to *Punch* and other newspapers and magazines. In 1968 he returned to Australia and worked for the *Sydney Daily Mirror* (1968) before joining the *Adelaide Advertiser* as Political Cartoonist later the same year. He also produces a daily strip, 'Word for Word', dealing with the origin of English words and phrases which is syndicated to more than 100 newspapers in the USA. MB

ATKINSON, John Augustus OWS (1775–c.1833). Painter, illustrator and caricaturist. J. A. Atkinson spent part of his childhood in Russia and returned in 1801 with sketchbooks full of material that he later used to illustrate a book on Russian life. His main achievement was as a watercolourist with a flowing line that is reminiscent of ROWLANDSON, and as an illustrator of colour-plate books on national costume, but in 1807 he issued a series of excellent caricatures, *The Miseries of Human Life*, published by Miller as individual prints and also in book form with a text by James Beresford. He was elected OWS (1808).
PUB: *A Picturesque Representation of the Manners, Amusements and Customs of the Russians* (1804), *A Picturesque Representation of the Naval, Military and Miscellaneous Costumes of Great Britain* (1807), *The Cutter* (1808), *Graphic Illustrations of the Defeat of Bonaparte and His Armies* (1819)
ILL: E. Orme (ed.), *Historic, Military and Naval Anecdotes* (1819)
EXHIB: RA; OWS
COLL: BM; V&A; C; Yale SH

ATKINSON, John Priestman (fl. 1864–94). Cartoonist and journalist. In 1864 whilst working as a clerk in Derby, Atkinson furnished cartoons to the *Derby Ram*, a satirical journal. He was recruited to *Punch* in 1865 and contributed to the magazine over the next 20 years, starting with pictorial initials and graduating to punning vignettes under the pseudonym 'Dumb Crambo Junior' which influenced the artists of early comics like *Ally Sloper's Half Holiday*. He also contributed humorous articles and verses to *Punch*. In the 1890s his cartoons were published in *Moonshine* and the *St James's Budget* and he illustrated some of the works of THACKERAY.
COLL: V&A SH

ATTWELL, Mabel Lucie SWA (1879–1964). Cartoonist, illustrator and writer. Mabel Lucie Attwell was born on 4 June 1879 in Mile End,

London, the daughter of a butcher. She attended the Cooper's Company School then studied painting and drawing at the Regent Street Polytechnic Art School and Heatherley's but didn't finish either course. Her first published drawings appeared in *Tatler*, *Little Folks*, *Pearson's* and other magazines. This led to commissions for illustrating series of children's books for Chambers, Hodder & Stoughton and Raphael Tuck's 'Raphael House Library of Gift Books' as well as postcards for Valentine & Sons. Specializing in sentimental children's pictures, she also designed dolls, textiles, china, posters (including one of the first for London Underground), produced comic strips and worked in advertising (for companies such as Boots and Osman Towels). Perhaps her most famous creations were Diddums, which became a bestselling doll, and The Boo-Boos baby gnomes. She married the illustrator Harold C. Earnshaw in 1908 and her immensely successful children's annual first appeared in 1922. Elected a member of the Society of Women Artists (1925), she also wrote children's stories and verse. Influenced by HILDA COWHAM, JOHN HASSALL, and CHARLES and WILLIAM HEATH ROBINSON, she died in Cornwall on 5 November 1964.
PUB: Many books including *The Lucie Attwell Annual* (1922–74), *The Boo-Boos* (1921–2), *Baby's Book* (1922), *Lucie Attwell's Fairy Book* (1932), *Lucie Attwell's Happy-Day Tales* (1932), *Lucie Attwell's Quiet Time Tales* (1932), *Great Big Midget Book* (1934–5), *Lucie Attwell's Story Book* (1943, 1945, 1953), *Lucie Attwell's Jolly Book* (1953)
ILL: Many books including M. Baldwin, *That Little Limb* (1905); Queen Marie of Romania, *Peeping Pansy* (1919), *The Lost Princess* (1924); A. Marshall, *Wooden* (1920), J. M. Barrie, *Peter Pan and Wendy* (1921); L. Carroll, *Alice in Wonderland* (1922)
EXHIB: SWA 1924; BN (centenary exhibition, 1979); CBG (1984)
COLL: V&A
LIT: C. Beetles, *Mabel Lucie Attwell* (1988) MB

ATTWELL, Michael 'Zoke' (b. 1943). Actor, political cartoonist and caricaturist. Michael Attwell was born in Watford, Hertfordshire, on 16 January 1943. A self-taught artist, he began work as an illustrator for IPC and D.C. Thompson children's comics such as *Bunty*, *Buster*, *Whizzer & Chips* and *Hotspur*. He transferred to newspaper cartoons as deputy to

FRANKLIN on the *Sun* and joined the *Sunday People* as Political Cartoonist in 1982, later moving to the *News of the World* (1984–8). Also a popular TV actor (he starred as Razor Eddie in 'Turtle's Progress' and Kenny in 'Eastenders'), his cartooning pseudonym comes from the names of his children – Zoe and Jake.　MB

AULD, Patrick Samuel Manson (1915–89). Cartoonist and landscape painter. Pat Auld was born in Reading on 24 February 1915 and educated at Reading School. He first drew (unsigned) a weekly series of strips 'Do You Know Your Reading' for the *Berkshire Chronicle* before moving into advertising. During World War II he served briefly in the Grenadier Guards before being invalided out. After the war he rose to become Art Director of Royds advertising agency. His cartoons were published in *Punch*, *Tatler* and *Lilliput* amongst others, and later in life he painted landscapes of Scotland, Spain and elsewhere. He died on 18 November 1989.　MB

AUSTIN, David (b. 1935). Pocket/strip cartoonist and illustrator. David Austin was born on 29 March 1935 in Chelmsford, Essex, and worked as an industrial chemist and schoolteacher before becoming a full-time cartoonist in 1976. He has produced a daily pocket cartoon for the *Guardian* since 1990 and his 'Hom. Sap.' strip set in Ancient Rome has appeared in *Private Eye* since 1970. In addition he has worked for *Spectator*, *Field*, *New Scientist*, *Mail on Sunday*, *Today*, *Daily Telegraph* and various other publications. He has a loose drawing style and hand-letters his captions, drawn without speech balloons for 'Hom. Sap' and inside oblong bubbles hanging from the top of the frame in his pocket cartoons.

PUB: *The Book of Love* (1970), *Private Eye David Austin* (1984), [with N. Newman & K. Williams] *Far From the Madding Cow!* (1990), *Annual Austin* (1993)

David Austin, *Guardian*, 13 April 1992

EXHIB: CG; TG
COLL: BM　　　　　　　　　　　　　　　　MB

AUSTIN, William (1721–1820). Etcher, drawing master, printseller and occasional caricaturist. As a printseller in London in the latter part of the eighteenth century, Austin was a rival of DARLY to whose opposition he attributed his failure to open a Museum of Drawings. As a caricaturist, producing both social and political satires, he was most active in the years 1773 and 1780. His consistent support of the Whig interest caused him to be known as 'Fox's Fool'. He has a distinctive style with strongly caricatured figures.
ILL: A. Locatelli, *A Specimen of Sketching Landscapes* (c. 1775)
COLL: BM; Yale　　　　　　　　　　　　　SH

B

BAB – see Gilbert, Sir William Schwenck

BAGHOT-DE-LA-BERE, Stephen RI (1877–1927). Painter, illustrator and cartoonist. Baghot-de-la-Bere was born in Leicestershire and educated at Ilkley College, Yorkshire. He moved

to London (c. 1900) and attended Westminster School of Art, then started to contribute illustrations and cartoons to the *Bystander*, *Illustrated London News*, *London Opinion* and *Pears Annual*. His cartoons in the *Sketch* (c. 1907), rather sinister in the manner of S. H. SIME, were

particularly arresting. At the same time he was painting expressionist watercolours, being elected RI (1908) and becoming a member of the London Sketch Club. During World War I he moved to Cranleigh, Surrey where he was a neighbour and friend of DULAC and LAWSON WOOD. His early cartoons were influenced by the posters of JOHN HASSALL but he developed a style akin to some of the artists of the German magazine *Simplicissimus* that is almost unique in British Art. Dulac believed that his work foreshadowed that of the Swiss abstract painter, Paul Klee.

ILL: J. Swift, *Gulliver's Travels* (1904); Cervantes, *The Adventures of Don Quixote* (1909); H. de Mendoza, *Lazarillo de Tomes* (n.d.)
EXHIB: RA; RI; RWA; FAS (1912)　　　SH

BAGNALL, Brian (b. 1921). Cartoonist and illustrator. Brian Bagnall was born in Manchester on 22 April 1921 and studied at Liverpool University School of Architecture. During World War II he served with the Duke of Lancaster's Own Yeomanry (1939–41) and the Royal Artillery (1941–6, PoW in Germany 1944–5). Formerly a professional architect, he turned full-time cartoonist in 1980, working in black and white but occasionally also in pen and wash. His drawings have appeared in *Private Eye*, *Spectator*, *Punch*, *Oldie*, *Observer* and elsewhere.

ILL: H. Cox, *Pressure Cookery* (1954); B. J. Ford, *101 Questions About Science* (1983), *Another 101 Questions About Science* (1984); S. Allison, *I Can't Cook* (1984); *Private Eye* 'Dear Bill' series (1985–90) and various books on architecture and law for Blackwells
EXHIB: Arts Club; Shalford Mill, Surrey
　　　MB

BAIRNSFATHER, Charles Bruce (1888–1959). Cartoonist, artist and journalist. Bruce Bairnsfather was born in Murree, India, on 9 July 1888, the son of a major in the Bengal Infantry. He was brought to England aged eight and attended Kipling's old school, the United Services College, Westward Ho! Then he attended an army crammer, Trinity College, Stratford-upon-Avon (selling sketches whilst there) and joined the Warwickshire militia (1911–14) but left to study art at JOHN HASSALL's school. He was working as an electrical engineer for a Stratford-upon-Avon firm installing generators when World War I broke out and he enlisted in the 1st Battalion Royal Warwickshire Regiment, achieving the rank of captain (1915). His first 'Fragment from France' drawing was published in the *Bystander* on 31 March 1915 while he was recovering from wounds in hospital. His most famous character, the pipe-smoking, walrus-moustached Cockney Tommy 'Old Bill' Busby, was greatly appreciated by the troops at the Front (even the Germans sympathized with his lot) but the establishment objected and questions were asked in Parliament about 'these vulgar caricatures of our heroes'. None the less his work so improved morale ('If you knows of a better 'ole, go to it!' [*Bystander*, 24 November 1915] is one of the most famous war cartoons of all time) that he was promoted Officer-Cartoonist and transferred to the Intelligence Department of the War Office. A *poilu* Old Bill was created for the French and the character was so popular that he appeared in books, plays, a musical (*The Better 'Ole*, 1917), two feature films, comic strips (*Daily Graphic*, 1921; *Passing Show*, 1934, and 'Young Bill' in *Illustrated*, 1940). A bus was even named after him and now resides in the IWM, but surprisingly he wasn't used in government poster campaigns until World War II. General Sir Ian Hamilton said of the artist: 'The creator of Old Bill has rendered great service to his Country, both as a soldier and as one who has done much to lighten the darkest hour.' Recent evidence has suggested that Old Bill was actually based on Lance Corporal Thomas 'Pat' Rafferty of the Royal Warwicks, who was killed in action in 1915. Bairnsfather also contributed cartoons to *Tatler*, *Life*, *New Yorker*, *Judge* and other publications and in World War II was Official War Cartoonist attached to the USAAF (1942–4). He died on 29 September 1959.

PUB: *The Bystander's Fragments from France* (8 volumes, 1916–19), *Bullets and Billets* (1916), *From Mud to Mufti* (1919), *Carry on Sergeant !* (1927), *The Collected Drawings of Bruce Bairnsfather* (1931), *Laughing Through the Orient* (1933), *Old Bill Looks at Europe* (1935), *Old Bill Stands By* (1939), *Old Bill Does it Again !* (1940), [with I. M. Dalrymple] *Old Bill & Son* (1940), *Jeeps and Jests* (1943), *No Kiddin'* (1944)
ILL: Anon, *A Temporary Gentleman in France* (1916); A. J. Dawson, *Somme Battle Stories* (1916), *Back to Blighty* (1917), *For France* (1917)
COLL: IWM
LIT: V. Carter, *Bairnsfather: A Few Fragments from His Life* (1918); W. A. Mutch, *The Bairnsfather Case* (1920); [autobiography] *Wide Canvas* (1939); T. & V. Holt, *The Best of*

'Fragments From France' (1978), *In Search of the Better 'Ole* (1985) MB

BAKER, Alfred Leslie John (1911–83). Cartoonist and watercolourist. Born in Durban, South Africa, on 2 July 1911 of British parents, Leslie Baker was educated at Mill Hill School and Chelsea School of Art (1928–32) where his contemporaries were Henry Moore, Graham Sutherland, BRIAN ROBB, RUSSELL BROCKBANK and typographic designer Peter Hatch. He joined Streets Advertising as a visualizer/artist (1932–40) and began producing cartoons from about 1935 for publications such as *Punch, Night & Day, Evening Standard, Titbits, Tatler & Bystander, Lilliput, Blighty, Strand Magazine, London Opinion, Evening News, Everybody's* and Kemsley Newspapers. During World War II he served in the Auxiliary Fire Service (stationed at South Ealing and Greenford), exhibited paintings of the Blitz and designed Home Front posters. After the war he returned to advertising, first at John Tate & Partners (1946 – *c*.1960) then Pemberton's (*c*.1960 – 9) where he was Art Director and later Director, retiring in 1969 to paint landscapes and birds. Married to art teacher and former Chelsea Art School colleague, Marjorie Bridson (1938), they had one son, cartoonist NICK BAKER. An admirer of Felix Topolski, ANTON and PONT as well as English watercolour artists such as Cotman and Bonnington, he died on 30 August 1983.
ILL: *Atlas of Breeding Birds in Britain and Ireland* (1976) and many drawings for the RSPB
MB

BAKER, Nicholas Bridson (b. 1940). Cartoonist and illustrator. The son of LESLIE BAKER, Nick Baker was born on 31 May 1940 in Strawberry Hill, Twickenham, Middlesex. He attended Mill Hill School (1951–6), Ealing Art School (1956–8), the London School of Printing (1958–60) and studied life drawing at evening classes at St Martin's School of Art. He worked for typographic designer Peter Hatch (1960–2) before becoming a visualizer/art director in advertising agencies (1962–73). His first cartoon was published in the *Evening Standard* in August 1966 and he became a full-time freelance in November 1973, contributing to *Punch, Private Eye, Oldie, Financial Times, Time Out, Guardian, Daily Mirror, Daily Express, European, Spectator, Mayfair, Reader's Digest, Town, King, Mail on Sunday* and *Tit-Bits*. He also drew the 'Smiler' page for IPC's *Whoopee!* children's comic

(1973–81) and was the *Financial Times*'s court artist at the Guinness trial (1990). He is a former committee member of the Cartoonists' Club of Great Britain.
PUB: *The Naughty Bath Book* (1976), *Songs to Sing in the Bath* (1976), *The One-Eyed Lion* (1983), *The Wonderful One-Eyed Lion* (1984), *Graham the Gorilla* (1985), [with B. Busselle] *Bad Losers* (1985), *Bad Manners* (1986); [with J. Monch] *Second Time Round* (1985)
ILL: R. Clifford's 'The Doctor' series of 6 books *c*.1975–80); J. Baldwinson, *Plonk and Superplonk* (1975); G. Thaw, *Ha! ha! ha!* (1976); R. Stark, *The Loaves and Fishes Miracle Cookbook* (1976); A. Sampson, *Cabinet Secrets* (1987); R. Griffiths, *Gorilla Number Games* (1988)
EXHIB: Waterman's Art Centre, Brentford, Middlesex
MB

BANKS, Jeremy 'Banx' (b. 1959). Cartoonist, strip cartoonist and pocket cartoonist. Jeremy Banks was born on 10 May 1959 and studied at Hounslow Borough College and Maidstone College of Art. His first cartoon was published in the *Evening Standard* in 1980 and he has since contributed to *Oink!*, Marvel Comics, *She, UK Press Gazette, You, Punch, Private Eye* and the *Financial Times*. A strip 'Cecil' also appeared in the *Daily Express*.
PUB: *Cubes* (1982)
ILL: Books by M. Harding and C. Tarrant
COLL: Bradford Museum
MB

BANX – see Banks, Jeremy

BARNARD, Frederick RBA, ROI (1846–96). Painter, illustrator and cartoonist. Barnard was born in London on 26 May 1846 and studied art at Heatherley's and in Paris under Bonnat. In 1863, whilst still at Heatherley's, the first of his illustrations appeared in the *Illustrated London News* and a cartoon was published in *Punch*. He became a prolific contributor to the magazines, his work appearing in *Ally Sloper's Half Holiday* (Supplement 1887/8), *Boy's Own Paper, Broadway, Cassell's, Chums, English Illustrated Magazine, Fun, Girl's Own Paper, Good Works, Harpers, Holly Leaves, Judy, Lika Joko, London Society, Once A Week*, and the *Penny Illustrated Paper*. He was particularly noted for his humorous studies of character, nowhere more than in his illustrations to 11 volumes of the Household Edition of Dickens (1871–9). He was elected RBA (1882), ROI (1883). Most of his cartoons are signed 'F. B.'. He died on 28 September 1896

from suffocation in a fire at a friend's house in Wimbledon. Barnard worked with distinction in a variety of media, his pen work giving rise to hyperbole – 'it cannot be surpassed in the whole range of black and white' wrote Charles Harper (*English Pen Drawings of Today*, 1892). To modern eyes his humour appears rather forced.
PUB: *A Series of Character Sketches from Dickens* (n.d.)
ILL: *Cassell's Illustrated Readings* (1867–8); T. Hood, *Petsetilla's Posy* (1870); G. R. Sims, *How the Poor Live* (1883); Sir W. Besant, *Amorel of Lyonesse* (1890); W. M. Thackeray, *The Four Georges* (1894).
EXHIB: RA; RBA; ROI; FAS (1896); Arts Council 'English Influences on Van Gogh' (1974–5)
COLL: V&A SH

BARTON, Leslie Alfred (b. 1923). Cartoonist, comic artist and illustrator. Les Barton was born on 8 December 1923 in Wareham, Dorset. A self-taught artist, he started work at the age of 14 as a telegraph clerk. His first published cartoon appeared in the *Militant Miner* in 1944. During World War II he served as a draughtsman in the Royal Signals and War Office Signals and produced his first regular cartoons for *WAM (West African Magazine)* when stationed in Lagos in 1946. After working as a photographic retouching artist, commercial artist in advertising and drawing strips for IPC and D. C. Thomson children's comics such as 'Billy Bunter', 'I Spy' and 'Harry's Haunted House', he became a regular contributor to *Punch* (from 1954), *Reveille*, *Private Eye*, *Spectator*, *Daily Mirror* and the *Daily Sketch*, drew political cartoons and caricatures for *The Statist* (1963) and was staff war artist on the *Sun* during the Falkands War (1982). He has also designed humorous greetings cards for Camden Graphics, Rainbow Cards and Cardtoons. A founder member of the Cartoonists' Club of Great Britain, he was the organization's Treasurer (1972–93). He also sometimes signs his work 'LEZZ'. Les Barton draws with a sketchy, uneven line and his figures have distinctive staring circular eyes with the pupils dead centre. His signature, in letter-spaced capitals, is often written in a wave pattern.
PUB: *Miles of Smiles* (1946), *The Best of Barton* (1960)
ILL: J. Rothman, *The World's Best Monster Joke Book* (1983), *The Most Awful Monster Book Ever* (1985); *Billy Bunter* (1972); *The Goodies* (1974) MB

BATEMAN, Henry Mayo (1887–1970). Cartoonist, strip cartoonist and caricaturist. H. M. Bateman was born as the son of an Englishman in Sutton Forest, New South Wales, Australia, on 15 February 1887. The family returned to England in 1889 and he attended Forest Hill House School, London. Encouraged by PHIL MAY he left school at 16 to study drawing and painting at Westminster School of Art, Goldsmith's Institute (New Cross, London) and later, on the recommendation of JOHN HASSALL, attended Charles van Havenmaet's studio (1904–7). Influenced at first by *Comic Cuts* and *Ally Sloper's Half Holiday*, his first humorous drawings were published in *Scraps* (1903), then *Tatler* (1904). He later produced regular full-page theatre caricatures for the *Sketch* whilst also submitting work to *Royal Magazine, London Magazine, Radio Times, Punch* (from 1915), *Bystander, Strand Magazine, Life, London Opinion* etc. He joined the London Regiment in World War I but was invalided out with rheumatic fever in 1915. Bateman was one of the highest paid cartoonists of his day and produced a considerable amount of work for advertising – notably for Lucky Strike, Moss Bros, Guinness, Erasmic Soap and Kensitas cigarettes. He also designed posters, and his World War II series for the Ministry of Health 'Coughs and Sneezes Spread Diseases' was very popular. An admirer of Caran D'Ache (indeed DAVID LOW described him as 'the British inheritor of Caran D'Ache') and OSPOVAT he was a master of the cartoon story without words. His most famous drawings, 'The Man who . . .' series of social gaffes, first appeared in 1912 in the *Tatler* ('The Missed Putt'). He worked in pencil, pen, ink and watercolour on Canson paper. He gave up cartooning in 1939 to concentrate on painting and died in Gozo on 11 February 1970.
PUB: *Burlesques* (1916), *A Book of Drawings* (1921), *Suburbia* (1922), *More Drawings* (1922), *Adventures at Golf* (1923), *A Mixture* (1924), *Colonels* (1925), *The Art of Drawing* (1926), *Rebound* (1927), *Brought Forward* (1931), *Considered Trifles* (1934), *The Art of Caricature* (1936), *The Evening Rise* (1960), *The Boy Who Breathed on the Glass at the British Museum* (1964), *The Best of H. M. Bateman: the Tatler Cartoons 1922–26* (1987) and others
ILL: G. Robey, *After Dinner Stories* (1920), *Thereby Hangs a Tale* (1921); L. Reed, *The Complete Limerick Book* (1924), *Nonsense Verses* (1925); D. Coke, *Our Modern Youth* (1924); L. Carroll, *Further Nonsense Verse and Prose* (1926); D. Clarke, *Bateman and I in*

Filmland (1926); W. Caine, *What a Scream!* (1927); J. Gordon, *Art Aint All Paint* (1944); G. Brennard, *Walton's Delight* (1953)
EXHIB: BSG; RA; FAS (1962); LG; LAN; RFH/NT (centenary exhib 1987), CGH
COLL: Annabels; CAT; V&A; BM; UKCC; A
LIT: *H. M. Bateman by Himself* (1937); M. Bateman, *The Man Who Drew the 20th Century* (1969); J. Jensen (ed.), *The Man Who ... and Other Drawings* (1975); A. Anderson, *The Man Who Was H. M. Bateman* (1982) MB

BAUMER, Lewis Christopher Edward RI (1870–1963). Painter, illustrator and cartoonist. Lewis Baumer was born on 8 August 1870 in St John's Wood, London. He attended the St John's Wood Art School, the RA Schools and the RCA, and then launched into a long and very successful career as a book illustrator and contributor to magazines. Starting in the *Pall Mall Magazine* (1893), his cartoons and illustrations were also published in the *Bystander*, *Cassell's*, *Graphic* (Christmas Numbers), *Humorist*, *Idler*, *Illustrated Bits*, *London Magazine*, *London Opinion*, *Minster*, *New Budget*, *Pall Mall Budget*, *Pears' Annual*, *Pearson's*, *Pick-Me-Up*, *Printers' Pie*, *Queen*, *Royal*, *St James's Budget*, *Sketch*, *Strand*, *To-Day* and the *Unicorn*. In 1897 his first cartoon was published in *Punch* and he remained as a regular contributor for 50 years (a record he shared with TENNIEL, STAMPA and SHEPARD). In *Punch* he was seen as DU MAURIER's successor, specializing in gently humorous scenes of middle- and upper-class life, many of them featuring children. He was also noted for his charming portraits of pretty women in the *Tatler* – 'the Baumer girl' acquiring the same sort of popularity as the 'LEECH girl' in a previous age. Baumer was elected RI (1921). He died on 25 October 1963. Baumer used many media – oil, watercolour, pen and ink, and etching with great proficiency. His light touch and his amiable outlook on life made him the ideal portrayer of the 'bright young things'.
PUB: *Jumbles* (1897), *Did You Ever?* (1903), *Bright Young Things* (1928)
ILL: More than 25 books including Mrs Molesworth, *Hoodie* (1897), *Hermy* (1898), *The Boys and I* (1899), *The Three Witches* (1900); H. Graham, *Deportmental Ditties* (1909), *Canned Classics* (c. 1910), *The Perfect Gentleman* (1912), *The Motley Muse* (1913), *The Complete Sportsman* (1914); I. Hay, *The Lighter Side of School Life* (1914), *The Shallow End* (1924);

R. Arkell, *Winter Sportings* (1929); J. B. Erntage, *Ski Fever* (1936).
EXHIB: RA; RI; RP; FAS (1913, 1924)
COLL: V&A; NPG SH

BAWDEN, Edward CBE RA (1903–89). Painter, illustrator, printmaker, designer and commercial artist. Edward Bawden was born on 10 March 1903 at Braintree, Essex, the son of an ironmonger and educated at the Friends' School in Saffron Walden. In 1919 he started at the Cambridge School of Art studying lettering and illumination, and in 1922 was awarded a scholarship to the RCA Design School where his chief interests were book illustration and poster design. On leaving, he designed advertisements etc. for a number of clients, much of his work being printed by the Curwen Press. In 1928–9, with Eric Ravilious, a friend from the RCA, he executed murals at Morley College, London, which were widely praised. He held his first one-man exhibition of watercolours in 1933. From 1940 to 1944 he was an Official War Artist in France and the Middle East. He was made CBE (1946), elected ARA (1947) and RA (1956), appointed a Royal Designer for Industry (1949) and a Trustee of the Tate Gallery (1951–8). In the *Observer* series he was voted the illustrators' illustrator. He died on 21 November 1989 in Saffron Walden. Bawden's wit is apparent in almost everything he did. Of the books and booklets he illustrated it shows most clearly perhaps in Ambrose Heath's pre-war books on food and in post-war books decorated with linocuts like *The Hound of the Baskervilles* (Folio Society, 1987). The best opportunities for humour were provided by advertisers – Fortnum & Mason, Shell and the London Underground. Some of his early work showed the influence of EDWARD LEAR and DICKY DOYLE, two artists he greatly admired, but his style became so intensely personal that Carel Weight, a fellow Academician, could write 'I know of no artist so uninfluenced by other artists or by current fashion whose work sits so perfectly in the modern scene.'
PUB: *Life in an English Village* (1949), *Take the Broom* (1952), *Hold Fast by Your Teeth* (1963), *A Book of Cuts* (1979).
ILL: More than 80 books including R. Paltock, *The Life and Adventures of Peter Wilkins* (1928); E. Sitwell, *Popular Song* (1928); R. Herring, *Adam and Evelyn at Kew* (1930); A. Heath, *Good Food Month by Month* (1932), *Good Food on the Aga* (1933), *More Good Food* (1933); *The Week End Book* (1939); R. B.

Serjeant, *The Arabs* (1947); J. Swift, *Gulliver's Travels* (1965); S. Johnson, *The History of Rasselas* (1975); T. Hennell, *Lady Filmy Fern* (1930); Sir T. Malory, *The Chronicles of King Arthur* (1982)
EXHIB: RA; FAS; MIN (1973); T 'Artists at Curwen' (1977); V&A (Retrospective 1989).
COLL: T; V&A; IWM; BED; many provincial and foreign galleries
LIT: D. P. Bliss, *Edward Bawden* (1979); R. McLean, *Edward Bawden: War Artist* (1989)
SH

BAXTER, Glen (b. 1944). Cartoonist, illustrator and writer. Glen Baxter was born in Leeds on 4 March 1944, the son of a welder and attended Leeds College of Art (1960–5). He taught at the V&A (1967–74) and was a part-time lecturer in Fine Art at Goldsmith's College (1974–86). His poems and short stories were first published in New York in 1970 in the magazine *Adventures in Poetry*, and he had his first solo exhibition of art in the city's Gotham Book Mart Gallery the same year. His work has appeared in numerous newspapers and journals throughout the world including *New Yorker, Observer, Het Parool* and *Globe Hebdo*, and his drawings are widely available as greetings cards. Glen Baxter's cartoons are influenced by old-style boy's adventure books and comic strips and often feature heroes like Biggles but with wildly inappropriate caption lines, producing a rather surreal effect.
PUB: *The Falls Tracer* (1970), *The Khaki* (1972), *Cranireons ov Botya* (1974), *The Handy Guide to Amazing People* (1974), *Fruits of the World in Danger* (1974), *The Works* (1977), *Atlas* (1979), *The Impending Gleam* (1981), *Glen Baxter: His Life* (1983), *Jodhpurs in the Quantocks* (1986), *The Billiard Table Murders* (1990), *Glen Baxter Returns to Normal* (1992), *The Collected Blurtings of Glen Baxter* (1993)
ILL: W. & B. Kennedy, *Charlie Malarkey and the Belly-Button Machine* (1986)
EXHIB: Gotham Book Mart, New York; Anthony Stokes Gallery; NIG; ICA; RFH; Galerie Samia Saouma, Paris; Adelaide Festival and others
COLL: AC; NYPL: V&A; Southampton University; T; Centre Georges Pompidou, Paris; Fondation National d'Art Contemporain, Paris and others
MB

BAXTER, William Giles (1856–88). Cartoonist. W. G. Baxter was born of English parents but spent part of his childhood in America. He was trained as an architectural draughtsman. In 1878 he was hired by the publisher J. A. Christie to draw cartoons for a new Manchester satirical weekly, *Momus*, of which he became joint editor. The paper lasted until 1883 when Baxter came to London, his first cartoons appearing in *Judy* in July of that year. Around that time he also designed humorous Christmas cards that were published by ALFRED GRAY and often based on his ideas. Baxter's great achievement, the large front-page cartoons for *Ally Sloper's Half Holiday*, started in July 1884 and his reputation was further enhanced by the double-page illustrations to *Ally Sloper's Christmas Holidays* and various spin-offs like 'The Sloper Award of Merit'. Baxter transformed the Sloper character he inherited from Marie Duval (see C. H. ROSS) equipped him with an entourage (foreshadowing the GILES family), included real people and introduced the old reprobate to some better society. Baxter was a brilliant comic draughtsman, primarily responsible for *Ally Sloper's Half Holiday's* instantaneous success. Pennell called him 'the people's artist more than anyone else has ever been'. He died on 2 June 1888.
PUB: *Sketches of Buxton* (*c.* 1876)
COLL: V&A
SH

BEARD, Albert Edgar (1902–91). Cartoonist, strip cartoonist and watercolourist. A.E. Beard was born in Birmingham on 16 January 1902. He studied at the Birmingham School of Art and with PERCY BRADSHAW. During World War II he served in the Intelligence Corps, interpreting aerial photographs. He contributed to such publications as *Punch* (50 years from 1927), *Answers, John Bull, Everybody's, Illustrated, London Opinion, Reveille, Tit-Bits, Evening Standard, Blighty, Daily Graphic, Humorist, Sketch, Laughter, New Scientist, Procurement Weekly* (10 years), was Political Cartoonist on *Sunday Chronicle* and created a popular strip about a family of TV addicts, 'The Gaisby-Knights' (1958–60). He also drew under the name 'Harvey' and designed advertisements for Standard Fireworks and others. A. E. Beard died on 3 May 1991.
ILL: R .L. Clarke, *Lighter Engineering* (1973)
EXHIB: RSAB
MB

BEARDSLEY, Aubrey Vincent (1872–98). Illustrator, author, occasional caricaturist. Aubrey Beardsley was born in Brighton on 21 August 1872 and educated at Brighton Grammar

CRUEL.

Twitterly asks a friend to dinner. The banquet turns out a most disastrous failure.

Discomfited Host.—AFTER ALL, YOU KNOW, THE BEEF ISN'T BAD FLAVOURED.
Friend.—BY NO MEANS, BY NO MEANS, DE' BOY! FACT IS—NO FLAVOUR AT ALL.

W. G. Baxter, *Judy*, 10 September 1884

School where he showed a precocious aptitude for caricature. He was employed as a clerk in an insurance office (1889–92) and in 1891 met BURNE-JONES who, having seen some of his sketches, encouraged him to take up art as a career. In 1892 he attended Westminster School of Art and the following year illustrated *Le Morte D'Arthur* and had some caricatures published in the *Pall Mall Budget*. The originality, and in some eyes the perversity, of his work was beginning to flutter the dovecotes and his fame was spread by Pennell's article in the first number of the *Studio* (1894). He contributed drawings to the *Yellow Book* (1894–5) and the *Savoy* (1896), of which he was Art Editor, and illustrated a number of books. He died of consumption in Mentone on 16 March 1898. Beardsley's influence on all black-and-white art was immense and enduring. As well as borrowing from him, contemporary cartoonists delighted in parodying his style. Not an avowed caricaturist himself, he nevertheless introduced caricatures into his drawings (e.g. those of Oscar Wilde in *Salome*) and his work was often motivated by shocking or satirical intentions.

PUB: *A Book of Fifty Drawings* (1897), *The Early Work of Aubrey Beardsley* (1899), *A Second Book of Fifty Drawings* (1899), *The Later Work of Aubrey Beardsley* (1901), *Under the Hill* (1904), *The Story of Venus and Tannhäuser* (1907), *The Uncollected Work of Aubrey Beardsley* (1925), *The Best of Beardsley* (1948).

ILL: T. Mallory, *Le Morte D'Arthur* (1893); W. Jerrold, *Bon Mots* (1892–4); O. Wilde, *Salome* (1894); Aristophanes, *Lysistrata* (1896); A. Pope, *The Rape of the Lock* (1896); E. Flaubert, *Mademoiselle de Maupin* (1898); B. Jonson, *Volpone* (1898)

EXHIB: V&A ('Aubrey Beardsley', 1966); T ('From Beardsley to Blomberg', 1993)

COLL: T; V&A; BM; NPG; A; F; Princeton; Harvard; Boston; New York.

LIT: A. E. Gallatin, *Aubrey Beardsley: Catalogue of Drawings and Bibliography* (1945); B. Reade, *Beardsley* (1967); B. Brophy, *Black and White: a Portrait of Aubrey Beardsley* (1968); H. Maas

et al. (ed.) *The Letters of Aubrey Beardsley*
(1970) SH

BEATON, Sir Cecil Walter Hardy (1904–80).
Photographer, stage designer, illustrator, author,
occasional caricaturist. Cecil Beaton was educated
at Harrow School and Cambridge University and
his first published works were theatre caricatures
for *Granta* whilst a student. He also attended
Slade School of Art and drew for *Vogue*. Best
known as a photographer, he illustrated several
of his books with sketchy witty drawings and
watercolours and drew affectionate caricatures
of actors, actresses and Society beauties like Lady
Diana Cooper, two of which were reproduced in
Caricatures of Today (1928). He was knighted in
1972.
PUB: *The Book of Beauty* (1930), *Cecil Beaton's
New York* (1938), *History under Fire* (1941),
Near East (1943), *The Glass of Fashion* (1954),
The Face of the World (1957).
ILL: P. Louys, *The Twilight of the Nymphs*
(1928); M. Arlen, *A Young Man Comes to Town*
(1932); R. B. Sheridan, *The School for Scandal*
(1939)
EXHIB: COO; RG; BC
COLL: NPG; TM
LIT: C. Beaton, *Photobiography* (1951); J.
Danziger, *Beaton* (1980); H. Vickers, *Cecil
Beaton* (1985) SH

BEDE, Cuthbert – see Bradley, Rev. Edward

BEERBOHM, Sir Henry Maximilian NEAC
(1872–1956). Caricaturist and author. Max
Beerbohm was born in Kensington, London, on
24 August 1872, the son of a prosperous corn-
merchant of mixed Baltic origins and the half-
brother of Beerbohm Tree, the actor-manager.
He was educated at Charterhouse School and
Merton College, Oxford, at both of which he
drew caricatures. At Oxford he was a prominent
aesthete and on moving to London joined the
circle of Oscar Wilde and of BEARDSLEY, who
admired his work. His first caricatures, published
in the *Strand Magazine* (1892), *Pick-Me-Up*
(1894) and *Vanity Fair* (1896) made an immediate
impact by their originality, penetration and wit.
Self-taught as an artist, he was a keen student of
caricature and revered the work of CARLO
PELLEGRINI and ALFRED BRYAN. In 1896 his
first book of caricatures was published, the
following year he was himself caricatured by
SICKERT in *Vanity Fair*, and in 1904 he held his
first one-man show. In 1910 he moved to Rapallo,

Italy, where he remained except for the war
years. *Zuleika Dobson*, his most famous book, a
fantasy which in Lord David Cecil's words
'exhibits in the most extreme form his character-
istic blend of the pretty and the comic' was
published in 1911. In 1919 some of his drawings
offended the Labour Party as future ones were to
offend royalty: he said 'I have to go on being
rude because that is [a part of] my nature.' In
1933–5 he delivered the Rede Lectures at
Cambridge. He died in Rapallo on 20 May 1956.
Shortly before expiring he is reputed to have
said: 'You will find my last words in the blotter.'
For Max Beerbohm, writing was work and draw-
ing was play. Untrained as an artist, he made the
most of his deficiencies, developing an extravagant
line to accord with his theory of significant
distortion and applying watercolour washes with
such subtlety that his drawings must be seen in
the original to appreciate their full merit. Yet it
was his wit, not his draughtsmanship, that marked
a complete break with the past and gave him his
influence amongst the civilized élite at whom his
caricatures were aimed – wit in the choice of
situation and the ultra-fastidious wording of the
caption. In some of the early caricatures – of
Oscar Wilde, George Moore and Kipling for
example – the wit is piercing; later he came to
believe that the best subject for a caricaturist was
someone he revered: '*On se moque de ce qu'on
aime*'.
PUB: [caricatures] *Caricatures of Twenty-Five
Gentlemen* (1896), *Cartoons, The Second
Childhood of John Bull* (1901), *The Poets'
Corner* (1904), *A Book of Caricatures* (1907),
Fifty Caricatures (1913), *A Survey* (1921),
Rossetti and his Circle (1922), *Things New and
Old* (1923), *Observations* (1925), *Heroes and
Heroines of Bitter Sweet* (1931)
EXHIB: Carfax; LG: GGG; PG; NEAC
COLL: T; V&A; NPG; A; MCO; CAT;
Princeton; Harvard; Chicago; Huntingdon Library
LIT: Lord David Cecil, *Max* (1972); R. Hart-
Davis, *Catalogue of the Caricatures of Max
Beerbohm* (1972), *The Letters of Max Beerbohm*
(1988); J. G. Riewald, *Beerbohm's Literary
Caricatures* (1977) SH

BELCHER, George Frederick Arthur RA (1875–
1947). Cartoonist, etcher and painter. George
Belcher was born in London on 19 September
1875 and educated at King Edward VI School,
Berkhamsted. He studied at Gloucester School of
Art then started to contribute social cartoons to
the periodicals, his two main outlets being *Punch*

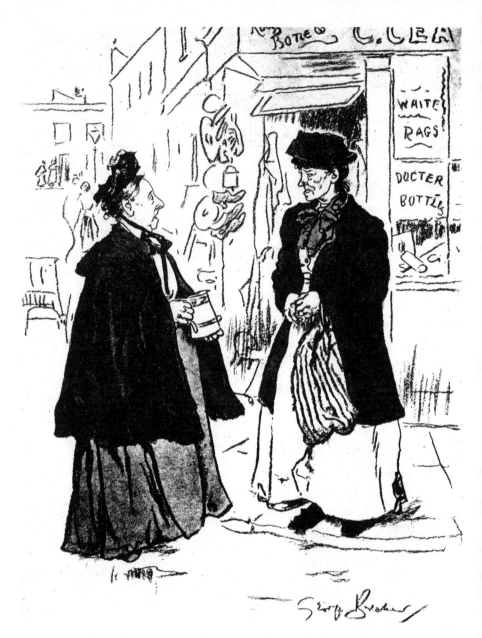

HER AILMENT

"YER KNOW, I'M ARMENIC, MRS. HARRIS."
"LOR, MRS. GREEN, I THOUGHT YOU WAS BRITISH!"
AH! YER DON'T UNDERSTAND, DEARIE: IT MEANS I AIN'T GOT NO BLOOD IN ME."

George Belcher, *Characters* (1922)

and the *Tatler* and his early work being strongly influenced by PHIL MAY. After appearing in its *Almanack* from 1906 he became a regular contributor to *Punch* from 1911, specializing in jokes about the working classes and their malapropisms. As well as joke cartoons he designed many humorous postcards, painted sporting pictures and made some highly praised etchings. In the 1920s and 30s he contributed cartoons to American periodicals like *Cosmopolitan* which include some of his best and most sympathetic work. Through a joint interest in sport he became a friend of Sir Alfred Munnings who promoted his candidature at the RA. He was elected ARA (1931) and RA (1946), the first cartoonist to be so honoured. He died at Chiddingfold, Surrey on 3 October 1947. Belcher's cartoons of charwomen in conversation and suchlike were admired in their day for their realism, observation and humanity but to later generations have represented in acute form what FOUGASSE called 'the humour of superiority'. Nevertheless the drawing, almost always in charcoal, is superb.

Steve Bell, [*Guardian* exhibition catalogue], October 1991

PUB: *Characters* (1922), *By George Belcher* (1926), *Taken from Life* (1929), *Potted Char* (1933)
ILL: F. Frankfort-Moore, *The Lighter Side of English Life* (1913)
EXHIB: RA; RSA; LG; FAS (1924); LAN
COLL: T; V&A; CAT SH

BELL, Steve (b. 1951), Editorial cartoonist and strip cartoonist. Steve Bell was born in Walthamstow, London, on 26 February 1951 and educated at Slough Grammar School, Teeside College of Art, Middlesbrough, and Leeds University, graduating in Fine Art in 1974. After taking a teaching certificate at Exeter University he taught art at a secondary school in Birmingham before becoming a freelance cartoonist in 1977. His first regular paid work was for *Whoopee!* comic in 1978. He has also contributed to *Cheeky, Jackpot, New Statesman, New Society, Leveller* ('Lord God Almighty' strip), *Social Work Today, NME, Journalist, Time Out* and *City Limits*. His most popular creation has been the 'If . . . ' strip series he has drawn for the *Guardian* since 1981. The earlier *Time Out* (later *City Limits*) series, 'Maggie's Farm' (begun 1979) was described in the House of Lords (March 1987) as 'an almost obscene series of caricatures'. He has also made animation shorts (with Bob Godfrey) for Channel 4 and BBC TV. He was voted CCGB Humorous Strip Cartoonist of the Year (1984, 1985). Left-handed, Steve Bell draws his cartoons to repro-duction size and works on card or watercolour paper using John Heath's Telephone Pen (Fine), brush and indian ink.
PUB: *Maggie's Farm* (1981), *Further Down on Maggie's Farm* (1982), *Maggie's Farm the Last Roundup* (1987), the 'If . . . ' series (11 titles since 1983), [with B. Homer] *Waiting for the Upturn* (1986), [with R. Woddis] *Funny Old World* (1991)
EXHIB: BC; CG; Oxford Gallery, Oxford
COLL: BM; V&A MB

BELLEW, Hon. Patrick Herbert (1905–after 1966). Cartoonist. Patrick (or Paddy) Bellew was the half-brother of the 5th Baron Bellew. He served in the RNVR during World War II and afterwards went to live in the USA. His cartoons, published regularly in the *Tatler* and *Men Only* during the 1930s, were in the contemporary *New Yorker* style and also owed something to H. M. BATEMAN.
PUB: *Point of View* (1935), *Private View* (1937)
ILL: H. J. C. Graham, *The Biffin Papers* (1933)
 SH

BELSKY, Margaret (1919–89). Pocket cartoonist and illustrator. Margaret Belsky was born Margaret Constance Owen in Dorset on 20 June 1919. Known as 'Cooee' (she had an Australian/Irish father), she attended Bournemouth School

of Art, won a *Punch* competition and went on to study illustration and engraving at the Royal College of Art. She began cartooning when her Czech soldier fiancé (later husband and celebrated sculptor), Franta Belsky, showed her work to the editor of *Lilliput*. The first woman to draw a daily front page cartoon for a national newspaper, she drew pocket cartoons for the *Daily Herald* (later the *Sun*) for 19 years (from 1951), producing more than 6000 cartoons for this paper alone. She also worked for *Punch, Guardian, Sunday Graphic, John Bull, New Statesman, Financial Weekly* and the *People*. In addition she illustrated children's books and designed jackets for Penguin Books. Regarding herself modestly as 'the poor man's OSBERT LANCASTER' her jokes often made fun of dogs and Tory ladies and she described her politics as 'pinkish'. She died on 26 January 1989.

ILL: 8 titles by A. Oates; R. Brown, *Chubb on the Trail* (1976); E. Ramsbottom & J. Redmayne, *Colour* (1978); P. Arnold & P. Scott-Kay, *The Gay Way Workbook* (1980) MB

BENNETT, Charles Henry (1829–67). Illustrator, author and cartoonist. Charles Bennett was apparently untrained in art and is first known as a cartoonist in *Diogenes* and the *Comic Times* (1855) and as the anthropomorphic illustrator of *Aesop* (1857). He went on to build up a reputation for his children's books and for 'shadow' pictures. After a spell as cartoonist for the *Comic News* (1863–5), he joined *Punch* (1865) and immediately added to his reputation by the little grotesques with which he festooned the pages in the manner of DICKY DOYLE and by his illustrations to the 'Essence of Parliament' series. Bennett was extremely popular with his *Punch* colleagues (by whom he was known as 'Cheerful Charlie') so that when he died young, leaving an impoverished family, they organized a successful 'benefit' on his relatives' behalf.

PUB: *The Fables of Aesop and Others: Translated into Human Nature* (1857), *Proverbs with Pictures* (1859), *The Nine Lives of a Cat* (1860), *Nursery Fun* (1863), *The Book of Blockheads* (1863), *The Stories that Little Breeches Told* (1863), *London People: Sketched from Life* (1863), *Mr Wind and Madam Rain* (1864), *The Sorrowful Ending of Noodledoo* (1865), *The Surprising . . . Adventures of Young Munchhausen* (1865), *The Frog Who Would A Wooing Go* (n.d.)

ILL: R. Brough. *The Fairy Tales of Science* (1859), *Shadow and Substance* (n.d.); J. Bunyan,

The Pilgrim's Progress (1860); F. Quarles, *Emblemes* (1861); W. H. Wills (ed.), *Poets' Wit and Humour* (1861); M. Lemon, *Fairy Tales* (1867) SH

BENNETT, David Neil 'NB' (b. 1941). Cartoonist and illustrator. Born in Warsop, Nottinghamshire, on 13 January 1941, Neil Bennett gained 'O'-level art at Brunts Grammar School, Mansfield, but is otherwise self-taught. After reading English at King's College, London University, he taught English for 23 years, mainly at the North Notts College of Further Education, Worksop, before resigning to become a full-time freelance cartoonist at the age of 46. His work has appeared in *Private Eye, Spectator, Law Society Gazette, Punch, Independent Saturday Magazine, Esquire* ('Jekyll and Heidi' strip), *Cricketer, Gramophone, Museums Journal, ECOS, Economic Affairs* and *Men Only*. Happiest drawing in black and white and in line, he rarely uses washes or colour. His cartoons are characteristically of squat figures with enormous, boat-shaped shoes and feature fine cross-hatching with solid blacks.

COLL: BM MB

BENTLEY, Nicolas Clerihew (1907–78). Cartoonist, illustrator, commercial artist and author. Nicolas Bentley was born in Highgate, London, the son of the writer (and inventor of the 'clerihew') E. C. Bentley and the godson of G. K. CHESTERTON. After education at University College School, London, he studied art at Heatherley's. For a short time he worked as a circus clown and as a film extra before joining Shell's publicity office (1927–30), where he drew a number of humorous advertisements. He decided to become a humorous illustrator because of the palpable shortage of artists who could 'draw funny' (as opposed to illustrators of jokes) and he soon had notable success with books by

Neil Bennett, *Independent*, 4 February 1989

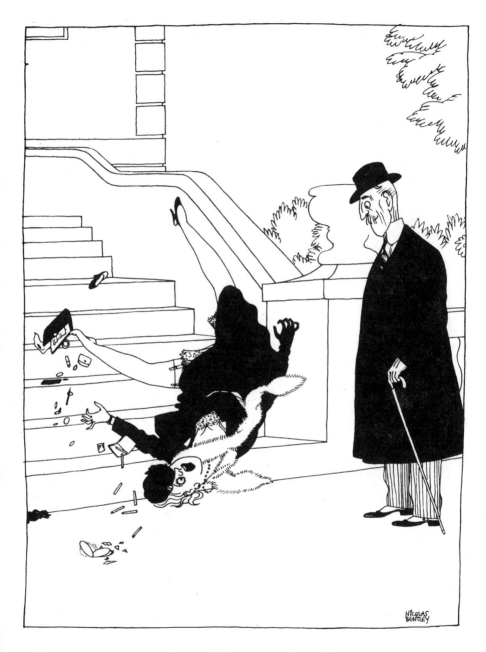

'Hullo – *tumbled over?*'

Nicolas Bentley, *Die? I Thought I'd Laugh!* (1936)

Belloc, J. B. Morton and Damon Runyon. Before the war he also contributed cartoons to the *Bystander, Lilliput, Men Only, Night & Day, Punch* and *Radio Times* in a spare style strongly influenced by the *New Yorker* cartoonist Ralph Barton and by the Frenchman Caran d'Ache. Clergymen and nuns were frequent targets of his wit. During the war he worked in the Ministry of Information and was a fireman in the London blitz. Afterwards he became a director of the publishing firm, André Deutsch, drew pocket cartoons for the *Daily Mail* and *Sunday Telegraph,* wrote historical thrillers and versions of autobiography and illustrated 37 more books (making 75 in all). Bentley's funniest work, illustrations for Belloc's books and cartoons for the *Bystander,* was done before the war when he played an important role in helping to popularize the sophisticated *New Yorker* style. His line was described by Ruari McLean as 'even as a black thread, with no variation from thick to thin, and no shadows to counterfeit roundness; just accurate drawing based on meticulous observation'.

PUB: [humorous drawings] *All Fall Down!* (1932), *The Beastly Birthday Book* (1934), *Die? I Thought I'd Laugh!* (1936), *The Time of My Life* (1937), *Ballet-Hoo* (1937), *Le Sport* (1939), *Animal, Vegetable and South Kensington* (1940), *How Can You Bear to be Human?* (1957), *Nicolas Bentley's Book of Birds* (1965)
ILL: 75 books including E. C. Bentley, *More Biography* (1929), *Baseless Biography* (1939); H. Belloc, *New Cautionary Tales* (1930), *Ladies and Gentlemen* (1932); J. B. Morton, *By the Way* (1931), *1933 and Still Going Wrong!* (1932); T. Benson & B. Askwith, *Foreigners* (1935), *Muddling Through* (1936); T. S. Eliot, *Old Possum's Book of Practical Cats* (1940); G. Mikes, *How to be an Alien* (1946); *The Duke of Bedford's Book of Snobs* (1965)
COLL: UKCC; BM; NPG; CAT
LIT: N. Bentley, *A Version of the Truth* (1960); R. McLean, *Nicolas Bentley Drew the Pictures* (1990) SH

BERGER, Oscar (1901–after 1960). Caricaturist. Born in Presov, Czechoslovakia, Oscar Berger won a scholarship to Berlin Art School (1920) and later joined the staff of the city's largest daily paper as artist. When Hitler came to power he left the country, travelling to Prague, Paris and Budapest before arriving in London in 1935, remaining in England throughout the war years. He wrote and illustrated a popular series 'World Adventures with a Sketch-Book' for the *Evening News,* drew a series of celebrity caricatures for *Sunday Dispatch* called 'Star Signs' and regularly produced work for *Daily Sketch, Referee, Daily Telegraph, Lilliput, Courier, News of the World, Le Figaro, Illustrated, Saturday Review, New York Times, Life, New York Herald-Tribune, This Week, Look* and *Picture Post.* In addition he produced posters for the theatre and worked in advertising for the Post Office, Shell, London Passenger Transport Board, Wolsey Socks and others. Berger was held in such high esteem that many celebrities (e.g. Roosevelt, Churchill, Garbo, Pavlova, Chaplin, Dietrich, King Victor Emmanuel) actually sat to have their caricatures drawn. After World War II he moved to the USA. He had a flamboyant, fluid line.
PUB: *Tip & Top* (n.d.), *Famous Faces* (1950), *A la Carte* (1951), *Aesop's Foibles* (1951), *My Victims* (1952), *I Love You . . .* (1960)
ILL: H. H. Ewers, *Die Traurige Geschichte meiner Trockenlegung* (1927) MB

BERRYMAN – see Ullyett, Royden

BESTALL, Alfred Edmeades MBE (1892–1986). Illustrator, cartoonist, strip cartoonist, commercial artist and painter. Alfred Bestall was born in Mandalay, Burma, on 14 December 1892, the son of Methodist missionaries, and was educated at Rydal School, Colwyn Bay (1904–11), from where he won a scholarship to Birmingham Central School of Art (1912–4). During World War I he served in the RASC in Flanders. On returning he attended the Central School of Art, London (1919–22), and trained to be an illustrator. He contributed cartoons to the *Bystander, Eve, Gaiety, London Opinion, Passing Show, Piccadilly, Punch* and more than 40 full-colour plates to the *Tatler.* In 1935 he took over the 'Rupert Bear' strip cartoon in the *Daily Express* from Mary Tourtel, which he continued for 30 years, contributing to the 'Rupert' Annuals up to his 90th year. To Rupert he 'introduced a surreal quality with action and humour replacing Tourtel's gentler depiction of suspense' (Whalley & Chester). He was appointed MBE (1985).
ILL: E. Blyton, *The Play's the Thing* (1927), *Plays for Older Children* (1941), *The Boy Next Door* (1944); A. Frome, *The Disappearing Trick* (1933); D. Glass, *The Spanish Goldfish* (1934); M. Inchfawn, *Salute to the Village* (1943): E. Jones, *Folk Tales of Wales* (1947); A. Dumas, *The Three Musketeers* (1950)
EXHIB: RA; RBA

LIT: C. & A. Bott, 'Alfred Edmeades Bestall' (Exhibition Catalogue, Rake Court, Godalming, Surrey, 1988) SH

BEUTTLER, Edward Gerald Oakley (*c.* 1879–*c.* 1965). Cartoonist. E. G. O. Beuttler was the eldest son of T. B. Beuttler, of Rugby and Cambridge and later one of the Directors of Education of Western Australia. He first went to sea in 1896 and joined the RNVR in 1898 as a midshipman, rising to the rank of lieutenant and later wing-commander. He was also Superintendent of Akbar Nautical School in Heswall, Cheshire (*c.* 1907). Before World War I he had contributed cartoons, many with a nautical flavour, to the *Bystander*, *Sketch* and *Winter's Pie*. Afterwards he was a regular contributor to the *Tatler* until *c.* 1942. He is most commonly seen in pen and wash, occasionally in colour, and his animated style owes a good deal to H. M. BATEMAN. Some of his cartoons were also produced as sets of postcards by The Syren & Shipping Ltd. The *Daily Sketch* said of him: 'Beuttler is to the Navy what BAIRNSFATHER is to the Army.' He died aged 86 in Bovey Tracey, Devon, *c.* 1965.
PUB: *Humours of the Merchant Marine* (1912), *Humour in the Royal Navy* (1916), *The Merry Mariners* (1917), *Humour Afloat* (1919) MB

BICKHAM, George the Younger (*c.* 1706–71). Caricaturist, printseller, illustrator and engraver. George Bickham was the son of G. G. Bickham, the celebrated calligrapher and author of *The Universal Penman* (1743). In the 1730s he had a print shop at the Royal Exchange, moving to Covent Garden in the early 1740s. From there he issued political satires, many attacking Sir Robert Walpole, and social satires including a series of burlesque prints of figures representing the various trades. In the mid 1740s he was one of a number of printsellers investigated by the Government on suspicion of selling obscene prints. He was a talented, robust and imaginative artist. Atherton called him 'a major contributor to the development of English graphic satire'.
PUB: *The Musical Entertainer* (1737–8)
ILL: *The Life and Death of Pierce Gaveston* (1740); C. Perry, *A View of the Levant, Particularly of Constantinople, Syria, Egypt and Greece* (1743)
COLL: BM: Pierpont Morgan Library; Yale
 SH

BINDER, Pearl [Lady Elwyn Jones] (1904–90). Illustrator, painter, author, broadcaster and caricaturist. Pearl Binder was born in Fenton, Staffordshire, the daughter of a tailor. She studied at Manchester School of Art, worked in Paris (1924) and in 1926 her first humorous book illustrations were published. In 1928 she studied lithography at the Central School, London, held her first solo exhibition and had one of her drawings reproduced in *Caricature of To-Day*. She went on to illustrate many more books for children and adults, contribute drawings to the *New Coterie*, *Sketch* and *Tatler* and pursue other branches of art in a long and versatile career. Her few caricatures were painterly and 'modern' in style.
PUB: *Odd Jobs: Stories and Drawings* (1935); *Misha and Masha* (1936), *The Peacock's Tail* (1958), *The English Inside Out* (1961), *Magic Symbols of the World* (1972)
ILL: Many books including C. Hobson, *Bed and Breakfast* (1926); L. de G. Sieveking, *All Children Must be Paid For* (1927); J. Driberg, *People of the Small Arrow* (1930); G. de Nerval, *Aurelia* (1932); P. Godfrey, *Back Stage* (1933); L. Golding, *The Dance Goes On* (1937); A. Lomax, *Harriet and her Harmonium* (1955); J. Gladstone, *Stories from Ladder Street* (1979)
EXHIB: BN (1968); MT (1973)
COLL: V&A; BN; BM SH

BIRD, Cyril Kenneth 'Fougasse' CBE (1887–1965). Cartoonist, writer and editor. Kenneth Bird was born on 17 December 1887 in London, the son of wine merchant and cricketer Arthur Bird. He attended Farnborough Park School, Hampshire (1898–1902), Cheltenham College (1902–4) and King's College, University of London, where he trained as an engineer. He also took evening art classes at Regent Street Polytechnic and the Bolt Court School of Photo-Engraving. A machine-gun instructor in the Artists' Rifles (1904–8) and employed at the Rosyth naval base (1909–14), he served in the Royal Engineers in World War I but was invalided out when shot in the spine at Gallipoli (1915). As 'Bird' was already in use as JACK YEATS' pseudonym, he began drawing cartoons as 'Fougasse' (the name given to a small antipersonnel mine, 'its effectiveness is not always reliable and its aim uncertain'), studying with PERCY BRADSHAW's Press Art School and contributing to *Tit-Bits*, *Punch* (1916–52), *Bystander*, *Graphic*, *London Opinion*, *Sketch* and *Tatler* and succeeded

GEORGE MORROW as Art Editor of *Punch* in 1937. He became Editor in 1949 – the only cartoonist ever to hold the post – and was also a member of the *Punch* Table. In addition he produced a number of drawings for advertising (Guinness, Austin Reed, Abdulla cigarettes, Pyramid handkerchiefs etc). An air-raid warden in World War II, perhaps his most memorable cartoons from this period are the posters he designed for government departments, such as the red-bordered 'Careless Talk Costs Lives' series (originally entitled 'Careless Talk May Cost Us All Dear') for the Ministry of Information. A pioneer of the idea that humour is more important than art – 'It is really better to have a good idea with a bad drawing than a bad idea with a good drawing' – he also lectured on cartooning on radio (he was a member of the BBC 'Brains Trust') and elsewhere. Elected a Fellow of King's College, London, in 1936 and created a CBE in 1946, he retired in 1953. Bird's distinctive, strikingly economical style, often using only a few lines but expressing great dynamism,

Fougasse (Kenneth Bird), *A School of Purposes* (1946)

is immediately recognizable and has influenced many artists. He died on 11 June 1965.

PUB: *A Gallery of Games* (1921), *Drawn at a Venture* (1922), *PTO* (1926), *E and OE* (1928), [with W. D. H. MacCullough] *Aces Made Easy* (1934), *Fun Fair* (1934), *The Luck of the Draw* (1936), [with W. D. H. MacCullough] *You Have Been Warned* (1935), *Drawing the Line Somewhere* (1937), *Stop or Go* (1938), *Jotsam* (1939), *The Changing Face of Britain* (1940), . . . *and the Gatepost* (1940), *Running Commentary* (1941), *Sorry – No Rubber* (1942), *The Fougasse Painting Book* (1942), [with A. W. Bird] *Just a Few Lines* (1943), *Family Group* (1944), *Home Circle* (1945), *A School of Purposes* (1946), *You and Me* (1948), *Us* (1951), *The Neighbours* (1954), *The Good-Tempered Pencil* (1956), *Between the Lines* (1958)

ILL: Many books including H. L. Wilson, *So This is Golf* (1923); H. J. C. Graham, *The World's Workers* (1928); G. Reed, *The Little Less* (1941)

EXHIB: FAS (Memorial, 1966); RSA

COLL: V&A; IWM; T

LIT: B. Hillier (ed.), *Fougasse* (1977) MB

BIRD, W. – see Yeats, Jack Butler

BIRDSALL, Timothy (1936–63). Political, strip and pocket cartoonist, illustrator and broadcaster. Timothy Birdsall was born on 10 May 1936 in Cambridge and attended Cambridge University where he was a contemporary and friend of Bamber Gascoigne and Michael Frayn. A talented artist as a student (he illustrated *Granta* while at Cambridge), his early professional cartoon work included a regular strip for *Variety* (1957–8). He later joined the *Sunday Times* (1960–2) to produce a series of pocket cartoons 'Little Cartoons by Timothy' and from 1962 until his death drew political caricatures for *Spectator* and cartoons for *Private Eye*. However, his biggest audience was as resident cartoonist drawing live on Ned Sherrin and David Frost's satirical BBC TV show 'That Was the Week That Was' (1963). Influenced by EMETT, SEARLE and FFOLKES, he was working on a book, *This Book is Good for You*, when he died of leukaemia on 10 June 1963. A tribute, *Timothy*, reproduced many of his cartoons. A highly inventive cartoonist, he was a fine draughtsman with a love of detail. 'Timothy didn't construct abstract cartoons out of created symbols which needed naming. He preferred to find some genuine context which fitted his intentions and he went further afield than most

'Wilson's Patent Leveller: The Establishment Machine.'

Timothy Birdsall, *Timothy* (1964)

cartoonists in his search for these contexts' (Bamber Gascoigne).
PUB: [M. Frayn & B. Gascoigne eds.] *Timothy* (1964)
ILL: R. Brook, *Really, Nurse!* (1960); J. Harborne, *The World in My House* (1960); R. Mander & J. Mitchenson, *The Theatres of London* (1961); M. Frayn, *The Day of the Dog* (1962); A. Elliot-Cannon and N. Adams, *Travelling Light* (1962); D. Frost and N. Sherrin (eds), *That Was the Week That Was* (1963)
EXHIB: William Ware Gallery MB

BLAKE, Quentin Saxby OBE, RDI, FSIAD (b. 1932). Cartoonist, illustrator and writer. Quentin Blake was born in Sidcup, Kent, on 16 December 1932, the son of a civil servant. He was educated at Chislehurst & Sidcup Grammar School, Downing College, Cambridge, and University of London. He also attended life classes at Chelsea School of Art and studied anatomical sculpture at Camberwell School of Art. During his National Service he taught English at Aldershot and illustrated a book for teaching illiterate soldiers to read. He contributed his first cartoon to *Punch* at the age of 16 and has worked as a freelance illustrator and teacher since 1957, teaching English (part-time) at the Lycée Français, London, and was Tutor (1965–78) then Head of the Department of Illustration at the Royal College of Art (1978–86), succeeding BRIAN ROBB. He is particularly well-known for his jackets and illustrations for children's books. He has also designed jackets for *Punch* and contributed to the *Spectator* (including covers). In 1979 he was joint winner of the Whitbread Award and in 1981 won the Kate Greenaway Medal for *Mr Magnolia*. Blake's scratchy style and zany humour have been strongly influenced by ANDRÉ FRANÇOIS, whom he greatly admires.
PUB: *Patrick* (1968), *A Band of Angels* (1969), *Jack and Nancy* (1969), *Angelo* (1970), *Snuff* (1973), *Lester and the Unusual Pet* (1975), *Lester at the Seaside* (1975), *The Adventures of Lester* (1977), *Mr Magnolia* (1981), *Quentin Blake's Nursery Rhyme Book* (1983), *Quentin Blake's ABC* (1989)
ILL: Many books including E. Blance & A. Cook's 'Monster' series; J. P. Martin's 'Uncle' series; J. Aitken's 'Mortimer' series; R. Dahl's books beginning with *The Enormous Crocodile* (1978); *Aristophanes, The Birds* (1971); C. Freud, *Grimble* (1974); L. Carroll, *The Hunting of the Snark* (1976); and books by S. Gibbons,

R. Hoban, E. Bowen, O. Nash, P. Campbell (7 titles) etc.
EXHIB: CG; NT; CBG; AI
COLL: BM; V&A MB

BLAM – see Blampied, Edmund

BLAMPIED, Edmund RE RBA (1886–1966). Printmaker, painter, cartoonist and illustrator. Edmund Blampied was born in St Martin, Jersey, Channel Islands, on 30 March 1886, the son of a farmer who died shortly before he was born. Educated locally and brought up on a farm, he developed a great interest in animals, peasants and rural life which became the staple of his future art. He studied life drawing and etching at the Lambeth School of Art (1903) and was awarded a scholarship by the LCC (1905). Most famed as an etcher and lithographer – he won a Gold Medal for lithography at the Paris International Exhibition (1925) – he also painted in watercolour and oil and made drawings in ink and pencil. As a humorous artist his London exhibition, 'Nonsense Show' (1931), was widely praised and his work was published in the *Bystander, Graphic, Hutchinson's, News Chronicle, Illustrated London News, Strand* and *Tatler*. Of the books he illustrated, those by Cecil Hunt contain comic drawings, some verging on surrealism, as do those in his own utterly individual book of cartoons, *Bottled Trout and Polo* (1936), to which the nearest resemblance might be the work of PAUL CRUM. Blampied lived in the Channel Islands during the German occupation (1940–4) and designed the Islands' Liberation stamps (1945). Some of his cartoons are signed 'Blam'. He died in Jersey on 26 August 1966.
PUB: *Hot Dogs* (1934), *Bottled Trout and Polo* (1936)
ILL: E. Nesbit, *The Phoenix and the Carpet* (1903), *The House of Arden* (1908); J. J. Farnol, *The Money Moon* (1914), *The Chronicle of the Imp* (1915); E. Dell, *The Way of an Eagle* (1916); R. L. Stevenson, *Travels with a Donkey* (1931); J. B. Priestley, *Albert Goes Through* (1934), C. Hunt, *Hand-Picked Howlers* (1937), *More Hand-Picked Howlers* (1938), *Ripe Howlers* (1939)
EXHIB: RA; RE; LG; L; RSA; Bull & Saunders
COLL: BM; V&A; Société Jersiaise; Boston Public Library; Cleveland Museum of Art (USA)
LIT: C. Dodgson, *A Complete Catalogue of the Etchings and Dry-Points of Edmund Blampied* (1926); M. Syvnet, *Edmund Blampied* (1986)
SH

Hell hath no fury like a woman's corn.

Edmund Blampied, *Ripe Howlers* (1939)

BOBBIN, Tim – see Collier, John

BOITARD, Louis Philippe (fl. 1733–67). Caricaturist, illustrator, painter and engraver. Boitard was born in France into a family of painters and settled in England in the 1730s, marrying an Englishwoman. He produced a number of caricatures (1740–60), the social ones often set in places of public assembly, the political satires sometimes striking a remarkably (considering his origins) anti-French attitude. He was good at handling crowded scenes. Horace Walpole called him 'a very neat workman'.
ILL: F. Nivelon, *The Rudiments of Genteel Behaviour* (1737); J. Coustos, *The Sufferings of J. Coustos for Freemasonry* (1746); R. O. Cambridge, *Scribleriad* (1751); J. Whitehead, *Hymn to the Nymph of Bristol Spring* (1751); R. Paltock, *The Life and Adventures of Peter Wilkins* (1751); R. Morris, *John Daniel, a Smith at Royston* (1751); J. Spence, *Polymetis* (1755)
COLL: BM; HM the Queen SH

BOND, Simon Patrick Everett (b. 1947). Cartoonist, illustrator, writer and publisher. Simon Bond was born on 19 August 1947 in New York. He attended West Sussex College of Art and Design (1965–8) and was a paste-up artist on *Tatler* (1969–70) and manager of a jewellery shop before returning to the USA on health grounds in 1970. For more than a decade he lived in Phoenix, Arizona, working in a variety of jobs and contributing cartoons to *Saturday Evening Post, Esquire, National*

Organized Crime

Simon Bond, *Uniformity* (1986)

Lampoon, *New Yorker*, *Men Only* and *Vole*. He returned to the UK in 1982 and has since produced freelance cartoons for *Punch* and *Private Eye*. Best known for his bestselling book, *101 Uses of a Dead Cat* (1981), he was also publisher and co-editor of *Squib* magazine (1992–3). He draws roughs with a 2H pencil on A4 cartridge paper and works up the cartoons with fine Edding needlepoint nylon-tip pen. He tends to draw actual size for bookwork and 9½ × 11½ in for *Punch* and *New Yorker* and never uses washes, tints or cross-hatching, preferring to draw up and down lines for shadows. For colour work he prefers coloured pencils.

PUB: *Real Funny* (1976), *101 Uses of a Dead Cat* (1981), *Unspeakable Acts* (1982), *101 More Uses of a Dead Cat* (1982), *Odd Visions and Bizarre Sights* (1983), *Success and How to Be One* (1984), *Teddy* (1985), (ed.) *Sherriffs at the Cinema* (1985), *Tough Ted and Desmond Dougall* (1986), *Uniformity* (1986), *Have a Nice Day* (1986), *Stroked Through the Covers* (1987), *A Bruise of Bouncers* (1987), *What Shall We Do with the Kids in the Holidays?* (1988), *Totally US* (1988), *Battered Lawyers and Other Good Ideas* (1989), *Odd Dogs* (1989), *Tough Ted and the Tale of the Tattered Ear* (1989), *Tough Ted Sticker Book* (1989), *Holy Unacceptable* (1990), *Dubious Practices* (1991), *Uses of a Dead Cat in History* (1992), *Commuted to Life* (1992)

ILL: P. Richter, *Don't Get Mad, Get Even* (1983), *How to Thrive on Rejection* (1985), *Richter's*

Legal Nuggets (1987); *Secrets of the Queen's Closet* (1988); *BA Fact Files 2* (1990)
EXHIB: NT; CG; CBG; Atlanta, Georgia USA (1988) **MB**

BOSWELL, James (1906–71). Painter, illustrator, cartoonist and writer. James Boswell was born on 9 June 1906 in Westport, New Zealand, the son of a schoolteacher of Scottish descent. In 1917 the family moved to Auckland where he attended Auckland Grammar School and Elam School of Art before leaving to study at the Royal College of Art in London (1925–9). He also studied in the studio of Frederick J. Porter and worked first as a landscape painter and lithographer, but by 1932 had given up painting, joined the Communist Party and taken to illustration and graphic design. In 1933 he was a founder member (later Chairman, 1944) of the Artists' International Association (with Misha Black, PEARL BINDER, JAMES FITTON, James Holland and Clifford Rowe). He was Art Director of the publicity department of Asiatic (later Shell) Petroleum (1936–47) and illustrator for *Left Review* from its launch (1934–8) while also contributing anti-fascist drawings to the *Daily Worker* as 'Buchan'. He also drew for *Poetry and the People*, *Current Affairs*, *Radio Times* and *Punch*. After service in the Royal Army Medical Corps as a radiographer in Iraq and the Middle East (1941–5) he joined *Lilliput* as Art Editor (1947–50). He then turned freelance and in 1951 Basil Spence commissioned him to paint a 20ft x 50ft mural for the Sea and Ships pavilion in the Festival of Britain. The same year he became Editor (until his death) of J. Sainsbury's house journal, *JS Journal*, and wrote the history of the firm. Designer and director of Topic Records, he also designed the Labour Party's posters and overall publicity campaign for the 1964 General Election, as well as numerous book jackets. He died in London on 15 April 1971.
PUB: *Painter and Public* (1950), [with R. Bennett] *Cat Meets Dog* (1951)
ILL: 16 books including J. Pudney, *Low Life* (1947); W. Mankovitz, *A Kid for Two Farthings* (1953); J. Symonds, *Dapplegray* (1962), *Conversation with Gerald* (1974); C. Mackenzie, *Little Cat Lost* (1965)
EXHIB: CG; RCA; ICA; LON; Senefelder Club; Charlotte Street Centre; RA (1947); Wolf Mankowicz Gallery; Paris Salon; John Moore Gallery, Liverpool; Drian Gallery; County Town Gallery, Eastbourne; Heal's Gallery; New Vision Centre; CI

COLL: BM; V&A; T; New Zealand NG (Wellington NZ); IWM; TOW
LIT: [autobiography] *The Artist's Dilemma* (1947); W. Feaver, *Boswell's London* (1978) **MB**

BOTTERILL, H. – see Thompson, Harold Underwood

BOUCHER, William Henry ARE (fl. 1868–d.1906). Political cartoonist and etcher. William Boucher drew the large cartoon for *Judy*, signed 'W. B.' (1868–87) and also provided title pages and headpieces for the magazine which, with *Fun*, was the only long-lived rival to *Punch* in the 19th century. Supporting his paper's strong pro-Tory stance, he spent much of his space abusing Gladstone. LOW called his caricatures 'splendid drawings that...might be splendid cartoons too were they about great issues instead of ephemeral party squabblings'. Boucher was also a competent etcher, being elected ARE (1890).
EXHIB: RA; RE **SH**

BOVEY (1900–after 1940). Cartoonist, caricaturist, illustrator and writer. Bovey's cartoon career began when his first submitted drawing (to *Pan*) was accepted when he was 19. He worked in a shipping office, then the Bank of England and whilst there collaborated with Sheridan Bickers on *Theatre World*, for which he drew many covers and caricatures. He left the Bank in 1926 to work in a succession of advertising agencies: Dorlands, Crawfords and Bensons – where he was part of the team that produced the famous Guinness and Bovril advertisements. During World War II he drew propaganda cartoons for the Ministry of Information and served in the Home Guard. He also illustrated children's books, wrote light verse, produced a regular full-page feature 'Delirious Dialogues' for the *Bystander* and contributed to *Passing Show*. **MB**

BOWERS, Georgina (fl. 1866–82). Sporting cartoonist and illustrator. Georgina Bowers lived in St Albans, Hertfordshire, and was encouraged to draw by JOHN LEECH. She contributed cartoons on hunting and flirting themes to *Punch* (1866–76) and also drew initials and vignettes. Her style contained elements of Leech and CALDECOTT without their sureness of touch and her humour was predictable, but she was popular enough for publishers to commission collections of her work. Spielmann in 1895 called her 'by far

THROWING DOWN THE GAUNTLET.

King Leo (to Ireland).—"Do you think I am going to deface my coat of arms to please you ?—certainly not."

William Boucher, [Parnell], *Judy*, 2 September 1885

the most important lady artist who ever worked for *Punch*'. She also worked for *Once a Week* and *London Society*.

PUB: *A Month in the Midlands* (1869), *Hollybush Hall* (1871), *Canters in Crampshire* (1878), *Leaves from a Hunting Journal* (1880), *Hunting in Hard Times* (1889), *Mr Cropp's Harriers* (1891)

ILL: Anon, *The Little Child's Fable Book* (1868); B. Hulton, *Castles and Their Heroes* (1868); G. Rooper, *Flood, Field and Forest* (1874), *The Fox at Home* (1877); 'Wanderer', *Across Country* (1882), *Fair Diana* (1884); Sir R. H. Roberts, *High-Flyer Hall* (n.d.) SH

BOXER, Charles Mark Edward 'Marc' (1931–88). Pocket cartoonist, strip cartoonist and caricaturist. Mark Boxer was born on 19 May 1931 in Berkhamsted, Hertfordshire, the son of an army officer. He was educated at Berkhamsted School and King's College, Cambridge, where he was editor of *Granta* (1952–3) and was briefly sent down for publishing a blasphemous poem. He then worked as a freelance cartoonist for *Ambassador, Lilliput, Vogue, House & Garden*

and *Punch* before becoming Art Director of *Queen* (1957–61). He was the first Editor of the *Sunday Times Magazine* (1962–5), a director of the *Sunday Times* (1964–6), Editorial Director of *London Life* (1965), Assistant Editor of *Sunday Times* (1966–79) a director of the book publishers Weidenfeld & Nicolson (1980–3), Editor of *Tatler* (1983–7), Editorial Director of Condé Nast Publications (1986–8) and Editor-in-Chief of *Vogue* and *Tatler* (1987–8). As a cartoonist he worked for *The Times* (diary illustrations) and *Sunday Times* (Atticus) (1969–83), *New Statesman* (caricatures, 1970–8), *Guardian* (1983–6), *Observer* (caricatures, 1983–8), *Daily Telegraph* (1986–8), *Sunday Telegraph* (caricatures, 1987–8) and *New Yorker* (caricatures). His most popular creations were Simon and Joanna String-Along – an awful upper-middle-class trendy couple from London's NW1 district based on characters from Alan Bennett's BBC series 'On the Margin'. They first appeared in the strip 'Life and Times in NW1' in the *Listener* in August 1967 and from 1969 featured as a pocket cartoon in *The Times*. A variant of the series continued in colour in *Nova* as 'Tinderbox Green:

Marc (Mark Boxer), *The Times*, February 1975

An Everyday Story of Estate Living', written by Peter Preston. Boxer also drew for advertising, notably Smirnoff Vodka, and produced book jackets for the Penguin edition of Anthony Powell's *A Dance to the Music of Time*. He admired LOW, VICKY, PONT, LANCASTER and Steinberg and was voted Cartoonist of the Year (1972). Mark Boxer used a dip pen with a Gillot 404 nib and calligraphic ink on A4 Croxley Script, drawing with a No. 3 or No. 4 brush for thick lines. His captions were typed on an old

Remington typewriter with a large typeface that used to belong to the short-sighted Lord Thomson of Fleet. Each caption was typed using fresh carbon paper cut into strips 3 x 4in. long. Hewison has commented that he possessed 'the best qualities of the untrained amateur drawing at the peak of his ability. . .That, coupled with a sharp sense of observation, can sometimes make a Marc caricature particularly devastating.' He died of cancer on 20 July 1988.

PUB: *The Trendy Ape* (1968), *The Times We Live In* (1978), *Marc Time* (1984) *People Like Us* (1986), *Paint Pots* (1988)
ILL: R. Ingrams (ed.), *Private Eye Book of Pseuds* (1973); C. James, *Felicity Fark* (1975), *Britannia Bright* (1976), *Charles Charming* (1981); A. Barrow, *The Great Book of Small Talk* (1987)
EXHIB: CG; Parkin Gallery; LAN
COLL: NPG; V&A MB

BOYD, Alexander Stuart RSW (1854–1930). Illustrator, cartoonist and painter. A. S. Boyd was born in Glasgow on 7 February 1854, the son of a manufacturer of muslin, and had drawing lessons at school. On leaving he spent six years as a clerk in a bank, painting in his spare time, his pictures being exhibited at leading Scottish galleries from 1877 onwards. In 1879 he left the bank, determined to become a full-time artist and received further training the next year at Heatherley's in London. He started as a cartoonist with the Glasgow paper *Quiz* in 1881, transferring to the *Baillie* in 1888, in both cases using the pseudonym 'Twym'. He was elected RSW (1885). In 1890 he was appointed Glasgow correspondent of the new *Daily Graphic* and moved to London the following year when he started to contribute to a number of magazines, his most attractive work being comic narratives printed in colour in the *Graphic*. His social cartoons were published in *Punch* from 1894 onwards. He emigrated to New Zealand in 1912, becoming President of the Auckland Society of Artists and dying there in August 1930. Boyd had a neat sense of humour and he drew neatly but not amusingly. His wife, Mary, was a writer and some of his best illustrations are for her travel books.
PUB: *When We Were Laddies at the Scule* (1902), *Glasgow Men and Women* (1905)
ILL: C. Blatherwick, *Peter Stonnor* (1884); W. Roberts, *The Birthday Book of Solomon Grundy* (1884); I. Zangwill, *Ghetto Tragedies* (1884); I. Maclaren, *The Days of Auld Lang Syne* (1898);

R. L. Stevenson, *A Lowland Sabbath Morn* (1898); M. Boyd, *One Stolen Summer* (1900), *A Versailles Christmas-Tide* (1901), *The Fortunate Isles* (1911).
EXHIB: RA; RSA; RSW; GI
COLL: V&A; G SH

BOYNE, John (1750–1810). Painter, engraver, drawing-master, occasional designer and publisher of caricatures. Boyne first earned his living as an actor with a company of strolling players, then established a drawing school in London in 1781. His caricatures on both social and political themes (1783–1807) are generally mild in tone and accomplished in drawing. He also exhibited genre pictures in watercolour (1788–1809).
EXHIB: RA
COLL: BM; V&A; F SH

BRADLEY, Rev. Edward 'Cuthbert Bede' (1827–89). Humorous author and illustrator, comic artist. Cuthbert Bede was born in Kidderminster, Worcestershire, the son of a surgeon and educated at University College, Durham. In 1847 he started to contribute humorous articles and drawings to *Punch*; he also contributed to *All the Year Round*, *Boy's Own Paper*, *Illustrated London News*, *Once a Week*, *Quiver* and the *St James's Magazine*. In 1850 he was ordained into the Church of England and subsequently held various livings in the Midlands. His great success came in 1853 with the publication of *The Adventures of Mr Verdant Green, an Oxford Freshman*, written and illustrated by himself, which sold upwards of 170,000 copies and led to two sequels. Bradley was given lessons in drawing by GEORGE CRUIKSHANK but his work remained patently that of an amateur. The limericks and illustrations in *Funny Figures*, arguably his best book, are derived from EDWARD LEAR.
PUB: 27 books including *The Adventures of Mr Verdant Green* (1853), *The Further Adventures of Mr Verdant Green* (1854), *Mr Verdant Green Married and Done For* (1857), *Funny Figures by A Funnyman* (1858), *Little Mr Bouncer and His*

John Boyne, [Fox–North coalition ministers as bandits], 1783

Friend, Verdant Green (1873), *Figaro at Hastings, St Leonards* (1877), *Humour, Wit and Satire* (1885)
COLL: BM SH

BRADSHAW, Percy Venner (1878–1965). Cartoonist, writer and art teacher. Percy Bradshaw was born in Hackney, London, and educated at Aske's School and Hatcham. At the age of 14 he became a clerk in an advertising agency and sold his first cartoon to *Boy's Own Paper*. He later transferred to the agency's art department and began evening classes at Goldsmith's and Birkbeck College. Turning full-time freelance cartoonist at the age of 18, he won first prize in a cartoon competition run by *Artist* magazine (he drew a jester's head) and contributed to *Home Chat* and *Sunday Companion* before joining the art staff of *Daily Mail*. He also freelanced for *Tatler*, *Sketch*, *Bystander* and *Windsor Magazine* (often signing his work 'PVB') and was one of the founder members (with PHIL MAY, TOM BROWNE, JOHN HASSALL and DUDLEY HARDY) of the London Sketch Club. In addition he wrote articles for the *Daily Graphic* and a series 'Black and White Drawing as a Profession' for *Boy's Own Paper* which received so many letters that he decided to found the Press Art School correspondence course in 1905. His first pupil was LEO CHENEY – later to create the famous Johnnie Walker whisky trademark figure. Other celebrated pupils included RIDGEWELL, D'EGVILLE, FOUGASSE, A. E. BEARD, Ern Shaw, Honor Appleton, JOE LEE, PETER FRASER and BERTRAM PRANCE. The school (of which he was principal for more than 50 years) was run from his home, Tudor Hall, in Forest Hill, London, where he had his own presses, and from 1914 produced 20 issues in portfolio form of *The Art of the Illustrator*. By 1915 Bradshaw was enrolling 3000 students a year and employed more than 20 staff. He also produced hundreds of postcards for companies such as Raphael Tuck, Moss and Misch, worked part-time for Royds advertising agency (1930) and in 1933 was London sales organizer for the printer Sun Engravings of Watford. A special six-month supplement to his course, 'Caricature and Humorous Drawing', was published in 1936. In addition he wrote a popular series of articles about cartoonists – 'They Make Us Smile' – in *London Opinion* in the 1940s which were later published as books. A member of the Savage Club, he wrote its official history in 1956. He died on 13 October 1965.
PUB: *The Art of the Illustrator* (1918), *Art in Advertising* (1925), *Fashion Drawing and Designing* (1936), *I Wish I Could Draw* (1941), *They Make Us Smile* (1942), *Marching On* (1943), *Drawn from Memory* (1943), *Nice People to Know* (1944), *I Wish I Could Paint* (1945), *Lines of Laughter* (1946), *Seen in Perspective* (1946), *The Magic of Line* (1949), *Water-Colour Painting* (1949), *Water-Colour* (1952), *Sketching and Painting Indoors* (1956), *Brother Savages and Guests* (1958) MB

BREEZE, Hector (b. 1928). Hector Breeze was born on 17 November 1928 in London and educated at Dartford Technical College. He was first employed in a government drawing office and studied art at evening classes before selling his first drawing to *Melody Maker* in 1957. He has since worked in advertising and produced cartoons for *Private Eye*, *Punch*, *Evening Standard*, *Guardian* (letters page) and *Daily Express*. Voted CCGB Feature Cartoonist of the Year (1984, 1985) he also practises letter-carving in stone but is best known for his drawings featuring impoverished gentry with characteristic chinless faces and tiny dot eyes. 'His happy stamping ground is Royalty on the blink and fly-blown Beckettian tramps . . . his people look as if they have been standing too close to the fire and have melted a little' (Hewison).
PUB: *Private Eye Hector Breeze* (1973)
ILL: T. Wogan, *The Day Job* (1981)
COLL: UKCC; V&A MB

BRIAN – see ffolkes, Michael

BRIGGS, Raymond Redvers DFA, FSIAD (b. 1934). Illustrator and cartoonist. Raymond Briggs was born in Wimbledon, London, on 18 January 1934, the son of a milkman. He was educated at Rutlish School, Merton, and studied at Wimbledon School of Art (1949–53) and, after National Service, at the Slade (1955–7). He has been a freelance illustrator since 1957 – working for clients such as BBC, Condé Nast magazines, OUP and Penguin Books – and has taught illustration part-time at Brighton Polytechnic (1961–87). Best known for his children's books such as *Father Christmas*, *Fungus the Bogeyman* and *The Snowman* (now a successful animated film), he has also produced work for the *Guardian*. He won the Kate Greenaway Medal for *The Mother Goose Treasury* (1966) – featuring more than 800 illustrations – and *Father Christmas* (1973). He works in line and watercolour, gouache, pencil and crayons.

PUB: Many books including *The Strange House* (1961), *Midnight Adventure* (1961), *Ring-a-Ring O' Roses* (1962), *Sledges to the Rescue* (1963), *Mother Goose Treasury* (1966), *Father Christmas* (1973), *Fungus the Bogeyman* (1977), *The Snowman* (1978), *Gentleman Jim* (1980), *When the Wind Blows* (1982), *Fungus the Bogeyman Plop-Up Book* (1982), *The Tin-Pot Foreign General and the Old Iron Woman* (1984), *Unlucky Wally Twenty Years On* (1989)
ILL: R. M. Sanders, *Peter and the Piskies* (1958); E. Vipont, *The Elephant and the Bad Baby* (1969); V. Haviland, *The Fairy Tale Treasury* (1972); I. Serrailler, *The Tale of Three Landlubbers* (1970)
COLL: V&A MB

BRIGHTWELL, Leonard Robert FZS (1889–after 1956). Cartoonist, strip cartoonist and illustrator. Leonard Brightwell was born and educated in London and drew animals – which became his speciality – from a very early age, spending long hours at the Zoo and becoming a member of the Zoological Society (1906). Whilst attending Lambeth School of Art he started to contribute humorous animal illustrations and strip cartoons to magazines and comics including eventually the *Boy's Own Paper*, *Bystander*, *Graphic*, *Happy Days*, *Humorist*, *Little Folks*, *Pall Mall*, *Pearson's*, *Puck*, *Royal*, *Sketch* and *Tatler*. He was very occasionally seen in *Punch* (1905–29). During World War I he served in the Army on the Western Front and afterwards took part in several expeditions as a member of the Marine Biological Association. His humorous work in pen and ink tends to be sketchy but colour plates in the *Tatler* and *Bystander* are fully realized. He admired the work of J. A. SHEPHERD.
PUB: 19 books including *A Cartoonist Among Animals* (1921), *The Tiger in the Town* (1930), *Zoo Calendar* (1934), *The Zoo You Knew* (1936), *The Zoo Story* (1952)
ILL: E. H. Barker, *A British Dog in France* (1913); E. Davies, *Our Friends at the Farm* (1920); C. Evans, *Reynard the Fox* (1921); L. Mainland, *Zoo Saints and Sinners* (1925); E. Boulanger, *A Naturalist at the Zoo* (1926); H. Chesterman, *The Odd Spot* (1928); M. Swannell, *Animal Geography* (1930); Sister Margaret, *Zoo Guy'd* (1935); O. Bowen, *Taddy Tadpole* (1946)
 SH

BROCK, Charles Edmund RI (1870–1938). Illustrator, portrait painter and cartoonist. C. E.

Brock was born in Holloway, London, on 5 February 1870, the son of a specialist reader in oriental languages for Cambridge University Press and the older brother of H. M. BROCK. He attended St Barnabas School and Paradise Street Higher Grade School, Cambridge, and his sole art training consisted of working in the studio of the Cambridge sculptor, Henry Wiles. His first published works were book illustrations for *The Parachute and Other Bad Shots* by J. R. Johnson (father of actress Celia and literary agent John), but he soon became a regular contributor to *Punch* (1901–10), *Good Words* (1895–6), *Illustrated London News*, *Fun*, *Graphic*, *Chums*, *Little Folks*, *Pearson's Magazine*, *Windsor Magazine* and other publications. He also illustrated Macmillan's 'Standard Novels' series and many other books. He shared a studio and worked closely with his younger brother, sketching on paper, then using Goodall's Bristol Board and Bradauers 518 and 515 nibs, ink and watercolour. In addition he painted portraits in oils. He was elected RI in 1908. C. E. Brock died on 28 February 1938.
ILL: Many books including titles by T. Hood, J. Austen, C. Lamb, O. Goldsmith, D. Defoe, W. Scott, Dent's 'English Idylls' series etc; J. R. Johnson, *The Parachute and Other Bad Shots* (1891)
EXHIB: L; RA; RI; GI; ROI; RSA
LIT: C. M. Kelly, *The Brocks* (1975) MB

BROCK, Henry Matthew RI (1875–1960). Illustrator, landscape painter and cartoonist. H. M. Brock was born in Cambridge on 11 July 1875, the son of a specialist reader in oriental languages for Cambridge University Press and the younger brother of C. E. BROCK. He attended St Barnabas School and Paradise Street Higher Grade School, Cambridge, and later studied at Cambridge School of Art. Like his older brother C. E. Brock (with whom he shared a studio), he worked mostly as a book illustrator (his first drawing was published in 1893), notably on Macmillan's 'Standard Novels' and other series – especially adventure stories – but also contributed to *Punch* (1905–40), *Graphic*, *Holly Leaves*, *Strand Magazine*, *Chums*, *Boy's Own Paper*, *Country Life* (including George V Coronation cover, 22 June 1911), *Fun*, *Humorist*, *Little Folks*, *Pearson's Magazine*, *Windsor Magazine*, *Sphere*, *Sketch*, *Sparkler* and others. He was elected an RI in 1906 and in the 1920s produced posters for D'Oyly Carte. In addition he worked in advertising, producing drawings for Ronuk polish and 100

Birds About Town

BY L. R. BRIGHTWELL

A DAY DOWN IN THE COUNTRY

COW : "Ever been painted ?" BILL SPARROW (*anxious to impress the "locals"*) : *"Yus — and sold"*
COW : *"As a water colour ?"* BILL : *"No — as a canary"*

Leonard Brightwell, *Bystander*, 20 June 1923

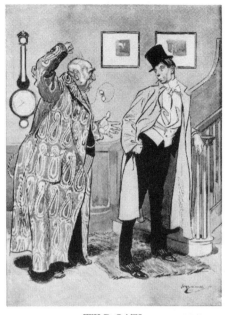

WILD OATS.

INFURIATED FATHER : If you will persist in these abominable habits I'll — I'll — shut you off with a killing !"

H. M. Brock, *Printers' Pie*, 1912

watercolour illustrations of Gilbert & Sullivan characters and 50 characters from fiction for Players cigarette cards in the 1920s. A cousin of FRED PEGRAM (whose sister Doris he married), he worked in watercolour, pen and ink. He died on 21 July 1960.

ILL: Many books including Thackeray's *Ballads, Sir Roger de Coverley* etc.
EXHIB: B; L; RA; RI; RSAB; GI; RSA
COLL: V&A
LIT: C. M. Kelly, *The Brocks* (1975) MB

BROCKBANK, Russell Partridge (1913–79). Cartoonist, strip cartoonist and art editor. Russell Brockbank was born on 15 April 1913 in Niagara Falls, Canada, of British parents. Educated at Ridley College, Ontario, he returned to England in 1929 and attended Chelsea School of Art. He was the manager of his father's industrial ceramics factory at the age of 19 and by the age of 24 had become a professional artist. He served as a lieutenant with the Royal Navy Volunteer Reserve during World War II (on northern convoys and in the Pacific). A specialist in motoring and aviation cartoons, he first drew for *Punch* in 1939 and was the magazine's Art Editor (1949–60). He also contributed to *Speed, Motor* (especially the famous 'Major Upsett' strip), *Commercial Motor, Cadet Journal, Lilliput,*

CITRON PRESSÉ

Russell Brockbank, *Up the Straight* (1953)

Aeroplane, Road & Track, Quattrorure, Car Graphic and other publications. Obsessed by cars ('I once got a D-type Jag up to 148 mph . . . near Godalming'), he most enjoyed drawing classic Alfa Romeos, Bugattis and Mercedes. His drawings were always completely accurate in detail and he discovered at an early age that 'you must make cars lean forward a bit and get their wheels off the ground if you want to give an impression of speed'. He used Cie Française fine nibs on Bristol board and sometimes used scraperboard. Russell Brockbank died on 14 May 1979.

PUB: *Round the Bend* (1948), *Up the Straight* (1953), *Over the Line* (1955), *The Brockbank Omnibus* (1957), *Manifold Pressures* (1958), *Move Over!* (1962), *The Penguin Brockbank* (1963), (ed.) *Motoring Through Punch* (1970), *Brockbank's Grand Prix* (1973), *The Best of Brockbank* (1975), [with R. Collier] *Bees Under My Bonnet* (1955)

ILL: J. B. Boothroyd, *Motor if You Must* (1960)
MB

BROOKE, William Henry (1772–1860). Portrait painter, illustrator and occasional caricaturist. William Henry Brooke was the son of the portrait painter Henry Brooke. He studied art under Samuel Drummond and exhibited portraits from 1810 onwards but is mainly known as a book illustrator in the decorative manner of Thomas Stothard. The *Satirist* published 16 caricatures by him (1812–13) which revealed little aptitude for satire.

ILL: T. Moore, *Irish Melodies* (1822); *Hone's Every Day Book* (1826–7); T. Keightley, *The Fairy Mythology* (1828); W. H. Harrison, *The Humorist* (1832)
EXHIB: RA; RI
COLL: BM; NPG; V&A
SH

BROOKES, Harris – see Stampa, Giorgio Loraine

BROOKES, Peter (b. 1943). Cartoonist, caricaturist and illustrator. Born in Liverpool on 28 September 1943, Peter Brookes trained as a pilot in the RAF (1962–5) whilst reading for a London University degree. He then attended Manchester College of Art (1965–6) and the Central School of Art, London (1966–9), and was a lecturer at the Central School (1976–8) and RCA (1979–90). He succeeded RANAN LURIE as political illustrator and cartoonist for *The Times* (1982) and has been cover artist (with GARLAND) of the *Spectator* since 1986. In addition he has con-

tributed to the *Times Literary Supplement*, *Radio Times*, *New Society*, *New Statesman*, *L'Expansion*, *Marie Claire*, *Cosmopolitan* and *Listener*, produced illustrations for The Folio Society and Glyndebourne Opera, and designed book jackets for Penguin Books and others. Elected to membership of the Alliance Graphique Internationale (1988) he has also won the Designers' & Art Directors' Silver Award (1985) and the W. H. Smith Award for Illustration (1989). He uses a dip pen with Gillot 404, 303 or 1950 nibs and Pelikan black ink on T. H. Saunders paper but also likes to work with watercolour and gouache.

ILL: J. Verne, *Around the World in Eighty Days* (1982); A. G. MacDonell, *England, Their England* (1986); A. Trollope, *Sir Harry Hotspur* (1992)
EXHIB: CG; RCA
COLL: IWM
MB

BROWN, Frank Hilton 'Eccles' (1926–86). Cartoonist. Frank Brown was born on 8 May 1926 in Forest Gate, London, and began cartooning during World War II while serving with the Royal Engineers in Ceylon, drawing for *SEAC Radio Times* and *Indian Listener*. After the war he qualified as an architect at the Regent Street Polytechnic and worked for the LCC Housing Department but continued to submit cartoons, jointly with his twin brother, Sidney, to *Punch* and other publications. A former Secretary of the British Cartoonists' Association, he is best remembered for his work as 'Eccles' over more than two decades on the *Daily Worker/Morning Star* which he joined in 1952, later taking over from 'Gabriel' (JAMES FRIELL). He also drew as 'Hilton'. Frank Brown died on 18 September 1986.
MB

BROWNE, Gordon Frederick RI (1858–1932). Illustrator, painter and nonsense artist. Gordon Browne was born at Banstead, Surrey, the son of HABLOT K. BROWNE ('Phiz'). He was educated privately and studied art at Heatherley's and the South Kensington Schools. Becoming an illustrator, he was one of the most prolific of all time, sometimes averaging seven books a year as well as contributing to numerous magazines, including *Punch*. Some of his book illustrations have a quiet humour but his main humorous achievement lies in the three books of nonsense rhymes for children he wrote and illustrated under the pseudonym 'A Nobody'. A very competent figure draughtsman in ink and watercolour, he was elected RI (1896). He died on 27 May 1932.

FOR SERVICES TO MANUFACTURING INDUSTRY

Peter Brookes, [John Major], *The Times*, 5 March 1993

PUB: *Nonsense for Somebody, Anybody and Everybody, Particularly the Baby-Body* (1895), *Some More Nonsense for the Same Bodies as Before* (1896), *A Nobody's Scrapbook* (1900). ILL: Many books
EXHIB: RA; RI; RBA; RWA; L
COLL: BM; V&A SH

BROWNE, Hablot Knight 'Phiz' (1815–82). Illustrator, painter, sporting artist and cartoonist. Hablot K. Browne was born on 11 June 1815 in Kennington, London, the son of a merchant who died when Hablot was aged nine. He was educated at a private school in Suffolk, where his precocious aptitude in drawing was encouraged. On leaving school he was apprenticed to Finden, the steel engraver, and whilst there was awarded a medal by the Society of Arts for an engraving of John Gilpin's ride (1833). In 1834, with a partner, he set up his own designing and engraving business and in 1836 drew illustrations for Dickens's anti-Sabbatarian squib, *Sunday under Three Heads*. This led in the same year, on the death of

SEYMOUR, to a commission to illustrate *Pickwick Papers* (under the pseudonym 'Phiz') and to a cooperation with Dickens lasting 28 years and involving 13 books. In 1839 he illustrated the first of 17 novels for Charles Lever. For *Punch* he drew the second cover in 1842 and between then and 1869 contributed more than 60 little comic drawings to the magazine. He also supplied humorous work to the *Great Gun* and *Life*. Phiz was in his prime between 1840 and 1860 after which his powers declined and the public taste in illustration switched from steel (his forte) to wood engraving. In 1867 he suffered a serious illness, probably polio, and did little work thereafter. He was saved from destitution by the sale of his watercolours and sporting prints, the publication of cartoons in *Judy* and the grant of an annuity by the RA. He died on 8 July 1882 in Brighton. Most of Phiz's cartoons, admittedly drawn after his illness, are negligible apart from the pretty girls. On the other hand he was a great comic illustrator. To begin with he modelled himself on GEORGE CRUIKSHANK but gradually he

developed a looser, more individual style tailored to the needs of his authors though sometimes, so they complained, with a tendency to exaggerate the comic dimension. His portraits of some of Dickens's characters – Micawber and Pecksniff, for example – are masterpieces of comic interpretation.

PUB: *Home Pictures* (1851), *Illustrations of the Five Senses* (1852), *Hunting Bits* (1862), *A Run with the Stag Hounds* (1863), *London's Great Outing* (1868), *Racing and Chasing* (1868), *Sketches of the Seaside and the Country* (1869), *A Shillingsworth of 'Phiz'!* (1874), *All About Kisses* (1876)

ILL: More than 200 books including C. Dickens, *The Life and Adventures of Nicholas Nickleby* (1839), *The Life and Adventures of Martin Chuzzlewit* (1844), *The Personal History of David Copperfield* (1850), *A Tale of Two Cities* (1859); C. Lever, *The Confessions of Harry Lorrequer* (1839), *The Knight of Gwynne* (1847), *Luttrell of Arran* (1865); H. Ainsworth, *Old St Paul's* (1847), *Mervyn Clitheroe* (1858); R. Surtees, *Hawbuck Grange* (1847); F. Smedley, *Lewis Arundel* (1852); G. Halse, *Sir Guy de Guy* (1864); L. Meadows, *Dame Perkins and her Grey Mare* (1866)

EXHIB: BI; SBA; FAS (Memorial 1883)
COLL: BM; V&A; M
LIT: D. Croal Thomson, *The Life and Times of Hablot Knight Browne* (1884); J. Buchanan-Brown, *Phiz! The Book Illustrations of Hablot Knight Browne* (1978) SH

BROWNE, Thomas Arthur RI RBA RMS (1872–1910). Cartoonist, strip cartoonist, illustrator, painter and postcard/commercial artist. Tom Browne was born in Nottingham of working-class parents. He left school aged 11, took a job as an errand boy and then became apprenticed to a printer where he discovered a talent for art. After only two terms at an art school some of his strip cartoons started to appear in the comic *Scraps* (1889) and he also contributed to *Chums* (1893–5). His characters Weary Willy and Tired Tim, a pair of endearing tramps who appeared in *Illustrated Chips* from 1896, have been described as 'the first great comic heroes'. Browne dominated the comics between 1896 and 1900, at one time drawing five front pages, each with six panels, every week but he left them to concentrate on painting in oil and watercolour – he was elected RBA (1898),

A BREAKDOWN.

Tom Browne, [postcard], *c.* 1900–10

RMS (1900) and RI (1901). He also designed humorous postcards, posters and advertisements in a style similar to JOHN HASSALL, and provided illustrations to magazines including *Black and White*, *Captain*, *Cassell's*, *Eureka*, *Graphic*, *Lady's Realm*, *London*, *Odd Volume*, *Pearson's*, *Pick-Me-Up*, *Printer's Pie*, *Royal*, *Sketch*, *Strand*, *To-Day* and the *Tatler*. His association with *Punch* was brief, his humour being too broad for its taste. He travelled widely on the continent, to the Far East and in America where he drew cartoons for several newspapers. A member of the Langham Sketch Club, he resigned from it to become a founder member of the London Sketch Club and its President (1907–8). He died on 16 March 1910. Tom Browne's bold and simplified style as well as his cheery approach to cartooning owed a lot to PHIL MAY. His work was extremely popular and his influence on the art of the comic has been long-lasting.

PUB: *Tom Browne's Annuals* (1904–5)
ILL: B. Pain, *The One Before* (1902); F. Richardson, *The Man who Lost his Past* (1903)
EXHIB: RA; RI; RBA; RMS; FAS
COLL: V&A
LIT: A. E. Johnson, *Tom Browne RI* (1909); *The Postcards of Tom Browne* (Postcards for Pleasure, 1978) SH

BROWNLIE, R. A. (fl. 1887–97). Cartoonist and painter. Brownlie, who signed with his initials R. A. B., was a frequent contributor of political and social cartoons to *Judy* in the 1890s, becoming Art Editor (*c*. 1896) when, in THORPE's view, the artistic standard of the magazine depreciated sharply. He also contributed to the *Pall Mall Magazine*, *Pick-Me-Up*, *St Paul's* and the *Sketch*. Apparently he lived most of his life in Glasgow.
EXHIB: RSA; RSW
COLL: V&A SH

BRUNTON, W. (fl. 1859–73). Cartoonist and illustrator. Brunton was the principal joke cartoonist on *Fun* from its foundation in 1861 to the early 70s. He signed his work with a monogram composed of his initials divided by an arrow. His favourite style was the outline as used by DICKY DOYLE in 'Bird's Eye Views' and he employed it on Doyle-like subjects and in strips. But he also experimented in *Fun* and other magazines – *Broadway*, *London Society*, *Moonshine*, *Punch* and *Tinsley's* – with other styles based on oriental and mediaeval art, justifying Kunzle's opinion that he was 'a true

Victorian eclectic'. He was a member of the Savage Club.
ILL: T. Hood, *Vere Vereka's Vengeance* (1865), *From Nowhere to the North Pole* (1875); *The Savage Club Papers* (1867–8); Lord Brabourne, *Mooshine* (1871), *Tales at Tea-Time* (1872); J. T. Lucas, *Prince Ubbely Bubble's New Story Book* (1871)
COLL: V&A SH

BRYAN, Alfred (1852–99). Cartoonist and caricaturist. Alfred Bryan's first appearance was as a political cartoonist and theatre-page caricaturist working for *Judy* in the early 1870s. He was soon after contributing to *Ally Sloper's Half Holiday*, *Hornet*, *Idler* and the *Illustrated Sporting & Dramatic News*. Most of his work was in pen and ink for which he had a great facility; that together with his gift for portraiture and his versatility make him one of the outstanding cartoonists of the time. MAX BEERBOHM greatly admired his work, especially the theatre caricatures in *Entr'Acte* and the political cartoons in *Moonshine* and declared 'there is more talent in his little finger than in half the emblazoned hierarchy of pen and ink draughtsmen on whose potterings and peddlings we all lavish so much admiration'. Apart from cartooning Bryan also illustrated a number of sheet-music covers and had drawing pupils, amongst them J. A. SHEPHERD.
COLL: V&A SH

BUCHAN – see Boswell, James

BULL, René (*c*. 1870–1942). Cartoonist, strip cartoonist, illustrator and war artist. René Bull was born in Dublin. As an engineering student in Paris (*c*. 1890) he took lessons in drawing from the great French cartoonist Caran D'Ache, then contributed wordless strip cartoons in his manner to *Pick-Me-Up* from 1893. In 1896 he was appointed 'special artist' for *Black & White* and reported on the Armenian massacres and the Graeco-Turkish war, the first of many such assignments. Around this time he contributed cartoons to the periodicals including *Black & White*, *Bystander*, *Cassell's*, *Chums*, *English Illustrated Magazine*, *Lady's Realm*, *London*, *London Opinion*, *New Budget*, *Pall Mall Budget*, *Pearson's*, *Printers' Pie*, *Royal*, *Strand* and the *Tatler*. His humorous 'inventions' in the *Sketch* foreshadow HEATH ROBINSON. The reputation he made in the magazines led to commissions to illustrate gift books in which he demonstrated high ability as a colourist. During World War I

TWO GREAT ACTORS.

Mr. Disraeli.—I came round to congratulate you on the unprecedented run of *Hamlet.*

Mr. Henry Irving.—Thank you very much; I hope your social drama at St. Stephen's will also have a prosperous time.

Mr. Disraeli.—The *Arabian Nights* were a thousand and one; I shall double that, and more. Shall I tell you my secret? *[Dialogue interrupted by Call-boy.]*

Alfred Bryan, [Disraeli and Henry Irving], *Hornet*, 10 March 1875

he served in the RNVR (1916) and the RFC (1917) and afterwards worked in the Air Ministry. He was a member of the London Sketch Club. An assured and lively pen artist, with a nice sense of absurdity, some of his cartoons are excellent reminders of the genius of Caran D'Ache.
ILL: J. C. Harris, *Uncle Remus* (1906); *The Arabian Nights* (1912); *The Rubaiyat of Omar Khayyam* (1913); A. E. Johnson, *The Russian Ballet* (1913); P. Mérimée, *Carmen* (1916)
EXHIB: BRU
COLL: V&A SH

BUNBURY, Henry William (1750–1811). Amateur caricaturist and painter. Bunbury was born in July 1750, the second surviving son of the Rev. Sir William Bunbury, 5th Baronet of Barton and Mildenhall, Suffolk. He was educated at Westminster School, where he started to draw caricatures, and briefly at Cambridge University (1768). The next year he went on the Grand Tour and on his return exhibited the caricature 'La Cuisine de la Poste' at the RA (1770), whose success was confirmed the following year with 'View on the Pont Neuf at Paris'. He went on to design many good-natured, well observed, mildly humorous scenes of social life that were engraved progressively by DARLY, Bretherton and Dickinson – a few by ROWLANDSON and GILLRAY. His greatest success came with 'A Long Minuet as Danced at Bath' (1787); in the same year he was appointed Groom of the Bedchamber to the Duke of York and attended the Court at Windsor. In 1808 his last pictures were exhibited at the RA. He died in Keswick on 7 May 1811. Bunbury's great popularity in his day – Horace Walpole called him 'the second HOGARTH' – had something to do with his convivial character, his social standing and his avoidance of coarseness. His contemporaries admired his powers of observation and overlooked his feeble draughtsmanship in the process of enjoying his good humour.
PUB: *An Academy for Grown Horsemen* (1787), *Annals of Horsemanship* (1791), J. Bailey (ed.), *A Folio of Shakespeare Engravings taken from the Drawings of Henry William Bunbury* (1976)
EXHIB: Gainsborough's House, Sudbury, Suffolk (1983)
COLL: HM the Queen; BM; V&A; NPG; C; B; CA; E; Yale
LIT: S. Brinton, *The Eighteenth Century in English Caricature* (1904) SH

BURGIN, Eric (1926–66). Cartoonist and strip cartoonist. Eric Burgin was born in Maidenhead

on 3 February 1926 and educated at Gordon Road School in the town, leaving at 14 to become an engineering apprentice in a local machine shop. He joined the RAF as an air-gunner in 1943, serving in Singapore and the Far East and later returning to Maidenhead to work in an aircraft components factory. He became a full-time freelance cartoonist in 1954 and produced 'Anagrins' (illustrated anagrams) for the *Evening News* and 'The Niteleys' strip (about a family of TV fanatics) for the *Daily Sketch* as well as numerous contributions to *Punch* and other publications. One of the founder members of the Cartoonists' Club of Great Britain, he was voted CCGB Humorous Cartoonist of the Year three times (1962, 1963 and 1964). An influential cartoonist, FOUGASSE said that his ideas had 'a touch of Thurber and [his] drawings would have also, if they hadn't learnt about perspective'. He died of a heart attack on 5 March 1966.
MB

BURKE, Christopher (b. 1955). Illustrator and caricaturist. Chris Burke was born in London on 4 October 1955, went to St Martin's School of Art (1974–5) and studied graphic design at Canterbury College of Art (1975–8). He worked for five years as an art director in small advertising agencies before becoming a freelance illustrator and caricaturist for *Radio Times, Sunday Times, Guardian, Sunday Telegraph, Evening Standard, Punch, Observer* and the *Listener*. He has also produced advertising work for Irish Tourist Board, Air India and posters for Welsh National Opera, COI and London Underground. In addition he has designed stamps and written and illustrated children's books. For his illustration work for the Save the Childen Fund he was awarded a Creative Circle Gold Medal (1989). He cites Daumier as his greatest influence.
PUB: *Rain and Shine* (1987), *Not Your Average GI Joe* (1989), *Who's Afraid Now* (1991), *Scaredy Cat* (1993)
EXHIB: Roughs Gallery; McGrath Gallery, Richmond; TG; Trinity Arts, Tunbridge Wells
COLL: V&A, LTM MB

BURNE-JONES, Sir Edward Coley Bt ARA (1833–98). Painter, illustrator, designer and occasional caricaturist. Burne-Jones was born in Birmingham on 28 August 1833, the son of a framer and gilder. He was educated at King Edward's School, Birmingham, where he had a reputation for drawing comic devils, and attended evening classes at the Government School of

Design. In 1853 he went up to Exeter College, Oxford, where he became close friends with William Morris and fell under the influence of ROSSETTI. His career as a painter leading the second phase of the Pre-Raphaelite movement, and as a designer in partnership with Morris, need not be restated here. As a reaction from his serious painting he made hundreds of humorous drawings to amuse his friends that are preserved in albums in the BM. Some of them have affinities with the humorous work of EDWARD LEAR. Of the caricatures those he made of William Morris are the most amusing. John Christian wrote 'he has the true caricaturist's gift of capturing an idea with great economy of means'. Burne-Jones also illustrated humorously many of his letters, notably those he wrote to Katie, the daughter of his solicitor, Sir George Lewis. He was elected ARA (1885, resigned 1893), created a baronet (1894) and received many European honours. He died on 16 June 1898.

PUB: *The Beginnings of the World* (1902), *Letters to Katie* (1925)
ILL: A. Maclaren, *The Fairy Family* (1857); various books published by the Kelmscott Press
EXHIB: GG; NEG; OWS; FAS (1896); T (1933); AC (1975)
COLL: T; BM; V&A; B; A; F and many provincial and foreign galleries
LIT: J. Christian, Catalogue of AC Exhibition (1975); L. Lambourne, 'Paradox and Significance in Burne-Jones caricatures' (*Apollo*, Nov. 1975)
SH

BURNETT, Hugh 'Phelix' (b. 1924). TV producer and broadcaster, cartoonist, writer and illustrator. Born in Sheffield on 21 July 1924, the son of a former Editor of the *Methodist Recorder*, Hugh Burnett was educated at Latymer School, Hornsey School of Art and the London School of Economics. During World War II he served in the Intelligence Corps and was posted to the Burma frontier (airport security) where his cartoons in *Soldier* magazine and other Forces periodicals led to a transfer to Radio SEAC in Ceylon and promotion to the rank of captain. After the war he worked in the War Office, joining the BBC Overseas Broadcasting Service in 1950. In addition he worked as a freelance cartoonist under the name of 'Phelix', contributing to *Daily Mail*, *Daily Herald*, *Sunday Dispatch*, *Daily Express*, *John O' London's Weekly*, *Tit-Bits*, *Modern Woman*, *News on Sunday*, *Evening News*, *Sunday Pictorial*, *Christmas Pie*, *Evening Standard*, *Gibraltar Chronicle*, *Everybody's*, *London Opinion*, *Men Only*, *Time*, *Life*, *New Statesman*, *Punch*, *Private Eye*, *She* and *Oldie*. He has also worked as a producer and presenter of TV documentaries (22 for the BBC to date), was the creator of the series 'Face to Face' and his drawings have appeared in four Video Arts films. He is particularly well known for his cartoons featuring monks, which were VICKY's favourite cartoon characters and one of which Augustus John hung on his bedroom wall. Hugh Burnett prefers to draw in silence, with a felt-tip pen and on any paper that is to hand. As his main founts of inspiration he cites a meeting with Picasso in Antibes, the work of PONT, Peter Arno and Steinberg and 'the delightful insanity which surrounds us all'.

PUB: *Top Sacred* (1960), *Sacred and Confidential* (1961), *Nothing Sacred* (1962), *Adam and Eve* (1963), [with F. Topolski] *Face to Face* (1964), *Beware of the Abbot* (1965), *Book of the Monk* (1966)
ILL: B. Campbell-Kemp, *Come Live With Me* (1974)
MB

BURNEY, Edward Francesco (1760–1848). Illustrator, painter and occasional caricaturist. Edward Burney was born in Worcester, the nephew of Charles Burney the musicologist and a cousin of Fanny Burney the novelist. He studied at the RA Schools and exhibited at the RA (1780–1803). Best known as a book illustrator, he also painted a number of highly regarded satirical watercolours of social mores such as 'An Elegant Establishment for Young Ladies' in the V&A and 'Amateurs of the Tye-Wig Music' in the Paul Mellon collection at Yale. He was a friend of SIR JOSHUA REYNOLDS and Charles Lamb.

ILL: T. Smollett, *Humphrey Clinker* (1785); S. Richardson, *Pamela* (1786); W. Shakespeare, *The Dramatic Writings* (1788), *The Plays* (1788–91); J. Milton, *Paradise Regained and the Minor Poems* (1796), *Paradise Lost* (1799); C. Johnstone, *Chrysal: or the Adventures of a Guinea* (1797); A. Pope, *The Rape of the Lock* (1798); Homer, *The Iliad and the Odyssey* (1810)
COLL: BM; V&A; NPG; N; BN; Yale
SH

BUSBY, Thomas Lord (fl. 1804–39). Painter, illustrator, engraver and caricaturist. Busby exhibited portrait miniatures at the RA (1804–39). Between 1825 and 1828 he published after his own designs and other artists (such as E. Penny), a long series of small-scale social satires

under the title 'Busby's Humorous Etchings', the humour consisting of puns.
PUB: *The Fishing Costume and Local Scenery of Hartlepool* (1819), *The Costume of the Lower Orders of London* (1820), *The Cries of London* (1823), *The Costume of the Lower Orders in Paris* (c. 1825).
ILL: H. A. Vincent, *Elements of Flower and Fruit Painting* (1814); R. Satchwell, *Scripture Costume* (1819).
COLL: BM SH

BUSS, Robert William (1804–75). Painter, illustrator and authority on caricature. Buss was born in London on 4 August 1804, the son of an engraver, and studied drawing under George Clint ARA. After illustrating various publications for Charles Knight he was chosen in 1836 to replace SEYMOUR as the illustrator of *Pickwick Papers* but failed after two plates due to his poor understanding of etching techniques. He went on to paint and exhibit portraits and pictures of humorous genre (some of which, like 'Raleigh's First Pipe in England' were engraved), and to become Editor of the *Fine Art Almanack*. In 1853 he delivered lectures on caricature and graphic design in various towns, which were published privately with etchings by himself. He died in London on 26 February 1875.
PUB: *English Graphic Satire* (1874)
ILL: F. Marryat, *Jacob Faithful* (1834), *Peter Simple* (1834); F. Trollope, *The Widow Married* (1840); H. Ainsworth, *James the Second* (1847)
EXHIB: RA; BI; RBA; NWS
COLL: BM; V&A; F SH

BUTTERWORTH, George Goodwin (1905–88). Political, strip and sports cartoonist, and illustra-

tor. George Butterworth was born in Woodsmoor, Stockport, Cheshire, on 5 January 1905 and after studying at Stockport Art School won a scholarship to Manchester College of Art where he was a contemporary of PEARL BINDER. At the age of 17 he was employed as a caricaturist and sports cartoonist on the *Stockport Express* and five years later joined Kemsley Newspapers as staff artist, working as 'Gee Bee' on the *Daily Dispatch* (sports cartoons) and was Political Cartoonist on various papers within the group (*Daily Dispatch*, *Evening Chronicle*, *Empire News* and *Sunday Chronicle*). In 1952 he introduced a regular strip, 'The Daily Dees' (featuring the Dee family) in the *Daily Dispatch*, and continued to work for the *News Chronicle*, when it absorbed the *Dispatch*, and the *Daily Mail*, when it in turn absorbed the *Chronicle*, until he retired in 1968. In addition, his drawings appeared in the *New York Times*, *Chicago Tribune*, *Malta Times* and the 1945 *Encyclopedia Britannica Yearbook*. He worked in pen and ink and also used brushes, charcoal and scraperboard. Butterworth died on 17 October 1988.
PUB: *Hitler and His Crazy Gang* (n.d.)
EXHIB: City Hall, Manchester MB

BYRON, Frederick George (1764–92). Caricaturist. F. G. Byron was a nephew of the 5th Lord Byron and a first cousin once removed of Lord Byron, the poet. He was a prolific designer of caricatures (1788–91), his social satires, published by William Holland, being somewhat in the manner of BUNBURY and having considerable charm.
COLL: BM SH

C

CALDECOTT, Randolph RI (1846–86). Illustrator and cartoonist. Randolph Caldecott was born in Chester on 22 March 1846, the son of an accountant, and educated at the King's School, Chester, where he won prizes for art. He then worked as a bank clerk (1861–72) in Whitchurch and Manchester. He attended evening classes at Manchester Art School and contributed humorous drawings to *Will O' the Wisp* and the *Sphinx*. Following acceptance of some illustrations by *London Society*, he moved to London in 1872

and that year exhibited an oil painting at the RA. In 1875 the publication of Washington Irving's *Old Christmas* launched his career as a book illustrator and the following year he started to contribute comic narrratives, painted in colour, to the Christmas and Summer numbers of the *Graphic*. His illustrations were also published in *Aunt Judy's Magazine*, *Belgravia*, *English Illustrated Magazine* and *Pictorial World*. The few drawings he contributed to *Punch* (1872–83) do not show him at his best. His greatest achieve-

ment, the 16 *Randolph Caldecott Picture Books* which won for him the title of 'lord of the nursery', started in 1878. In 1882 he was elected RI. He died in Florida on 12 February 1886. Caldecott's nostalgia for the simple open-air life of the 18th century, the gaiety of his fancy and the delicacy of his colour influenced many artists and can still enchant. PHIL MAY in particular capitalized on his economical drawing style and his claim that he had 'studied the art of leaving out as a science'.

PUB: *Randolph Caldecott's 'Graphic' Pictures* (1883), *A Sketchbook of R. Caldecott's* (1883), *More 'Graphic' Pictures* (1887), *The Complete Collection of Randolph Caldecott's Picturesque Songs* (1887), *Randolph Caldecott's Last 'Graphic' Pictures* (1888), *Gleanings from the 'Graphic' by Randolph Caldecott* (1889), *Randolph Caldecott Sketches* (1890)

ILL: W. Irving, *Old Christmas* (1875), *Bracebridge Hall* (1877); H. Blackburn, *Breton Folk* (1880); J. H. Ewing, *Jackanapes* (1883), *Daddy Darwin's Dovecote* (1884), *Lob Lie-by-the-Fire* (1885); *Some of Aesop's Fables with Modern Instances* (1883)

EXHIB: RA; RI; M (1977–8)

COLL: BM; V&A; A; F; WAG; Houghton Library, Harvard

LIT: H. Blackburn, *Randolph Caldecott, A Personal Memoir* (1886); R. Engen, *Randolph Caldecott, 'Lord of the Nursery'* (1976); M. Sendak, *Caldecott and Co.* (1988). MB

CALDWELL, William (b. 1946). Political cartoonist. Bill Caldwell was born in Glasgow on 30 September 1946. Self-taught, he has worked for *Sunday Sport*, *Sunday Mail* and in advertising. He has been Political Cartoonist on the *Daily Star* since October 1978 and draws in the realistic style of GILES, MAC and JAK.

PUB: *The Star Caldwell Cartoon Book One* (1985); *The Star Caldwell Cartoon Book Two* (1987); annuals since 1990 MB

CALMAN, Mel FRSA FSIA AGI (1931–94). Pocket cartoonist, illustrator and writer. Mel Calman was born in Hackney, London, on 19 May 1931, the son of a timber merchant. He was educated at Perse School, Cambridge, and studied illustration at St Martin's School of Art and Goldsmith's College. He was cartoonist on *Daily Express* (1957–63), *Sunday Telegraph* (1964–5), *Observer* (1965–6), *Sunday Times* (1969–84) and *The Times* (1979–94). He also contributed to *Cosmopolitan* and *House &*

Garden and founded The Cartoon Gallery (formerly The Workshop) – a gallery devoted to cartoon art. In addition he produced an animated cartoon, *The Arrow*, for the BFI and contributed illustrations to many books and periodicals. Co-founder (with Simon Heneage) of the Cartoon Art Trust, he was its Chairman 1993–4. He also worked in advertising, was resident cartoonist on BBCTV's 'Tonight' programme (1963–4), and wrote three plays for BBC Radio. His cartoons, which regularly featured a naif-style 'little man' character, were always drawn in pencil, using 4B or 5B for the main illustration and 4B for lettering. He tended to draw at twice reproduction size on Croxley Script paper. Influenced by Thurber, he said his 'little man' was 'not auto-biographical. At least not totally.' In HEWISON's view, 'His rudimentary little people have a cosy charm and the way they are rendered has about it an aura of fashionable smartness.' He died in London on 10 February 1994.

PUB: *Through the Telephone Directory* (1962), *Bed-Sit* (1963), *Boxes* (1964), *For Such As Are of Riper Years* (1965), *Calman and Women* (1967), *The Penguin Calman* (1968), *My God* (1970), *Couples* (1972), *This Pestered Isle* (1973), *The New Penguin Calman* (1977), *Dictionary of*

Mel Calman, *My God* (1989)

Psychoanalysis (1979), *But It's My Turn to Leave You* (1980), *How About a Little Quarrel Before Bed?* (1981), *Help! and Other Ruminations* (1982), *The Big Novel* (1983), *Calman Revisited* (1983), *It's Only You That's Incompatible* (1984), *Modern Times* (1988), *Merrie England plc* (1990), *Calman at the Movies* (1990), *Calman at the Royal Opera House* (1990)
ILL: J. de Manio, *To Auntie With Love* (1967); K. Whitehorn, *Whitehorn's Social Survival* (1968); B. James, *1001 Money Saving Tips* (1976); B. Redhead & K. McLeish (eds), *Pieces of Hate* (1982)
LIT: [autobiography] *What Else Do You Do?* (1986)
EXHIB: CG
COLL: BM; V&A; CAT MB

CANE, Arthur R. (fl. 1910s–40s). Cartoonist. The great grandson of the painter/engraver Robert Pollard and the son of a schoolmaster, Arthur Cane left school at 16. He was Assistant Master at a Poor Law institution in the Midlands before leaving in 1905 to enlist in a Lancer Regiment, travelling with the army to South Africa (1907). During World War I he served with the cavalry, infantry and mounted police, was wounded three times and had his left leg amputated a fortnight before the Armistice. He later studied at Chelsea School of Art and worked in a number of advertising agencies while contributing freelance cartoons to *Punch*, *London Opinion*, *Men Only*, *Tatler*, *Sketch*, *Illustrated*, *Passing Show* and others. He was influenced by GILBERT WILKINSON. MB

CAR – see Churchill, Robert Frederick Goodwin

CASALI, Kim [née Marilyn Judith Grove] (b. 1941). Cartoonist. Kim Casali was born in Auckland, New Zealand, on 9 September 1941 and at the age of 19 travelled to Europe and the USA. A self-taught artist, her illustrated messages to Italian computer engineer Roberto Casali (whom she met at a ski club in Los Angeles in 1967) were the original vehicle for the 'Love is . . .' cartoons for which she is best known. The first drawing, which served as a thumbnail signature to a domestic note, featured Kim herself with freckles and long hair (a male figure, representing Roberto, came later). After producing a booklet of 100 of these drawings a friend suggested she showed them to a contact on the *Los Angeles Times*, in which they were first published on 9 January 1970. From there the cartoons were quickly syndicated worldwide, appearing in the

UK originally in the *Daily Sketch* in April the same year, continuing in the *Daily Mail* when it took over the *Sketch*. The Casalis were married in 1971 and moved to England in 1972. Kim Casali (who signs herself 'Kim') now has her work reproduced on T-shirts, watches, jewellery, underwear etc. worldwide.
PUB: More than 25 'Love is . . .' collections (since 1972) MB

CHALON, Alfred Edward RA (1780–1860). Portrait and history painter, and theatrical caricaturist. Alfred Chalon was born in Geneva and came to England as a child when his father was appointed Professor of French at the Royal Military Academy, Sandhurst. In 1797 he entered the RA Schools and in 1801 exhibited at the RA, continuing to do so until the year of his death. He became an extremely fashionable painter of portraits in watercolour, usually about 15 inches high, many of his portraits of Society beauties being reproduced in albums, keepsakes etc. At the same time, and for his private amusement only, he painted caricatures of actors, singers and dancers – many are now in the V&A – that are remarkable for their wit and *joie de vivre*. With his brother J. J. Chalon RA, who also drew caricatures, he established the Chalon Sketching Society (1808–51). He was elected ARA (1812) and RA (1816). Being the first to paint Queen Victoria after her accession (1837) he was appointed 'Painter in Watercolour to the Queen'. He died in Kensington on 3 October 1860.
ILL: L. Fairlie, *Portraits of Children of the Nobility* (1838); M. Blessington, *The Belle of the Season* (1840)
EXHIB: RA; BI
COLL: V&A; HM the Queen SH

CHARLES, William (1776–1820). Caricaturist and illustrator. A native of Scotland, William Charles produced some crude anti-Napoleon caricatures, imitations of GILLRAY, in 1803. Around 1806 he fled to New York having incurred the wrath of Scottish ecclesiastics by issuing a print which reflected on their morals. He is best known for the 20 or 30 anti-British caricatures he published during the Anglo-American war of 1812 in which the virulence of his passion triumphs over the rawness of his technique. Like Ackermann in London he established a 'Repository of the Arts' from which, inter alia, he issued versions of the *Syntax* books and *The Vicar of Wakefield* with his own copies of ROWLANDSON's plates. He died in Philadelphia.

ILL: *Pinkerton's Travels* (1810–2)
COLL: BM; LC
LIT: H. B. Weiss, *William Charles, Early Caricaturist, Engraver and Publisher of Children's Books* (1932) SH

CHASEMORE, Archibald (fl. 1867–1902). Cartoonist. Chasemore was born in Fulham, London, educated in or near Horsham, Sussex, and was a self-taught artist. His first appearance as a humorous artist was in *Punch* (1867). In the 1870s he became one of the mainstays of *Judy*, specializing in theatrical subjects which he treated in a distinctive outline manner. Over the next 30 or so years he also contributed to *Ally Sloper's Half Holiday, Boy's Own Paper, Fun, Illustrated Sporting & Dramatic News, Lady's Pictorial, Million, Pick-Me-Up, Pictorial World, Queen, Ross's, St Stephen's Review* and the *Sketch*. He was a friend of CHARLES KEENE and one of those who supplied him with jokes. His cartoons, mostly signed 'A.C.', are invariably decorative but too carefully drawn to be amusing.
ILL: C. H. Ross, *All the Way* (1877), *The Twopenny Twins* (1878), *The Penny Wedding* (1879)
COLL: V&A
LIT: J. G. Reid, *At the Sign of the Brush and Pen* (1898) SH

CHEERO – see Studdy, George Ernest

CHEN, Jack (b. 1908). Political cartoonist and writer. Born in China, Jack Chen worked for *Tribune* and *Daily Worker* and during World War II drew the last cartoon published before the latter paper was closed down by the government. He has also written on art for *The Studio* and *Art & Industry*.
PUB: *Japan and the Pacific Theatre of War* (1942), *Soviet Art and Artists* (1944), *The Chinese Theatre* (1949), *Russian Painting of the 18th and 19th Centuries* (1948), *New Earth* (1957), *A Year in Upper Felicity* (1973), *Inside the Cultural Revolution* (1976), *The Sinkiang Story* (1977)
MB

CHENEY, Leo (1878–1928). Cartoonist, caricaturist and illustrator. Leo Cheney was a bank clerk in Accrington who had been selling illustrations to a local paper when he became the first pupil of PERCY BRADSHAW's cartoon correspondence course. Bradshaw subsequently helped him sell drawings to *Boy's Own Paper, Bystander* and other publications. He later became staff

cartoonist on a Manchester paper and then *Passing Show* in London. He is perhaps best remembered as the creator of the most famous version of the 'Johnnie Walker' character for John Walker & Sons Whisky (earlier versions had been drawn by TOM BROWNE, PARTRIDGE, RAVEN HILL and H. M. BROCK). He also drew advertisments for Chairman tobacco and others. He died on 29 March 1928.
ILL: J. B. Nichols, *The Valet as Historian* (c. 1934)
MB

CHESTERTON, Gilbert Keith (1874–1936). Author and humorous artist. G. K. Chesterton was born in Kensington, London, on 29 May 1874, the son of a prosperous estate agent who was also an amateur artist. He was educated at St Paul's School where he showed a talent for fantastic caricature, then studied art at the Slade School but, deciding he had learned nothing, went on to pursue a distinguished career in literature and journalism. However, he did not altogether forsake art, illustrating two of his own books, his own paper *G. K.'s Weekly* and eight 'Chester Belloc' novels. Throughout his life he drew caricatures to amuse children or release ideas (Gladstone, Napoleon and Bernard Shaw being favourite subjects). He also made fantastic pictures with coloured chalks on brown paper, some of which are reproduced in *The Coloured Lands*. EDWARD LEAR was his early inspiration but his style is entirely individual and often, as in *Biography for Beginners*, extremely funny. Most of his caricatures are unsigned.

*George the Third
Ought never to have occurred.
One can only wonder
At so grotesque a blunder.*

G. K. Chesterton, [George III], in E. C. Bentley *More Biography* (1929)

PUB: [with illustrations by the author] *Greybeards at Play* (1900), *The Club of Queer Trades* (1905), *The Coloured Lands* (1938)
ILL: E. C. Bentley, *Biography for Beginners* (1905), *More Biography* (1929); H. Belloc, *The Green Overcoat* (1912), *Mr Petrie* (1925), *The Emerald* (1926), *The Haunted House* (1927), *But Soft – We are Observed* (1928), *The Missing Masterpiece* (1929), *The Man Who Made Gold* (1930), *The Postmaster-General* (1932), *The Hedge and the Horse* (1936)
EXHIB: NBL, 'G. K. Chesterton. A Centenary Exhibition' (May 1974)
COLL: BL
LIT: A. S. Dale, *The Art of G. K. Chesterton* (1985) SH

CHESTERTON, Raymond Wilson 'Ray' (b. 1912). Cartoonist, humorous illustrator, writer and designer. Ray Chesterton was born on 22 February 1912 and had his first cartoons published in *London Opinion* during World War II. He later contributed to *Lilliput*, *Punch*, *Men Only* and other journals and regularly illustrated BERNARD HOLLOWOOD's 'Family Money-Go-Round' column in *Daily Telegraph* and Joyce Chesterton's 'Family Affair' column in *Daily Mirror*. In addition he has designed annual reports and educational material.
ILL: R. G. G. Anderson, *Heard in the Line-Out* (1969), *Heard in the Slips* (1967), *Heard at the Helm* (1968) MB

CHIC – see Jacob, Cyril Alfred

CHRYS – see Chrystal, George Fraser

CHRYSTAL, George Fraser 'Chrys' (1921–72). Political and sports cartoonist. George Chrystal was born in Aberdeen and attended Gray's School of Art, Aberdeen. After war service in the RAF, he worked for Aberdeen Journals Ltd, and produced sporting cartoons for the *Scottish Daily Mail* before joining the *Daily Mail* and *News of the World* as political cartoonist. He also contributed to *Punch* and other magazines and drew regularly for *Farmer & Stockbreeder* and its successor *British Farmer & Stockbreeder* from the 1950s to his sudden death in December 1972. His work bore considerable similarity to that of GILES.
PUB: *The Best of Chrys* (c. 1973) MB

CHURCHILL, Robert Frederick Goodwin (b. 1910). Cartoonist, illustrator and painter.

Robert Churchill was born in Liverpool on 28 October 1910, the son of a pioneer motor-car designer and manufacturer. He attended the Liverpool Institute (former pupils had included Arthur Askey and Tommy Handley) and started work as a trainee in the Dunlop Rubber Company while studying in the evenings at Liverpool School of Art. He later moved to the company's headquarters in London where he continued his studies at Hornsey Art School and the London School of Process Engraving. His first drawings were published in technical magazines, *Practical Mechanics* and *Practical Motorist* before he met art agent Percy Lisby, after which he worked for *London Opinion*, *Men Only*, *Humorist*, *Punch* and others. In 1939 he joined the Auxiliary Fire Service and was a fire officer in World War II, attaining the rank of captain. He also produced a daily current affairs cartoon for the *Evening Standard* (1943–6) and – under the pseudonym 'Car' – a weekly strip 'Saturday News Reel' (1945–6). In 1946 he moved to *Sunday Pictorial* where he continued the weekly strip (this time under his own name as 'Sunday Newsreel') and a feature cartoon under the pseudonym 'Goodwin'. Emigrating to Montreal, Canada, in 1948, he contributed to *Saturday Evening Post*, *New Yorker* and other publications before returning to the UK in 1955. By then his work as an international marketing and advertising executive had taken over and he ceased to draw cartoons. He retired in 1973 and now paints professionally, exhibits regularly, and is an active member of the council of the London Sketch Club.
PUB: *The Cartoonist's Bible* (1980) MB

CLEAVER, Reginald Thomas (fl. 1887–d. 1954). Graphic journalist, illustrator and cartoonist. Reginald Cleaver started contributing illustrations to the *Graphic c.* 1887 and was recruited to the *Daily Graphic*, the first illustrated daily newspaper, on its inception in 1890. He and A. C. CORBOULD became the leading artists on that paper, founding a *Daily Graphic* school of pictorial news reporting, his own speciality being parliamentary scenes. In 1891 he started an association with *Punch* that lasted until 1937, his social cartoons being drawn with a sure line and expressing an orthodox humour. He also contributed to *Pearson's* and the *Strand*. An exceptional draughtsman in pen, pencil and wash, Cleaver developed a style of shading with parallel lines in place of cross-hatching that reproduced

to excellent effect on all qualities of paper and was widely influential.

PUB: *A Winter Sport Book* (1911), *Included in the Trip* (1921)

ILL: *Humorous Tales from Rudyard Kipling* (1931)

COLL: V&A SH

CLUFF – see Longstaff, John

COLE, Richard Anthony (b. 1942). Editorial cartoonist, caricaturist, illustrator, painter and sculptor. Richard Cole was born on 19 August 1942 in Wimbledon, London, the son of an ecclesiastical woodcarver. He began illustrating covers for *Audio Record Review* (later *Hi-Fi News*) in 1957 when still at school and later attended Wimbledon School of Art (1960–3) and Brighton College of Art (1964). Between 1965 and 1970 he taught art at France Hill Comprehensive School, Camberley, Surrey, and Woking Grammar School and his first political caricatures appeared in *Kingston Borough News* in 1970. Full-time freelance work followed with profiles and political cartoons for *The Times* (1973–87), daily TV caricatures for the *Daily Express* (1978–80), caricatures and illustrations for the book pages of the *Daily Telegraph* (from 1988) and editorial/political cartoons, caricatures and general illustrations for the *Sunday Times* since 1973. Other work has included illustrations for BBCTV's 'Tonight' and 'Panorama' programmes

Richard Cole, [Robert Maxwell], *Daily Telegraph*, 1988

and Channel 4 News. In addition he has been CBS News Contract Artist since 1983, covering parliamentary debates, criminal trials etc. At first influenced by the German Expressionists and DAVID LOW, in the 1980s he began a series of woodcuts, the discipline of this technique having a dramatic effect on his work. He abandoned the use of steel nib and cross-hatching and developed a much simpler linear style with brush and ink. Cole also works in black conté and watercolour.

EXHIB: Heffers Gallery, Cambridge; Edwin Pollard Gallery MB

COLLET, John (*c.* 1725–80). Painter and caricaturist. Collet was born in London, studied art at St Martin's Lane School and became a pupil of George Lambert and possibly of HOGARTH. His watercolour pictures – exhibited at the Free Society (1761–83) – were mostly scenes from contemporary middle-class life and sporting subjects, treated in a quietly comic fashion that was far removed from the powerful satire of Hogarth. Many of these pictures were engraved as mezzotints for the printseller Carington Bowles and had a great vogue in plain and hand-coloured versions. Collet was a member of the Beefsteak Club and late in life received a handsome legacy from a relative. He died at his house in Cheyne Row, Chelsea.

COLL: BM; V&A; HM the Queen SH

COLLIER, John 'Tim Bobbin' (1708–86). Caricaturist and author. John Collier was born in Urmiston, Lancashire, on 16 December 1708, the son of a poor curate. In 1729 he became a teacher and from 1739 to 1786 was master of Milnrow School, Rochdale, Lancashire. He wrote satirical poems in the Lancashire dialect under the pseudonym 'Tim Bobbin' (1739–71). An amateur painter too, he used to decorate tavern walls with grotesque figures and in 1772–3 issued a series of 26 grotesque engravings entitled 'The Passions Humorously Delineated by Tim Bobbin'. These, despite the crude drawings, proved popular and were reprinted in book form in the 19th century. Collier also drew a few social caricatures published by DARLY. He died in Milnrow on 14 July 1786.

PUB: *A View of the Lancashire Dialect* (1746), *The Passions Humorously Delineated by 'Tim Bobbin'* (1772–3)

COLL: BM SH

COLLINGS, Samuel (fl. 1780–d. 1793). Painter, caricaturist and author. In the 1780s and early

90s Collings contributed caricatures, mostly political, to the *Wits Magazine*, the *Carlton House Magazine* and the *Attick Miscellany*. He was a drinking companion of ROWLANDSON, who in 1786 engraved a series of 20 humorous plates after his designs for *The Picturesque Beauties* of Boswell, a work that was reprinted in the late 19th century. Some of the lively originals are in the V&A. Other caricatures signed 'Annibal Scratch' have been attributed to Collings. For a time he was Editor of the *Public Ledger* and wrote satirical verses. He died in 1793 on the steps of a hotel in Soho.

ILL: *Six Illustrations to Roderick Random* (1800)
EXHIB: RA
COLL: BM; V&A
LIT: J. Riely, *Samuel Collings's Designs for Rowlandson's Picturesque Beauties of Boswell* (1975) SH

COLLINS, Clive Hugh Austin (b. 1942). Editorial cartoonist, caricaturist, illustrator and comic artist. Born in Weston-super-Mare, Avon, on 6 February 1942, Clive Collins studied graphic design at Kingston School of Art (1958) and worked in marine insurance, as a film extra, helped to run a film studio and repped for a small artwork studio before becoming Editorial and Political Cartoonist – together with PAUL RIGBY – on the *Sun* (1969). He left in 1970 to become the first ever Political Cartoonist on the *People*, returning to the *Sun* in 1971 on the death of GORDON HOGG to become 'Lucky Jim', a cartoon racing-tipster (1971–85). During the same period he also became stand-in cartoonist for FRANKLIN on the *Sun* and JAK on the *Evening Standard* (adopting the pseudonym 'Ollie' for the latter work during the Falkands War). He has been Deputy Editorial Cartoonist (under GRIFFIN) on the *Daily Mirror* since 1985 and has also been sports illustrator for the paper's Mike Langley column since 1991. In addition he has illustrated the *Reader's Digest* 'Buy-Lines' advertising feature since 1985, contributes a weekly topical sporting cartoon to *Sporting Life* and has free-lanced for *Punch* (1964–92), Shell UK house magazine, *Daily Mirror*, *Oui*, *Mad*, *Odds On*, *Squib* and *Playboy* (USA). Other work has included occasional copywriting, scriptwriting, audio-visual work, greetings card designs etc.

Clive Collins, *Squib*, 1993

Chairman of the CCGB (1990–4), and Editor of the Club's newsletter (1987–94), he has won numerous awards including First Prize at international cartoon competitions in the UK (Glen Grant Cartoonist of the Year, 1979); Knokke-Heist, Belgium (1982); Montreal (1984); Skopje, Macedonia (1986); Amstelveen, Netherlands (1987) and nine medals for the annual Japanese Yomiuri Shimbun competition since 1980. He was voted CCGB Cartoonist of the Year in 1984, 1985 and 1987, and has been on the judging panels of many international competitions, being elected President of the International Salon Jury in Montreal in 1985. Influenced by GILES, STARKE, George Price, Charles Addams, R. B. Wilson and George Booth, he is a particular admirer of CHARLES GRAVES. Clive Collins draws roughs in pencil, then works with a 0.5 Pilot Marquer à Dessin, using a Speedball A5 pen to 'heavy' the lines if required. For expansive line work he uses a 00 sable brush, gouache colours or inks, and Rotring black.

PUB: *Montreal Cartoonist of the Year* (1985), *Handbook on Sailing and Watersports* (1989)
ILL: G. Bel, *The Joys of Moving Home* (1989); J. McCulloch, *Sir Edward and Nimrod* (1989); J. Pascoe, *The Idiot's Guide to Sex* (1991), *1992 and All That* (1991); E. Laine, *A Hard Man is Good to Find* (1988)
EXHIB: Central Library, Margate; BC; CG
MB

CONCANEN, Alfred (1835–86). Illustrator and lithographer. Alfred Concanen's family came from Galway, Ireland, his father being an artist or entertainer. Recognized as the leading illustrator of sheet music covers of his day (*c.* 1860–85) he drew either straight portraits of music-hall stars or humorous genre scenes, mainly of London outdoor life. As a skilled lithographer drawing on stone, some of his work shows considerable gifts in composition and in the restrained use of colour, besides providing insights into the jollier aspects of Victorian life.

ILL: H. S. Leigh, *Carols of Cockayne* (1869); J. Greenwood, *The Wilds of London* (1874); *Low Life Deeps* (1876); W. E. Windus, *Broadstone Hall* (1875)
LIT: R. Pearsall, *Victorian Sheet Music Covers* (1972)
COLL: V&A
SH

COOKSON, Bernard (b. 1937). Editorial cartoonist and illustrator. Born in Manchester on 3 January 1937, Bernard Cookson attended Manchester Art School (1953–6) and was a visualizer in an advertising agency before doing his National Service as a Photographic Interpreter with the RAF in Cyprus. He became a freelance cartoonist in 1967, succeeded DAVID MYERS on the *Evening News* as Social/Political Cartoonist (1969–76), and took over the TV strip 'The Niteleys' from ERIC BURGIN on the *Daily Sketch*. Influenced by Eric Burgin, he has also contributed to *Punch*, *Spectator*, *Today* and the *Sun*. He is also a former committee member of the Cartoonists' Club of Great Britain.

PUB: *Till Divorce Us Do Part* (1976), *Cookson's Wine Lovers* (1993)
ILL: H. Vickers & C. McCullough, *Great Country House Disasters* (1982); J. Timpson, *The Lighter Side of Today* (1983); W. Donaldson, *Great Disasters of the Stage* (1984); S. Tumin, *Great Legal Fiascos* (1985)
MB

CORAM, Robert S. E. 'Maroc' (fl. 1930s–40s). Cartoonist, strip cartoonist and pocket cartoonist. Robert Coram was the son of an advertising man and attended St Dunstan's School, Catford, London. He studied at Goldsmith's College in the evenings while working for a papermaking firm. He served in the Fire Service in World War II. Maroc contributed regularly to *Punch*, *London Opinion*, *Blighty*, *Children's Own Favourite*, *Men Only* and *Razzle*, and drew pocket cartoons for the *Evening Standard*.

PUB: *Recipe for Laughter* (1945)
MB

CORBOULD, Alfred Chantrey RBA (1852–1920). Cartoonist, graphic journalist and painter. A. C. Corbould was the son of a portrait painter and the nephew of CHARLES KEENE. There were other painters in the family, too, but despite this he was self-taught as an artist. He was a regular contributor of cartoons to *Punch* on hunting and countryside topics from 1871. In 1890 he joined the *Daily Graphic* as a pictorial journalist covering with distinction a wide range of subjects. He also contributed cartoons, mostly sporting, to *Black & White*, *Cornhill*, *Fun*, *Illustrated Police News*, *London Society*, *New Budget*, *Pick-Me-Up*, *St James's Budget* and *St Paul's*. His drawing style owed something to RANDOLPH CALDECOTT and his sporting jokes were in the LEECH tradition. He was elected RBA (1893).

PUB: *The Corbould Sporting Alphabet* (1900)
ILL: E. O'Reilly, *Dinglefield* (1883), *Kingie* (1886), *Kitty's Adventures* (1886); N. O'Donoghue, *The Common Sense of Riding:*

Riding for Ladies (1887); H. S. Pearse, *The 'Comet' Coach* (1895)
COLL: V&A SH

COWHAM, Hilda Gertrude (1873–1964). Illustrator, cartoonist, poster and postcard designer, and painter. Hilda Cowham was the daughter of a Professor of Education. After attending Wimbledon College she studied at Lambeth School of Art and the RCA and contributed cartoons to *Pick-Me-Up* and the *Sketch* while still a student. She later appeared in the *Girl's Realm, Graphic, Little Folks, Pearson's, Printer's Pie, Queen, Tatler* and the *Windsor Magazine* and was one of the few women artists to be published in *Punch*. From the start her cartoons, postcards and humorous illustrations, almost always of children, were distinctive; she habitually drew with the brush rather than the pen and her lacy, calligraphic style has echoes of Japanese prints and the great French cartoonist, Forain. She was said to have popularized children with thin black legs. Although a prolific illustrator she also found time to paint landscapes and interiors in watercolour and to etch. She was married to the painter Edgar Lander.
PUB: *Fiddlesticks* (1900), *Peter Pickle and His Dog Fido* (1906), *Blacklegs* (1911), *Curly Heads and Long Legs* (1914)
ILL: E. Player, *'Our Generals'* (1903); A. Golsworthy, *Ping Pong People* (*c.* 1905); J. Lea, *Willie Wimple's Adventures* (1908); R. Jacoberns, *The Record Term* (*c.* 1910); P. Morris, *The Adventures of Willy and Nilly* (1921)
EXHIB: RA; RI; WG
COLL: V&A SH

CRANE, Walter RWS ROI (1845–1915). Painter, illustrator, decorator, designer, art-educator, author, political cartoonist. Walter Crane was born in Liverpool on 15 August 1845, the son of Thomas Crane the portrait miniaturist. In 1857 he moved to London to become apprenticed for five years to W. J. Linton, the wood engraver, who not only gave him a thorough grounding in the theory and practice of illustration but encouraged his interest in politics. At the age of 17 he was considered a child prodigy and his reputation was confirmed by the 36 *Toybooks* he designed in strong outline and clear bright colours that were printed from wood blocks by Edmund Evans (1865–76). His interest in politics was stimulated by William Morris with whom he co-operated on various decorative projects. He joined the Socialist League (1883), the Fabian Society

(1885) and contributed cartoons to the socialist periodicals *Justice, The Commonweal* and the *Clarion,* some of which were reprinted in *Cartoons for the Cause* (1896). These cartoons are altogether too decorative, too sentimental and too crowded to be convincing. Much more attractive are the humorous drawings he made from time to time for private circulation. Crane was at the forefront of the Arts & Crafts movement, becoming President of the Royal College of Art (1898–9) and being elected RI (1882, resigned 1886), ROI (1893) and RWS (1899). His work as an educator was supplemented by his copious writings on art which influenced many contemporaries, notably AUBREY BEARDSLEY. He died in Kensington on 14 March 1915.
PUB: *Walter Crane's New Toybook* (1874), *The Baby's Opera* (1877), *The Baby's Bouquet* (1878), *Pan Pipes* (1883), *Flora's Feast* (1889), *Queen Summer* (1891), *The Claims of Decorative Art* (1892), *Of the Decorative Illustration of Books Old and New* (1896), *Line and Form* (1900), *A Flower Wedding* (1905), *An Artist's Reminiscences* (1907)
ILL: R. Wise, *The New Forest* (1863), *The First of May* (1881); Mrs Molesworth, *Grandmother Dear* (1878), *Rosy* (1882), *Us* (1883); *The Rectory Children* (1889); W. Morris, *The Story of the Glittering Plain* (1894); E. Spenser, *The Faerie Queen* (1895), C. Lamb, *A Masque of Days* (1901)
EXHIB: RA; OWS; NWS; RI; DG; GG; FAS (1891)
COLL: BM; V&A; C; A; F
LIT: P. G. Konody, *The Art of Walter Crane* (1902); R. Engen, *Walter Crane as a Book Illustrator* (1975); I. Spencer, *Walter Crane* (1976)
 SH

CRAWHALL, Joseph the Elder (1821–96). Illustrator, author and amateur cartoonist. Joseph Crawhall was born in Newcastle, inherited a rope-making factory and developed other business interests including coalfields and canals. He had a lifelong enthusiasm for the production of books and put together several published by the Leadenhall Press which he illustrated with his own quaintly humorous woodcuts coloured by hand. This form of whimsical archaism influenced other artists – like William Nicholson and Claud Lovat Fraser – to experiment with woodcuts. In 1872 he met CHARLES KEENE and during their ensuing friendship supplied him with sketches for cartoons and ideas for jokes, Keene making use of around 150 subjects.

PUB: *The Compleatest Angling Book that Ever was Writ* (1859), *A Collection of Right Merrie Garlands* (1860), *Border Notes and Mixty Maxty* (1880), *Chap Book Chaplets* (1883), *Olde Tayles* (1883), *Isaak Walton: His Wallet Booke* (1885)

COLL: BM; NEW; G

LIT: C. S. Felver, *Joseph Crawhall the Newcastle Wood Engraver* (1972) SH

CROMBIE, Charles M. (1885–1967). Cartoonist, illustrator and commercial artist. In the early part of the 20th century Charles Crombie contributed joke cartoons to the *Bystander, Graphic, Holly Leaves, Humorist, London Magazine, Pearson's, Printer's Pie, Royal Magazine, Sketch, Golf Illustrated* and the *Strand Magazine* (in which he illustrated stories by P. G. Wodehouse in the 1920s). He is best known for his sporting subjects, especially the coloured lithographs he drew in 1905–6 on the humours of golf, cricket and motoring. The series on golf, commissioned by Perrier (1905), featured Puritans in Jacobean clothes and was later used on postcards and as transfer-printed decorations on a range of pottery made by Royal Doulton. Crombie painted in the popular style of JOHN HASSALL – heavy outlines with broad masses of colour – shared the Hassall sense of humour and may well have been his pupil.

PUB: *Some Classic Rules of Golf* (1905), *The Laws of Cricket* (1906), *Motoritis* (1906), *Simple Simon and his Friends* (1906)

ILL: J. Sherratt, *The Goblin Gobblers* (1910); W. M. Thackeray, *Vanity Fair* (1924); J. Allan, *The Canny Scot* (1932)

EXHIB: BUR SH

CROQUIS, Alfred – see Maclise, Daniel

CROWQUILL, Alfred – see Forrester, Alfred Henry

CRUIKSHANK, George (1792–1878). Illustrator and caricaturist. George Cruikshank was born in Bloomsbury, London, on 27 September 1792, the son of ISAAC CRUIKSHANK and the younger brother of ROBERT CRUIKSHANK. Having been taught to draw and etch by his father, he was designing lottery tickets aged eight and in 1806

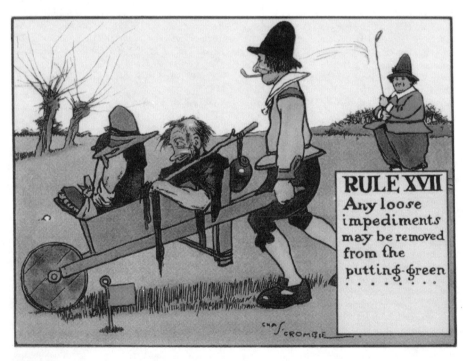

Charles Crombie, *Some Classic Rules of Golf* (1905)

his first caricature was published. His early work was very much in the manner of GILLRAY, some of whose unfinished plates he later completed. He contributed etched caricatures to the *Scourge* (1811–6) generally more artistic but no less scurrilous than the work of his rivals. This scurrility was maintained in his wood-engraved illustrations to the pamphlets of Hone which ridiculed George IV (1819–21), and the bribe which the King paid to 'show him no more in immoral situations' was not honoured for long. By this time he was the leading caricaturist of his day, Gillray being dead and ROWLANDSON engaged in book illustration. He excelled as much in social caricatures (sometimes based on the ideas of others) as in political, his highest achievement in this field being the satires on extremes of fashion that he called 'Monstrosities' (1816–29). Following the success of his plates in *Life in London* (1821) he turned increasingly from caricature to illustration, issuing collections of his own comic drawings and visual puns like *Scraps and Sketches* (1828–32) interspersed with serious illustration for authors (and friends) like Dickens and Ainsworth. The publication of 'The Bottle' in 1847, a series of plates indicting the evils of drink, heralded his conversion to the cause of Total Abstinence which from then on absorbed much of his energies. He died in London on 1 February 1878 and is buried in St Paul's Cathedral – in recognition of his work for Temperance. Although his work went out of fashion well before his death Cruikshank, as the premier illustrator and comic artist of the 1820s and 30s, had a great influence on men like PHIZ and LEECH and was desperately (and unsuccessfully) sought after by *Punch*. His forte was small-scale etchings of London life, treated with the sort of grotesque humour which has only recently returned to favour. As Baudelaire remarked, his distinctive quality is 'an inexhaustible abundance of grotesque invention'.

PUB: *Phrenological Illustrations* (1826), *Illustrations of Time* (1827), *My Sketch Book* (1833–4), *Cruikshankiana* (1835), *The Comic Almanack* (1835–53), *George Cruikshank's Omnibus* (1841), *The Bachelor's Own Book* (1844), *George Cruikshank's Table Book* (1845), *George Cruikshank's Fairy Book* (1853–4).

ILL: Many books including W. Combe, *The Life of Napoleon* (1815); W. Hone, *The Political House that Jack Built* (1819); D. Carey, *Life in Paris* (1822); H. Southern, *Points of Humour* (1823–4); J. & W. Grimm, *German Popular Stories* (1823); A. von Chamisso, *Peter Schlemihl*

(1824); C. Dickens, *Sketches by Boz* (1836), *Oliver Twist* (1838); *The Loving Ballad of Lord Bateman* (1839); H. Ainsworth, *The Tower of London* (1840); R. Brough, *The Life of Sir John Falstaff* (1858)

EXHIB: V&A (1974); Touring Exhibition, 'Cruikshank 200' (1992–3)

COLL: V&A; BM; T; BGM; Manchester; Louisville and Princeton Universities; New York Public Library

LIT: A. M. Cohn, *George Cruikshank: A Catalogue Raisonné* (1924): J. Wardroper, *The Caricatures of George Cruikshank* (1977); M. Bryant (ed.), *The Comic Cruikshank* (1992); R. L. Patten, *George Cruikshank's Life Art and Times* (Vol. 1, 1992) SH

CRUIKSHANK, George Junior (1842–after 1894). Cartoonist. George Cruikshank Junior was born on 13 December 1842, the son of PERCY CRUIKSHANK and the great nephew of GEORGE CRUIKSHANK, whose style he imitated on occasion, causing family disputes. He contributed cartoons and illustrations to *Aunt Judy's Magazine, Beeton's Annual, Father Christmas Annual, Fun, Hornet, London Society* and the *Torch*. Many of his drawings are excessively crowded. He was gazetted bankrupt in the 1860s.

ILL: S. Novello, *The History of Bluebeard's Wives* (1875)

COLL: V&A SH

CRUIKSHANK, Isaac (1764–1811). Caricaturist, illustrator and painter. Isaac Cruikshank was born in Edinburgh on 5 October 1764, the son of a customs inspector turned book- and printseller, and came to London (*c*.1784) where he married a fellow Scot (1788). By 1789 he was into his stride as a caricaturist, concentrating on political satires and working mainly for the publisher Fores. His most productive period was 1793–7 when he was averaging a plate a week and had acheived a position second only to GILLRAY and ROWLANDSON. Besides his own caricatures he etched the satirical designs of amateurs like G. M. WOODWARD (what his son George called 'taking in other people's washing') and illustrated books, chapbooks, broadsides and songsheets. He also painted in watercolour, exploiting a taste for the humour of graveyards and ghosts. In everything the quality of his work was variable; at his best, as in some of his many caricatures of Napoleon, he produced forceful and imaginative prints, but at other times he was derivative or purely spiteful. After 1800, probably due to

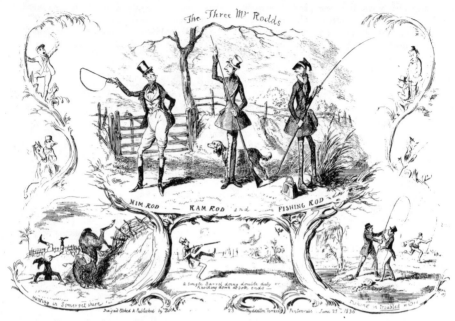

George Cruikshank, *My Sketch Book* (1833)

alcohol, his output declined and deteriorated. He died in early April 1811 after a drinking bout.
PUB: *The Cruikshankian Momus* (1892)
ILL: *The Attick Miscellany* (1790–1); *Beautiful Extracts* (1794–5); *London, a Fortnight's Ramble* (1795); J. Wallace, *Savillon's Elegies* (1795); G. Shaw, *General Zoology* (1800–26)
COLL: BM; V&A; CAT; F
LIT: E. B. Krumbhaar, *Isaac Cruikshank: A Catalogue Raisonné* (1966) SH

CRUIKSHANK, Isaac Robert (1789–1856). Caricaturist, illustrator and portrait miniaturist. Robert Cruikshank was born in London on 27 September 1789, the eldest son of ISAAC CRUIKSHANK and the brother of GEORGE CRUIKSHANK. After his schooling he went to sea as a midshipman (*c*.1804) and returned in 1806 having been presumed lost. Then, besides helping his father in etching, he embarked on a short career as a portrait miniaturist. His first caricatures appear around 1810. They were often produced in conjunction with his brother George and the two shared a studio where bucks and sportsmen, especially the leading prize-fighters, were made welcome. This gave them the background knowledge which helped to make their illustrations

to *Life in London* (1821) such a huge success. As a caricaturist Robert, although a skilful draughtsman, worked in the same style as George and was rather overshadowed by him, especially in political satires. Of his social satires, those he made of the dandies and the fashion for 'hobby horses' in the early 1820s are amongst the most attractive. After 1830 he drew few caricatures and turned to book illustration for which at first he was much in demand. When he died, on 13 March 1856, he was poor and largely forgotten.
PUB: *Comicalities* (1830), *Facetiae* (1831–4), *Cruikshank at Home* (1834)
ILL: P. Egan, *Boxiana* (1812), *Life in London* (1821), *Sporting Anecdotes* (1825), *The Finish to the Adventures of Tom, Jerry and Logie* (1830); C. Westmacott, *Points of Misery* (1823), *The English Spy* (1825), *The Punster's Pocket Book* (1826); *The Universal Songster* (1825); ' Paul Pry ', *Oddities of London Life* (1838); M. H. Barker, *The Old Sailor's Jolly Boat* (1844); C. W. Manby, *Tom Racquet and his Three Maiden Aunts* (1848)
COLL: BM; V&A
LIT: W. Bates, *George Cruikshank ... With Some Account of His Brother Robert* (1878) SH

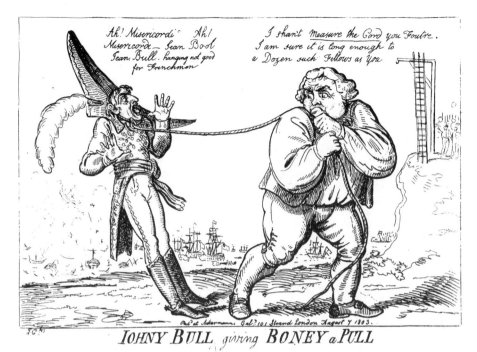

IOHNY BULL giving BONEY a PULL

Isaac Cruikshank, [Napoleon], 1803

CRUIKSHANK, Percy (1817–after 1871). Illustrator and cartoonist. Percy Cruikshank was born in Holborn, London, on 8 May 1817, the son of ISAAC ROBERT CRUIKSHANK. In 1842 he signed some wood engravings 'Cruikshank the Younger' which led to a strong (and eventually successful) protest from his uncle GEORGE CRUIKSHANK. His lithographs for *Sunday Scenes in London and the Suburbs* were published in 1854 and in the early 1860s he illustrated in colour 58 Toy and Story Books and some Panoramic Books for the publishers Read & Co. He wrote an unpublished memoir of the lives of George and Robert Cruikshank which is in the library of Princeton University, USA.
PUB: [panorama] *The Comic History of the Russian War* (c.1851), *Percy Cruikshank's Comic Almanack* (1865), *Panorama of the Franco-Prussian War* (c. 1871)
COLL: BM SH

CRUM, Paul – see Pettiward, Roger

CUMMINGS, Arthur Stuart Michael, OBE (b. 1919). Editorial cartoonist, caricaturist.

Michael Cummings was born in Leeds on 1 June 1919, the son of A. J. Cummings, Political Editor of the *News Chronicle*. He was educated at The Hall, Hampstead, and Gresham's, Holt. After attending Chelsea School of Art (1945–8), where he was taught by Graham Sutherland and specialized in etching, he was Political Cartoonist on *Tribune* (1948), *Daily Express* (1949–90) and *Sunday Express* (1958–90). He has also worked freelance for *Punch* (1953–8), *Daily Mail* (from 1990), *Oldie* (from 1992), *Paris-Match*, *L'Aurore* and *Candide*. In addition, he taught art for a short while at St Albans Girls' Grammar School. Cummings roughs out his cartoons in pencil on A3 layout paper and uses a dip pen and brush with Pelikan ink on Daler board (half imperial size) for the finished work. Described by ACANTHUS as having 'an unusual staccato line' with a lot of solid black areas, Cummings was Churchill's favourite cartoonist. He was awarded an OBE in 1983.
PUB: *These Uproarious Years* (1954), [with M. C. Hollis] *The Ayes and the Noes* (1957), *How to Become an MP* (1959), *On the Point of My Pen* (1985)

53

ILL: T. Arthur, *Ninety-five Per Cent is Crap* (1975)
EXHIB: GG; HAM

COLL: UKCC MB

CYNICUS – see Anderson, Martin

D

DANCE, George the Younger RA (1741–1825). Architect, portrait draughtsman and caricaturist. George Dance was born in London, the son of George Dance the Elder, a mason turned architect, and the brother of NATHANIEL DANCE. He studied architecture in Rome (1758–64). On his father's death in 1768 he succeeded him as the City of London's Clerk of the Works and in the same year he became a foundation member of the RA, the portrait drawings he made of his fellow Academicians in the 1790s being engraved and published. As well as portraits, George Dance made a number of accomplished comic drawings in ink and pencil, including some caricatures, which reveal considerable powers of humorous invention. Unfortunately, from the point of view of attribution they are virtually indistinguishable from those of his brother Nathaniel. He was Professor of Architecture at the RA (1798–1805) and retired in 1815. He died on 14 June 1825.
PUB: *A Collection of Portraits Sketched from the Life Since 1793* (1808, 1814)
EXHIB: WD; GM 'George Dance' (1972)
COLL: BM; V&A; RA; NPG; HM the Queen; A
LIT: D. Stroud, *George Dance, Architect* (1971)
 SH

DANCE, Nathaniel [later Sir Nathaniel Dance Holland Bt] RA (1735–1811). Portrait and history painter, and comic draughtsman. Nathaniel Dance was born in London on 18 May 1735, the son of George Dance the Elder, architect, and the brother of GEORGE DANCE THE YOUNGER. He was educated at Merchant Taylors' School then became a pupil of Francis Hayman RA. He had a prolonged period of study and painting in Italy (1754–65 or slightly later) before returning to England and taking part in the activities which led to the formation of the RA of which he was a founder member (1768). In 1782 he gave up professional painting, married a rich widow the next year and became MP for West Grinstead in 1790. The comic portrait drawings he made over the years are very difficult to distinguish from the work of his brother George but those which are undoubtedly by him are excellent in conveying

character. Two of them were etched by GILLRAY and may well have played a part in converting him from the emblematic tradition to portraits in caricature. Nathaniel Dance added the name 'Holland' to his own in 1800, the year he was created a baronet. He died on 15 October 1811.
EXHIB: WD; KH 'Nathaniel Dance' (1977)
COLL: BM; V&A; NPG; RA SH

DARLY, Mary (fl. 1756–77). Printseller and caricaturist. Mary Darly was the wife of MATTHEW DARLY, the London printseller, and in the 1760s had her own shop in Leicester Fields, London (now Leicester Square). In 1762 she published and apparently illustrated a manual on caricature which she recommended as 'a diverting species of designing that will certainly keep those that practise it out of the hipps or vapours'. She etched a portrait of David Garrick and dedicated to him the title page she drew for a set of 'Darly's Comic Prints' (1776). Her husband drew an affectionate caricature of her titled 'A Female Conoiseur [*sic*]' (1772).
PUB: *A Book of Caricatures . . . with ye Principles of Designing in that Droll and Pleasing Manner* (1762)
COLL: BM SH

DARLY, Matthew (fl. 1750–88). Printseller, caricaturist, engraver and drawing master. Matthew Darly was the leading publisher of political caricatures of his day (*c.* 1755–65). In 1756 he co-operated with GEORGE TOWNSHEND in pioneering a new form of print, 'cards', that were mounted on pasteboard and small enough to send through the post. In 1766 he abandoned politics for personal caricatures, specializing in the 'Macaroni', the dandies of the day, and encouraging amateurs to send him their 'hints and sketches' for engraving. He became dominant in this field too, publishing in the 1770s sets of 'comic Prints of Characters, Caricatures, Macaronis etc.', many designed by himself, and holding an exhibition of them in his London shop (*c.* 1773). He was married to the printseller and caricaturist MARY DARLY.

BUCKLES AND BUTTONS
I AM THE THING, DEM—ME.

Matthew Darly, [a Dandy], 1777

ILL: G. Edwards, *A New Book of Chinese Designs* (1754); R. M. Lesuire, *The Savages of Europe* (1764)
COLL: BM SH

DAVIDSON, Lilli Ursula Barbara Victoria FSIA (b. 1915). Humorous illustrator and cartoonist. 'Victoria' (as she signs her work) was born in Munich on 8 January 1915, the daughter of painter Armin Commichau, and studied at the Lette Haus in Berlin under Siebert-Wernekink. She was a regular contributor of cartoons and illustrations to *Lilliput* (including covers and 'Gulliver's Diary'), *Picture Post* (readers' letters, 1937–57) and *Radio Times* (1947–62). She has also contributed to the *Daily Sketch*, *The Bureau of Current Affairs*, COI, *Die Neue Auslese* and *Süd Deutsche Zeitung*. In addition she has drawn for advertising campaigns for Stock Brandy, Nestlé, Guinness, Kelloggs, Persil and the GPO, and has designed posters for London Transport. In the 1960s she produced three-dimensional fabric collages in the spirit of Victorian decoration

and has just finished writing and illustrating a book on cats (1993).
PUB: *A Number Book* (1938), *Life and Adventures of Timothy Turnip* (1943), [with Rachel Ferguson] *Memoirs of a Fir-Tree* (1946)
ILL: *Latham's Nonsense Verses* (1948)
COLL: Museum of Modern Art, New York
 MB

DAVIES, Robert Russell (b. 1946). Journalist, broadcaster, actor and caricaturist. Russell Davies was born on 5 April 1946 in Barmouth, Merionethshire, and educated at Cambridge University. He has been a freelance journalist and broadcaster since 1970. His work for the BBC has included the presentation of the TV arts programme, 'Saturday Review' as well as BBC2 jazz programmes and writing and presenting a history of radio comedy for Radio 4. He has also been acting editor of *Punch* and worked for *Observer* and other newspapers and magazines. Russell Davies has been cartoonist on *Liberal News* and resident caricaturist on *Times Literary Supplement*.
PUB: [with L. Ottaway] *Vicky* (1987), *Ronald Searle* (1990); (ed.) *The Diaries of Kenneth Williams* (1993); (ed.) *The Kenneth Williams Letters* (1994)
ILL: C. James, *Peregrine Prykke's Pilgrimage* (1976) MB

DAVIS, Roy (b. 1921). Cartoonist, strip cartoonist and scriptwriter. Roy Davis was born in London on 9 October 1921 and attended West Kensington Central School. His first job was as a wallpaper designer with A. Sanderson's Studio from 1938 and he had his first cartoon published in *Answers* in 1939. He joined the RAF in 1940 and was commissioned in the RAF Regiment in 1944, serving in France, Holland, Germany, India and Java. After the war he rejoined Sandersons briefly, leaving to join GB Animation in Cookham as a storyman (1946–50). On the company's demise he became a freelance cartoonist, his work appearing in *Tatler*, *Punch*, *Tit-Bits*, *Daily Sketch*, *Daily Mirror* and *Sporting Record*. During this period he also wrote and drew strips for juvenile publications such as *Mickey Mouse Weekly*, *Sun*, *Comet* and *Sunny Stories* and in 1964 he joined the staff of IPC Magazines, writing scripts for *Whizzer & Chips*, *Shiver & Shake*, *Knockout*, *Princess Tina*, *Buster* and others. He left IPC in 1974 but continued to produce scripts on a freelance basis for the company until 1992. A founder member of the

Cartoonists' Club of Great Britain, he was voted Top Scriptwriter (1979) by the Society of Strip Illustrators. Influenced by HEATH ROBINSON and EMETT, he works mainly in pen and ink (though his scrap-metal sculptures have appeared twice on BBCTV's 'Vision On' programme). MB

D'EGVILLE, Alan Hervey FRGS, FCI (1891–1951). Cartoonist, illustrator and writer. Alan d'Egville was born on 21 May 1891, the son of Louis d'Egville of the Academy of Dramatic Art who taught dancing and deportment to royalty, and maternal grandson of the painter John Dawson Watson RWS. Educated in Berkhamsted (Hertfordshire), France, Germany and Spain, he studied motoring at Daimler, Paris (1912), and taught the tango at his father's academy before working as private secretary to the chairman of Rolls-Royce. Meanwhile, he had subscribed to PERCY BRADSHAW's Press Art School and was studying for the Indian Civil Service when World War I broke out. Enlisting as an interpreter, he transferred to the Intelligence Department, where he was mentioned in despatches and became Chief Intelligence Officer, 4th Corps. After the war he was a tour guide in the Near East for Arnold Lunn Travel, wrote and illustrated travel articles for *Britannia & Eve*, and contributed political caricatures to *Bystander*, theatrical cartoons to *Pan* and humorous drawings to *Sketch*, *Passing Show*, *Men Only*, *London Opinion*, *Tatler*, *Punch* and others. He briefly took over from HASELDEN on the *Daily Mirror* before a period of travel and travel writing, two years as a cartoonist in New York and Hollywood, and two years as a humorous columnist on *Daily Sketch*. In World War II he served in the Security Service, attaining the rank of major. After the war he contributed to *Life* and *Judge*, and wrote scripts for Fox Films, co-founded Kandahar Ski-racing Club and worked in advertising. An expert award-winning skiier (he taught King Albert of Belgium), he often drew on this subject. He died on 15 May 1951.

PUB: *S'No Fun* (1925), *Modern Ski-ing* (1927), *Slalom* (1934), [with G. D'Egville] *Darts with the Lid Off* (1938), *The Game of Ski-ing* (1938), [with K. R. G. Browne] *Huntin', Shootin' and Fishin'* (1939), *Brass Tacks for Britain* (1945), *Calling All Fly-Fishers* (1946), [with D. Rooke] *A Touch of the Sun* (1947), *Call Me Mister!* (1946), *Rude Health* (1948), *Let's Be Broad-Minded* (1948), *Calling All Coarse Fishers* (1949), *Calling All Sea Fishers* (1950); *Ski-ing* (1947), *Money for Jam* (1947)

LIT: *Adventures in Safety – an Autobiography* (1937) MB

DE LA NOUGEREDE, Alan Nightingale (b. 1932). Editorial cartoonist, strip cartoonist and caricaturist. Born in Nowgong, India, on 12 December 1932, the son of a forest officer in the Indian Civil Service and one of six brothers (Cedric Nightingale is a Sussex watercolourist), Alan de la Nougerede came to England on 27 March 1947. Self-taught, he studied oil painting and drawing with St John Earp and Cynthia Weller, sharing a studio with them. He was a professional accountant in the City and the provinces before becoming a full-time artist/cartoonist. Editorial cartoonist on the *People* (1986–8) he has also worked in advertising for Star Computers and Moores Rowland chartered accountants, amongst others, and freelanced as a strip cartoonist for the *Daily Express*, *Evening News* and *Post* and as a joke cartoonist for the *Sun*, *Daily Mirror*, *Daily Sketch*, *Daily Star*, *Mayfair*, *Fiesta*, *Penthouse* (USA), *Playboy*, *The Director*, *Certified Accountant*, *Accountants' Weekly*, *Listener*, *Weekend*, *Punch* (1970–92), *Private Eye*, *Oldie*, *Printing Industries*, *Ariel*

"IF YOU'VE GOT IT, FLAUNT IT,
I ALWAYS SAY !"

Alan de la Nougerede, *Private Eye*, 29 March 1991

(BBC staff magazine) and others. In addition he has drawn numerous caricatures on commission and at social functions. Working mostly with Rotring indian ink and a Gillot 1290 nib, and occasional watercolour (his early magazine work was drawn in coloured inks), he cites BILL TIDY as being the biggest influence on his humour and MIKE WILLIAMS and QUENTIN BLAKE on his art.
ILL: 'Septimus', *Newby Revisited* (1980), L. Hopkins, *Business Ratios* (c. 1980), *Credit Rating Reports* (1988)
EXHIB: [watercolours] Ebury St Gallery; Bayswater Rd MB

DE MORGAN, William Frend (1839–1917). Potter, novelist, inventor and comic artist. William de Morgan was born in London on 16 November 1839, the son of a Professor of Mathematics at University College, London. He was himself educated at University College before entering the RA Schools (1859). He then had a distinguished career as a potter and ceramic artist, which included his rediscovery of the lost process of making colour lustres, and a fruitful association with William Morris at Merton Abbey (1882–8). De Morgan had a delightful gift for nonsense and comic drawing which was expressed in letters to his close friends BURNE-JONES and Morris and to various children; it can also be seen in sketchbooks in the V&A. Lack of commercial success caused De Morgan to exchange pottery for a more profitable career as a novelist in 1905. He died on 15 January 1917.
PUB: *Joseph Vance* (1906), *Alice-for-Short* (1907), *Somehow Good* (1908), *It Never Can Happen Again* (1909), *An Affair of Dishonour* (1910), *A Likely Story* (1911), *When Ghost Meets Ghost* (1914), *The Old Madhouse* (1919)
ILL: M. de Morgan, *On a Pincushion and Other Fairy Tales* (1877)
COLL: V&A
LIT: A. Stirling, *William de Morgan and his Wife* (1922) SH

DENIM – see Joss, Frederick

DENT, William (fl. 1783–93). Caricaturist. William Dent was probably an amateur and nothing is known of his life. The political caricatures that he designed and etched (1783–93) were mostly published by himself and sold through printsellers. They are remarkable for their naif drawing and their pungency. His indecent caricatures of the Duchess of Devonshire canvassing in the Westminster election of 1784

were denounced at the time as 'filthy prints'. Some of his later plates, in drawing if not in taste, are a great improvement on the early work. Dorothy George wrote 'he had a gift for burlesque portraiture, uninhibited personalities and ribald comment which made his prints very popular'.
COLL: BM SH

DERRICK, Thomas (1885–1914). Illustrator, painter, art-teacher and cartoonist. Thomas Derrick was born in Bristol and studied at the RCA. In 1910 he exhibited his watercolours and later painted a number of murals. After the war he became well known for his illustrations to books and ephemera issued by the St Dominics Press and commercial publishers, especially for witty stylized wood engravings that typified the 'modern style', and for book jackets and bindings commissioned by Chatto & Windus. From 1932 he contributed charcoal sketches to *Punch* which in Price's words were 'quite unlike any of the main traditions of *Punch* draughtsmanship'; in some respects 'his work looked forward perhaps to the 1960s'. His drawings also appeared in the *Bookman*, *GK's Weekly*, *London Mercury*, *Sunday Express* and *Time & Tide*. He taught decorative painting at the RCA and his style influenced the caricaturist R. S. SHERRIFFS.
PUB: *Everyman* (1927), *The Prodigal Son and Other Parables* (1931), *The Muses* (1933)
ILL: J. de la Fontaine, *Les Fables* (1910); A. Bierce, *Battle Sketches* (1930); G. K. Chesterton, *The Turkey and the Turk* (1930); H. Belloc, *Nine Nines* (1931); C. Alington, *Cautionary Catches* (1931); S. L. Robertson, *The Shropshire Racket* (1937); Rev. A. Tooth, *The Pagan Man* (n.d.)
EXHIB: RA; NEAC; FAS
LIT: H. R. Westwood, *Modern Caricaturists* (1932) SH

DE WILDE, Samuel (1748–1832). Painter, printmaker and caricaturist. De Wilde was born in Holland and brought to London as a child by his widowed mother. He was apprenticed to a wood-engraver, then entered the RA Schools in 1769. During the early part of his career he made etchings and mezzotints after well-known artists but from 1795 he devoted himself to painting theatrical portraits in oil and watercolour, some of which now hang in the Garrick Club. The series of his political caricatures in the *Satirist* (1807–9), many signed 'T' or 'Thomas Scrutiny', vary in quality and are inferior to the plates in the same journal by the young GEORGE CRUIKSHANK published a few years later.

William Dent, [Duchess of Devonshire importuning a butcher], 1784

Apparently De Wilde attempted no more caricatures. He died on 19 January 1832.
EXHIB: RA; BI; SA
COLL: BM; V&A; A; GC SH

DICKENS, Frank William Huline (b. 1932). Strip cartoonist, illustrator and writer. Frank Dickens was born in Hornsey, North London, on 2 February 1932, the son of a painter and decorator. He went to Stationer's School, left at 16, and was a buying clerk in North London before becoming a racing cyclist (1946–70). A self-taught artist, he moved to Paris after National Service in Air-Sea Rescue and began selling cycling cartoons to *Paris-Match* and *L'Equipe* in 1959, followed by *Evening Standard*, *Daily Sketch* and *Daily Mirror*. He had his first strip – about a crook called Oddbod – accepted by the *Sunday Times* in 1960. Five times voted CCGB's Strip Cartoonist of the Year (1962, 1963, 1964, 1965, 1989), he is best known as the creator of Bristow, the bowler-hatted 'ineffectual rebel' with a toothbrush moustache who works in the offices of R. L. Chester-Perry Co. Ltd. Originally developed from a character in his book, *What the Dickens* (1961), the strip first appeared in the *Preston Journal* and other regional papers before being taken up by the *Evening Standard* on 6 March 1962. It has since been widely syndicated internationally and even produced on stage (ICA, 1971, starring Freddie Jones). Dickens' work has also appeared in *Daily Mail*, *Daily Express*, *Sunday Express*, *Sunday Times*, *Punch*, *Today* and *TV Times*, and he has worked in advertising for companies such as British Telecom, London Transport, Haig Whisky, Peugeot and Mercedes-Benz. In addition he has written two thrillers and a number of children's books. He used to work (without roughs) on CS10 Fashion Board with a dip pen, a No.8 Rapidograph and Pelikan ink, though nowadays he uses felt-tip pen. He also paints in watercolours and oils.
PUB: *What the Dickens* (1961), [R. Steadman ill.] *Fly Away Peter . . .* (1964), *The Great Boffo* (1972), *Boffo: the Great Air Race* (1976), *Boffo: the Motor Cycle Race* (1976), *Albert and the Space Rocket* (1978), *Albert Herbert Hawkins, the Naughtiest Boy in the World* (1980), *Albert and the Olympics* (1980), [novel] *A Curl Up and Die Day* (1980), *Teddy Pig* (1980), *Teddy Pig and Julia's Birthday* (1981), *The Golden Violin*, *The Naughty World of Albert Herbert Hawkins* (1990) plus 7 Bristow books from *Bristow* (1966)
ILL: C. Ward, *How to Complain* (1974), *Our Cheque is in the Post* (1980); M. Parkin, *Molly*

Frank Dickens, [Bristow], 1993

Parkin's Purple Passages (1979); N. Charles & J. James, *The Rights of Woman* (1990)
EXHIB: Belgrave Gallery MB

DICKINSON, Geoffrey Samuel (1933–88). Cartoonist, painter and art editor. Geoffrey Dickinson was born in Liverpool on 5 May 1933 and was educated at Southport School of Art (1950–3) and the Royal Academy Schools (1953–7). Originally intending to be a professional landscape painter, he taught art full-time at Tavistock Boys' School, Croydon (1957–8), and part-time at Selhurst Grammar School, Croydon (1958–67) – where pupils included MARTIN HONEYSETT – whilst freelancing for BBCTV, producing graphics and animation. A contributor to *Punch* since 1963 he won first prize at the International Federation of Periodical Publishers Congress in Rome in 1965 for his cover for the magazine and later joined the staff as Deputy Art Editor (1967) under BILL HEWISON, becoming a member of the *Punch* Table in 1969. In addition, he drew two covers for *Time* magazine (1966 and 1969) and contributed to *Reader's Digest*, *Which?*, *Esquire*, *Highlife*, Hallmark Cards and others. He left *Punch* in 1984 and joined the *Financial Times*, drawing daily pocket cartoons as well as humorous illustrations for the weekend supplement. An admirer of Cézanne, Japanese printmakers, FRANÇOIS, KEENE and LOW, he worked mostly in pen and ink but also used gouache, acrylics, watercolour, coloured inks, scraperboard, wood engraving, etching and oils. He died on 21 March 1988.
PUB: *There's a Lot of It About* (1985), *Probably Just a Virus* (1986)
ILL: S. Oram, *Starters Places – England* (1972);

'Oh God – it's his locum again'

Geoffrey Dickinson, *Probably Just a Virus* (1986)

D. Barlow, *Sexually Transmitted Diseases* (1979);
R. Morley, *Book of Bricks* (1978), *Book of Worries* (1979); H. Davies, *Father's Day* (1981); E. Prosser & A. O'Brien, *Learning to Drive with Hannah Gordon* (1975); R. Gordon, *Fifty Years a Cricketer* (1986), *Gordon in the Garden* (1987)
EXHIB: RA; RSBA; RE; CG
COLL: V&A; UKCC MB

DICKSON, Ian Oscar (1905–87). Cartoonist and illustrator. Ian Dickson was born in Dunedin, New Zealand, on 15 January 1905 and moved to Melbourne when he was aged eight. Largely self-taught as an artist, he later moved to Adelaide to work on the *Adelaide Register News Pictorial* as cartoonist and illustrator for a year before it folded. Moving again, he became staff artist on *Brisbane Telegraph* and produced illustrations for Queensland Government tourist brochures. He then emigrated to England where he sold work to *Razzle* and drew illustrations for film

companies. Then followed a period in Ceylon working for the *Times of Ceylon* and *Ceylon Observer* and then back to Britain and regular contributions to *Punch, London Opinion, Men Only* and *Blighty*. He also drew the 'Mum' weekly strip in *Sunday Graphic* for 15 years until the paper folded. During World War II he served in the RAF. Renowned for his pictures of glamour girls, he was influenced by the style of *Esquire* artists and particularly admired the work of John Held Jr and Russell Patterson. He died on 21 July 1987. MB

DIGHTON, Richard (1795–1880). Caricaturist. Richard Dighton was the son of ROBERT DIGHTON and successfully continued his father's series of mild caricatures of the leading figures of the day (1818–28). These small hand-coloured portrait etchings which depicted the subjects full-length and usually in profile, foreshadow the caricatures in *Vanity Fair*. They are generally rather stiff and

the most attractive are soldiers in uniform (the originals were bought by George IV). Dighton also etched a few anti-reform caricatures and some scenes of social comedy of which the best known are the set 'A London Nuisance' (1821) that were reprinted in *Cruikshankiana* (1835). He served in the Worcestershire Yeomanry (*c.* 1834) and some caricatures he made of his brother officers are in the Royal Library at Windsor. He died on 13 April 1880.

PUB: *The Mirror of Fashion* (1822)
ILL: *Real Life in London* (1821)
COLL: HM the Queen; BM; V&A; NPG; BN; A
LIT: D. Rose, *Life Times and Recorded Works of Robert Dighton . . . and Three of his Artist Sons* (1981) SH

DIGHTON, Robert (1752–1814). Caricaturist, actor, printseller and drawing master. Robert Dighton was born in London, the son of a tradesman (possibly a printseller). He entered the RA Schools in 1772 and exhibited his first watercolours at the RA in 1774. Carington Bowles, requiring a successor to COLLET, started to publish mezzotints after his watercolours in 1781, the series being continued by Bowles & Carver after 1793. These prints, for which Dighton is principally known, show scenes of contemporary life in London and the country featuring clerics, lawyers, doctors, soldiers, sportsmen, actors, harlots etc., generally impersonal and satirized with good humour. They give a vivid picture of the age and their effect owes more to contrasting planes of colour than to subtleties of line. He also drew a few political caricatures in the 1780s. As well as painting, Dighton often acted and sung at Sadler's Wells and other theatres, apparently giving his last performance in 1797. In the early 1790s he embarked on a series of mildly caricatured portrait etchings that was continued by his son, Richard. He confessed in 1806 to having stolen prints from the British Museum over a period of years but for some reason was not prosecuted.

PUB: *Caricatures of Celebrities and Remarkable Characters* (1812).
ILL: *Bell's Shakespeare* (1773–4)
EXHIB: RA; FSA
COLL: BM; V&A; NPG; A; B; BN; F; M; Yale
LIT: Sotheby's Catalogue 'Watercolours by Robert Dighton' (23 February 1978); D. Rose, *Robert Dighton* (1981) SH

DIZ – see Ardizzone, Edward Jeffrey Irving

DODD, Maurice Stanley (b. 1922). Cartoonist, strip cartoonist, illustrator, scriptwriter and author. Maurice Dodd was born in Hackney, London, on 25 October 1922. Leaving school at 15 he volunteered for the RAF in World War II and served as an engine fitter with the Servicing Commando in North Africa, the Mediterranean, the Netherlands and Germany. On demobilization he attended Hammersmith School of Arts & Crafts (1946–50) and in 1952 joined Halas & Batchelor to work on the UK's first full-length animated feature film, *Animal Farm*. He subsequently worked for a number of advertising agencies as writer/artist – creating Young & Rubicam's 'Clunk Click' seatbelt campaign and other road-safety campaigns which won 13 international awards. In 1959 he went into partnership with Dennis Collins, taking over the scriptwriting and ideas for 'The Perishers' cartoon strip in the *Daily Mirror*, and taking over the drawing as well in 1983 when Collins retired. In 1992 he again went into partnership, enlisting the aid of Bill Mevin to produce the finished drawings for the strip. He has also storyboarded 20 animated versions of the strip for BBC TV and created the non-Perisher characters Gernommy, Churchmouse, Cellmate (for the charity Prisoners Abroad) and Merrymole. Maurice Dodd cites his influences as Al Capp's 'Li'l Abner', Segar's 'Popeye', Bernard Graddon's 'Just Jake' and Walt Kelly's 'Pogo'.

PUB: [with D.Collins] 'The Perishers' books from 1963; *The Perishers' Dotty Dictionary* (1977), *The Perishers' Very Big for Its Size Story Book* (1979), *The Perishers' Rather Big Little Book* (1979), *The Tale of a Tail* (1981), *Merrymole the Magnificent* (1982), *Merrymole the Intrepid* (1984)
ILL: M. Ende, *Jim Button and Luke the Engine-Driver* (1963)
EXHIB: [paintings] RA
COLL: UKCC MB

DONNISON, T. E. (fl. 1893–1903). Cartoonist and illustrator. T. E. Donnison was born in Ireland in the early 1860s and educated at Rugby School. He then studied law and practised as a solicitor for 15 years but, finding the profession uncongenial, took art lessons. In the mid-1890s his humorous work started to appear in periodicals including the *Boy's Own Paper*, *Fun*, *Longbow* and *Moonshine*. He became known for 'prehistory' cartoons in *To-Day* – a vein more notably exploited by E. T. REED and GEORGE MORROW in *Punch*. Most of his work is in pen and ink.

'Mr Deputy Dumpling and Family Enjoying a Summer Afternoon'

Robert Dighton, 1781

PUB: *The Jaw-Cracking Jingles* (1899), *Odds and Ends and Old Friends* (1902), *'Pure Fun' for Boys of All Sizes* (1903) SH

DOUGLAS – see England, Thomas Douglas

DOWD, James Henry (1884–1956). Cartoonist, painter and etcher. A regular contributor to *Punch* (1906–48) – especially of humorous illustrations of children, film and theatre – his *Punch* obituary described him as 'one of the early pioneers of the vital expressive line that seems to be part of the subject, instead of merely illustrating it'. He also worked for *Graphic* and *Bystander*, and designed government health posters. He died on 16 March 1956.
PUB: *The Doings of Donovan In and Out of Hospital* (1918), [with texts by B. E. Spender] *Important People* (1930), *People of Importance* (1934) and *Serious Business* (1937)
ILL: J. Drinkwater, *Robinson of England* (1937)
EXHIB: G; L; RA; RMS; RSA; AG; GI; International Society; RP; COO
COLL: BM; [posters] IWM; V&A MB

DOYLE, Charles Altamont (1832–93). Illustrator and comic artist. Charles Doyle was born in London, the son of JOHN DOYLE (HB) and a younger brother of RICHARD and HENRY DOYLE. He was taught to draw by his father and in 1849 went to Edinburgh to work as an architectural draughtsman in the Scottish Office of Works where as Assistant to the Surveyor for over 27 years he helped to design a number of public monuments. In his spare time he illustrated books, in some cases humorously, contributed to periodicals including *Diogenes, Good Words, Illustrated Times* and *London Society* (1862–4), and painted watercolours, often of fairy subjects. Suffering from epilepsy and bouts of melancholia he was forced into early retirement in 1876. He spent his last years in various lunatic asylums, dying at one in Dumfries on 10 October 1893. His son, Sir Arthur Conan Doyle, wrote: 'his brush was concerned not only with fairies . . . but with wild and fearsome subjects so that his work has a very peculiar style of its own, mitigated by great natural humour'.
PUB: *The Doyle Diary* (1889–published 1978)
ILL: Anon, *Coelebs the Younger in Search of a Wife* (1859); D. Defoe, *The Life and Surprising Adventures of Robinson Crusoe* (1859); J. Bunyan, *The Pilgrim's Progress* (1860); W. Cowper, *The Diverting History of John Gilpin* (1866); F. Crucelli, *Mistura Curiosa* (1869); J.

H. A. Macdonald, *Our Trip to Blunderland* (1877)
EXHIB: RSA; BSG (1924); V&A 'Richard Doyle and his Family' (1983–4); Maas Gallery
COLL: BM; V&A; NGS; NGI; Huntington; Texas University
LIT: M. Baker, *The Doyle Diary* [Introduction] (1978) SH

DOYLE, Henry Edward CB RHA (1827–92). Portrait painter, arts administrator and cartoonist. Henry Doyle was born in Dublin, the son of JOHN DOYLE (HB) and a younger brother of RICHARD DOYLE. Having received some art training in Dublin and from his father, came to London to pursue a career as a painter of portraits and religious pictures. He contributed humorous initials to *Punch* (1844–6), cartoons to the *Great Gun* and caricatures – large heads on small bodies, signed 'Hen' or 'Fusbos' – to *Fun* (1867–9). In 1869 he was appointed Director of the National Gallery of Ireland and held the post until his death on 17 February 1892. He was elected RHA (1874) and created CB (1880).
ILL: H. Zschokke, *The Lover's Stratagem and Other Tales* (1849); *An Illustrated History of Ireland* (1868)
COLL: NGI SH

DOYLE, John 'HB' (1797–1868). Caricaturist and portrait painter. John Doyle was born in Dublin of an ancient family and trained there as a landscape and portrait painter. He came to England (*c.* 1820) to practise as a miniaturist, exhibiting at the RA in 1825. In 1827 he embarked on political caricature, his lithographs at first appearing unsigned. Being encouraged by the publisher McLean, he started in 1829 on the celebrated series of 'Political Sketches' under the pseudonym 'HB' which ran for 20 years and embraced over 900 subjects. McLean advertised the series as 'entirely free from whatever could offend the most scrupulous or wound the most susceptible' and THACKERAY called them 'polite points of wit, which strike one as extremely clever and witty and cause one to smile in a quiet gentlemanlike kind of way'. HB thus began the tradition of using the caricature for good-humoured political comment rather than vulgar derision in the GILLRAY manner and paved the way for LEECH and TENNIEL. The destruction of the old style was helped by HB's introduction of lithography, a softer medium than etching, and his use of truthful, unexaggerated portraiture. McLean issued the 'Political Sketches' in bound

John Doyle, [George IV & Duke of Cumberland], 1829

volumes and kept the identity of HB a closely guarded secret which assisted speculation and sales. Yet they were amongst the last of McLean's separately issued caricature prints and declined in popularity after 1842; by 1850 caricature had moved to *Punch* and other illustrated journals and by the time he died on 2 January 1868, HB's mild satires which had been aimed at a small sophisticated audience, interested in parliamentary debates, had been largely forgotten.

PUB: *Political Sketches* (1829–49, 1851)
EXHIB: RA
COLL: BM; V&A; RL
LIT: G. M. Trevelyan, *The Seven Years of William IV, A Reign Cartooned by John Doyle* (1952)
SH

DOYLE, Richard (1824–83). Illustrator, painter, cartoonist and strip cartoonist. Dicky Doyle was born in London in September 1824, the son of JOHN DOYLE (HB) and the brother of HENRY and

CHARLES DOYLE. He was taught to draw by his father and illustrated a variety of juvenilia in which he showed a love of mediaeval chivalry and much originality in comic decoration. In 1843 he joined the staff of *Punch* and over seven years established himself, with LEECH, as the outstanding artist on the paper, for which he drew over 1000 humorous designs including, in 1849, a cover which lasted until 1954. Political cartoons did not suit him and it was perhaps the border designs of tiny elves and sprites which best showed his powers of whimsical invention. His two best-known series in *Punch* were his outline drawings for 'Manners and Customs of Ye Englyshe', remarkable for the composition of crowd scenes, and the strip cartoon which in book form became *The Foreign Tour of Messrs Brown, Jones and Robinson*. He left *Punch* in 1850, because as a Roman Catholic he objected to the magazine's anti-papal stance, and subsequently his only humorous drawings of note

MANNERS AND CVSTOMS OF Ye ENGLYSHE IN 1849. Nº 30.

HERE COMES Ye FARMER

NOTYCE MAN TRAPS & SPRING GVNS

→A PARTIE OF SPORTSMEN OVT A SHVTYNGE.

Richard Doyle, *Manners and Customs of Ye Englyshe* (1849)

were the outline illustrations of Society which he contributed to the *Cornhill Magazine* edited by his friend THACKERAY (1861–2). Otherwise he illustrated many books with distinction and painted fairy pictures and moorland scenes. He died on 11 December 1883.

PUB: *The Tournament, or the Days of Chivalry Revived* (1840), *Manners and Customs of Ye Englyshe* (1849), *An Overland Journey to the Great Exhibition* (1851), *The Foreign Tour of Messrs Brown, Jones and Robinson* (1854), *Bird's Eye Views of Society* (1864), *In Fairyland* (1870), *Dick Doyle's Journal* (1885), *Jack the Giant Killer* (1888)

ILL: Many books including W. H. Maxwell, *The Fortunes of Hector O'Halloran* (1842–3); C. Dickens, *The Chimes* (1845); L. Hunt, *A Jar of Honey from Mount Hybla* (1848); J. Ruskin, *The King of the Golden River* (1851); W. M. Thackeray, *The Newcomes* (1854–5); T. Hughes, *The Scouring of the White Horse* (1859); Lord Brabourne, *Higgledy-Piggledy* (1876); A. Lang, *The Princess Nobody* (1884)

EXHIB: RA; GG; V&A 'Richard Doyle and his Family' (1983–4)

COLL: BM; V&A; A; F; NGI; Pierpont Morgan Library; Huntington

LIT: D. Hambourg, *Richard Doyle* (1948); R. Engen, *Richard Doyle* (1983) SH

DREDGE, Peter (b. 1952). Cartoonist. Pete Dredge was born in Nottingham on 20 September 1952 and studied art and graphic design at Trent Polytechnic, Nottingham (1971–5). A former gag-writer for BBCTV's 'Not the Nine O'Clock News' (*c.* 1980) he has been a professional cartoonist since 1976 and has contributed cartoons to *Punch, Private Eye, Radio Times, Spectator, Listener, Daily Star, Oldie, Penthouse, Men Only, Times Educational Supplement, Times Magazine, Ariel, National Lampoon, Risqué, Daily Express, Mayfair, Sun, Daily Mirror, Fiesta*

and *Knave* and has worked in advertising for such clients as Boots, Bass, Fisons, Pretty Polly and IT & T. Influenced by HARRY HARGREAVES, MIKE WILLIAMS, ALBERT RUSLING and Frank Bellamy, he was voted CCGB Joke Cartoonist of the Year (1986) and Provincial Press Cartoonist of the Year (1987).
EXHIB: Nottingham Playhouse; BC MB

DRENNAN, Patricia (b. 1933). Cartoonist, strip cartoonist and illustrator. Pat Drennan was born in Belfast on 16 May 1933 and studied at Belfast College of Art (1950–4) and the Accademmia delle Belle Arte, Palermo (1957–8). She has had cartoons published in *Daily Mirror*, *Daily Star*, *Sun*, *News of the World*, *Mail on Sunday*, *Medical Digest*, *Punch*, *Reader's Digest* and elsewhere. She also drew a regular strip cartoon for the *Evening News*, has worked in advertising for Fortnum & Mason, Radio Rentals, Chivas Regal and others, designed charity Christmas cards and illustrated books. In addition she has taught art in Belfast and London, and won first prize in the Waddington's Cartoon Awards (1988). Influenced by the artists of the *New Yorker* and *Saturday Evening Post*, she uses a Gillot 303 nib with Higgins ink or fibretips but also likes working in pencil, coloured pencil, coloured inks and watercolour (especially seaside scenes).
ILL: D. George, *Mimoon and the Jug* (1977); A. Loudan, *Dear Sir Anthony* (1987); P. Hichens & J. Wilkerson, *Marriage Around the Clock* (1989); M. Stacey, *Superscrooge* (1991), *Superscrooge 2* (1992) MB

DULAC, Edmund (1882–1953). Illustrator, designer, painter and caricaturist. Edmund Dulac was born in Toulouse on 22 October 1882, the son of a commercial traveller. He studied law at Toulouse University then art at the Ecole des Beaux-Arts before coming to England in 1904 to seek his fortune as an illustrator. At the London Sketch Club he met most of the best-known illustrators of the day and soon made a reputation as a brilliant colourist, influenced by Persian miniatures, and becoming with Arthur Rackham the leading illustrator of 'Gift Books' (1907–14). His comic talents were seen in his illustrations for *Lyrics Pathetic and Humorous from A to Z* (1908) and in caricatures he exhibited at the International Society and the Leicester Galleries (1914). In this field his greatest opportunity came in 1919 with a commission to illustrate weekly profiles of prominent people in politics and the arts for the *Outlook*. The 59 witty caricatures in

pen and ink he produced over an 18-month period were so popular that it was planned to publish a selection in book form but the project came to nothing. As well as drawing caricatures, Dulac also made a number of caricature dolls, concentrating on people he disliked. Apart from book illustration he designed costumes and sets for the theatre, postage stamps, banknotes, medals, coins, musical instruments and furniture, deserving the description that he was 'a man in love with craftsmanship'. His friends included Charles Ricketts, Sir Henry Beecham and W. B. Yeats. He died of a heart attack, brought on by his demonstration of flamenco dancing, on 25 May 1953.
PUB: *Lyrics Pathetic and Humorous from A to Z* (1908), *Edmund Dulac's Picture Book for the French Red Cross* (1915), *Edmund Dulac's Fairy Book* (1916)
ILL: *Stories from the Arabian Nights* (1907); W. Shakespeare, *The Tempest* (1908); *The Rubaiyat of Omar Khayyam* (1909); *The Sleeping Beauty and Other Fairy Tales* (1910); *Stories from Hans Andersen* (1911); E. A. Poe, *The Bells* (1912); *Princess Badoura* (1913); *Sinbad the Sailor and Other Stories from the Arabian Nights* (1914); R. L. Stevenson, *Treasure Island* (1927)
EXHIB: LG (Memorial 1953)
COLL: BM; V&A; IWM; LM; NYPL; Texas University; CAT
LIT: R. Davies, *Caricature of To-Day* (1928); C. White, *Edmund Dulac* (1976) SH

DU MAURIER, George Louis Palmella Busson (1834–96). Cartoonist, illustrator and author. Du Maurier was born in Paris on 6 March 1834. His father was a French inventor with delusions of grandeur; his English mother was the daughter of Mary Ann Clarke whose liaison with the Duke of York had afforded ROWLANDSON much unseemly mirth. He was educated in France and came to London (1851) to study chemistry and practise as an analytical chemist. Having no success, he returned to Paris (1856) to study art (later described in his novel *Trilby*) and continued his studies in Antwerp (1857–60), where he lost the sight of one eye. Settling in London in 1860 he started to contribute occasional cartoons that year to *Punch* and to illustrate the periodicals – *Black & White*, *Cornhill*, *English Illustrated Magazine*, *Leisure Hour*, *London Society*, *Once a Week* and *Sunday at Home* – becoming one of the esteemed illustrators of the decade. In 1864 he was appointed to the staff of *Punch* to succeed LEECH as the social cartoonist. Some of his early

THE SIX-MARK TEA-POT.

Æsthetic Bridegroom, "IT IS QUITE CONSUMMATE, IS IT NOT?"
Intense Bride, "IT IS, INDEED! OH, ALGERNON, LET US LIVE UP TO IT!"

George du Maurier, *Punch*, 30 October 1880

work was keenly satirical – such as the skit on Rossetti and his circle, 'A Legend of Camelot' (1866) – but he gradually restricted himself to making respectful jokes in homage to Society with reminders of sharpness at the expense of aesthetes and vulgarians. He invented a memorable cast of characters – Sir Gorgius Midas the upstart millionaire, Mrs Ponsonby de Tomkyns the social climber, the cultured Mrs Cimabue-Brown, the aesthetes Maud and Postlethwaite – and recorded their exploits in captions of extravagant length. With all his snobbishness he became *Punch*'s most popular contributor and was an influence on Victorian Society; his tall beauties were said to have added two inches to the Englishwoman's height. But over his 30-year stint in *Punch* his taut pen line weakened and his ironies became repetitious. His popularity might have faded had it not been for the three novels he wrote and illustrated late in life. He died in Hampstead on 8 October 1896, leaving a body of cartoons that provide a feast for the social historian.

PUB: *Society Pictures . . . from 'Punch'* (1888, 1891), *Social Pictorial Satire* (1898), *A Legend of Camelot* (1898), *Peter Ibbetson* (1892), *Trilby* (1894), *The Martian* (1898)
ILL: Mrs Gaskell, *Sylvia's Lovers* (1863), *Cranford* (1864), *Wives and Daughters* (1866); D. Jerrold, *The Story of a Feather* (1867); W. M. Thackeray, *The History of Henry Esmond* (1868); S. Brooks, *Sooner or Later* (1868); O. Meredith, *Lucile* (1868); F. Montgomery, *Misunderstood* (1874)
EXHIB: FAS; LG
COLL: BM; V&A; NPG; A; F; NGS; Pierpont Morgan Library; Texas University
LIT: T. M. Wood, *George du Maurier, the Satirist of the Victorians* (1913); L. Ormond, *George du Maurier* (1969) SH

DUNCAN, Riana (b. 1950). Cartoonist, illustrator and writer. Riana Duncan was born in Paisley, Scotland, on 2 July 1950 and studied graphics under Georg Hadeler and Nol Kroes at the Free Academy of Fine Arts, The Hague (1968–71). She spent several years exhibiting graphics and textiles before turning to writing and illustrating children's books, and took up cartooning in 1979. Her work has appeared in *Guardian*, *Punch*, *Men Only*, *Weekend*, *Spectator*, *Observer*, *Nieuwe Revu* and *She*. She draws in ink using Rotring pens with a minimal line, rarely cross-hatching, and also uses watercolours applied with a very fine brush.

PUB: *A Tale of Ten Town Mice* (1978), *A Nutcracker in a Tree* (1980), *History and Her Story* (1986), *Not Tonight* (1987), *If You Were a Bird* (1987), *The Mating Game* (1988), *Emily's Paintbox* (1988), *When Emily Woke Up Angry* (1989), *The ABC of Sex* (1989), *Monogamy* (1990), *Emily's Bed* (1990)
ILL: M. Rogers, *Cindy and the Silver Enchantress* (1978); S. Cline & D. Spender, *Reflecting Men* (1987); M. Rosen, *Rude Rhymes* (1989), *Dirty Ditties* (1990), *Who Drew On the Baby's Head?* (1991), *Vulgar Verses* (1991) MB

DYSON, William Henry (1880–1938). Political cartoonist, caricaturist and etcher. Will Dyson was born in Ballarat, Australia, on 3 September 1880, the younger brother of Edward Dyson, writer and *Sydney Bulletin* journalist, and Ambrose Dyson, cartoonist of the *Sydney Bulletin* and *Adelaide Critic*. Educated in Melbourne, Dyson was a self-taught artist and his work was first published in the *Sydney Bulletin* and *Lone Hand* when aged 17. In 1903 he took over from his brother on the *Adelaide Critic*, producing Australia's first cartoons printed in colour and later worked for *Gadfly* (1906) and drew colour caricatures for covers of *Clarion* (1908). He moved to England in 1909 and married Ruby Lindsay, the sister of cartoonist, writer and painter Norman Lindsay, in 1910 (Ruby herself was a successful illustrator who later drew covers for *The Suffragette*). In London he worked first for *New Age* and later the Labour Party paper, the *Daily Herald* and during World War I produced a series of anti-Kaiser drawings, 'Kultur Cartoons', which were published as a book. In 1915 he was sent to the Front as official war artist to the Australian Imperial Forces and was twice wounded. He also contributed to *Weekly Dispatch*, *World* (colour caricatures in the *Vanity Fair* style signed 'Emu'), *Daily Chronicle*, *New English Weekly*, *Daily Sketch*, *London Mercury*, *Pearson's Magazine*, *Reveille* and *Odd Volume*. Returning to Australia in 1925 he was staff cartoonist on the *Melbourne Herald*, and also worked for *Melbourne Punch* and *Table-Talk*. He later went back to England to produce front-page cartoons for the *Daily Herald* in August 1931, including perhaps his best-known drawing, 'Curious, I seem to hear a child weeping', predicting the cause of World War II. A passionate Socialist and an immensely influential artist, he was much praised by DAVID LOW who none the less felt that he had a tendency to overcaricature – his capitalists were too bloated,

NEW WORLD
*The Modern Young Alexander Prematurely
sighs for New Worlds to conquer*
Will Dyson, *Kultur Cartoons* (1915)

working men too idyllic etc. – and the *Herald*
itself tried to limit the number of devils that crept

into his drawings. JOHN JENSEN has said of his
work: 'Stylistically Dyson had few imitators – his
work was too complex – but the power of his
ideas brought back to British cartooning the
strong flavour and impact of a GILLRAY after
years of Victorian politeness.' Feaver has des-
cribed his etchings as being 'reminiscent of
BEERBOHM, in a more rugged, muscular guise.'
Dyson died on 21 January 1938.
PUB: *Cartoons* (1913), *More Cartoons* (1914),
Kultur Cartoons (1915), *Conscript 'Em* (1915);
Will Dyson's War Cartoons (1916), *Australia at
War* (1918), *Poems: In Memory of a Wife* (1919),
(ed.) *The Drawings of Ruby Lind* (1919), *Old
King Coalition* (n.d.), *Mister Asquith* (n.d.),
Collected Drawings (1920), *Artist Among the
Bankers* (1933)
ILL: E. Dyson, *Fact'ry 'Ands* (1906), *Spats'
Fact'ry: More Fact'ry 'Ands* (1914); E. Pataud &
E. Pouget, *Syndicalism and the Co-operative
Commonwealth* (1913); G. Gould, *Lady Adela*
(1920)
EXHIB: Melbourne (1909); LG; RHA; RSA;
Ferargil Galleries, New York; Gumps Gallery,
San Francisco; SGG; CG
COLL: V&A; Australian War Memorial; NG of
NSW; NG of Victoria; UKCC; IWM; [litho-
graphs] BM
LIT: R. McMullin, *Will Dyson* (1984)

MB

E

ECCLES – see Brown, Frank

ECKHARDT, Oscar RBA (fl. 1892–1902). Car-
toonist, graphic journalist and painter. Oscar
Eckhardt received his art training in Brighton
and in 1890 joined the staff of the *Daily Graphic*,
the first illustrated daily newspaper. He was soon
contributing to many other periodicals including
Black & White, *Butterfly*, *Eureka*, *Illustrated
Bits*, *Lady's Pictorial*, *Lady's Realm*, *Ludgate*, *St
James's Budget*, *St Paul's*, *Sketch*, *Strand*, *To-
Day*, *Unicorn* and the *Windsor Magazine*. Much
of his work was decorative, in the manner of
DUDLEY HARDY and the French poster artists; the
many ink-and-wash cartoons he drew for *Pick-
Me-Up* often have mildly humorous and salacious
captions. In his book on the 1890s Holbrook
Jackson listed Eckhardt as one of the leading
black-and-white artists of the period. At the RBA

he was closely associated with SIME and Manuel,
his colleagues on the *Butterfly*, and was admired
for his rendering of contemporary women's
dresses.
EXHIB: RBA, ROI
COLL: V&A

SH

EDGELL, David (b. 1930). Editorial and adver-
tising cartoonist, actor and photographer. David
Edgell was born in Leicester on 29 June 1930 and
attended Leicester School of Art (1946–9). Staff
cartoonist in the Features Department of the
Daily Express (1962–86), he has also worked for
the *Sunday Times* and *Observer* and produced a
considerable amount of advertising work for
clients such as Shell, British Airways, Egg
Marketing Board, Air Canada, American
Express, Abbey National Building Society,
Woolwich Building Society, Financial Times, BP

and British Rail. He has also lectured at Hornsey College of Art (1982–3), been Food Photographer for *Vogue* and *Sunday Times* and is a professional actor holding an Equity card.

PUB: *A Book of Melancholy* (1981) MB

EF – see Fraser, Eric George

EGERTON, M. 'ME' (fl. 1821–8). Amateur caricaturist. Egerton's designs of sporting scenes, social comedy, jokes about the weather etc. were signed 'ME.' and usually engraved as aquatints by G. Hunt. They are some of the most attractive prints of the period.

PUB: *Humorous Designs* (1824), *A Day's Journal*

*'The same to you, sir, and
many of 'em.'*

M. Egerton, *c.* 1825

of a Sponge (1924), Collinso Furioso (1825), Airy Nothings (1825), Here and There Over the Water (1825), The Matrimonial Ladder (1825), Crossed Readings (1826), Olla Podrida (1827) The Melange of Humour (n.d.)
COLL: BM SH

ELMES, William (fl. 1811–20). Caricaturist. Elmes drew and etched political and social caricatures and seems to have had a special interest in naval subjects. His style was described by Dorothy George as 'genuine caricature, broadly burlesqued, naïvely drawn, decorative and effective'.
COLL: BM SH

EMETT, Frederick Rowland OBE (1906–90). Cartoonist, illustrator and comic inventor. Rowland Emett was born in London on 22 October 1906, the son of a journalist-inventor, and studied at the Birmingham School of Arts & Crafts. Before World War II he worked as a draughtsman in a Birmingham firm of process engravers and in 1931 exhibited paintings at the RA and NEAC. In 1939 his cartoons started to appear in *Punch*. He soon became one of the leading attractions of the magazine and remained so until 1958 when he gave up drawing because of the strain on his eyesight. His cartoons were elegantly drawn fantasies, with a strongly nostalgic flavour, about locomotives and their drivers. Sharing an appreciation of the comic potential of machines with HEATH ROBINSON, he was often described as his follower but the essential difference is that Emett's spindly creations, quaint people and Gothic settings were never intended to convince. During the war he worked as a draughtsman on the development of jet engines. In the 1940s and 50s he drew humorous advertisements for companies like Shell and Guinness and contributed cartoons to *Lilliput* and various American magazines. He became well known to the general public in 1951 with 'The Far Tottering and Oyster Creek Railway' and the engine 'Nellie' that he designed for the Festival of Britain. These led on to many commissions for comic inventions from clients in England and America, including eight machines for the film *Chitty Chitty Bang Bang* (1967). This sort of work absorbed him for the last 30 years of his life and his open-air sculptures can now be seen at Nottingham and Basildon; others are in the Ontario Science Museum, the Smithsonian Institute in Washington and the Houston Space Center. He died in Hassocks, Sussex, on 13 November 1990.

PUB: *Engines, Aunties and Others* (1943), *Anthony and Antimacassar* (1943), *Sidings and Suchlike* (1946), *Home Rails Preferred* (1947), *Saturday Slow* (1948), *Buffers End* (1949), *Far Twittering* (1949), *High Tea* (1950), *The Forgotten Tramcar* (1952), *Nellie Come Home* (1952), *Hobby Horses* (Guinness, 1958), *The Early Morning Milk Train* (1976), *Alarms and Excursions* (1977), *Emett's Ministry of Transport* (1981)
ILL: W. de la Mare, *Peacock Pie* (1941), *Bells and Grass* (1941)
EXHIB: CBG (1988)
COLL: V&A; T; CAT SH

EMMWOOD – see Musgrave-Wood, John

EMU – see Dyson, William Henry

EN – see Norfield, Edgar George

ENDER, Peter (fl. 1930s–40s). Cartoonist, writer and illustrator. Peter Ender worked for *Punch*, *Guide & Ideas, Answers, Topical Times, Daily Express, London Opinion, Leader, Star, Illustrated, Lilliput, Blighty, Soldier* and *Razzle*. During World War II he was Art Editor of *Soldier*.
PUB: *Back to the Front* (1942), *Up the Garden Path* (1944) MB

ENGLAND, Thomas Douglas (1891–1971). Cartoonist and strip cartoonist. Douglas England was born on 7 January 1891 and worked in a bank before serving in France in World War I. He later lived in East Africa, returning to England to study at the Royal Academy Schools. He then worked as a commercial artist, designing advertisements for Moss Bros, Schweppes, Crosville Buses and others and contributed regularly to *Punch*, producing cartoons in colour and black-and-white and sharing the 'Charivari' illustrations with FOUGASSE (and later taking over from him). Signing his drawings 'Douglas' he worked in brush and indian ink. 'Often his pictures burlesqued the glossy hats, the stylish prance of advertisement characters. He was fertile in jokes that depended on this contrast between the smart and the tripped-up' (Price). He died in March 1971.
 MB

EVANS, Powys Arthur Lenthall 'Quiz' (1899–1981). Caricaturist and painter. Powys Evans was born on 2 February 1899 in London, the son of a Welsh county court judge. At an early age

Powys Evans, [G. K. Chesterton], *Eighty-Eight Cartoons* (1926)

he studied art under Spencer Gore RA and later attended the Westminster School of Art and the Slade School (1915–17). He then served in the Welsh Guards on the Western Front. The success of his exhibition of caricatures in 1922 led to publication of weekly caricatures in the *Saturday Review*, under the pseudonym 'Quiz', and contributions to *Everyman*'s, *GK's Weekly*, *The Golden Hind*, *John O'London*'s and *Time & Tide*. He was a caricaturist of personality rather than ideas and the best of his work was incisive,

graceful and witty. Like KAPP he alternated between caricature and straight portrait drawing – e.g. in the *London Mercury* – as well as painting topographical scenes and fantasies in watercolour. The catalogue of his exhibition in 1924 included a complimentary preface by MAX BEERBOHM and his standing in 1928 can be judged by the fact that he was the most illustrated artist in *Studio Magazine*'s publication *Caricature of To-Day*. He seems to have given up caricaturing in the 1930s and moved to Wales where he continued to paint.

PUB: *The Beggars' Opera* (1922), *Eighty-Eight Cartoons* (1926), *Fifty Heads* (1928)
EXHIB: NEAC; LG; GOU; COO; LAN (Retrospective 1975)
COLL: NPG; BM; V&A SH

EVANS, Treyer Meredith (1889–after 1954). Cartoonist and illustrator. Treyer Evans was born on 6 June 1889 in Chichester, Sussex, the son of a dentist, and educated at Grosvenor House School, Bognor. Before World War I he contributed cartoons and illustrations to *Pearson's Magazine*; afterwards his work is found in *Punch*, *Little Folks*, *Nash's*, *Royal Magazine*, *Sketch*, and the *Tatler*. Some of his best cartoons were published in the *Humorist* (including covers) and some of his most striking illustrations were for stories by P. G. Wodehouse in the *Strand Magazine*. He had an unsophisticated sense of humour and a lively style.

PUB: *Pull-Out Painting Books* (1957)
ILL: A. Brazil, *A Fortunate Term* (1921); F. Inchfawn, *Will You Come As Well?* (1931), *The Verse Book of a Garden* (1932); A. Armstrong, *England Our England* (1948); G. Trease, *The Hills of Varna* (1948); E. Blyton, *The Mystery of the Vanished Prince* (1951), *The Mystery of the Strange Bundle* (1952), *The Mystery of Holly Lane* (1953), *The Mystery of Tally-Ho Cottage* (1954) SH

F

FALCONER, Pearl FSIA (?–after 1975). Cartoonist, painter, costume designer and illustrator. Pearl Falconer was born in Dundee and studied at St Martin's School of Art and at Central School of Arts & Crafts. Her drawings appeared in *Harper's Bazaar*, *Listener*, *New York Herald-Tribune* and *Radio Times* amongst

others. She was married (1938–47) to RICHARD WINNINGTON.
ILL: H. Phillips, *Something to Think About* (1958); N. Savage Carson, *The Happy Orpheline* (1960), *The Orphelines in the Enchanted Castle* (1963), *A Pet for the Orphelines* (1963); P. Farmer, *The China People* (1960); M.

Treadgold, *The Winter Princess* (1962)
COLL: V&A MB

FANTONI, Barry Ernest (b. 1940). Cartoonist, novelist, broadcaster and jazz musician. Barry Fantoni was born in London on 28 February 1940 and educated at Archbishop Temple School and Camberwell School of Arts & Crafts (1954–8). He has been on the editorial staff of *Private Eye* since 1963 (co-writer with Richard Ingrams of 'Sylvie Krin', 'E. J. Thribb' and 'Old Jewett' columns). Editor of *St Martin's Review* (1969–74) he was Diary cartoonist of *The Times* (1983–91). He has also drawn for *The Listener* (1968–89) and *Radio Times*, been art critic of *The Times* (1973–7) and record reviewer for *Punch* (1976–7). In addition he has appeared as a film and TV actor, written detective novels featuring 'Mike Dime', created a one-man show 'From the Dragon's Mouth' and in 1990 formed Barry Fantoni's Jazz Circus. As well as his familiar spiky, kindergarten-style pocket cartoons, he is also known for his pop-art caricatures. 'An accomplished painter of neo-realist portraits and a fine draughtsman [he] opts for the Faux-naif style in his cartooning and because he can draw well he has to push his cartoon method to the opposite extreme' (HEWISON).
PUB: [with R. Ingrams] *The Bible for Motorists* (1970), *Private Eye Barry Fantoni* (1975), *The Times Diary Cartoons* (1984), *Barry Fantoni's Chinese Horoscopes* (1985), *Barry Fantoni Cartoons* (1987), *The Best of Barry Fantoni* (1990)
ILL: *How to be a Jewish Mother* (1966); *The BP Festivals and Events in Britain* (1966); G. Melly, *The Media Mob* (1980)
EXHIB: [as 'Stuart Harris' with W. Rushton] RA (1963); [as Barry Fantoni] RA (1964, 1975, 1978); Woodstock Gallery; Comara Gallery, Los Angeles; Brunel University; [with P.Fantoni] LAN; Annexe Gallery; Katherine House Gallery; Fulford Cartoon Gallery; NGG; Arts Club; Old Town Books
COLL: UKCC; V&A MB

FAWKES, Walter Ernest 'Trog' (b. 1924). Caricaturist, political cartoonist, pocket cartoonist, strip cartoonist and jazz musician. Born in Vancouver, Canada, on 21 June 1924, Wally Fawkes came to England in 1931 and left school at 14 to study art at Sidcup Art School and under John Minton at Camberwell (where he was a contemporary of HUMPHREY LYTTELTON). During World War II he drew maps and painted camouflage and in 1945 was 'discovered' in an art competition run by the *Daily Mail*'s political cartoonist, LESLIE ILLINGWORTH, and offered a job on the paper, eventually taking over from him (1968–71). His work has also been published in *Punch* (especially covers, from 1971), *Spectator* (since 1959), *New Statesman* (since 1965), *Today* (since 1986), *London Daily News* and *Private Eye*, and his well-known series 'Flook' (originally a children's strip 'Rufus and Flook' created by Douglas Mount on 25 April 1949) ran for 35 years (1949–84) on the *Daily Mail*, with writers Humphrey Lyttelton, George Melly (1956–71), Barry Norman, Barry Took and Compton Mackenzie as well as himself. Since 1984 the strip has appeared in the *Mirror* (written by Keith Waterhouse). Flook was so-named because originally the magical creature could only make that sound (Trog's own name comes from 'troglodyte' later the name of one of his jazz bands). Fawkes has been Political Cartoonist and Caricaturist on the *Observer* (since 1965), for whom he also produces a regular pocket cartoon 'Mini-Trog'. Twice winner of Granada TV's

'Apparently his self-portrait was painted by someone else.'

Barry Fantoni, *The Best of Barry Fantoni* (1990)

Trog (Wally Fawkes), [Margaret Thatcher], *Spectator*, 6 June 1987

'What the Papers Say' Cartoonist of the Year Award, he has also won the US Cartoonists' & Writers' Syndicate World Award (1976) and was voted International Political Cartoonist of the Year (1976) by the International Salon of Cartoons and CCGB Strip Cartoonist of the Year (1981). An admirer of DAVID LEVINE ('the best caricaturist in the world') he uses either Truline or Bristol board, Higgins black ink and a dip pen with Gillot 291 nib and a brush (he also does his roughs with a brush), though he has also worked in scraperboard. An accomplished clarinettist, Wally Fawkes was a co-founder of Humphrey Lyttleton's jazz band (1948). A firm believer that making a political cartoon is like condensing the action, conflict and character development of a play into a single line, Fawkes also sees it as uniquely dependent on caricature. At first influenced by Illingworth, he introduced a *grisaille* tonal style using gouache when working on the *Mail* and has since employed a variety of techniques, notable successes being his striking colour caricature covers for *Punch*. 'There is an astonishingly sharp focus . . . particularly in the caricature, which makes the characters seem larger than life, as if seen under a brilliant light and a powerful

lens . . . his blacks seem to be blacker than black' (RAYMOND BRIGGS).

PUB: [with D. Mount] *Rufus and Flook v. Moses Maggot* (1950), [with R. Raymond] *Rufus and Flook at School* (1951), [with G. Melly] *Flook* (1958), [with G. Melly] *I, Flook* (1962), *A Flook's Eye View of the Sixties* (1970), [with G. Melly] *Flook by Trog* (1970), [with Barry Took] *Flook and the Peasants' Revolt* (1975), *The World of Trog* (1977), *Trog Shots* (1984)

ILL: R. Eckersley, *Some Nonsense* (1946); M. L. Norcott, *Out and About with Undertakers* (1946); *Our Dogs* (1948); G. Melly, *Owning-Up* (1965); *Mellymobile: 1970–81* (1982); B. Took (ed.), *The Max Miller Blue Book* (1975)

EXHIB: CG; Cambridge (1980)

COLL: BM; IWM; UKCC; V&A

LIT: F. Whitford, *Trog: 40 Graphic Years* (1987)

MB

FEARON, Percy Hutton 'Poy' (1874–1945). Political/editorial cartoonist. Percy Fearon was born in Shanghai, China, on 6 September 1874. He studied at the Art Students League and Chase School of Art in New York and subsequently under Hubert Herkomer in Bushey, Hertfordshire.

His first cartoons were published in *Judy*. He was cartoonist on the *Manchester Evening Chronicle* and later the *Sunday Chronicle* and *Daily Dispatch* until joining the London *Evening News* (1913–35), and *Daily Mail* (1935–8). His most famous creations were John Citizen, Cuthbert the World War I conscientious objector, Dilly and Dally, Dux and Drakes, Government Gus and Dora (personifying the Defence Of the Realm Act, 1914). His pseudonym is said to originate from the American pronunciation of his name – Poycee – whilst he was in New York. Philip Connard RA once described him as 'the prettiest draughtsman of all cartoonists'. He retired in 1938, being succeeded at the *Daily Mail* by LESLIE ILLINGWORTH, and died on 5 November 1948.
PUB: *Poy's War Cartoons* (1915), [with W. McCartney] *Dilly and Dally in Pictures and Words* (1919), *100 Poy Cartoons* (1920), *How to Draw Newspaper Cartoons* (1936)
COLL: UKCC MB

FENWICK, Ian (fl. 1930s–d. 1944). Cartoonist, illustrator and painter. Ian Fenwick was educated

"I say, there—I said 'halt' ages ago !"

Ian Fenwick, *Tatler & Bystander*, 22 December 1943

at Winchester College. In the 1930s he became known for smart social cartoons in the *Bystander*, *Humorist*, *London Opinion*, *Men Only*, *Strand* and the *Tatler*, which were influenced by the *New Yorker* and in particular by Peter Arno. He also painted decorative watercolours of scenes in London. During the war he invented a character called 'Trubshaw' and drew good-natured cartoons of officers in the Brigade of Guards. As a major in the First Special Air Service Regiment he was killed in action behind enemy lines. He was a close friend of the film star, David Niven.
PUB: *The Bed Book* (1935), *I'm Telling You When and Where to Winter Sport* (1937), *Enter Trubshaw* (1944)
ILL: 'A. N. Other', *Pick-me-up* (1933); P. Barrington, *Songs of a Sub-Man* (1934); J. C. Squire, *Weepings and Wailings* (1935); A. Clitheroe, *Car Canny* (1939) SH

FERRIER, Arthur (1891–1973). Cartoonist, illustrator and painter. Arthur Ferrier was born in Glasgow the son of an organist. He qualified as an analytical chemist and sent his first cartoons to GEORGE WHITELAW, then cartoonist on the *Glasgow Evening News*, and with his encouragement began selling material to the *Glasgow Daily Record*. When the paper's editor (William McWhirter, father of the *Guinness Book of Records* twins) moved to London to edit the *Sunday Pictorial*, Ferrier followed, still working as a chemist and submitting cartoons to the paper in his spare time. His most memorable creation of this period was the 'Our Dumb Blonde' feature which ran for seven years (from 1939) in *Sunday Pictorial* and was succeeded by 'Spotlight on Sally' in *News of the World* (from 1945), 'Film Fannie' in two colours for *Everybody's* and 'Eve' (with a script by George Webb) in the *Daily Sketch* (1953–6). He also drew theatre cartoons for *News of the World* (1923–59) and a series 'Ferrier's World Searchlight', and contributed to *Punch* (from April 1918), *Razzle, London Opinion, Parade, Escort, Passing Show* and *Blighty*. Best known for his pin-up pictures and cartoons featuring leggy blondes (Keith Mackenzie described him as 'the Charles Dana Gibson of his day'), his work was very popular with the troops in World War II. In addition he worked in advertising (e.g. covers and fashion plates for Hector Powe tailors' house journal, *POW*, Bear Brand Hose and others), painted portraits in oils of stage stars such as Jack Hulbert and Evelyn Dall, and owned a pet

monkey. His dictum was 'There's no better medicine than laughter.' He died on 27 May 1973.
PUB: *Arthur Ferrier's Lovelies Brought to Life by Roye* (1941), *Beauty at Butlin's* (1946), *Arthur Ferrier's Dumb Blonde* (1946) MB

ffOLKES, Michael [real name Brian Davis] FCSD, FSIAD (1925–88). Cartoonist, caricaturist and illustrator. Michael ffolkes was born the son of the graphic artist Walter Lawrence Davis MSIAD in London on 6 June 1925. He attended Leigh Hall College, Essex, then studied art at St Martin's School of Art (1941–3) under wood engraver John Farleigh. After working in various commercial art studios he joined the Royal Navy (1943–6) and then studied painting at Chelsea School of Art (1946–9). He turned professional cartoonist soon afterwards, adopting the name of 'Michael ffolkes' after flipping through *Burke's Peerage* (he sometimes signed his work simply 'ff'). His work appeared primarily in *Punch* from 1946 – he had his first drawing accepted (as 'brian') in 1942 at the age of 17 – for whom he also drew regular film-star caricatures (1961–72 and 1978–88), numerous covers and illustrated David Taylor's 'Passing Through' column. He also contributed to *Strand Magazine, Leader, Lilliput, Daily Telegraph, Country Fair, Daily Sketch, Spectator, Sunday Telegraph, Playboy, Private Eye, New Yorker, Connoisseur, Reader's Digest, Basler Zeitung, Krokodil, Esquire* and *Pardon* (Germany). In addition he illustrated 'The Way of the World' column (written by Michael Wharton) in the *Daily Telegraph* from 1955 until his death, featuring such characters as Peter Simple, Dr Spaceley-Trellis, Dr Heinz Kiosk and others. ffolkes' drawings were elegant, stylish and flamboyant and often featured mythological and historical subjects, frequently adorned with large sexy ladies ('ffolkes draws the most stylish nudes in the business' [HEWISON]). Influenced by Disney, PONT, EMETT, RONALD SEARLE, ANDRÉ FRANÇOIS, Rubens and Saul Steinberg, he worked in pen and ink and wash but was particularly adept with watercolours. Of his *Playboy* cartoons a perceptive American admirer said they were 'a mixture of buttercups and gin'. He used Daler board or Daler Langton watercolour paper and Higgins black ink or Dr Martin's coloured inks with a dip pen and a Perry Durabrite No. 16 nib, though he did sometimes also use Pentel pens and pastels. He was elected a member of the *Punch* Table in 1978, was Vice-President of the British Cartoonists' Association and a member of the Savage and Toby Clubs. He also designed clothes

for Anya Scott as 'ffanya'. Michael ffolkes died on 18 October 1988.
PUB: [with B. A. Young] *Tooth and Claw* (1958), *ffanfare!* (1953), *Hic!* (1962), *How to Draw Cartoons* (1963), *ffolkes' Companion to Sex* (1965), *ffolkes' Companion to Matrimony* (1966), *ffolkes' Companion to the Pop Scene* (1967), *Mini Art* (1968), *Private Eye ffolkes* (1976), *ffolkes' ffauna* (1977), *ffolkes' Companion to Mythology* (1978), *Rude As You Please* (1981), *Ruder If You Please* (1982)
ILL: More than 50 books including P. Roberts, *Tinpanalley* (1958); A. Russell, *The Anna Russell Song Book* (1960); M. Wharton, *The Best of Peter Simple* (1963), *The Stretchford Chronicles* (1980); M. Pyke, *Butter Side Up!* (1976); S. Raven, *The Fortunes of Fingel* (1976); N. Rees, *Quote ... Unquote* (1978); H. Vickers, *Great Operatic Disasters* (1979); A. Loos, *Gentlemen Prefer Blondes* (1985?)
EXHIB: RA; LG; Arthur Jeffress Gallery; CG; NFT; Palace Theatre
COLL: V&A; BM; T; SAM; BFI; CAT
LIT: [autobiography] *ffundamental ffolkes* (1985) MB

FIDDY, Roland John (b. 1931). Cartoonist, strip cartoonist, illustrator and artist. Born in Plymouth, Devon, on 17 April 1931, Roland Fiddy attended Devonport High School and studied illustration at Plymouth College of Art (1946–9) and – after National Service in the RAF (1949–51) – at the West of England College of Art, Bristol (1952–3). He worked as an art teacher in Bristol for two years before turning professional cartoonist, selling his first cartoons to *Lilliput* (July 1949) and *Punch* (1952) and later contributing to *Daily Mail, Daily* and *Sunday Express, Eagle, News Chronicle, Everybody's, Daily Mirror, Evening Standard, Politiken, Sofia News, De Tijd, Weekend, She, Harper's Bazaar, Woman's Realm* and others. Advertising work has included Thorn EMI, American Express, Royal Bank of Scotland and Chivas Regal. Strip cartoons by Roland Fiddy include 'Tramps' for *Daily* and *Sunday Express* (1976–85), 'Him Indoors' for the *People* (1986–90) and 'Paying Guest' for the *Sunday Express* (1985–6). His work has been syndicated by the Cartoonists' and Writers' Syndicate of the USA since 1988 and he has won numerous awards for his work, including first prize at international competitions in Knokke-Heist, Belgium (1990), Netherlands International Cartoon Festival (1985, 1986), Beringen Festival, Belgium (1984, 1986), Sofia Festival (1986), São

"You'll like Sir Frederick, he's terribly English"

Michael ffolkes [Brian Davis], *Playboy* c. 1975

Paolo, Brazil (1987) and medals at the Japanese Yomiuri Shimbun contest (1984–6, 1988–9 and 1991–3). Married to the Danish artist Signe Kolding, he uses a Rotring Art pen and admires the work of ANDRÉ FRANÇOIS, EMETT, SEARLE, Sempé, Steig and Steinberg.
PUB: *The Best of Fiddy* (1966), [with I. Reid] *Tramps in the Kingdom* (1979), *For Better, For Worse* (1989), *Crazy World of Love* (1988), *Crazy World of the Handyman* (1988), *Fanatic's Guides* (series of 11 books 1989–92)
EXHIB: [paintings & illustration] RA; Odense Art Gallery, Denmark MB

FISH, Anne Harriet (1890–1964). Caricaturist, illustrator and artist. Born in Bristol and educated at home in London, Anne Fish studied art under C. M. Q. Orchardson, JOHN HASSALL and at the New School of Art in Paris. She worked in London from 1913, contributing humorous illustrations to *Eve*, *Punch*, *Tatler*, *Vanity Fair*, *Vogue*, *Harper's Bazaar*, *Cosmopolitan* and others. Her most memorable creation was the strip cartoon 'The Adventures of Eve' drawn by Fish and 'written and designed by Fowl' which appeared in *Tatler* during World War I and led to 12 silent two-reel comedy films produced by Gaumont (1918). She also painted in oils and watercolour, created textile designs, and drew advertisements for Abdulla cigarettes, Eno's Salts

Anne Fish, in Sidney Tremayne, *Tatlings* (1930s)

and others. Anne Fish (Mrs Sefton) died on 10 October 1964.
PUB: [with Fowl] *The Eve Book* (1917), *The New Eve* (1917), *The Third Eve Book* (1919); [with M. Lavington] *Noah's Ark Book* (1918), *High Society* (1920), *Awful Weekends – and Guests* (1938), *All's Well that Ends Swell* (1939)
ILL: *The Marionettes' Calendar 1916* (1915); G. Frankau, *One of Us* (1917); S. Leacock, *Behind the Beyond* (1919); 3 books by Lady K. Vincent (1925–7); E. Fitzgerald, *The Rubaiyat of Omar Khayyam* (1922); H. J. C. Graham, *The World We Laugh In* (1924) and others
EXHIB: FAS; RA; Dulwich (1987); London Salon
COLL: V&A MB

FITTON, James RA FSIA (1899–1982). Painter, graphic designer, illustrator and cartoonist. James Fitton was born in Oldham, Lancashire, on 11 February 1899, the son of an engineer. He attended Watersheddings Board School, Oldham (1904–13), and left aged 14 to become apprenticed to a calico print designer. He was then an office boy on *Manchester Daily Citizen* (1915) and worked for a textile merchants (1915–21) while taking evening classes at Manchester School of Art (where he was contemporary and close friend of L. S. Lowry). He moved to London *c.* 1920 and was a studio assistant with Johnson Riddell Printers before turning freelance illustrator and designer, working for British Gas Association, Lasky Films etc., producing cartoons for the *Daily Worker* as 'Alpha' and studying at the Central School of Art under A. S. Hartrick in the evenings. In 1933 he taught lithography at the Central School, pupils including his friends PEARL BINDER, JAMES BOSWELL and EDWARD ARDIZZONE, and in the same year was a founder member, with James Boswell, of the left-wing Artists' International Association. He, Boswell and James Holland – all committed socialist illustrators – were known as the 'Three Jameses'. During World War II he produced posters for the Ministry of Information and Ministry of Food (1939–45) and was later Art Director of C. Vernon & Sons advertising agency and Chief Assessor to the Ministry of Education National Diploma of Design (1940–65). He also designed posters for London Transport, Abbey National, Shell and Ealing Studios films such as *Kind Hearts and Coronets*. Elected ARA (1944) and RA (1954), he contributed humorous illustrations and cartoons to *Lilliput*, *Left Review*, *Everyman*, *Our Time*, *Leader*, *John Bull*, *Guardian*, *Daily*

Express, Evening Standard, Strand Magazine and Time & Tide. Influenced by George Grosz, Fitton's cartoons were drawn in ink, watercolour, wash and crayon (sometimes also including newspaper cuttings). Regarded as one of the finest graphic designers of the 1930s, he also painted in oils and watercolours, produced lithographs and designed stage sets. Fitton was married to the painter and illustrator Margaret Cook. He died on 2 May 1982.

PUB: [with H. F. Hutchinson] The First Six Months Are the Worst (1939), [with S. Pearce] Hyacinth Pink (1947)

EXHIB: Arthur Tooth Gallery; RSAB; GI; L; LG; NEAC; RA; RG; COO; Z; Manchester Academy of Fine Arts; W; LON

COLL: CAS; T; V&A; BM; IWM; CA; Museum of Western Art, Moscow MB

FLATTER, Joseph Otto (1894–1988). Political cartoonist, painter and illustrator. Joseph Flatter was born in Brigittenau, Vienna, on 26 May 1894 and was a student at the Royal Academy of Fine Art in the city when World War I broke out. He served in the Austrian Imperial Army, and after the war earned a living as a portrait painter and art lecturer. He came to England in 1934 to research English art for a lecture tour of Czechoslovakia but in 1936, aware of the growing power of the Nazis, decided to stay. In 1940 he was arrested and interned on the Isle of Wight, despite being classified as a 'harmless alien'. However, after three months as camp cook, the Ministry of Information – at the suggestion of DAVID LOW and others – procured his release to work on anti-Nazi cartoons for its Overseas Department. He also drew for the Belgian Refugee Government, the Free French paper and later Die Zeitung, a German paper published in London. In addition he produced a series of illustrations satirizing Hitler's Mein Kampf, which were exhibited around the country and in 1946 was sent to Nuremberg to draw the defendants in the Nazi War Crimes Trials. Before 1937 he worked in oils and charcoal; during World War II he used pens, brushes and ink, heightened with colour; and after the war he used gouache. Flatter wrote an unpublished autobiography, A Painter's Monologue.

EXHIB: Kunstlerhaus, Vienna (1981); RP; Wiener Library

COLL: Vorarlberger Landesarchiv, Bregenz, Austria; Dokumentationszentrum des Osterreichisches Widerstandes, Vienna; IWM
MB

FLUCK, Peter (b. 1941). Cartoonist, caricaturist, animator and writer. Peter Fluck was born on 7 April 1941 in Cambridge and attended Cambridge Art School (1957–62) where he met ROGER LAW. He was later paste-up artist on Private Eye, artist-reporter on New Statesman and produced weekly political cartoons for Labour Weekly (1971–81). In addition, he has produced models for covers of the Economist, illustrations for Radio Times and other work for New York Times, Der Spiegel, Panorama (Netherlands), National Lampoon and Penguin Books. (For details of the 'Luck & Flaw' partnership and 'Spitting Image' see entry for Roger Law.) Other work has included caricature animation/robotics and the design and building of non-caricature moving sculpture. For his caricature work he uses pen, plasticine and clay.

PUB: [as Spitting Image] The Appallingly Disrespectful Spitting Image Book (1985), Spitting Images (1987), The Appallingly Disrespectful Spitting Image Giant Komic Book (1988), Goodbye (1992), Thatcha – The Real Maggie Memoirs (1993)

ILL: [as Luck & Flaw] C. Dickens, A Christmas Carol (1979), R. L. Stevenson, Treasure Island (1986); L. Chester, Tooth & Claw – The Inside Story of Spitting Image (1986)

EXHIB: [as Spitting Image] CG MB

FORD, Frank (fl. 1930–51). Cartoonist. Frank Ford was perhaps more influenced than any other British cartoonist by the New Yorker style and the mixture of sophistication and absurdity made popular by men like Whitney Darrow and Peter Arno. He contributed to London Opinion, Night & Day, Lilliput, Razzle, Pie and the Tatler and some of his best work was published in the Bystander.

PUB: You Needn't Laugh! (1935), [with G. Ford] Digby's Holiday (1951)

ILL: D. Fiske, Why Should Penguins Fly? (1937)
SH

FORD, Noel (b. 1942). Cartoonist and author/illustrator of children's books. Noel Ford was born on 22 December 1942 in Nuneaton, Warwickshire, and was educated at King Edward VI Grammar School, Nuneaton, and Birmingham College of Arts & Crafts (1958). He was lead guitarist in a travelling band (appearing on TV's 'New Faces' talent show), a furniture salesman, lab technician, clerk and screen-printer before drawing political cartoons for electoral reform author John Creasey (1968). He then dabbled in

short-story writing for magazines and BBC Radio, turning full-time cartoonist in February 1975. Deputy Editorial Cartoonist on the *Daily Star* (1979–92), he has also been Editorial Cartoonist on *Church Times* since September 1989. In addition he has contributed to *Private Eye*, *Punch* (from 1976 until its demise), *Weekend*, *Truck & Driver*, *The Golfer* and others, worked in advertising and drawn greetings cards (one of which was voted Best Humorous Greetings Card 1989/90). The awards which he has won for his work have included medals in the Yomiuri Shimbun contests, United Nations Cartoonists Against Drug Abuse Exhibition and others. He was also voted Dog Cartoonist of the Year by the National Canine Defence League/Spillers Bonio (1990).
PUB: *Deadly Humorous* (1984), *Golf Widows* (1988), *Cricket Widows* (1989), *Business Widows* (1990), *Nuts* (1991), *Limeroons* (1991), *The Lost Wag* (1993), *An Earful of Aliens* (1993)
ILL: Many books including A. Davidson's 'Catfoot' series; J. Hunter's 'Harry, Mari & Squib' series; J. Rothman, *The Cannibal Cookbook* (1982)
EXHIB: Various in UK
COLL: MOCA MB

FORRESTER, Alfred Henry 'Alfred Crowquill' (1804–72). Illustrator, comic artist and stage designer. Alfred Crowquill was born in London, the son of a rich city lawyer and the brother of the writer Charles Forrester who also used the pseudonym 'Alfred Crowquill'. The first caricatures, designed but not at that stage etched by him, were published in 1824 and in 1826 he and his brother, dressed as Regency Bucks, appear in his print 'Beauties of Brighton' etched by GEORGE CRUIKSHANK. Strongly influenced in style by Cruikshank, he also followed his lead in issuing collections of his own humorous work, sometimes with a text by his brother, as in *Absurdities in Prose and Verse* (1827). In his book illustrations he changed in the 1850s from humour to fairy stories. His contributions to *Punch* in its earliest days (1841–4) included a few unremarkable political cartoons. Far more interesting were some of the large drawings published in the *Illustrated London News* (1844–70), caricatures of human heads and anthropomorphic drawings of animals, which showed a great talent for fantastic invention. He also contributed to *Bentley's Miscellany*, *Illustrated Times*, *London Society* and the *New Monthly Magazine*. Crowquill was a versatile, proficient and amus-

ing artist whose work, especially in the field of fantasy, has been neglected.
PUB: *Alfred Crowquill's Sketch Book* (1827), *Pictures Picked from the Pickwick Papers* (1837), *Leaves from the Memorandum Book of Alfred Crowquill* (1837), *A Good-Natured Hint about California* (1849), *Funny Leaves for the Younger Branches* (1852), *Fun* (1854), *Picture Fables* (1854), *Fairy Tales* (1857), *Fairy Footsteps* (1861), *The Two Puppies* (1870)
ILL: More than 40 books including 'Septimus Globus' [J. A. Apel], *Der Freischutz Travestie* (1824); C. Forrester, *Absurdities in Prose and Verse* (1827), *The Pictorial Grammar* (1842); *Phantasmagoria of Fun* (1843); W. F. von Klosewitz, *Eccentric Tales* (1827); 'Bon Gaultier', *The Book of Ballads* (1845); Lt Col. Hort, *The Guards and the Line* (1851); R. Raspe, *The Adventures of Baron Munchhausen* (1859); K. Mackenzie, ed. *The Marvellous Adventures . . . of Master Tyll Owlglass* (1860)
EXHIB: RA
COLL: BM: V&A SH

FOUGASSE – see Bird, Cyril Kenneth

FRANCIS, Clive (b. 1946). Actor and caricaturist. Best known as a theatre, TV and film actor, Clive Francis was born on 26 June 1946 in Eastbourne, Sussex, the great nephew of the landscape painter Donald Towner. He attended the local art school on Saturday mornings but gave up at the age of 13. It was Towner who first introduced him to BEARDSLEY and the posters of Toulouse-Lautrec, both of whom were an early influence on his style. Later artists he has admired are BEERBOHM, BERGER, BENTLEY, NERMAN, SHERRIFFS, LEVINE, SEARLE and Hirschfeld. He began caricaturing professionally in 1983 and has designed posters for productions at the London Palladium and National Theatre as well as covers for many books. Of his work he has written: 'Caricature is in a way rather akin to plastic surgery. As bits are taken away so bits are added on. The only difference being that the caricaturist reveals, mercilessly, warts, tucks and all . . . I would define my work as tongue in cheek portraiture.'
PUB: *Laugh Lines* (1989)
ILL: J. Gielgud, *Stage Directions* (1963), *Early Stages*; A. Guinness, *Blessings in Disguise* (1985); M. Denison, *Double Act* (1985); C. Freud, *Clement Freud's Book of Hangovers* (1986)
EXHIB: IML Gallery; Snow Goose Gallery, Brighton; Lyric Theatre; NT MB

Clive Francis, [John Gielgud], *Laugh Lines* (1989)

FRANÇOIS, André [real name André Farkas] (b. 1915). Cartoonist, illustrator, designer, painter and sculptor. André François was born in Timisoara, Romania, on 9 November 1915 and studied at the Budapest School of Fine Arts before moving to France. There he studied at the Ecole des Beaux-Arts with poster artist A. M. Cassandre (1935–6) before beginning drawing cartoons under the name 'André François' in 1944. He has contributed to *La Tribune des Nations* (1953–60), *Holiday*, *Sports Illustrated*, *Femina*, *Lilliput*, *Vogue* (France), *Life*, *Punch*, *New Yorker*, *Esquire* and *Fortune* (including covers for these last four) and others. He has also worked in advertising for Kodak, Olivetti, Wilmot Breeden car components, Citroën, Pirelli and Esso and produced animated TV ads for Jack-in-the-Box restaurants and the American Gas Association. In addition he has designed stage sets for Roland Petit's ballet company (1956), Peter Hall's *The Merry Wives of Windsor* (1958) and Gene Kelly's *Pas de Dieux* (1960). He feels his work is more a defence against what goes on in the world around him, than an attack upon it. Since 1960 he has concentrated mostly on painting. He is a Chevalier de Légion d'Honneur and is an Honorary Doctor of the University of London (RCA). François' deceptively rough-hewn, scratchy line and child-like style has been much admired by artists such as RONALD SEARLE and QUENTIN BLAKE, who said of his work: 'Part of the charm is that the drawings don't appear to have gone through a process of preparation; it is as though they had just been scratched down on the paper at the moment they were thought of. And yet they are instinct with a sense of drawing.'

PUB: *Issy-les-Brioches* (1946), [with Chaval & Mose] *Magnigances* (1952), *André François' Double Bedside Book* (1952), *The Tattooed Sailor* (1953), *Mit Gestraubten Federn* (1955), *Crocodile Tears* (1955), *The Half-Naked Knight* (1958), *The Biting Eye* (1960), *Penguin André François* (1964), *You are Ri-di-cu-lous* (1970), *André François* (1976)

ILL: Diderot, *Jacques le Fataliste* (1947); Balzac, *Contes Drôlatiques* (1957); A. Jarry, *Ubu-Roi* (1958); J. le Marchand, *The Adventures of Ulysses* (1960); J. Prevert, *Lettre des Iles Baladar* (1967), J. Symonds, *William Waste* (n.d.); R. McGough, *Mr Noselighter* (1976); Queneau, *Si Tu Imagines* (1979); B. Vian, *L'Arrache de Coeur* (1982) and many children's books

EXHIB: New York; Galerie Delpire, Paris;

André François (André Farkas), *The Half-Naked Knight* (1958)

Stedelijk Museum, Amsterdam; MAD; Chicago Arts Club; Palais des Papes, Avignon; Musée Saint-George, Liège; Musée Tavet, Pontoise; Galerie Bartsch-Chariau, Munich; MAM (Retrospective, 1986); Chateau-Musée, Dieppe

MB

FRANKLIN, Stanley Arthur (b. 1930). Editorial/ political and strip cartoonist and caricaturist. Born on 30 October 1930 in Bow, London, Stanley Franklin studied lithography at Mornington Crescent Working Men's College (1946–8) and life drawing at Hammersmith

School of Arts & Crafts (1948–51). His staff cartoon work began with the 'Mr Farthing' strip on the *Daily Herald* (1954–5) and he was Political Cartoonist for the *Daily Mirror* (1959–70) then Editorial Cartoonist on the *Sun* (1974–92), for whom he still draws on a weekly basis. He has also freelanced as a political cartoonist for the *New Statesman* (1974) and produced cartoon graphics for BBCTV comedy shows (1971–3) such as 'The Marty Feldman Show', 'Them' and 'Lame Ducks'. Other work has included 'relief painting' and making pottery figurines (including six London characters for the Royal Adderley Pottery, Stoke-on-Trent in 1971). Voted CCGB Cartoonist of the Year as well as Social and Political Cartoonist of the Year (1981), Franklin was also awarded a Victor Silvester gold medal for ballroom-dancing (1958). He works with a mapping pen and brush and draws a third up on Bristol board. Franklin's mascot is the little man with a big nose called Raspberry (so called because of his spotty nose) who appears looking on in all his cartoons (a pigeon was added when he joined the *Sun*).

ILL: J. Speight, *The Thoughts of Chairman Alf* (1973), *Alf Garnett Scripts* (1973); *Dick Emery in Character* (1973)
EXHIB: [relief paintings, pottery and drawings] Daily Mirror Building; Treadwell Gallery; Richmond Art Gallery, Surrey
COLL: NPG; [Falklands War cartoons] IWM; [Silver Jubilee Cartoons] Buckingham Palace; [relief paintings] Dunedin Art Gallery, New Zealand MB

FRASER, Eric George (1902–83). Illustrator, painter, commercial artist, art-teacher and cartoonist. Eric Fraser was born in Westminster on 11 June 1902, his father being a solicitor's clerk and his mother a headmistress. He was educated at Westminster City School and studied at Westminster School of Art and at Goldsmith's College, to which he won a scholarship (1919). In the 1920s and 30s he divided his time between teaching (including graphic design at Camberwell School of Art (1928–40)), illustrating (notably in *Radio Times* from 1926), commercial art (creating the famous 'Mr Therm' design for the Gas, Light & Coke Company in 1931) and cartooning, contributing occasional pen-and-ink drawings to *Britannia & Eve*, *Bystander*, *Harper's Bazaar*, *Leader*, *Lilliput*, *Listener*, *Nash's*, *Night & Day*, *Men Only* (covers) and *Punch*. Some of these drawings showed a nice sense of absurdity. An extremely versatile artist, Eric Fraser practised

etching, lithography, mural and easel painting and stained-glass design but is best known for strong clean drawings in pen-and-ink or scraperboard for *Radio Times* and books published by the Golden Cockerel Press and the Folio Society. He sometimes signed his work 'ef'.

ILL: E. V. Knox, *Here's Misery!* (1928); *The Complete Shakespeare* (1951); Tacitus, *The Reign of Nero* (1952); I. Nievo, *The Castle of Fratta* (1954); Ovid, *The Art of Love* (1971); J. R. R. Tolkien, *The Lord of the Rings* (1977), *The Hobbit* (1977)
EXHIB: RA; V&A 'The Art of *Radio Times*' (1981–2); RCA 'Eric Fraser, An Illustrator of Our Time' (1991)
COLL: V&A
LIT: A. Davis, *The Graphic Work of Eric Fraser* (1974) SH

FRASER, George Gordon (fl. 1880s–d. 1895). Painter, cartoonist and strip cartoonist. George Gordon Fraser was born in Ireland. In the 1880s he contributed cartoons and illustrations to *Judy*, the *Idler* and *Ludgate Magazine*. His strip cartoons in *Fun* from 1888 were influenced by J. F. SULLIVAN. In 1893 his strip 'The Balls Pond Banditti' started publication in *Larks* and marked the first appearance of child heroes in a British comic. As a painter he was best known for landscapes.
EXHIB: RA; RI; DG SH

FRASER, Peter (1888–1950). Cartoonist and illustrator. Born in the Shetlands on 6 November 1888, Peter Fraser studied at the Central School of Arts & Crafts and via PERCY BRADSHAW's correspondence course. He worked in the City of London (1907–10) and first contributed to *Punch* in 1912, producing nearly 200 illustrations for the magazine up to 1941. He also drew for *Sketch*, *Time & Tide*, *Happy Days* and *Tatler*. Many of his drawings featured Cockney children whom he met during his work in missions in the Old Kent Road and Stepney. He died on 5 March 1950.
PUB: *Funny Animals* (1921), *Tufty Tales* (1932), [with E. Fraser] *Jack and Jock's Great Discovery* (1944), *Camping Out* (1945); *Moving Day* (1945)
ILL: W. H. Harrison, *Humour in the East End* (1933); S. Rye, *The Blackberry Picnic* (1946), *Bevis and the Giant* (1948) MB

FRIELL, James 'Gabriel' (b. 1912). Cartoonist and journalist. James Friell was born in Glasgow on 13 March 1912. Leaving school at 14 he

worked in a solicitor's office and taught himself to be a cartoonist, freelancing regularly for Glasgow evening papers, especially the *Glasgow Evening Times* (1930–9). He then attended Glasgow School of Art from where he was recruited as a 'graphics man' by the advertising department of Kodak who sent him to London in 1932. Billed as 'Fleet Street's greatest discovery since DAVID LOW' he joined the *Daily Worker* as Political Cartoonist in 1936 (as 'Gabriel') whilst also contributing to *World's Press News*. In World War II he served in the Royal Artillery but was kept under observation as a 'Dangerous Red' by the War Office. He helped set up *Soldier* magazine in 1944, working as cartoonist, art editor, layout man and printer liaison. When the Soviet Union invaded Hungary in 1956 he left the *Daily Worker* and joined the *Evening Standard* (1957–62), drawing as 'Friell'. He later drew cartoons for consumer-interest programmes on Thames TV and was awarded a Bronze Medal at the International Film and TV Festival for his cartoons for the Grand Metropolitan Catering Service.
PUB: *Gabriel Cartoons* (1938), *Daily Worker Cartoons* (1944), *Gabriel's 1946 Review* (1946)
ILL: [as Field] D. Gamblin, *Water on the Brain* (1979)
EXHIB: UKCC
COLL: UKCC MB

FRIERS, Rowel Boyd MBE RUA UWS (b. 1920). Painter, illustrator, designer and cartoonist. Born in Belfast, Northern Ireland, on 13 April 1920, Rowel Friers left school at 16 to be apprenticed as a lithographic and letterpress artist. The following year he graduated to poster and showcard design while studying two afternoons a week and most evenings at the Belfast Municipal College of Art (1935–43). When the printers went into liquidation he started a commercial studio and had his first cartoon published in *Portsmouth Evening News* (1940). He also contributed to *Dublin Opinion, Reynold's News, Economist, Belfast Telegraph, Irish Times, Punch, Daily Express, London Opinion, Radio Times, Sunday Independent* and *Men Only*. In addition he has produced watercolours, oil paintings and murals (for the Ministry of Food during World War II and in Belfast restaurants) and was a member of the Committee and Council of the Royal Ulster Academy. Elected a full Academician of RUA in 1940 and a member of Ulster Watercolour Society in 1977, he was awarded an MBE in 1977 for his contribution to art and journalism,

and received an Honorary MA from the Open University in 1981. An admirer of ILLINGWORTH, EMETT, GEORGE MORROW, SCARFE, SEARLE and STEADMAN, he has also designed more than 100 stage sets for theatre and opera, and has worked for Ulster TV and the BBC.
PUB: *Wholly Friers* (1950), *Mainly Spanish* (1951), *Riotous Living* (1971), *Pig in the Parlour* (1974), *The Book of Friers* (1973), *The Revolting Irish* (1974), *On the Borderline* (1982), *Trouble Free!* (1988), *Friers Country* (1992)
ILL: More than 50 books including J. McNeill (nine titles, 1955–70); R. Harbinson, *Tattoo Lily* (1961); W. White, *The Beedy Book* (1965); F. M. McDowell, *Other Days Around Me* (1966); W. B. Yeats (ed.), *Irish Folk Tales* (1973) and others
EXHIB: CB; Grendor Gallery, Holywood; Davis Gallery, Dublin; Irwin Gallery, Armagh
COLL: UAA MB

FURNISS, Harry (1854–1925). Caricaturist, cartoonist, illustrator, author, lecturer and film producer. Harry Furniss was born in Wexford, Ireland, on 26 March 1854, the son of a civil engineer from Yorkshire. Moving to Dublin aged 10 he was educated at the Wesleyan College and studied at the Royal Hibernian Schools and the Hibernian Academy but, typically, regarded himself as self-taught. He contributed some cartoons to *Zozimus* (the Irish *Punch*) in 1873 before coming to England that year. Before long he had made a name for himself in the *Illustrated Sporting & Dramatic News* and the *Illustrated London News*, for which he acted as an illustrator and a graphic reporter. He also contributed to *Black & White, Cassell's, Cornhill, English Illustrated Magazine, Good Words, Graphic, Illustrated Bits, London Society, Pall Mall, Pears Annual, Pearson's, St James's Budget, Sketch, Vanity Fair* and the *Windsor Magazine*. His fame was at its peak in the years 1880 to 1894 when he illustrated 27 books and contributed over 2600 drawings to *Punch*, of which the best remembered are the illustrations to 'Essence of Parliament' and particular caricatures such as Gladstone in an enormous winged collar. He spent almost every day in the Press Gallery of the House of Commons and may have been the first caricaturist whose sketches made on the spot were printed a few hours afterwards. His most famous cartoon for *Punch* was the tramp's testimonial for Pears Soap: 'Two years ago I used your soap since when I have used no other.' In 1888 he started to give public lectures, illustrated in a variety of ways, on 'The

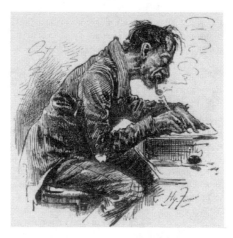

GOOD ADVERTISEMENT.

"I USED YOUR SOAP TWO YEARS AGO ; SINCE THEN I HAVE USED NO OTHER."

Harry Furniss, *Punch*, 26 April 1884

Humours of Parliament'. He quarrelled with *Punch* in 1894 and started two short-lived humorous magazines, *Lika Joko* and *New Budget*. Thereafter he spent most of his prodigious energies in writing, illustrating, and making and acting in films. He died in Hastings on 14 January 1925. Harry Furniss was quarrelsome, conceited and none too scrupulous, but he was a force to be reckoned with in caricature. Only looking for eccentricity of appearance or personality in his subjects and working with amazing speed, his drawings impress by their theatricality, vitality and spontaneity. A great admirer of CHARLES KEENE ('the greatest artist in black and white England ever produced'), his own style was a pointer to the future. As he said, 'Today one must draw real people with the fewest lines.' His daughter Dorothy also worked as an illustrator on some of his books.

PUB: 17 books including *Pictures at Play* (1881), *A River Holiday* (1883), *Parliamentary News* (1885), *Harry Furniss's Royal Academy* (1887), *MPs in Session* (1889), *Royal Academy Antics* (1890), *Harry Furniss at Home* (1904), *How to Draw in Pen and Ink* (1905), *More About How to Draw in Pen and Ink* (1915), *Garrick Gallery Caricatures* (1923), *Some Victorian Women* (1923), *Some Victorian Men* (1924), *The Two Pins Club* (1925)

ILL: Many books including G. A. Henty, *Seaside Maiden* (1880); L. Sterne, *Tristram Shandy* (1883); W. Besant, *All in a Garden Fair* (1884); J. Payn, *The Talk of the Town* (1885); G. A. Beckett, *The Comic Blackstone* (1887); F. C. Burnand, *The Incompleat Angler* (1887); L. Carroll, *Sylvie and Bruno* (1889), *Sylvie and Bruno Concluded* (1893); G. E. Farrow, *The Wallypug of Why* (1895), *The Wallypug Book* (1905); *The Charles Dickens Library* (1910); *The Works of Thackeray* (1911)

EXHIB: RA; RHA; FAS (1894, 1898, Memorial 1925); NPG 'Harry Furniss' (1983); Gainsborough Galleries

COLL: NPG; V&A; HCL; H; LC; BM

LIT: H. Furniss, *Confessions of a Caricaturist* (1901), *My Lady Cinema* (1914), *My Bohemian Days* (1919) SH

FUSBOS – see Doyle, Henry Edward

G

GABRIEL – see Friell, James

GAIS – see Gaisford, R. G.

GAISFORD, R. G. 'Gais' DFC (fl. 1930s–40s). Cartoonist. Gaisford served as a wireless operator/air gunner in the RAF during World War II and was awarded a DFC. After the war he wrote and designed advertisements and drew cartoons for *Punch, London Opinion, Tatler, Lilliput, Daily Mirror* and *Evening Standard*.

MB

GALE, George (b. 1929). Editorial cartoonist. George Gale was born on 11 June 1929 in Leven, Fife. He was educated in Scotland but has been living in London since the 1950s. After studying as a draughtsman and spending a period as a commercial artist, he began freelancing, selling cartoons to *The Times* (from 1973), *Economist, Tribune, Financial Times* and other British and European newspapers and journals. He was Editorial Cartoonist of the *Daily Telegraph* (1986–9) and is currently Editorial Cartoonist of the parliamentary weekly, *The House Magazine*. Influence by GILLRAY, CRUIKSHANK, LOW and VICKY, he works mainly in pen and ink, gouache and crayon.
ILL: I. Gale, *The Flying Hammer* (1985)
EXHIB: Leatherhead Theatre; Jacey Galleries; Waterman Gallery (1992)
COLL: Florence Nightingale Museum, London; University of Edinburgh; Sussex Yeomanry Museum, Taunton MB

GAMMIDGE, Ian Berwick TD (b. 1916). Cartoonist, strip cartoonist and scriptwriter. Born in Ashstead, Surrey, on 15 April 1916, Ian Gammidge is a self-taught artist and was an insurance salesman before serving in the Army in World War II (later gaining a Territorial Decoration (1950)). After the war he attended St Martin's School of Art and sold his first cartoon to *Lilliput* in May 1946. Freelance since then, his work has appeared in *John Bull, Everybody's, Tatler, London Opinion, Draper's Record* and other trade papers. He joined the staff of the *Daily Mirror* in May 1947, taking over from Jack Hargreaves as writer of 'The Flutters' strip, and then succeeding Brian Cooke as writer of 'The Larks' and Bill Connor ('Cassandra') as writer of

'Ruggles'. He still produces strip cartoons for the paper and has also drawn weekly joke cartoons for *Sunday Pictorial* (later the *Sunday Mirror*) (1947–81) and wrote the last episodes of NORMAN PETT's creation, 'Jane'.
PUB: [with Fel] *Little Joe* (1975), [with J. Dunkley] *Mr Digwell's Everyday Gardening Book* (1977), [with J. Dunkley & B. Cooke] *Life with the Larks* (1978), *Gardener's Mirror* (1981)
MB

GARLAND, Nicholas Withycombe (b. 1935). Political cartoonist and strip cartoonist. Nicholas Garland was born on 1 September 1935 in Hampstead, London, the son of a doctor, and emigrated to New Zealand at the age of 12 (1947–54). Returning aged 19, he attended the Slade School of Fine Art (1954–7). After working for some years as stage manager at the Royal Court Theatre and co-director of plays at the Phoenix, he created, with writer Barry Humphries, the 'Barry Mackenzie' strip in *Private Eye* (1964–74). 'Barry Mackenzie's chin was taken from Desperate Dan, and his double-breasted suit, striped tie and wide-brimmed hat were inspired by (the outfits of) a group of middle-aged Anzacs I once saw marching down Whitehall during a Remembrance Day parade. The name Mackenzie came from an Australian cricketer and Barry, of course, from Barry Humphries.' Two films were made featuring the character, which caused problems with the censor even in Australia. (In *The Adventures of Barry Mackenzie* (1972), scriptwriter Barry Humphries himself played the part of Mackenzie's aunt Edna Everidge.) Eventually the *Eye* dropped the strip and Garland went on to become the first Political Cartoonist on the *Daily Telegraph* (1966–86), leaving to join the newly founded *Independent* (1986–91) and returning to the *Telegraph* in 1991. He has also drawn weekly political cartoons for the *New Statesman* (1971–6), and contributed to the *Spectator* (from 1964, including covers), *Queen* and *Investor's Chronicle*. In addition he has designed book jackets and has been voted Cartoonist of the Year twice by Granada TV (1972, 1987). An admirer of VICKY, who influenced his style, he produces roughs on A4 layout paper using 3B pencil before transferring to Daler NOT wash-and-line board and a Sheaffer fountain pen (fine and medium nib) with Sheaffer

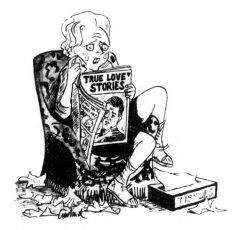

Nicholas Garland, [Margaret Thatcher & Cecil Parkinson], *Spectator*, 15 October 1983

cartridge ink. He also uses indian ink with a brush for filling in large areas.
PUB: [with B. Humphries] *The Wonderful World of Barry Mackenzie* (1968), *Bazza Pulls It Off!* (1972), *The Complete Barry Mackenzie* (1988); *An Indian Journal* (1983), *Twenty Years of Cartoons by Garland* (1984), *Travels With My Sketchbook* (1987), *Not Many Dead* (1990)
ILL: T. B. Macaulay, *Horatius* (1977); A. McPherson & A. Macfarlane, *Mum – I Feel Funny!* (1982); W. Cope, *The River Girl* (1991)
EXHIB: CG; Vilnius Art Gallery, Lithuania
COLL: V&A; A; UKCC; CAT MB

GARY – see Smith, Gary James

GASKILL, David Thomas (b. 1939). Editorial cartoonist, caricaturist, strip cartoonist and illustrator. Dave Gaskill was born in Liverpool on 27 May 1939 and is self-taught apart from two years of evening classes at Stockport College, Cheshire. He worked as an engineering/design draughtsman before becoming a full-time cartoonist, first in Johannesburg, South Africa (1973–85), where he worked for *Sunday Express*, *Citizen*, *Star*, *Financial Mail*, *Sunday Times* and *Rand Daily Mail*; then Australia (1986–7) on *West Australian* and *Business Daily*; and New Zealand (1987) for *New Zealand Herald*. Returning to the UK in 1987 he has been Editorial Cartoonist on *Today* since 1988. He has also freelanced for *Reader's Digest* (South Africa), *Signature Magazine*, *Diners Club*, *Republican Press* and various national and international advertising agencies in South Africa. He received

four awards for his work in South Africa where he was also resident cartoonist on a TV series.
PUB: *Dave Gaskill's World* (1992)
EXHIB: BC MB

GED – see Melling, Gerard

GEE BEE – see Butterworth, George Gordon

GHILCHIK, David Louis ROI (1892–1972). Cartoonist, portrait/landscape painter and illustrator. David Ghilchik was born in Romania and came to England at the age of five. He studied at Manchester School of Art, in Italy on a travelling scholarship, and at the Slade. In World War I he served first as a driver/mechanic in the British Army Service Corps and later in the Intelligence Corps in Italy. His contributions to *Punch* (1920–39) were very much in the tradition of LEWIS BAUMER. He also drew for *Humorist*, *Bystander* and *Daily Sketch*. A founder member of SWE (1920) he was also President of the London Sketch Club, Vice-President of the United Society of Artists, a member of the Savage Club and was elected ROI (*c.* 1960). He died on 24 November 1972.
PUB: *Drawing Children* (1961)
ILL: J. A. Hammerton, *The Rubaiyat of a Golfer* (1946)
EXHIB: RA; ROI; RI; RBA; NEAC; L; RP MB

GIBBARD, Leslie David (b. 1945). Editorial/political cartoonist and film animator. Les Gibbard was born on 26 October 1945 in Kaiapoi, New Zealand, and as a schoolboy in Auckland was tutored in charcoal and pastels by Franz Szirman. Working at first as a newspaper journalist (1962–7) he also produced cartoons, caricatures and illustrations for *Auckland Star*, *New Zealand Weekly News*, *Sunday News* and *Melbourne Herald* as well as *New Zealand Herald* where he was coached and greatly influenced by MINHINNICK. He came to London on 1 June 1967 and worked as a freelance cartoonist occasionally under the name of 'Spike' before becoming arts caricaturist and pocket cartoonist for *Sunday Telegraph* (1967–70) and succeeding BILL PAPAS as Political Cartoonist on the *Guardian* (1969–1994). He has also contributed to the *Daily Mirror* (caricatures), *Daily Sketch*, *Daily Telegraph*, *Sunday Mirror*, *Evening Standard*, *Time Out*, *Melody Maker* and others. In addition he has worked as an animator for Richard Williams's studio (1973–5) – where he

attended life classes by Disney animator Art Babbitt – and has produced his own animated political cartoon series 'Newshound' for Granada TV's 'Reports Politics' (1976–7) and key-animated the stories of Beatrix Potter for TV. He has also drawn weekly political cartoons for BBCTV's 'On the Record' (from 1988) and 'Newsnight' programmes and Channel 4's 'A Week in Politics' (1980–2). Gibbard was voted BISFA Slide/Strip Artist of the Year (1980) and National Canine Defence League Dog Cartoonist of the Year (1989). During the Falklands War, when the Argentinian cruiser *General Belgrano* was sunk with a loss of 362 lives, Gibbard drew a pastiche of ZEC's famous World War II cartoon, re-captioning it 'The Price of Sovereignty Has Increased – Official'. This caused a brief furore in the tabloid press, with the *Sun*'s leader writer branding him a traitor. He works in pen and ink using a Gillot 404 nib on cartridge paper, an HB pencil and a No. 4 sable brush. For TV drawings he uses Daler line-and-wash board with a neutral tint wash. He cites his influences as being LOW, MINHINNICK, TOM WEBSTER, SEARLE and Disney.
PUB: *Gibbard's Double Decade Omnibus* (1991)
ILL: A. Mitchell, *The Half Gallon Quarter Acre Pavlova Paradise* (1972), *Westminster Man* (1982); F. Keating, *Caught by Keating* (1979)
EXHIB: Holland Gallery; UKCC
LIT: N. Harris, *Flyaway People* (1971) MB

GILBERT, Sir William Schwenck 'Bab' (1836–1911). Playwright, comic poet and illustrator. W. S. Gilbert was born in London on 18 November 1836, the son of a surgeon-turned-novelist. He was educated in Ealing and at London University (1857). From 1857 to 1861 he was a clerk in the Privy Council Office and in 1863 he was called to the Bar. As an impecunious barrister he supplemented his income by contributing comic sketches, articles and verses to *Fun* and illustrating books by his father. In 1866 his 'Yarn of the Nancy Bell' was rejected by *Punch* as 'too cannibalistic'; signed 'Bab' and illustrated with tiny thumbnail sketches by the author it formed one of the celebrated 'Bab Ballads' published in *Fun* (1866–71). Gilbert's comic illustrations in *Fun*, *Broadway Annual*, *Good Words for the Young*, *London Society*, *Punch* and *Tom Hood's Comic Annual* showed much talent and it is regrettable that he never developed this side of his gifts. He went on to collaborate with Sir Arthur Sullivan in a long series of comic operas and was knighted in 1907. Life, he felt, was essentially absurd and

LORENZO DE LARDY.

W. S. Gilbert, *The 'Bab' Ballads* (1869)

his clever topsyturvydom came to be known as 'Gilbertian humour'. He died in Harrow on 29 May 1911.
PUB: *Ruy Blas* (1866), *The 'Bab' Ballads* (1869), *More 'Bab' Ballads* (1873), *Songs of a Savoyard* (1890)
ILL: W. Gilbert, *The Magic Mirror* (1866), *King George's Middy* (1869), *The Seven-League Boots* (1869)
COLL: BM
LIT: H. Pearson, *Gilbert and Sullivan* (1935); *Selected Bab Ballads with Note on Gilbert as Illustrator by Philip James* (1955) SH

GILES, Carl Ronald OBE (b. 1916). Cartoonist, animator and journalist. Carl Giles was born on 29 September 1916 in Islington, London, the son of a tobacconist and grandson of a jockey who had ridden for Edward VII. He attended Barnsbury Park School – where he was taught by the severe, skeletal Mr Chalk who later featured in his cartoons – and left at the age of 14, working first as an office boy and then as an animator in Wardour Street, London. Moving to Elstree he joined Alexander Korda's studios (1930–5) and was one of the principal animators of Korda's *The Fox Hunt* (artist Anthony Gross), the first British animated colour cartoon with sound. On

'You say the lady kissed your head under the mistletoe, thereby causing you sexual harassment?'

Carl Giles, *Daily Express*, 21 December 1982

the death of his brother he returned to London to work for *Reynolds News* (1937–43), producing political cartoons and a strip 'Young Ernie'. He moved to the *Daily* and *Sunday Express* in 1943 as Deputy Cartoonist (to STRUBE) and war correspondent, eventually taking over from Strube. During World War II he also produced animated films for the Ministry of Information and his cartoons were reproduced as posters for the Railway Executive Committee and others. In addition he has drawn advertising cartoons for Guinness, Fisons and others and designed Christmas cards for the RNLI, Royal National Institute for the Deaf and Game Conservancy Research Fund. He was awarded the OBE in 1959 and the Cartoonists' Club of Great Britain Special Award for Distinguished Services to Cartooning in 1962. He has also received Granada TV's 'What the Papers Say' Award for his work and is President of the British Cartoonists' Association. Giles is best known for his Express 'family' especially the character Grandma, 'a bleakly menacing figure drawn from his dark subconscious, bird in hat, umbrella in hand and "reeking of bombazine" ' (Keith Mackenzie). An animated version of the series appeared as a TV advertisement for Quick Brew tea with voices supplied by Nigel Stock as Father, Meg Johnson as Mother and Pat Hayes as Grandma. Giles cites his influences as BAIRNSFATHER and PONT ('When he went I felt I had lost a dear friend'), and he has himself directly influenced the style of JAK, MAC and others. Described by VICKY as 'a present-day Hogarth', SEARLE has said of him 'in his superb understanding of human behaviour no one can touch him' and Lord Beaverbrook called him 'a man of genius ... who takes the solemnity out of the grand occasion and helps the world to keep sane by laughing at its soaring moments'. He draws without distortion with his cartoon figures set against elaborately detailed naturalistic backgrounds, often with fascinating 'sub-plots' occurring away from the main focus of the picture.
PUB: Giles annuals from 1946, *Children* (1955), *Nurse!* (1975)
ILL: Philip, Duke of Edinburgh, *The Wit and Wisdom of Prince Philip* (1965), *More Wit and Wisdom of Prince Philip* (1973)
EXHIB: L; NMCA; CAT (1993)
COLL: CAT; [animated film] IWM
LIT: P. Tory, *Giles: A Life in Cartoons* (1992)
MB

GILLETT, Frank RI (1874–1927). Cartoonist and painter. Frank Gillett was born in Worlingham, Suffolk, on 23 July 1874, the son of a parson, and was educated at Gresham's School. He started to contribute cartoons to *Fun* (1895) whilst working as a clerk at Lloyd's

(1890–6). In 1898 he joined the staff of the *Daily Graphic*, concentrating on sporting subjects and soon after his 'Topicator' feature started in the *Bystander*. Other magazines to which he contributed around this time were *Black & White*, *Idler*, *Judy*, *Little Folks*, *Ludgate Magazine*, *Odd Volume*, *Pearson's Magazine* and the *Illustrated Sporting & Dramatic News* (1910–23). Most of his work is in pen and ink, is crisply drawn and best in equestrian subjects. He was elected RI in 1909.

EXHIB: RA; RI; G; L SH

GILLIAM, Terence Vance (b. 1940). Cartoonist, illustrator, animator and film director. Born in Minneapolis, Minnesota, USA, on 22 November 1940, Terry Gilliam studied Political Science at Occidental College, Los Angeles (1958–62), where he edited the college humour magazine. Moving to New York he became Associate Editor of *Help!* magazine (1962–5), founded by *Mad's* Harvey Kurtzman, and after working as a freelance cartoonist and illustrator joined Carson Roberts Advertising Agency as Art Director/Copywriter (1966–7). In 1967 he moved to London working as a freelance illustrator for *Sunday Times*, *Nova* and *Queen* and was Art Director of *The Londoner*. After selling comedy sketches to TV's 'Do Not Adjust Your Set' (1968) he was resident cartoonist on the 'We Have Ways of Making You Laugh' TV series for which he also produced an animated cartoon. This led to animation for BBC2's 'Marty' series (starring Marty Feldman, 1969) and 'Do Not Adjust Your Set'. He was a founder member of the 'Monty Python's Flying Circus' team on BBCTV in 1969. Other work includes animated title sequences for *Cry of the Banshees* (1970) and *William* (1972) and animation for ABCTV's 'The Marty Feldman Comedy Machine' (1971). Film credits (as animator, co-writer and actor for 'Python' films) include *The Miracle of Flight* (1971), *Monty Python's And Now for Something Completely Different* (1971), *Monty Python and the Holy Grail* (co-director, 1974), *Jabberwocky* (director, 1976), *Monty Python's Life of Brian* (designer, 1978), *Time Bandits* (producer-director 1980), *Monty Python's Meaning of Life* (1983), *Brazil* (co-writer, director 1980), *The Adventures of Baron Munchhausen* (director and co-writer, 1989) and *The Fisher King* (director, 1991). He was made an Honorary Doctor of Fine Arts by Occidental College, Los Angeles (1987), and the RCA (1987).

PUB: *Animations of Mortality* (1978), [with M.

Palin] *Time Bandits* (1981), [with C. McKeown] *The Adventures of Baron Munchhausen* (1989)
ILL: H. Kurtzman, *Harvey Kurtzman's Fun and Games* (1965); [Monty Python team], *Monty Python's Big Red Book* (1971), *The Brand New Monty Python Book* (1973), *Monty Python and the Holy Grail* (1977), *Monty Python's Scrapbook* (1979), *Monty Python's Life of Brian* (1979), *The Complete Works of Shakespeare and Monty Python* (1981) and *Monty Python's Meaning of Life* (1983); R. McGough, *Sporting Relations* (1976); A. Yule, *Losing the Light* (1991), *The Fisher King* (1991)
LIT: J. Matthews, *The Battle of Brazil* (1987)
 MB

GILLRAY, James (1756–1815). Caricaturist. Gillray was born in Chelsea, London, on 13 August 1756, the son of a disabled Scottish ex-soldier and member of the Moravian Brotherhood, an extreme Protestant sect that believed in 'the total depravity of man'. After attending Moravian schools he was apprenticed to an engraver, then briefly joined a company of actors before entering the RA Schools (1778) to study engraving under Bartolozzi. His earliest caricatures (1775–80) were much influenced in style by MORTIMER and often scatological in content. During the 1780s he turned increasingly to political satire. At this time he was also engraving illustrations and portraits but from 1786 concentrated exclusively on caricature. Having a superb command of print-making techniques, a distinctive and occasionally beautiful line, a good knowledge of politics, a bold and fertile imagination and the steady support of the leading West End printseller, Mrs Hannah Humphrey, he soon outdistanced his rivals. At first he attacked Pitt, George III and the Tories, but in 1793, alarmed by developments in France, he turned on the Whig Opposition, accepting a pension from Pitt in 1797. His ferocious attacks on the French Revolutionaries and later Napoleon played a large part in rallying support for the government. But about a third of his caricatures were on social rather than political themes, often etchings based on designs by amateurs like SNEYD and BROWNLOW NORTH. In these his savage mockery, although not always his instinct for indecency, is restrained. Some of them, indeed, have a graceful rococo charm. His health began to decline in 1807, probably exacerbated by alcohol, and in 1810 he went insane. He died in his room above Mrs Humphrey's shop in St James's Street on 1 June 1815. Gillray so dominated the art of caricature that a German

Uncorking–Old–Sherry–

the hon.ble Gent.n tho he does not very often address the House; yet when he does, he always thinks proper to pay off all arrears, & like a Bottle just uncorkd bursts all at once, into an explosion of Froth & Air,– then, whatever might for a length of time lie lurking & corked up in his mind, whatever he thinks of himself or hears in conversation,–whatever he takes many days or weeks to sleep upon, the whole common place book of the interval is sure to burst out at once, stored with studied Jokes, Sarcasms, arguments, invectives, & every thing else, which his mind or memory are capable of embracing whether they have any relation or not to the Subject under discussion.— See Mr P.tts Speech in ye Gen.l Defence Bill March 6.th 1805

James Gillray, [William Pitt], 1805

journalist, writing in 1806, called him 'the fore-most living artist in the whole of Europe'. HOGARTH had made caricature into a popular art form and an instrument of morality. Gillray re-fashioned it into a political weapon of such power that Napoleon lamented his country's inability to respond. Yet the excesses of his imagery provoked a reaction that lasted until the time of DYSON and LOW when passion was restored to the art. Low's words could well stand as Gillray's justification, 'understand, we car-toonists are not here to pass honest judgement but to purvey matter the other side doesn't like'.
PUB: *The Caricatures of Gillray* (1818), *The Genuine Works of Mr James Gillray* (McLean, 1830), *The Works of Gillray* (Bohn, 1851)
EXHIB: AC Touring Exhibition (1967); V&A 'British Caricature, 1620 to the Present' (1984)
COLL: BM; V&A; NPG; A; RL; HLL; BOD; LC; NYPL
LIT: J. Grego, *James Gillray the Caricaturist* (1873); Draper Hill, *Mr. Gillray the Caricaturist* (1965), *Fashionable Contrasts* (1966)　　SH

GILROY, John Thomas Young ARCA, FRSA (1898–1985). Advertising artist, portrait and landscape painter. John Gilroy was born in Newcastle-upon-Tyne on 30 May 1898, the son of a painter. He attended Heaton Park School and studied at the King Edward VII School of Art, Newcastle, and the RCA, London (1919), becoming a British Institute Scholar (1921) and an RCA Travelling Scholar (1922). During World War I he served in the Royal Artillery. He later became a teacher at the RCA, designing poster advertisements in his spare time. In 1925 he joined the staff of S. H. Benson and quickly established himself as one of the most gifted and imaginative artists in the history of British ad-vertising. Perhaps his best remembered campaign was for Guinness (1925–68), but he also designed numerous greeting cards for Royle's and produced illustrations (including covers) for *Radio Times* (from 1932). After World War II he concentrated on portrait painting and his sitters included Queen Elizabeth and many other members of the Royal Family, as well as Churchill, Pope John, and numerous politicians and actors. He received an Honorary MA from Newcastle University in 1976 and died on 11 April 1985.
ILL: *Rough Island Story* (1931–5); *McGill, The Story of a University* (1960); D. L. Sayers, *The Recipe Book of the Mustard Club* (n.d.)
EXHIB: Upper Grosvenor Galleries; RA: ROI; RBA: NEAC; Leighton House　　MB

GIOVANNETTI, Pericle Luigi (b. 1916). Cartoonist. Giovannetti was born in Basel, Switzerland, on 22 June 1916 and gave birth to his most famous creation, Max the Hamster in *Punch* in April 1953. Also published in *Nebelspalter* and *Glamour*, the cartoon was quickly syndicated worldwide and even appeared in Japan as 'Mr Makkusu-san'. He was also adopted as a mascot on HMS *Birmingham* in 1953 and in 1957 as the motif for Jet Fighter Squadron No. 21 of the Swiss Air Force. Endear-ing but without the cloying sentimentality of some earlier animal characters, the pot-bellied Max, normally seen squatting face on, is drawn in crisp outline in ink, with occasional use of hatching and solid blacks. Unframed, the multi-picture sequence progresses in a variety of geo-metrical patterns over the page, with sometimes as many as 12 images. Price wrote, 'What was enjoyable in Max was that, with him, some of the humours of animal and child returned to *Punch* purged of sentimentality.'
PUB: *Aus Meine Menagerie* (1951), *Gesammelte Zeichnungen* (1948), *Max* (1954), *Max Presents* (1956), *Beware of the Dog* (1958), *Nothing But Max* (1959), *Birds Without Words* (1961), *The Penguin Max* (1962)
ILL: C. King, *Hamid of Aleppo* (1958)
COLL: SAM　　MB

GLASHAN, John [real name John McGlashan] (b. 1931) Cartoonist, illustrator, writer and painter. John Glashan was born in Glasgow on 24 December 1931, the son of portrait painter Archibald McGlashan SRA. He was educated at Woodside School and studied painting at Glasgow School of Art. Moving to London in the 1950s he began as a portrait painter but lack of work led him to drop the 'Mc' from his name and become a cartoonist and illustrator. His first success was in *Lilliput* followed by regular features in *Queen*, *Holiday*, *Private Eye*, *Daily Telegraph*, *Harpers & Queen*, *Tatler*, *Sunday Times* ('Woman' feature), *Evening Standard*, and illustrations for the William Hickey column in *Daily Express*. His first joke published in *Punch* – about a man who turned his home into a replica of the House of Commons – was an inspiration for the play, *The One Way Pendulum*. In 1978 he took over Jules Feiffer's spot on the *Observer Magazine* and began his 'Genius' strip featuring Anode Enzyme (IQ 12, 794) and his patron Lord Doberman, the richest man in the world, drawn as tiny sketchy figures against a huge backdrop of fantastical

John Glashan (John McGlashan), *John Glashan's World* (1991)

architecture. This ran until 1983 when he turned to landscape painting, drawing cartoons again for *Spectator* from 1988. He has also worked in advertising for companies such as ICI and Blue Nun and illustrated books. An admirer of ANDRÉ FRANÇOIS, he uses A4 typing paper and a dip pen, adding watercolour for extra dimension, and never draws roughs. Another feature is his handwritten captions which tend to appear within the pictures themselves. 'I have discovered that the nearer humour approaches seriousness, the funnier it will be. "Being funny" is not funny. Humour is seriousness in disguise.'
PUB: *The Penguin John Glashan* (1967), *The Eye of the Needle* (1961), *Private Eye John Glashan* (1975), *John Glashan's World* (1991)
ILL: C. Logue (ed.), *Sweet and Sour* (1983)
EXHIB: Francis Kyle Gallery; FAS; CG
COLL: BM MB

GOETZ, Walter (b. 1911). Cartoonist, illustrator and landscape painter. Walter Goetz was born on 24 November 1911 in Cologne, Germany, and went to school in England (from 1923). Self-taught as an artist, he drew the 'Colonel Up and Mr Down' and 'Dab and Flounder' strips for the *Daily Express* (1934–54) under the name of 'Walter'. During World War II he worked in the propaganda section of the Political Intelligence Department, producing aerial leaflets in German, later transferring to the French section where he edited *Cadran* magazine for distribution in liberated France. His work has appeared in *Punch, Bystander, Lilliput, Vogue, Harpers, Night & Day, Contact, News Chronicle* and *Paris-Match*. In addition he has designed costumes for opera and illustrated a number of books, notably the 'Major Thompson' series written by Pierre Daninos, which led to a wax figure based on his portrait of the Colonel being exhibited in the Musée Grevin wax museum in Paris. He works in pen and ink (also wash) for his cartoons and gouache and watercolour when painting.
ILL: D. Miller, *Who's Who in the Wars* (1940);

J. Laver (ed.), *Memorable Balls* (1954); P. Daninos, *Les Carnets du Major Thompson* (1954), *Major Thompson Lives in France* (1955), *Le Secret du Major Thompson* (1956), *Major Thompson and I* (1957)
EXHIB: [landscape paintings] LG; SGG; Galeries Roux & Hentschel, Paris; RG; [costume designs for *The Pearl Fishers*] Music & Theatre Gallery; Lefevre Gallery
COLL: V&A; CAT MB

GOG – see Hogg, Gordon

GOODWIN – see Churchill, Robert Frederick Goodwin

GORDON, Gay – see Hogg, Gordon

GORDON, Michael (b. 1948). Humorous illustrator, greetings cards designer and writer. Mike Gordon was born in Middleton, Lancashire, on 16 March 1948 and spent one year at Rochdale School of Art (1963) before working as a heating engineer, producing cartoons in his spare time. A full-time cartoonist since 1983, his principal freelance work has been for book publishers such as HarperCollins, Headline, Ladybird, Longman, Puffin, Random Century, Reed International and Simon & Schuster. Since 1982 he has also produced over 300 greetings cards for Hanxon White/Accord, Hallmark, Design Concept and Russ Berrie as well as cartoons for advertising and character origination for Alton Towers theme park (1988). He has won a number of awards for his work including Berol Cartoonist of the Year (1988) and cites his influences as Tony Ross, Paul Coker and RALPH STEADMAN. Mike Gordon uses dip-pens, airbrush and water-soluble inks on Scholleshammer paper.
PUB: *Duffer's Guides* (seven titles 1983–8), *Haunted House* (1989), 'Fascinating Facts' series (1989), *Phallic Thimbles* (1990)
ILL: More than 40 titles including 'Lift & Look' series (1985); C. Clarke, *Grub on a Grant* (1985), *Mean Beans* (1993); G. Steddy, *The Adventures of Henry Hound* (1988); N. & T. Morris, 'Practise at Home' series (1990); R. Powell, 'Mini-Boo' series (1990); 'I'm Alive' series (1991–3); M. Butterfield, *Dinosaur Dice Games* (1992) MB

GOULD, Sir Francis Carruthers (1844–1925). Cartoonist, illustrator and painter. F. C. Gould was born in Barnstaple, Devon, on 2 December 1844, the son of an architect. Educated privately,

he started to draw caricatures at an early age but received no art training. At the age of 20 he moved to London to work as a broker on the Stock Exchange. In 1879 his first cartoon was published in Labouchère's journal, *Truth*, and he continued to illustrate the Christmas numbers until 1895. He left the Stock Exchange in 1888 to work on the *Pall Mall Gazette*, becoming the first staff caricaturist on a daily newspaper. The appointment lasted five years when he switched to the *Westminster Gazette* where he stayed until his retirement in 1914. Gould also contributed seven caricatures to *Vanity Fair*. Keenly interested in politics and once described by Lord Roseberry as 'one of the most remarkable assets of the Liberal Party', he was knighted after the Liberal victory in 1906. His impact came partly from his clever ideas and powers of witty allusion (especially effective in parodies of TENNIEL's 'Alice' characters), partly from his portraiture and partly from a general apprehension that although his cartoons could be trenchant they were never malicious. His drawing has often been criticized, but LOW called it 'adequate, fit for its purpose, one with the material'. He died on 1 January 1925.
PUB: *Froissart's Modern Chronicles* (1902–8), *Political Caricatures* (1903–40), *The Goulden Treasury* (1906)
ILL: *Fairy Tales from Brentano* (1885); H. Begbie, *The Political Struwwelpeter* (1899), *The StruwwelpeterAlphabet* (1900); H. H. Munro, *The Westminster Alice* (1902); H. W. Lucy, *Peeps at Parliament* (1903), *Later Peeps at Parliament* (1904); Sir W. Lawson, *Cartoons in Rhyme and Line* (1905)
EXHIB: BSG; WG
COLL: BM; V&A; NPG SH

GRAHAM, Alexander Steel (1917–91). Cartoonist and strip cartoonist. Born in Glasgow on 2 March 1917, Alex Graham was educated at Dumfries Academy and Glasgow School of Art (where he won the Newbury Medal). During World War II he served in the Argyll & Sutherland Highlanders and began selling cartoons to *Tatler* whilst in the Army. In 1944 he sold a strip to the *Glasgow Weekly News* and became a full-time cartoonist in 1945, contributing 'Wee Hughie' (unsigned) to the *Dundee Weekly News*, followed by 'Our Bill' (1946). 'Briggs the Butler' featured in *Tatler & Bystander* from 9 July 1946 until 1963, but perhaps his most famous creation was 'Fred Basset – the Hound That's Almost Human', which began in the *Daily Mail* on 9 July 1963

SIR JOSEPH DE BIRMINGHAM PROMISETH OLD-AGE PENSIONS TO THE PEOPLE.

F. C. Gould, *Froissart's Modern Chronicles* (1902)

and continued to run after his death from cancer in 1991. Fred the Basset hound never speaks but his thoughts appear in balloons. The strip was syndicated worldwide to nearly 200 papers (the dog's name changing to Wurzel, Lorang, Koraskoira and others) and was made into 20 short films for TV from 1976, featuring the voice of Lionel Jefferies. Other examples of Alex Graham's work appeared regularly in the *New Yorker*, *Woman's Journal*, *Housewife*, *Golfing* and *Sunday Graphic* (Willy Nilly' strip, 1947). He is particularly remembered for his *Punch* cartoons, especially the 'Graham's Golf Club' series (a later series with the same name appeared in the *Sunday Telegraph* from 1988) and in HEWISON's view 'has probably got more mileage out of the Cocktail Party than any other cartoonist'. He died on 3 December 1991.

PUB: More than 40 Fred Basset annuals (from 1964), *Please Sir, I've Broken My Arm* (1959), *The Eavesdropper* (1961), *The Doctor and the Eavesdropper* (1961), *Graham's Golf Club* (1965), *Oh Sidney – Not the Walnut Tree* (1966), *To the Office and Back* (1967), *Normally I Never Touch It* (1968), *Daughter in the House* (1969), *I Do Like to Be . . .* (1970), *At Least I'm Practically Alone* (1972), *It's Spring, Arthur, Spring!* (1973), *All the Other Men Have Mellowed* (1974), *Augustus and His Faithful Hound* (1978), *Graham's Golf Club* (1990)

ILL: M. Parkinson, *Football Daft* (1968); W. Loving, *A Lively Retirement* (1975) and others
EXHIB: RSA; FR
COLL: V&A MB

GRANT, Charles Jameson (fl. 1830–46). Caricaturist. Grant started as a designer and etcher of accomplished caricatures, both social and political (*c.* 1830), that are rather in the manner of W. HEATH. Like many other caricaturists of the period he switched from etching to lithography then designed for the wood-engraver. Evidently a man of strong Radical sympathies, his crude but powerful woodcuts

published in *Cleave's Penny Gazette of Variety*, *Cleave's Weekly Police Gazette*, the *Penny Satirist* and the *Political Drama* in the 1830s and 40s embody Chartist and working-class views. Some of them were reissued in sheets as *Cleave's Gazette of Caricatures*.

PUB: *A Political Alphabet* (1837)
EXHIB: SB Touring Exhibition, 'Folly and Vice' (1989–90)
COLL: BM; CP SH

GRAVE, Charles (1886–1944). Cartoonist. Charles Grave was born in Barrow-in-Furness in July 1886 and educated at Tottenham Grammar School, London. He contributed cartoons to the *Bystander, Daily Chronicle, Daily Graphic, Printer's Pie, Sporting Life, Strand* and the *Tatler*, specializing in jokes about sailors and dockers. His first contribution to *Punch* was published in 1912 and his largely sea-centred cartoons, drawn in pen and ink in a conventional manner, remained a popular feature until 1939. In World War I he served in the Middlesex Regiment and the Royal Tank Corps.

PUB: *Bluejackets and Others* (1927)
ILL: H. R. Murray, *Kultur and the German Blunder(buss)* (1914); T. C. Wignall, *The Story of Boxing* (1923); Sir W. H. Flower, *A Book* (1925): E. P. Leigh-Bennett, *All at Sea* (Moss Bross, n.d.) SH

GRAY – see Jolliffe, Gray

GRAY, Alfred (fl. 1883–1906). Cartoonist, strip cartoonist and humorous artist. In the 1880s Alfred Gray published humorous Christmas cards after his own designs, some of which were drawn by W. G. BAXTER, and contributed joke cartoons to *Judy, Pick-Me-Up* and *Scraps*. He is best known for his strip cartoons published in the 1890s in *Funny Cuts*, the *World's Comic* and the *Coloured Comic*, Britain's first regular coloured comic, for which he invented the characters 'Bleary Billy and Inky Ike' (1906). SH

GREENALL, Jack (1905–83). Cartoonist and strip cartoonist. Jack Greenall was born in Whitefield, Lancashire, in 1905. He sold his first cartoon at the age of 15 and his first strip, 'Pa, Ma and the Boy' appeared in *Weekly Pictorial* in 1929. He also contributed to *Ideas, Punch, Bystander, Passing Show, Razzle* and children's comics such as *Sparkler* and *Jolly Comic*. His most famous creation was Useless Eustace – a comical Everyman figure who later appeared in

many guises but was originally a bowler-hatted office clerk – which ran in the *Daily Mirror* from 21 January 1935 until Greenall's retirement in 1975, after which it was continued by PETER MADDOCKS. A variant, 'Useless Eunice', appeared in *Woman's Sunday Mirror*. In *Drawing Secrets!* he recommends students use HB pencil, Waverley pen, No.2 or No.3 brushes and black ink so there is some evidence that he used these himself. He died in July 1983.

PUB: *Drawing Secrets!* (1944), *Useless Eustace* (1945, 1947), *Drawing's Fun* (1946), *Draw Your Own Christmas Cards* (1947), *Draw My Way* (1948), *Pencil Pranks* (1949) MB

GREIFFENHAGEN, Maurice William RA NEAC (1862–1931). Painter, illustrator, art-teacher and cartoonist. Maurice Greiffenhagen was born in London on 15 December 1862 and was of Baltic German descent. He entered the RA Schools in 1878, where he won a number of awards, and exhibited at the RA from 1884 onwards. His early career was largely spent in illustration: of books, notably his watercolour and gouache drawings for the novels of Rider Haggard; of stories, published in the *Butterfly* and the *Lady's Pictorial*; and of jokes, published in *Judy* (1885–95). These cartoons had very little humour in the idea and none whatsoever in the drawing, the figures being formidably square-jawed and square-shouldered. Nevertheless they are interesting as the work of a gifted painter, especially in their lighting and composition. In 1893 his dashing poster for the *Pall Mall Budget* helped to pioneer the French style. After *c*. 1900 Greiffenhagen concentrated on painting, winning medals at international exhibitions and being elected ARA (1916) and RA (1922). From 1906 to 1929 he taught at the Glasgow School of Art. He died on 26 December 1931.

ILL: Sir H. Rider Haggard, *She* (1887), *Allan's Wife* (1889), *Cleopatra* (1889), *Montezuma's Daughter* (1894), *Swallow* (1899), *Ayesha* (1905); W. W. Jacobs, *The Lady of the Barge* (1902), *Many Cargoes* (1912); M. Pemberton, *The Gold Wolf* (1903), *White Walls* (1910); Sir R. Crockett, *Strong Mac* (1904); J. M. Forman, *Bianca's Daughter* (1910)
EXHIB: RA; NEAC; RSA; B; L; M; Munich; Dresden; Ghent; Pittsburgh
COLL: T; V&A; G SH

GREN – see Jones, Grenfell

GRIFFIN, Charles William Langmead (b. 1946). Social/political cartoonist and caricaturist. Charles Griffin was born on 20 May 1946 in Ruislip, Middlesex. After studying at Harrow School of Art (1971) he specialized in graphics at Bath Academy of Art (1971–3). He joined the *Sunday People* as Political Cartoonist (1983), later moving to the *Daily Mirror* (1985), for both of which papers he also does freelance cartoon work. Voted CCGB Social and Political Cartoonist of the Year (1985, 1986) and Feature Illustrator of the Year (1984), Griffin also specializes in the study and detailed painting of cavalry uniforms. Influenced by CARL GILES, he used to draw on cartridge paper but found that a dip pen scratched the surface, so now uses a smooth coated paper.
ILL: D. J. Taylor & M. Berkmann, *Other People* (1990); J. Archer, *First Among Equals* (1985)
MB

GRIMES, Leslie (1898–1983). Political cartoonist and strip cartoonist. Leslie Grimes was born on 27 November 1898 in Chertsey, Surrey. He attended an orphanage school then Kingston Art School where his work came to the attention of Philip de Laszlo who helped him to study in Paris. In World War I he served in the Army (1915) then RFC and later worked as a commercial artist. He also designed Tube posters for LCC Evening Continuation Schools, Ministry of Labour/RoSPA industrial accident warnings ('A Cat Can Afford to Risk a Life or Two – You Keep Away') and others. While in advertising he contributed humorous sketches to *The Motor Cycle*. He joined the *Star* as Political Cartoonist in 1927 (succeeding DAVID LOW and later handing over to WYNDHAM ROBINSON) and created the hugely successful 'All My Own Work' series for the paper in 1938. He resigned from the *Star* in May 1952 and went to Ibiza to paint. Grimes used to draw with Conte chalk, sitting on the floor, and would often use the side of the chalk for shading. For his work on the *Star* he would use a brush and always worked in tone because it was a quicker process than engraving line blocks. He died in London on 28 March 1983.
COLL: [posters] IWM
MB

GRIMM, Samuel Hieronymus (1733–94). Painter, poet and occasional caricaturist. S. H. Grimm was born in Burgdorf, Switzerland, on 18 January 1733, the son of a Swiss lawyer. He trained as an artist and from 1758 made drawings of Swiss scenery, moving in 1765 to make similar drawings and paintings in France. In 1768 he settled in England and the next year his landscapes were included in the first exhibition at the RA. His caricature designs for Maccaroni fashions etc., published as mezzotints by Carington Bowles in the early 1770s, are amongst the most attractive prints of the time.
ILL: E. B. Lamb, *Studies of Ancient Domestic Architecture* (1846); G. White *The Antiquities of Selborne* (1950)
COLL: BM; V&A; NGI; A; B; BN; D; F; LE; NGS
LIT: R. M. Clay, *Samuel Hieronymus Grimm* (1941)
SH

GRISET, Ernest-Henry (1843–1907). Illustrator and cartoonist. Ernest Griset was born in Boulogne, France, on 24 October 1843 and came to England at an early age. After a short period of study under the Belgian painter Louis Galliat and longer studies at the London Zoo, he sold drawings of animals from a shop near Leicester Square. In 1866 he started to contribute bizarre anthropomorphic cartoons to *Fun* and the next year began a short association with *Punch* (1867–9). He also contributed to the *Boy's Own Annual*, *Girl's Own Annual*, *Little Folks* and *London Society*. His grotesque fantasies, influenced by Grandville and comparable with Gustave Doré, were extremely well drawn and he was a sensitive colourist. But although he loved animals, many of his animal jokes now seem more frightening than funny and some of his illustrations are marred by an element of cruelty. The vogue for his work lasted about 10 years: by 1877, when news of his death was falsely circulated, he was going out of favour; by 22 March 1907 when he died he was quite forgotten. Being so well known as an animal satirist he could never succeed as a 'straight' animal painter. His life, as Lionel Lambourne has said, is 'a classic example of the dangers of falling between two stools'.
PUB: *Griset's Grotesques or Jokes Drawn on Wood* (1867), *Ernest Griset's Funny Picture Book* (1874)
ILL: J. Greenwood, *The Hatchet Throwers* (1866), *Legends of Savage Life* (1867), *The Purgatory of Peter the Cruel* (1868); D. Defoe, *Robinson Crusoe* (1869); *Aesop's Fables* (1869); Sir R. Burton, *Vikram the Vampire* (1870); E. B. Hamley, *Our Poor Relations* (1872); Lord Brabourne, *The Mountain Sprite's Kingdom* (1881); W. Manning, *A Child's Dream of the Zoo* (1889).

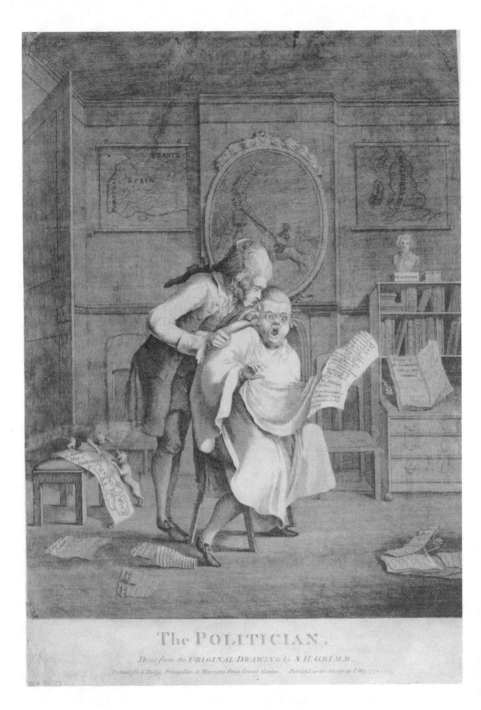

The POLITICIAN.

Done from the ORIGINAL DRAWING by S. H. GRIMM.

Printed for J. Bridge, Printseller, in Henrietta Street Covent Garden — Published as the Act directs 1 May 1772.

S. H. Grimm, [Lord North], 1771

COLL: V&A; Z; UG
LIT: L. Lambourne, *Ernest Griset* (1979) SH

GROSE, Captain Francis (*c.* 1731–91). Antiquary, author, topographical draughtsman and caricaturist. Francis Grose was of Swiss extraction. He studied art at Shipley's Drawing School and his interest in antiquarian matters led to his appointment as Richmond Herald (1755–63). He exhibited topographical drawings at the RA (1767–77) and illustrated his own works on the antiquities of Great Britain. In 1788 he published *Rules for Drawing Caricatures with an Essay on Comic Painting* 'with twenty-one copper plates, seventeen of which etched by himself', an influential work that was reprinted in 1791. There is a caricature portrait of him by JOHN KAY. In his youth he was Adjutant and Paymaster of the Surrey Militia.
PUB: *A Burlesque Translation of Homer* (1770), *The Antiquities of England and Wales* (1773–87), *The Antiquarian Repertory* (1775), *Advice to Officers of the British Army* (1782), *A Classical Dictionary of the Vulgar Tongue* (1785), *A Treatise on Ancient Armour and Weapons* (1786–9), *The Antiquities of Scotland* (1789–91), *The Antiquities of Ireland* (1791), *The Olio* (1793)
COLL: BM; A; BN; NGS SH

GROSSMITH, Walter Weedon (1854–1919). Actor and humorous illustrator. Weedon Grossmith was born in London on 9 June 1854, the brother of the entertainer and singer George Grossmith. He studied at the RA Schools and the Slade and exhibited his pictures but, opting for the stage, became a comic actor well known for his portrayal of 'dudes' and 'cads'. He illustrated the comic masterpiece *The Diary of a Nobody* (1894) which he wrote jointly with his brother George and which first appeared in the pages of *Punch*. He died in London on 14 June 1919.
PUB: *From Studio to Stage* (1913)
EXHIB: RA: RBA; ROI: RHA; GG; B; M; L SH

GUS – see Smith, George William

H

HAILSTONE, Harold William (1897–1982). Cartoonist and illustrator. Harold Hailstone was born in London on 14 July 1897, the son of a dentist and brother of the portrait painter Bernard Hailstone. He was educated at Sir Andrew Judd School, Tonbridge, and joined the Army in World War I, later transferring to the RFC (training as a pilot). After the war he attended Goldsmith's College where colleagues included Graham Sutherland. He drew frequently for *Illustrated London News, Humorist, Pearson's, Passing Show, Bystander, Tatler, Sketch, Britannia & Eve, Strand Magazine* and *Punch*. He was a Flight–Lieutenant in the RAF (1938–45) and an official war artist (1944–5). Hailstone worked in ink, oil and watercolour. He died on 21 November 1982.
COLL: IWM MB

HALDANE, David (b. 1954). Cartoonist, strip cartoonist, illustrator and scriptwriter. David Haldane was born on 10 November 1954 in Blyth, Northumberland, and studied graphic design at Newcastle-upon-Tyne Polytechnic. He began cartooning in 1978 and has contributed to *Punch* (1979–92), *Guardian* (1989–91), *Sunday Times, Mail on Sunday, Sun, Oink!, Spectator, Observer, Private Eye* and *Daily Mirror*. He has also produced greetings cards for Camden Graphics, drawn illustrations for advertising (e.g. Asda, Pedigree Chum), written scripts for Central TV's 'Spitting Image' and lectured in graphic design at Northumberland College.
PUB: *The Zoo Goes to France* (1982) MB

HALKETT, George Roland (1855–1918). Caricaturist, editor and illustrator. G.R.Halkett was born in Edinburgh on 11 March 1855. He studied art in Paris and, returning to Scotland, became art critic of the *Edinburgh Evening News* in 1876. His *New Gleanings from Gladstone*, the first of a series of booklets of political cartoons with a strong anti-Gladstone bias, was published in 1880. He came to London in 1892 to take F. C. GOULD's place as caricaturist of the *Pall Mall Gazette* but although his work was better drawn it did not have the same success because of its comparative lack of wit and the fierceness of his Tory sympathies. Both as Art Editor of the *Pall Mall Gazette* and Editor of the *Pall Mall*

Magazine (1900–5) he greatly improved the quality of the illustrations. In 1897 he was elected President of the Society of Illustrators, recently founded by Joseph Pennell. Halkett had a scholarly interest in Greek and Egyptian art and travelled extensively in the Middle East. He died in London in December 1918.

PUB: *The Irish Green Book* (1888), *The C. B. Book* (1906)

ILL: J. & W. Grimm, *Rumpelstiltskin* (1882); M. Hunt, *Our Grandmother's Gowns* (1884); *The Elves and the Shoemaker* (n.d.)

EXHIB: RSA; GI

COLL: V&A

LIT: J. A. Hammerton, *Humorists of the Pencil* (1905) SH

HAMMOND, Aubrey Lindsay (1894–1940). Caricaturist, theatre and poster designer, illustrator and art-teacher. Aubrey Hammond was born in Folkestone, Kent, and educated at Bradfield College, Berkshire. He studied at the Byam Shaw School of Art, London, and the Academie Julian, Paris. His caricatures published in the *Evening News*, *Evening Standard*, *Nash's* and the *Tatler* during the 1920s and 30s have a decorativeness and sharpness that is very characteristic of the period. He taught commercial and theatrical art at the Westminster School of Art and designed several menu cards for the Savage Club, of which he was a member.

ILL: L. Melville, *The London Scene* (1926); P. Traill, *Under the Cherry Tree* (1926); D. Greville, *The Diary of Mr Niggs* (1932)

EXHIB: PG; RG

COLL: V&A; BN SH

HANDELSMAN, John Bernard (b. 1922). Cartoonist, pocket cartoonist, illustrator, animator and writer. Bud Handelsman was born on 5 February 1922 in New York City, USA, the son of a teacher, and started drawing cartoons as a child. He attended the Art Students League, New York (1938–42) and served in the US Army Air Corps in World War II. After the war he studied electrical engineering at New York University (1945–6) and worked for various advertising agencies as a commercial artist and typographic designer until 1960 when he turned freelance cartoonist. He came to England in 1963 and began contributing pocket cartoons to *Evening Standard* and joke cartoons to *Observer*, *New Statesman*, *Punch* (including covers and the popular 'Freaky Fables' series), *New Yorker*, *Saturday Review*, *Saturday Evening Post*, *Look*,

Esquire and *Playboy*. In addition he has written scripts and humorous articles, worked in graphic design, received *Playboy*'s award for Best Black and White Cartoon (1978) and created a 10-minute animated film, *In the Beginning*, based on the Creation and broadcast on BBCTV on Christmas Eve 1992. He returned to the USA in 1981.

PUB: *You're Not Serious, I Hope* (1971), *Freaky Fables* (1979), *Freaky Fables* (1984), *Further Freaky Fables* (1986)

ILL: A. McGovern, *If You Sailed on the Mayflower* (1969); J. Fritz, *Who's That Stepping on Plymouth Rock?* (1975); R. B. Gross, *A Book About Benjamin Franklin* (1975); A. Hilton (ed.), *This England* (1978); J. Cleese & R. Skynner, *Families and How to Survive Them* (1983), *Life and How to Survive It* (1993); D. Frost & M. Shea, *The Mid-Atlantic Companion* (1986)

COLL: Cincinnati Art Museum, Ohio; UKCC
 MB

HARDING, Leslie Clifford 'Styx' (1914–91). Cartoonist. Leslie Harding was born in London on 2 June 1914 and studied at Leyton School of Art. He began cartooning at the age of 18, producing sporting strips for the *Daily Mail* and later contributed regularly to *Daily Express*, *Weekend* (10 years), *Shoot!* (15 years) and children's comics, and illustrated advertising campaigns for British Rail ('Away Day' posters) amongst others. During World War II he served in North Africa with the Tank Corps. Himself a great admirer of BRUCE BAIRNSFATHER he also taught other artists, including REG SMYTHE the creator of 'Andy Capp', and was Honorary President of the Laurel & Hardy Fan Club. He died in Portsmouth on 11 May 1991.

PUB: *Styx Christmas Fun Book* (1957), *Pick of the Famous Weekend Styx Cartoons* (1957), *Laugh With Styx* (1958), *Styx Holiday Fun Book* (1958), *Weekend Styx Calendar 1959* (1958), *The Best of Styx* (1959), *Styx Again!* (1959), *Weekend Fun Book* (1960), *The Styx Cartoon Show* (1963) MB

HARDY, Dudley RI RBA ROI RMS (1865–1922). Painter, poster artist, illustrator and cartoonist. Dudley Hardy was born in Sheffield on 15 January 1867, the son of Thomas Bush Hardy, a leading marine painter. He was trained in art by his father and then at a succession of art schools in Düsseldorf, Antwerp and Paris. His first picture, an oil painting, was exhibited at the

RA in 1885. During the 1890s he became internationally famous for his posters, especially 'The Yellow Girl' advertising the magazine *To-Day*, and a series advertising productions at the Savoy Theatre. These pretty and cheeky designs were influenced by the French artist, Chéret. At the same time, Dudley Hardy was contributing illustrations and cartoons of flirtatious actresses to periodicals, notably to the *Sketch* and *Pick-Me-Up*, which epitomized the 'Naughty Nineties' and he became equally well known for Eastern scenes and studies of Dutch and Breton peasants. An immensely prolific artist, he also designed humorous postcards and a variety of advertisements. Many of his wash cartoons were potboilers done in a hit-or-miss style but his best work charms by its verve, spontaneity and skilful use of colour. Elected RBA (1889), RI (1897) and ROI (1898), he was also a member of the London Sketch Club. He died on 11 August 1922.

ILL: A. Werner, *The Humour of Holland* (1894); B. Harte, *The Bell Ringer of Angels* (1897); F. E. Weatherley, *Lays for the Little Ones* (1898); E. H. Cooper, *Wyemarke and the Sea-Fairies* (1899); R. Strong, *Sensations of Paris* (1912)
EXHIB: RA; RI; RBA; ROI; RMS; FAS
COLL: LE; NE
LIT: A. E. Johnson, *Dudley Hardy* (1909); P. V. Bradshaw, *The Art of the Illustrator 19, Dudley Hardy* (1918) SH

HARGREAVES, Harry MSIAD (b. 1922). Cartoonist, strip cartoonist, illustrator, animator and writer. Harry Hargreaves was born in Manchester on 9 February 1922 and educated at Chorlton High School, Manchester. A former Manchester Cathedral choirboy (1930–3), he taught himself cartooning from the age of nine and at 17 was producing weekly strips for *Beano* and *Dandy*. He trained as a furniture designer at Manchester School of Art (part-time, 1938) and then as an engineer, working for companies such as Rolls-Royce and Ford (1938–9) and during World War II served in the RAFVR Signals in the Far East (1940–5). After the war he joined J. Arthur Rank's Gaumont British Animation Ltd as a cartoon animator (1946–9). When the Cartoon Unit disbanded he turned freelance for three years, creating and developing strips (e.g. 'Harold Hare') for Amalgamated Press comics such as *Sun*, *Comet* and *Knockout*, producing advertising work for Rowntrees, Dunlops and Pickerings, and designing toys for Mettoy. He then joined the Toonder Film Studios, Amsterdam,

HARGREAVES.

Harry Hargreaves, *Punch*, *c.* 1968

as a Master Cartoonist (1953) and produced a cartoon strip, 'Little Panda' which was syndicated to 150 daily newspapers across Europe, including the London *Evening News*. Returning to the UK in 1954 he continued the strip for eight years (until 1961) whilst freelancing for publications such as *Illustrated, Lilliput, Men Only, Daily Sketch, Daily Graphic, Daily Telegraph, Tatler, Life, Christian Science Monitor, Countryman, Eureka!* (Italy), *Air Safety, The Cricketer, TV Comic, Daily Mirror, TV Times* (USA), *Animals Magazine* and *Der Stern*. Perhaps his most celebrated creation, the Bird, first appeared in *Punch* on 29 October 1958 and has been published worldwide, including in colour (as 'Early Bird', 1985–7) on TV-am. His daily strip, 'Hayseeds'

ran in the *Evening News* (1968–81) and has also been syndicated internationally. In addition, he has had his own TV programme, 'Discs-a-Gogo' on TWW. Advertising clients have included Barclays Bank, Kelloggs, Guinness, Saxa Salt, Coal Board, Walls and Post Office Telegrams and he has provided illustrations for Army Air Corps and Wildfowl & Wetlands Trust publications, produced greetings cards for Sharpes (1987–8), and been involved in mechanical and soft-toy design. Influenced by Disney, Da Vinci, Rembrandt, RACKHAM, SHEPHERD and ILLINGWORTH, he works in pencil, pen and ink, watercolours and acrylics. HEWISON has remarked on his 'outstanding skill at drawing movement. This is not merely technique but a real knowledge of how animals move, fall, skid, collide et cetera – [rather] than an ability to caricature movement.' PUB: *How's That!* (1959), *Not Out!* (1960), *The Bird* (1961), *The Bird and Others* (1962), *It's a Bird's Life* (1965), *Strictly for the Bird* (1967), *The Bird Set* (1968), *Birds of a Feather* (1969), *Googlies* (1971), *Hayseeds* (1971), *Hayseeds 2* (1972), *Bird for All Seasons* (1973) ILL: S. Raven, *Quick Quiz* (1981); K. Grahame, *The Wind in the Willows* (1983); Dennis Henshaw, *Brush Your Teeth with Wine* (1961) and *Canny Curlew* (1988) COLL: Musée des Hommes, Montreal

MB

HARO – see Hodson, Haro Reginald Victor

HARPUR, Merrily (b. 1948). Cartoonist, illustrator and writer. Merrily Harpur was born on 2 April 1948 and educated at Headington School, Oxford, and Trinity College, Dublin. After a period restoring oil paintings she became a freelance cartoonist and writer working for *Guardian* (from 1978), *Punch*, *The Times*, *Sunday Telegraph*, *Listener*, *Field*, *Country Living* and others. She has also produced cartoon backdrops and animated titles for Miles Kington's TV series, 'Let's Parler Franglais'. PUB: *The Nightmares of Dream Topping* (1984), *Pig Overboard!* (1984), *Unheard of Ambridge* (1989) ILL: M. Kington, 'Let's Parler Franglais' series (from 1979) MB

HARRISON, Charles (fl. 1883–d. 1943). Cartoonist and illustrator. Charles Harrison was born in the 1860s of a theatrical family and was a child actor before taking a commercial job in the City. He had drawing lessons and, leaving the

SIMPLE SIMON AND THE PIEMAN.
The Nursery Rhyme in Ancient Egypt.

Charles Harrison, *Printers' Pie*, 1911

City, alternated for a time between magazine illustration and the stage. The 'Toy Books' series he illustrated in 1883 were imitations of CRANE and CALDECOTT; more original were his cartoons in the comics, notably in *Funny Folks*, and his contributions to *Cassell's Saturday Journal*, *Passing Show*, *Pearson's* and the *Sketch*. His early style as a cartoonist was based on simple outlines but he later used cross-hatching. He was a regular contributor to *Punch* (1895–1926) and his cartoons were also published in the *Daily Express*. An artist with an individual style he was at his best in parodies of Japanese or Egyptian art. PUB: *Rhymes and Jingles* (1883), *The Prince and the Penny* (1883), *Accidents Will Happen* (1907), *A Humorous History of England* (1920) ILL: S. H. Hamer, *Master Charlie* (1899); R. Andom, *Troddles and Us and Others* (1901); H. Rowan, *London Japanned* (1910); F. McAbe, *A Living Machine* (1921) SH

HART, Frank (1878–1959). Cartoonist, illustrator and lecturer. Frank Hart was born in Brighton on 1 November 1878. His work appeared in the

Humorist (1920s and 30s), *Little Folks*, *Odd Volume* and *Printer's Pie*. His contributions to *Punch* (1911–29) were generally outdoor subjects and were sketched with a lively free line. He gave lectures on black-and-white art throughout Britain.
PUB: *Dolly's Society Book* (1902), *The Best Nursery Rhymes* (1910), *The Animals Do Their Bit in the Great War* (1918), *Andrew, Bogle and Jack* (1919), *One Long Holiday!* (1921), *Everyhorse* (1935)
ILL: M. Fisher, *The Golliwog's Dream and Other Stories for Little Folk* (c. 1910)
EXHIB: RA; RI SH

HASELDEN, William Kerridge (1872–1953). Cartoonist and caricaturist. Born on 3 December 1872 in Seville, Spain, the son of an English civil engineer, W. K. Haselden was self-taught as an artist. He left school at 16 and worked as an underwriter at Lloyd's for 13 years while free-lancing cartoons for *The Sovereign, St James's Gazette* and *Tatler*. He joined the *Daily Mirror* (1904–40) under Hamilton Fyfe as Editorial Cartoonist and also produced regular theatre sketches for *Punch* (1906–36). Regarded as the father of the British newspaper strip cartoon, Haselden is also celebrated as the creator of 'The Sad Experiences of Big and Little Willie', lampooning Kaiser Wilhelm of Germany and his son during World War I (it first appeared on 2 October 1914) and which the Kaiser himself later admitted to have been 'damnably effective'. Other characters created by Haselden include Miss Joy Flapperton, Colonel Dugout and Burlington Bertie. Admired by BEERBOHM and SICKERT (who called him the 'English Aristophanes') and Paul Nash (who compared him to LEECH as 'one of the best draughtsmen we possess'), he was offered a knighthood by Baldwin but turned it down as he 'didn't want all the fuss'. Haselden worked with a pen and indian ink on board. He died on 25 December 1953.
PUB: *Daily Mirror Reflections* (annuals 1908–35), *The Sad Adventures of Big and Little Willie* (1915)
ILL: C. Harrison, *Accidents Will Happen* (1907), *The Globe 'By the Way' Book* (1908), E. B. Tweedie, *America As I Saw It* (1913)
EXHIB: Dore Gallery; Aldeburgh Festival
COLL: BM; NPG, UKCC; CAT MB

HASSALL, John RI RMS (1868–1948). Cartoonist, illustrator, poster and commercial artist, and painter. John Hassall was born in Walmer, Kent, on 21 May 1868, the son of a naval officer who died young. He was educated in Worthing, at Newton Abbot College, and in Heidelberg. Having failed the exam for the Royal Military Academy, Sandhurst, he went to farm in Manitoba, Canada, for three years with his brother. He returned in 1890 after some drawings had been published in the *Graphic*, determined to become an artist, and studied first in Antwerp, then in Paris under Bougereau. Back in London and following in the footsteps of his close friend DUDLEY HARDY, he became a leading poster artist specializing in trade posters for products like Colman's Mustard and being most famous for the Jolly Fisherman design, 'Skegness is *so* bracing' (1909). The Hassall style, which was very influential, combined jolly humour with strong outlines and broad masses of flat colour. Bevis Hillier has described him as 'by nobody's standards a great artist – but he was, one might say, a hack of genius'. The same joviality powered his cartoons, which were published in *Bibby's Annual, Captain, Cassell's, Eureka, Holly Leaves, Idler, Illustrated Bits, Judy, London Opinion, Moonshine, New Budget, Odd Volume, Pall Mall, Pears Annual, Pick-Me-Up, Printer's Pie, St Paul's, Sketch* and *Tatler*. Extremely energetic, he illustrated numerous books and book jackets, painted watercolours for exhibition – including many pictures of Red Indians – founded an art school in 1905, and spent much convivial time at the London Sketch Club and the Savage Club. He was elected RI (1901). After World War I his popularity declined and, bedevilled by money worries caused by carelessness and generosity, he drank heavily. In 1939 he was awarded a Civil List pension for 'services to posters'. He died on 8 March 1948.
PUB: *Two Well-Worn Shoe-Stories* (1899), *The Book of John Hassall* (1907), *The Hassall ABC* (1918)
ILL: Many books including A. A. Spurr, *A Cockney in Arcadia* (1899); P. Montrose, *Oh! My Darling Clementine* (1900); G. C. Bingham, *Six and Twenty Boys and Girls* (1902); W. Emanuel, *People* (1903), *Keep Smiling* (1914); D. Tovey, *The Coronation Picture Book* (1903); G. E. Farrow, *Absurd Ditties* (1903), *Round the World ABC* (1904); S. H. Hamer, *The Princess and the Dragon* (1908); W. C. Jerrold, *Mother Goose's Nursery Rhymes* (1909); C. Perrault, *The Sleeping Beauty* (1912); *Blackie's Popular Nursery Stories* (1931)
EXHIB: RA; RI; FAS; LH 'John Hassall' (1968)
COLL: V&A; SC

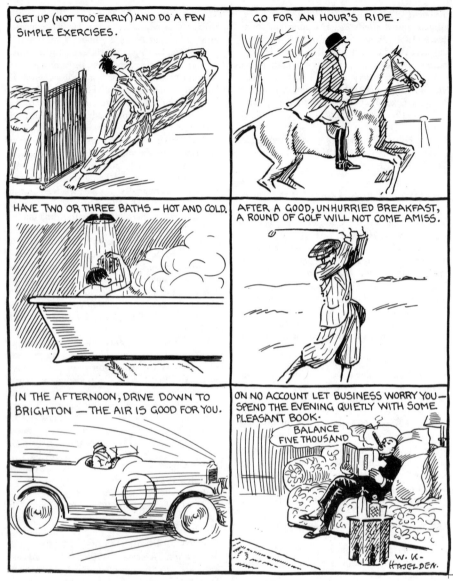

How to prevent colds

W. K. Haselden, *Daily Mirror*, 17 November 1924

LIT: A. E. Johnson, *John Hassall* (1907); D. Cuppleditch, *The John Hassall Lifestyle* (1979)

SH

HAWKER, David (b. 1941). Cartoonist and illustrator. Born in Earlsfield, London, on 9 October 1941, David Hawker has worked as a salesman, gardener, laundry assistant, cleaner and driving instructor. Self-taught apart from a short correspondence course in art, he sold his first cartoon while working as an architectural draughtsman in 1967 and turned full-time free-

lance in 1969. His cartoons have appeared in *Punch* (from 1970), *Spectator* and *Private Eye*. Advertising clients include BUPA and TV commercials for Terrys of York. Hawker uses a Waverley nib for a variety of line and is an admirer of the work of *New Yorker* cartoonist Richard Taylor.
EXHIB: various Hampshire galleries MB

HB – see Doyle, John

HEATH, Henry 'HH' (fl. 1822–51). Caricaturist. In 1822 Henry Heath designed and etched a series of comic theatrical portraits and from 1824 produced many political and social caricatures similar in style to the work of WILLIAM HEATH, whose brother he may have been. In 1831 he switched from etching to lithography and, using the pseudonym 'HH', drew political prints in open imitation of HB. His most individual works are the comic vignettes – usually pictorial puns – which were published in sets like CRUIKSHANK's *Scraps and Sketches*. He contributed one political cartoon to *Punch* in 1842 and is believed to have emigrated to Australia.
PUB: *My Lord Mayor's Album or Cockney Sports* (c. 1825), *Old Ways and New Ways* (1828), *Tit Bits* (1830), *The Book of Etiquette* (1830), *The Art of Tormenting* (1834), *The Caricaturist's Scrap Book* (1840), *The Sporting Alphabet* (1842), *Domestic Bliss* (1848), *Industry and Idleness Contrasted* (1851)
ILL: *Flowers of Anecdote, Wit, Humour, Gaiety and Genius* (1831)
COLL: BM SH

'Say listeria'

Michael Heath, 1989

HEATH, Michael John (b. 1935). Political and strip cartoonist. The son of Fleetway Press children's comics illustrator Henry Heath, Michael Heath was born on 13 October 1935 in Bloomsbury, London, and attended Brighton Art College (1952–3). His first cartoon was published in *Melody Maker* (1954) and he has contributed to *Man About Town, Lilliput, Mail on Sunday, Honey, Woman's Sunday Mirror, Sunday Times, Evening Standard, Evening News, Guardian, Private Eye* (from 1964, especially the series 'Great Bores of Today'), *Spectator* (from 1957), and *Punch* (from 1958, including covers). He has been Cartoon Editor of *Spectator* since 1991 and has been full-time Political Cartoonist on the *Independent* since 1990. He has been voted CCGB Pocket Cartoonist of the Year (1977), Granada TV's 'What the Papers Say' Cartoonist of the Year (1979) and Glen Grant Cartoonist of

the Year (1977). Heath draws on layout paper using dip pen and indian ink and doesn't use pencil at all. His distinctive fine line work, with occasional use of collage, has been widely admired and Hewison has described him as having 'the best visual memory in the business', being particularly good on dress and interiors.
PUB: *Private Eye Michael Heath* (1973), *Michael Heath's Automata* (1976), *Book of Bores* (1976), *The Punch Cartoons of Heath* (1976), *Love All?* (1982), *The Best of Heath* (1984), *Welcome to America* (1985), *Baby* (1988), *The Complete Heath* (1990)
ILL: Many books including E. G. Hardy (ed.), *Bloomers* (1966); S. Oram, *France* (1972); W. Donaldson, *1992 and All That* (1990)
EXHIB: CG; RFH
COLL: BM; A; UKCC; V&A MB

Henry Heath, 1830

106

HEATH, William 'Paul Pry' (1795–1840). Caricaturist and illustrator. William Heath described himself on one caricature print as 'portrait and military painter' and was referred to by Dr John Brown, LEECH's biographer, as 'poor Heath, the ex-Captain of Dragoons, facile and profuse, unscrupulous and clever'. He pursued two careers in tandem, one as the illustrator of colour-plate books like *The Martial Achievements*, the other as a prolific caricaturist who, in the early 1820s after CRUIKSHANK had turned to book illustration and before the arrival of SEYMOUR, dominated the field. His earliest caricatures date from *c.* 1810, apparently the work of a boy but a remarkably well informed one. He produced a trickle of prints up to 1820 when the trickle became a flood, fullest *c.* 1828–30. In 1827 he adopted the pseudonym 'Paul Pry' (after a popular character from the stage) but renounced it in 1829 because it had been much plagiarized. He edited and illustrated the *Northern Looking Glass* (1825–6), Europe's first caricature magazine, and illustrated its successor, McLean's *Looking Glass or Caricature Annual* (1830) until his etchings were supplemented by Seymour's lithographs. After 1830 he turned from caricature to illustration. His satires are well drawn, relatively good-natured and politically intelligent.

PUB: *Historical Military and Naval Anecdotes* (1815), *The Martial Achievements of Great Britain and Her Allies* (1815), *The Life of a Soldier* (1823), *Studies from the Stage* (1823), *Rustic Sketches* (1824), *Common-Place Book* (1825), *Illustrations of Heraldry* (1828), *Parish Characters* (1829), *The Sayings of the Ancients* (1831), *Fashion and Folly* (1832)

ILL: W. Combe, *The Wars of Wellington* (1819); *Real Life in Ireland* (1821), *Real Life in London* (1822)

COLL: BM; V&A; NGS SH

HEBBLETHWAITE, Sidney (fl. 1898–d. 1914). Cartoonist. Sidney Hebblethwaite's earliest cartoons published in *Pick-Me-Up* in the late 1890s were strongly influenced by the French cartoonist, Caran d'Ache. He later contributed to the *Graphic* and the *Tatler* and became known for his rapid execution and fluent style. THORPE wrote, 'his work showed promise of great possibilities which was, however, defeated by his early death'.

ILL: 'Dodo', *A Trip to Mars* (1901) SH

HEHL, Captain Simon (fl. 1814–32). Amateur caricaturist. Captain Hehl, an assistant quarter-master-general at the War Office, drew caricatures for reproduction by others that are almost all concentrated into the years 1817–18. They deal either with dandies of both sexes or consist of broad jokes, and the figures, large and simplified, were sometimes very grotesque. Published by Fores, their main interest lies in the fact that most of them were lithographed by GEORGE CRUIKSHANK using a new pen process that was supposed to resemble etching. Captain Hehl retired on half pay in 1826, having been disgraced, according to PERCY CRUIKSHANK, for betraying military scandals to Fores.

COLL: BM SH

HELLMAN, Louis Mario MBE (b. 1936). Architect, cartoonist, caricaturist, illustrator and writer. Born in London on 19 March 1936, Louis Hellman attended the Bartlett School of Architecture, London (1955–62), and the Ecole des Beaux-Arts, Paris (1960–1). An architect by profession, he has drawn cartoons for *Architects Journal* since 1967 featuring his 'bearded and bow-tied homunculus architect' (Knevitt) with his eyes at the top of his bald, earless and oblong head. He has also regularly contributed caricatures to *Architectural Review* (since 1984) and cartoons to *Building Design* (since 1987) and the *Observer* (since 1989). Other publications his work has appeared in include *Sunday Times*, *New Statesman*, *European*, *Guardian*, *Private Eye*, *Spectator*, *Built Environment* and *RIBA Journal*. He also made an animated film on architectural history for BBC2 TV, *Boom!* (1976), has produced an annual calendar for Hepworth Building Products (since 1991), has lectured on architecture internationally and written extensively on the subject in periodicals. Influenced by Steinberg, LOW, Feiffer, FRANÇOIS and VICKY, he uses pen and ink, collage, watercolour and acrylic. Sir High Casson has described his work as 'blissfully funny. As . . . a sharp observer on our industry he is unrivalled' and Pevsner as 'by far the best architectural lampooning known to me'.

PUB: *A is For Architect* (1975), *All Hellman Breaks Loose* (1980), *Architecture for Beginners* (1986)

ILL: Many books including G. Brandreth, *The Big Book of Secrets* (1977); C. Knevitt, *Perspectives* (1986)

EXHIB: AA; NEC; RIBA
COLL: RIBA
LIT: C. Knevitt, *Seven Ages of the Architect* (1991) MB

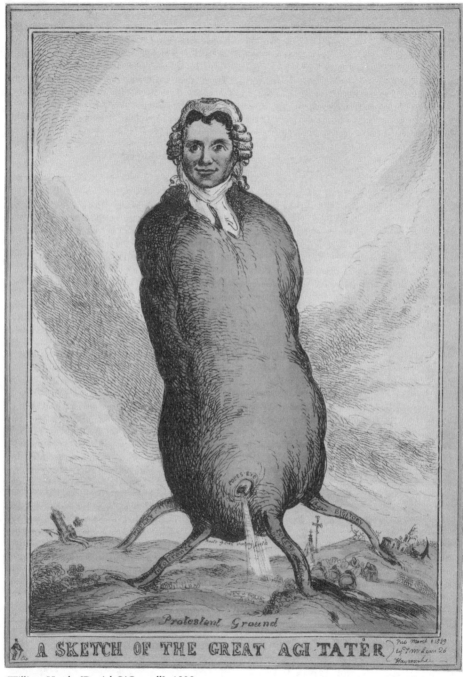

William Heath, [Daniel O'Connell], 1829

HEN – See Doyle, Henry Edward

HENNING, Archibald Samuel (fl. 1841–d. 1864).
Cartoonist and illustrator. A. S. Henning was
born in Edinburgh, the son of John Henning, a
well-known sculptor. As a young man he assisted
his father in sculpting friezes on London monu-
ments. In 1841 he joined his brother-in-law,
KENNY MEADOWS, on the staff of the new
magazine *Punch*, becoming its first political car-
toonist and the designer of its first cover. He left
Punch the following year to be cartoonist on
various short-lived magazines – the *Comic Times*,
Great Gun, *Joe Miller the Younger*, *Man in the
Moon* and *Squib* – and to illustrate books.
ILL: A. Smith, *The Natural History of the Gent*
(1847), *The Natural History of the Ballet-Girl*
(1847), *The Natural History of 'Stuck Up' People*
(1847); Comte Chicard, *The Natural History of
the Bal Masqué* (1849) SH

HEWISON, William Coltman MSIA (b. 1925).
Caricaturist, editorial cartoonist, designer, illus-
trator and writer. Bill Hewison was born in
South Shields, Co. Durham, on 15 May 1925,
the son of a signwriter/decorator. Educated at
South Shields Art School (1941–3), he was a
Gunner/Wireless Operator with the Royal Tank
Regiment in World War II and was eventually
demobbed with the rank of sergeant in July
1947. He then attended Regent Street Polytechnic
Art School (1947–9) – where he gained a bronze
medal for Life Drawing – and the Institute of
Education, London University (1949–50). His
first cartoon was published in *Lilliput* in 1949,
followed by *Punch* in 1950, whose staff he
joined in 1956 as Assistant Art Editor, Art
Editor (1960–84), theatre caricaturist (1961–
92), illustrator and occasional political cartoonist
as well as art critic (1984–7), book reviewer and
feature writer. His work has also appeared in
*Truth, Listener, Sunday Times, The Times, High-
life, Executive World, Architecture Journal,
Classical Music* and *Europe*, and advertising
clients have included BP and Robeco. Since 1992
he has been regular theatre caricaturist for *The
Times*. He has also taught art part-time at Latymer
Upper School, Hammersmith (1950–6). Elected
a Member of the Society of Industrial Artists
(1953) and a member of the *Punch* Table (1960)
he married the artist Elsie Hammond in 1950. He
uses a mapping pen and indian or coloured inks.
Of his deftly executed style, Feaver has said: 'His
line has been described as having the power of a
rhino whip and the spikiness of barbed wire.'

William Hewison, [Antony Sher & Malcolm
Storry in *Tamburlaine the Great*], *The Times*,
3 September 1992

PUB: *Types Behind the Print* (1963), [novel]
Mindfire (1973), *The Cartoon Connection* (1977),
[with R. Thomson] *How to Draw and Sell
Cartoons* (1985), and he has edited and intro-
duced 19 *Punch* cartoon collections on various
themes (1987–91)
ILL: R. Lewis, *What We Did to Father* (1960);
H. F. Ellis, *Mediatrics* (1961) and *A. J. Wentworth,
B. A. (Retd.)* (1962); B. Took & M. Feldman,
Round the Horn (1975); M. Becket, *Economic
Alphabet* (1976); P. G. Wodehouse, *The Great
Sermon Handicap* (1989)
EXHIB: NT
COLL: BM; V&A; TM; UKCC MB

HEWITT, Harold (fl. 1940s–50s). Cartoonist.
Harold Hewitt contributed to *Night & Day,
Punch, Bystander* and *Lilliput* and also produced
advertisements for Schweppes, Bowaters and
others. He was married to the novelist Kathleen
Hewitt. MB

HH – see Heath, Henry

HICKLING, P. B. (fl. 1895–1955). Cartoonist
and illustrator. P. B. Hickling's first cartoons

seem to have been published in *Fun* in 1895. He became a prolific contributor of pleasant illustrated jokes, drawn in pen and ink in a conventional style, to the *Boy's Own Paper, Cassell's, Girl's Realm, Grand, Graphic, Humorist, Hutchinson's, Pearson's, Royal Magazine* and *Tatler*. During World War I a few of his cartoons were published in *Punch*. He was a friend of the ROBINSON brothers and a member of their 'Frothfinders Club'.

ILL: J. Long, *The Three Clerks* (*c.* 1908); J. F. Fraser, *Life's Contrasts* (1908); C. F. Parsons, *All*

Change Here! (1916); N. Barr, *The Inquisitive Harvest Mouse* (1949) SH

HILL, Leonard Raven (1867–1942). Cartoonist and illustrator. Raven Hill was born in Bath on 10 March 1867 and educated at Bristol Grammar School. He studied with F. H. TOWNSEND at the Lambeth School of Art – where he contributed some joke cartoons to *Judy* signed 'Leonard Hill' (1885) – and then at the Académie Julian in Paris under Bougereau (1885–7). On his return he became a prolific contributor of joke cartoons,

NERVOUS OLD LADY.—Oh dear, oh dear ! it'll go over, I know it will ! Oh, Mr. Sailor, you won't let it capsize, will you ?
SAILOR (*grumpily*).—Wot! afore I've took the fares? Not likely!

Leonard Raven Hill, *Pick-Me-Up*, 18 July 1891

theatrical caricatures and illustrations to period-icals and newspapers – *Black & White*, *Cassell's*, *Daily Chronicle*, *Daily Graphic*, *Idler*, *Ludgate Magazine*, *Minster*, *Pears Annual*, *Pall Mall Gazette*, *Printer's Pie*, *Reveille*, *St Paul's*, *Sketch*, *Strand* and the *Windsor Magazine*. In 1890 he was appointed Art Editor of *Pick-Me-Up* and virtually carried the paper to success. He was also Joint Editor of the *Butterfly* (1893), a 'humorous and artistic weekly', which in its short life had a considerable *succès d'estime*, as did the *Unicorn* which he started in 1895. Altogether he was one of the most celebrated black-and-white artists of the period by the time he joined *Punch* in 1896 to begin an association that lasted 40 years. At first he drew social cartoons – being seen in both style and content as the natural successor to CHARLES KEENE – and he was more suited to social comedy than to political cartoon-ing which he practised as the junior to BERNARD PARTRIDGE (1910–35). He left *Punch* in 1935 when his eyesight began to fail. In his prime he was a fine strong draughtsman, good at portray-ing character and making the most of a wide range of jokes.

PUB: *The Promenaders* (1894), *Our Battalion* (1902), *An Indian Sketch Book* (1903)
ILL: R. Kipling, *Stalky and Co.* (1899); T. Coutts, *The Pottle Papers* (1899); Sir W. Besant, *East London* (1901); J. H. Harris, *Cornish Saints and Sinners* (1906); E. V. Lucas, *Slowcoach* (1910); K. Howard, *The Happy Vanners* (1911)
EXHIB: RA; RI; RBA; RSA; FAS
COLL: BM; V&A; B SH

HILTON – see Brown, Frank Hilton

HINE, Henry George VPRI (1811–95). Cartoon-ist, illustrator and painter. H. G. Hine was born in Brighton, the son of a coachman. After being apprenticed as a draughtsman to Henry Meyer, the portrait painter, he worked as a wood-engraver for Ebenezer Landells, one of the founders of *Punch* (1841). He joined *Punch* himself in its first year as an all-round humorous artist, occasionally supplying the Cartoon, and stayed until 1844 when he left to work as a comic artist for other papers and to develop his con-siderable talent as a landscape painter in watercolour. In 1847 he illustrated a funny and ingenious strip cartoon by Albert Smith called 'Mr Crindle's Rapid Career upon Town' in the *Man in the Moon* and followed it in 1948 with 'The Surprising Adventures of Mr Touchango Jones, an Emigrant'. He also contributed agreeable

H. G. Hine in R. B. Brough, *A Cracker Bon-Bon for Christmas Parties* (1852)

and competent cartoons to the *Great Gun*, *Joe Miller the Younger* and *Mephistopheles*. In later life he confined himself to watercolours, being elected RI (1864) and RI Vice-President (1888–95). He died in London on 16 March 1895.
PUB: *Tuft Hunters and Toadies* (1850?)
ILL: H. Mayhew, *Model Men* (1848), *Model Women and Children* (1848), *Change for a Shilling* (1848); H. & A. Mayhew, *Acting Charades* (*c*. 1850); R. Brough, *A Cracker Bon-Bon for Christmas Parties* (1852); *The Comic Almanack* (1853); *The Turkish Alphabet* (1854); J. H. Pepper, *The Boy's Playbook of Science* (1881)
EXHIB: RA; RI; RBA; FAS (1896)
COLL: BM; V&A; F; LE; TOW; M; LEI; Sydney Art Gallery SH

HOAR, Harold Frank 'Acanthus' PhD, FRIBA (1909–76). Architect and cartoonist. Frank Hoar attended Plymouth College and won a scholarship to the Bartlett College of Architecture, London University, at the age of 15. While being taught life drawing at the Slade his caricatures of teachers attracted the attention of the art school's head, Professor Tonks, and he was encouraged to caricature the entire tutorial staff. Trained as an architect under Sir Albert Richardson, he was joint winner of an architectural competition for developing Gatwick Airport (1936) and became

'You and your "All roads lead to Rome!" '

Acanthus (Frank Hoar), *Ancestral Manners* (1961)

a greatly respected town-planning consultant. His cartoons were first published in *London Opinion*, then *Punch*. In World War II he worked in the Rescue Service during the Blitz. Some of his best cartoon work was for *Building* from 1960 and political cartoons for the *Sunday Tele-* *graph* but he also contributed to *Men Only*, *Builder* and other publications. Frank Hoar used Perry 606 or Gillot 303 nibs. He died on 3 October 1976.

PUB: *Pen and Ink Drawing* (1955), *Ancestral Manners* (1961), *An Introduction to English*

Architecture (1963), *European Architecture from Earliest Times to the Present Day* (1967) ILL: [as Frank Hoar] C. Scott, *Westminster Abbey* (1976)
EXHIB: RA; Arts Club; RWCS MB

HOD – see Hollowood, Albert Bernard

HODSON, Haro Reginald Victor 'Haro' (b. 1923). Cartoonist, illustrator, poet and writer. Haro Hodson was born in Glasgow on 9 February 1923, the second son of a Gloucestershire hunting parson. At 16 he left school to study at Stroud School of Art (1939). During World War II he served in the Army and was later attached to GHQ New Delhi as an official war artist. His first published drawing appeared in *Lilliput* in 1941 and after the war he read English at Oxford University and spent a year at Corsham Art School. During this period his poems were published in the *Observer* and *Adelphi* and broadcast on the BBC. He joined the staff of the *Observer* as an illustrator (1948–64) and has contributed, freelance, to the *Daily Mail* (and later *Mail on Sunday*) since 1964. His drawings have also appeared in *Punch, Tatler, Time & Tide, Harpers & Queen* and *New York Herald-Tribune*. He has additionally drawn posters for the Royal College of Nursing, produced illustrations for Berry Brothers, designed Christmas cards for Gallery 5, been occasional TV critic on the *Daily Mail* (1978–85) and produced book/theatre reviews for *Observer, Daily Mail* and *Glasgow Herald*. He married the writer Elizabeth Mavor in 1953. A great admirer (and friend) of MAX BEERBOHM, he cites other influences as Blake, the 13th-century 'Master of the Leaping Figures', and PHIL MAY. At the start of his career he worked with pen and indian ink but now uses a variety of Pentels for speed. He draws with a flamboyant, minimal line.
PUB: [poetry] *The Visitor* (1951)
ILL: Many books including eight titles by P. Jennings from *Oddly Enough* (1950); D. Parsons, *True to Type* (1955); M. Moore, *And What Do You Do?* (1960); A. Adburgham, *A View of Fashion* (1966) MB

HOFFNUNG, Gerard FSIA (1925–59). Cartoonist, caricaturist, writer, musician and broadcaster. Gerard Hoffnung was born in Berlin on 22 March 1925 and came to England in 1938, attending Highgate School and Hornsey and Harrow Schools of Art (*c.* 1943). He spent the remainder of the war years washing bottles at the

Express Dairy Farm near Golders Green, then taught art at Stamford School (1945–6), was staff artist on the *Stamford Mercury* (*c.* 1946) and the *Evening News* (1947) and assistant art master at Harrow School (1948–50). During this period he also freelanced for *Lilliput* (which he had first contributed to aged 15), *Seven, Contact, Strand Magazine, Housewife, Tatler* and *Radio Times* and produced advertising work for Kia-Ora and others. This was followed by a short interval in New York working for Cowles Magazines (staff artist on *Flair*) returning to England in 1951 to work regularly for *Daily Express, Punch* (from 1952), Guinness and others. A frequent broadcaster on the BBC (from 1951), he also created the Hoffnung Music Festivals at the Royal Festival Hall (1956, 1958 and 1959) and produced designs for the Chelsea Arts Ball (1957) and a Glyndebourne Opera programme. In addition he published numerous books, which were the basis of seven short animated films by Halas & Batchelor, *Tales from Hoffnung*. Hoffnung was an accomplished bass tuba player and music was always a great influence on his work. He mainly drew with a mapping pen and indian ink and also used watercolours and wax crayons. He died on 28 September 1959.
PUB: *The Maestro* (1953), *The Hoffnung Symphony Orchestra* (1955), [with J. Symonds] *The Isle of Cats* (1955), *The Hoffnung Music Festival* (1956), *The Hoffnung Companion to Music* (1957), *Hoffnung's Musical Chairs* (1958), *Ho Ho Hoffnung* (1959), *Hoffnung's Acoustics* (1959), *Birds, Bees and Storks* (1960), *Hoffnung's Little Ones* (1961), *Hoffnung's Constant Readers* (1962), *The Penguin Hoffnung* (1963), *Hoffnung's Encore* (1968), *Hoffnung's Harlequinade* (1979), *Hoffnung's Humoresque* (1984)
ILL: J. Broughton, *The Right Playmate* (1951); Lady Pakenham, *Points for Parents* (1954); P. Cudlipp, *Bouverie Ballads* (1955); Colette, *The Boy and the Magic* (1964)
EXHIB: Many shows including RFH; WAC tour; Berlin Festival; Edinburgh Festival; Japanese tour (1992); Lincoln Center, New York (1970); V&A; OHG; CAT
LIT: [various authors], *O Rare Hoffnung* (1960); A. Hoffnung, *Gerard Hoffnung* (1988) MB

HOGARTH, William (1697–1764). Painter, engraver, pictorial satirist and author. William Hogarth was born in Smithfield, London, on 10 November 1697. In 1707 or 1708 his father, a schoolmaster, was sent to prison for debt and for five years the family lived within the precincts of

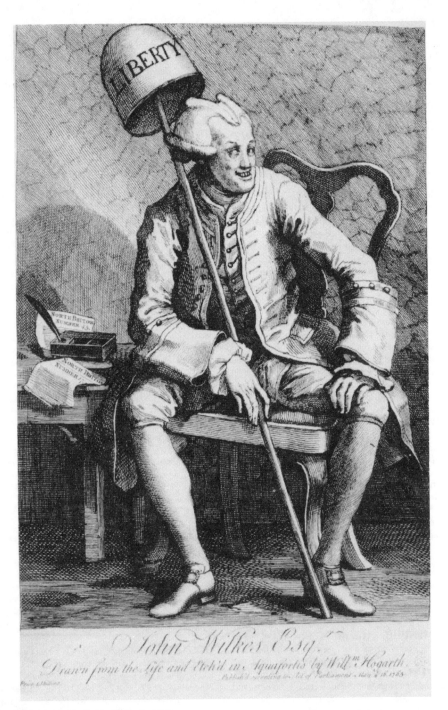

William Hogarth, [John Wilkes], 1763

114

the Fleet Prison, an experience which affected Hogarth for life. He was apprenticed in 1713 to a silver engraver and left in 1720 to practise as an engraver-designer himself, studying art in his spare time at Vanderbank's Academy. His first major commission came in 1726 when an edition of Butler's mock-epic poem *Hudibras* was published with his illustrations. The next year he eloped with the daughter of Sir James Thornhill, History Painter to the King. In 1731–2 he painted the series 'A Harlot's Progress' which, when engraved as prints and sold by himself by subscription (dispensing with a printseller), had a great success and encouraged him to paint and engrave 'The Rake's Progress' in 1735. The 'Progresses', of which the greatest was 'Marrriage à la Mode' (1745), were designed as satires on the follies and vices of the age; he called them 'modern moral subjects' to distinguish between his sermonizing purpose and the frivolous impulse of amateurs who, following Italian examples, practised the fashionable art of personal caricature. He has been called 'the father of English caricature' because by the nature of his purpose, the strength of his imagination, the power of his art and the response it evoked from the public, pictorial satire was dignified into an art form. Not that dignity was a hallmark of his art; the adjective 'Hogarthian' derives from caricatures like 'Gin Lane' which showed scenes of drunkenness, squalor and debauchery. He had no successors; the next generation of caricaturists abandoned moral themes for political propaganda and pictorial jokes. *The Analysis of Beauty*, his controversial treatise on Art which itself provoked caricatures, was published in 1753. In 1757 he was appointed Serjeant Painter to the King and from that time his health and his art declined. In his last years, one of his very rare political caricatures provoked attacks in print by Wilkes and in caricatures by PAUL SANDBY. He died on 25 October 1764. On his tombstone at Chiswick these lines were written:

'If Genius fire thee Stranger, stay,
If Nature touch thee, drop a tear,
If neither move thee, turn away,
For Hogarth's honoured dust lies here.'

PUB: *The Analysis of Beauty* (1753), *The Original Works of Hogarth* (1790), *The Works . . . from the Original Plates Restored by James Heath* (1822)
ILL: S. Butler, *Hudibras* (1726)
EXHIB: BM, 'Hogarth's Prints and Drawings' (1964); T 'William Hogarth' (1971–2), 'Manners and Morals: Hogarth and British Painting 1700– 1760' (1987)
COLL: NG; T; BM; V&A; NPG; Sir John Soane Museum; HM the Queen; Thomas Coram Foundation; F; A
LIT: R. Paulson, *Hogarth's Graphic Works* (1965), *Hogarth, His Life Art and Times* (1971), *Hogarth* (1992–3); D. Bindman, *Hogarth* (1981); R. S. Cowley, *Marriage à la Mode* (1983)　SH

HOGG, Gordon 'Gog' (1912–73). Cartoonist and strip cartoonist. Born in London, Gordon Hogg won a London County Art Scholarship at the age of 14 and studied art with Ruskin Spear for three years before becoming a commercial artist. His first cartoon was published in the *Daily Sketch* in 1938. During World War II he was Offical War Artist to the Indian Army under Auchinleck. After the war he became chief editorial artist on the *Daily Sketch* and took over the 'Pop' cartoon for 15 years when MILLAR WATT retired. When the strip eventually folded he worked for children's comics such as *Wham*, *Sunday Extra* and *Smash*. He also drew a strip 'Miss Muffet' and was 'Gay Gordon' the racing/ sports cartoonist on the *Sun*. He died in March 1973.　MB

HOLDER, Trevor 'Holte' (b. 1941). Cartoonist and illustrator. Trevor Holder was born in Birmingham on 5 January 1941 and is a self-taught artist. He left school at 15 and worked as a technical illustrator and graphic designer, producing cartoons in his spare time, until turning freelance cartoonist in 1981. His drawings have appeared in *Punch* (including the magazine's final cover), *Listener*, *Reader's Digest* and elsewhere and he has also produced cartoons for advertising for companies such as Esso. He works in pen and ink, watercolour, gouache and oils.　MB

HOLLAND, John Anthony (b. 1932). Cartoonist and illustrator. Tony Holland was born on 7 August 1932 in Peterborough, Lincolnshire, and is a self-taught artist. After studying at Sheffield University (1950–3) he spent his National Service in the RAF (1953–5) before becoming a professional cartoonist, contributing to the *Daily Telegraph*, *Sunday Telegraph*, *Punch*, *Accountancy* and various financial journals. He works in felt-tip pen using Pantone colours.
ILL: A. Twort, *A Hole in My Bucket* (1963); N. Buchanan, *Know Your New Pension Rights*

(1976); 'Ivanhoe Career Guides' (annually from 1989) MB

HOLLOWOOD, Albert Bernard 'Hod' FRSA (1910–81). Economist, pocket cartoonist, author, broadcaster and editor. Bernard Hollowood was born in Burslem, Staffordshire, on 3 June 1910 and educated at Hanley High School and St Paul's College, Cheltenham. He studied economics at London University and lectured on the subject at the School of Commerce, Stoke-on-Trent, and Loughborough College (1932–43). He then joined the staff of the *Economist* (1944–5), was Research Officer at the Council of Industrial Design (1946–7) and Editor of *Pottery & Glass* (1944–50). A self-taught artist, he was elected to the *Punch* Table in 1945 and was the magazine's Editor (1957–68). He was also pocket cartoonist for *Sunday Times* (1957–60) and a regular contributor to *The Times, Geographical Magazine, Socialist Commentary, Surrey Advertiser, London Opinion, Lilliput, New Yorker, Evening Standard, Daily* and *Sunday Telegraph*. He was in addition a member of the Court of Governors of the London School of Economics and played cricket for Staffordshire. An admirer of the work of PONT and PAUL CRUM, he divided joke drawings into two types: the 'immediate' (e.g. LANGDON) and the 'continuous performance' (e.g. PONT, EMETT, BATEMAN, HEATH ROBINSON) – a succession of chuckles rather than one quick guffaw. Bernard Hollowood died on 28 March 1981.
PUB: *Direct Economics* (1943), *Money is No Expense* (1946), *An Innocent at Large* (1947), *Britain Inside Out* (1948), *Scowle and Other Papers* (1948), *Poor Little Rich World* (1948), *Pottery and Glass* (1949), *The Hawksmoor Scandals* (1949), *Cornish Engineers* (1951), *The Story of Morro Velho* (1954), *Money* (1957), *Tory Story* (1964), *Pont* (1969), *Cricket on the Brain* (1970), *Tales of Tommy Barr* (1970), *Funny Money* (1975)
ILL: G. Reynolds, *Organo Pleno* (1970), *Full Swell* (1972)
EXHIB: US; LSE; Staffordshire University MB

HOLTE – see Holder, Trevor

HONEYSETT, Martin (b. 1943). Cartoonist and illustrator. Born in Hereford on 20 May 1943, Martin Honeysett attended Selhurst Grammar School, where he was taught art by GEOFFREY DICKINSON, and Croydon School of

Art (1960–1). He then worked briefly in a London animation studio and in a factory in Manchester before emigrating to New Zealand (1962–5), where he had a variety of jobs, from lumberjack to stage hand for New Zealand Ballet Co. After a further period in Canada (1965–8), he returned to England to work as a bus-driver for London Transport whilst cartooning in his spare time. He sold his first cartoon to the *Daily Mirror* in May 1969 and turned full-time freelance in 1972, contributing to *Punch* (from 1970), *Private Eye, Daily Mirror, Evening Standard, TV Times, Radio Times, Observer* and *Sunday Telegraph*. Honeysett's spidery style of drawing emphasizes his often macabre sense of humour.
PUB: *Private Eye Martin Honeysett* (1974), *Honeysett at Home* (1976), *Martin Honeysett* (1977), *The Motor Show Book of Humour* (1978), *Microphobia* (1982), *The Not Another Book of Old Photographs Book* (1981), *Fit for Nothing* (1983), *The Joy of Headaches* (1984), *Animal Nonsense Rhymes* (1984), *The Best of Honeysett* (1985), *Witch Doctor?* (1985)
ILL: I. Cutler, *Life in a Scotch Sitting Room Vol. 2* (1984), *Gruts* (1986), *Fremsley* (1987), *One-and-a-Quarter* (1987), *Glasgow Dreamer* (1990), *Fly Sandwich* (1992); D. King-Smith, *H. Prince* (1986), *Farmer Bungle Forgets* (1987); S. Townsend, *The Queen and I* (1992)
EXHIB: CG; BC
COLL: V&A MB

HOOD, Thomas (1799–1845). Poet, editor, comic illustrator. Thomas Hood was born in London, the son of a Scottish bookseller, and in his adolescence contributed comic sketches to periodicals in Dundee. He was apprenticed to several London engravers before becoming sub-editor of the *London Magazine* in 1821. In that capacity he met Lamb, Hazlitt, De Quincey and many of the leading literary figures of the day. He designed and etched a large satirical print in 1826 called 'The Progress of Cant'. The following year his first collection of verse was illustrated with 'picture-puns', an idea he seems to have originated. They demonstrated an amazing fertility in punning invention but have no artistic merit. He illustrated many of his own publications with comic vignettes and contributed a single cartoon to *Punch* which Spielmann called 'wonderful'. His poem 'The Song of the Shirt', published in *Punch* in 1843, tripled the magazine's circulation.
PUB: *Whims and Oddities* (1826–7), *Hood's Comic Annual* (1830–9), *Hood's Own* (1838–

"SAYING THE BOGEYMAN WILL GET HIM DOESN'T SEEM TO HAVE TOO MUCH EFFECT THESE DAYS".

Martin Honeysett, *c.* 1980

9), *Up the Rhine* (1839), *Hood's Magazine* (1844), *Whimsicalities* (1844), *Collected Works* (1882–4)
COLL: BM
LIT: W. Jerrold, *Thomas Hood* (1907) SH

HOOPER, William John 'Raff' (b. 1916). Cartoonist, strip cartoonist, writer and broadcaster. Bill Hooper was born in West London on 21 August 1916. He worked as a laboratory assistant in a medical clinic in Windsor before volunteering for RAF aircrew in 1939 (later joining 54 Squadron, Fighter Command HQ and Intelligence). Self-taught as an artist, he is best known as 'Raff' (the name comes from his dog whilst in the RAF), the creator of Pilot Officer Percy Prune. The name 'Prune' was a schoolboy term for new recruits and PO Prune was a persistently inept pilot who first appeared

(unnamed) in *Forget Me Nots for Fighters* (*c.* 1940), a book produced after the Battle of Britain to show the lessons learnt for fighter pilots. The character was then christened and appeared regularly in *TEE EMM* (for *Training Memorandum*), an aircrew training magazine edited by *Punch* writer Anthony Armstrong from 1 April 1941. Another creation was Aircraftsman Plonk, Prune's mechanic, Prune's girlfriend WAAAF Winsum and his mascot dog Binder. Prune variants included a bearded Fleet Air Arm version, Sub-Lt Swingit, the Free French Air Force Aspirant Praline (created for the *Bulletin de Forces*) and a French resistance variant. Like JON's Two Types, Prune and his colleagues were not based on real people but (by mistake) his name got into the Air Ministry phone book, his portrait was hung in the National Gallery and the Luftwaffe awarded him an Iron Cross. Raff

117

also made mannikins of the Prune characters for a display in the RAF Museum. After the war Hooper worked on a training magazine for an Anglo-US company, and two dog characters from *TEE EMM*, based on his own pets Toro and Willy, were featured in a BBCTV animated film *Willy the Pup* (*c.* 1946). He was then a children's TV presenter and animator for the BBC (15 years), created the 'Did You Know That?' strip for the *Star* (three years) and for 12 years (until *c.* 1970) worked as a journalist on the *Sunday Pictorial* (later *Sunday Mirror*). The Prune cartoons were originally drawn in cartridge-paper sketchbooks.

PUB: [as '977950'] *Forget Me Nots for Fighters* (*c.* 1940), [as Raff] *Behind the Spitfires* (1941), [with A. Armstrong] *Plonk's Party of ATC* (1942), *Prune's Progress* (1942); *Nice Types* (1943), *More Nice Types* (1944), *Whiskers Will Not be Worn* (1945), *Goodbye Nice Types!* (1946), [as Bill Hooper] *The Odd Facts of Life* (1965), *The Passing of Pilot Officer Prune* (1975); [as Bill Hooper with D. Dickinson] *Clangers* (1970), [as K. de Barri] *The Bucks and Bawds of London Town* (1972)
ILL: A. Armstrong, *Sappers at War* (1949); J. H. Coombs, *Bar Service* (1965)
EXHIB: RAF (1991)
COLL: RAF; IWM
LIT: [as Bill Hooper] *Pilot Officer Prune's Picture Parade* (1991); T. Hamilton, *The Life and Times of Pilot Officer Prune* (1991) MB

Raff (William J. Hooper), [Pilot Officer Prune], *Prune's Progress* (1942)

HOPKINS, Everard (1860–1928). Painter, illustrator and cartoonist. Everard Hopkins was born in Hampstead, London, the brother of the poet Gerard Manley Hopkins and of Arthur Hopkins RWS, who like himself contributed occasional cartoons to *Punch*. He was educated at Charterhouse School and studied art at the Slade School (1878). His illustrations were published in *Black & White*, *Cassells*, *Gentlewoman*, *Graphic* and *Illustrated London News*. The *Punch* cartoons of the 1890s are gracefully drawn but rather humourless. He died on 17 October 1928.
PUB: *Lydia* (1910)
ILL: M. Gray, *A Costly Freak* (1894); L. Sterne, *A Sentimental Journey* (1910); A. Tennyson, *The Princess* (1911)
EXHIB: RA; RI; NWS
COLL: V&A SH

HORNER, Arthur Wakefield (b. 1916). Political and strip cartoonist, caricaturist, illustrator and animator. Arthur Horner was born in Melbourne, Australia, on 10 May 1916. When he was 13 his family moved to Sydney where he attended Sydney High School and East Sydney Technical College and began writing and acting in radio plays. As a cartoonist he was a regular contributor to the *Sydney Bulletin* and was on the staff of *Smith's Weekly* and later *ABC Weekly* before serving in the Army in World War II, first as OC of a camouflage unit in New Guinea and later as head of a Military History Field Unit in Borneo. Moving to London in 1946, he studied at the Central School of Arts & Crafts under Ruskin Spear and Bernard Meninsky before drawing regularly for *Lilliput* and becoming Political Cartoonist on *Tribune*. In the early 1950s he was pocket cartoonist on the *News Chronicle*, succeeding VICKY as the paper's Political Cartoonist in 1954. Whilst there he created the 'Colonel Pewter' strip which ran for 18 years in its different incarnations in the *Chronicle* (1952–60), Daily Mail (1960–4) and *Guardian* (where it was the paper's first cartoon strip, 1964–70) and was widely syndicated abroad. The eccentric Colonel Hugo Pewter (Rtd) lived in The Chukkas in the English village of Much Overdun with his great-nephew Martin and Sirius the dog (offspring of a local bitch and a visiting space-dog). On retiring the Colonel in 1970 Horner created a daily 'first-person' strip, 'The Thoughts of Citizen Doe' which ran for about two years. He has also been Political Cartoonist on *New Statesman* (1966–71), *Times Higher Education Supplement* and *Humanist* and his work has featured in

Private Eye, Punch, Sunday Times and on BBCTV. Horner returned to Australia in 1976 to produce political cartoons, caricatures and theatre drawings for Melbourne's *The Age*. He is married to the Australian artist Victoria Cowdroy ('Royston'). Horner has mostly worked in line (pen and ink, fibre pen or crayon), line and wash, and occasionally line and spirit colours. For early newsprint reproduction he developoed a unique way of getting half-tone effects for line-block processing by manipulating textured plates under a drawing while rubbing a crayon on top. He has also produced lithographs, etchings, aquatints and seriographs, and experimented with animated film. He cites his influences as being OSPOVAT, the artists of *Simplicissimus*, Lautrec, Topolski and BATEMAN.
PUB: *Colonel Pewter in Ironicus* (1957), *Dog-Star; and Come Back, Sirius* (1972), *The Penguin Colonel Pewter* (1978), *The Book of Uriel* (1979)
ILL: R. Woddis, *Lot '71* (1971), *Sex Guyed* (1973); T. Kavanagh, *The ITMA Years* (1975); M. Lurie, *Toby's Millions* (1978)
EXHIB: CG; Victorian Ministry of Arts, Australia (1977)
COLL: UKCC; State Library of Victoria; National Museum, Canberra; Mitchell Library, Sydney MB

HOWARD, Captain Henry R. (fl. 1853–d. 1895). Cartoonist. Henry Howard was born near Watford, the son of a country gentleman. He studied art in Hanover under RAMBERG, the painter and caricaturist. His numerous comic initials and decorations in *Punch* (1853–67) often took an anthropomorphic form and have a grotesque quality that is reminiscent of GEORGE CRUIKSHANK. When LEECH died in 1864, Howard aspired to be his successor but was in no way good enough. SH

HUGHES, David (b. 1952). Editorial cartoonist, illustrator and caricaturist. David Hughes was born in Twickenham, Middlesex, on 6 January 1952 and studied at Twickenham College of Technology (1968–72). Staff cartoonist on the *Daily Express* (1973–4), he has also been a full-time postman (1975–7), a graphic designer at Granada TV (1980–4) and Lecturer in Illustration at Manchester Polytechnic (1987–90 and part-time 1990–2). He illustrated 'A Doctor Writes' in the *Observer* (1990–2), drew covers for *Punch* (1990–2) and has also worked for *New Yorker*. Other clients have included *Telegraph Sunday*

Magazine, Illustrated London News, Creative Review, The Times, Washington Post, Observer Magazine, Radio Times, GQ (USA), *American Health*, Central TV's 'SPITTING IMAGE' and book publishers Sphere, Transworld, Viking, Faber & Faber, Walker Books and Abacus. He has also won a number of awards for his work including the Mother Goose Award (1990) and Creative Review Humour Award (1991).
PUB: *Black & White* (1986), *Bully* (1993)
ILL: E. Morecambe, *Eric Morecambe on Fishing* (1984); C. Martin–Jenkins (ed.), *The Cricketer Book of Cricket Eccentrics* (1985); J. Mark, *Strat and Chatto* (1989)
EXHIB: John Holden Gallery, Manchester; AI Gallery; Beint & Beint Gallery; Museo Civico, Spoleto, Italy; Assembly Rooms, Edinburgh MB

HUMPH – see Lyttelton, Humphrey Richard Adeane

HURST, Hal RBA ROI VPRMS (1865–c. 1938). Painter, illustrator and cartoonist. Hal Hurst was born in London on 26 August 1865, the son of an explorer, and was educated at St Paul's School. After working for a time in America as a special artist for the *Philadephia Press* and other papers he went to Paris for seven months to study at the Académie Julian. Returned to London, he contributed illustrations and cartoons in the 1890s to *Cassell's, Fun, Gentlewoman, Harmsworth, Idler, Illustrated Bits, Illustrated London News, Minster, Nash's, Pall Mall Magazine, Pearson's, St Paul's, Strand and To-Day*. His style, modelled on the American Charles Dana Gibson, is very 'swish' – his claim to be 'the artist of the man and woman about town' is reflected in his cartoons for *Fun* and *Pick-Me-Up*. He drew one caricature in *Vanity Fair*. The vogue for his drawings, mostly in wash, did not survive the 90s and he later concentrated on portraiture. He was elected RBA (1896), ROI (1900) and was Vice-President of the RMS (1896–1913). THORPE referred to his work as 'meaningless smartness' but is so repetitiously disparaging that one suspects a personal antipathy.
ILL: G. A. Henty, *The Sikh War* (1894); St Leger, *Sou'Wester and Sword* (1894); M. Twain, *The American Claimant* (1897)
EXHIB: RA; RI; RBA; RWS; RMS SH

HUSBAND, William Anthony (b. 1950). Cartoonist, strip cartoonist, illustrator, scriptwriter. Born in Blackpool, Lancashire on 28

August 1950, Tony Husband is a self-taught artist. He worked on the printing side of an advertising agency and as a window-dresser and jewellery repairer before becoming a cartoonist. His first cartoons were published in *Weekend* and *Daily Mirror* and he turned full-time freelance in 1984. Co-editor/founder of the children's comic *Oink!* (1985–8), he has drawn the pop-music cartoon for the *Daily Star* and topical football cartoons for *Shoot!* His work has also appeared in *Punch*, *Private Eye* (including 'The Yobs' strip since 1986), *Spectator, Oldie, The Times, Sunday Times* ('Mr Clean' strip), *Men Only, Club International, Playboy, Fiesta, BA News, Solicitors Journal, Reader's Digest* and many German publications. In addition he was co-writer and deviser of the award-winning children's TV programme 'Round the Bend' (featuring puppets by SPITTING IMAGE) and the successful touring play, 'Save the Human' (in which giant cartoons were projected on a screen behind the actors). He has designed numerous greetings cards including a 100-card series 'Rhino's Revenge' for Camden Graphics. Husband was voted CCGB Joke Cartoonist of the Year (1984, 1985, 1987), CCGB Strip Cartoonist of the Year (1988) and *The Times* Strip Cartoonist of the Year (1989). Influenced by MIKE WILLIAMS, Sempé, ALEX GRAHAM, BILL TIDY and LARRY, he works very fast using Artline Drawing System 08 pens on cartridge paper and Pantone markers for colour on bleedproof layout paper. He has a loose sketchy style and an often black sense of humour.

For your own sake as well as his, Ivor, you've got to let go sometime

Tony Husband, *Private Eye*, 1992

"Your leading seaman's been leading me up the garden path."

Edward Hynes, *Men Only*, April 1940

PUB: *Use Your Head* (1984), *Bye Bye Cruel World* (1985), *Animal Husbandry* (1986), *The Greatest Story Never Told* (1988), *Yobs and Other Cartoons* (1988), [with D. Day] *True Tales of Environmental Madness* (1990), *Save the Human* (1991) [with J. Banks, R. Lowry and J. Jackson] *100 Things to do with a Black Lace Record* (1990); *Save the Human* (1990); *Dinos* (1993), and six collections published in Germany
ILL: J. Eastwood, *100 Per Cent British* (1989), *100 Per Cent Japanese* (1990), *100 Per Cent Australian* (1990); F. Snelson (ed.) *NSPCC Book of Famous Faux Pas* (1990)
EXHIB: CG; Librays Theatre, Manchester MB

HUSTLEBUCK – see Wood, Clarence Lawson

HUTCHINGS, Anthony (b. 1946). Cartoonist, illustrator and greetings card designer. Anthony Hutchings was born in London on 17 August 1946 and studied commercial art at Southend College of Art. A freelance cartoonist, he works mostly for children's comics such as *Whoopee!*,

Buster, Whizzer & Chips, and *Roy of the Rovers* but has also had drawings published in *Punch, Private Eye, Mayfair, Daily Mail, Sun, Daily Mirror, Daily Star, Club International, Men Only, Fiesta, Knave, Accountancy, Weekend* and others. In addition he has produced humorous greetings cards for Royle and Otter House and advertising cartoons for ICI. Twice voted CCGB Joke Cartoonist of the Year (1987, 1989), he prefers working in full colour with inks.

PUB: Purnell's 'Word Book' series (from 1977), *Middle Age Sex* (1991), *Bosom Buddies* (1991), *The Very Best of Essex Girl Jokes* (1991), *Keep Fit Sex* (1992), *Laugh at the Olympics* (1992), *Columbus* (1992)
ILL: M. Young's 'SuperTed' series (from 1983) and many titles by A. Gelman MB

HYNES, Edward S. (fl. 1930s–50s). Cartoonist and caricaturist. The son of a surgeon from Co. Clare, Ireland, Edward Hynes was a naval cadet and navigator for ten years before studying medicine in Sheffield. He later contributed cartoons to *Daily Sketch, Evening News, Humorist, Razzle, Sunday Express, Bystander, London Calling, Night & Day* and *London Opinion.* Hynes is perhaps best known for his colour caricature covers for *Men Only* (July 1937–June 1956), taking over from ERIC FRASER and being himself succeeded by SHERRIFFS. He also drew theatre caricatures for *Sporting & Dramatic News* and designed advertisements for Player's Tobacco, Wright's Coal Tar Shaving Cream and others.

PUB: *Cocktail Cavalcade* (1937) MB

I

ILLINGWORTH, Leslie Gilbert (1902–79). Political cartoonist and illustrator. Leslie Illingworth was born in Barry, Glamorgan, on 2 September 1902, the son of a Yorkshire quantity surveyor. He was educated at Barry County School and Cardiff Art School, drawing for the *Western Mail* while still a student. In 1920 a scholarship to the Royal College of Art brought him to London, contemporaries including Barbara Hepworth, Henry Moore, Eric Ravilious, EDWARD BAWDEN and JOHN GILROY. Offered the job of Political Cartoonist on the *Western Mail* when STANIFORTH died, he returned to Wales (1921–7), later continuing his interrupted art studies in Paris at the Académie Julian and supporting himself by freelancing for *Nash's, Passing Show, Strand Magazine, Good Housekeeping, London Opinion, Red Magazine, Wills' Magazine, Answers, Tit-Bits* and later *Life.* He also produced illustrations for advertisements such as 'Beer is Best', Eiffel Tower Lemonade and Wolsey underwear. His first contribution to *Punch* was in 1927, and he succeeded BERNARD PARTRIDGE as Second Cartoonist opposite E. H. Shepard in 1945, becoming a member of the *Punch* Table in 1948 and later taking over from Shepard as Cartoonist, alternating with NORMAN MANSBRIDGE (1949–68). Towards the end of 1939 he submitted drawings to the *Daily Mail,* under the pseudonym 'MacGregor' (his mother's maiden name) and joined the paper as Political Cartoonist that year, retiring in 1969 (succeeded

by WALLY FAWKES). He later returned to Fleet Street for three years to work as guest cartoonist on the *Sun* and *News of the World.* During the war he produced work for the Ministry of Defence and in 1963 drew a cover for *Time* magazine. He was voted CCGB Political and Social Cartoonist of the Year in 1962. Illingworth always claimed he was unable to caricature women and preferred to paint them in oils. He used a Gillot 290 pen with Higgins ink on hot-pressed fashion board, roughing out in pencil first, and was one of the first cartoonists to employ scraperboard. Widely admired by his fellow cartoonists, his 'classical' style has been likened to the early work of TENNIEL and the best of RAVEN HILL and Geipel has said of him: 'By juxtaposing deftly wrought detail with areas of thunderous black, Illingworth has achieved a richness and authority that distinguish his work from all his contemporaries.' He had a 'faultless pen-and-ink technique, a technique which is essentially naturalistic yet masterly in its variety of textures, arrangement of tones, and subtle atmospheric perspective. It is hardly cartooning . . .' (HEWISON). In his *Guardian* obituary, Malcolm Muggeridge believed that Illingworth's cartoons would last longer than LOW's: 'Illingworth's go deeper, becoming, at their best, satire in the grand style rather than mischievous quips; strategic rather than practical'. He died on 20 December 1979.

PUB: *On Target, c.* 1940?

"It's never been stronger"

Leslie Illingworth, *Punch*, 26 February 1964

ILL: B. Hollowood, *The Hawksmoor Scandals* (1949)
COLL: UW; UKCC; BM; V&A MB

INCE, Charles RI RBA (1875–after 1940). Painter and cartoonist. Charles Ince was born in London on 10 June 1875, the son of a printer, and was educated at King's College, London. He contributed humorous illustrations to the *Bystander* and the *Tatler* (1900–10) and a few cartoons to *Punch*. His charcoal drawings were strongly influenced by GEORGE BELCHER. Mainly known as a landscape painter, he was elected RBA (1912) and RI (1927). He became a director of the family firm of printers, Charles F. Ince & Sons.

EXHIB: RA; RI; RBA; RWS; ROI; GI; FAS; GOU SH

IONICUS – see Armitage, Joshua Charles

IRELAND, John (b. 1949). Caricaturist and illustrator. John Ireland was born on 19 March 1949 in Aldershot, Hampshire. He studied graphic design at Farnham and Ravensbourne Art Schools and has contributed to *Radio Times*, *Punch*, *Sunday Times* and *Daily Telegraph* amongst other publications. He works in ink with watercolour wash and cites influences as RONALD SEARLE and the artists of *Beano* and *Dandy* comics.

PUB: *Cricket Characters* (1987), *Racing Characters* (1988), *Golf Characters* (1989), *Snooker Characters* (1989), *Rugby Characters* (1990).

ILL: T. Wogan & T. Fairbairn, *To Horse! To Horse!* (1982); P. Tinniswood, *Uncle Mort's North Country* (1986); J. Timpson, *Early Morning Book* (1986); J. Virgo, *Snooker Sideshow*

MB

J

JACKSON, Raymond Allen 'JAK' (b. 1927). Editorial/political cartoonist. JAK was born in London's West End on 11 March 1927, the son of a tailor, and attended Clipstone Road School and Willesden School of Art before spending three years in the Army Education Corps teaching conscripts to paint. His first job was retouching pubic hair on photos for *Health & Efficiency* and he contributed to *Punch*, *Lilliput* and other publications before joining the *Evening Standard*, first as an illustrator on the TV page then as Political Cartoonist in 1966 (succeeding VICKY) while also drawing for the *Daily Express* (then *Mail*) on Saturdays. One of his

"... THE TENTH DUKE AT MAFEKING, THE ELEVENTH ON THE SOMME, THE TWELFTH AT PLAMEIN, AND PATER WATCHING WOGAN WITH A TAKEAWAY TV DINNER!"

JAK (Raymond Jackson), *Evening Standard*, 18 July 1989

cartoons, 'Homo-electrical-sapiens Britannicus 1970', nearly resulted in the *Standard*'s closure by industrial action. An admirer of SEARLE, Oliphant, STEADMAN and GILES (whose detailed and realistic style has influenced him greatly), he roughs cartoons out in 2B pencil on A2 layout paper, using CS6 abraded board for finished artwork (17 x 21½ in, reducing to five columns) and Pelikan ink (brush and mapping pen), tints being indicated with pale blue ink. JAK always draws hands with three fingers in the style of Disney animators and signs his name in capitals with 'blob' serifs. A judo blackbelt, his motto is 'Never Explain; Never Complain'. He was voted CCGB Political/Social Cartoonist of the Year (1985).
PUB: 25 annuals since *The Nutty World of JAK* (1966)
EXHIB: HAM; BM
COLL: V&A MB

JACOB, Cyril Alfred 'Chic' (b. 1926). Cartoonist, illustrator and scriptwriter. Born on 25 February 1926 in Dulwich, London, 'Chic' Jacob (a contraction of a childhood pet-name 'Chica-biddy' that stuck) is self-taught. During World War II he was evacuated to Sussex and worked on local farms before serving as a radar rating in the Royal Navy (1944–7), mostly in SE Asia Command. Thereafter he returned to farm work, then moved to London, drawing cartoons in his spare time (his first in a national publication was for *Everybody's* in 1950). He later became staff financial cartoonist on the *Daily Express* (1964–73) and then the *Observer* (1973–92). His work has also appeared in *Punch*, *Picturegoer*, *Star*, *Daily Sketch*, *Sunday Dispatch*, *Accountancy Age* and *Law Society's Gazette*. The second Chairman of the Cartoonists' Club of Great Britain (succeeding IAN SCOTT) and Treasurer of the British Cartoonists' Association he was voted CCGB Topical Cartoonist of the Year (1964) and Strip Cartoonist of the Year (1965). A freelance scriptwriter for BBCTV's 'Vision On' and 'Beyond Belief' he has also written radio scripts for comedians Dick Emery and Roy Hudd. A stylish artist, he works in ink with a flowing line and a subtle use of colour, usually watercolour or gouache. Geipel has described his work as 'neat, chunky figures with truncated limbs'.
PUB: *A Boy's Own War* (1990).
ILL: [with J. Mortimer] *Laugh With the Motorist* (1963); M. Harding, *The 14½lb Budgie* (1980);

D. Hunn, *Aiming High* (1984); A. de Courcy, *A Guide to Modern Manners* (1985)
EXHIB: BC
COLL: UKCC MB

JALLAND, G. H. (fl. 1888–1910) Cartoonist. G. H. Jalland contributed illustrations to *Holly Leaves* and the *Pall Mall Magazine* in the 1890s but is best known for his hunting and sporting subjects in *Punch* (1888–1905) in which he continued the tradition established by LEECH, BOWERS, and A. C. CORBOULD. He also contributed to *Fore's Sporting Magazine*. His finished drawings in ink or wash tend to be stiff although his pencil sketches were said to be very lively.
PUB: *The Sporting Adventures of Mr. Popple* (1890)
ILL: T. Smith, *The Life of a Fox* (1896); Hon. G. Berkeley, *Reminiscences of a Huntsman* (1897); P. Beckford, *Thoughts on Hunting* (1899); G. Collins, *Tales of Pink and Silk* (1900)
EXHIB: FAS (1901) SH

JAS – see Shepherd, William James Affleck

JENNINGS, Nicola (b. 1958). Caricaturist and illustrator. Nicola Jennings was born in London on 10 September 1958 and studied theatre design at Wimbledon School of Art. She spent most of the 1980s working backstage in the theatre and illustrating books and in 1987 began caricature work for the *London Daily News*. Now a regular contributor to the *Daily Mirror* (since 1987), *Observer* (since 1990) and *Guardian* (since 1991) she uses pen and ink.
ILL: J. Ebdon, *Ebdon's Iliad* (1982); G. Ewart (ed.), *Other People's Clerihews* (1983), *The Ewart Quarto* (1984); R. Irvine, *A Girl's Guide to the English Public Schoolboy* (1983); R. Taylor, *The Human Cookbook* (1986); F. Bressler, *Beastly Law* (1986) MB

JENNIS, Gurnell Charles ARE (1874–1943). Cartoonist and etcher. Charles Jennis contributed small caricatures to *Pick-Me-Up* in 1896 and joke cartoons to the *Bystander* and the *Graphic* in the early 1900s. His cartoons for *Punch* (1913–24) are mostly of country and domestic scenes and being densely hatched look dark on the page. He was elected ARE (1914).
EXHIB: RA; RE; NEAC; L SH

JENSEN, John (b. 1930). Cartoonist, strip cartoonist, caricaturist, illustrator and writer. Born in Sydney, Australia, on 8 August 1930, the

Jensen

Les Dawson

John Jensen, [Les Dawson], in J. Nettles,
Nudity in a Public Place (1991)

son of the cartoonist Jack Gibson, John Jensen
(he adopted the 'new' surname in the 1940s)
studied at the Julian Ashton Art School, Sydney
(1946–7), and began freelancing as a cartoonist
thereafter for publications such as *Australia
National Journal, Pertinent* and the *Sun* (Sydney).
Emigrating to England in 1950 he was Pocket
Cartoonist on the *Birmingham Gazette* (1951–3)
and *Glasgow Bulletin* (1953–6), returning to
London in 1956 and doing freelance work for
Punch (from 1953), *Lilliput, Daily Express,
Evening News, New Statesman, Sketch, Daily
Sketch, Weekend* and *Sunday Dispatch*. Political
Cartoonist on the *Sunday Telegraph* (1961–79),
he also regularly drew theatre caricatures for
Tatler (1973–7), social cartoons for *Spectator*
(1973–6), a weekly strip for *Now!* magazine
(1979–81) and cartoons and illustrations for
Sunday Correspondent. He has also written
occasional journalism, mostly on cartoonists and
cartoons. Ambidextrous, he is an admirer of
BATEMAN, OSPOVAT, Peter Arno, BERT THOMAS,

TRIER and DAVID LEVINE and prefers to watch his
subjects on video in addition to photographs. He
works on paper and draws twice publication size
using a dip pen, brush and Pelikan ink. For
colour work he uses watercolour paper and
Winsor & Newton gouache paints. 'Consistently
inventive and aesthetically pleasing' (Geipel) his
draughtsmanship and versatility have been
widely admired, not least by Frank Keating
whose sports column he illustrated in *Punch* for
many years: '. . . his line is so varied. Sometimes
it can be brilliantly grotesque, other times it has
a lovely smooth flow. He's master of both.'
PUB: [ed.] *The Man Who . . . and Other
Drawings* [H. M. Bateman] (1975), *The Only
Good Bank Manager is . . .* (1991)
ILL: More than 60 books including M. Green's
'The Art of . . .' series (from 1960); W. Davis,
The Supersalesman's Handbook (1986)
EXHIB: CG; NT [with B. Hewison]; CBG; BC
COLL: V&A; CAT; UKCC; TM; A; National
Museum of Australia, Canberra; SAM

MB

JMS – see Staniforth, Joseph Morewood

JOHNSTON, Thomas (b. 1953). Cartoonist,
pocket/strip/political cartoonist and musician.
Tom Johnston was born in Belfast on 18 May
1953 and attended Leeds Art College (1972–5)
and the University of London (1975–6). His first
cartoon was published in *Daily Mirror* in 1976
and he became a full-time freelance the same
year. He contributed at first mostly to the music
press, appearing in *Melody Maker, Sounds* and
Smash Hits but later moved to the *Evening
News*, then *Evening Standard* and is currently
Political Cartoonist on the *Sun*. His work has
also been published in *Today, News of the World*
('Short John Silver' strip), *Punch* and *Private Eye*
amongst others. In addition he has been a
professional bass guitarist in rock bands and was
a founder member of the group The The in 1977.
An admirer of the French cartoonist Reisir and
MICHAEL HEATH he works in felt-tip pen on
paper.
PUB: *Tom Johnston* (1992) MB

JOLLIFFE, Gray (b.1937). Cartoonist and illus-
trator. Gray Jolliffe was born in Cornwall on 3
June 1937 and after National Service in the RAF
started his career as an advertising copywriter
and became creative director (part-time) of both
Chetwyndd and Dewe Rogerson. He has also
directed commercials. Since the success of his

'Wicked Willie' books featuring a talking penis he has become a full-time cartoonist. His cartoons have appeared in *Sunday Express, You, Cosmopolitan, Hello, Evening Standard, Oldie, Men Only, Club Pour Hommes* and elsewhere and he has also worked in advertising for Hamlet Cigars, Perrier, Nicorettes, Ricoh Brobat Bloo Loo, Scottish Widows, Solo Softener, Batchelors Cuppa Soup and others. In addition he has produced greetings cards, 'Wicked Willie' videos and numerous books. Jolliffe, who signs his work 'Gray', draws distinctive frog-eyed figures with sausage-shaped noses and works with felt-tip pen and Magic Markers on paper.

PUB: *Christmas Already!* (1978); [with P. Mayle] *The Honeymoon Book* (1983), *Man's Best Friend* (1984), *Twinkle Winkle* (1985), *Wicked Willie's Guide to Women* (1986), *Wicked Willie's Low-Down on Men* (1987), *Dear Willie* (1989), *Wicked Willie Stand-Up Comic* (1990) and *Willie's Leg-Over Handbook* (1991); [with O. Dalton] *The Whole Hog* (1987), [with L. Graham] *Pussy Pie Hits Town* (1988), *The Unadulterated Cat* (1989)
ILL: G. Search & D. Denison, *Getting in Shape* (1988)
COLL: V&A [Christmas cards] MB

JON – see Jones, William John Philpin & Musgrave-Wood, John

JONES, Grenfell 'Gren' MBE (b. 1934). Editorial cartoonist, illustrator and writer. Gren Jones was born in Hangoed, Wales, on 13 June 1934. Employed at first as an engineering designer (1958–63), he worked as a freelance cartoonist for a number of years before joining the *Western Mail* and *South Wales Echo* in 1968. Best known for his creation of the village of Aberflyarff, he was awarded the MBE (1990) for his services to the newspaper industry and has been voted CCGB Provincial Cartoonist of the Year four times (1983, 1985, 1986, 1987).

PUB: *My Wales* (1971), *More of My Wales* (1973), 12 annual volumes of collected cartoons from *South Wales Echo* (from 1982), 'Duffer's Guide' series (eight titles from 1985), 'A Portrait of . . .' series (three titles from 1987), 'Welshman' series (from 1989)
ILL: T. Bellion, *'And the Tanker Spent a Comfortable Night'* (1979); D. Parry-Jones, *Boots, Balls and Banter* (1980); M. Boyce, *I Was There* (1981)
EXHIB: WAC touring exhibition (1985–6)
COLL: Wales Tourist Board; WAC MB

JONES, Thomas Howell (fl. 1824–40s). Caricaturist and illustrator. T. H. Jones designed and etched political and social caricatures (1824–31) that are lively and well drawn; those of George IV and his mistresses have a particularly saucy appeal. In 1832 he designed small caricatures for *Punch in London*. His music covers of the 1840s are remarkable for the variety of media he employed – etchings, lithographs, chromolithographs, zincographs and woodcuts. It has been suggested that he may have been 'Sharpshooter', a prolific political caricaturist (1829–31) but Dorothy George favoured PHILLIPS.
COLL: BM SH

JONES, William John Philpin 'JON' MBE (1913–92). Political cartoonist and pocket cartoonist. Born on 17 August 1913 in Llandrindod Wells, Wales, the son of a bookmaker, 'JON the cartoon' first showed a talent for drawing as a boy by winning a prize at the National Eisteddfod and had his first cartoon published in the *Radnor Express* (*c*. 1929). After studying at the Birmingham School of Art he won a scholarship to the RCA in London but didn't complete the course, returning to Wales to work as a cartoonist on the *Western Mail*. Later he joined Godbolds advertising agency in London and in World War II served at first in the Welch Regiment. Attached to Princess Patricia's Canadian Light Infantry during the Sicily landings in 1943, he was Assistant Military Landing Officer at Salerno and Anzio. He later joined the British Newspaper Unit under Hugh (now Lord) Cudlipp and contributed cartoons to *Eighth Army News* (where his famous 'Two Types' series first appeared under the title 'Page Two Smile' in July 1944 as 'The Two Types' on 16 August 1944), *Union Jack, Crusader* ('Philpin' weekly political cartoons) and *Soldier*, which were later syndicated elsewhere. After the war he followed Cudlipp to the Mirror Group, working on the *Sunday Pictorial* (sports cartoons May 1946–52) and in 1952 joined Kemsley Newspapers, working on the *Daily Graphic, Sunday Graphic, Empire News* and *Sunday Times*. In 1955 he moved to the *News Chronicle*, creating two daily pocket cartoons – 'The Sporting Types' and a political series – and continued to draw for the newspaper when it was absorbed by the *Mail* in 1960. Over the next 21 years he contributed over 15,000 cartoons on politics, current affairs and sport to the paper, and was elected CCGB Topical & Sports Cartoonist of the Year (1966) and Pocket Cartoonist of the Year (1981). He retired from

'Last saw those two at El Agheila'

JON (W. J. P. Jones), *Eighth Army News*, 1944

the *Daily Mail* in 1981 but continued to draw for the new *Mail on Sunday* until 1988 and for the *South Wales Argus* and *Abergavenny Chronicle* until 1990. He died on 28 June 1992. JON is perhaps best remembered for his immortal creations, The Two Types – a roguish pair of moustachioed Desert Rat officers – which rank with BRUCE BAIRNSFATHER's 'Old Bill', DAVID LOW's 'Colonel Blimp' and NORMAN PETT's 'Jane' as classic British comic characters. Though only some 300 Two Types cartoons appeared between 1943 and 1946, over a million copies of wartime collections of the drawings were published. Their effect on allied morale was tremendous and earned JON an MBE from Churchill.

PUB: *The Two Types* (1945), *JON's Two Types in Italy* (1945), *The Two Types* (1960), *Wilson in Wonderland* (1968), *JON Cartoons* (1978), *Maggie* (1979)
ILL: L. Sellers, *Cooking with Love* (1970); B. Sanctuary, *How to Eat Cheaply and Well* (1970); [with R. Ullyett] *'I'm the Greatest!'*

(1975); S. Philpin Jones, *Cooking for Baby* (1976)
EXHIB: CG; Austin Reed
COLL: CA; IWM; UKCC
LIT: W. J. P. Jones, *JON's Complete Two Types* (1991) MB

JOSS, Frederick 'Denim' (*c.* 1909–after 1947). Political cartoonist, pocket cartoonist, strip cartoonist, caricaturist and writer. Fred Joss studied art in Vienna and by the age of 19 was working as a cartoonist in Rio de Janeiro. He joined the *Star* as Political Cartoonist in 1934. During World War II he served as a gunner (achieving the rank of sergeant) and also drew cartoons under the name of 'Denim'. In addition he wrote a novel about arms racketeers using the pseudonym 'F. J. Joseph', and contributed a popular Saturday strip to the *Star*, 'Round-Up'. As 'Denim' he drew on small sheets of airmail paper using a fountain pen and blue pencil. He committed suicide by jumping from the roof of the Tokyo Hilton Hotel.

PUB: [as F. J. Joseph] *Amateurs in Arms* [novel] (1938); [as Denim] *200 Cartoons by Denim* (1946), *Another 200 Cartoons* (1946) and *Up Against It* (1947)

ILL: G. Tabour, *Blackmail or War* (1938)
EXHIB: LEG MB

JWT – see Taylor, John Whitfield

K

KAL – see Kallaugher, Kevin

KALLAUGHER, Kevin 'KAL' (b. 1955). Political cartoonist and caricaturist. Kevin Kallaugher was born in Norwalk, Connecticut, USA, and took a degree in Visual & Environmental Studies at Harvard where he produced an animated colour film as part of his thesis and drew a weekly strip 'In the Days of Disgustus' in *Harvard Crimson*. After graduating in 1977 he came to England on a bicycle tour and stayed, working first as a semi-professional basketball player before joining the *Economist* as the weekly's first ever resident caricaturist in March 1978. He has also been Political Cartoonist on the *Oxford Sunday Journal* (1980), *Observer* (1983–6), *Today* (1986–7) and *Sunday Telegraph* (1987–91). He returned to the USA in 1991 to work for *Baltimore Sun*. Widely syndicated, his work has appeared in more than 100 papers worldwide. An admirer of Oliphant, McNelly and LEVINE, his work for the *Economist* was unsigned (in line with magazine policy) but he always included his name in the drawing somewhere. His caricatures of Margaret Thatcher and Neil Kinnock were animated by Richard Williams' studio for use as a TV commercial for *Today* newspaper. CCGB Feature Cartoonist of the Year (1982), KAL has also been British and European editor of *Target* magazine.
PUB: *Drawn from the Economist* (1988), *KAL-toons* (1993)
COLL: UKCC MB

KAPP, Edmond Xavier (1890–1978). Caricaturist. Kapp was born in Islington, London, on 5 November 1890 and educated at Owen's School and Christ's College, Cambridge, where his caricature drawings were published in *Granta* and the *Cambridge Magazine*. Before the war his caricatures also appeared in the *Daily News*, *Onlooker* and *News Weekly*. He served in the Royal Sussex Regiment on the Western Front in World War I, later becoming a captain in Intelligence. The catalogue of his first exhibition

of caricatures in 1919 included a flattering letter from MAX BEERBOHM and reviewers praised the subtlety of his characterization. In 1924 he drew portraits of judges and lawyers, all mildly caricatured, for the *Law Journal* and in the 1920s and 30s his drawings appeared in the *Apple*, *Bystander*, *Onlooker*, *Observer*, *Radio Times*, *Tatler* and most prominently, *Time & Tide*, where they were reproduced full-page. He also drew some lithographs. In much of this work he was not acting as a caricaturist – with satirical intent – so much as a character-portraitist. Indeed, he disliked the term 'caricature' and claimed to have only produced three. The majority of his subjects came from the world of the arts, notably from the world of music in which he was keenly interested. His drawings, executed in a variety of media (some of his best results coming

Edmond Kapp, [H. G. Wells], *Reflections* (1922)

from chalk), have both psychological and aesthetic interest. During World War II he was an Official War Artist (drawing 'Life Under London') and afterwards Official Artist to Unesco (1946–7). In addition to his drawing he wrote nonsense verse under the name 'Otto Watteau'. Kapp died on 29 October 1978.

PUB: *Personalities* (1919), *Reflections* (1922), *Ten Great Lawyers* (1924), *Minims* (1925), [with Y. Cloud] *Pastiche* (1926)
ILL: L. Housman, *Trimblerigg* (1924)
EXHIB: LG; W (retrospective 1961); Wildenstein Gallery; LM; IWM; BAR
COLL: BM; V&A; NPG; A; B; M SH

KAPP, Helen (b. 1901). Painter, illustrator, art administrator and comic artist. Helen Kapp was born in London and studied art at the Slade School, the Central School and in Paris. She illustrated, often humorously, a number of books and the outline drawings in her own book *Toying with a Fancy* show a delightful aptitude for nonsense art, somewhat in the manner of MERVYN PEAKE. From 1951 to 1961 she was Director of the Wakefield City Art Gallery and from 1961 to 1967 of the Abbot Hall Gallery, Kendal. She painted in various media and was also a wood engraver.

PUB: *Take Forty Eggs* (1938), *Toying with a Fancy* (1948), *Enjoying Pictures* (1975)
ILL: G. Ballett (ed.), *Seed of Israel* (1927); H. Morland, *Fables and Satires* (1945)
EXHIB: RA; AIA; LON; Society of Wood Engravers; Nicholsons Gallery SH

KAY, John (1742–1826). Caricaturist and portrait artist. John Kay was born near Dalkieth, Scotland, in April 1742, the son of a mason who died when he was aged six. Having served his apprenticeship he became a barber, establishing his own business in 1771. He devoted his spare time to making portrait sketches which won him local admirers and when one of them died in 1784, leaving him an annuity, he gave up barbering to become a portrait-caricaturist. Altogether he etched around 900 plates, which he sold from his shop in Edinburgh, and his subjects included Adam Smith and most of the leading Scotsmen of the day. The element of caricature is slight, the treatment is stiff and quaintly humorous but the likenesses were thought to be accurate. He died on 21 February 1826.

PUB: *A Series of Original Portraits and Caricature Etchings* (1837–8)
COLL: BM; NPGS; RSA SH

KEENE, Charles Samuel (1823–91). Cartoonist, illustrator and etcher. Charles Keene was born in Hornsey, London, the son of a solicitor. The family moved to Ipswich when he was a child and he was educated at Ipswich Grammar School. After brief employment in the offices of a solicitor and an architect, he became apprenticed to the Whymper brothers, engravers, drawing book illustrations on wood blocks (*c.* 1840–5). In 1846 – in company with JOHN TENNIEL – he drew burlesque illustrations in coloured chalks for Thomas Barrett's unpublished *Book of Beauty*. The next year he started to illustrate books and periodicals, including the *Illustrated London News* and (from 1859) *Once a Week* which published some of his most notable work. His long association with *Punch* began in 1851; in 1854 he was contributing signed drawings and in 1864, on the death of LEECH, he joined the staff, continuing until 1890. Altogether he drew over 2000 cartoons for *Punch* and became, in Spielmann's words, the magazine's 'greatest artist'; his greatness lying in his powers of observation, his truth to life and his warm human feeling. He illustrated, realistically, jokes supplied by friends like CRAWHALL and CHASEMORE; jokes about the life of the London streets, Scotsmen, Volunteers, inebriates and maiden ladies. Endlessly experimenting with inks, pens and paper, the subtleties of his drawing often defeated the engravers and it is only in the originals that one can appreciate the full merits of his technique. It was this technique, in the treatment of facts, that so aroused the admiration of fellow artists, WHISTLER, SICKERT, Degas and Pissaro amongst them. His work was awarded a gold medal at the Paris Exhibition of 1889. He died on 10 January 1891.

PUB: *Our People . . . from the Collection of Mr Punch* (1881), *Twenty-One Etchings by Charles S. Keene* (1903)
ILL: D. Defoe, *Robinson Crusoe* (1847); Mrs Sherwood, *The De Cliffords* (1847); H. Vaughan, *The Cambridge Grizette* (1862); F. C. Burnand, *Tracks for Tourists* (1864); D. W. Jerrold, *Mrs Caudle's Curtain Lectures* (1866); W. M. Thackeray, *Roundabout Papers* (1879); J. T. Bedford, *Robert, or Notes from the Diary of a City Waiter* (1885); C. Reade, *The Cloister and the Hearth* (1890)
EXHIB: FAS (Retrospective 1891); AC 'Drawings by Charles Keene' (1952); CHR (1991); T (1991)
COLL: T; V&A; BM; NPG; NGS; A; F; NG of Victoria, Melbourne
LIT: G. S. Layard, *The Life and Letters of*

THE HONEYMOON.

Wife (after a little "tiff"). "BUT YOU LOVE ME, DEAR"—*(sniff)*—"STILL ?"
Husband ("Cross old thing !"). "OH LOR', YES, THE STILLER THE BETTER !"

Charles Keene, *Punch*, 17 May 1884

Charles Keene (1892); J. Pennell, *The Work of Charles Keene* (1897); D. Hudson, *Charles Keene* (1947) SH

KEM – see Marengo, Kimon Evan

KENT, Capel John (b. 1937). Cartoonist, strip cartoonist, illustrator and writer. John Kent was born on 21 June 1938 in Oamaru, New Zealand, and came to London in 1959. A self-taught artist, he worked at first as a copywriter and art director in advertising before having his first strip 'Grocer Heath' accepted by *Private Eye* in 1969, closely followed by the controversial 'Varoomschka' for the *Guardian* (1969–79). Probably inspired by the 1970s fashion model Verushka and originally based on his wife, Nina, Kent has described Varoomschka as 'the permanent link between absurdities. A Miss Everyone who, unlike most people, manages to retain a sense of incredulity at all she encounters.' An innocent blonde beauty asking simple questions of wily politicians in the Wilson/Callaghan era, Kent's character exposed hypocrisy and self-interest in government, and trade-union leader Jack Jones even brought libel proceedings against one attack made in the cartoon. John Kent still works regularly for *Private Eye* – combining political comment and caricature with a strip format (Geipel has described him as a 'satirist *à outrance*') – and has also contributed to *Sunday Times* (1980–3, 1990 to date), *Evening Standard* (1982–6) and *Daily Mail* (from 1974). In addition, he has lectured at the RIBA and elsewhere. Influenced by Al Capp, he works mostly in felt-tip pen.
PUB: *Varoomschka* (1972), *Varoomschka's Bumper Colouring Book Annual* (1975), *John Kent's Venice* (1989), *John Kent's Florence and Sienna* (1989)
ILL: R. Huggett, *The Wit and Humour of Sex* (1975); B. Norman, *Tales of the Redundance Kid* (1975)
EXHIB: De Marco Gallery, Edinburgh; ICA
COLL: IWM; V&A MB

KIM – see Casali, Kim

KING, William Gunning NEAC (1859–1940). Painter, etcher, illustrator and cartoonist. Gunning King was born in South Kensington on 2 September 1859 and educated at the Western Grammar School. He studied at the South Kensington Schools and the RA Schools where he won a silver medal for drawing. His illustrations and cartoons appeared in *Cassell's*, *Illustrated London News*, *Illustrated Sporting & Dramatic News*, *Pick-Me-Up*, *Quiver* and *Sketch*. For a time he was one of the best cartoonists in *Punch* (1905–16), his style, his subject matter and his sympathy being strongly reminiscent of CHARLES KEENE. He was a painter too – of landscapes, portraits and still life – and won a gold medal at the International Exhibition at the Crystal Palace (1899). But it was as a draughtsman in ink and chalk with a strong clean line and rich effect of light and shade that he excelled.
EXHIB: RA; RI; RBA; NEAC; RSA; L; G; GG
COLL: V&A SH

L

LAIDLER, Gavin Graham 'Pont' ARIBA (1908–40). Cartoonist. Graham Laidler was born on 4 July 1908 in Jesmond, Newcastle upon Tyne, only son of the proprietor of a distinguished firm of painters and decorators (founded in 1823). He was educated at Trinity College, Glenalmond, Perth and at the Architectural Association's School of Architecture in London (1926). Towards the end of his course he contracted tuberculosis and, after a major operation in 1932, was unable to pursue an architectural career. His first cartoon strip, 'The Twiff Family' ran in *Woman's Pictorial* (1930–7) until taken over by Fred Robinson, and he had his first cartoon accepted by *Punch* in August 1932 (he also produced illustrated Christmas catalogues for W. Glendenning & Sons, Wine Merchants, in 1931 and 1932). The first drawing in his celebrated series 'The British Character' ('Adaptability to Foreign Conditions') appeared in the magazine on 4 April 1934 and when *Night & Day* tried to lure him away *Punch* signed him up for a unique exclusive contract. Pont, whose name arose from a family joke concerning 'Pontifex Maximus' was, with PAUL CRUM immensely influential: 'these two, Pont and Pettiward, probably did more during this period to carry the development of modern pictorial humour a whole stage further than any two or twenty others put together' (FOUGASSE). He worked in pen, ink and wash and sometimes watercolour. 'Descended from W. BIRD rather than TOWNSEND,' says Price, Pont 'set a fashion for the small single-figure drawing with a single short line of dialogue . . . which epitomised the whole of the situation or the whole of the character.' HEWISON has described his 'easy assurance and wiry delicacy of line . . . in spite of their cross-hatchery and careful composition [his cartoons] are untutored and amateur in the best sense of the word – the work of a natural draughtsman . . . he was able to tackle subjects that would scare the daylight out of most trained artists, and bring them off beautifully.' Curiously, Pont himself insisted: 'I do not try to draw funny people. I have no sense of humour. I try very hard to draw people exactly as they are.' He died suddenly of poliomyelitis on 23 November 1940.

PUB: *The British Character* (1938), *The British at Home* (1939), *The British Carry On* (1940), *Pont* (1942), *Most of Us Are Absurd* (1946), *The World of Pont* (1983)
EXHIB: CS; LAN; CG
COLL: V&A; CAT
LIT: B. Hollowood, *Pont* (1969); R. Ingrams (ed.), *The British Character and the World of Pont* (1985) MB

Pont (Graham Laidler), *The British Character* (1938)

LAMB, Kathryn (b. 1959). Cartoonist, strip cartoonist and illustrator. Kathryn Lamb was born in Bahrain on 25 May 1959, the daughter of Sir Archie Lamb, former Britsh Ambassador to Kuwait and Norway. After studying English at Oxford University, where she contributed cartoons to student papers, she worked for a variety of publications, in particular *Private Eye* where she created the strip 'Lord Arthur and His Square Table' (1979) which ran for eight years. She currently illustrates 'Pseuds Corner' for *Private Eye*, produces a regular strip 'M'Lud' for the *Oldie* and has contributed to *Punch*, *Spectator*, *Daily Telegraph*, *Big Farm Weekly* and *The Times*. In addition she has drawn greetings cards for businesses and The Alzheimers Society and

was commissioned to design a 'get well' card for King Hussein of Jordan. Although the majority of her work is produced in very fine detailed pen and ink she also uses watercolour washes.
PUB: *Animal Madness* (1989), *Lamb's Tales* (1989), *One Ewe Over the Cuckoo's Nest* (1991)
ILL: J. Gladstone, *Up Country* (1988); S. Milligan, *Condensed Animals* (1991)
EXHIB: CG
COLL: BM MB

LANCASTER, Sir Osbert (1908–86). Cartoonist, illustrator, author, theatre designer and painter. Osbert Lancaster was born in Notting Hill, London, on 4 August 1908, the son of a businessman who was killed in World War I. He was educated at Charterhouse School and at Lincoln College, Oxford, where he became a close friend of John Betjeman. After failing to pass his examinations for the Bar, he studied art at the Byam Shaw, Ruskin and Slade Schools and exhibited paintings at the NEAC in 1932 and 1934 before renouncing easel painting for book illustration. Through Betjeman's influence he worked on the *Architectural Review* (1934–9). In 1937 he was the art critic of *Night & Day*, a brilliant but short-lived magazine modelled on the *New Yorker*. From 1939 to 1981 he drew around 10,000 pocket cartoons for the *Daily Express*, revealing himself as, with MAX BEERBOHM, the wittiest of British cartoonists. Like Max he was a dandy and looked at the world from a civilized, upper-middle-class standpoint, creating a cast of characters of whom Maudie Littlehampton and her husband are best known but Canon Fontwater, Father O'Bubblegum and Mrs Rajagojollibarmi are also memorable. He also drew large political cartoons, as 'Bunbury', for the *Sunday Express* (named not after the caricaturist but rather after the imaginary character in Oscar Wilde's play, 'The Importance of Being Earnest'). After the war, which he spent working for government departments, he painted some caricatures for the *Strand Magazine*, continued writing and illustrating books and from 1951 turned increasingly to stage designs for the Royal Opera House, Sadler's Wells, Glyndebourne and the Bulgarian State Opera. He was created CBE (1953) and knighted (1957). His second marriage in 1967 was to the author and journalist, Anne Scott-James. In 1973 his drawings for *The Littlehampton Bequest* were exhibited at the NPG. He died on 27 July 1986. His role in cartooning was like the role of the cavalry in warfare 'to add tone to what would otherwise be a vulgar brawl'.

'I bet whoever gets *your* liver won't wake up bright and smiling!'

Osbert Lancaster, *Daily Express*, 7 May 1968

PUB: *Progress at Pelvis Bay* (1936), *Pillar to Post* (1938), *Homes Sweet Homes* (1939), *Classical Landscape with Figures* (1947), *Saracen's Head* (1948), *Drayneflete Revealed* (1949), *Façades and Faces* (1950), *Signs of the Times* (1961), *All Done from Memory* (1963), *The Penguin Osbert Lancaster* (1964), *With an Eye to the Future* (1967), *Sailing to Byzantium* (1969), *The Littlehampton Bequest* (1973), *Scene Changes* (1978), *The Life and Times of Maudie Littlehampton* (1982) and 14 collections of *Daily Express* pocket cartoons
ILL: M. Barsley, *Grabberwocky* (1939); V. Graham, *Say Please* (1949); S. Lambert, *London Night and Day* (1951); C. N. Parkinson, *Parkinson's Law for the Pursuit of Progress* (1958), *In-Laws and Outlaws* (1962); N. Mitford, *The Water Beetle* (1962); N. Dennis, *An Essay on Malta* (1972); M. Beerbohm, *Zuleika Dobson* (1975); Saki, *Short Stories* (1976), *The Unbear-*

able Bassington (1978); A. Scott-James, *The Pleasure Garden* (1977)
EXHIB: NPG (1973); Redfern Gallery (Retrospective 1980); CG
COLL: T; V&A; NPG; ROH; FS; CAT
LIT: E. Lucie Smith (ed.), *The Essential Osbert Lancaster* (1988); R. Boston, *Osbert* (1989)
SH

LANDSEER, Sir Edwin Henry RA (1802–73). Painter, sculptor and occasional caricaturist. Edwin Landseer was born in London on 7 March 1802, the son of John Landseer, engraver to William IV, and the brother of THOMAS LANDSEER. He was an infant prodigy: an etching at the V&A was done when he was aged eight, aged 11 he won the Silver Palette of the Society of Arts for animal drawing, aged 14 he entered the RA Schools and aged 15 started exhibiting. In 1826, as soon as he had reached the statutory age, he was elected ARA; RA in 1831. He became the Royal Family's favourite painter and the most popular artist of his day (more than 400 etchings and engravings of his work were published in his lifetime), famed in paintings like 'The Monarch of the Glen' and 'The Old Shepherd's Chief Mourner' for his power to imbue animals with sentiment and relate their characters to the characters of men. On his travels in the Highlands of Scotland and around the country he made many pen-and-ink sketches of his hosts and people he met that are wonderfully observed and often wittily caricatured. Landseer was knighted in 1850 and declined the Presidency of the RA in 1865. He died on 1 October 1873 after several years of illness and depression and was buried in St Paul's Cathedral.
PUB: C. Monkhouse, *Edwin Landseer's Works Illustrated by Sketches from the Collection of Her Majesty* (1888)
EXHIB: RA (Retrospectives 1874 & 1961); T (1982)
COLL: HM the Queen; NG; BM; V&A; NPG; F
LIT: F. G. Stephens, *The Life and Works of Sir Edwin Landseer* (1881); J. A. Manson, *Sir Edwin Landseer* (1902); G. Lennie, *Landseer: The Victorian Paragon* (1976)
SH

LANDSEER, Thomas ARA (1795–1880). Engraver and illustrator. Thomas Landseer was born in London, the eldest son of John Landseer, engraver to William IV, and the brother of EDWIN LANDSEER. He was taught engraving by his father and painting by B. R. Haydon. Opting for engraving as a career, he devoted most of his life to reproducing the works of his brother but as a young man he drew comic illustrations of animals in human clothes that had a considerable vogue (the caricatures in *Monkeyana* are peculiarly misanthropic). He was elected ARA in 1868.
PUB: *Monkeyana, or Men in Miniature* (1828), *Characteristic Sketches of Animals* (1832), *The Life and Letters of William Bewick* (1871)
ILL: *The Flowers of Anecdote* (1829); R. Southey & S. T. Coleridge, *Ten Etchings Illustrative of the Devil's Walk* (1831); E. Taylor, *The Boy and the Birds* (1835); T. Bingley, *Stories Illustrative of the Instincts of Animals* (1840), *Stories about Dogs* (1864)
EXHIB: RA
COLL: HM the Queen; BM
SH

LANE, Theodore (1800–28). Caricaturist, illustrator and painter. Theodore Lane was born in Isleworth, Middlesex, the son of a drawing master and apprenticed to a colourer of prints. If Dorothy George's attribution is correct, he produced some sharp and decorative anti-Caroline caricatures in 1820–1 from ideas supplied by Theodore Hook. His other caricatures (1821–7) are good-humoured jokes on social themes – theatre, card-games, street-scenes etc. – and an unusually high proportion are aquatints which, engraved by G. Hunt, constitute some of the most attractive prints of the period. As well as designing and etching caricatures, Lane painted in oil and watercolour, one of his oil paintings exhibited at the RA being 'upwards of 17 feet in length'. He was beginning to make a considerable name for himself when he died tragically on 21 February 1828 by falling through a skylight.
ILL: *The Attorney General's Charges against the Late Queen* (1820); P. Egan, *The Life of an Actor* (1825), *Anecdotes of the Turf, Chase, Ring and Stage* (1827), *The Show Folks* (c. 1831)
EXHIB: RA
COLL: BM; V&A
SH

LANGDON, David OBE, FRSA (b. 1914) Cartoonist, caricaturist, illustrator. Born in London on 24 February 1914, David Langdon studied art at Davenant Grammar School, London, but otherwise is self-taught. He went on to work in the London County Council Architects Department (1931–9), was an Executive Officer in the London Rescue Service (1939–41) and was a squadron leader in the RAF (1941–6), editing the *Royal Air Force Journal* (1945–6). A regular contributor to *Punch* (1937–92, elected to the

Table 1958) and *Sunday Mirror* (since 1948), his drawings have also appeared in *Lilliput, Sunday Pictorial, Paris-Match, Radio Times, Saturday Evening Post, Aeroplane, Royal Air Force Review, Collier's, True* and the *New Yorker*. He has also produced an annual racing calendar for Ladbrokes since 1959, drawn a set of caricatures of High Court judges, and produced a considerable amount of advertising work including the famous wartime 'Billy Brown of London Town' series for London Transport as well as drawings for Bovril, Schweppes and others. Elected FRSA, he is also official artist for the Centre Internationale de Recherche et des Etudes at St Ghislain, Belgium. An occasional lecturer and a designer of corporate logos, he works in ink with a brush over a pencil outline drawn half larger than reproduction size on white board. He cites his influences as Daumier and FOUGASSE. Praised by Price as 'the great master of the topical comic idea' Langdon has an economic, diagrammatic style ('My line tends to be firm in execution, more staccato than mobile') and claims to have introduced the open mouth into humorous art.

PUB: *Home Front Lines* (1941), *All Buttoned Up!* (1944), [with R. B. Raymond] *Slipstream* (1946), *Meet Me Inside* (1946), *The Way I See It* (1947), *Hold Tight There* (1949), *Let's Face It* (1951), [with D. Clayton] *Wake Up and Die* (1952), *Look at You* (1952), *All in Fun* (1953), *Laugh with Me* (1954), *More in Fun* (1955), *Funnier Still* (1956), *A Banger for a Monkey* (1957), *Langdon at Large* (1958), *I'm Only Joking* (1960), (ed.) *Punch with Wings* (1961), *How to Play Golf and Stay Happy* (1964), *David Langdon's Casebook* (1969), *How to Talk Golf* (1975), (ed.) *Punch in the Air* (1983)

ILL: C. H. W. Jackson, *It's a Piece of Cake* (1943); G. Mikes, *Little Cabbages* (1955), *The Best of Mikes* (1962), *Germany Explored* (1969); D. Rooke, *Camper Beware!* (1965); Sports Council, *Sport For All* (1975); B. Boothroyd, *Let's Move House* (1977); F. Trueman & F. Hardy, *You Nearly Had Him That Time* (1978); J. Goldsmith & V. Powell-Smith, *Against the Law* (1980); P. G. Wodehouse, *The Parrot and Other Poems* (1988)

EXHIB: Various shows in Oxford, Ottawa, New York, London, Lille and elsewhere

COLL: V&A; UKCC; BM MB

LARRY – see Parkes, Terence

LAW, Roger (b. 1941). Caricaturist, illustrator and writer. Roger Law was born on 6 September

"Haircut, please, in a silence broken only by the busy snip-snip of the scissors"

David Langdon, *Lilliput*, December 1947

1941 in Littleport, Cambridgeshire, the son of a builder and attended Littleport Secondary Modern and (aged 14) Cambridge School of Art (where he met PETER FLUCK and was taught by Paul Hogarth) until expelled in 1959. With his future wife, quilt designer Deirdre Amsden, he art-edited six issues of *Granta* and became an active CND campaigner, designing posters and pamphlets for the cause. He later moved to London, producing illustrations for *Queen* and was resident artist designing weekly 14ft murals for Peter Cook's Establishment Club. With Cook he also produced his first national strip 'Almost the End' in the *Observer* (1962) and freelanced for *Town, Topic, Sunday Times, Nova, Men Only, Ink* and others. He then joined the *Sunday Times* as journalist and caricaturist (1964–8) and co-designed record covers for Track Records (e.g. 'The Who Sell Out' and Hendrix's 'Axis Bold as Love' – which subsequently became one of the bestselling posters of the 1960s). He won a Designers' & Art Directors' Association Silver Award (1967) for his first published caricature models in *Nova* (1966) and was artist-in-residence at Reed College, Portland, Oregon (1967), where he produced his first puppet film. After working in New York for Bush Bins Studio

(1969), *Esquire* and other publications he returned to England and the *Sunday Times Magazine* (1970–5). The 'Luck & Flaw' partnership with Peter Fluck began with work for *New York Times* (1976) followed by *National Lampoon, Sunday Times, Economist, Men Only, Marxism Today, Der Spiegel, Panorama* (Holland), *Stern, Time* and *Private Eye* (poster). They also produced huge carnival heads of Hitler and others for an Anti-Nazi League rally, Thatcher teapots etc. The 'Spitting Image' TV programme, using Law and Fluck's animated caricature puppets, was first conceived in 1982 and the first pilot was screened in June 1983, produced by John Lloyd and directed by former Muppets director Philip Casson, for Central TV. Roger Law has also lectured at the RCA, Central School of Art and Hornsey College of Art and won the Society of Illustrators' Award for Consistent Excellence (1983). He has been influenced by the artists of *L'Assiette au Beurre* and George Grosz.

PUB: [as Spitting Image] *The Appallingly Disrespectful Spitting Image Book* (1985), *Spitting Images* (1987), *The Appallingly Disrespectful Spitting Image Giant Komic Book* (1988), *Goodbye* (1992), *Thatcha – The Real Maggie Memoirs* (1993)

ILL: [as Luck & Flaw] C. Dickens, *A Christmas Carol* (1979), R. L. Stevenson, *Treasure Island* (1986); L. Chester, *Tooth & Claw – The Inside Story of Spitting Image* (1986)

EXHIB: [ceramics, with J. Tchalenko] V&A; [as Spitting Image] CG

LIT: [autobiography, with L. Chester & A. Evans] *A Nasty Piece of Work* (1992) MB

LEAR, Edward (1812–88). Painter, author and comic illustrator. Edward Lear was born in Holloway, London, on 12 May 1812, the son of a stockbroker and the 20th of his 21 children. As a child he developed a passion for natural history and aged 16 sold drawings of animals. In 1829 he was employed as a draughtsman at the Zoological Society and in 1830 started to issue beautiful lithographs of parrots. These caught the eye of Lord Stanley who invited him to make drawings of the animals at his menagerie at Knowsley Hall near Liverpool. There (1832–6) he became friends with the Stanley children and entertained them by composing and illustrating limericks that were later published as *A Book of Nonsense* (1846). In 1837 he abandoned ornithological work to embark on his extensive travels as a landscape painter in watercolour, returning occasionally to sell pictures and see his numerous friends. On one such stay in England (1846) he gave drawing lessons to Queen Victoria whom he called 'a dear and absolute duck'. On another (1850) he studied at the RA Schools and took lessons in oil painting from Holman Hunt. In the 1860s whilst his reputation as a landscape painter began to decline, his fame as a nonsense writer spread. Adults as well as children began to respond to his verses, as they were responding to Lewis Carroll, and to clamour for more. The appeal of the verses, and the comic illustrations from which they were inseparable, lay in Lear's ability to become a child again. As Eric Newton has written, 'he was the first post Renaissance artist to understand and use the child's way of drawing, of thinking and then putting a line round his think. His influence on subsequent nonsense art has been incalculable.' The beguiling melancholy in the verses reflected the sadness of Lear's situation – a lifelong epileptic and depressive, an unrequited lover and a wanderer. He was quite delighted when in 1886 Ruskin wrote 'I really don't know any author to whom I am half so grateful, for my idle self, as Edward Lear.' When he died, in San Remo, Italy, on 29 January 1888, most of his countrymen would have agreed 'how pleasant to know Mr Lear'.

PUB: *Illustrations of the Family of Psittacidae or Parrots* (1832), *Views in Rome and its Environs* (1841), *Illustrated Excursions in Italy* (1846), *A Book of Nonsense* (1846), *Journals of a Landscape Painter in Albania etc.* (1851), *Journals of a Landscape Painter in Southern Calabria etc.* (1852), *Views in the Seven Ionian Islands* (1863), *Journals of a Landscape Painter in Corsica* (1870), *Nonsense Songs, Stories, Botany and*

*There was an Old Man who said, "How shall I flee from that horrible cow?
I will sit on this stile, and continue to smile,
Which may soften the heart of that cow"*

Edward Lear, *The Book of Nonsense* (1846)

Alphabets (1871), *More Nonsense, Pictures, Rhymes, Botany etc.* (1872), *Laughable Lyrics* (1877)
ILL: *Poems by Alfred Lord Tennyson* (1889)
EXHIB: AC 'Edward Lear' (1958); RA 'Edward Lear' (1985)
COLL: BM; T; V&A; HM the Queen; A; F; Houghton Library, Harvard; Gennadius Library, Athens
LIT: A. Davidson, *Edward Lear, Landscape Painter and Nonsense Poet* (1938); V. Noakes, *Edward Lear: The Life of a Wanderer* (1969); S. Chitty, *That Singular Person Called Lear* (1988)

SH

LEE, Joseph (1901–75). Cartoonist, political cartoonist, strip cartoonist and journalist. Joe Lee was born on 16 May 1901 in Burnley-in-Wharfedale, Yorkshire, won a scholarship to Leeds Grammar School and learnt cartooning via PERCY BRADSHAW's Press Art School correspondence course. He also attended Leeds School of Art (*c.* 1915–18), where his contemporaries were Henry Moore and Barbara Hepworth, with the intention of becoming an architect. On Christmas Eve 1919 he came to London to take up a scholarship at the RCA but was unable to pay his way. Working freelance at first (his first cartoon appeared in the *Bystander* in 1920), by the following year, aged 19, *Strand Magazine* described him as 'the youngest of the men of his craft who have now an established reputation'. He joined the *Pall Mall Gazette* (1920) as cartoonist and political writer and when that folded moved to the *Liverpool Daily Courier* as cartoonist and Art Editor. Thence to the *Sunday Express* from which, a committed Socialist, he resigned during the General Strike. Then followed work for the *Daily Chronicle*, syndicated cartoons for Allied Newspapers, a strip 'Pin-Money Myrtle' for the *Daily Mail* (1933) and freelance work for *Bystander, Tatler, Sketch, London Opinion, Punch* and others. On 14 May 1934 he created the hugely popular 'London Laughs' series of joke drawings with a London background (retitled 'Smiling Through' during World War II) for the *Evening News* (1934–66). These were the first non-political topical cartoons in the UK (there was a brief 'New York Laughs' series in 1946). Nearly 9000 cartoons later, having become the longest running daily cartoonist in history, he retired to Norwich in July 1966 but continued to produce political cartoons three days a week for the local *Eastern Daily Press* and work for children's comics like *Wham!* and *Whizzer*

& Chips. In 1963 the CCGB presented him with an award for Special Services to Cartooning. He worked mostly in black and white using a brush and watercolour and was influenced by ROWLANDSON and PHIL MAY. He was particularly good at depicting cricket-loving colonels, chubby and slightly vulgar ladies with sparkling jewellery and dapper City gents, and had 'an enviably perceptive eye for detail, particularly when drawing architecture' (COOKSON). His second marriage was to the painter Kathleen Seaman, daughter of writer/editor H.W.Seaman. He died on 15 March 1975.
PUB: *London Laughs 1934–51* (1951)
ILL: J. Mardle, *Broad Norfolk* (1973)
EXHIB: IWM; CG
COLL: UKCC; CAT

MB

LEECH, John (1817–64). Cartoonist and illustrator. John Leech was born on Ludgate Hill in London on 23 August 1817, the son of a coffee-house proprietor and vintner of Irish extraction. He was educated at Charterhouse School where he was a contemporary of THACKERAY. His subsequent training as a medical student was abandoned after his father's bankruptcy (1835) and he turned to drawing humorous lithographs influenced by French cartoonists like Daumier. He was taught to etch by GEORGE CRUIKSHANK and in 1840 became second artist to him on *Bentley's Miscellany*, illustrating amongst other things *The Ingoldsby Legends*. By this time his comic talent was apparent; he was engaged by *Punch* soon after its foundation in 1841 and rapidly became the magazine's chief attraction. 'Fancy a number of *Punch* without Leech's pictures! What would you give for it?' said Thackeray in 1854 (to the irritation of his colleagues). What delighted the Victorians about Leech was his absence of coarseness. 'Always the drawings of a gentleman,' said Dickens and Ruskin praised him for introducing 'the great softening of the English mind'. Whether in social comedy or in sporting subjects, or even in political cartoons after some early exceptions, his humour was inoffensive to the upper and middle classes in complete contrast to the Regency ribaldry. A hunting man himself, he was at his best in field-sports cartoons and created in 'Mr Briggs' the first great comic character since ROWLANDSON's Dr Syntax. Largely self-taught, he was not a strong draughtsman but his drawings have an attractive spontaneity and were good enough for Millais to propose him for membership of the RA. Obsessed by the noise of street musicians

"I tell you it aint safe to be abaht the Garden now the blinkin' ballet's back!"

Joe Lee, *Evening News*, 21 February 1946

No. VII. TRIUMPHANT SUCCESS OF MR BRIGGS

Somehow or other (assisted by his little boy Walter), he catches a jack, which, to use Mr B's own words, flies at him, and barks like a dog.

John Leech, *Pictures of Life and Character*, 1886–7

and worried about money, he died comparatively young on 29 October 1864, having set the tone for *Punch*, which set the tone for British cartoon art.

PUB: *Portraits of Children of the Mobility* (1841), *The Rising Generation* (1848), *Young Troublesome* (1850), *John Leech's Etchings* (c. 1850), *Mr Briggs and his Doings* (1860), *Follies of the Year* (c. 1866), *Pictures of Life and Character* (1886–7)

ILL: R. H. Barham, *The Ingoldsby Legends* (1840); P. Leigh, *The Fiddle Faddle Fashion Book* (1840), *The Comic English Grammar* (1840); C. Dickens, *A Christmas Carol* (1843); W. H. Maxwell, *The Fortunes of Hector O'Halloran* (1843); G. A. Beckett, *The Comic History of England* (1847–8), *The Comic History of Rome* (1852); D. Jerrold, *A Man Made of Money* (1849); R. S. Surtees, *Mr Sponge's Sporting Tour* (1853), *Handley Cross* (1854), *'Ask Mamma'* (1858), *'Plain or Ringlets'* (1860), *Mr Facey Romford's Hounds* (1865)

EXHIB: Egyptian Hall, Piccadilly (1862); Grolier Club, New York (1914)

COLL: BM; V&A; CS; F; M; N; S; BAR; Houghton Library, Harvard

LIT: W. P. Frith, *John Leech, His Life and Works* (1891); J. Rose, *John Leech* (1950); S. Houfe, *John Leech and the Victorian Scene* (1984) SH

LEES [real name Peter Lees Walmesley] (c.1908–42). Cartoonist and strip cartoonist. Born in Norfolk, the son of the managing director of the Great Yarmouth Gas Company, Lees attended Nelson's old school at North Walsham and Norwich Art School. His first published drawing was of gas appliances on a leaflet for his father's company and he joined Dorlands Advertising Agency in London in 1927, producing illustrations for Bovril and others for six years before turning freelance and contributing strips to London dailies and joke cartoons to *Lilliput*, *Bystander*, *Night & Day* and elsewhere. His first strip was 'Wilhelmina' in *Daily Express*, followed by 'Hector' the dog in *Daily Chronicle* (and later *News Chronicle*), and then 'The Kid' in *John Bull*. A gunner in the Army during World War II, he continued to contribute drawings to papers, including editorial cartoons for the

Sunday Graphic. Lees was influenced by Peter Arno's wash-and-line technique. **MB**

LEETE, Alfred Chew (1882–1933). Cartoonist, strip cartoonist and illustrator. Alfred Leete was born the son of a farmer on 28 August 1882 in Thorpe Achurch, Northants, and educated at Kingsholme School, Weston-super-Mare and the Weston School of Science & Art, leaving at the age of 12 to be office boy to a Bristol architect. Self-taught as an artist, he began drawing professionally at the age of 15 and had his first cartoon accepted by *Daily Graphic* the following year. After another year, working in furniture design and contributing to *Bristol Magpie*, he moved to London and his drawings began to appear in *Ally Sloper's Half-Holiday*, *Pall Mall Gazette*, *Pick-Me-Up* – which ran his series, 'Play Titles Travestied' for eight years – *Bystander*, *Sketch*, *Passing Show* and *Punch* (1905–33). In 1914 he created the hugely successful 'Schmidt the Spy' strip for *London Opinion* which was later published as a book and turned into a film in April 1916 by Phoenix Films with Lewis Sydney playing Schmidt. His best known work is Kitchener's recruiting poster 'Your Country Needs You', which first appeared as a cover of *London Opinion* on 5 September 1914 and was later copied by James Montgomery Flagg in the USA, with Uncle Sam replacing Kitchener. Leete also produced posters for the Tank Corps ('Let Professor Tank Teach You a Trade'), Underground Electric Railways and others and drew for advertising, clients including Bovril and Rowntrees chocolate, for whom he created the character Mr York of York, Yorks, who featured in the first British animated commercial with sound. He died on 17 June 1933.
PUB: *Schmidt the Spy* (1915), *The Bosch Book* (1916), *The Worries of Wilhelm* (1916), *A Book of Dragons* (1931), *The Work of a 'Pictorial Comedian'* (1936)
ILL: T. R. Arkell, *All the Rumours* (1916)
EXHIB: Woodspring Museum, Weston-super-Mare (1982) **MB**

LEVINE, David (b. 1926). Caricaturist, illustrator and watercolourist. David Levine was born on 20 December 1926 in Brooklyn, New York, and studied at Tyler School of Fine Arts, Temple University, Philadelphia (1944, 1946–9) and the Hans Hoffman School, New York City (1949). He served with the US Army in 1945–6. His first caricature appeared in *Esquire* in 1958 but he has since become particularly associated with

New York Review of Books which has featured his caricatures and satirical drawings since its inception (1963). He has also worked for *Sunday Times* and others and has received numerous awards, including the Gold Medal for Graphics by the American Academy in 1992. Influenced by DOYLE, TENNIEL, Doré and Daumier, he always works from photographs and draws his caricatures on sheets 13¾ × 11in., first in pencil and then in pen and ink. Immensely influential (TROG has called him 'the best caricaturist in the world'), Levine's fine, cross-hatched style has been greatly admired and frequently imitated by a number of contemporary caricaturists, worldwide.
PUB: *A Summer Sketchbook* (1963); *The Man from M. A. L. I. C. E.* (1966), *Pens and Needles* (1969), *Caricatures* (1969); *Identikit* (1969); *No Known Survivors* (1970), *The Arts of David Levine* (1978)
ILL: Many books including E. Kirtland, *Buttons in the Back* (1958); W. Irving, *Rip Van Winkle* (1963); W. Kauff, *The Heart of Stone* (1964); J. P. Wood, *The Snark was a Boojum* (1966); A. E. Kahn, *Smetana and the Beetles* (1967); *The Fables of Aesop* (1975)
EXHIB: Forum Gallery, New York; Weslyan University; Brooklyn Museum; Princeton University; Galerie Yves Lambert, Paris; Yale University; Hirshhorn Museum, Washington, D. C. (1980); Davis Gallery, New York; SI (1970); Pierpont Morgan Library; A (1987)
COLL: A; Brooklyn Museum, New York; Cleveland Museum of Art, Ohio; NPG; Fogg Art Museum, Harvard; NAD; Princeton University Library, New Jersey **MB**

LEZZ – see Barton, Leslie Alfred

LISLE, Joseph (fl. 1820–30). Caricaturist. Pierce Egan records in *The Finish to the Adventures of Tom, Jerry and Logic* (1830): 'the Buffalo Society was first established in August 1822 by an eccentric young man of the name of Joseph Lisle, an artist'. His etchings in the BM (1825–30) are all on social subjects. His forte seems to have been pictorial puns and c. 1830 McLean published a series of small, crudely executed but lively etchings by him entitled 'Lisle's Play upon Words'.
PUB: [*The Essayists*] (1828–30)
COLL: BM **SH**

LOCKWOOD, Sir Francis (1847–97). Politician, lawyer, amateur caricaturist, cartoonist and illustrator. Frank Lockwood was educated at

Manchester Grammar School, St Paul's School, London, and Caius College, Cambridge. He was called to the Bar in 1872; in 1882 he was appointed QC and in 1884 Recorder of Sheffield. Keenly interested in politics, he represented York as a Liberal (1885–97) and was Solicitor-General (1894–5), being knighted on appointment. For much of his career he drew caricatures of legal personalities and cartooned legal occasions. Some of his sketches were published in *Punch*, the *Sketch* and the *Strand Magazine*, his early contributions to *Punch* being worked up by E. T. REED, and although the drawing was very weak it was judged to be offset by the humour and insight. He died on 19 December 1897.

PUB: *The Frank Lockwood Sketch Book* (1898)
ILL: Anon, *Lays of Modern Oxford* (1874); A. E. Pease, *Hunting Reminiscences* (1898)
LIT: A. Birrell, *Frank Lockwood: A Biographical Sketch* (1898) SH

LONGSTAFF, John 'Cluff' (b. 1949). Cartoonist and strip cartoonist. Born in Darlington, Co. Durham, on 25 June 1949, John Longstaff studied graphics at Teesside College of Art and worked in local government before becoming a cartoonist in 1982. His work has appeared in *Private Eye*, *Punch*, *Brain Damage*, *Gas*, *Spectator*, *Times Saturday Review*, *Independent Magazine*, *Sunday Telegraph*, *Northern Echo* (pocket cartoons) and *Literary Review*. Influenced by MICHAEL HEATH, McLACHLAN, MATT, SEARLE, PAUL CRUM, GLASHAN and HUSBAND, he mostly draws in black and white but sometimes also adds watercolour for strips. MB

LORAINE-SMITH, Charles (1751–1835). Landowner and amateur sporting and comic artist. Charles Loraine was born on 1 April 1751, the second son of Sir Charles Loraine, 3rd Baronet. He was educated at Eton and Christ's College, Cambridge, then went on the Grand Tour and whilst in Italy developed an interest in sketching. On inheriting a fortune he added the name Smith to his own and settled at Enderby Hall, Leicestershire, where he became known as an ardent foxhunter with the Quorn and Pytchley Hunts. He was also a magistrate and, for a time, a Member of Parliament. In his later years he painted hunting scenes, some of which were engraved as aquatints, and drew entertaining sketches of the life around him in Leicestershire. The few caricature prints bearing his initials in the eighteenth century are like inferior BUNBURYs, but in 1804 GILLRAY etched two fine plates –

'Posting in Ireland' and 'Posting in Scotland' – after his designs.
EXHIB: WD
COLL: BM SH

LOUTHERBOURG, Philippe Jaques de RA (1740–1812). Painter and occasional caricaturist. P. J. de Loutherbourg was born in Strasburg on 31 October 1740. He studied art in Strasburg and later in Paris, becoming known for his landscapes and battle pictures and being elected to the Académie Royale in 1767. In 1771 he came to England and worked for David Garrick, designing scenery and costumes for productions at Drury Lane Theatre. He drew occasional social and political caricatures (1775–94) that were influenced by his study of HOGARTH and Ghezzi and, after he had set up as a faith healer, was himself caricatured as a quack. He was elected ARA (1780) and RA (1781) and was George III's favourite painter. Hardie described him as 'a highly acomplished draughtsman who anticipated ROWLANDSON in his treatment of lively groups of figures'.

PUB: *Caricatures of the English* (1775), *The Romantic and Picturesque Scenery of England and Wales* (1805)
ILL: *The Dramatick Writings of Will Shakespeare* (1788); T. Macklin (ed.), *The Holy Bible* (1791–1800); D. Hume, *The History of England* (1812)
EXHIB: RA; KH, 'de Loutherbourg' (1973–4)
COLL: NG; BM; V&A; HM the Queen; DUL; D; N: M; G; NGI; Louvre; Strasburg; Stockholm
LIT: R. Joppien, [Catalogue of Kenwood Exhibition] (1973) SH

LOW, Sir David Alexander Cecil (1891–1963). Political cartoonist, caricaturist and illustrator. David Low was born in Dunedin, New Zealand, of Scottish-Irish parents, on 7 April 1891 and was educated at Boys' High School, Christchurch. Self-taught, apart from a correspondence course at a New York school of caricature (*c.* 1900) and a brief stay at Canterbury School of Art, he was attracted to caricature through reading English comics such as *Chips*, *Comic Cuts*, *Larks* and *Ally Sloper's Half Holiday*. Early influences were *Punch* artists such as TOM BROWNE, KEENE, SAMBOURNE and PHIL MAY and caricaturists GILLRAY, Daumier and Philipon. At the age of 11 his first strip was published in *Big Budget* and a topical cartoon accepted by the *Christchurch Spectator*. He then began to win

drawing competitions in the Australian women's magazine, *New Idea*, and contributed police-court drawings to *New Zealand Truth*. In 1907 he joined the *Sketcher* and in 1908 became the *Spectator*'s full-time Political Cartoonist, later moving to *Canterbury Times* (1910) and the *Sydney Bulletin* (1911). At the *Bulletin* his technique benefited from the influence of WILL DYSON and Norman Lindsay and his bestselling *The Billy Book* lampooning Australian PM Billy Hughes drew praise from Arnold Bennett ('Low draws as the fishes swim'), and led to his move to England. Arriving in London in August 1919, his signature changed from 'Dave Low' to 'Low' when he began work on the *Star* in 1919, moving to the *Evening Standard* in 1927, *Daily Herald* (1950) and *Manchester Guardian* (1953). In addition, he contributed to *Picture Post*, *Ken*, *Graphic*, *New Statesman* (of which he later became a director), *Punch*, *Illustrated*, *Colliers*, *Nash's Magazine* and others. He received honorary doctorates from the universities of New Brunswick, Canada (1958) and Leicester (1961), and was knighted in 1962. Low has been perhaps the most influential cartoonist and caricaturist of the 20 century – he produced over 14,000 drawings in a career spanning 50 years and was syndicated worldwide to more than 200 newspapers and magazines. He also created a number of memorable comic characters, including the TUC carthorse, Musso the pup, the Coalition Ass and the walrus-moustached Colonel Blimp. He drew in pencil for the two famous series of caricatures of politicians and literary figures published in the *New Statesman* in the 1920s and 30s but otherwise worked mainly in ink using a pen and brush. Alternately praised and attacked by Churchill who called him 'a green-eyed young Antipodean radical' and tried to ban a film based on the character Colonel Blimp, Low always regarded himself as 'a nuisance dedicated to sanity'. He died on 19 September 1963.
PUB: *Low's Annual* (1908), *Caricatures* (1915), *The Billy Book* (1918), *Man, the Lord of Creation* (1920), *Lloyd George & Co* (1921), [with F. W. Thomas] *Low & I* (1923) and *The Low & I Holiday Book* (1925), *Sketches by Low* (1926), [with 'Lynx' (R. West)] *Lions & Lambs* (1928), *The Best of Low* (1930), [with K. Martin] *Low's Russian Sketchbook* (1932), *Caricatures by Low* (1933), [with H. Thorogood] *Low & Terry* (1934), [with R. West] *The Modern Rake's Progress* (1934), *Ye Madde Designer* (1935), *Low's Political Parade* (1936), *Low Again* (1938), [with Q. Howe] *A Cartoon History of*

"Gad, sir, we can't negotiate with that feller! He's on the other side!"

BLIMP IN CYPRUS

David Low, *Manchester Guardian*, 29 August 1956

Our Times (1939), *Europe Since Versailles* (1940), *Europe at War* (1941), *Low's War Cartoons* (1941), *Low on the War* (1941), *The World at War* (1941), *British Cartoonists, Caricaturists and Comic Artists* (1942), *Years of Wrath* (1946), *Low's Company* (1952), *Low Visibility* (1953), *Low's Cartoon History 1945–53* (1953), *The Fearful Fifties* (1960)
ILL: J. Adderley, *Old Seed on New Ground* (1920); H. G. Wells, *The Autocracy of Mr Parham* (1930); P. Fleming, *The Flying Visit* (1940)
EXHIB: London Gallery; National Museum of Canada; Monks Hall Museum, Eccles; National-museum, Stockholm; Queen Elizabeth Second Arts Council of New Zealand; LAN; NPG; CG
COLL: UKCC, NPG; New Zealand House; V&A; Victoria State Library, Melbourne; Turnbull Library, Wellington, NZ; LSE (cuttings collections); Yale University (letters & papers); BM; CAT
LIT: [autobiography] *Low's Autobiography* (1956); C. Seymour-Ure & J. Schoff, *David Low* (1985); M. Bryant (ed.), *The Complete Colonel Blimp* (1991) MB

LOWRY, Raymond (b. 1944). Cartoonist, strip cartoonist, illustrator and journalist. Ray Lowry was born on 28 August 1944 in Cadishead, near Manchester. Self-taught as an artist, he started work in an advertising agency in Manchester and turned professional cartoonist in 1969, contri-

buting cartoons to *Punch, Private Eye, Vox, International Times, Oz* and *Guardian. He is* perhaps best known for his work in the music press, notably the strip 'Only Rock 'n' Roll' in *New Musical Express* (from 1977). In addition he has designed record sleeves (e.g. The Clash's *London Calling* in 1979) and wrote a monthly column for *The Face* magazine for three years. Simon Frith writing in *New Society* has described him as 'a jaded rock 'n' roll fan, a 1950s person, cynical and angry . . . Lowry's real hate-figures aren't businessmen but the *Sunday Times* bourgeois pop person'. His cartoons also often feature the juxtaposition of images from two types of spectacle – war and entertainment – combining, for example, Nazi Germany with Hollywood. He has a distinctive, sketchy pen line and uses a lot of wash, signing his work 'R. LOWRY'.

PUB: *Only Rock and Roll* (1981), *This Space To Let* (1986)

ILL: C. Heylin (ed.), *The Penguin Book of Rock and Roll Writing* (1992)

EXHIB: Gallery Downstairs, Burnley; CG

COLL: V&A MB

LOYE, Charles Auguste 'G. Montbard' (1841–1901). Landscape painter and cartoonist. Loye was born in Montbard, France (from which he drew his pseudonym), on 2 August 1841. In France his illustrations were published in the *Chronique Illustrée* and in 1868 he drew some landscapes for the *Illustrated London News*. He was a strong supporter of the Paris Commune and, being proscribed after its fall, settled in London (1871). He drew for *Judy* (1871), contributed seven caricatures to *Vanity Fair* (1872) and made some fine cartoons for *Funny Folks* (1874) but thereafter devoted himself to straight illustration in the magazines, becoming well known for his series 'English Homes' in the *Illustrated London News*. He died in London on 5 August 1905.

PUB: *The Land of the Sphinx* (1894)

EXHIB: RA; RBA; RI; ROI; M SH

LUCK & FLAW – see Fluck, Peter & Law, Roger

LUDLOW, Henry Stephen (1861–after 1934). Portrait painter and cartoonist. Hal Ludlow was born in Newport, Wales, on 15 January 1861 and studied art at Heatherley's and Highgate College. In the 1880s and 90s he contributed illustrations and cartoons to *Ally Sloper's Half*

Holiday, Cassell's, Chums, Illustrated London News and the *Penny Illustrated Paper*. He was the political cartoonist for *Judy* (1889–90) for which he produced competent but rather lifeless drawings in the manner of TENNIEL. Around 1900 he left the periodicals to concentrate on portrait painting. He was an excellent golfer, winning the Welsh Championship in 1905.

ILL: E. Warren, *Laughing Eyes* (1881), *The Queen of Coquettes* (1881), *The White Cat* (1882), *Winning Ways* (1882), *With This Ring* (1884)

EXHIB: RA; RI; L; G

COLL: V&A SH

LUMLEY, Savile (fl. 1899–1949). Cartoonist and illustrator. Savile Lumley was probably related to the Earl of Scarborough. His cartoons were published in *Sketchy Bits* in the late 1890s and before World War I his drawings appeared in a number of magazines including the *Tatler*. He became famous for his recruiting poster (*c.* 1915), 'Daddy, what did *you* do in the Great War?' Afterwards he illustrated books and comics for children, including the *Boys and Girls Daily Mail*, and contributed cartoons to the *Humorist* in the 1920s and 30s. Most of his work is in pen and ink.

ILL: E. Everett-Green, *A Disputed Heritage* (1911); C. Howard, *Chappie and Others* (1926); R. L. Stevenson, *The Black Arrow* (1949) SH

LUNT, Wilmot (fl. 1900–23). Cartoonist and painter. Wilmot Lunt was born in Warrington, Cheshire, and educated locally at the Boteler Grammar School. He studied at the Lancashire School of Art and at the Académie Julian in Paris, exhibiting a large oil painting at the Paris Salon (1901). He contributed joke cartoons to the *Bystander, Cassell's, Idler, London Opinion, Odd Volume, Pearsons, Printer's Pie, Royal Magazine, Sketch* and *Tatler*. His cartoons were also published in *Punch* (1910–23) and they are quite well drawn but not distinctive.

ILL: *The Caxtons* (1905), *Eugene Aran* (1905)

EXHIB: RA; RI SH

LURIE, Ranan Raymond (b. 1932). Caricaturist, political cartoonist and illustrator. Ranan Lurie was born on 26 May 1932 in Port Said, Egypt, and was educated at Herzelia College, Tel Aviv, and Jerusalem Art College. He started work as a journalist on *Ma'ariv Daily* (1950–2). He then became Features Editor of *Hador Daily* (1953–4), Editor-in-Chief of the weekly, *Tavel* (1954–5) and

"OH, WILLIE, WE HAVE MISSED YOU !"

JUDY HEARS THAT MR. GLADSTONE HAS MADE NO DEFINITE ARRANGEMENTS FOR A POLITICAL TOUR AT
PRESENT, BUT HE WILL PROBABLY UNDERTAKE ONE IN NOVEMBER ; MEANTIME THE G. O. M. HAS BEEN
IMPROVING THE SHINING HOURS AT THE PARIS EXHIBITION.

Hal Ludlow, [William Gladstone], *Judy*, 11 September 1889

Political Cartoonist on *Yedioth Aharonot Daily* (1955–65). At the invitation of *Life* he emigrated to the USA in 1968, drawing political cartoons for the magazine until 1973. He then moved to *Newsweek* (1974–6) and at the same time was Editor and Political Cartoonist of *Vision Magazine*. A freelance contributor to *Wall Street Journal, New York Times* (since 1970) and *Paris-Match*, he has also been staff Political Cartoonist on *Honolulu Advertiser* (1979), *Die Welt* (1980–1), *The Times* (1981–3, the paper's first ever), *Asahi Shimbun* (1983–4) and *US News and World Report* (1984–5). In addition he has been Chief Editorial Director of Editors' Press Syndicate since 1985, has frequently appeared on TV in the USA, Germany and elsewhere, and has taught 'The Philosophy of Political Cartooning' at University of Hawaii, West Point Academy and Stanford University. Listed by the *Guinness Book of Records* as the world's most widely syndicated political cartoonist, his work appears in 1015 publications in 79 countries with a circulation of 85 million copies (March 1993). He has received numerous awards including US Headliners Award (1972), Outstanding Editorial Cartoonist by US National Cartoonists' Society (1972–8), New York Front Page Award (1972, 1974, 1977), John Fischetti Political Cartoon Award (1982) and has been granted the unique honour of a US Senate exhibition of his art. He sees every cartoon as a four-wheeled vehicle, the wheels are: the humour, the drawing of the metaphor, the caricature and the facts – the vehicle itself is the message the cartoon has to convey to the reader. 'Lurie – the man they call Van Gogh with a sense of humour' (*Punch*). He draws in ink with fine hatching and a liberal use of solid blacks, but also paints in oils and sculpts.
PUB: *Among the Suns* (1952), *Lurie's Best Cartoons* (1961), *Nixon Rated Cartoons* (1973), *Pardon Me, Mr President* (1974), *Lurie's Worlds 1970–1980* (1980), *So Sieht Es Lurie* (1981), *Lurie's Almanack* (1982, 1983), *Taro's International Politics* (1984), *Lurie's Middle East* (1986), *Lurie's Mideast Almanac* (1986), *Lurie's*

Fareast Views (1987)
ILL: Several books
EXHIB: Numerous shows worldwide MB

LYNCH, John Gilbert Bohun (1884–1928). Author and caricaturist. Bohun Lynch was born on 21 May 1884. Of Irish extraction, he lived at Northlew, Devon, and was educated at Haileybury and University College, Oxford, where he was captain of the Oxford boxing team. He was an authority on boxing, old furniture and caricature, writing not only a book on caricature but the article on that subject in the *Encyclopaedia Britannica*. A caricaturist himself, he contributed occasionally to the *London Mercury* and one of his drawings is reproduced in the studio publication *Caricature of To-Day* (1928).
PUB: *Oxford Quips* (1908), *Glamour* (1912), *Cake* (1913), *The Complete Amateur Boxer* (1913), *Prominent Pugilists of Today* (1914), *Unofficial* (1915), *The Tender Conscience* (1919), *Max Beerbohm in Perspective* (1921), *A Muster of Ghosts* (1924), *The Prize Ring* (1925), *A History of Caricature* (1926), *Respectability* (1927)
ILL: R. Berkeley, *Unparliamentary Papers and Other Diversions* (1924); H. Wolfe, *Lampoons* (1925) SH

LYTTELTON, Humphrey Richard Adeane 'Humph' (b. 1921). Jazz musician, journalist, broadcaster and cartoonist. Humphrey Lyttelton was born in Eton, Buckinghamshire, on 23 May 1921, the son of Hon. George Lyttelton. He was educated at Sunningdale School and Eton College and trained at Camberwell School of Art. During World War II he served in the Grenadier Guards (1941–6). Best known as a musician, he produced regular cartoons for the *Daily Mail* (1949–53) as 'Humph' and also contributed to *Bystander*, *Punch* and other publications.
PUB: *Second Chorus* (1958), *I Play As I Please* (1954), *Take it From the Top* (1975), *Why No Beethoven?* (1984)
ILL: T. Brooke-Taylor et al., *I'm Sorry I Haven't a Clue* (1980) MB

M

MAC – see McMurtry, Stanley

McALLISTER, Bryan (b. 1945). Pocket cartoonist and journalist. Bryan McAllister was born in

Peterborough on 3 April 1945, but moved to Bath in his early teens and attended Keynsham Grammar School. He started work packing chickens, then spent two years as a clerk in the

Ministry of Defence in Bath while contributing cartoons to the local paper. Leaving the civil service for a graphics course at West of England College of Art, he became daily topical cartoonist for the *Western Daily Press* while still a student (aged 19). He then worked for the London Press Exchange advertising agency as a copywriter for clients such as Cadburys and Beechams, leaving to join a TV production company and then Vernons advertising agency where he was a writer/producer. At this time he also drew a strip for *TV Times* about two philosophical tramps whose only possession was a TV set. However, he is best known for his trenchant pocket cartoons for the *Guardian* ('committed wisecracks', Brian Redhead), which appeared from the mid-1970s until the radical redesign of the paper in 1989. He was also the original writer of 'The Belchers' strip in *Vole* before illustrator BRYAN READING took over the script himself. A characteristic of McAllister's drawings is that his figures' feet never appear in the picture. He received Granada TV's 'What the Papers Say' Award in 1979.
PUB: *Little Boxes* (1977), *More Little Boxes* (1980), *Look, No Feet!* (1987) MB

McCONNELL, William (fl. 1850–90). Cartoonist, strip cartoonist and illustrator. William McConnell was the son of an Irish tailor who settled in London. Recruited to draw for *Punch*, he contributed a number of social and two political cartoons (1850–2). Leaving *Punch* because he thought he was underpaid, he drew comic strips for *Diogenes* (1853). For *Town Talk* he drew 'The Adventures of Mr Wilderspin on his Journey Through Life', a strip with some concern for social issues. McConnell also worked for the *Illustrated London News*, *Illustrated Times* (as a political cartoonist), *London Society*, *Comic News* and the *Sunday Magazine*. His promising career was cut short by illness and he died of consumption. Following the examples of HINE and RICHARD DOYLE he was one of the earliest recruits to the strip form of cartooning.
ILL: 'O. Oldfellow', *Our School* (1857); G. F. Pardon, *The Months* (1858); A. W. Cole, *Lottimer Littlegood* (1858); G. F. Sala, *Twice Round the Clock* (1859); *Tom Thumb's Alphabet* (c. 1860); A. Halliday, *The Adventures of Mr Wilderspin* (1861); R. J. Shield, *The Knight of the Red Cross* (1861); T. Hood, *Upside Down* (1868); *The Turtle Dove's Nest* (1886); *Nursery Rhymes* (1890) SH

MACDONALD, A. K. (fl. 1898–1945). Illustrator and cartoonist. Considering the length of his career and the quality of his work, it is surprising that so little has been recorded of A. K. Macdonald's life. His earliest work appeared in the *Longbow* in 1898. In 1900 he was contributing illustrations to *Pearson's* and soon after became one of the leading cartoonists on the *Bystander*. His work also appeared in *Cassell's*, *Holly Leaves*, *London Opinion*, *Nash's*, *Pears*, *Royal Magazine*, *Sketch* and *Strand*. In the 1920s to the end of the 1930s he was one of the main humorous illustrators of the *Tatler*. His pen work is distinguished by its liveliness and he made the most of the opportunity to use colour.
ILL: Lady Cynthia Asquith, *The Silver Ship* (1926), *The Treasure Ship* (1926), *Sails of Gold* (1927), *The Children's Cargo* (1930); A. Armstrong, *The Naughty Princess* (1945) SH

McGILL, Donald Fraser Gould (1875–1962). Cartoonist and postcard designer. Donald McGill was born on 25 January 1875 in Regent's Park, London, the son of an Army captain and a relative of the founder of McGill University, Montreal. He was educated at Blackheath Proprietary School where he lost a foot after a rugby accident at the age of 16. He then attended Blackheath Art School (1891) and worked in the drawing office of Maudleys, a company of naval architects in London (1893–6). Apprenticed to Thames Ironworks, Shipbuilding & Engineering Co until 1907, he began sending painted postcard cartoons to The Pictorial Postcard Company in 1904 and worked full-time in this profession from 1908. McGill was a partner in the firm of Hutson Bros (1908–10), leaving to work freelance for The Pictorial Postcard Co. (1910–14) and when its owner, Joseph Asher, was interned as an alien during World War I, he moved to Inter-Art Co. (1914–31) and freelanced once more from 1931 to 1936. The years 1936–52 were spent largely working for Asher's new firm D. Constance – where he produced 'The New Donald McGill Comics Series' – and he was later contracted to the company (1952–62), becoming director in charge of postcard design when Asher died. Considerable critical attention was given to McGill's work as an art form with the publication of George Orwell's essay 'The Art of Donald McGill' in *Horizon*, February 1941 (Orwell described his jokes as 'a chorus of raspberries'), but some were less appreciative. D. Constance were fined under the Obscene Publications Act, 1857, but McGill always claimed he was a

'There's a man here who's very much struck by my personality.'

Donald McGill, [postcard], c. 1930

'seaside artist' depicting 'honest vulgarity'. Described as 'King of the Saucy Postcards' in his *Sunday Telegraph* obituary, Donald McGill produced approximately 10,000 designs over a period of over 50 years, two of his most famous being 'Please, Lord, excuse me while I kick Fido!' and 'I can't see my little Willie'. He died on 13 October 1962.

EXHIB: Brighton Festival (1967); LAN; Littlehampton Museum, Sussex

COLL: V&A

LIT: A. Calder-Marshall, *Wish You Were Here* (1966); B. N. Buckland, *The World of Donald McGill* (1976); E. Buckland, *The World of Donald McGill* (1984) MB

McGLASHAN, John – see Glashan, John

MacGREGOR – see Illingworth, Leslie Gilbert

McLACHLAN, Edward Rolland (b. 1940). Cartoonist, writer, illustrator and designer. Born in Humberstone, Leicestershire, on 22 April 1940, Ed McLachlan attended Wyggeston Grammar School, Leicester College of Art (1956–8) and was a lecturer in graphics at Leicester Polytechnic (1966–9). As a cartoonist he has been a regular contributor to *Sunday Mirror* (1967–70), *Punch* (1961–92) and *Private Eye* (since 1967). Other markets have included *Spectator*, *Daily Mirror*,

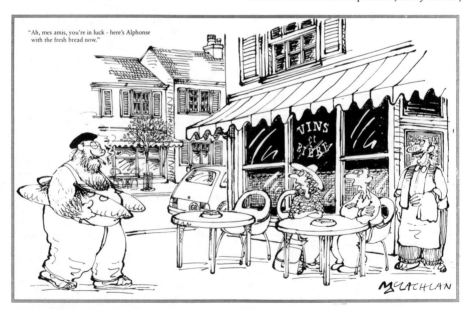

Edward McLachlan, *The Cartoonist*, 25 August 1993

Reader's Digest, Radio Times, The Times, Play-boy, Sunday Telegraph, Ad Weekly and various book publishers. He also draws for advertising, has designed and written more than 300 commercial advertising films, and was voted CCGB Advertising Cartoonist of the Year (1981) and Illustrator of the Year (1980). In addition he wrote and designed the ITV series 'Simon and the Land of Chalk Drawings' and designed 'Bangers & Mash' for the same company. Geipel has described his style as 'hunched, gross-bodied figures ... scratched down with a ruthless finality and a jaggedly astringent line'.
PUB: 'Simon' series (1969–74), *The Dragon That Only Blew Smoke* (1971), *The Cartoons of Edward McLachlan* (1973) and others
ILL: More than 200 children's books including J. English, *Tippy the Tipper Wagon* (1969); P. Groves, 'Bangers & Mash' series (26 books, 1975–9); R. Kilroy, 'Graffiti' series (1979–81); G. Brandreth, *Cockburn's A–Z of After Dinner Entertainment* (1985)
EXHIB: CG
COLL: UKCC MB

McLEAN, Talbert (1906–92). Painter and cartoonist. Talbert McLean was born in Dundee, Angus on 15 October 1906 and studied design at the Dundee School of Art, later teaching there part-time for five years. He then came to London and painted scenery at the Old Vic and Covent Garden, supplementing this activity with freelance cartoons, often in watercolour, under the name of 'Talbert' for *Men Only* (from its first issue), *London Opinion, Night & Day, Bystander, Everybody's, Pearson's, Strand Magazine, Lilliput, Passing Show* and *Tatler*. In 1937 he moved to Liverpool and in World War II served first in North Africa with the Royal Tank Regiment as a driver and wireless operator, then with the Royal Engineers in their map repro section. He returned to Angus after the war. His style was influenced by Peter Arno, *New Yorker* cartoonists and the work of painter William Scott. A distinctive trademark was the addition of splashes of line or ovals of tone around his drawings to 'pull them together'. He died on 29 May 1992.
EXHIB: Talbot Rice Gallery, University of Edinburgh; Cyril Gerber Gallery, Glasgow
COLL: E; G; HUN; DUN · MB

MACLISE, Daniel RA (1806–1870). Painter and caricaturist. Daniel Maclise was born in Cork, Ireland, on 25 January 1806, the son of a Highland soldier named McLeish. After attending Cork Art School he came to London (1827) and entered the RA Schools, winning a gold medal in 1829. The 84 sketches of his contemporaries, 'A Gallery of Illustrious Literary Characters' (including GEORGE CRUIKSHANK) which he contributed to *Fraser's Magazine* (1830–8) under the pseudonym 'Alfred Croquis', have often been referred to as caricatures. They attracted much favourable comment and were republished in 1874 and 1883. Many of the originals are now in the V&A. Maclise also illustrated a number of books, notably for his close friend Charles Dickens, but is primarily known as a painter of history and allegory, often on a huge scale like his frescoes 'The Meeting of Wellington and Blücher' (1861) and 'The Death of Nelson' (1864) in the House of Lords. He declined many honours including the Presidency of the Royal Academy (1866). He died in London on 25 April 1870.
PUB: *The Story of the Norman Conquest* (1866)
ILL: C. Croker, *Fairy Legends* (1826); J. Barrow, *A Tour Round Ireland* (1826); C. Dickens, *The Chimes* (1845), *The Cricket on the Hearth* (1846), *The Battle of Life* (1846); T. Moore, *Irish Melodies* (1854); A. Tennyson, *Poems* (1857); *The Story of the Norman Conquest* (1866)
EXHIB: NPG 'Daniel Maclise' 1972
COLL: V&A; BM; NG; NPG; T; NGI; A
LIT: N. O'Driscoll, *A Memoir of Daniel Maclise* (1872); R. Ormond & J. Turpin, *Daniel Maclise* (1972) SH

McMURTRY, Stanley 'Mac' (b. 1936). Political cartoonist, animator, illustrator and writer. Born in Edinburgh on 4 May 1936, Stan McMurtry moved to Birmingham at the age of eight, attended Birmingham College of Art (1950–3) and spent his National Service in the Royal Army Ordinance Corps (1954–6). He was a cartoon film animator at Henley-on-Thames producing films for ITV (two of which won awards at Cannes Film Festivals) before becoming a freelance cartoonist in 1965. As 'Mac' he was Political and Social Cartoonist of the *Daily Sketch* (1969–71), then the *Daily Mail* (since 1971), and has contributed joke cartoons (as 'Stan McMurtry') to *Punch* and elsewhere. In addition he has worked in advertising, book illustration and greetings cards design, written comedy scripts (in collaboration with BERNARD COOKSON) for Dave Allen and Tommy Cooper, and produced a children's book, *The Bunjee Venture*, which

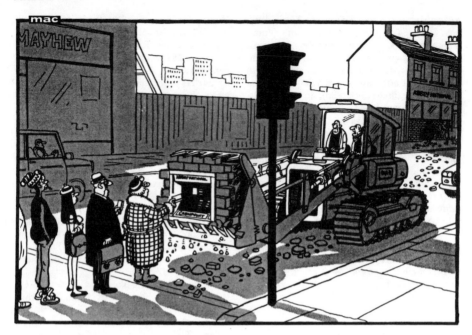

'I told you not to stop at the lights!'

MAC (Stan McMurtry), *Daily Mail*, 21 April 1992

was made into a cartoon film by Hanna-Barbera. Twice voted CCGB Social and Political Cartoonist of the Year (1983, 1984) and twice CCGB Cartoonist of the Year (1983, 1988), he has also been voted Man of the Year by RADAR. He roughs out ideas in pencil on A2 layout paper and draws the finished cartoon on No. 3 Art Line board in half imperial size using a Gillot 404 nib (and a brush for large black areas) and Pelikan black ink, using blue ink for tone areas. When dry he covers the drawing with Kodatrace, going over the tone areas in black ink as a guide for the mechanical tint. A miniature portrait of his blonde wife Janet has always featured somewhere in his *Mail* cartoons since 1980 – unless the subject is purely political – and he signs his work with a sans-serif, lower-case script label. His work for the *Mail*, which is realistically drawn with authentic details, shows the stylistic influence of GILES.

PUB: *MAC's Year* (annuals since 1979), *The Bunjee Venture* (1977).

EXHIB: Bohun Gallery, Henley-on-Thames; HAM

COLL: UKCC MB

MADDOCKS, Peter (b. 1928). Cartoonist, animator and scriptwriter. Born in Birmingham on 1 April 1928, Peter Maddocks was taught by NORMAN PETT at Moseley School of Art, Birmingham (1939–42) but left to join the Merchant Navy aged 15 (1943–9). On his return he set up his own advertising agency, designing cinema posters, and produced his first cartoons for the *Daily Sketch* (1953–4). He then moved to the *Daily Express* (1955–65) and created the popular strip 'Four D. Jones' – featuring a cowboy with a 'time hoop' through which he travelled in the fourth dimension – which ran for 10 years, and 'No. 10' for the *Sunday Express* during the Heath government (which ran for 21 years). He was Cartoon Editor of Express Newspapers (1965–6), Special Features Editor of *King* magazine (1968–71) and ran the London School of Cartooning correspondence school in Fleet Street (1977–90). He has also contributed to *Daily Star*, *Daily Record* ('Cop Shop' strip), *Manchester Evening News*, *Mail on Sunday*, *Private Eye*, *Daily Mirror*, *Daily Telegraph* (from 1977), *Evening Standard* (sports cartoons 1966–70), *Evening News* (1974–7), *Sunday Telegraph*

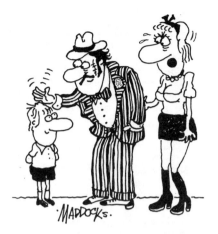

"HOW DO YOU EVER EXPECT TO BE
PUBLIC ENEMY NUMBER ONE IF YOU
CARRY ON LIKE THAT ?"

Peter Maddocks, *Evening News*, c. 1978

(1971–3), *Mayfair* (1967–84), *Woman's Own* (1976–7) and others. In addition he has produced animated commercials for Halas & Batchelor and created animated films for BBCTV since 1984 (notably 'The Family Ness', 'Jimbo and the Jet Set' and 'Penny Crayon') and GMTV from 1993. Founder of the British Cartoonists' Association (with backing from CARL GILES and OSBERT LANCASTER) in 1967, he is currently its Vice-President. He uses a black Parker fibretip or No. 6 Rotring pen on cartridge paper or 85 gsm A4 typing paper and Dr Martin's watercolours. His characters tend to be slightly goggle-eyed with splayed-out fingers.
PUB: *No. 10* (1973), *Private Eye Maddocks* (1981), *Peter Maddocks' Animal Antics* (1982), *Men – A Field Guide* (1983), *Speedy-Ness Saves the Day* (1984), *Ferocious-ness Loses His Roar* (1984), *So You Want to Be a Cartoonist?* (1982), *How to be a Super Cartoonist* (1985), 'Jimbo' series (from 1986), *Condomania* (1987), *Condomania Through the Ages* (1988), *Caricature and the Cartoonist* (1989), *How to Draw Cartoons* (1991), *Cartooning for Beginners* (1992), *Hard Times* (1993)
ILL: J. Amos, *Spain* (1987), *France* (1987) MB

MAHOOD, Kenneth (b. 1930). Political cartoonist, pocket cartoonist and painter. Kenneth Mahood was born in Belfast on 4 February 1930, worked in a solicitor's office and was an apprentice lithographer (1945–9) before becom-

ing a professional painter in 1950, exhibiting in Belfast, London and Dublin and winning a CEMA scholarship to study art in Paris. His first cartoon was accepted by *Punch* when he was 18 and he later became a regular contributor and the magazine's Assistant Art Editor (1960–5). He has also been Political Cartoonist on *The Times* (1966–8), and Pocket Cartoonist on the *Financial Times* (1972–82) and *Daily Mail* (since 1982). In addition he has contributed drawings to the *New Yorker*, produced a number of books and worked in collage. His work has been admired by HEWISON who has described him as having 'one of the sharpest (and most subtle) minds among the present generation of cartoonists'. He was elected to the *Punch* Table in 1978.
PUB: *Not a Word to a Soul* (1958), *Fore!* (1959), *The Laughing Dragon* (1970), *Clanky, the Mechanical Boy* (1971), *Why Are There More Questions Than Answers, Grandad?* (1974), *Losing Willy* (1977), *The Secret Sketchbook of a Bloomsbury Lady* (1982), *The Gospel According to Mahood* (1984), *Name Droppings* (1986), *Star-Crossed Lovers* (1986)
ILL: B. Hollowood, *Tory Story* (1964); S. Oram, *Italy* (1972); R. Benedictus, *Fifty Million Sausages* (1975); Oxfam, *The Crack-a-Joke Book* (1978); W. C. Bindweed, *Not Another Cube Book!* (1981)
EXHIB: [painting] WAD, Dublin and London; RA
COLL: V&A; IWM; UKCC MB

MALLETT, Harcourt Dennis MSIAD (1909–88). Cartoonist, writer and illustrator. Dennis Mallet was born in Wallington, Surrey, on 23 May 1909 and was educated at Parkside Preparatory School, Tonbridge School and Goldsmith's, London. His first published cartoon appeared in *Novel* magazine while he was still a student and from 1932 he contributed regularly to *Punch* (30 years), *Tatler* (35 years, including commissioned illustrations of George VI's Lying in State, 1953), *London Opinion*, *Sketch*, *Men Only*, *Lilliput*, *Humorist*, *Sunday Graphic*, *Countryman* and others, and his children's strips for *Eagle* and *Swift* ran for 400 consecutive weeks during the 1950s. He was particularly fond of combining cartoons with his own verse, as instanced by his long-running series 'My Aunt' in *Tatler* & *Bystander*. During World War II he served in the RAF (1940–6). An admirer of H. M. BATEMAN, RONALD SEARLE and Peter Arno, Dennis Mallett also designed numerous greetings cards, illustrated language courses for Oxford

University Press and in the 1970s was commissioned to draw promotional cartoons for Les Ambassadeurs Club in Piccadilly. He died on 23 November 1988. His son, Lyndon, is a cartoonist and writer.

ILL: L. F. Feaver, *Up Fell, Down Dale* (1937); H. Farjeon, *Herbert Farjeon's Cricket Bag* (1946); L. Brewer, *Vote for Richard* (1948); J. Thurston Thrower (ed.), *The Spice of Life* (1950); K. Waterhouse & G. Deghy, *How to Avoid Matrimony* (1957); G. Deghy, *Paradise in the Strand* (1958); *The Countryman Book of Humour* (1975); *The Story of Father Christmas*; 12 humour and travel titles by D. Hay; more than 20 educational books for OUP MB

MANSBRIDGE, Norman Arthur (1911–93). Cartoonist, illustrator and writer. Norman Mansbridge was born on 22 July 1911 in Wanstead, Essex, the son of an illustrator and writer. He attended Forest School, Essex, and Heatherley's in London. Apprenticed to a commercial art studio, he spent several years in advertising before becoming a freelance cartoonist, contributing his first drawing to *Punch* in 1937. During World War II he served in the Auxiliary Fire Service and was a radio officer in the Merchant Navy, during which time he had a roving commission as a war artist. After the war he returned to London and worked for *News Chronicle, Sunday Times, Lilliput, Daily Sketch* and *Birmingham Post* before becoming Political Cartoonist on *Punch*. The only cartoonist to have had eight colour pages in a single issue of *Punch* ('The Pursuit of Happiness') he also exhibited oil paintings at the Royal Academy and taught art. In addition he drew covers for books (e.g. Basil Boothroyd's, *The Whole Thing's Laughable,* 1964). He was elected a member of the *Punch* Table in 1958. Preferring to memorize a subject rather than draw it on the spot, Mansbridge worked first in pencil and then with a fountain pen and black ink. He died on 6 March 1993.

PUB: *The Modern Mariner* (1946), *The Pale Artist* (1947)
ILL: J. Dyrenforth & M. Kester, *Adolf in Blunderland* (1939); L. M. Bates, *Tideway Tactics* (1947); L. Gibb, *The Joneses; How to Keep Up With Them* (1959), *The Higher Joneses* (1961); M. Muggeridge, *Things Past* (1978)
EXHIB: [oil paintings] RA
COLL: V&A; MET; UKCC MB

MANSERGH, Richard St George (fl. 1772–?d. 1797). Amateur caricaturist. Dorothy George

has suggested that Mansergh came from Headfort, Northern Ireland, was wounded in the American War of Independence and killed in the Irish Rebellion of 1797. His caricature designs of social subjects and 'Macaroni' (1772–8) were engraved by others and mostly published by DARLY. They are highly individual in character, some having an almost surrealist flavour.
COLL: BM SH

MARC – see Boxer, Charles Mark Edward

MARENGO, Kimon Evan 'Kem' DPhil (1904–88). Political cartoonist and caricaturist. Kem was born in Zifta, Egypt, on 22 January 1904 of Greek parents and grew up in Alexandria. He edited and illustrated the political weekly, *Maalesh* (1923–31), and later moved to Paris to study at the Ecole Libre des Sciences Politiques. His cartoons were published in *Le Petit Parisien, John Bull, La Bourse Egyptienne, New York Times, Liberal News, Daily Herald* and *Daily Telegraph*. During World War II he ran the 'KEM Unit' in the Political Information Department of the Foreign Office, producing propaganda cartoons for the Middle East. Many of his drawings also appeared as postcards and posters. After the war he studied at Exeter College, Oxford, and submitted a DPhil thesis on 'The Cartoon as a Political Weapon in England 1784–1832'. When his pseudonym was copied he was forced to litigate up to the House of Lords and the case, 'Marengo v. *Daily Sketch* and *Sunday Graphic* Ltd [1948]' set a precedent for civil litigation. He was awarded the Légion d'Honneur and Croix de Guerre. Kem died on 4 November 1988.

PUB: *Oua Riglak!* (1926), *Alexandrie, Reine de la Mediterranée* (1928), *Gare les Pattes!* (1929), *Toy Titans* (1937), *Adolf and His Donkey Benito* (1940), *Lines of Attack* (1944) MB

MARIO – see Armengol, Mario Hubert

MARKS, Lewis [or J. L.] (fl. 1814–32). Caricaturist, etcher and print publisher. Marks first appears as a designer in 1814 and a publisher of political caricatures in 1817. His earliest work is in clear imitation of GEORGE CRUIKSHANK but he came to develop a style that was grosser and to promote more radical views. He made political and social prints and in both was described by Dorothy George as the caricaturist 'least hampered by considerations of propriety' with 'a seeming love of vulgarity for its own sake'.

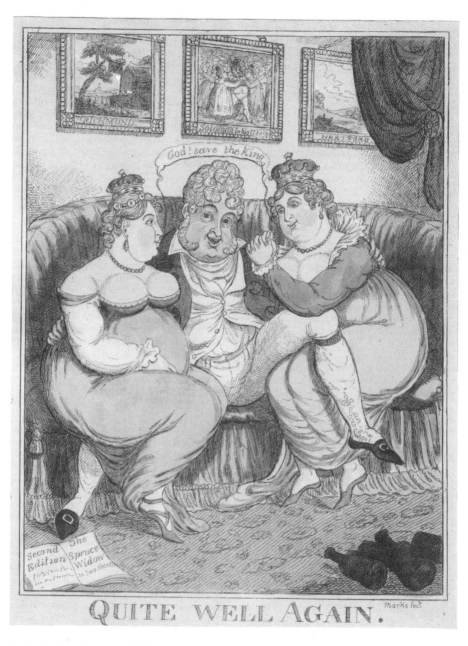

Lewis Marks, [Duchess of Richmond, George IV & Lady Hertford], 1820

Totally unscrupulous, he blackmailed George IV and was paid to suppress certain caricatures and broadsides (1819–22). In the 1820s he etched some attractive theatrical prints under such titles as 'Illustrations of Plays'. His last political prints, trenchantly pro Reform, were issued in 1832.
COLL: BM SH

MARKSMAN – see Walker, J. C.

MAROC – see Coram, Robert S. E.

MARRYAT, Captain Frederick RN CB FRS (1792–1848). Sailor, novelist and comic artist. Frederick Marryat was born on 10 July 1792, the son of Joseph Marryat MP, an immensely rich banker and plantation-owner in the West Indies. In the course of a naval career in which he showed much gallantry (awarded the gold medal of the Royal Humane Society for saving life at sea), ability (created CB, 1826) and scientific ingenuity (elected FRS, 1819) he made sketches of humorous subjects when he needed ready cash which were etched by his friend GEORGE CRUIK-SHANK (1814–24). Some of these like 'The Progress of a Midshipman' capitalized on his experiences, some, like 'The New Union Club', were political, some were *jeux d'esprit*. As sketches they are unskilled and lifeless but show much fertility of invention. Captain Marryat went on to write a series of popular novels about life at sea and spent his last years farming in Norfolk and writing stories for children. He died on 9 August 1848.
PUB: *The Naval Officer: or Scenes and Adventures in the Life of Frank Mildmay* (1829), *Peter Simple* (1834), *Jacob Faithful* (1834), *Japhet in Search of a Father* (1836), *The Pirate and Three Cutters* (1836), *Mr Midshipman Easy* (1836), *Poor Jack* (1840), *Masterman Ready* (1841), *The Settlers in Canada* (1844), *The Children of the New Forest* (1847)
COLL: BM; V&A
LIT: C. Lloyd, *Captain Marryat and the Old Navy* (1939) SH

MARTIN, Sidney William (1919–93). Cartoonist and illustrator. Bill Martin was born in Babikin, Western Australia, on 28 December 1919, the son of a wheat farmer. He worked first as a messenger boy, then for a process engraver and after war service in the RAAF became a freelance illustrator. He came to England in 1953 and worked for the *Sunday Express* as cartoonist, illustrator and latterly Art Director. He also drew

for *Sporting Life* as 'Williams'. Bill Martin died on 4 June 1993.
ILL: M. Davidson, *The Sunday Express Weekend Gardening Book* (1976) MB

MASON, George Finch (1850–1915). Humorous hunting and racing artist, and cartoonist. George Finch Mason was the son of a master at Eton. He attended the school himself (1860–4) and drew caricatures of school life. The seven cartoons on hunting subjects he contributed to *Punch* (1881–3) are weakly drawn and he is seen to better advantage in the large oblong folios published by Fores starting in 1886.
PUB: *Humours of the Hunting Field* (1886), *Tit Bits of the Turf* (1887), *The Run of the Season* (1902) SH

MATT – see Pritchett, Matthew

MAY, Philip William RI NEAC (1864–1903). Cartoonist and illustrator. Phil May was born in Leeds on 22 April 1864. His father was an unsuccessful businessman who died nine years later, his mother was an Irishwoman connected with the stage. He was educated up to the age of 13 at local schools then, after trying various jobs, joined a touring theatrical company (1879) in which he acted and designed scenery. At the same time he contributed comic drawings to two Yorkshire papers. In 1883, virtually penniless, he went to London and the following year his political cartoons were published in the *St Stephen's Review* and his work was accepted by other papers. This led in 1885 to a three-year engagement in Australia as the leading cartoonist on the *Sydney Bulletin*. On his return he scored his first great public success with his illustrations to *The Parson and the Painter* (1891). By now he was established as a brilliant black-and-white artist with a strong, economical and seemingly spontaneous line that was perfectly adapted to the new photo-mechanical methods of printing. In 1890 he started to contribute to the *Graphic* and the *Daily Graphic*, in 1892 to the *Illustrated London News* and in 1893 to the *Sketch* and *Punch*; by the end of the decade there was scarcely any illustrated magazine of consequence that had not published his cartoons. His 'Annuals', containing much of his best work, started in 1892. As well as the conciseness of his drawing and captions which influenced most of the cartoonists of his time, his choice of subject matter, cockney urchins and costers, charwomen and cabbies, treated with sympathetic humour,

brought something new to *Punch*. He was elected
NEAC (1894), RI (1897) and might have been
elected ARA in 1896 had not his sponsor, Lord
Leighton, died. His life was generous, irregular
and convivial and he died on 5 August 1903 of
cirrhosis of the liver. His advice to other cartoon-
ists was 'draw firm and be jolly'.
PUB: *Phil May Winter and Summer Annuals*
(1892–1904), *Phil May's Sketch Book* (1895),
Gutter-Snipes (1896), *Phil May's Graphic Pic-
tures* (1897), *A. B. C.* (1897), *Phil May Album*
(1899/1900), *Sketches from 'Punch'* (1903), *Phil
May Folio* (1904)
ILL: 'Rev. Joseph Slapkins' [W. Allison], *The
Parson and the Painter* (1891); H. Pearse, *The
Comet Coach* (1895); A. Patchett, *The Withered
Jester* (1895); C. Bertram, *Isn't it Wonderful?*
(1896); F. C. Burnand, *Z. Z. G. or Zig Zag
Guide* (1897); W. Besant, *East London* (1902);
Mrs M. Spielmann, *Littledom Castle* (1903)
EXHIB: FAS (1895); LG (1903, 1908); LE
(1913, 1936)
COLL: BM; V&A; NPG; T; G; L
LIT: J. Thorpe, *Phil May, Master Draughtsman
and Humorist* (1932) SH

INFORMATION WANTED

FAT PARTY : "Say, boy, do my boots want
cleaning ?"

Phil May, *The Phil May Album* (1900)

MAYBANK, Thomas – see Webb, Hector Tho-
mas Maybank

MAYS, Douglas Lionel (1900–91). Cartoonist,
painter and illustrator. D. L. Mays was born on
4 August 1900 in Kingston-upon-Thames, Surrey,
and educated at Tiffin School. He served in the
Rhineland Army of Occupation and then studied
illustration at Goldsmith's College (1920–3)
where his contemporaries were Graham Suther-
land and ERIC FRASER. He worked for *Beano, Big
Budget, Holiday Annual* and *Dandy* before his
first drawing for *Punch* was accepted in June
1932 (he continued to work for *Punch* until
1954). A pacifist during World War II, he spent
the period as a farmer. Mays' drawings were in
the tradition of GEORGE DU MAURIER and often
featured the upper middle classes, especially
women and children, the models for whom were
his wife and four daughters. He also handled
architectural, romantic and topographical sub-
jects, drew for *John Bull* and designed Christmas
cards for Royles. Mays was greatly admired by
FOUGASSE who called him 'a really magnificent
pen-draughtsman'. He died on 19 May 1991.
PUB: *Percy's Progress* (1944)
ILL: Many books including A. Chaffee, *Wandy,
the Wild Pony* (1933); N. Streatfield, *Tennis
Shoes* (1937), *The House in Cornwall* (1940),
Curtain Up (1944); M. Twain, *The Adventures of
Tom Sawyer* (1962); A. Buckridge, 11 'Jennings'
titles; A. Brazil, *Three Terms at Uplands* (n.d.)
EXHIB: RA MB

ME – see Egerton, M.

MEADOWS, Joseph Kenny (1790–1874). Illus-
trator and cartoonist. Kenny Meadows was born
in Cardigan, Wales, on 1 November 1790, the
son of a retired naval officer. By the early 1830s
he was contributing illustrations and cartoons to
the periodicals and went on to become a popular
book illustrator best known for his illustrations
of Shakespeare. His drawings in *Punch* (1842–4)
far surpassed in fancy and design what had gone
before, his cherubs and elves being especially
winning. A jovial character, he was well liked by
his *Punch* colleagues but left them to draw
cartoons for the *Great Gun* and the *Man in the
Moon* and to contribute some of his best work
to the *Illustrated London News* and the *Illumin-
ated Magazine*. He was awarded a Civil List
pension in 1864 for 'services to illustrative art'.
His work was uneven but his reputation has
suffered unfairly because in *Punch* he was com-

THE PARLOUR ORATOR.

Turn him to any course of policy,
The Gordian knot of it he will unloose,
Familiar as his garter.

HENRY V.

Kenny Meadows, *Heads of the People* (1840)

peting with and eclipsed by the far stronger talents of LEECH and DOYLE. He was the brother-in-law of A. S. HENNING. Meadows died in London in August 1874.
ILL: Many books including J. Trueba y Cosio, *The Romance of History: Spain* (1834); *The Autobiography of Jack Ketch* (1836); W. Shakespeare, *Works* (1839–43); D. Jerrold, *Heads of the People* (1840-1), *Punch's Letters to his Son* (1843); *Punch's Complete Letter Writer* (1845); L. Hunt, *Palfrey* (1842); J. Jones, *Hints to Servants* (1843); E. Bulwer-Lytton, *Leila* (1847); L. Blanchard, *Sketches from Life* (1847); H. Mayhew, *Fear of the World* (1850); Hon. L. Greene, *A Winter and Summer at Burton Hall* (1861)
EXHIB: RA; RBA
COLL: BM; V&A SH

MECHAM, William 'Tom Merry' (1853–1902). Caricaturist. Tom Merry's name is inseparable from that of *St Stephen's Review* to which he contributed over a long period (being at his best in the 1880s) caricatures of Gladstone and other politicians. These large lithographs printed in two or more colours were often framed or preserved in portfolios. The likenesses of the subjects are good and they are sometimes presented in

dramatic action. Tom Merry also appeared on the music-hall circuit drawing 'lightning cartoons' and in 1895 one of the earliest motion pictures was made of his stage presentation. He died at Benfleet, Essex, on 21 August 1902.
ILL: A. A. Daly, *The History of Canvey Island* (n.d.)
COLL: BM; HCL SH

MELLING, Gerard 'GED' (b. 1934). Pocket cartoonist. Ged Melling was born in Stirling, Scotland, on 6 January 1934, and left school at 15 to become an apprentice house painter. He studied at St Martin's School of Art, graduating in 1964, and has been a professional cartoonist since 1984. He has worked for *The Times* and *Economist* since 1989 and has also contributed to *Daily* and *Sunday Telegraph*, *Financial Times*, *Spectator*, *Observer*, *Oldie* and *Private Eye*.
PUB: *Guttae* (1974)
ILL: A. James, *Memoirs of a Fen Tiger* (1986); P. Howard, *A Word in Time* (1990)
EXHIB: [drawings and paintings] London, Dublin, Canada MB

MENDOZA, Philip (fl. 1930s–60s). Cartoonist. Mendoza worked for *Lilliput* and other magazines and also drew posters for the Ministry of Labour and Royal Society for the Prevention of Accidents, a notable series featuring Percy Vere. He also produced strips for children's comics such as *Knockout*, *Jack & Jill* and *Captain Vigour*.
EXHIB: RA
COLL: [posters] IWM MB

MERRY, Tom – see Mecham, William

MILLS, Arthur Wallis (1878–1940). Cartoonist and illustrator. Wallis Mills was born in Windmill Hill, Sussex, on 21 October 1878, the son of a clergyman, and educated at Bedford School. He studied art at the South Kensington Schools and before the end of the century was contributing cartoons to *Judy*, *Ludgate Magazine*, *Royal Magazine* and *To-Day*. He became a regular contributor to *Punch* (1905–39) of good-natured social comedy and Price's judgement 'banal in caption, amateurish in drawing' seems harsh, especially when applied to his later work in pencil. He also contributed to the *Bystander*, *Cassell's*, *Graphic*, *Humorist*, *Printer's Pie*, *Sketch Book*, *Strand* and *Tatler*. During World War I he served in the Artillery and the Camouflage Corps. He died on 4 April 1940.

ILL: A. Williams, *Petrol Peter* (1906); Jane Austen, *Works* (1908); A. Lang, *The Red Book of Heroes* (1909)
EXHIB: RA SH

MINET, Francis 'Pav' (b. 1913). Political and social cartoonist, stained-glass artist and restorer. Pav was born in Islington, London, on 20 August 1913 and attended St Martin's School of Art (1928–34). A stained-glass artist with Heaton Butler & Bayne in London (1924–39), he served in the Royal Artillery during World War II designing camouflage and was a prisoner of war in Germany (1940–5). After the war he continued working as a stained-glass artist with Goddard & Gibbs Studios, London (1946–78). He also drew political cartoons for left-wing and anti-fascist organizations (1936–9) and contributed cartoons to *Punch* (1957–73) – including many covers – *Private Eye, Daily Sketch, Daily Herald, Daily Mirror, Daily Express, Evening Standard, Evening News, Star, Sunday Dispatch, Reynold's News, Everybody's, Weekend, Reveille, Tit-Bits, Portsmouth News* and *Portsmouth Journal*. Geipel has said of him that his effects 'have been aptly described as "tightened SIGGS" '.
EXHIB: [paintings] Hampstead Art Gallery
COLL: UKCC MB

MINHINNICK, Sir Gordon Edward George KBE OBE (1902–92). Political/editorial cartoonist. Minhinnick was born on 13 June 1902 in Torpoint, Cornwall, the son of a naval engineer, and educated at Kelly College, Tavistock, Devon, before moving to New Zealand in 1921. There he worked as an architectural draughtsman (1923–5) whilst drawing cartoons in his spare time for the *Free Lance* (1925–6). He then worked for *Christchurch Sun, Auckland Sun* (1927–30) and was Political/Editorial Cartoonist of the *New Zealand Herald* (1930–87). During World War II he created the popular 'Soldier Sam' strip for the *Herald*. In 1950 the *Evening Standard* in London offered him the chair vacated by DAVID LOW but he preferred to stay in New Zealand. Himself influenced by Low, Minhinnick drew his cartoons left-handed with broad brushstrokes and lettered them with a right-handed pen. He received an OBE (1950) and a KBE (1976) and died on 19 February 1992. Former New Zealand Prime Minister, Sir Robert Muldoon, said of Minhinnick's work (which had commented on 13 administrations and 11 prime ministers): 'I never saw better anywhere.'

PUB: *Minhinnick Cartoons* (1938), *Min's Pie* (1952), *Min's Sauce* (1976) and four other books
MB

MINNION, John Robert (b. 1949). Caricaturist and illustrator. Born in Guildford, Surrey, on 13 August 1949, John Minnion was largely self-taught apart from a short course on typography and magazine production at the London College of Printing (1976–7). After producing and selling his own versions of Lewis Carroll's *Jabberwocky* (1973) and *The Hunting of the Snark* (1976), he was Political Caricaturist at the *New Statesman* (1978–88). He has also contributed to *Listener, The Times, Guardian, Marxism Today, Nursing Times, Classic CD* and *New Zealand Listener*. Preferring to work in black and white, he uses a mapping pen and brush with indian ink or coloured inks. He lists his influences as BEARDSLEY and TROG.
PUB: *Maestri* (1983), [with N. Kenyon] *Britannia Rules the Staves* (1988), *Thatcherian Values* (1990), [with J. Beadle and R. Ainsley] *The Sideways Guide to Composers* (1993)
ILL: L. Carroll, *Jabberwocky* (1973), *The Hunting of the Snark* (1976)
EXHIB: Turnstile Gallery; RFH; Fairfield Halls, Croydon; BC; Brighton Festival; Wigmore Hall
MB

MONTBARD, G. – see Loye, Charles Auguste

MOON, Sidney (fl. 1930s–40s). Political cartoonist. Sid Moon worked on the *Cambridge Daily News* (where he was succeeded by RONALD SEARLE) before moving to London in the mid 1930s to work for the *Sunday Dispatch* and *Daily Worker*. He trained by correspondence course. Moon signed his work with an anthropomorphic crescent moon. MB

MORGAN, Matthew Somerville (1839–90). Cartoonist and illustrator. Matt Morgan was born in London on 27 April 1839, the son of an actor. In 1859 he was sent by the *Illustrated London News* as a 'special artist' to cover the Austro-Italian war and in the 1860s his cartoons and illustrations appeared in the *Illustrated Times, London Society, Judy, Britannia* and *Will O' the Wisp*. His political cartoons in *Fun* (1862–7) were notable for powerful drawing and sincerity of feeling. In 1867 he became part-owner and chief cartoonist of the radical magazine *Tomahawk*, in which he daringly attacked the Queen's hibernation, the Prince of Wales's

"DON'T DESERT ME."

(DEDICATED TO H.R.H. THE PRINCE OF WALES BY BRITANNIA.)

Matt Morgan, *Tomahawk*, 28 November 1868

licentiousness and various social evils. Emigrating in 1870 to America, he drew pro-Democrat political cartoons for *Frank Leslie's Illustrated Paper* and was fondly remembered by fellow artists for his claret-filled washtub. Later he founded several enterprises, drew theatrical lithographs, painted backdrops for Buffalo Bill's Wild West Show and supplied some powerful social cartoons to the *Illustrated London News* (1886). He spent his last two years as Art Editor of *Collier's Magazine* and died in New York on 2 June 1890. His strong social conscience, exercised paramountly in the *Tomahawk* (where his drawings were printed on tinted paper), makes Matt Morgan one of the most interesting of 19th-century cartoonists.

PUB: *The American War; Cartoons by M. Morgan etc.* (1874)
ILL: W. H. D. Adams, *Neptune's Heroes* (1861)
COLL: BM; Library of Congress SH

MORROW, George (1869–1955). Cartoonist and illustrator. George Morrow was born in Belfast, the son of a decorator and the brother of Albert and Edwin Morrow, both minor cartoonists and contributors to *Punch*. He studied art in Paris and in 1896 his cartoons started to appear in *Pick-Me-Up* and other periodicals; at the same

time he started on his long career as a book illustrator. However, it is as a *Punch* artist (1906–54) that he is best known. His broad sympathies and excellent sense of humour allowed him to tackle a range of subjects but his speciality was historical jokes of the type pioneered by E. T. REED. Price wrote 'for issue after issue . . . he was one of the two artists who were trying to make people laugh with both drawing and caption . . . he often carried the paper on his shoulders'. Some of his most amusing and accomplished drawings were his skits entitled 'Royal Academy Perversions'. He was Art Editor of *Punch* (1930–7) but happily relinquished the post to FOUGASSE. George Morrow was by no means a great draughtsman but his *joie de vivre* disguised the fact. When he died on 18 January 1955, the *Times* obituarist called him 'probably the most consistently comic artist of his day'.

PUB: *George Morrow, His Book* (1920), *Podgy and I* (1926), *Some More* (1928)
ILL: M. R. Mitford, *Country Stories* (1896); H. Graham, *Familiar Faces* (1907); C. L. Graves, *Musical Monstrosities* (1909); E. V. Lucas, *Swollen-Headed William* (1914), *In Gentlest Germany* (1915); Marcus, *Morals for the Young* (1915); A. P. Herbert, *The Wherefore and the Why* (1921), *Tinker Tailor* (1922); E. V. Knox,

Parodies Regained (1921), *Fiction as She is Wrote* (1927); A. Marshall, *Simple Stories* (1927), *Simple People* (1928); A. Herbertson, *Hurrah for the O-Pom-Pom* (1931); J. B. Morton, *The Death of the Dragon* (1934); I. Plunkett & R. Mitchell, *Ye Goode Old Days* (*c.* 1936)
EXHIB: RA; RBA SH

MORTIMER, John Hamilton ARA (1740–79). Painter, etcher, illustrator and caricaturist. J. H. Mortimer was born in Eastbourne on 17 September 1740, the son of a prosperous mill-owner and customs officer. At the age of 16 or 17 he was apprenticed for three years to Thomas Hudson, the portrait painter, and won prizes for drawing from the St Martin's Lane Academy (1758–63). His pen-and-ink drawings of 'monster' and 'banditti' subjects as well as the few caricatures he drew, some of which were engraved after his death, had a strong influence on the early styles of GILLRAY and ROWLANDSON. In Dorothy George's opinion 'his combination of fantasy, caricature and the grand manner marks the beginning of a new school'. Mortimer was elected a Fellow of the Society of Artists (1765), President (1774) and ARA (1778). During the early 1779s he apparently led a dissipated and reckless life which ruined his constitution and he died on 4 February 1779.
ILL: *Bell's Poets of Great Britain* (1777–82); F. Burney, *Evelina* (1779); *Bell's British Theatre* (1780)
EXHIB: RA; SA; Towner Gallery, Eastbourne, & Kenwood, Hampstead (Retrospective 1968)
COLL: BM; V&A; HM the Queen; T; C; A; E; N; NOR; Yale; Princeton
LIT: J. Sunderland, *John Hamilton Mortimer, His Life and Works* (1988) SH

MOSLEY, Charles (*c.* 1720–*c.* 1770). Political caricaturist, engraver and printseller. Mosley's caricatures start to appear in the late 1730s, notably a clever series entitled 'The European Race' (1738) which satirized the state of Europe prior to the War of the Austrian Succession. Most of his caricatures deal with foreign affairs and he reveals himself in them as a versatile draughtsman with a gift for composing and detailing large scenes. In 1749 he was one of six printsellers examined by the government on suspicion of selling obscene satires. As an engraver he was employed by HOGARTH on 'The Gate of Calais' (1749) and engraved a number of portraits and history paintings including Van Dyck's equestrian portrait of Charles I.

ILL: E. Jenkins, *Joe Miller's Jests; or the Wit's Vade Mecum* (1742)
COLL: BM SH

MURRAY, Webster (fl. 1930s–d. 1952). Cartoonist. Webster Murray was born in Toronto, Canada, the son of a clergyman. He left school at 17 to join the Maclean Publishing Company as a junior artist while studying art in the evenings under a nephew of GEORGE CRUIKSHANK who had also taught Charles Dana Gibson. Four years later he came to London and studied at St John's Wood Art School, the Slade and the Regent Street Polytechnic. During World War I he served in the infantry, attaining the rank of captain. After the war he started working for the new weekly, *Pan*, with GILBERT WILKINSON and others and then produced double-page drawings for TATLER. He then went to live in Paris for two years before returning to London to work for the *Sketch, Bystander, Men Only, Eagle* and others. In World War II he joined the RAF but later became an Air Raid Warden. He married the children's book illustrator Joan Kiddell-Monroe. Murray was also well-known for his portraits of leading society figures of the time. He died in February 1952.
PUB: [with A. St H. Brock] *Fireworks and Fêtes* (1946)
ILL: Apuleius, *The Golden Asse* (1946); Longus, *Daphnis and Chloe* (1947); R. S. Young, *Cricket on the Green* (1947) MB

MUSGRAVE-WOOD, John 'Emmwood' (b. 1915). Political cartoonist and painter. John Musgrave-Wood was born in Leeds, Yorkshire, the son of a landscape painter. Educated at Leeds Modern School and Leeds College of Art, he worked in his father's studio until he died. He then served as a steward on a cruise liner and began drawing cartoons to entertain his shipmates. During World War II he joined the Duke of Cornwall's Light Infantry as a PT instructor, was later commissioned in the Sherwood Foresters and while in India in 1941 volunteered to join Orde Wingate's Chindits, serving in Burma and China and attaining the rank of major. Demobilized in 1946 he produced a book (with Patrick Boyle, later Earl of Cork and Orrery) about his experiences with the Chindits, signing himself 'JON'. He also studied painting at Goldsmith's (*c.* 1948) whilst contributing illustrations ('Emmwood's Aviary') and theatre caricatures to *Tatler & Bystander* (1948–54), taking over from TOM TITT. He also drew TV illustrations for

Emmwood (John Musgrave-Wood), [Margaret Rutherford in *The Way of the World*], *Tatler & Bystander*, c. 1950

Punch, showbusiness illustrations for the *Sunday Express* and political cartoons for *Evening Standard* – taking over from DAVID LOW. He was in addition editor of the *Junior Express* newspaper and contributed to *Life* magazine. In 1957 he joined the *Daily Mail* as Political Cartoonist and when the paper went tabloid in 1971 began to alternate his drawings with those of MAC. He retired in 1975 and moved to France.

PUB: [with P. Boyle] *Jungle, Jungle, Little Chindit* (1946)
ILL: D. Parsons, *Never More Time* (1960)
COLL: UKCC; NPG
EXHIB: FR MB

MYERS, David (b. 1925). Editorial cartoonist, pocket cartoonist, illustrator and greetings card designer. David Myers was born in London on 8 December 1925 and served in the Royal Fusiliers (1944–7). After demobilization he attended the Sir John Cass Art School (1947–8) and St Martin's School of Art (1949–51). Then, when his fiancée moved to Australia, he followed and became

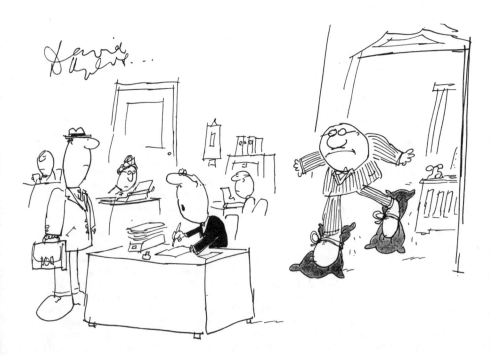

"YOU NEVER QUITE KNOW WHEN HE'S GOING TO CREEP UP ON YOU . . .

David Myers, *c.* 1987

Pocket Cartoonist on the *Melbourne Argus* (1951–2). Returning to London he got a job as OSBERT LANCASTER's holiday understudy on the *Daily Express* and later became Editorial Cartoonist on the *Evening News* (1965–8). He resigned when they refused to publish an anti-Enoch Powell cartoon and turned freelance, contributing cartoons to *Punch, People, Daily Mail, Daily Mirror* and *Star*, and also producing greetings cards and advertising work. He later devised and wrote the BBCTV children's series 'Sebastian the Incredible Drawing Dog'. Voted CCGB Social and Political Cartoonist of the Year (1966), he is also a former Treasurer of the Club. His is best known for his distinctive sketchy style featuring figures with bulbous noses and balloon-like feet.
PUB: 'Sebastian the Incredible Drawing Dog' series (four titles, 1987) MB

N

NASH, John Northcote CBE RA (1893–1977). Landscape painter, illustrator, wood-engraver, art teacher, botanical artist and comic draughtsman. John Nash was born in Kensington, London, on 11 April 1893, the son of a barrister and the brother of the artist Paul Nash. He was educated at Wellington College. From a young age he had made comic and landscape drawings of much originality and in 1913, without any training, decided to become an artist, having a successful joint exhibition in London with his brother. The following year he was elected to the newly formed London Group. In 1916 he joined the Artists Rifles and served on the Western Front, being appointed an Official War Artist in 1918. Much of 1919 was occupied in comic work: theatrical cartoons in *Land & Water*, illustrations for *Art & Letters* and the *Owl*. His comic illustrations for *Dressing Gowns and Glue* were warmly commended in a preface by MAX BEERBOHM. Although primarily a landscape painter in oil and watercolour, he went on to illustrate more than 50 books and booklets, taught at the Ruskin School and the RCA, produced excellent wood engravings and designed comic advertisements for Shell and Guinness. Douglas Bliss in his *History of Wood Engraving* (1928) referred to 'his sense of humour which enables him to make the best comic drawings of today'. Lamenting the lack of pictorial humour in *Punch* and believing that comic draughtsmanship was the precondition for representing a comic idea, he modelled his own drawing on EDWARD LEAR (who had been in love with his aunt Augusta Bethell) and revealed a similar genius for absurdity. He was elected ARA (1940), RA (1951), created CBE (1964) and in 1967 became the first living artist to be honoured by his fellow Academicians with an exhibition in the main galleries of Burlington House. He died on 23 September 1977.
ILL: More than 50 books including L. de G.

Sieveking, *Dressing Gowns and Glue* (1919); *Bats in the Belfry* (1926); 'Belinda Blinders' [D. Coke], *The Nouveau Poor* (1921); W. Cobbett, *Rural Rides* (1930); *One Hundred and One Ballades* (1931); G. White, *The Natural History of Selborne* (1951); *Happy New Lear* (Guinness, 1959); R. Nett, *Thorntree Meadows* (1960)
EXHIB: RA (Retrospective 1967); NGG (Memorial 1978); MIN (1986)
COLL: T; V&A; MIN; many provincial galleries
LIT: J. Lewis, *John Nash, the Painter as Illustrator* (1978); Sir John Rothenstein, *John Nash* (1983); A. Freer, *John Nash: 'The Delighted Eye'* (1993) SH

NB – see Bennett, David Neil & Bentley, Nicolas Clerihew

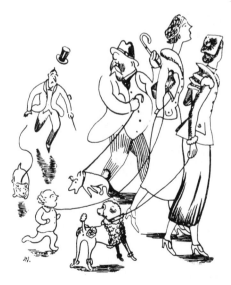

John Nash, *Night & Day*, 1937

NEB – see Niebour, Ronald

NERMAN, Einar (1888–1980). Caricaturist, portrait painter, illustrator and theatre designer. Einar Nerman was born in Norrköping, Sweden, and studied art in Stockholm and in Paris with Matisse but was mainly influenced by BEARDSLEY. His first drawings were published in a Swedish magazine when he was aged 19 and he first visited London in 1919 as a ballet dancer at the London Coliseum. In 1921, after encouragement by Ivor Novello who had seen his décor for Rolf's cabaret nightclub in Stockholm in 1918, he returned and produced weekly theatre caricatures for the *Tatler* and monthly caricatures of singers and musicians for *Eve* until 1930. He then went back to Sweden and later worked in New York for *New Yorker* and drew Hollywood stars for *Journal American*. He finally returned to Sweden in 1950 to concentrate on portrait painting, illustration and theatre design.
PUB: *Gosta Berlings-bilder* (1916), *30 Brekfort* (c. 1920), *Bland Vackra Barn Och Fula Gubbar* (1929), *Darlings of the Gods* (1930), *Gubbar Med Rim* (1931), *Den Lustige Langdansen* (1947), *Middagen pa Traneholm* (1968), *Divor Och Divaner* (1974), *Caught in the Act* (1976)
ILL: H. C. Andersen, *The Swineherd* (1924); E. M. Besly, *The Second Minuet* (1929); E. M. E. Wagner, *Den Namnlosa* (1929)
EXHIB: TM (1976) MB

Einar Nerman, [Gladys Gooper in *Magda*], 1923

NEWMAN, Nicholas Anthony (b. 1958). Cartoonist, pocket cartoonist and scriptwriter. Nick Newman was born in Kuala Lumpur, Malaya, on 17 July 1958 and is a self-taught artist. He read History at Oxford where he founded *Passing Wind* magazine and was a business journalist on *Management Today* (1979–83) before becoming a cartoonist. Pocket cartoonist on the *Sunday Times* (since 1989) he has also worked regularly for *Private Eye* (since 1981), drawing single cartoons and strips such as 'Battle for Britain', 'Dan Dire' and 'Snipcock & Tweed'. He also produces (with Ben Woolley) 'Megalomedia' for the *Guardian* (since 1989) and has contributed to *Spectator*, *Independent Magazine*, *Yachting Monthly*, *Marxism Today* and *Punch*. A scriptwriter for Central TV's 'SPITTING IMAGE' (1983–8) he has co-written (with Ian Hislop) two 'Murder Most Horrid' BBCTV shows and contributed sketches to ITV's 'The Harry Enfield Show' and others.
PUB: *Newmanship* (1985), [with I. Hislop] *The Battle for Britain* (1987), *The Best of Nick*

"The tip's small, but beautifully presented."

Nick Newman, *Spectator*, 1992

Newman (1990), [with D. Austin & K. Williams] *Far from the Madding Cow !* (1990), (ed.) *Spitting Image: The Giant Komic Book* (1985)
ILL: *Private Eye, The Thrid* [sic] *Book of Boobs* (1985)
EXHIB: CG; BC MB

NEWMAN, William (fl. 1835–64). Cartoonist and illustrator. In the 1830s William Newman contributed 'comic cuts' (usually pictorial puns in the manner of THOMAS HOOD) to *Figaro in London* and in 1841 on the foundation of *Punch* was employed as a general utility artist, occasionally contributing the political cartoon but mainly drawing small-scale decorations, silhouettes and initials. He stayed with *Punch* until 1850 although being poor he was poorly paid and not accepted by the other staff because of what Spielmann called his 'lack of breeding and common manners'. Around this time he also contributed comic drawings to *Squib, Puppet Show* and *Diogenes*. In 1864 his drawings appeared in the *Comic News*, after which he emigrated to the United States where, to quote Spielmann again, 'more lucrative employment awaited him'.
PUB: *Moveable Shadows for the People* (1859), *Zoological Oddities* (1859)
ILL: R. K. Philp, *The History of Progress in Great Britain* (1858) SH

NEWTON, Richard (1777–98). Caricaturist, miniature painter and illustrator. Newton's first caricature was published when he was aged 13 and altogether in his brief career he etched some 200 satirical prints. He worked initially for the radical London publisher William Holland, taking charge of the shop when Holland was imprisoned for sedition (1793–4). His political caricatures include some rude assaults on the Royal Family and the young Napoleon but most of his drawings were on social themes and were remarkable for extravagant burlesque and schoolboy smut. One of the interesting aspects of his work was the pioneering use of the 'strip' technique on a single plate. A master of the grotesque, some of his later drawings also display a certain elegance and when he died, aged 21, the world may have lost an outstanding caricaturist.
ILL: L. Sterne, *Sentimental Journey Through France and Italy* (1795); H. Fielding, *Illustrations to Tom Jones* (1799)
EXHIB: SBC 'Folly and Vice' (1989–90)
COLL: BM; V&A SH

NIEBOUR, Ronald (fl. 1930s–after 1960). Pocket cartoonist and strip cartoonist. Ronald Niebour was at school in Wales with ILLINGWORTH and then spent two years in the Merchant Navy. He worked on the *Oxford Mail* before joining the *Daily Mail* in 1938, contributing regular brush-drawn pocket cartoons until his retirement on 1 December 1960. Cartoons by Neb and Illingworth were found in a file in Hitler's Chancellery after the war.
COLL: UKCC MB

NIXON, John (fl. 1780–d. 1818). London merchant, amateur painter, illustrator and caricaturist. Caricature prints by or after John Nixon start to appear around 1780 and continue until 1807. Most of them are good humoured personal or social satires, with the occasional excursion into City politics, but the large print 'French Liberty' (1793) is a powerful assault on French Revolutionary excesses and was much admired by the De Goncourts. For his topographical drawings, and caricatures in watercolour, which have been widely admired, Nixon made frequent sketching tours, one of which, to Ireland (1791), was in company with CAPTAIN GROSE. He was secretary of the Beefsteak Club and the friend of many artists, including ROWLANDSON, who influenced his style. A large collection of his drawings and watercolours belonging to the French Hospital of La Providence was sold at Christie's (1974–9). Much of his work is unsigned or signed with initials.
ILL: W. Watts, *Seats of the Nobility and Gentry* (1779–86); T. Pennant, *Journey from London to the Isle of Wight* (1801); *Guide to the Watering Places* (1803)
EXHIB: RA
COLL: BM; V&A SH

NOBODY, A. – see Browne, Gordon Frederick

NORFIELD, Edgar George 'EN' (fl. 1930s–d. 1977). Cartoonist, painter and illustrator. Edgar Norfield studied art in Cambridge, London and Paris and drew cartoons for *Night & Day, Men Only, London Opinion* and *Punch*. An admirer of C. E. BROCK, he owned Brock's desk easel.
PUB: *Hic, Haec, Hock!* (1934), *Steady, Boys, Steady* (1943), [with C. R. Benstead] *Alma Mater* (1944), *Mother of Parliaments* (1948), *Gyp's Hour of Bliss* (n.d.)
ILL: L. Dutton, *Rags, M. D.* (1933); J. Gibbons, *Roll On, Next War!* (1935); P. Gallico, *The Small Miracle* (1951)
EXHIB: RI MB

NORTH, Brownlow (1778–1829). Amateur caricaturist. Brownlow North was the second son of the the Rt Rev. and Hon. Brownlow North, Bishop of Worcester (later Bishop of Winchester) and brother of Frederick, later 6th Earl of Guildford. Whilst an undergraduate at Cambridge (1798) he designed a set of hunting caricatures. His scenes of social comedy, usually involving comic accidents, were engraved by GILLRAY and others (1800–6) and are signed with a compass pointing north. He died on 28 September 1829.

COLL: BM SH

O

OLLIE – see Collins, Clive Hugh Austin

ONWHYN, Thomas (fl. 1837–d. 1886). Illustrator and cartoonist. Thomas Onwhyn was born in London, the son of a bookseller. His etchings were published under the pseudonym 'Sam Weller' in an unauthorized edition of Dickens's *Pickwick Papers* and the performance was repeated in 1838 with *Nicholas Nickleby* under the pseudonym 'Peter Palette'. The style is similar to PHIZ but broader in treatment. He went on to illustrate a number of books by H. Cockton and others and to issue some attractive albums of humorous etchings, mostly published by Rock in the 1860s. His work for *Punch* (1847–50) is undistinguished because he never took to drawing on the wood block. He gave up drawing in 1870 and died on 5 January 1886.
PUB: *Etiquette Illustrated . . . by an ex-M. C.* (1849), *Mr Perry Winks Submarine Adventures & Dream at Sea* (c. 1850), *Mr and Mrs John Brown's Visit to London* (1851), *Mr Goggleye's Visit to the Exhibition of National Industry* (1851), *Visitors' Souvenir of the Seaside* (1855), *Peter Palette's Tales and Pictures in Short Words for Young Folks* (1856), *Cupid and Crinoline* (1858), *Marriage à la Mode* (n.d.), *Precious Juveniles at the Seaside* (n.d.), *Mamma at the Seaside* (n.d.), *Pleasures of the Water Cure* (n.d.)
ILL: H. Cockton, *The Life and Adventures of Valentine Vox, the Ventriloquist* (1840), *George St George Julian, the Prince* (1841), *The Sisters* (1844), *Sylvester Sound, the Somnambulist* (1844), *The Love Match* (1845), *The Steward* (1850); C. Selby, *Maxims and Specimens of William Muggins* (1841); E. Sue, *The Mysteries of Paris* (1844)
COLL: BM SH

ORPEN, Sir William RA (1878–1931). Portrait and genre painter, and occasional comic artist. William Orpen was born in Stillorgan, Co. Dublin, on 27 November 1878, the son of a solicitor and amateur watercolourist. He left school aged 12 to attend the Metropolitan School of Art, Dublin (1890–6), and later regretted his lack of formal education. Moving to the Slade School in London he was hailed as a prodigy and his brilliant reputation was confirmed by paintings exhibited at the NEAC (1900). He went on to make an extraordinarily successful career as a portrait painter and an Official War Artist, was knighted (1918) and elected RA (1919). The numerous comic sketches with which he habitually covered his letters and envelopes reveal much wit and imagination besides demonstrating his astonishing fluency as a draughtsman. He died in London on 29 September 1931.
PUB: *An Onlooker in France 1917–1919* (1921), *Stories of Old Ireland and Myself* (1924)
EXHIB: RA, B; M (Memorial 1933)
COLL: T; NPG; IWM; NGI; provincial museums
LIT: R. Pickle, *Sir William Orpen* (1923); P. G. Konody & S. Dark, *Sir William Orpen, Artist and Man* (1952) SH

ORR, Cecil Edward Parker (1909–65). Cartoonist, strip cartoonist, poster artist, caricaturist, illustrator and writer. Cecil Orr was born in Glasgow on 29 September 1909, the son of a fish and poultry merchant. He was educated at Gourock and Greenock High Schools. At the age of 11 he drew posters for local cinemas and shops in Gourock and produced and illustrated the school magazine. After studying at Glasgow School of Art he began drawing illustrations for Collins' boys' annuals and turned professional at the age of 18, joining Associated Scottish Newspapers (1928–41) as illustrator and cartoonist. During World War II he served in the RAF. Orr was a prolific artist working for *Radio Times*, *Sunday Mail*, *Red Poppy*, *Sketch*, *Glasgow Daily Record* (political cartoons) and numerous children's comics (e.g. *June*, *Swift*, *Knockout*). He also produced posters for the theatre and the

Scottish Department of Agriculture, designed stage scenery, drew advertisements and caricatures, and illustrated children's books. Orr worked in line, wash and colour and used Gillot 290 and 170 pens with ball-pointed writing nibs such as Waverley or Ruby for lettering and Drawlet for anything larger. He died on 23 August 1965.

ILL: L. Lane, *How to Become a Comedian* (1945)
COLL: BFI MB

OSPOVAT, Henry (1877–1909). Illustrator and caricaturist. Born in Russia, the son of a Jewish Talmudist, Henry Ospovat emigrated with his family to Manchester and studied at the Manchester School of Art. In 1897 he was awarded a scholarship to study lithography at the South Kensington Schools. His talent and originality soon led to commissions for book illustration and the illustration of stories in magazines like the *Idler*. In these he developed a powerful style influenced by the Pre-Raphaelites and the Birmingham School but much of his work showed little feeling for the text. At the same time he drew many caricatures and they convey a vivid idea of personality. His plan to issue a book of his caricatures under the title 'Stars of the Music Hall Stage' was aborted by his early death on 2 January 1909.

ILL: W. Shakespeare, *Sonnets* (1899), *Songs* (1901); M. Arnold, *Poems* (1900); C. E. Maud, *Heroines of Poetry* (1903): R. Browning, *Men and Women* (1903); *The Song of Songs* (1906)
EXHIB: BG; NEAC
COLL: BM; V&A
LIT: O. Onions, *The Work of Henry Ospovat* (1911) SH

OWEN, William (1869–1957). Cartoonist, illustrator and commercial artist. Will Owen was born in Malta, the son of a naval officer. He was educated in Rochester and studied at the Lambeth School of Art. From 1890 he contributed cartoons and humorous illustrations to many periodicals, including the *Bystander*, *Girl's Realm*, *Grand*, *Graphic*, *Holly Leaves*, *Humorist*, *London Magazine*, *London Opinion*, *Pears Annual*, *Pearson's*, *Pick-Me-Up*, *Printer's Pie*, *Punch*, *Temple* and the *Windsor Magazine*. His bold, economical style was influenced by PHIL MAY and his breezy sense of humour is reminiscent of JOHN HASSALL. He was seen to best advantage in full-page cartoons, often featuring fishermen or sailors, in the *Sketch* and *Tatler*. From 1899, in the *Strand Magazine*, he illustrated many of the humorous stories of W. W. Jacobs in what came to be a celebrated partnership. His cheerful outlook on the world and his liking for strong outlines and broad masses of colour made him well suited to commercial work and his most famous poster 'Ah, Bisto!' also demonstrated his love of children.

PUB: *Alleged Humour* (1917), *Three Jolly Sailors and Me* (1919), *Old London Town* (1921), *Potted London* (1934), *Mr Peppercorn* (1940)
ILL: W. W. Jacobs, *A Master of Craft* (1900), *At Sunwich Port* (1902), *Odd Crafts* (1903), *Dialstone Lane* (1904), *Short Cruises* (1907), *Salthaven* (1908), *Sailors' Knots* (1909); A. E. Copping, *Jolly in Germany* (1910); J. K. Jerome, *A Miscellany of Sense and Nonsense* (1923); D. MacCulloch, *Gardening Guyed* (1931); B. T. Jones, *What's the Buzz?* (1943)
EXHIB: BSG
COLL: BM; V&A SH

P

PALETTE, Peter – see Onwhyn, Thomas

PAPAS, William (b. 1927). Political cartoonist, strip cartoonist, illustrator and painter. Bill Papas was born on 15 July 1927 in Ermelo, Transvaal, South Africa of Greek/German parents and after World War II studied art in Johannesburg, at Beckenham Art School, Kent, and at St Martin's (1947–9). He then returned to South Africa to work as cartoonist on the *Cape Times*, *Johannesburg Star* and *Drum Magazine*

(1952–8), leaving to become a farmer and timber trucker. Papas came back to the UK in 1959, succeeding LOW drawing political cartoons for the *Guardian* (being succeeded in turn by LES GIBBARD in 1969) and contributing to *Sunday Times* (1960–5) and *Punch* (1959–70). Banned from South Africa since 1980 because of his cartoons on apartheid, he went to Greece on a sabbatical from the *Guardian* in 1969 and stayed till 1983, producing book illustrations and exhibiting his artwork. He then moved to Geneva

and thence to Portland, Oregon, in 1984 and has since produced illustrations and pen-and-ink and watercolour pictures of American cities. In 1992 he began a self-syndication service and intermittently supplies political cartoons to *Los Angeles Times*, *Newsday*, *Kansas City Star* and other US and Canadian papers.

PUB: [with A. Sussens] *Under the Tablecloth* (1952), *The Press* (1964), [with G. Moorhouse] *The Church* (1965), [with N. Shrapnel] *Parliament* (1966), *Tasso* (1967), *No Mules* (1967), *A Letter from India* (1968), *A Letter from Israel* (1968), *Taresh the Tea Planter* (1968), *Theodore, or the Mouse Who Wanted to Fly* (1969), *Elias the Fisherman* (1970), *The Monk and the Goat* (1971), *The Long-Haired Donkey* (1972), *The Most Beautiful Child* (1973), *The Zoo* (1974), *People of Old Jerusalem* (1980)

ILL: Many books including G. Mikes, *Jamaica* (1965), *How to Be Affluent* (1966); T. Papas, *Mr Nero* (1966); J. Stone, *The Law* (1966); M. Muggeridge, *In the Valley of the Restless Mind* (1977); C. S. Lewis, *The Screwtape Letters* (1979); A. Oz, *Soumchi* (1980)

EXHIB: Greek Centre; Indian Tea Centre; Dowmunt Gallery; BCO, Athens; Gallerie Kourd, Athens; Old City Museum, Jerusalem; Galerie Weber, Geneva; O'Grady Galleries, Chicago; Senate Office Building, Washington DC; Gusman Cultural Center, Miami; Plaza of the Americas, Dallas; C. G. Rein Galleries, Houston; Calgary Stampede, Canada; LA 90 Art Fair, Los Angeles; Oregon Historical Society, Oregon

COLL: UKCC; NPG; V&A MB

PARKES, Terence 'Larry' (b. 1927). Cartoonist and illustrator. Born in Birmingham on 19 November 1927, the son of a welding foreman in a motor-car factory, Larry studied at the College of Arts & Crafts in Birmingham. He spent his National Service in the Army (1946–8) and taught art at Lincoln Road Secondary Modern School in Peterborough, Lincolnshire (1951–4), before turning freelance in 1957, working for *Punch*, *Birmingham Evening Mail*, *Soldier*, *Private Eye*, *Oldie*, *Guardian* and *Daily Telegraph* as well as working in advertising promoting Double Diamond, Newcastle Brown and Heineken beers amongst others. He has also produced cartoons and commentary for Granada TV's 'Afternoon Edition' (1963–4) and for a short while (1973–4) was a scenery painter in Joan Littlewood's Theatre Royal. His pseudonym derives from Larry Parks, star of the film, *The Al Jolson Story*,

which was shown in Peterborough when he was teaching there in 1954 – the pupils' nickname for their art master stuck. Elected an Honorary Fellow of Birmingham Polytechnic (now University of West Midlands) in 1991, he began experimenting with sculptured clay cartoons on art themes in 1992. Larry's cartoons never have captions and he draws without roughs on 10 × 8in. typing paper using a Rolinx dip pen and Rotring black ink (sometimes also watercolour). An admirer of Daumier, Lautrec and Van Gogh, his own work has been praised by Charles Schulz and Harpo Marx. 'One of the most prolific and unerringly funny of all the current graphic humorists [he] goes in for everyday situations which he dashes off in a deceptively ingenuous "off the cuff" scrawl that emphasises, far more effectively than could an elaborately overworked illustration, the basic inanity of human activities' (Geipel). 'His work demonstrates that perfect marriage between style of idea and style of drawing' (HEWISON). He is perhaps best known for his art (particularly 'Rodin' sculpture) jokes and those featuring his 'Man' character, of whom he has written: 'This bloke I draw is what I'd like to be. He's not a great soldier. I can't see him charging. He's more like Old Bill – a survivor. He wouldn't know what love is about but he's reliable, He's not practical, of course, but he's ingenious, and he gets there in the end.'

PUB: *Man in Apron* (1959), *More Man in Apron* (1960), *Man in Office* (1961), *Man at Work*

Larry (Terence Parkes), *Punch. c.* 1978

(1962), *Man at Large* (1964), *Man and Wife* (1965), *Man's Best Friend* (1966), *Man in Garden* (1966), *More Man in Garden* (1967), *The Larry Omnibus* (1967), *Man in Motor Car* (1968), *Man in School* (1972), *Man on Holiday* (1973), *Larry* (1974), *Larry's Art Collection* (1977), *Larry on Art* (1978), *Best of Larry* (1983), *Garden Lot* (1988), *DIY Man* (1989)
ILL: Many books including J. Herriot, *Vets Might Fly* (1976); E. Harlow (ed.), *101 Instant Games* (1977); G. Mikes, *How to be Poor* (1983); K. W. Parsons, *The Way of the Wally* (1984); S. Pile, *The Return of Heroic Failures* (1988)
EXHIB: L; CBG; CG
COLL: V&A; BM; EU; UKCC
LIT: [with M. Bryant] *Larry on Larry* (1994)
MB

PARKINSON, William (fl. 1890–1900). Cartoonist and illustrator. W. Parkinson contributed to a number of periodicals in the 1890s including *Ally Sloper's Half Holiday*, *Black & White* and *Pick-Me-Up*. His best work is in *Judy* during its palmy days (1890–5) when in THORPE's words 'it was an excellent production with a list of artists almost equal to those of *Punch*'. Parkinson's full-page political cartoons are lively in drawing and could bite, though latterly he overdid the TENNIEL-style symbolism.
PUB: *The Knight Errant of the Nursery* (n.d.)
ILL: G. Macdonald, *A Rough Shaking* (1900)
EXHIB: RA
COLL: V&A
SH

PARTRIDGE, Sir J. Bernard RI NEAC (1861–1945). Cartoonist, illustrator and painter. Bernard Partridge was born in London on 11 October 1861, the son of Ralph Partridge, President of the Royal College of Surgeons and the nephew of John Partridge, Portrait Painter Extraordinary to Queen Victoia and the Prince Consort. Educated at Stonyhurst College, he then studied at the West London School of Art and for a short time practised as a decorator of church interiors. At the same time, having a deep love of the theatre, and acting in several professional productions, he

LEADERSHIP.

AS IT SHOULD HAVE BEEN ; BUT AS IT IS.

William Parkinson, [Gladstone], *Judy*, 24 September 1890

could not choose between art and the stage as a career. He exhibited oil paintings, watercolours and pastels and was elected NEAC (1893) and RI (1896). In the late 1880s he drew cartoons for *Moonshine*, *Judy* (from 1885) and the *Playgoer* and in the '90s his work appeared in *Black & White*, *Illustrated Bits*, *Illustrated Sporting & Dramatic News*, *Lady's Pictorial*, *New Budget*, *Pick-Me-Up*, *Quiver* and the *Sketch*. It was with a considerable reputation as a comic draughtsman that, recommended by DU MAURIER, he started in *Punch* (1891), joining the staff the following year. To begin with he contributed joke cartoons and theatrical caricatures and his draughtsmanship often sparkled. In 1899, with considerable misgiving, he started political cartooning, succeeding LINLEY SAMBOURNE as chief cartoonist in 1910 and continuing as such for 35 years. He followed the example of TENNIEL: a strong simple image academically drawn, magisterial comment, heavy reliance on symbolism, and by the time of his death the style was looking very old-fashioned. But his draughtsmanship, especially his portraiture and his minute attention to detail, was greatly respected, as was his personality, and he was knighted in 1925. He died on 9 August 1945. Considering the liveliness of his early book illustrations and social cartoons, some critics have regretted that political cartoons came to dominate his life.

PUB: *Punch Drawings* (1921), *Fifty Years with Punch* (1946)

ILL: J. K. Jerome, *Stageland* (1899); F. Anstey, *Voces Populi* (1890), *The Travelling Companions* (1899), *Mr. Punch's Pocket Ibsen* (1893), *Under the Rose* (1894), *Lyre and Lancet* (1895), *Puppets at Large* (1897), *A Bayard from Bengal* (1902); M. Wyman, *My Flirtations* (1892); A. Dobson, *Proverbs in Porcelain* (1893); J. M. Barrie, *Tommy and Grizel* (1901); R. Browning, *Rabbi Ben Ezra and Other Poems* (1915)

EXHIB: RA; RI; NEAC; FAS (1902, Memorial 1946)

COLL: BM; V&A; NPG; UKCC; IWM

LIT: D. P. Whiteley, *Bernard Partridge and Punch* (1952) SH

PATCH, Thomas (1725–82). Painter, engraver and caricaturist. Thomas Patch was born in Exeter, Devon, and in 1747 went abroad to study painting under C. J. Vernet. He made his way, chiefly on foot, to Rome, arriving in 1749, and the portraits he painted there soon became popular with Englishmen on the Grand Tour, one of his

principal patrons being Lord Charlemont. For mysterious reasons he was expelled from the Papal States in 1755 and settled in Florence where he was made welcome by the English envoy, Sir Horace Mann. In Florence his main activity was to make engravings of the frescoes but he also painted a number of 'caricature conversation pieces' in oils of English tourists that were highly esteemed by their subjects and by others like Horace Walpole. As Richard Godfrey has said, 'the essence of the activity is that the joke was shared. Artist and sitter combined in a conspiracy of mutual facetiousness that argued a degree of sophistication beyond the dullards at home.' Many of these caricature paintings still hang in the houses to which they were originally consigned. As well as conversation pieces Thomas Patch etched a number of single-portrait caricatures. He died on 30 April 1782.

COLL: BM; NPG; F; HC

LIT: F. J. B. Watson, *Thomas Patch* (1950) SH

PAV – see Minet, Francis

PAYNE, Charlie Johnson 'Snaffles' (1884–1967). Sporting artist and caricaturist. 'Snaffles' was born in Leamington, Warwickshire, on 17 January 1884, the son of a bootmaker. He served in the Royal Garrison Artillery (1902–5) and on leaving started to sell sketches of hunting and horse-racing subjects although he was entirely self-taught as an artist. In 1907 the *Bystander* published some of his caricatures signed 'Snaffles' (the name possibly deriving from one of Surtees' characters) and in 1908 Fores published a set of five humorous prints after his drawings. His long association with the *Illustrated Sporting & Dramatic News* started in 1910 with the publication of 'Hunting Types'. By the outbreak of World War I he was established as a sporting artist and humorist in the tradition of LEECH, his work being much influenced by that of his friend CECIL ALDIN and by H. M. BATEMAN. During the war he served in the Royal Naval Auxiliary and was commissioned in the RNVR. At this time he also contributed to the *Graphic* (signing his work 'Charlie J. Payne' or 'Charlie Payne' and added to his reputation with romantic or nostalgic prints. He produced his best work in the 1920s and '30s and became famous for his sporting prints, especially those on pigsticking in India, and for a series of books he wrote and illustrated himself. His style became distinctive, his powers

of composition improved greatly and his wry sense of humour was widely admired. At the start of World War II he contributed some drawings to *Punch* for the first time. He died on 30 December 1967.

PUB: *My Sketchbook in the Shiny* (1930), *'Osses and 'Obstacles* (1935), *More Bandobast* (1936), *A Half Century of Memories* (1949), *Four Legged Friends and Acquaintances* (1951), *I've Heard the Revelly* (1953)

ILL: G. Brooke, *Horse Lovers* (1928); M. J. Farrell, *Red Letter Days* (1933); J. K. Stanford, *Mixed Bagmen* (1947)

EXHIB: Court Gallery; Malcolm Innes Gallery

COLL: British Sporting Art Trust

LIT: J. Welcome & R. Collins, *Snaffles: The Life and Work of Charlie Johnson Payne* (1987)

SH

PEAKE, Mervyn Lawrence (1911–68). Illustrator, novelist, poet, painter, art teacher and comic artist. Mervyn Peake was born on 9 July 1911 in Kuling, China, the son of a medical missionary. Aged 11 he came to England and was educated at Eltham College where he excelled at drawing. He entered the RA Schools (1929) and on leaving in 1933 joined an artists' colony on the Island of Sark, then became a part-time teacher at the Westminster School of Art. The publication of *Captain Slaughterboard* (1939) revealed him as an illustrator with an outstanding talent for the comic-grotesque and he enhanced this reputation in many other books. Goya was his favourite painter and in much of his work the grotesque prevailed over the comic. On the other hand the illustrations to his nonsense poems (for which he had great aptitude) and books like *Figures of Speech* reveal another side of a nature which delighted in fantastic fooling. *Titus Groan*, the first book in his Gothic trilogy, was published in 1946; *Gormenghast*, which won the Royal Society of Literature Prize, appeared in 1951. During the 1950s he wrote, illustrated, painted and taught at the Central School but his work was increasingly affected by Parkinson's disease and his creative life ended in 1960. He died on 17 November 1968.

PUB: *Captain Slaughterboard Drops Anchor* (1949), *Ride-a-Cock-Horse and Other Nursery Rhymes* (1940), *Rhymes Without Reason* (1944), *The Craft of the Lead Pencil* (1946), *Letters from a Lost Uncle* (1948), *Drawings by Mervyn Peake* (1949), *Mr Pye* (1953), *Figures of Speech* (1954), *The Rhyme of the Flying Bomb*

(1962), *A Book of Nonsense* (1972), *The Drawings of Mervyn Peake* (1974)

ILL: Many books including L. Carroll, *The Hunting of the Snark* (1941), *Alice's Adventures in Wonderland and Through the Looking Glass* (1954); S. T. Coleridge, *The Rime of the Ancient Mariner* (1943); A. M. Laing, *Prayers and Graces* (1944); C. Hole, *Witchcraft in England* (1945); Grimm Brothers, *Household Tales* (1946); R. L. Stevenson, *Treasure Island* (1949); H. de Balzac, *Droll Stories* (1961)

EXHIB: LG; NBL (Memorial 1972)

COLL: BM; V&A

LIT: J. Batchelor, *Mervyn Peake* (1974); J. Watney, *Mervyn Peake* (1976)

SH

PEARS, Charles ROI (1873–1958). Marine painter, cartoonist, illustrator and author. Charles Pears was born in Pontefract, Yorkshire, on 9 September 1873 and educated at Pontefract College. In 1895 he contributed theatrical sketches to the *Yorkshireman* and soon after some drawings were published in the *Idler* and *Judy*. In 1897 he settled in London and the following year succeeded S. H. SIME as theatrical caricaturist for *Pick-Me-Up*. He became a frequent contributor of joke cartoons, often with a maritime flavour, to *Punch* and his humorous work was also published in the *Butterfly*, *Bystander*, *Cassell's*, *Dome*, *Girl's Realm*, *Illustrated London News*, *London*, *London Opinion*, *Longbow*, *Ludgate Magazine*, *Nash's*, *Odd Volume*, *Pears Annual*, *Pearson's*, *Printer's Pie*, *Quartier Latin*, *Sketch*, *Strand*, *Tatler* and the *Windsor Magazine*. As well as comic work and illustration he painted marine pictures and founded the Society of Marine Artists. He was elected ROI (1913). During World War I he served in the Royal Marines and was Official War Artist to the Admiralty (1915–8). Pears drew posters for the London Underground and the Empire Marketing Board and in later life wrote several books on sailing.

PUB: *'Men', Drawn and Rhymed About* (1902), *Mr Punch's Book for Children* (1902), *Mr Punch's New Book for Children* (1903).

ILL: G. James, *Toby and His Little Dog Tan* (1903); W. M. Thackeray, *Some Round-About Papers* (1908); R. H. Dana, *Two Years Before the Mast* (1911); J. Masefield, *Salt-Water Poems and Ballads* (1911); C. Dickens, *Works* (1913); R. P. Gossop, *In the Press and Out Again* (1913); P. F. Westerman, *Sea-Scouts All* (1920); L. Carroll, *Alice's Adventures in Wonderland* (1922)

EXHIB: RA; ROI
COLL; V&A; IWM
LIT: J. A. Hammerton, *Humorists of the Pencil*
(1905) SH

PEATTIE, Charles William Davidson (b. 1958).
Cartoonist and strip cartoonist. Charles Peattie
was born in Manchester on 3 May 1958 and
attended St Martin's School of Art. After a
successful period as a portrait painter he became
a full-time cartoonist creating (with Mark Warren)
the strips 'Ad Nauseam' for *Direction* (1986–8),
'Dick' for *Melody Maker* (1985–8) and 'Celeb',
a sympathetic depiction of an unashamed and
unrepentant has-been rock star, for *Private Eye*
(since 1987). However, he is perhaps best known
as the creator (with Russell Taylor) of the 'Alex'
strip about a 25-year-old high-finance whizz kid
notable for an impressive degree of self-
confidence, intolerance and gadget-obsession.
The series began in the *London Daily News*
(February–July 1987), moved to the *Independent*
(1987–91) and has been running in the *Daily
Telegraph* since 1992. Peattie uses a dip-pen and
ink on white marker-pad paper and describes his
influences as 'too numerous to mention, but they
include MICHAEL HEATH, Robert Crumb,
RONALD SEARLE, CARL GILES, Claire Brétecher,
Parker and Hart'.
PUB: [with M. Warren] *The Pocketsized Dick*
(1987), *Celeb* (1991), [with R. Taylor] 'Alex'
series (6 titles from 1987)
ILL: 'The Secrets of . . .' series (1988)
EXHIB: CG; BC
COLL: V&A; IWM MB

PEGRAM, Frederick RI (1870–1937). Illustrator
and cartoonist. Fred Pegram was born in London
on 19 December 1870, being a cousin of H. M.
and C. E. BROCK and becoming the brother-in-
law of the former. He studied at the Westminster
School of Art and spent three months in Paris,
where he claimed to have learned little. In 1886
his theatrical sketches were published in the *Pall
Mall Gazette* and soon his carefully finished pen
drawing and conscientious outlook made him in
high demand as an illustrator and cartoonist. His
work was published in *Black & White*, *Cassell's*,
Daily Chronicle, *Fun*, *Harmsworth*, *Holly
Leaves*, *Idler*, *Illustrated London News*, *Illus-
trated Sporting & Dramatic News*, *Judy*, *Lady's
Pictorial*, *Minster*, *New Budget*, *Printer's Pie*,
Queen, *Quiver* and *Tatler*. Most of his later
career was with *Punch* (1894–1937) where his
social cartoons were marked by classic drawing

and a sense of humour that was par for the
course. Pegram also painted in watercolour
(being elected RI in 1925), etched, made some
fine portrait drawings in pencil and undertook
some commercial work. He died in London on
23 August 1937.
ILL: B. Disraeli, *Sybil* (1895); F. Marryat, *Mr
Midshipman Easy* (1896), *Masterman Ready*
(1897); F. Mathew, *The Rising of the Moon*
(1898); Sir W. Scott, *The Bride of Lammermoor*
(1898); Sir W. Besant, *The Orange Girl* (1899),
M. Edgeworth, *Ormond* (1900); C. Dickens,
Martin Chuzzlewit (1900)
EXHIB: RA; RI; FAS (Memorial 1938)
COLL: V&A; BM SH

PELLEGRINI, Carlo 'Ape' (1839–89). Carica-
turist and portrait painter. Carlo Pellegrini was
born in Capua, Italy, of an aristocratic family. As
a young man he drew portrait caricatures of
Neapolitan Society and fought with Garibaldi. In
1864 he arrived penniless in England but his
originality and charm soon gained him friends in
high places, including the Prince of Wales. A
meeting with Thomas Gibson Bowles, the pro-
prietor of *Vanity Fair*, led to his drawing in 1869
the first caricature (of Disraeli, signed 'Singe') to
appear in the magazine and from that time until
his death he was, under the pseudonym 'Ape', the
paper's leading artist and chief attraction. His
method, the *portrait-charge*, well established on
the Continent, was new to English art. The aim
was to reveal the personality of the subject and,
in exaggerating pertinent characteristics, to
amuse rather than to deride. Ape, by his honesty,
perception and wit, proved himself to be a master
of the art. He greatly influenced MAX BEERBOHM
who dedicated his first book of caricatures to his
shade and called him the only significant carica-
turist of the Victorian era. LOW described his
drawings as 'probably more like the person they
depict than were the persons themselves'. Ape
was short and stout, generous, funny, eccentric
and hugely popular. He died on 22 January 1899
after friends had clubbed together to insure him
against poverty.
EXHIB: NPG 'Vanity Fair' (1976)
COLL: NPG; V&A; BM; RL
LIT: E. Harris, 'Carlo Pellegrini: Man and Ape'
(*Apollo*, January 1976) SH

PETT, Norman (c. 1902–c. 1957). Strip cartoon-
ist. Norman Pett taught art at Moseley Rd Junior
Art School in Birmingham where one of his
pupils was PETER MADDOCKS. However, he is

best known as the creator of 'Jane' for the *Daily Mirror*. Jane was originally based on Pett's wife Mary, who in real life had actually received a telegram asking her to look after a distinguished visitor who spoke no English, 'Count Fritz von Pumpernickel' – who turned out to be a red dachshund. At first a single-panel series, 'Jane's Journal' began on 5 December 1932 and featured a Bright Young Thing and her dog. When writer Don Freeman was engaged in December 1938 – introducing the idea of the character playfully shedding clothing during her adventures, and adopting the multi-panel format – and professional model Christabel Drury took over as Jane (1940), the strip became immensely popular. During World War II Jane's appeal was such that Hannen Swaffer, talking of her influence on the RAF in 1943 commented: 'The morale of the RAF depended on how much clothing she had left on in the *Daily Mirror* that morning. A legend grew up that Jane always stopped for victory. She was the anti-Gremlin.' Always accompanied by her faithful dachshund, Fritz, she was in love with Secret Service officer Georgie Porgie. When Pett retired, his assistant Mike Hubbard took over the drawing (1 May 1948) until the strip's final episode on 10 October 1959. Pett himself went on to create a similar striptease character, 'Susie', for the *Sunday Dispatch* (who had a white poodle) and continued to draw for children's comics until his death. As well as a number of books, Jane also appeared on stage, in a Keystone-New World film, *The Adventures of Jane* (1949), starring Christabel Drury, and in a BBC South TV documentary, 'Jane' (1989). Pett was an accomplished draughtsman and preferred drawing from life.
PUB: *Jane's Summer Idle* (1946), *Jane's Journal* (1946), *Jane on the Sawdust Trail* (1947), *Susie of the Sunday Dispatch* (1956), *Farewell to Jane* (1960), *Jane at War* (1976) MB

PETTIWARD, Daniel (b. 1913). Painter, writer, broadcaster and cartoonist. Born in Polzeath, Cornwall, on 7 November 1913, the younger brother of ROGER PETTIWARD ('Paul Crum'), Daniel Pettiward was educated at Eton and University College, Oxford, where he was President of his college Athletic Club. During World War II he served in RASC (1940–6) and later attended Salisbury School of Art. In the 1950s he invented 'Non-Art', 'A Guide to becoming a successful cartoonist without actually being able to draw' and wrote and

illustrated a number of articles on the subject for *Punch* (to which he contributed in several disciplines from 1937 to 1970) and *Young Elizabethan*, which were later collected into a book, *Money for Jam*. Described by FOUGASSE (rather to his annoyance) as being 'of the tribe of Thurber' he worked in pen, pen and wash, watercolour or gouache, and admired Crum, HOFFNUNG and ROWLANDSON. In the late 1960s he gave up drawing for publication – mainly out of pique as *Punch* and others considered his 'non-art' cartoons funnier than his properly drawn ones. In 1970, though continuing as Drama Critic for *Southern Evening Echo*, he abandoned writing as well, in favour of painting, cartooning and caricaturing for sale to the general public. Several combined and solo exhibitions of his work have been held and for 10 years he was a regular contributor to the Royal Institute of Painters in Watercolours exhibitions at the Mall Galleries.
PUB: [illustrated by P. Crum] *Truly Rural* (1939), *Money For Jam* (1956)
ILL: V. Graham, *A Cockney in the Country* (1958)
EXHIB: RSW; Salisbury Playhouse; Heron Gallery; The North Canonry, Salisbury; Hemyngsby, Salisbury MB

PETTIWARD, Roger 'Paul Crum' (1906–42). Cartoonist and painter. Roger Pettiward was born on 25 November 1906 in Suffolk, the second child of a well-to-do landowning father who was a gifted amateur draughtsman. He went to Eton where he won all the drawing prizes as well as the middleweight boxing cup (he was 6ft 5½in at school), leaving in 1925 to study agriculture at Christ Church, Oxford, where he was captain of the college Rowing Club and drew caricatures for *Isis*, *Sunday Express* and *Bystander*. He then studied art at the Vienna Academy and in Munich, the Slade and Paris, and accompanied Peter Fleming on his 1932 expedition to Brazil (recounted in Fleming's *Brazilian Adventure*). He also drew illustrations of restaurant scenes for *London Week* (1935–60) and Fortnum & Mason's catalogues. A contributor to *Punch* (from 1936) and *Night & Day* (1937), he signed sometimes with an anticlockwise spiral whorl. One of his most famous cartoons was of two hippos in a pool with the caption 'I keep thinking it's Tuesday'. He was immensely influential and FOUGASSE said 'these two, PONT and Pettiward, probably did more during this period to carry the development of

'I suppose they're all vaguely waterproof?'

Paul Crum (Roger Pettiward), *Night & Day*, 1937

modern pictorial humour a whole stage further than any two or twenty others put together'. The brother of *Punch* writer and illustrator DANIEL PETTIWARD, he died on 19 August 1942 while leading 'F' troop of No. 4 Commando in the raid on Dieppe. He usually drew in line or line and wash as well as colour, but occasionally used scraperboard. In Pettiward's view, every line in a cartoon, not just faces and noses, should be witty and the people should be recognizable types not non-existent grotesques. He introduced 'a new style of bleak, fantastic humour, in which drawing and idea formed a unity. He created a world of precise insanity ... He led the way to a humorous art that could be responded to without complete cognition ... a most individual humorist whose magnificent inconsequences had equally magnificent solidity of foundation' (Price). HEWISON has compared his near-surreal sense of humour with that developed much later in 'The Goon Show' and 'Monty Python's Flying Circus'. A member of the Euston Road Group, Crum admired Topolski, BERT THOMAS, FRANK REYNOLDS and George Grosz. A collection of his work, edited by Ruari McLean, was published after his death.

PUB: [ed. R. McLean] *The Last Cream Bun* (1984)
ILL: P. Fleming, *Variety* (c. 1933); D. Pettiward, *Truly Rural* (1939)
EXHIB: Eton; CG; LG; M; NEAC; RP; RBA

MB

PETTY, Bruce Leslie (b. 1929). Cartoonist, illustrator and filmmaker. Bruce Petty was born in Doncaster, Melbourne, on 23 November 1929. He attended Box Hill High School and studied art and design at Royal Melbourne Technical College (1945). In 1946 he joined Owen Bros advertising agency, Melbourne, working on animation, and in 1950 joined Colorgravure Publications, Melbourne, as an illustrator. Moving to London in 1953, he worked as a freelance illustrator for ABCTV, *Sunday Pictorial*, AEI, International Wool Secretariat and contributed cartoons to *Punch* (including covers), *Lilliput*, *Spectator*, *Esquire*, *Graphis*, *This Week*, *New Yorker* and *Saturday Review*. After six months in New York (1958) he returned to Melbourne in 1959 and worked for World Records, British Nylon Spinners, Volkswagen and Briggs & James advertising agency before joining the *Sydney Daily Mirror* and the newly-formed *Australian* in 1965, moving to the *Melbourne Age* in 1976. He won an Academy Award for his animated short film, *Leisure* (1976). 'Of the many *Punch* artists employing a deliberately chaotic scrawl, Petty comes nearest to achieving complete incoherence; an impression that gives his work a frantic urgency' (Geipel). HEWISON has also observed that 'Bruce Petty's ideas are nearly always placed in the centre of some violent action; action as it is happening or just after it has stopped happening.'

PUB: *Australian Artist in South East Asia* (1962), *Petty's Australia* (1967), *The Best of Petty* (1968), *The Penguin Petty* (1972), *The Petty Age* (1978)
ILL: K. F. Barnsley, *Mr Paley* (1957); P. Solsona, *Casa Pepe Book of Spanish Cooking* (1957)

MB

PHELIX – see Burnett, Hugh

PHILLIPS, John 'Sharpshooter'[?] (fl. 1825–42). Caricaturist and illustrator. John Phillips was the son of an eccentric painter in watercolour. He designed and etched social and political caricatures somewhat in the manner of HENRY HEATH (1825–32). In 1841 he was recruited to join the newly founded *Punch* as a general-purpose artist but left at the end of 1842 and subsequently contributed some comic drawings to the *Illustrated London News*. Dorothy George attributed to him the numerous political caricatures signed 'Sharpshooter' published 1829–31.

PUB: *London Clubs* (1829)
ILL: G. W. M. Reynolds, *Pickwick Abroad* (1838)
COLL: BM SH

PHILLIPS, Watts (1825–74). Cartoonist, playwright and novelist. Watts Phillips was born in November 1825, his father, of Irish extraction, being 'in commerce'. He was taught to etch by GEORGE CRUIKSHANK. His comic drawings appeared in *Punch* (1844–6), *Puck* and *Diogenes* (for which he drew political cartoons), but he was best known for illustrated comic narratives like *MP* published in the late 1840s and early 50s which incorporated a good deal of political satire. He lived for some years in Paris but settling in London in 1854 virtually abandoned art and pursued a successful career as a playwright and novelist. He died in London on 3 December 1874.
PUB: *The Model Republic* (1848), *A Case of Bankruptcy* (c. 1850), *An Accomodation Bill* (c. 1850), '*MP*' (c. 1850), *The Wild Tribes of London* (1855)
ILL: C. Mackay, *The Whiskey Demon* (1860)
LIT: E. Watts Phillips, *Watts Phillips, Artist and Playwright* (n.d.) SH

PHILPIN, William – see Jones, William John Philpin

PHIZ – see Browne, Hablot Knight

PIERROT – see Weisz, Victor

POELSMA, Dominic (b. 1936). Cartoonist, strip cartoonist and caricaturist. Dominic Poelsma was born in Leeuwarden, Holland, on 14 January 1936. A largely self-taught artist, he has worked in advertising in Holland, Australia and London, and attended Melbourne Technical College part-time in the 1950s. Political cartoonist for the Australian publication, *Newsweekly* (1957–9), he produced a series of 'English Worthies' caricatures for *Evening Standard*'s 'Londoner's Diary' in 1971 with humorous verse by Angus McGill. In addition he has drawn theatre cartoons for *Evening Standard* (1973–5) and caricatures ('The Chairman Says . . .') for *Spectator* (1973–5). However, he is perhaps best known for his collaboration with McGill on the *Standard*'s 'Augusta' strip which was originally entitled 'Clive'. Influenced by Doeve, Hergé, Schultz and Low, he works in pen and ink, watercolours and felt-tip markers.

PUB: [with A. McGill] *Clive* (1968), *Clive in Love* (1970), *Clive and Augusta* (1971), *Augusta the Great* (1977), *I, Augusta* (1978), *Augusta* (1989)
ILL: M. Markham, *Old is Great* (1978), *A Chauvinist is . . .* (1979); P. Brown, *Beware of the Teenager!* (1986); J. Morrison, 'Reading Games' series (four books, 1988); D. Gillett, *Rescuing the Nation's Health* (1993) MB

POND, Arthur FRS (1701–58). Painter, engraver and art dealer. After completing his education in London, Arthur Pond visited Italy with the sculptor Roubilliac. There he painted portraits in oil and pastels and made prints after Poussin and other masters, culminating in a volume of aquatints. He also engraved two sets of caricature prints after Italian artists, including 12 after Ghezzi (1736–47) which popularized personal caricature as a fashionable pursuit in England. This so aggravated HOGARTH that he issued the print 'Characters and Caricatura' to contrast the silly diversion of amateurs with his own depiction of 'character' for the purpose of moral satire. Pond's 'caricatura' were reprinted in 1823 and 1832 under the title 'Eccentric Characters'. He died on 9 September 1758.
COLL: BM; V&A; NPG
LIT: L. Lippincot, *Selling Art in Georgian London: the Rise of Arthur Pond* (1983) SH

PONT – see Laidler, Gavin Graham

POSY – see Simmonds, Rosemary Elizabeth

POTT, Charles L. (1865–after 1907). Cartoonist and painter. Charles Pott was born in Hampstead, London, on 9 January 1865, the son of Laslett John Pott, a well-known painter of historical genre. At school, in Germany and elsewhere, he showed a talent for comic sketches and, after a brief spell in the City, studied at Calderon's Art School in St John's Wood. He then started painting landscapes but in 1887 some of his illustrations were published in the *Illustrated London News* and from 1890 he worked for periodicals, mostly for *Cassell's Saturday Journal* but also for *Chums, Illustrated Bits*, the *Graphic* and *Punch* (1900–7). He was a keen Volunteer and many of his cartoons were on military subjects. The outline style he often favoured, deriving from DICKY DOYLE, was well suited to large numbers of figures.
EXHIB: RBA; ROI

LIT: J. A. Hammerton, *Humorists of the Pencil* (1905) SH

POY – see Fearon, Percy Hutton

PRANCE, Bertram (1889–after 1940). Painter and cartoonist. Bertram Prance was born in Bideford, Devon, and was taught by PERCY BRADSHAW. He contributed to *Humorist* (1924–40), *Punch*, *Strand Magazine*, *Nash*'s and other magazines and was a friend of W. HEATH ROBINSON. His draughtsmanship was sure and unfussy in the classic tradition.
EXHIB: RA; Arlington Gallery SH

PRITCHETT, Matthew 'Matt' (b. 1965). Cartoonist and pocket cartoonist. Matt Pritchett was born on 14 July 1964, the son of journalist Oliver Pritchett and grandson of novelist Sir Victor (V.S.) Pritchett. He studied graphics at St Martin's School of Art and, unable to get work as a film cameraman, was for a time a waiter in a pizza restaurant, drawing cartoons in his spare time. He had his first drawings published in *New Statesman*. His work has also appeared in *Punch*, *Spectator*, *Sunday Telegraph* and other publica-

MATT (Matthew Pritchett), *Daily Telegraph*, 1991

tions and he has been Pocket Cartoonist on the *Daily Telegraph* since 1988, succeeding MARK BOXER. Winner of Granada TV's 'What the Papers Say' Cartoonist of the Year Award in 1992, his drawing style has been influenced by that of BRYAN MCALLISTER and Sempé. He uses a fine Profipen felt-tip with occasionally Letratone or watercolour.
PUB: *The Best of Matt* (1991, 1992) MB

PRO – see Probyn, Peter Clive

PROBYN, Peter Clive (1915–91). Cartoonist, strip cartoonist, animator and arts administrator. Born on 18 November 1915, the son of Frank Probyn, Professor of the Horn at the Royal College of Music and a member of the London Philharmonic Orchestra, Peter Probyn went to Kipling and BRUCE BAIRNSFATHER'S old school, the United Services College. He left at 16 and worked in an advertising agency until bad health forced him to recuperate in Midhurst, Sussex, where he decided to become a humorous artist. At the age of 19 he sold six sketches to *Men Only* on the day the magazine first appeared, submitting the drawings under the pseudonym 'PRO' (he didn't use his full name until he was 21). He also contributed to *Night & Day*, *Punch*, *Illustrated London News*, *Current Affairs*, *Homes & Gardens*, *Lilliput* and *Tatler & Bystander*. During World War II he served in the Home Guard and was later a teacher before returning to work as a freelance artist and designer, mainly in advertising for companies such as Electrolux, Stewart & Lloyds Steel, BOAC, Royal Insurance and especially Ind Coope for whom he created the popular Double Diamond 'Little Man' with his bowler hat and Scottie dog which appeared on hoardings in the 1950s. He also designed greetings cards for Royles and Book Tokens, drew strip cartoons for *Eagle* and produced animated films for NATO. In 1962 he became County Art Advisor to East Sussex Education Authority and was a governor of Brighton College of Art, chairman of the Art Advisers Association and a committee member of the South East Arts Council. In addition, a life-long wine enthusiast and expert, he was for 25 years a member of the publications committee of the Co-operative Wine Society (for whom he drew many illustrations). Married to the artist Kissane Keane (1946), he worked mostly in line or line and wash and was particularly influenced by the work of *New Yorker* cartoonists. He died on 2 November 1991.

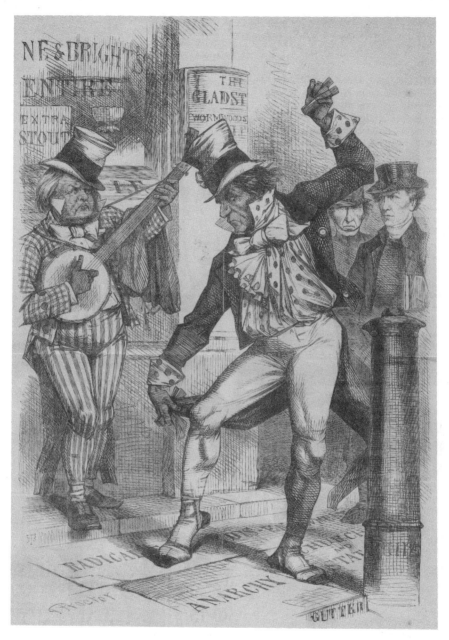

A CHAPTER OF AUTOBIOGRAPHY,
OR,
THE POLITICAL JIM CROW.

John Proctor, [William Gladstone], *Will-o'-the-Wisp*, 28 November 1868

PUB: (ed.) *The Complete Drawing Book* (1970)
ILL: Novels by F.Clifford, E.Fearon and others
COLL: Wine Society, Stevenage MB

PROCTOR, John (1836–after 1898). Cartoonist
and illustrator. John Proctor was born in Edin-
burgh and apprenticed for six years to a local
engraver before coming to London (1859) and
working as a graphic journalist for the *Illustrated
London News*. Around the same time he made
some children's book illustrations under the
pseudonym 'Puck'. He was Political Cartoonist
of *Judy* (1867–8) and produced vigorous draw-
ings in the generally accepted manner of
TENNIEL. In the 1870s he drew fantastic illustra-
tions for stories in *Young Folks' Weekly Budget*
and in 1874 designed the coloured covers of
Funny Folks, which has been called 'Britain's
first comic'. He also drew cartoons for *Cassell's
Saturday Journal, Illustrated Bits, Moonshine,
Sketch* and *Will O' the Wisp*. His political
cartoons in *Fun* (1894–8) are notable for portrai-
ture and skill in drawing animals. THORPE
describes Proctor as 'one of the best cartoonists
of the time with a fine bold method of using a
pen and a good sense of design'.
PUB: *The Rt Hon. W. E. Gladstone from Judy's
Point of View* (1878)
ILL: 'R. Quiz', *King Pippin* (*c.* 1860); *Grand-
mamma's Bright Thoughts for the Little Ones*
(1866); *Dame Dingle's Fairy Tales* (1866–7); W.
Reid, *Off Land's End* (1867); W.Sawyer, *The
Legend of Phyllis* (1872); R.Crawley, *The Book
of Manly Games for Boys* (1873); R.Quittenton,
Grant Land (1874); F. Owen, *Harty the Wan-
derer* (1879); G. A. Henty, *The Young Buglers*
(1880) SH

PRY, Paul – see Heath, William

PUCK – see Proctor, John

PVB – see Bradshaw, Percy Venner

"WHAT'S THE MATTER WITH YOU ? –
HAVEN'T YOU SEEN A CHARTERED
ACCOUNTANT BEFORE ?"

Ken Pyne, *Private Eye*, 29 May 1987

PYNE, Kenneth (b. 1951). Cartoonist, caricatur-
ist and strip cartoonist. Ken Pyne was born in
London on 30 April 1951. Self-taught, he was a
layout artist on *Scrap & Waste Reclamation &
Disposal Weekly* before becoming a freelance
cartoonist. He has contributed to *Private Eye,
Today, The Times, Independent, Guardian,
Evening Standard, Punch, People, Observer* and
Which? Voted CCGB Joke Cartoonist of the
Year (1981) he has also done a considerable
amount of advertising work.
PUB: *The Relationship* (1981), *Martin Minton*
(1982), *Silly Mid-Off* (1985), *This Sporting Life*
(1986), *In the Bleak Mid-Winter* (1987)
ILL: Several books
EXHIB: BC; CG
COLL: V&A; BM MB

Q

QUIZ – see Evans, Powys Arthur Lenthall

R

R – see Rushton, William George

RAFF – see Hooper, William John

RALSTON, William (1848–1911). Cartoonist, illustrator and photographer. William Ralston was born in Milton, Dumbartonshire, the son of a pattern designer who became a photographer. After school he worked for four years in a Glasgow warehouse and spent three years digging for gold in Australia. Returning to Scotland, he started to draw, learning from his brother, a talented artist who died young. In 1870 his work first appeared in *Punch* and up to 1880 he contributed 227 cartoons and comic drawings to the magazine. His best work, printed in colour for Christmas and Summer numbers, was published in the *Graphic* in the 1880s and 90s and often consisted of humorous stories or verses illustrated in many small scenes. In 1890 he was recruited as one of the original artists of the *Daily Graphic*. Around that time, on the death of his father, he returned from London to Glasgow to run the family photography business and thereafter his work was seen in periodicals much less frequently. He illustrated a number of books and was especially known for portraying the comic misadventures of big-game hunting.
PUB: *Sketches of Highland Character* (1873), *The Story of the Jovial Elephant* (1905), *Letters from a Grandfather about Billy* (1906), *Tippoo, the Tale of a Tiger* (1886), *Messrs Kamdene, Barnesburie and D'Alston's Tour in the North* (n.d.), *Kamdene, Barnesburie and D'Alston Go North Again, Golfing this Time* (1894), *K., B. and D'A's Yachting Holiday* (1896)
LIT: J. A. Hammerton, *Humorists of the Pencil* (1905) SH

RAMBERG, Johann Heinrich (1763–1840). Painter, printmaker, illustrator and caricaturist. Johann Ramberg was born in Hanover, Germany, on 22 July 1763, the son of a Councillor of State at the electoral court of Hanover who was also an amateur painter. He showed precocious powers as an artist and in 1781 came to London as a protégé of George III to study at the RA under REYNOLDS, West and Bartolozzi. Whilst there he made a number of caricatures, both social and political, which are burlesques of the Grand Manner in the style of

MORTIMER, those on the Prussian war with the Dutch (1787) being especially notable. He embarked on a four-year tour of Europe (1789–93) before pursuing a career as a book illustrator, court painter and printmaker in Hanover. Ramberg made many humorous prints (1825–8) including 'The Iliad Serious and Comic', a parody of Flaxman and the Neo-Classical style. He died in Hanover on 6 July 1840.
COLL: BM; N; Hanover
LIT: D. Kunzle, *The Early Comic Strip* (1973) SH

RAUSCH – see Whitford, Francis Peter

RAY – see Chesterton, Raymond Wilson

RAYMONDE, Roy Stuart (b. 1929). Cartoonist, comic painter and illustrator. Roy Raymonde was born on 26 December 1929 in Grantham, Lincolnshire, and attended Harrow School of Art (1944–6) where one of his teachers was GERARD HOFFNUNG. After National Service in Malaya (1948–50), he joined the studio of a Fleet Street advertising agency as an illustrator (1950–60), during which time he began freelancing as a cartoonist for such publications as *Daily Mirror, Daily Sketch, Star, Men Only* and *Fashion Weekly*. Around 1960, after selling his first cartoon to *Punch*, he became a full-time cartoonist, contributing regularly to *Sunday Telegraph, Mayfair, Punch* (including covers and illustrations for 'Doc Brief' 1985–8), *Reader's Digest* and, since 1971, *Playboy* (USA and Germany). Regular features for *Sunday Telegraph* (1969–72) have included 'Patsy & John' 'The Bergs', 'Them', 'Boffins at Bay', 'Raymonde's Blooming Wonders' and 'Raymonde's Rancid Rhymes'. In addition, he drew covers and illustrations for the short-lived revival of *Time & Tide* (1988–91) and has given lectures and talks in Korea and Japan (1990, 1991, 1992). Voted CCGB Feature Cartoonist of the Year (1966), he works in many media, including watercolour, gouache, pen and brush and admires Tomi Ungerer, QUENTIN BLAKE and Adolf Born. His son, Paul, is also a professional cartoonist and muralist. Geipel has described him as a 'debonair social satirist in the PONT tradition . . . a rich range of tonal washes against sharply incisive lines'.
PUB: *The Constant Minx* (1961), *More Constant*

Minx (1961), *Starters Russia* (1972), [with R. Holles] *The Guide to Real Village Cricket* (1983), *The Guide to Real Subversive Soldiering* (1985)
EXHIB: Marunie Gallery, Kyoto
COLL: SIM; Ritsumeikan Peace Museum, Kyoto; Kyoto Seika University, Kyoto; V&A
MB

READING, Bryan Lawrence (b. 1935). Cartoonist, strip cartoonist and illustrator. Bryan Reading was born in London on 24 February 1935 and after serving an apprenticeship in printing worked in advertising studios, producing cutaway technical drawings for Jaguar and Austin Motors as well as exhibition and leaflet designs. A contributor to *Punch*, *Private Eye* and other magazines, his first strip, 'The Belchers' (at first written by BRYAN MCALLISTER), appeared in Richard Boston's monthly *Vole* (1977–81). He has also drawn strips for the *Evening Standard* (1976–80), *Building Design* (1978–92) and *Traditional Homes* (since 1985) and feature cartoons for *Daily Mail* (1978–86), *Rolls-Royce News*, *Sun*, *London Daily News* (1987) and *Guardian* (1980–8). In addition, he has produced film animation for BP (1957) and artwork for film and TV productions (Euston Films, 1989–91). His 'Consumer Counsel' strip in the *Evening Standard* won the Argos Consumer Award (1980) and, a former committee member of the CCGB, he has been voted CCGB Feature Cartoonist of the Year three times (1983, 1987, 1988). A meticulous worker, especially with regard to architectural detail, he usually works in line without tints or wash.
PUB: *The Belchers* (1983), *Drawing Cartoons and Caricatures* (1987), *Cruel Britannia* (1993); *Morgan Mania* (1993)
ILL: More than 50 books including Mary Danby, *The Awful Joke Book* (1979), *The Armada Funny Story Book* (1980), *The Even More Awful Joke Book* (1982), *The Most Awful Joke Book Ever* (1984), *The Batty Cartoon Book*, and *Fun for Six Year Olds* (1989)
EXHIB: Building Centre; BC
COLL: V&A
MB

REED, Edward Tennyson (1860–1933). Cartoonist and illustrator. Born on 27 March 1860 in Greenwich, London, E. T. Reed was the son of Sir Edward Reed, Chief Naval Architect and MP for Cardiff. On leaving Harrow School he accompanied his father on a visit to Egypt and the Far East (1879–80). In 1883 he took up

drawing and his talent was encouraged by BURNE-JONES. His first contributions to *Punch* came in 1889 and in the *Punch Almanack* of 1893 appeared the first of the 'Prehistoric Peeps', a series of anachronistic jokes which proved extremely popular. Reed succeeded HARRY FURNISS as *Punch*'s parliamentary caricaturist in 1894 and continued as such until 1912. Some of his best political and legal cartoons were published in the *Sketch* (from 1893) and the *Bystander*. The popularity of Reed's work was due to its good-humoured tone and the artist's capacity to achieve excellent facial likenesses however distorted the bodies. He also had a gift for parody, notably of BEARDSLEY. Although many of his cartoons are in pen and ink he preferred pencil, in which he excelled.
PUB: *Mr Punch's Prehistoric Peeps* (1896), *Mr Punch's Animal Land* (1898), *Mr Punch's Book of Arms* (1899)
ILL: Lord Alfred Douglas, *Tails with a Twist* (1898); H. W. Lucy, *A Diary of the Unionist Parliament 1895–1900* (1901); *The Balfourian Parliament 1900–1905* (1906); R. C. Lehmann, *The Adventures of Picklock Holes* (1901); E. de la Pasture, *The Unlucky Family* (1907); M. Pigott, *The Beauties of Home Rule !* (1914); E. E. Spicer & E. C. Pegler, *De Mortuis Nil Nisi Bona* (1914); W. H. Burnet, *Quite So Stories* (1918)
EXHIB: FAS (1899); LG
COLL: V&A
LIT: Sir Shane Leslie (ed.) *Edward Tennyson Reed* (1957)
SH

REID, Arthur [ARthur REID] (b. 1936). Cartoonist, caricaturist, illustrator and sculptor. Born in Inverurie, Aberdeenshire, on 24 April 1936, Arthur Reid attended Aberdeen College of Commerce before studying sculpture and ceramics at Gray's School of Art, Aberdeen (1971–6), and art and design education at Aberdeen College of Education (1976–7). A part-time art and design specialist on Grampian Regional Council, his work has appeared in *Punch*, *Private Eye*, *Playboy*, *Penthouse*, *Mayfair* and in various advertising campaigns. Organizer of the annual FECO Edinburgh International Cartoon Festival since 1986 he is also Founder and President of the Cartoon Art Society and the founder of the School of Cartoon Sculptors. The winner of numerous awards, he has also served as a judge at international festivals at Knokke-Heist, Belgium (1981) and Margate, Kent (1989). His

E. T. Reed, *Mr Punch's Prehistoric Peeps*, 1896

main influence has been the work of THOMAS ROWLANDSON.

EXHIB: Artspace, Aberdeen

COLL: KN MB

REPTON, Humphry (1752–1818). Landscape gardener and occasional caricaturist. Humphry Repton was born in Bury St Edmunds, Suffolk, and educated in Norwich and Rotterdam. Having lost a fortune in the textile trade he turned to landscape gardening, his first commission at Cobham in 1790 leading to employment by many noblemen and by the Prince of Wales for the Pavilion at Brighton (1808). He published a number of books on the theory and practice of landscape gardening – including the celebrated 'Red Books' for clients – many of which were illustrated with ingenious aquatint plates after his own watercolours, operated on a sliding 'before and after' system. His occasional caricatures are on social subjects, principally fashion.

PUB: *Sketches and Hints of Landscape Gardening* (1794), *Observations on the Theory and Practice of Landscape Gardening* (1803), *Odd Whims and Miscellanies* (1804), *Designs for the Pavilion at Brighton* (1808), *Fragments of the Theory and Practice of Landscape Gardening* (1816)

EXHIB: RA

COLL: V&A; RIBA; Society of Antiquaries; BM

LIT: D. Stroud, *Humphry Repton* (1962) SH

REYNOLDS, Frank RI (1876–1953). Cartoonist and illustrator. Born in London on 13 February 1876, the son of an artist, Frank Reynolds studied at Heatherley's and was soon contributing to the periodicals including *Judy*, *Longbow*, *Pick-Me-Up*, *Playgoer* and, in powerfully-drawn cover designs, to *Sketchy Bits*. Most influential in helping him to make his mark were the full-page humorous drawings *c.* 1900 in the *Sketch*. In 1901 he was elected RI. In 1906 he began his long association with *Punch*, becoming one of the main social cartoonists and succeeding his brother-in-law F. H. TOWNSEND as Art Editor (1920–30). In 1910 he was chosen to illustrate a

Gift Book edition of *Pickwick Papers* and established himself over several titles as a sympathetic interpreter of Dickens. During World War I his 'Hunnish' cartoons in *Punch*, especially 'Study of a Prussian Household Having its Morning Hate' were widely admired. He played a leading role in *Punch* up to 1948, much of his best work appearing in colour in the Almanacks and Summer Numbers, including some memorable pastiches. His drawings in an unusual variety of media – pen, pencil, crayon, gouache and watercolour – were sometimes criticized as ugly but were always effective in depicting 'types', and he was also known for his habit of catching the significant moment, for his sporting scenes and for conveying emotion in backs. FOUGASSE once described him as 'a latter-day JOHN LEECH with the added fluidity and linear expression that "process" allowed'. He died on 18 April 1953. His son John illustrated *1066 and All That*.

PUB: *'Punch' Pictures by Frank Reynolds RI* (1922), *The Frank Reynolds Golf Book* (1932), *Hamish McDuff* (1937), *Off to the Pictures* (1937), *Humorous Drawing for the Press* (1947)
ILL: W. Sapte, *By the Way Ballads* (1901); K. Howard, *The Smiths of Surbiton* (1906); J. N. Raphael, *Pictures of Paris and Some Parisians* (1908); C. Dickens *The Adventures of Mr Pickwick* (1910), *David Copperfield* (1911), *The Old Curiosity Shop* (1913)
EXHIB: RI; WG
COLL: V&A; F
LIT: A. E. Johnson, *Frank Reynolds RI* (1907); P. Bradshaw, *The Art of the Illustrator 8: Frank Reynolds and His Work* (1918) SH

REYNOLDS, Sir Joshua PRA (1723–92). Portrait and history painter, writer and caricaturist. Born in Plympton, Devon, on 16 July 1723, the son of a schoolmaster, Reynolds studied in Italy (1749–52) and went on to become the leading portrait painter in England and President of the Royal Academy on its foundation in 1768. He was knighted in 1769 and was vastly influential as much because of his ideas as his artistic accomplishments. When in Rome he painted a number of caricature portaits of English visitors of which the most famous is 'Travesty of the School of Athens' (1751) in the National Gallery of Ireland, Dublin. On his return to London he abandoned caricature as being inconsistent with his notions of High Art and portraiture in the Grand Manner. But, ironically, 'The School of Athens' in which

English connoisseurs pose as Raphael's philosophers, is 'one of the most striking anticipations of the mentality and methods of the graphic satirists'. Reynolds died on 25 February 1792 and was buried in St Paul's Cathedral.
LIT: D. Holland, 'Characters and Caricatures' in *Reynolds* (RA Catalogue 1986) SH

RIDDELL, Christopher (b. 1962). Political cartoonist, illustrator and writer. Chris Riddell was born on 13 April 1962 in Cape Town, South Africa, and came to the UK in 1963. He attended Epsom School of Art and Design and studied illustration at Brighton Polytechnic Art School. He has been Political Cartoonist on the *Economist* since 1988 and *Independent* and *Independent on Sunday* since 1991. In addition he has drawn political cartoons for *Sunday Correspondent* (1989–90) and was business cartoonist on the *Observer* (1990–1). He has also written and illustrated a number of children's books such as *The Wish Factory* ('Magical and inventive – like HEATH ROBINSON with a few drinks inside him . . .' [*Independent*]).
PUB: *Ben and the Bear* (1986), *The Fibbs* (1987), *Bird's New Shoes* (1987), *Mr Underbed* (1986), *When the Walrus Comes* (1989), *The Wish Factory* (1990)
ILL: Many books including T. Hughes, *Ffangs the Vampire Bat and the Kiss of Death* (1986); M. Hoffman, *Beware, Princess!* (1986), R. McCrum, *The Dream Boat Brontosaurus* (1987); A. Gibson, *The Abradizil* (1990)
EXHIB: UKCC
COLL: IWM; UKCC MB

RIDGEWELL, William Leigh (1881–1937). Cartoonist and humorous illustrator. Ridgewell was born on 8 September 1881, the son of a commercial traveller, and educated at Brighton Grammar School. He was then apprenticed to an engraver and studied at Brighton School of Art in his spare time. Before World War I he practised as a freelance commercial artist, producing advertisements, posters and postcards. During his war service in India (1914–9) he contributed cartoons and sketches to *Indian Ink* and *The Looker-On* and, as he put it, 'got into the habit of thinking humorously' so that afterwards he found a ready market for his joke cartoons in *Punch*, *Humorist* and *London Opinion* in the 1920s and 30s and to a lesser extent in *Tit-Bits*, *Bystander* and *Passing Show*. His *Punch* drawings were realistic and, in contrast with most of the magazine's artists of the period, they con-

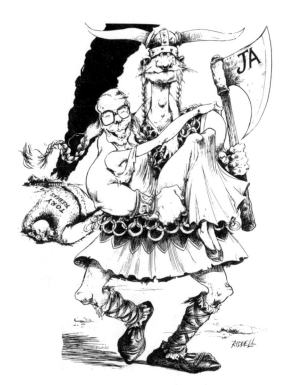

Chris Riddell, [John Major] *The Cartoonist*, 2 June 1993

veyed spontaneity, being in Price's words 'the harbinger of a complete change of style in the paper'. His humour was based on affectionate observation of suburban man and he borrowed a number of mannerisms from H. M. BATEMAN and FOUGASSE. He died on 7 November 1937.
PUB: *Line and Laughter, a Book of Drawings by Ridgewell* (1934)
ILL: H. Graham, *More Ruthless Rhymes for Heartless Homes* (1930) SH

RIGBY, Paul Crispin (b. 1924). Political cartoonist, painter and illustrator. Paul Rigby was born in Sandringham, Melbourne, on 25 October 1924 and studied art at Brighton Technical School in Melbourne, leaving aged 15 to work in a commercial art studio and then as a freelance commercial artist and book/magazine illustrator (1940–2). After serving in the Royal Australian Air Force in World War II (1942–6), he joined Western Australian Newspapers (1948–52) as an illustrator and in 1952 became Political Cartoonist on the *Daily News* (Western Australia). He then moved to London to join the

Sun (1969–74) whilst also working for the Springer Group in Germany and *National Star* (USA). Rigby returned to Australia and the *Sydney Daily Telegraph* in 1975 and moved to the USA to work for the *New York Post* in 1977, then *New York News* (his son Bay taking over his job on the *Post*). His cartoons have won five Australian Walkely Awards (1960, 1961, 1963, 1966, 1969), the New York Press Club Award (1981) and the US Newspaper Guild's Page One Award (1982). He works in pen and ink on Bristol board (Grafix or Craftint).
PUB: 20 books including [with B. K. Ward] *Willow Pattern Walkabout* (1959), *Rigby* (1970), *Paul Rigby's Course of Drawing and Cartooning* (1976), *New York and Beyond* (1984)
ILL: B. K. Ward, *Perth Sketchbook* (1966); A. Linkletter, *Linkletter Down Under* (1968)
EXHIB: Melbourne Gallery MB

RITCHIE, Alick P. F. (fl. 1892–1918). Caricaturist and illustrator. Alick Ritchie contributed to periodicals in the 1890s including *Eureka,*

Marooned Holiday-maker: "Do you know, Enid, to add to our troubles, I'm very much afraid it's going to be wet."

W. L. Ridgewell, *London Opinion*, June 1931

STUDIES IN STRAIGHT LINES AND
CURVES.
"Well, Uncle, I can hardly believe *you* are in
straightened circumstances !"

Alick Ritchie, *Pick-Me-Up*, 1 September 1894

*Ludgate Magazine, Penny Illustrated Paper, Pall
Mall Budget, St Paul's* and *Sketchy Bits*. His
cartoons in *Pick-Me-Up* (1894), consisting of a
few straight lines and curves, are advanced in
treatment, anticipating artists like FISH. *Vanity
Fair* published 15 of his caricatures (1911–3) and
he was a regular contributor of caricatures to the
Bystander during World War I.
PUB: Y? *Studies in Zoo-all-awry* (1912) SH

ROBB, Brian (1913–79). Illustrator, cartoonist,
teacher and painter. Brian Robb was born on 7
May 1913 in Scarborough, Yorkshire, and edu-
cated at Malvern College. He studied at Chelsea
School of Art (1930–4) and the Slade School
(1935–6). Before World War II he contributed
cartoons to *Night & Day* (1937) and *Punch*
(1937–9) and also drew humorous advertise-
ments for Shell. He served in the Middle East
during World War II and the cartoons he drew
for *Crusader* and *Parade* were collected into a
book. After 1945 he turned from cartooning to

book illustration – ARDIZZONE called him 'a born
illustrator in the great tradition of the 19th
century' – and became Head of the Illustration
Department at the RCA (1963–78). He also
painted in watercolour, notably views of his
beloved Venice. Brian Robb had a delightful,
slightly surreal sense of humour but his cartoons,
mostly in pen and ink, were a little too close to
the style of 'PONT' for his comfort. He died in
August 1979.
PUB: *My Middle East Campaigns* (1944), *My
Grandmother's Djinn* (1976), *The Last of the
Centaurs* (1978)
ILL: Aywos, *Hints on Etiquette* (1946); L. N.
Andreyev, *Judas Iscariot* (1947); R. Raspe,
*Twelve Adventures of the Celebrated Baron
Munchhausen* (1947); L. Apuleius, *The Golden
Ass* (1947); L. Sterne, *A Sentimental Journey*
(1948), *Tristram Shandy* (1949); H. Fielding,
Tom Jones (1953); Aesop, *Fables* (1954); J.
Roose Evans, *The Adventures of Odd and
Elsewhere* (1971), *The Secret of the Seven Bright
Shiners* (1972), *Odd and the Great Bear* (1973),
Elsewhere and The Gathering of the Clowns
(1974), *The Return of the Great Bear* (1975)
EXHIB: LON
LIT: E. Ardizzone, 'Brian Robb' in *Signature*
(1950) SH

ROBINSON, Charles RI (1870–1937). Illustra-
tor and occasional cartoonist. Born on 22
October 1870 in Islington, London, Charles

'It says "Beat the eggs until stiff". I've been
beating for two hours and I'm still as fresh as a
daisy.'

Brian Robb, *Night & Day*, 8 July 1937

Robinson was the son of Thomas Robinson and an elder brother of WILLIAM HEATH ROBINSON. After leaving Old Islington High School he was apprenticed for seven years to the printers Waterlow and studied in the evenings at the West London School of Art and Heatherley's. Following the success of his drawings for R. L. Stevenson's *A Child's Garden of Verses* (1895), he went on to illustrate more than 100 books, mostly for children, in a decorative style that initially owed a lot to BEARDSLEY but developed, especially in his sensitive use of colour, along very individual lines. Under the pseudonym 'Awfly Weirdly' he parodied Beardsley's style in *Christmas Dreams* (1896), a book of Christmas cards, menus etc. Although primarily an illustrator, he drew a number of cartoons in ink and wash that were published in the *Bystander* and the *Tatler* (c. 1902–12) and have a flavour of his brother William's style without his partiality for invention. He was elected RI (1932) and died on 13 June 1937.

PUB: *Christmas Dreams* (1896), *The Ten Little Babies* (1905), *Fanciful Fowls* (1906), *Peculiar Piggies* (1906), *Black Bunnies* (1907), *Black Doggies* (1907), *Black Sambos* (1907)

ILL: More than 100 books including R. L. Stevenson, *A Child's Garden of Verses* (1895); H. D. Lowry, *Make Believe* (1896); E. Field, *Lullaby Land* (1897); *Fairy Tales from Hans Christian Andersen* (1899); W. Canton (ed.), *The True Annals of Fairyland* (1900); W. Jerrold, *Nonsense! Nonsense!* (1902); I. H. Wallis, *The Cloud Kingdom* (1905); L. Carroll, *Alice's*

"Authors are not of the slightest use at rehearsals."

Charles Robinson, *Pall Mall*, February 1914

Adventures in Wonderland (1907); P. B. Shelley, *The Sensitive Plant* (1911); F. Hodgson Burnett, *The Secret Garden* (1911); O. Wilde, *The Happy Prince* (1913); A. A. Milne, *Once On a Time* (1925)

EXHIB: RA; RI; L

COLL: V&A

LIT: L. de Freitas, *Charles Robinson* (1976) SH

ROBINSON, William Heath (1872–1944). Cartoonist, illustrator and commercial artist. Heath Robinson was born on 31 May 1872 in Islingon, London, the son of Thomas Robinson, chief staff artist of the *Penny Illustrated Paper* and younger brother of Thomas and CHARLES ROBINSON, who were to become distinguished illustrators in their turn. After attending local schools, he went to Islington School of Art aged 15 and from there to the RA Schools (1892–7). On leaving he spent several months painting landscapes in watercolour and, failing to sell them, decided to pursue the family trade of illustration, initially in a style that was influenced by BEARDSLEY. His individuality was first seen in his own fairy story, *Uncle Lubin* (1902), and his humour, after a false start with whimsical allegories in the *Bystander* and the *Tatler* (1905–6), first appeared in full-page drawings in the *Sketch*, starting in 1906. Sir Bruce Ingram, the *Sketch*'s Editor, steered him away from the grotesque (influenced by S. H. SIME) and towards comic ingenuity which led to the contraptions and gadgets which brought him fame and caused his name to enter the language. Many of his best drawings were published in World War I, in the *Sketch*, *Bystander*, *Strand* and *London Opinion*. Unlike any other cartoonist, he saw warfare and the panoply of war as totally absurd and his superb book of satirical drawings, *The Saintly Hun*, was the nearest he could get to malice. After the war, beside his cartoons and his 'serious' book and magazine illustrations, he did a great deal of comic work for advertisers and demonstrated his full range of skills in large semi-humorous fantasies in watercolour published in the *Graphic* and *Holly Leaves*. By 1939 he was beginning to repeat himself but he rose again to the challenge of a world war and found as much humour in the imagined exploits of his countrymen as of the enemy. He died in Highgate on 13 September 1944. Some of the more sophisticated critics have either commended Heath Robinson as the satirist of the Machine Age, and therefore the champion of humanity, or they have dismissed him as fatuous. For most people he seemed to

CHRISTIAN SPIRIT.

A benignant Boche returning good for evil.

W. Heath Robinson, *The Saintly Hun* (1917)

be the founder of the DIY movement. He also seemed, in the most lovable way, to be mad. All the supporting detail in the cartoons as well as the earnest application of the protagonists were supposed to suggest that the artist believed in his own creations – and this required great artistry. 'I do not roar with laughter at Heath Robinson,' wrote H. G. Wells, 'so much as savour and enjoy his deliberate cold-blooded absurdity.' The drawings gave him 'a peculiar pleasure of the mind like nothing else in the world'.

PUB: *Some Frightful War Pictures* (1915), *Hunlikely!* (1916), *The Saintly Hun: A Book of German Virtues* (1917), *Flypapers* (1919), *Get On With It* (1920), *The Home Made Car* (1921), *Quaint and Selected Pictures* (1922), *Humours of Golf* (1923), *Absurdities* (1934), *Railway Ribaldry* (1935), *Let's Laugh* (1939), *Heath Robinson at War* (1941), *The Penguin Heath Robinson* (1966)

ILL: [humorous drawings] R. Johnson & T. O'Cluny, *The Merry Multifleet and the Mounting Multicorps* (1904); R. Carse, *The Monarchs of Merry England* (1907–8); N. Hunter, *The Incredible Adventures of Professor Branestawm* (1933); Heath Robinson & K. R. G. Browne, *How to Live in a Flat* (1936), *How to Be a Perfect Husband* (1937), *How to Make a Garden Grow* (1938), *How to Be a Motorist* (1939); R. F. Patterson, *Mein Rant* (1940); Heath Robinson & Cecil Hunt, *How to Make the Best of Things* (1940), *How to Build a New World* (1941), *How to Run a Communal Home* (1943)

EXHIB: FAS (1924, Memorial 1945); Medici Galleries (1972); Mappin Art Gallery, Sheffield (1977); CBG (1987, 1992); RFH (1992); CG

COLL: BM; V&A; CAT

LIT: W. Heath Robinson, *My Line of Life* (1938); J. Lewis, *Heath Robinson, Artist and Comic Genius* (1973); J. Hamilton, *William Heath Robinson* (1992); G. Beare, *Heath Robinson Advertising* (1992) SH

ROBINSON, Wyndham (*c.* 1883–after 1941). Political cartoonist. Born in London, Wyndham Robinson studied at Lambeth Art School under Philip Connard and at Chelsea School of Art. In World War I he served in the Artists' Rifles and later contributed illustrations to *Strand Magazine* and fashion drawings to *Queen*. He then became a farmer in Southern Rhodesia, but failed in the slump of 1928 and turned to drawing once more, becoming caricaturist and cartoonist on the *Cape Times*. He served in Burma in World War II and later returned to

London. Here he contributed cartoons to *Night & Day*, *Punch* and *Lilliput*, succeeded DAVID LOW at the *Star* (1927) and was Political Cartoonist on the *Morning Post* in the 1930s. His style was greatly influenced by Low's.

PUB: *Cartoons from the Morning Post* (1937) MB

ROSS – see Thomson, Harry Ross

ROSS, Charles Henry (*c.* 1842–97). Journalist and cartoonist. As a civil servant working at Somerset House, Ross's spare-time writings and drawings attracted the attention of the publisher Tinsley, two of whose annuals he edited in the 1860s. In 1867 he became Editor of *Judy or The London Serio-Comic Journal*, a rival to *Punch*, and there created a bald-headed, bulbous-nosed, spindle-shanked, huge-footed reprobate called Ally Sloper (so called because he sloped down the alley when he saw the rent collector coming). The escapades of Ally and his friend Ikey Mo, although crudely drawn in strip form by Ross, and later by his French wife who signed herself Marie Duval, caught on with the public and in 1873 were collected in *Ally Sloper: A Moral Lesson*, which has been called the first comic-book. Other collections followed, *Ally Sloper's Comic Kalendar* starting in 1875 and *Ally Sloper's Summer Number* in 1880. In 1883 Ross sold the rights in Ally Sloper to the engraver and publisher Dalziel who in 1884 launched *Ally Sloper's Half Holiday* in which the definitive Sloper was created by W. G. BAXTER. Ross also wrote a number of 'Penny Dreadfuls' and plays.

PUB: *Ye Booke Of Pictures* (1864), *The Great Gun, An Eccentric Biography* (1865), *A Seaside Sensation at Wilkington-super-Mare* (1866), *Roundabout Rhymes and Roundabout Stories* (1866), *A Book of Cats* (1868), *Merry Conceits and Whimsical Rhymes* (1870), *The Comic Album of Folly* (1870), *A Collection of Unlikely Tales* (1872), *'Crackers' and 'Kisses'* (1876), *All the Way* (1877), *The Book of Brighton* (1881), *The Earth Girl* (1893) SH

ROSSETTI, Dante Gabriel (1828–82). Poet, painter and occasional caricaturist. Born in London on 12 May 1828, the son of an Italian professor, Rossetti entered the RA Schools in 1846 and with Millais and others founded the Pre-Raphaelite Brotherhood. He made a small number of comic drawings, mostly of his friends, including a delightful caricature of William Morris reading to his wife in the bath entitled

'The Ms at Ems' which is now in the British Museum. He died on 9 April 1882.

EXHIB: RA 'Dante Gabriel Rossetti, Painter and Poet' (1973).

COLL: NG; T; V&A; BM; NPG; B; M

LIT: O. Doughty, *A Victorian Romantic* (1968); V. Surtees, *Dante Gabriel Rossetti, the Paintings and Drawings, A Catalogue Raisonné* (1971)

SH

ROTH, Arnold (b. 1929). Cartoonist and illustrator. Arnold Roth was born in Philadelphia, USA, on 25 February 1929, the second of six children of a wholesale cut-flower salesman. He studied at the Central High School and the University of the Arts and has been a freelance artist since 1951. His work has appeared in *Holiday*, *Saturday Evening Post*, *Playboy*, *Punch*, *Esquire*, *Time*, *Fortune*, *New York Times*, *Washington Post*, *Newsweek*, *New Yorker* and many other publications. A past president of the National Cartoonists' Society, he has also been elected a member of the *Punch* Table and is currently on the board of the Museum of Cartoon Art (USA). In addition, he has lectured widely on cartoon art and received numerous awards for his work, including the NCS Reuben Award (1984) and Best Illustrator Cartoonist award (13 years). He draws with a pen and indian ink, and also uses watercolour.

PUB: *Pick a Peck of Puzzles*, *Crazy Book of Science*, *A Comick Book of Sports*, *A Comick Book of Pets*

ILL: *Grimms' Fairy Tales* (1963)

ROUNTREE, Harold (1878–1950). Cartoonist, strip cartoonist and illustrator. Harry Rountree was born in Auckland, New Zealand, the son of a banker. He was educated at Queen's College, Auckland, and began work as a lithographer in a commercial studio, designing labels for jam jars etc. Moving to London in 1901, he studied with Percival Gaskell at the Regent Street Polytechnic, and later contributed to *Punch*, *Graphic*, *Strand Magazine*, *Humorist*, *Playtime*, *Boy's Own Paper*, *Sketch*, *Little Folks* and others. In addition, he drew illustrations for travel books and children's annuals, produced posters, and worked in advertising, notably a series featuring mice for Cherry Blossom shoe polish. During World War I he served as a captain in the Royal Engineers. A President of the London Sketch Club, his motto was 'If you want to be happy – Draw animals!' There is a commemorative plaque to him in St Ives, Cornwall, where he died on 26 September 1950.

PUB: Many books including *The Child's Book of Knowledge* (1903), *Harry Rountree's Annual* (from 1907), *Birds, Beasts and Fishes* (1929), *Jungle Tales* (1934), *Rabbit Rhymes* (1934)

ILL: Many books including L. Carroll, *Alice's Adventures in Wonderland* (1908), *Through the Looking Glass* (1928); A. Conan Doyle, *The Poison Belt* (1913); A. Dumas, *The Dumas Fairy Tale Book* (1924); L. Rountree, *Me and Jimmy* (1929), *Ronald, Rupert and Reg* (1930), *Dirty Duck and Wonderful Walter* (1931); E. Blyton, *The Children of Cherry-Tree Farm* (1940), *The Children of Willow Farm* (1942)

LIT: P. Bradshaw, *The Art of the Illustrator* (1918)

MB

ROWLANDSON, Thomas (1756/7–1827). Watercolourist, illustrator, caricaturist and etcher. Rowlandson was born in Old Jewry, London, in July 1756 or 1757 (the date is still disputed), the son of a wool and silk merchant who went bankrupt in 1759, leaving him to be educated by direction of his uncle and aunt. In 1772 he entered the RA Schools, exhibiting at the RA (1775–87) and winning the Academy's Silver Medal in 1777. His early work, which included a number of portrait drawings, was strongly influenced by J. H. MORTIMER. In about 1780 his watercolours of the social scene became more humorous and in 1784 he scored a large success with 'Vauxhall Gardens'. In the same year he etched a series of prints on the Westminster Election which although they did not rival those of DENT in coarseness heralded a lack of inhibition that was to become characteristic. In 1789 he inherited around £2000 from his aunt and rapidly lost it in gambling. From then until the end of the century he spent much time travelling in England and on the Continent in the company of friends like WIGSTEAD and recorded his experiences in many topographical and sporting views and scenes of rustic genre. After 1800 he turned increasingly to illustration and caricature. For the publisher Ackermann he illustrated several humorous books and his *Tours of Dr Syntax* became the talk of the town, spawning Syntax hats, wigs and coats and earning Rowlandson the distinction of creating the first English 'cartoon' character. For the publisher Tegg he etched a great many social and political caricatures, some after the designs of amateurs like WOODWARD, which tended to be rude when they were not bawdy. He became seriously ill in 1825 and died

A MAN OF FEELING.

Thomas Rowlandson, 1811

186

on 21 April 1827. Most of Rowlandson's caricature prints are pot-boilers which cannot bear artistic comparison with his watercolours, especially the early ones. He had little interest in politics and no discernible political or moral viewpoint apart from a loathing of Napoleon. On the other hand he could be lively enough when presented with a scandal like the Duke of York's indiscretions with Mrs Clarke. His value lies in his consistently humorous uncritical attitude to his age in all its rumbustiousness and grossness and his employment of a 'bounding' line that is one of the most graceful in English art.

PUB: *Picturesque Beauties of Boswell* (1786), *Outlines of Figures, Landscape and Cattle* (1790–2), *Comforts of Bath* (1798), *Loyal Volunteers of London and Environs* (1798–9), *Hungarian and Highland Broadsword* (1799), *Miseries of Human Life* (1808), *Scenes in Cornwall* (1812)

ILL: *History of the Westminster Election* (1784); H. Wigstead, *An Excursion to Brighthelmstone* (1790); J. Britton, *Pleasures of Human Life* (1807); H. Bunbury, *An Academy for Grown Horsemen* (1809); W. Combe, *The Three Tours of Dr Syntax* (1809, 1820, 1821), *The English Dance of Death* (1815–16), *The Grand Master or Adventures of Qui Hi in Hindustan* (1816), *The Dance of Life* (1817), *The History of Johnny Quae Genus* (1822); D. Roberts, *The Military Adventures of Johnny Newcome* (1816); A. Burton, *The Adventures of Johnny Newcome in the Navy* (1818)

EXHIB: Frick, New York (1990); BM Touring (1990)

COLL: HM the Queen; BM; V&A; A; F; B; W; CAT; Yale; Boston Library; Huntington

LIT: J. Grego, *Rowlandson the Caricaturist* (1880); J. Hayes, *Rowlandson: Watercolours and Drawings* (1972)　　SH

ROWLEY, Hon. Hugh (1833–1908). Humorous author and illustrator. Rowley was the son of the 2nd Lord Langford and was educated at Eton and Royal Military Academy, Sandhurst, being commissioned into the cavalry (1852). Retiring from the Army in 1854 he became known as a humorous author, plumbing new depths in puns. He illustrated his own books with small vignettes in the manner of W. S. GILBERT. For much of the time he lived in Brighton where he died on 12 May 1908.

PUB: *Puniana or Thoughts Wise and Other-Wise* (1866), *Gamosagammon or Hints on Hymen*

(1870), *Sage Stuffing for Green Goslings* (1872), *More Puniana* (1875)　　SH

ROWSON, Martin George Edmund (b. 1959). Caricaturist, editorial and strip cartoonist, and illustrator. Martin Rowson was born on 15 February 1959 in London and is a self-taught artist. His first published cartoon series was 'Scenes from the Lives of the Great Socialists' in the *New Statesman* (1983). He has also contributed to *Financial Weekly* (1984–9), *Sunday Today* (1986–7), *Today* (pocket cartoons, 1986–93), *Sunday Correspondent* (caricatures and strips, 1989–90), *Independent on Sunday* ('Logorrhoea' strip since 1991), *Independent* (since 1989), *Guardian* (1987–8), *Weekend Guardian* (1991–3), *Time Out* (since 1990) and *Dublin Sunday Tribune* (since 1991). In addition, he has worked as book reviewer for *Sunday Correspondent* (1989–90) and *Independent on Sunday* (since 1990) and has been a council member of the Zoological Society of London since 1992.

PUB: [with K. Killane] *Scenes from the Lives of the Great Socialists* (1983), *Lower Than Vermin: An Anatomy of Thatcher's Britain* (1986); *The Waste Land* (1990)

EXHIB: Ravensdale Gallery　　MB

RUSHTON, William George (b. 1937). Actor, author, caricaturist, cartoonist, illustrator and broadcaster. Born in London on 18 August 1937, Willie Rushton was educated at Shrewsbury School where he was a contemporary of Richard Ingrams and with him founded *Private Eye* in 1961. He has also been an actor on stage, TV and in films and regularly appears on TV and radio shows such as 'I'm Sorry I Haven't a Clue' (since 1976). He works with pen and ink, roughing out faces in pencil first (he often signs his drawings simply 'R'). Geipel has observed that his 'appalling old roués, cadaverous matrons and degenerate city gents are incised with an almost painfully sensitive line'.

PUB: *William Rushton's Dirty Book* (1964), *The 'I didn't know the way to King's Cross when I first came here but look at me now' Book* (1966), *How to Play Football* (1968), *The Day of the Grocer* (1971), *Sassenach's Scotland* (1975), *The Geranium of Flüt* (1975), *Superpig* (1976), *Pigsticking, A Joy for Life* (1977), [with F. Ward] *Unarmed Gardening* (1979), *The Reluctant Euro* (1980), *The Filfth Amendment* (1981), *W. G. Grace's Last Case* (1984), *Willie Rushton's Great Moments in History* (1985), *The Alterna-*

GREAT HEAVENS, WOMAN, NOT ON THE STEPS OF THE CLUB!

Willie Rushton, *The Filfth Amendment* (1981)

tive Gardener (1986), *Marylebone Versus the World* (1987), (ed.) *Spy Thatcher* (1987)
ILL: Many books including J. Talbot, *Elephant on the Line!* (1979); J. Needle, *Wild Wood* (1981); R. I. Fishall, *Bureaucrats: How to Annoy Them!* (1981); M. Rosen, *A Cat and Mouse Story* (1982); R. Mash, *How to Keep Dinosaurs* (1983); D. Rushton, *The Queen's English* (1985)
EXHIB: CG
COLL: V&A MB

RUSLING, Albert (b. 1944). Cartoonist. Albert Rusling was born in Liverpool on 27 October 1944 and left school at 15 to work in an advertising agency. A self-taught artist, he turned full-time professional cartoonist in 1968 and has contributed to many magazines and newspapers including *Punch*, *Private Eye*, *Guardian* and *Financial Times*, and has written and illustrated a number of books.
PUB: *The Mouse and Mrs Proudfoot* (1984), [with M. Williams] *The Very, Very Last Book Ever* (1986), *The Criminals' Bumper Fun Book* (1990) MB

RYAN, John Gerald Christopher (b. 1921). Author/illustrator, animator and cartoonist. John Ryan was born in Edinburgh on 4 March 1921, the son of a diplomat, and after Ampleforth College, York, attended the Regent Street Polytechnic (1946–8). During World War II he served in the Lincolnshire Regiment in Burma and India (1942–5). After the war he was Assistant Art Master at Harrow School (1948–55) during which period he began contributing strips to children's comics such as *Eagle* and *Girl*. His best-known creation, 'Captain Pugwash' – 'the bravest, most handsome pirate of the Seven Seas', first appeared in *Eagle* comic on 14 April 1950, was screened on BBCTV from *c.* 1958 and later appeared in *Radio Times* for eight years. Other memorable cartoon series include 'Harris Tweed – Extra Special Agent', 'Sir Prancelot', 'Mary, Mungo and Midge' and 'Lettice Leefe' – many having also appeared in animated versions for BBCTV. In addition he has worked as a staff cartoonist on the *Catholic Herald* since 1966 and has written and illustrated a number of children's books. Influenced by H. M. BATEMAN, John Ryan works in pen and indian ink with watercolour or wash.
PUB: *Rolling in the Aisles* (1975) plus more than 40 children's books including 'Captain Pugwash' series (14 titles from 1956), 'The Ark Stories' series (12 titles from 1980), 'Crockle' series, *Dodo's Delight* (1977), *Doodle's Homework* (1978), *Mabel and the Tower of Babel* (1990), *Jonah, a Whale of a Tale* (1992)
EXHIB: RA; Trafford Gallery; Royal Pavilion, Brighton
COLL: UKCC; MOMI MB

John Ryan, *Oldie*, 1 May 1992

S

SALA, George Augustus Henry (1828–96). Journalist, novelist, illustrator and cartoonist. George Augustus Sala was educated in France and studied drawing in London. He became a humorous illustrator for *The Man in the Moon* in the late 1840s and drew a powerful cover design for a pamphlet by Alfred Burr entitled *A Word With Punch* (1847), lampooning the staff of that magazine and earning the Editor's denunciation as a 'graceless young whelp'. In 1848 he was appointed Editor of *Chat* and went on to be a literary contributor to *Household Words, All the Year Round, Illustrated London News, Sunday Times* and *Daily Telegraph*, in which his turgid prose style excited mockery. GEORGE CRUIKSHANK gave him lessons in drawing and engraving and he clearly had some talent. Except for a few illustrations in *Cornhill Magazine* he abandoned

illustration for journalism in the 1850s. He was a founder of the Savage Club.

PUB: [panoramas] *The Great Glass House Opend* (1851), *The House that Paxton Built* (1851), *The Funeral Procession of Arthur, Duke of Wellington* (1852)

LIT: G. A. Sala, *The Life and Adventures of George Sala* (1895); R. Straus, *George Augustus Sala* (1942) SH

SALLON, Ralph [real name Ralph Zielun] MBE (b.1899). Caricaturist. Ralph Sallon was born on 9 December 1899 in Sheps, Poland. He came to England at the age of four and attended Crouch End School and Hornsey School of Art (1914). He served in the Army in World War I and in 1922 moved to South Africa where his first caricature was published in the *Natal Mercury* in 1923. After two years he returned to England, studied at St Martin's School of Art and joined *Everybody's Weekly* (1925–45), whilst also contributing caricatures to *East Africa* (1930–9). Resident caricaturist on the *Jewish Chronicle* (c. 1930–91) he has worked freelance for *Tatler*, *Bystander*, *Vanity Fair*, *Sporting & Dramatic News*, *Daily Herald* (1943–8), *Daily Mail*, *Blighty*, *Sunday Empire News*, *Daily Sketch*, *Reader's Digest*, *Observer*, *British Digest* and *Daily Express*. During World War II he produced propaganda cartoons for aerial leaflets etc., including *Message*, the Free Belgium newsletter produced in London. Staff caricaturist on *Daily Mirror* (1948–91), he has also produced 'Vanity Fair'-style full-colour caricature prints of 12 Lord Chief Justices (1962) and five Lord Chancellors (1989) for Butterworths publishers. In addition he has worked in advertising for BP, GPO and others and drawn covers for *Time* and *Life*. He was awarded an MBE in 1977.

COLL: Wig & Pen Club; BFI MB

SAMBOURNE, Edward Linley (1845–1910). Cartoonist and illustrator. Linley Sambourne was born in London on 4 January 1845, the son of a prosperous City merchant. Educated at the City of London School and Chester College, he was apprenticed as a draughtsman to a firm of marine engineers in Greenwich. In his spare time he drew, and when one of his sketches was seen in 1867 by Mark Lemon, editor of *Punch*, he was engaged to work for the paper, joining the staff in 1871. Having had almost no artistic education, his early work was feeble but he laboured at it and formed a decorative style of his own, at first influenced by CHARLES BENNETT. He was

promoted to illustrating 'Punch's Essence of Parliament', in which his intricate drawings showed much invention and humour, and providing caricatures for 'Mr Punch's Portraits'. When in the 1880s he turned to political cartooning in *Punch* as the understudy to TENNIEL, his work was distinguished by occasionally surreal comedy, extreme accuracy in detail (aided by a library of 100,000 photographs) and consummate draughtsmanship which greatly influenced the technique of his fellow cartoonists. TENNIEL once said of his work 'although a little hard and mechanical, it is of absolutely inexhaustible ingenuity and firmness of touch' and LOW commented that he 'evolved a style which for sheer purity of line and solid correctness of draughtsmanship has not been excelled among British artists'. Although essentially a *Punch* artist, he contributed to a few other magazines and in them, as well as in his book illustrations, can be seen his flair for the decorative-grotesque. He became chief cartoonist of *Punch* (1901–10) and died at his house, 18 Stafford Terrace, Kensington (now Linley Sambourne House) on 3 August 1910.

ILL: F. C. Burnand, *The New History of Sandford and Merton* (1872), *The Real Adventures of Robinson Crusoe* (1893); J. C. Molloy, *Our Autumn Holiday on the French Rivers* (1874), *Our Holiday in the Scottish Highlands* (1875); Lord Byron, *Venice from Childe Harold* (1878); C. Kingsley, *The Water Babies* (1885); Lord Brabourne, *Friends and Foes from Fairyland* (1886); M. Noel, *Buz or the Life and Adventures of a Honey Bee* (1889); W. M. Thackeray, *The Four Georges* (1894); *Papers from Punch* (1898); *Three Tales from Hans Andersen* (1910)

EXHIB: RA; FAS (1893)

COLL: V&A; Linley Sambourne House

LIT: C. Veth, *Comic Art in England* (1930)

SH

SANDBY, Paul RA (1725–1809). Landscape and topographical painter in watercolour, etcher, drawing master and occasional caricaturist. Born in Nottingham, Paul Sandby came to London in his teens and in 1746 was employed by the Board of Ordnance to make sketches and plan roads in Scotland following the suppression of the '45 Rebellion. He then spent about 10 years at Windsor Park painting watercolours and in 1760 came to London and played an active part in the schemes which led to the foundation of the Royal Academy in 1768. In that year too he was appointed Chief Drawing Master at the Royal

Linley Sambourne, *Punch*, 14 December 1877

Military Academy, Woolwich, a post which he held until 1796. He exhibited regularly at the RA from 1769 to 1809, the year of his death. His main importance as a painter – 'the father of English watercolour' and the first artist to experiment with the aquatint process – has obscured the fact that Sandby was also an admirable caricaturist. He was the scourge of HOGARTH, producing a series of prints satirizing the *Analysis of Beauty* (1752–3) and another flurry came afer the publication of Hogarth's political caricature 'The Times Plate 1' (1762). These etchings show much wit and are altogether more sophisticated than most of the designs of the time. However, he later came to recognize Hogarth's stature as a painter and withdrew these prints from sale. In 1765 Sandby published a set of social satires, *Twelve London Cries Done*

from the Life; and in the 1780s made a few aquatints which include some outstanding early balloon caricatures.

COLL: HM the Queen; BM; V&A; AB; A; BN; D; F; G; NMM; LE; M; Y; NGI; NGS

LIT: A. P. Oppé, *Drawings and Watercolours of Paul and Thomas Sandby at Windsor Castle* (1947); L. Henmann, *Paul and Thomas Sandby* (1986) SH

SAYERS [or SAYER], James (1748–1825). Caricaturist and propagandist. James Sayers was articled as a lawyer in Yarmouth, Norfolk, and came to London around 1780. From 1781 he drew and etched political caricatures that were extremely effective because of his gift for portraiture and his understanding of affairs. For a time in the 1780s he even eclipsed GILLRAY. Violently opposed to Charles James Fox, he established in various 'Carlo Khan' prints an image of the man that was copied by the other caricaturists; Fox is reported to have said that Sayers' caricatures had done him more mischief than the debates in Parliament or the works of the press. Pitt fed him with information and gave him a sinecure post as Marshal of the Court of Exchequer. Although his drawing improved over the years it was always the work of an amateur. After 1795 his prints only appeared at rare intervals and included the occasional social caricature. He also wrote political propaganda in prose and verse.

PUB: *The Foundling Chapel Brawl* (1804), *Elijah's Mantle* (1806), *All the Talents Garland* (1807), *Hints to J. Nollekens Esq* (1808)

COLL: BM SH

SCARFE, Gerald (b. 1936). Caricaturist, illustrator and film-producer. Gerald Scarfe was born on 1 June 1936 in St John's Wood, London, the son of a banker. Bedridden with asthma until the age of 11, he won a prize for an Ingersoll watch advertisement in *Eagle* (beating David Hockney) and began drawing regularly for the comic while still at school. He started work in his uncle's commercial art studio while studying at St Martin's School of Art in the evenings and then turned freelance, his first cartoons being published in the *Daily Sketch* (1957), *Evening Standard* and *Punch* (1960). But it was at *Private Eye* (from 1961) that he really found his style, and his cover for the 1963 annual caused it to be banned by the four largest book wholesalers (including W. H. Smith). He also produced giant puppets of Wilson, Smith and President Johnson

for a CND rally in London (1966) and later joined the *Daily Mail* as a war artist (1967–8). He then moved to the *Sunday Times* and made papier-mâché caricature models for *Time* magazine covers (1967) whilst also contributing to *Esquire* and *Fortune*. A commission from the COI led to the construction of a 30ft-high scrap-metal Gulliver figure for Expo 70 in Japan (1970). At this time he also directed a film, *Hogarth*, for BBCTV's 'Omnibus', followed by the animated film, *A Long Drawn-out Trip* (1973). This brought him to the attention of pop group Pink Floyd and work on another film, *The Wall* (1982), for MGM, which he art-directed and for which he produced puppets, inflatables and animation sequences. He has also designed for the theatre (including sets for the English National Opera). As well as drawing and painting, Scarfe has worked in papier-mâché, metal, plaster and chicken wire, leather and a wide variety of other media. An admirer of SEARLE (who later admired him), John Berger has described him as '. . . a natural satirical draughtsman. GILLRAY was one, ROWLANDSON wasn't. George Grosz was one, but LOW isn't. The supreme examples are Goya and Daumier.' Scarfe's distinctively violent and grotesquely distorted images reflect his own attitudes to his subjects: 'I can only express good by a comparison between evil and greater evil.' He is married to actress and author, Jane Asher.

PUB: *Gerald Scarfe's People* (1966), *Indecent Exposure* (1973), *Expletive Deleted* (1974), *Gerald Scarfe* (1982), [with B. Mooney] *Father Kissmass and Mother Claws* (1985), *Seven Deadly Sins* (1987), *Lines of Attack* (1988), *Scarfeland* (1989)

ILL: R. West, *Sketches from Vietnam* (1968); J. Asher, *Moppy is Happy* (1987), *Moppy is Angry* (1987); T. Jones, *Attacks of Opinion* (1988)

EXHIB: Tib Lane Gallery, Manchester; Waddell Gallery, New York; GG; CG; Chester Arts Centre (Retrospective, 1978); MAN; Vincent Price Gallery, Chicago; Bradford Art Gallery; Graves Art Gallery, Sheffield; NPG; RFH and York, Cleveland, Bristol etc. tour (1983–4); CBG

COLL: NPG; [poster] BM

LIT: *Scarfe by Scarfe* (1986) MB

SCHWADRON, Harley L. (b. 1942). Cartoonist and illustrator. Harley Schwadron was born on 23 November 1942 in New York City and was educated at Bowdoin College, Brunswick, Maine (graduating in philosophy, 1964) and University

THE MIRROR OF PATRIOTISM

James Sayers, [Fox seeing himself as Cromwell], 1784

of California, Berkeley (MA in journalism, 1967). He worked as a newspaper reporter in Connecticut and as a public information officer at the University of Michigan before becoming a full-time cartoonist. A self-taught artist, his work has appeared in *Punch, Wall Street Journal, Washington Times, Playboy, Penthouse, Omni, Good Housekeeping, Natural History* and others. He received the Scripps Howard Founda-tion's Charles Schulz Award for his work in 1983.

ILL: More than 20 books including *No Husband Should be Without a Wife* (1983), *Men* (1991), *Job Search Time Manager* (1993) and many college textbooks and University of Michigan campus guides (1985–93)

EXHIB: University of Michigan School of Art, Ann Arbor, Michigan

COLL: Gerald Ford Library, University of Michigan MB

SCOTT, Ian James ARCA (b. 1914). Political cartoonist and cartoonists' agent. Born in London on 30 July 1914, Ian Scott attended St Martin's School of Art (1928–32) and the Royal College of Art (1932–5). During World War II he served with the Royal Engineers in the Middle East and subsequently ran the Drawing Office of RE Base depot in Ismailia where he edited a wall newspaper and wrote and produced shows for the troops. After the war he was Political Cartoonist on the *Daily Sketch* (1954–6), resigning to join the *News Chronicle* (1956–7). He then left to set up a specialist art agency for cartoonists, Kingleo Studios (1954–87), which represented more than 100 artists. He was also the founder and first Chairman of the Cartoonists' Club of Great Britain in 1960 and is now Honorary Life President.
PUB: (ed.) *British Cartoonists' Album* (1962), (ed.) *British Cartoonists' Year Book* (1964), (ed.) *From Russia With Laughter* (1965) MB

SCRATCH, Annibal – see Collings, Samuel

SCRUTINY, Thomas – see De Wilde, Samuel

SCULLY, William (b. 1917). Cartoonist. Bill Scully was born in Ilkeston, Derbyshire, on 12 June 1917, the son of a builder, and studied at Nottingham School of Art. He then spent seven years in an artificial silk factory before having his first cartoons accepted by the *Bystander*. During World War II he served in the Army Ordnance Corps and became Editor of *AIM* magazine. His work has appeared in *Punch*, *Bystander*, *Spectator*, *Sketch*, *New Yorker*, *London Opinion*, *Men Only*, *Lilliput*, *Tatler*, *Soldier* and other publications. Scully's cartoons show the influence of *New Yorker* cartoonists and 'couples an ethereal, fantastic humour with a vigorous and dynamic style of drawing' (Geipel). HEWISON has described his work as 'marvellously free and autographic but with a tight control over the use of tone. You are always aware of *space* in a Scully drawing.' MB

SEARLE, Ronald William Fordham AGI (b. 1920). Caricaturist, cartoonist, illustrator, designer and publisher. Ronald Searle was born in Cambridge on 3 March 1920, the son of a railwayman, and educated at Boys' Central School, Cambridge. He started work as a solicitor's clerk, then joined the hire-purchase department of the Co-op, studying in the evenings and later full-time at Cambridge Technical College and School of Art (1935–9) where contemporaries included Joan Brock, daughter of H. M. BROCK. His first cartoons, published in *Cambridge Daily News*, October 1935–9 (where his predecessor was SIDNEY MOON) and *Granta* (1936–9), were signed 'R. W. F. Searle'. During World War II he served with 287 Field Co, Royal Engineers from 1939, contributing to *Daily Express* (1939), *Discovery*, *London Opinion* (1940) and *Lilliput* (1941) until captured by the Japanese at the fall of Singapore and from 1942 to 1945 was a prisoner of war in Siam and Malaya (Changi, where he met GEORGE SPROD). Returning to England, he began work for *Illustrated*, *Strand Magazine*, *John Bull*, *Daily Herald*, *Pie*, *Tatler*, *Radio Times*, *The Studio* and *Lilliput*. He was cartoonist on *Tribune* (1949–51), *Sunday Express* (1950–1), Special Feature Artist on *News Chronicle* (1951–3) and cartoonist for the same paper (1954), and cartoonist and theatre artist for *Punch* (1949–62), succeeding STAMPA. He has also contributed to numerous other publications including *New Yorker*, *Life*, *Sketch*, *Der Spiegel*, *Men Only*, *Le Canard Enchaîné*, *London Opinion*, *Time & Tide*, *Holiday*, *Saturday Evening Post*, *Young Elizabethan*, *Figaro Littéraire*, *Sports Illustrated*, *Graphis* and others. His extensive advertising work has included Lemon Hart Rum, American Express, Cadbury's and others. In addition he has designed medals for the French Mint (from 1974) and the British Art Medal Society (from 1983) and been a designer and or/drawn animation sequences for a number of films including *John Gilpin* (1951), *On the Twelfth Day* (1954) – which was nominated for an Academy Award – *Energetically Yours* (1957), *Those Magnificent Men in Their Flying Machines* (1965), *Monte Carlo or Bust* (1969), *Scrooge* (1970) and *Dick Deadeye* (1975). Founder of the Perpetua Press he has received many international awards for his work, including National Cartoonists' Society of America Awards (1959, 1960, 1966). Particularly memorable characters created by Searle include the devilish schoolgirls of St Trinian's (featured in three films) and Nigel Molesworth in the books written by Geoffrey Willans. Left-handed, he works in a variety of media, but mostly pen and ink with wash, gouache or watercolour. He sketches in fountain pen but uses dip pen for final artwork. For many years he

'Come along, prefects. Playtime over.'

used woodstain instead of ink (Stephens Liquid Stains: Ebony) but has since worked with Super Yang-tse Encre de Chine. Immensely influential, Geipel, writing in 1972, said of him: 'Searle's mannerisms, particularly his use of spindly, spiky limbs and rhythmically elegant embellishments . . . are now among the most distinctive earmarks of contemporary British cartooning.' And HEWI-SON has described him as 'arguably the foremost graphic artist this century'.

PUB: More than 40 books including *Forty Drawings* (1946), *Hurrah for St Trinian's* (1948), *The Female Approach* (1949), [with K. Webb] *Paris Sketchbook, Refugees* (1960); *Back to the Slaughterhouse* (1951), [with D. B. Wyndham Lewis], *The Terror of Trinian's* (1952), [with G. Willans] six books from *Down With Skool!* (1953); *Souls in Torment* (1953), *The Rake's Progress* (1955), [with A. Atkinson] four books from *The Big City* (1958); *The Penguin Ronald Searle* (1960), *Searle in the Sixties* (1964), *Searle's Cats* (1967), *The Square Egg* (1968), *Dick Deadeye* (1975), *More Cats* (1975), [with I. Shaw] *Paris! Paris!* (1977), *The King of Beasts* (1980), *Ronald Searle's Big Fat Cat Book* (1982), *The Illustrated Winespeak* (1983), *Ronald Searle's Golden Oldies* (1985), *To the Kwai – and Back* (1986), *Something in the Cellar* (1986), *Ah Yes, I Remember it Well* (1987), *Ronald Searle's Non Sexist Dictionary* (1988), *Slightly Foxed – But Still Desirable* (1989), *The Best of St Trinian's* (1993)

ILL: More than 40 books including P. Campbell, *A Long Drink of Cold Water* (1949), *A Short Trot with a Cultured Mind* (1950), *Life in Thin Slices* (1951); R. Braddon, *The Piddingtons* (1950), *The Naked Island* (1952); W. Cowper, *The Diverting History of John Gilpin* (1954); C. Fry, *An Experience of Critics* (1952), *A Phoenix Too Frequent* (1959); C. Dickens, *A Christmas Carol* (1961), *Great Expectations* (1962), *Oliver Twist* (1962); J. Thurber, *The Thirteen Clocks and the Wonderful O* (1962)

EXHIB: Batsford Gallery; LG; New York; Hanover; La Pochade, Paris; Galerie Gurlitt, Munich; GG; Cooper-Hewitt Museum, New York; Neue Galerie Wien, Vienna, IWM; BM; F; BIB (1973); Museum of Fine Arts, San Francisco and others

COLL: CAT; V&A; BM; IWM; BIB; Kunsthalle, Bremen; WBM; Stadtmuseum, Munich; Art Museum, Dallas; Staatliche Museum, Berlin-Dahlem; Cooper-Hewitt Museum, New York; University of Texas, Austin

LIT: *Ronald Searle* (1978); *Ronald Searle in*

Perspective (1984); R. Davies, *Ronald Searle* (1990) MB

SECCOMBE, Lt-Col. Thomas Strong (fl. 1865–85). Amateur military painter, illustrator and cartoonist. Thomas Seccombe was commissioned into the Royal Artillery and spent a considerable part of his Army life abroad. In the 1860s he contributed humorous drawings to *Fun, Illustrated Times, London Society* and *Punch*. His humorous books published in the 1870s and 80s, mostly with coloured plates, were popular with both adults and children. Seccombe had a vigorous style, good for communicating adventure, but his figures are rather stiff.

PUB: *Army and Navy Drolleries* (1875), *Military Misreadings of Shakspere* (1880), *The Story of Prince Hildebrand and the Princess Ida* (1880), *The Good Old Story of Cinderella* (1882), *Army and Navy Birthday Book* (1881), *Comic Sketches of English History* (1884)

ILL: T. Hood, *Miss Kilmansegg* (1870); A. Pope, *The Rape of the Lock* (1873)

EXHIB: RI; RBA SH

SEYMOUR, Robert (1789–1836). Caricaturist and illustrator. Born in Somerset, Robert Seymour was the son of a gentleman who, falling on hard times, moved to London and died soon afterwards. He was apprenticed to a pattern designer then started as a portrait and history painter in oils, one of his pictures being exhibited at the RA. In 1827 he turned to caricature, mostly of social subjects. He produced several series of etched vignettes in the manner of GEORGE CRUIKSHANK and briefly succeeded WILLIAM HEATH as the leading caricaturist of the day, supplanting him in 1830 as the illustrator of *The Looking Glass or McLean's Monthly Sheet of Caricatures*, for which he moved from etching to lithography. At the end of 1831 he became the illustrator, in wood-engraving, of *Figaro in London*, a precursor of *Punch*, and the following year of the *Comic Magazine*, both publications being edited by Gilbert A'Beckett. In 1833 he started to issue his *Humorous Sketches*, chronicling the adventures and misadventures of Cockney sportsmen, which had a great vogue in the 19th century. He was employed as the first illustrator of *Pickwick Papers* and produced seven plates before overwork acting on a nervous temperament led to his suicide on 20 April 1836. Seymour was a versatile humorous artist with a considerable talent for the comic-grotesque. It was his misfortune to be at the height of his

"He sat like Patience on a monument smiling at grief"
Shakespeare.

Robert Seymour, *Sketches by Seymour* (1860)

powers when the public taste was changing from the grotesque to the polite, in the shape of caricatures by 'HB'. He would have sympathized with Maria Edgeworth's character who, discovering the company had no appetite for a book of caricatures, remarked 'the world is grown mighty nice. For my part give me a good laugh when it is to be had.'
PUB: *Seymour's Comic Annual: a Perennial of Fun* (n.d.), *The March of Intellect* (1829), *The Heiress* (1830), *New Readings of Old Authors* (1830–5), *Journal of a Landsman from Portsmouth to Lisbon* (1831), *Humorous Sketches* (1834, 1836, 1846)
ILL: P. S. Grafton, *Vagaries in Quest of the Wild and Wonderful* (1827); R. Penn, *Maxims and Hints for an Angler* (1833); T. K. Hervey, *A Book of Christmas* (1836); *The Cabinet Songster* (1836)
COLL: BM
LIT: *Seymour's Sketches* (J. C. Hotten, c. 1860)
SH

SHARPSHOOTER – see Phillips, John

SHAW, John Byam Liston RI ROI ARWS (1872–1919). Painter, illustrator, teacher and cartoonist. Byam Shaw was born on 13 November 1872 in Madras, the son of the Registrar of the High Court who returned with his family to England in 1878. He entered St John's Wood Art Schools (1887) and went from there to the RA Schools (1890–3) during which time he contributed some humorous drawings to *Comic Cuts*, *Illustrated Bits* and *Moonshine*. He went on to paint allegories, boldly designed, richly coloured, often chivalrous or religious in spirit, taught at King's College, London, and in 1910 jointly founded the Byam Shaw and Vicat Cole Art School which still exists. At the same time he illustrated about 25 books and contributed to some periodicals including a few social satires to *Punch*. His book of satirical drawings, *Life's Ironies*, was published in 1912. During World War I his cartoons, staunchly patriotic, were published in the *Cartoon*, *Daily Call*, *Daily Chronicle*, *Daily Express*, *Dump*, *Evening Standard*, *Punch* and the *Sunday Times*. The humour in his pen-and-ink cartoons is ponderous or arch but they are interesting because of his fastidious draughtsmanship and his talent for decorative design. He died on 26 January 1919.
PUB: *Life's Ironies* (1912)
ILL: More than 25 books including R. Browning, *Poems* (1897); J. Jacobs (ed.), *Tales from Boccaccio* (1899); *The Chiswick Shakespeare* (1899); *Old King Cole's Nursery Rhymes* (1902); J. C. Hadden, *The Operas of Wagner* (1908); F. Sedgwick (ed.), *Ballads and Lyrics of Love* (1908); *Legendary Ballads* (1908); F. A. Steel, *The Adventures of Akbar* (1913); L. Hope, *The Garden of Kama* (1914)
EXHIB: RA; RI; RWS; ROI; DOW
COLL: V&A; B; BR; LE; L
LIT: R. Vicat Cole, *The Art and Life of Byam Shaw* (1932)
SH

SHEPARD, Ernest Howard OBE MC (1879–1976). Cartoonist, illustrator and painter. E. H. Shepard was born on 10 December 1879 in St John's Wood, London, the son of an architect, and was educated at St Paul's School. He studied art at Heatherley's and then at the RA Schools (1897–1902) at which he won two scholarships. He first exhibited at the RA in 1901 and his painting, 'Followers' (1904) was bought by the Durban Art Gallery. As well as painting in oil and watercolour he illustrated books and

periodicals including the *Graphic, Illustrated London News, London Opinion, Nash's, Odd Volume, Pears Annual* and the *Sketch*. In 1907 his first cartoons were published in *Punch*. His work was distinguished by movement so that as Price said, 'with Shepard the rest of *Punch* began to look static'. In World War I he served in the Royal Artillery and won the Military Cross at Ypres (1917). Shepard's greatest triumph came in 1924 with his illustrations in *Punch* for A. A. Milne's verses, 'When We Were Very Young', which led on to the 'Pooh' books. He succeeded RAVEN HILL as Second Cartoonist on *Punch* in 1935 and was Senior Cartoonist succeeding PARTRIDGE (1945–9) but he was not well suited to the job, having no great interest in politics nor much skill in capturing likenesses. Shepard was not really a satirist, but a poker of gentle fun, mostly at the upper middle classes and their children in the DU MAURIER tradition. The humour lay in the situation rather than the drawing but Shepard's drawing none the less had, like the man himself, great charm. He ended his long association with *Punch* in 1958. In 1972 he was appointed OBE. He died on 24 March 1976.

PUB: *Fun and Fantasy* (1927)
ILL: Nearly 100 books including G. Agnew, *Let's Pretend* (1927); K. Grahame, *The Golden Age* (1928), *Dream Days* (1930), *The Wind in the Willows* (1931); E. V. Knox, *Mr. Punch's County Songs* (1928); Jan Struther, *Sycamore Square* (1932); R. Jefferies, *Bevis* (1932); L. Housman, *Victoria Regina* (1934), *The Golden Sovereign* (1937); Sir J. C. Squire, *Cheddar Gorge* (1937)
EXHIB: RA; UKCC (1974); V&A (Memorial, 1969)
COLL: BM; V&A; US; UKCC
LIT: E. H. Shepard, *Drawn from Memory* (1957), *Drawn from Life* (1961); R. Knox (ed.), *The Work of E. H. Shepard* (1979) SH

SHEPHERD, William James Affleck 'JAS' FZS (1867–1946). Cartoonist and illustrator. J. A. Shepherd was born in London on 29 November 1867, the son of a cigar importer. He became a pupil of ALFRED BRYAN for two or three years and spent much of his time studying and drawing animals at London Zoo, becoming in time a Fellow of the Zoological Society. He then started to contribute illustrations to periodicals, mainly comic drawings of animals in human clothes following a tradition established by Grandville and GRISET. They were published in *Black &*

White, Boy's Own Paper, Cassell's, Chums, Good Words, Illustrated London News, Illustrated Sporting & Dramatic News, Judy (1886–9), *Moonshine* (1890–3), *Sketch* and *Tatler*. His most notable series were his 'Zig-Zags at the Zoo' (1892) and 'Fables', both published in the *Strand Magazine*. In 1893 his first comic animals appeared in *Punch* and he continued as a contributor for 40 years. He was awarded a gold medal at the International Exhibition of Humour in Rivoli, Italy, in 1911. In 1919 his 'Zig-Zags' were made into animated cartoons on film for Phillips Philm Phables. He drew mainly in outline but when he used wash or colour, it was with excellent effect. The secret of his success lay in his profound knowledge of and respect for animals, allied to a pleasant wit. He died on 11 May 1946.
PUB: *Zig-Zag Fables* (1897), *The Frog Who Would A-Wooing Go* (1900), *Who Killed Cock Robin* (1900), *A Thoroughbred Mongrel* (1900), *The Donkey Book* (1903), *Old Dedick's Tales* (1904), *Funny Animals and Stories About Them* (1904), *The Life of a Foxhound* (1910), *A Frolic Round the Zoo* (1926), *Animal Caricature* (1936)
ILL: A. Morrison, *Zig-Zags at the Zoo* (1895); A. Chester, *Tommy at the Zoo* (1895); J. C. Harris, *Uncle Remus* (1901); E. W. D. Cumming, *Wonders in Monsterland* (1901); *Three Jovial Puppies* (1907), *Idlings in Arcadia* (1934); E. Selous, *Jack's Insects* (1910), *The Zoo Conversation Book* (1911), *Jack's Other Insects* (1920); E. Rostand, *The Story of Chanticleer* (1911); *The Bodley Head Natural History* (1913); W. Garstang, *Songs of the Birds* (1922)
EXHIB: PAG (1922)
COLL: BM SH

SHEPPERSON, Claude Allin ARA ARWS RI ARE (1867–1921). Painter, illustrator and cartoonist. Born in Beckenham, Kent, on 25 October 1867, Claude Shepperson first studied law then changed to art, spending two years in Paris and at Heatherley's. Soon afterwards he was exhibiting landscapes and scenes of social life in a variety of media – oil, watercolour, pastel, ink and pencil. Later he practised etching and lithography as well. In the 1890s, besides illustrating books in a manner reminiscent of the American, E. A. Abbey, he contributed to periodicals such as *Black & White, Cassell's, English Illustrated Magazine, Graphic, Harmsworth, Idler, Illustrated Bits, Illustrated London News, Pall Mall, Pears Annual, Queen, St Paul's, Sketch, Strand, Tatler, Wide World* and the

Windsor Magazine. Most of his humorous work appeared in *Punch* (c. 1905–20). At first he dealt with a variety of subjects but came to specialize in 'Society' episodes featuring tall graceful women, beautiful children and elegant 'bucks', often with Kensington Gardens as a background. The charm of his figures, the variety of his drawing and the spaciousness of his compositions – all the work of a highly accomplished artist – contrast with what now seem dreadfully snobbish jokes. But his contemporaries praised his 'well-bred distinction'. He died on 30 December 1921.

ILL: S. Weyman, *Shrewsbury* (1898); W. Shakespeare, *The Merchant of Venice* (1899), *As You Like It* (1900); G. Borrow, *Lavengro* (1899); B. Disraeli, *Coningsby* (1900); Sir W. Scott, *The Heart of Midlothian* (1900); E. Philpotts, *Up-Along and Down-Along* (1905); E. V. Lucas, *The Open Road* (1913); J. Keats, *Poetical Works* (1916)

EXHIB: RA; RI; RWS; LG (Memorial, 1922)

COLL: V&A; B; LE; BM

LIT: P. V. Bradshaw, *The Art of the Illustrator 5: C. A. Shepperson* (1918) SH

SHERRIFFS, Robert Stewart (1906–60). Caricaturist and illustrator. R. S. Sherriffs was born in Arbroath on 13 February 1906. An arts medallist at Arbroath High School, he studied art and heraldic design at Edinburgh College of Arts. His first published caricature (of actor John Barrymore) was spotted in the *Bystander* by Beverley Nichols who asked him to illustrate the 'Woad' series of celebrity profiles he wrote in the *Sketch*. This led to Sherriffs producing regular full-page theatre and film drawings for the magazine. A contributor to *Radio Times* from 1927, he also took over the illustration of the series 'Both Sides of the Microphone' on the sudden death in an air crash of the magazine's cartoonist ARTHUR WATTS in 1935, and occasionally drew covers. During World War II he served in the Tank Regiment, Royal Armoured Corps, making drawings for education and aircraft recognition. He succeeded JAMES DOWD as film caricaturist on *Punch* (1948–60) and was one of the contenders considered for DYSON's spot on the *Daily Herald* (GEORGE WHITELAW was eventually chosen – Sherriffs not being considered 'sharp' enough). In addition, he illustrated stories for *Evening News*, drew advertisements and menus (Masonic dinners, Savage Club) and wrote a comic novel, *Salute If You Must* (1944), but never achieved his ambition to draw a wordless novel in 300

pictures. Influenced by the linear quality of DULAC (with whom he had once worked) and BEARDSLEY, he developed a decorative calligraphic approach to caricature and preferred working in brush to pen, using Chinese inks for colour illustrations. Price has described his caricatures as 'sculptural, the face built up in rocky planes on a base of firmly apprehended character', and the artist himself as 'a bitter fantastic with a whirling imagination'. Sherriffs had a photographic memory and once said: 'I regarded caricatures as designs and the expressions on faces merely as changes in a basic pattern.' He died on 26 December 1960.

R. S. Sherriffs, [Jessie Matthews], *Evergreen*, 1 August 1934

SHERWOOD

PUB: [Simon Bond ed.] *Sherriff's at the Cinema* (1985)
ILL: C. Marlowe, *The Life and Death of Tamburlaine the Great* (1930); E. Fitzgerald, *The Rubaiyat of Omar Khayyam* (1947); C. Dickens, *Captain Boldheart* and *Mrs Orange* (1948); H. S. Deighton (ed.) 'A Portrait of Britain' series (from 1951); J. Herbert, *Playing the Game*
EXHIB: Times Bookshop; NFT; NT; CG
COLL: NPG; BFI; UKCC; V&A MB

SHERWOOD, G. S. (fl. 1925–d. 1958). Cartoonist. G. S. Sherwood contributed social cartoons to the *Humorist* (1925–40) and *Punch* (1930–8). His drawings are neat, elegant and unemotional; the humour is deadpan and often very funny. Price believed that, with RIDGEWELL, Sherwood was an agent for change in *Punch*. In the *Humorist* during the later 1930s his work stands out for its excellence.
ILL: H. F. Ellis, *The Pleasure's Yours* (1933), *Much Ado* (1934), *Mr Punch's Limerick Book* (1934); L. Carroll, *Verses from Alice* (1944)
 SH

SICKERT, Walter Richard RA PRBA NEAC ARE (1860–1942). Painter, etcher, art critic and teacher, and occasional caricaturist. Walter Sickert was born on 31 May 1860 in Munich, the son of a Danish painter who was also on the staff of *Fliegende Blätter*, the German satirical magazine. He came to England in 1868 and was educated at King's College, London, from which he went to become an actor (1877–81). Abandoning the stage, he studied art briefly at the Slade School (1881), at Heatherley's, in Paris and under Whistler. Primarily a painter – one of the most distinguished of the British School, noted especially for his scenes of the London Music Hall and working-class domestic interiors – he also drew outstanding caricatures of George Moore, Israel Zangwill and MAX BEERBOHM for *Vanity Fair* in 1897 and others in 1911 for the *New Age*. He was elected ARA (1924), RA (1934) and resigned the following year. He died on 22 January 1942 in Bathampton, Somerset.
EXHIB: NG (1941); T (1960); RA (1992)
COLL: V&A; BM; various provincial galleries
LIT: L. Browse, *Sickert* (1960); D. Sutton, *Walter Sickert* (1976) SH

SIGGS, Lawrence Hector (1900–72). Cartoonist. Lawrie Siggs was born in Wolverton, Buckinghamshire, on 30 March 1900. Deeply interested

in country life, he started drawing animals and birds as a child, modelled in candle-grease until his parents bought him Plasticine. Appendicitis interrupted his wireless studies at the London Telegraph Training College and he was greatly influenced while convalescing by the illustrator Albert Morrow who was in the same ward with a broken jaw. He became a Wireless Operator with Marconi at the age of 18 and went to sea, serving on five ships. He later left Marconi and began to work as a commercial artist and cartoonist, designing advertising campaigns, posters and illustrating Middleton's gardening column for the *Daily Express*. He also contributed to *Lilliput, Men Only, Punch* (35 years), *Bystander, Daily Telegraph, John Bull, Evening Standard, Saturday Evening Post, New Yorker* and *Poppy Annual*. Ideas for his cartoons were often inspired by domestic situations, with particular emphasis on children and animals. The humour was gentle and never sarcastic or satirical. He once said that 'A joke is only good if an editor picks it.' Siggs worked mostly in pen and ink but occasionally also used colour wash or watercolour. Price has described him as 'the most careful delineator of the suburban background, and also the most poetic and fantastic in humour'. In HEWISON's view his finely balanced cartoons have a strange, lingering resonance: 'he does not take us directly to the target but sends us through a series of ricochets until we reach the bull's eye from an oblique angle'. He died on 1 July 1972.
COLL: Natural History Museum; V&A; HM the Queen Mother MB

SILLINCE, William Augustus RWS, FSIA, RBA, SGA (1906–74). Cartoonist, illustrator, painter and writer. William Sillince was born on 16 November 1906 in Battersea, London, the son of a Royal Navy marine engineer. He was educated at Osborne House, Romsey, and studied at the Regent Street Polytechnic School of Art and the Central School of Arts & Crafts. Sillince began as a designer in advertising (1928–36), working for Haddons agency and clients such as Players cigarettes and Guinness, before turning freelance, contributing to *Punch* (1936–74), *Bystander* and other magazines as well as illustrating books. He also taught part-time at Brighton College of Art (1949–52), was lecturer in Graphic Design at Hull Regional College of Art (1952–71) and designed the Alice in Wonderland Room at Burton Constable Hall (1967). In addition he created the series 'John Bull's Other Region' for

200

MR. AND MRS. JOYBELL DISCOVER A WAY OF SEEING THE COUNTRYSIDE.

G. S. Sherwood, *Humorist*, 1936

BBCTV (North), contributed to *Yorkshire Post* (1964–74) and wrote on cartooning in *The Artist*. An accomplished watercolourist, he was elected associate (1949) then full member (1958) of the Royal Society of Painters in Watercolour and elected FRSA in 1971. His cartoon work is very distinctive as he always used soft pencil on textured/canvas-grained paper (though he used pen and ink in his earlier work). FOUGASSE has described him as 'a humorist-stylist and, technically, a most excellently equipped artist, with an enthusiasm for experiment'. He died on 10 January 1974.

PUB: *We're All in It* (1941), *We're Still All in It* (1942), *United Notions* (1943), *Combined Observations* (1944), *Minor Relaxations* (1945), *Comic Drawing* (1950), *Yorkshire Life* [poems] (1966)

ILL: D. L. Sayers, *Even the Parrot* (1944); R. Rangemoore, *This Merrie English* (1954), E. Hartwood, *It Don't Cost You a Penny* (1955), L. Berg, *The Story of the Little Car* (1955); V. Ross, *Basic British* (1956), H. Treece, *The Jet Beads* (1961)

EXHIB: HU; RA

COLL: BM; IWM; SM; NG New Zealand; Sunderland; Worthing; Hull MB

SIME, Sidney Herbert RBA (*c.* 1865–1941) Painter, illustrator, theatre designer and cartoonist. Sidney Sime was born in Manchester, most likely in 1865, and after school worked for some years as a pit-boy in a colliery where he made sketches and painted for his own amusement. He attended Liverpool School of Art (1883–8) and in his last year won prizes for drawing. Coming to London in the early 1890s, he started to contribute to periodicals and exhibited pictures at the RBA, becoming a member in 1896. His after-life cartoons in *Pick-Me-Up* (1895) provoked accusations of blasphemy. Sime's gift for the comic-macabre was also seen in the *Idler*, *Butterfly*, *Sketch*, *Tatler* and *Eureka*, which he briefly edited. In 1898 his uncle, a prosperous solicitor in Edinburgh, left him money and property worth £14,000, some of which he used to buy the *Idler*, installing himself as the often absent co-editor in 1899. The venture failed and he sold the goodwill in 1901 for £5. In 1905–6 he spent six months in the USA, working for Hearst who called him 'the Greatest Living Imaginative Artist'. He continued to contribute comic and fantastic drawings to the periodicals intermittently until the mid-1920s but disliked the work, once exploding, 'Magazines! Those

God-forsaken sponge-cakes of the suburban soul!' In 1905 he illustrated fantastically the first of 10 books by Lord Dunsany and in 1909–14 designed sets and costumes for plays written or staged by Lord Howard de Walden. From 1903 he lived reclusively at Worplesdon in Surrey, dying there on 22 May 1941. In the approved manner of the 1890s when his star shone brightly, Sime said that his ambition was to make his pictures 'ever more mysterious'. Even the comic work is an extraordinary mixture of mystery, horror and humour. Perhaps his greatest comic achievement lay in his theatrical caricatures. In this area LOW called him 'a beautifully imaginative artist with a mordant fancy that sometimes overlaid his observation of character, but whose studies of people nevertheless are full of true and well-balanced caricature'.

PUB: *Bogey Beasts* (1923)

ILL: Lord Dunsany, *The Gods of Pegana* (1905), *Time and the Gods* (1906), *The Sword of Welleran* (1908), *A Dreamer's Tales* (1910), *The Book of Wonder* (1912), *Tales of Wonder* (1916)

EXHIB: RBA; SGG

COLL: V&A; Worplesdon Memorial Hall

LIT: S. Heneage & H. Ford, *Sidney Sime* (1980) SH

SIMMONDS, Rosemary Elizabeth 'Posy' (b. 1945). Strip cartoonist, illustrator and writer. Posy Simmonds was born on 9 August 1945 in Cookham Dene near Maidenhead, Berkshire, the daughter of a farmer. She attended Queen Anne's School, Caversham, and studied fine art and French at the Sorbonne in Paris and graphic design at the Central School, London (1964–8). Her first cartoon was published on *The Times'* women's page in 1968 and her first regular daily cartoon feature was 'Bear', which began in the *Sun* on 17 November 1969. However, she is perhaps best known for her work on the *Guardian* since 1972, first as an illustrator, then with her celebrated weekly strip about the Weber family in May 1977 (originally entitled 'The Silent Three'). She has also contributed to *Sunday Times*, *Observer*, *Spectator*, *Radio Times*, *Punch*, *New Society*, *Cosmopolitan*, *Country Living* and *Harpers*. In addition she has produced a number of books – including children's books – and a cartoon documentary, 'Tresoddit for Easter' (1991) for BBCTV, lectured at literary festivals and broadcast on

"I say, I only know "All in a Row," and "Beer, Glorious Beer !"

Sidney Sime, *Pick-Me-Up*, 8 February 1896

Posy Simmonds, *Mrs Weber's Diary* (1979)

BBC radio. She was voted Cartoonist of the Year in Granada TV's 'What the Papers Say' Awards (1980) and in the British Press Awards (1981). Posy Simmonds has also been a committee member of the Cartoonists' Club of Great Britain. Ambidextrous, she drew the Webers strip on semi-transparent A2 layout paper using 0.2–0.4 Rapidographs with Rotring ink using a dip pen for white lettering and a fat pen for spoken text and narrative – the bastardized typeface used she has christened 'Anal Retentive'. She admires the work of SEARLE, GILES and Steinberg. The sister of Richard Simmonds MEP, she is married to designer and typographer Richard Hollis.

PUB: *Bear Book* (1969), *Bear* (1974), *More Bear* (1975), *Mrs Weber's Diary* (1979), *True Love* (1981), *Pick of Posy* (1982), *Very Posy* (1985), *Pure Posy* (1987), *Fred* (1987), *Lulu and the Flying Babies* (1988), *The Chocolate Wedding* (1990)
ILL: K. Wright, *Rabbiting On and Other Poems* (1978), *Hot Dog and Other Poems* (1981), *Cat Among Pigeons* (1989); H. Carpenter, *The Captain Hook Affair* (1979); D. Ashford, *The Young Visiters* (1984); A. Rusbridger, *A Concise History of the Sex Manual* (1986); H. Belloc, *Matilda* (1991)
EXHIB: CG; MOMA; Manor House Museum & Art Gallery, Ilkley; RFH
COLL: V&A; BM MB

SINGE – see Pellegrini, Carlo

SMILBY – see Wilford-Smith, Francis

SMITH – see Weisz, Victor

SMITH, A. T. (fl. 1899–1930). Social cartoonist. A. T. Smith's first recorded appearance was in *Fun* in 1899. A fairly frequent contributor to *Punch* (1902–15) in a style similar to WALLIS MILLS, he also contributed to the *Bystander*, *Odd Volume* and *Sketch* during the 1920s and was probably seen at his best in the *Humorist*.

SH

SMITH, David Edward (b. 1943). Caricaturist. David Smith was born on 7 September 1943 in King's Lynn, Norfolk. He studied at St Martin's School of Art and the Central School of Arts & Crafts (1962–6), later taking a BA in History of Art at the Courtauld Institute (1977–80) and an MA at Birkbeck College, University of London. He began producing caricatures for the *Guardian*'s book page in 1981, contributed a weekly caricature to the *Frankfurter Allgemeine Magazin* (1981–5) and has worked for the *Independent* since its inception in 1986. In adddition, his drawings have been published regularly in *Observer*, *Daily Telegraph*, *Daily Mail* (sports profiles), *Times Literary Supplement* (including covers), *Literary Review*, *Punch*,

Listener, Musical Times, Toronto Star, Paris-Match, Liberation, Le Point, Aamulehti, Etela-Suomen Sanomat and Investors' Chronicle among others. Using strictly black pen-and-ink, he employs a tight cross-hatching technique using a crow-quill nib; for his colour work he generally uses the same technique with added wash. He is an admirer of André Gill, DAVID LEVINE and TROG (especially his colour work).
ILL: S. Barnes, A la Recherche du Cricket Perdu (1989); E. Abelson, Misalliance (1989); S. Hoggart, America, A User's Guide (1990)
COLL: A; UKCC MB

SMITH, Gary James 'Gary' (b. 1963). Caricaturist. Gary Smith was born in Portsmouth on 5 December 1963 and is self-taught. Concentrating on arts (especially theatre and film) caricature and illustrations for book reviews, his work has appeared in the Daily Mirror (1982–7), London Daily News (1987), International Herald-Tribune (1989–91), Sunday Times (from 1983), Daily Mail (from 1987) and Radio Times (from 1989). He has also contributed to Vogue, Tatler, Elle, Today and Punch and designed covers for books by Keith Waterhouse and others. Influenced by Hirschfeld, Covarrubias, Don Bevan,

GARY

Gary Smith, [Marlene Dietrich], unpublished

NERMAN and SHERRIFFS, he works with brush and ink or (for colour) brush and gouache on paper.
EXHIB: LAN; Rebecca Hossack Gallery MB

SMITH, George William 'Gus' (b. 1915). Pocket cartoonist. Born in Upney, Essex, on 8 December 1915 George Smith left school at 16 to work as a clerk in the Russian Oil Company. He then trained as an architect at Exeter University and began to draw cartoons in 1939. After World War II, in which he served with the RASC (achieving the rank of captain), he worked as a surveyor for Shell-Mex while still freelancing as a cartoonist for such publications as Punch, Radio Times, Everybody's, Sketch, Bystander, John Bull, Lilliput and Men Only. He then joined the BBC's overseas service (1946) before becoming staff cartoonist on the Evening News (1953–72). He has also designed posters for the Royal Society for the Prevention of Accidents.
ILL: B. Lampitt, Trogs in the Suburbs (1973)
COLL: UKCC MB

SMYTHE [real name SMYTH], Reginald (b. 1917). Cartoonist and strip cartoonist. Reg Smythe was born on 10 July 1917 in Hartlepool, Cleveland, the son of a boat-builder. He attended Galleys Field School and left at 14 to work as an errand boy for a butcher. In 1936 he joined the Northumberland Fusiliers (becoming a sergeant in 1945) and submitted cartoons to Cairo magazines during World War II. After the war he worked as a post-office telephone clerk in London (1946) and began freelancing cartoons in 1950, selling his first drawing to Everybody's and creating 'Smythe's Speedway World' for Speedway World and 'Skid Sprocket' for Monthly Speedway World. He joined the Daily Mirror in 1954, producing the regular feature 'Laughter at Work' before creating the 'Andy Capp' strip for the Daily and Sunday Mirror in 1957. To date it has been syndicated to 1700 newspapers in 51 countries outside the UK, has been translated into 14 languages and is read by 250 million people. An ITV series based on the character (starring James Bolam in the title role) was also screened in the UK in 1988. The flat-capped Northerner, Andy, was created when Smythe was on holiday. As the artist himself has said: 'Andy Capp was born on the A1. The trip was seven hours, and the name took three – the pun on "handicap" was irresistible. He's a horrible little man, but he's been very good to Reg.' Andy is supposedly based on a real person,

ARE YER COMIN' 'OME THIS WEEK?! — IT TAKES TWO T' MAKE A MARRIAGE WORK, Y'KNOW!

Reg Smythe, [Andy Capp & Florrie], *Laugh Again with Andy Capp*, No. 13 (1975)

but Smythe has never revealed who. However, Capp's wife, Florrie, is named after his mother. Andy always wears his cap and the only time he has ever been pictured without it was in his bed, with Florrie shouting 'You can get up now, your cap's been handed in.' Smythe is left-handed and works with an Osmiroid left-handed pen using a broad nib for lettering and Daler Trimline board. He returned to Hartlepool in 1976 after 40 years' absence.
PUB: *Smythe's Speedway World* (1952), 'Andy Capp' series (annuals from 1959)
COLL: UKCC; BM
LIT: [with L. Lilley] *The World of Andy Capp* (1990) MB

SNAFFLES – see Payne, Charlie Johnson

SNARK, THE – see Wood, Starr

SNEYD, Rev. John (1763–1835). Amateur caricaturist. John Sneyd was the son of a country gentleman, Ralph Sneyd of Keele Hall, Staffordshire, and was educated at Christ Church, Oxford (1782–8), where he probably met George Canning, the future Prime Minister. As an amateur caricaturist (of much talent, according to his friends) he met GILLRAY in the early 1790s. In 1792 he became Rector of Elford, Staffordshire, where in 1795 Gillray stayed with him. Over a long period Sneyd supplied Gillray

with ideas and sketches for caricatures, including the famous 'Very Slippy Weather' (1808) showing the window of Mrs Humphrey's printshop in St James's Street. Sneyd, as a friend of both Canning and Gillray was the go-between in negotiations which led to Gillray accepting a pension from Pitt in return for supporting the government. Mrs Humphreys died in 1818 and left him all Gillray's sketchbooks and drawings in her will. Sneyd himself died on 2 July 1835. Sneyd's nephew, the Rev. Walter Sneyd FSA (1809–88), was also an amateur caricaturist and in 1829 his book, *Portraits of the Spruggins Family*, a forerunner of OSBERT LANCASTER's *Littlehampton Bequest*, was published privately, Sneyd's drawings being lithographed by the Countess of Morley. SH

SPIKE – see Gibbard, Leslie David

SPITTING IMAGE – see Law, Roger, Fluck, Peter & Stoten, David Alan

SPRINGS, John (b. 1962). Caricaturist and painter John Springs was born in Leeds on 6 February 1962 and attended drama school before becoming a full-time caricaturist and painter. His first drawing was published in the *Spectator* (1980) and his work has also appeared in *Literary Review*, *Tatler*, *Sunday Times*, *Harpers & Queen*, *Financial Times*, *Spectator*, *Daily Telegraph*, *New Yorker* and other publications. He uses a fine-nib pen with elaborate cross-hatching and sometimes also adds watercolour and gouache.
ILL: F. Maclean, *The Isles of the Sea* (1985)
EXHIB: NT; Sally Hunter Gallery (1992)
COLL: V&A MB

SPROD, George Napier (b. 1919). Cartoonist and writer. George Sprod was born in Adelaide, South Australia, on 16 September 1919 and attended Norwood High School and Urrbrae Agricultural High School. During World War II he served as a gunner in 2/15 Field Regiment, Australian Artillery, but was taken prisoner at the fall of Singapore. He then spent three and half years working on the Burma railway and in Changi Prison, Singapore, where he met RONALD SEARLE. After the war he worked as a political cartoonist for Frank Packer in Sydney (1945–9) and later came to London to work for various Fleet Street publications including *Punch*, before returning to his home country. Malcolm Muggeridge's favourite cartoonist, he works mostly in pen and ink, and has been described by

Geipel as (with FFOLKES) the leading exponent of 'the more filigree type of decorative cartooning'.
PUB: *Chips off a Shoulder* (1956), *Bamboo Round My Shoulder* (1982), *Sprod's View of Sydney* (1984), *When I Survey the Wondrous Cross* (1990)
ILL: Many books including G. Ashe, *The Tale of a Tub* (1950); J. B. Boothroyd, *The House About a Man* (1959); C. L. Woolley, *As I Seem to Remember* (1962); V. B. Holland, *An Explosion of Limericks* (1967)
EXHIB: (Various 1949–69) London; New York; Sydney; Amsterdam
COLL: Australian War Memorial, Canberra; UKCC; V&A
LIT: [autobiography] *Life on a Square-Wheeled Bike* (1987) MB

George Sprod, *Lilliput*, October 1950

SPY – see Ward, Sir Leslie Matthew

STAMPA, Giorgio [later George] Loraine (1875–1951). Cartoonist and illustrator. G. L. Stampa was born in Constantinople on 29 November 1875, the second son of the architect G. D. Stampa – who designed Manchester Free Trade Hall, the British Embassy in Therapia and the Sultan's Palace in Constantinople amongst other buildings – and a descendant of the Italian Renaissance poet Gaspara Stampa (1520–54). He was educated at Appleby Grammar School, Bedford Modern School, Heatherley's School of Art (1892–3) and the RA Schools (1893–5), where fellow students included W. HEATH ROBINSON and LEWIS BAUMER. Stampa shared a studio with SAVILE LUMLEY. His first drawing for *Punch* appeared in March 1894 and in 1900 he became a full-time illustrator and cartoonist mainly working for *Punch* but also contributing to *Bystander, Humorist, Graphic, Strand Magazine, London Opinion, Moonshine, Pall Mall Magazine, Sketch, Tatler, Windsor Magazine, Cassell's Magazine* and others. Greatly influenced by CHARLES KEENE and PHIL MAY in his early work, Stampa gradually found his own style and is best remembered for his drawings of Cockneys and street urchins, his book illustrations and his theatre cartoons for *Punch* (sometimes signed 'Harris Brooks') which he produced for 56 years (1894–1949), being succeeded by RONALD SEARLE. Deemed unfit for service in World War I and too old for service in World War II, Stampa was a genial eccentric and his *Punch* obituary described him as 'the last of the Bohemians'. He always carried a drawing pad and a pencil stub (new pencils were cut into four pieces) and worked in ink, oil, pastel and watercolour on Velum paper and board at a drawing board tilted at 45 degrees. Described as 'a master of black and white . . . but a humorist in the great LEECH tradition' (*Daily Chronicle*), he died on 26 May 1951.
PUB: *Loud Laughter* (1907), *Ragamuffins* (1916), *Humours of the Street* (1921), (ed.) *In Praise of Dogs* (1948)
ILL: 14 books including E. V. Lucas, *Specially Selected* (1920), *Urbanites* (1921); A. Armstrong, *Easy Warriors* (1923); R. Kipling, *Supplications of the Black Aberdeen* (1929), *Thy Servant a Dog* (1930), *Collected Dog Stories* (1934)
EXHIB: RA; WG; WAC tour (1986); CG; Italian Cultural Institute; Salisbury Festival; BC; NT; Abbott Hall, Kendal; Hatton Gallery,

Hereford; Nelson Museum, Monmouth; and others
COLL: UKCC; A; CAT; V&A; BM; TM
LIT: F. Stampa Gruss, *The Last Bohemian: G. L. Stampa* of Punch (1991) MB

STANIFORTH, Joseph Morewood (1863–1921). Political cartoonist, illustrator and painter. J. M. Staniforth (who often signed his work 'JMS') was born on 16 May 1863 and educated at St John's School, Cardiff. He was then apprenticed to the Lithographic Department of the *Western Mail* (1878) and ten years later joined the editorial staff as an illustrator, drawing daily cartoons from 1893. In addition, he drew regularly for *Cardiff Evening Express* and the *News of the World*, contributed to Punch and, a member of the South Wales Art Society, painted in oils and watercolours. Succeeded on the *Western Mail* by ILLINGWORTH, he died on 17 December 1921.
PUB: *The General Election 1895* (*c.* 1895), *Cartoons of the Boer War* (1900), *Cartoons of the Welsh Revolt* (1905), *Cartoons by J. M. Staniforth* (1909), *Cartoons of the War* (1914) MB

STARKE, Leslie Hugh (1905–74). Cartoonist and illustrator. Leslie Starke was born in Cupar, Fife, on 25 November 1905. Badly mauled by a

Leslie Starke, *Starke and Unashamed* (1953)

sheepdog at the age of three, he worked in a solicitor's office in Cupar for ten years and was a self-taught artist drawing caricatures of local cricketers on the *Fife Herald* (1928–9) before coming to London as a songwriter (he was an accomplished pianist). He then worked in the theatre and for a firm of automatic machine contractors. During World War II he served in the RAF (1941–5) and continued drawing cartoons, also producing advertisements for the Ministry of Food, including one claimed as the largest in the world displayed across the face of County Hall and proclaiming 'Food is a Munition of War – Don't Waste It'. He became a full-time freelance in 1946, working for *Punch*, *New Yorker*, *Lilliput*, *John Bull*, *Men Only*, *Sketch*, *London Opinion*, *World's Press News*, *New Elizabethan*, *Illustrated*, *Esquire*, *Saturday Evening Post* and *Collier's*, as well as producing a considerable amount of advertising work, including calendars for the Royal Society for the Prevention of Accidents. Starke always used a brush and was a firm believer that the best jokes don't need captions. His monks and company directors are 'the denizens of a limbo-land on the borders between fantasy and reality' (Geipel) and Price has said that 'with ANTON and TAYLOR, he represented the first generation of crazy humorists at their best'. He died on 16 November 1974.
PUB: *Starke and Unashamed* (1953), *Starke Staring* (1955), *Starke Parade* (1958)
ILL: T. Berkeley, *We Keep a Pub* (*c.* 1955); N. R. Smith, *Things to Collect* (1971); L. Hurley, *Shamus and the Green Cat* (1972)
EXHIB: CG
COLL: V&A; CAT MB

STEAD – see Steadman, Ralph Idris

STEADMAN, Ralph Idris (b. 1936). Cartoonist, illustrator, printmaker and writer. Born on 15 March 1936 in Wallasey, Cheshire, the son of a commercial traveller, Ralph Steadman attended Abergele Grammar School. He worked as a trainee manager with F. W. Woolworth, Colwyn Bay, was an apprentice aircraft engineer with De Havillands in Chester, and spent his National Service in the RAF (1954–6) before joining the Kemsley Newspaper Group as a cartoonist (1959–61). He studied art part-time at East Ham Technical College (1959–66), the London College of Printing (1961–5) and with PERCY BRADSHAW, and freelanced cartoons for *Punch*, *Private Eye* and the *Daily Telegraph* – signing

Ralph Steadman, *Sigmund Freud* (1979)

himself at first 'STEAD' – until he became Artist-in-Residence at Sussex University (1967). He later worked for the National Theatre (1977), *The Times* (1970–1) and the *New Statesman* (1976–80) and has contributed cartoons to *Rolling Stone, Radio Times, Black Dwarf, New York Times, Times Higher Education Supplement, New Scientist, Observer, Sunday Times* and *Independent.* He has won numerous awards for his work including the V&A's Francis Williams Book Award (1973), Designers' & Art Directors' Association Gold Award (1977), American Institute of Graphic Arts Illustrator of the Year (1979), W. H. Smith Illustration Award (1987) and BBC Design Award (1987). In addition, he has directed a film for TVS (1992), designed for the stage, written libretti, designed stamps for the GPO (1986), given lectures and designed Oddbins catalogues (1987–93). Ralph Steadman uses pens, brushes, inks, acrylics, oils, etching, silkscreen and collage. His brutal, savage style has some similarity to that of SCARFE and Lucie-Smith has referred to Steadman as 'a moralist in the tradition of HOGARTH'.
PUB: *Two Cats in America* (1964), *The Little Prince and the Tiger Cat* (1965), *Ralph Steadman's Jelly Book* (1967), *Still Life with Raspberry* (1969), *Dogs' Bodies* (1970), *Little Red Computer* (1970), *Ralph Steadman's Bumper Book for Children* (1973), *Flowers for the Moon* (1974), [with F. Saint] *Two Donkeys and the Bridge* (1974), *The Yellow Flowers* (1968), *America* (1974), *Cherry Wood Cannon* (1978), *Sigmund Freud* (1979), *No Good Dogs* (1982), *I, Leonardo* (1983), *Paranoids* (1986), *Scar Strangled Banner* (1987), *That's My Dad* (1986), *The Big I Am* (1988), *No Room to Swing a Cat* (1989), *Near the Bone* (1990), *Tales of the Weirrd* (1990), *The Grapes of Ralph* (1992).
ILL: More than 50 books including M. Damjan, *The Big Squirrel and the Little Rhinoceros* (1965); H. Wilson, *The Thoughts of Chairman Harold* (1967); L. Carroll, *Alice in Wonderland* (1967), *Through the Looking Glass* (1972), *The Hunting of the Snark* (1975); J. Devenson, *Night Edge* (1972); H. S. Thompson, *Fear and Loathing in Las Vegas* (1972), B. Stone, *Emergency Mouse* (1978), *Inspector Mouse* (1980), *Quasimodo Mouse* (1984); T. Hughes, *The Threshold* (1979); R. L. Stevenson, *Treasure Island* (1985); F. O'Brien, *The Poor Mouth* (1971)
EXHIB: NT; RFH; WBM; October Gallery; Tricycle Theatre; Exeter Arts Festival; Canterbury Festival; CG
COLL: UKCC; V&A; CAT

LIT: R. Steadman, *Between the Eyes* (1984)

MB

STOTEN, David Alan (b. 1962). Caricaturist, sculptor, designer and TV director. Born in Barton le Cley, Bedfordshire, on 28 April 1962, David Stoten attended Icknield High School, Luton, where he was a contemporary of comic artist Steve Dillon, and studied graphic design and illustration at St Martin's School of Art (1981–4). A regular contributor to *Mad* magazine (1981–5), he began work for SPITTING IMAGE Productions in 1984 as a caricaturist, designing and modelling the puppets. Since studying film direction at the National Film & Television School his work at Spitting Image has also included directing animation and title sequences for the programme. In addition, he has freelanced for the *Economist, Guardian, Sunday Express* and *New Yorker* and lectured at the RCA and Royal College of Surgeons. He works mostly in pencil, then models in clay followed by a plaster (or fibreglass) mould filled with latex (or foam).
PUB: contributor to all Spitting Image books (see ROGER LAW entry)
EXHIB: [as Spitting Image] CG

MB

STOTT, William Ronald (b. 1944). Cartoonist. Bill Stott was born in Preston, Lancashire, on 20 May 1944 and studied painting and lithography at Harris College of Art, Preston (1961–5), and Liverpool Art School (1965–6). A regular contributor to *Times Educational Supplement* since 1987 he has also done freelance work for *Punch, Private Eye, Daily Express, Amateur Photographer, Yachting World, Education, Automobile* and numerous specialist magazines. In addition he has produced drawings for advertising (e.g. National Breakdown) and is a popular after-dinner speaker.
PUB: 14 titles in 'The Crazy World of . . .' series (from 1988), eight titles in 'Jokes' series (from 1990)
ILL: D. Shiach, *Steps to Spelling* (1984)
EXHIB: BAG

MB

STOWELL, Gordon (b. 1928). Cartoonist and illustrator. Gordon Stowell was born on 3 November 1928 in Worsley, Manchester, and apart from training with the Press Art School correspondence course run by PERCY BRADSHAW is self-taught. Freelance since 1955, his cartoons have appeared in *Punch, Stamp News, What Mortgage, What Finance, What Investment, Prep*

School, Civil Service Opinion, Oldie and others. He uses pen and ink only for his cartoon work with the addition of watercolour for children's book illustrations. His wife Janet is also an illustrator and printmaker.
PUB: *Going with the Crowd* (1962), 'Glow-Worm Books' series (1967–71), 'Little Fish Books' series (1975–84), *Bats in the Belfry* (1985)
ILL: Many books including A.Knowles 'Hippity Dog' series (from 1979); C. Matthews, *Dimitra of the Greek Islands* (1980); J. Piggott, *Kiku of Japan* (1980); P. Seymour, *Our Wonderful World* (1981); H. Davies, *The Joy of Stamps* (1983) MB

STRUBE, Sidney Conrad 'George' (1892–1956). Political cartoonist. Born in Bishopsgate, London, on 30 December 1892, Sidney Strube (known familiarly as 'George' from his habit of addressing others by this name) attended St Martin's School of Art. He began work as a junior draughtsman designing overmantels for a furnishing company, then after working in an advertising agency he attended the JOHN HASSALL School of Art, where Hassall encouraged him to submit caricatures to the *Conservative & Unionist* (later renamed *Our Flag*) during the 1910 election. After four were accepted he had work published in *Bystander, Evening Times* and *Throne & Country*. When the latter publication refused a drawing he took it to the *Daily Express* who published it and by 1912 he had an exclusive freelance contract with the paper. After service as a PT instructor in the Artists' Rifles in 1914–18 he joined the staff of the *Express* as Political Cartoonist (1918–48) and created the immortal 'Little Man' with his umbrella, bow-tie and bowler hat, who became a national symbol of the long-suffering man-in-the-street 'with his everyday grumbles and problems, trying to keep his ear to the ground, his nose to the grindstone, his eye to the future and his chin up – all at the same time', in Strube's own description. An immensely popular artist he was also one of the highest paid, reputedly earning £30,000 a year in 1933. On retiring from the *Express* (succeeded by GILES) he continued to freelance for *Sunday Times, Time & Tide, Everybody's* and *Tatler*. During World War II he also produced a number of memorable poster campaigns including 'Yield Not an Inch! Waste Not a Minute' and 'The Three Salvageers'. He was made a Freeman of the City of London and a member of the Sketch Club and the Savage. In 1927 he married the *Daily*

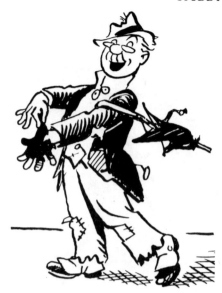

Sidney Strube, [Little Man], 1930s

Express fashion artist Marie Allright. Strube (whose name rhymes with 'Ruby') never allowed malice to enter his cartoons and, a fastidious worker, his motto was 'Never let it go until you are satisfied – and never be satisfied!' An admirer of PARTRIDGE, FRANK REYNOLDS and LOW, he worked on Whatman board with indian ink after sketching preliminary outlines in pencil. His son really was called George.
PUB: [with W. F. Blood] *The Kaiser's Kalendar for 1915* (1914), 12 volumes of cartoons (1927–47) including *Cartoons from the Daily Express* (1927–8), *Strube's Annual* (1929–30), *100 Cartoons* (1931–5), *Strube's War Cartoons* (1944)
COLL: V&A; UKCC MB

STUDDY, George Ernest (1878–1948). Cartoonist, strip cartoonist, illustrator and animator. G. E. Studdy was born on 23 June 1878 in Devonport, Devon, the son of a lieutenant in the Argyll & Sutherland Highlanders. He was educated at Clifton College, Bristol, and Dulwich College, London (left 1896), and would have gone into the Army but for a childhood accident when a pitchfork went through his foot. He attended evening classes at Heatherley's and spent a term at Calderon's School of Animal Painting but worked as an apprentice engineer for Thames Iron Works then as a stockbroker

TRIUMPHANT.

G. E. Studdy, *Printers' Pie*, 1912

before becoming a cartoonist. His first contributions were strips to boys' story papers like *Big Budget*, *Boys' Weekly* and *Comic Cuts* but by World War I he was working regularly for the *Sketch* (full-page wash plates, often rather weird), *Tatler* ('New Illustrations for Old German Fairy Tales' series, 1915), *Bystander*, *Graphic* and *Illustrated London News*. He also produced animation shorts for Gaumont, the films appearing monthly under the title 'Studdy's War Studies' (1915–16). In addition he worked for *The Field*, *Punch* (only once, 24 December 1902), *Little Folks*, *Windsor Magazine*, *Passing Show*, *Humorist* and in advertising (e.g. Pan Yan Pickle, Swan Ink), produced postcards for Valentine's of Dundee, and was elected President of the London Sketch Club in 1921. Perhaps his most famous creation was 'Bonzo', a white bull terrier pup with black spots who began life as an incidental dog in illustrations and first appeared with this name (christened by *Sketch* Editor, Bruce Ingram) in the *Sketch* on 8 November 1922 (the 'Studdy Dog' had appeared in the magazine since 1918). Enormously popular, the sleepy-eyed Bonzo – who walked on two feet, smoked cigarettes and often wore a bow-tie –

featured widely in merchandizing from clocks and cigarette cards to car mascots. He also appeared on stage (e.g. at the Lyceum in 'Sleeping Beauty' in 1924), as a miniature in Queen Mary's Doll's House, and was used to advertise D. W. Griffith's film, *One Exciting Night*, as well as Eclipse razors, Wolsey cars and – in the first neon-light advertisement in Piccadilly Circus in 1924 – Pinnace cigarettes. In the pre-Disney era his only serious rival was Felix the Cat and by 1926 he had become the star of 26 silent animated short films produced by New Era Films (the first of which was the occasion of the first ever royal film première on 14 October 1924), supported by a weekly strip in *Tit-Bits* the same year which was later syndicated in the USA. Bonzo last appeared in the *Sketch* in July 1927 and was replaced by a Bonzo-like cat – Oozoo – in 1929. Studdy (whose own dogs were a succession of cocker spaniels always called Ben) also produced McGill-style postcards under the pseudonym 'Cheero'. He died on 25 July 1948.
PUB: *The Studdy Dogs Portfolio* (1922), *Uncle's Animal Book* (1923), plus nearly 30 Bonzo books from *The Bonzo Book* (1925) and nine *Bonzo Annuals* (1930–52) to *Jeek* (1940).
ILL: H. T. Sheringham, *Fishing – A Diagnosis* (1914), *Fishing – Its Cause, Treatment and Cure* (1925); F. Rayle, *Dopey and Dotty* (n.d.), *A Day with Dopey* (n.d.)
EXHIB: BSG; L
COLL: US National Film Archive (Bonzo animation); IWM
LIT: P. Babb & G. Owen, *Bonzo: The Life and Work of George Studdy* (1988) MB

STYX – see Harding, Leslie Clifford

SULLIVAN, Edward Joseph RWS RE (1869–1933). E. J. Sullivan was born in London on 6 September 1869, the son of a drawing-master from Hastings and the brother of J. F. SULLIVAN. Trained by his father, he was one of the talented team of illustrators recruited for the *Daily Graphic* (1890) and from there went on to illustrate more than 20 periodicals and more than 30 books, his masterpiece being Carlyle's *Sartor Resartus* (1898). Most of his work is in pen and ink which he used with vigour, intelligence and occasionally wit. However, wit is signally absent from the cartoons he drew (1914–8) to excoriate the German enemy, some of which appear in *The Kaiser's Garland*. THORPE described it as a 'whole-hearted hymn of hate ... the venom is often overdone and one

THE PRUSSIAN BUTCHER

Edmund J. Sullivan, *The Kaiser's Garland* (1915)

feels sometimes more disposed to laugh than to share the hatred and anger', but he called them 'fascinating, excellent drawings'. Much the same could be said of the few cartoons Sullivan contributed to *Punch* in the 1920s and 30s. He was an influential teacher of book illustration at Goldsmith's College, London, and was a regular exhibitor of watercolours and etchings, being elected RWS (1929) and RE (1931). He died in London on 17 April 1933.
PUB: *The Kaiser's Garland* (1915), *The Art of Illustration* (1921), *Line* (1922)
ILL: More than 30 books including G. Borrow, *Lavengro* (1896); I. Walton, *The Compleat Angler* (1896); A. Tennyson, *A Dream of Fair Women* (1900), *Maud* (1922); H. G. Wells, *A Modern Utopia* (1905); F. de la Motte Fouqué, *Sintram and his Companions* (1908); T. Carlyle, *The French Revolution* (1910); G. Outram, *Legal and other Lyrics* (1916)

EXHIB: RA; RWS; RE
COLL: BM; V&A; CAT
LIT: J. Thorpe, *E. J. Sullivan* (1948) SH

SULLIVAN, James Francis (1853–1936). Cartoonist, strip cartoonist and author-illustrator. J. F. Sullivan was the son of a drawing-master from Hastings and an elder brother of E. J. SULLIVAN. He studied art at the South Kensington Schools and in 1871 started to contribute strip cartoons to *Fun* becoming over 25 years the magazine's most popular illustrator. His most famous strips were 'The British Working Man' and its sequels. In these he satirized the cheating, laziness, greed and ineptitude of the working class from the point of view of the lower middle class (the readers of *Fun*). In another series, 'Grandmotherly Government' (from 1874), he attacked the abuses of industrialization – pollution of the environment in all its forms, dangers to public health, overcrowding of cities, vandalism, unsafe buildings etc. – attacks which can be contrasted with the limited social concerns of the artists in *Punch* and other so-called 'satirical' journals. During the 1890s he contributed strips, single-panel cartoons and caricatures to *Black & White*, *Cassell's*, *Cassell's Saturday Journal*, *Lady's Pictorial*, *New Budget*, *Pearson's*, *Pick-Me-Up*, *Punch* (1893), *St Paul's*, *Sketch* and the *Strand Magazine*. He also wrote and illustrated some children's books and he seems to have retired in the early 1900s. Sullivan once apologized for his draughtsmanship as an inadequate vehicle for airing his social prejudices. The figures in his cartoon strips are often crudely drawn and harshly lit but they are funny and powerful. Part-reformist, part-conservative and wholly idiosyncratic, Sullivan in challenging the moral perceptions of his time was a throwback to HOGARTH. That, together with his development of the strip form, makes him one of the most important figures in British cartoon art.
PUB: *The British Working Man* (1878), *The British Tradesman* (1880), *Among the Freaks* (1896), *Here They Are* (1897), *Here They Are Again* (1899), *The Great Water Joke* (1899), *Queer Side Stories* (1900)
ILL: Various children's books
EXHIB: FAS (1898)
COLL: V&A
LIT: D. Kunzle, *The Early Comic Strip* (1973) SH

J. F. Sullivan, *Fun*, 24 September 1879

T

TALBERT – see McLean, Talbert

TAYLOR, John Whitfield 'JWT' MSIA (1908–85). Cartoonist. J. W. Taylor was born in Stoke-on-Trent, Staffordshire, on 11 May 1908 and first showed interest in cartoons when he received a collection of FRANK REYNOLDS' drawings for a Christmas present at the age of 14. Educated at the Orme Boys' School, Newcastle-under-Lyme, and at Manchester University (where he read French and drew for *Rag Bag*), he was a schoolteacher in the Potteries when he began to take art lessons from PERCY BRADSHAW's course. His first cartoons were accepted by *Punch* (1935) quickly followed by *Men Only, London Opinion, Lilliput* and others. He also contributed to *Eagle* ('Educating Archie' strip), *Staffordshire Evening Sentinel* and (as a headmaster) *The Teacher*. Greatly admired by his contemporaries ('one of the greatest cartoonists of the 20th century' BUD HANDELSMAN), he worked at first in pen and ink or charcoal and wash but later concentrated on brushwork and excelled at producing very witty ideas with a spare, uncluttered line. Price has described him as 'the most consistent of the crazy artists . . . He was, perhaps, best when barest, nothing distracting attention from the purity of his nonsense.' J. W. Taylor died on 12 December 1985. (His son, David, was Editor of *Punch* (1986–9).
COLL: BM MB

Plain English !

JOHN BULL. "Look here, my little Friend, I don't want to hurt your little feelings—but, COME OFF THAT FLAG!!!"

John Tenniel, *Cartoons* (1901)

TENNIEL, Sir John RI (1820–1914). Cartoonist and illustrator. John Tenniel was born in Kensington, London, on 28 February 1820, the son of a fencing and dancing master. Destined to be a *maître d'armes* he taught himself to draw instead and attended briefly the RA Schools and the Clipstone Street Academy, where he became friends with his future colleague CHARLES KEENE, the two of them supplying humorous drawings of much charm for Thomas Barrett's unpublished *Book of Beauty* (1846). He had proposed to be a history painter but, losing the sight of an eye in a fencing bout with his father, turned to black-and-white art, illustrating several books in the 1840s. One of these, *Aesop's Fables* (1848), caught the eye of Douglas Jerrold of *Punch* and in 1850, on the departure of DICKY DOYLE, he joined the magazine, at first drawing humorous initials, illustrations to poems etc. He soon progressed to political cartoons, replacing LEECH as Chief Cartoonist in 1864, and thereafter until his retirement in 1900 created cartoons of dignity and authority, being more responsible than anyone else for turning *Punch* into a national institution. This work he took seriously and once asked 'do they suppose there is anything funny about *me?*' To begin with some of his cartoons were strongly partisan – especially those directed against Abraham Lincoln – but gradually his judgements came to seem Olympian and impartial, requiring the consent of all fair-minded men. Although his *Punch* work claimed the bulk of his time, his book illustration included his imperishable work for Lewis Carroll's 'Alice' books and his droll humour can also be seen in *Puck on Pegasus* (1861) and *The Ingoldsby Legends* (1864). Tenniel was elected RI (1874) and was

knighted in 1893. He died on 25 February 1914. Tenniel, in Frances Sarzano's words, 'pulled the sting out of caricature'. 'HB' had begun the reaction against Georgian scurrility, Leech extended it, Tenniel completed it. His method of drawing on the wood block, which defied the engravers to interpret the subtlety of his pencil lines, resulted in a stiff style that well suited a solemn message and carried immediate impact. He created an 'official' manner of political cartooning – metaphorical art incorporating symbols like Britannia, the British Lion and a respectable John Bull – which all *Punch*'s rivals copied and which lasted for upwards of 100 years.

PUB: *Cartoons by Sir John Tenniel Selected from the Pages of 'Punch'* (1901)
ILL: F. de la Motte Fouqué, *Undine* (1845); S. Brooks, *The Silver Chord* (1860), *The Gordian Knot* (1860); T. Moore, *Lalla Rookh* (1861); L. Carroll, *Alice's Adventures in Wonderland* (1866), *Through the Looking Glass* (1872); W. Thornbury, *Historical and Legendary Ballads and Songs* (1876)
EXHIB: RA; RI; FAS (1895, 1900)
COLL: BM; V&A
LIT: F. Sarzano, *Sir John Tenniel* (1948); R. Engen, *Sir John Tenniel: Alice's White Knight* (1988) SH

THACKER, Cecil Fox 'Bill' (b. 1915). Cartoonist and strip cartoonist. Bill Thacker was born on 16 June 1915 in Denbighshire, North Wales, and is self-taught. He sold his first cartoons to *Motor Cycle* in 1939 and later contributed regularly to the magazine (1954–71). In World War II he flew with the Air Transport Auxiliary Service and after the war worked as a technical artist for BOAC before turning freelance cartoonist. His work has appeared in various publications but especially *Autocar* (1958–72), *Aeroplane*, *Tit-Bits*, *Everybody's*, *Reveille*, *Daily Mirror*, *BOAC Review* (*c.* 1952–75), *Amateur Photographer* and *Do It Yourself* (1968–83). He also drew a captionless strip featuring a character called Battersby in *Practical Gardener* for 12 years. Bill Thacker works in pen and ink.

PUB: *The Taming of the Screw* (1984) MB

THACKERAY, Lance RBA (d. 1916). Cartoonist, illustrator, painter and postcard designer. In the 1890s Lance Thackeray's humorous art was published in the *Sketch* and *Sketchy Bits* and later in the *Graphic* and *Punch* (1905–8). In 1900 he produced the first of around 950 comic postcard designs, mostly for the firm Raphael Tuck, in which sporting themes predominate. He also made several series of humorous prints, like his friend CECIL ALDIN, a neighbour in Bedford Park, Chiswick. In addition, he travelled to Egypt and the pictures he painted there were exhibited in London. He was a founder member of the London Sketch Club (1898) and was elected RBA (1899). On the outbreak of war he enlisted with the Artists' Rifles but died in 1916.

PUB: *The Light Side of Egypt* (1908), *The People of Egypt* (1910)
ILL: G. Frankau, *The XYZ of Bridge* (1906)
EXHIB: LG (1908); FAS (1910); WG (1913)
LIT: T. Warr & K. Lawson, *The Postcards of Lance Thackeray* (1979) SH

THACKERAY, William Makepeace (1811–63). Author and comic artist. W. M. Thackeray was born in Calcutta on 18 July 1811, the only child of a high official in the East India Company who died four years later. He came to England in 1817 and was educated at Charterhouse School (1822–8) with LEECH and briefly at Trinity College, Cambridge. After dissipating his inheritance in foreign travel and various ventures, he studied art in Paris (1835) and the following year issued a series of lithographs satirizing the ballet entitled 'Flore et Zéphyr'. He failed in his application to illustrate Dickens's *Pickwick Papers* on the death of SEYMOUR (1836). His sketchy art training was supplemented by lessons in etching from GEORGE CRUIKSHANK whose work he greatly admired, publishing his *Essay on the Genius of George Cruikshank* in 1840. Around this time he started, with variable success, to illustrate his own books. From 1842 to 1854 he worked for *Punch*, mainly as a writer but also as the illustrator of his own work and as a contributor of occasional cartoons, initials and comic decorations. These, although they appear amateurish beside the work of LEECH and DOYLE, have an individuality and spontaneity that is attractive. Thackeray was a keen student of caricature and exulted in the passing of the old scurrility: 'We have washed, combed, clothed and taught the rogue good manners,' he wrote in 1854. No great draughtsman, the best of his illustrations – as in *The Rose and the Ring* – have delighted successive generations by their humour. He died in London on 24 December 1863.

PUB: *The Paris Sketch Book* (1840), *Comic Tales and Sketches* (1841), *The Irish Sketchbook* (1843), *Mrs. Perkin's Ball* (1846), *Vanity Fair*

(1847–8), *Doctor Birch and his Young Friends* (1848), *Pendennis* (1848–50), *The Rose and the Ring* (1854), *The Virginians* (1857–9)
COLL: BM; V&A; F; NYPL
LIT: J. Buchanan-Brown, *The Illustrations of W. M. Thackeray* (1979) SH

THELWELL, Norman (b. 1923). Cartoonist, illustrator and landscape painter. Norman Thelwell was born on 3 May 1923 in Birkenhead, Cheshire, and was educated at Rock Ferry High School, Birkenhead. In World War II he served in the East Yorkshire Regiment, Royal Electrical and Mechanical Engineers (1942–6). While Art Editor of an Army publication, he had his first cartoons published in *London Opinion*. After the war he attended Liverpool College of Art (1947–50) and lectured on design and illustration at Wolverhampton College of Art (1950–7). He sold his first drawing to *Punch* in 1950 and contributed more than 1600 cartoons – including 60 covers – to the magazine (1952–77) as well as working for *News Chronicle* (1956–60), *Sunday Dispatch* (1960–1), *Sunday Express* (1963–71) and *Tatler* (1971–6). His

W. M. Thackeray, *The Thackeray Alphabet* (1929)

Norman Thelwell, *The Pony Club Book* (*c.* 1960)

freelance work has included *London Opinion, Lilliput, Daily Express, John Bull, Illustrated, Picture Post, Eagle, New Review, Farming Express, Farmers Weekly, Countryman* and *Esquire.* He has also produced book jackets and worked in advertising (W. H. Smith, GPO etc) and for TV. A fine draughtsman, Thewell has a realistic style, placing 'cartoon' figures in naturalistic settings and with great attention paid to detail. He is particularly well known for his cartoons on fishing, sailing, motoring and English country life – especially those (from 1953) featuring young girls and ponies. His cartoons are signed 'thelwell' written with blob serifs in a wavy line while his landscapes and other paintings have the signature 'NORMAN THELWELL'.

PUB: More than 30 books, including *Angels on Horseback* (1957), *Thelwell Country* (1959), *The Penguin Thelwell* (1963), *The Compleat Tangler* (1967), *A Plank Bridge by a Pool* (1978), *Thelwell Annual* (1980), *Some Damn Fool's Signed the Rubens Again* (1982), *How to Draw Ponies* (1982)

ILL: M. J. Baker, *Away Went Galloper* (1962); C. Ramsden, *Racing Without Tears* (1964)

EXHIB: TRY; CBG

COLL: V&A; CAT

LIT: [autobiography] *A Millstone Around My Neck* (1981), *Wrestling with a Pencil* (1986)

MB

THOMAS, Herbert Samuel MBE (1883–1966). Cartoonist, caricaturist and illustrator. Bert Thomas was born in Newport, Monmouthshire, on 13 October 1883 the son of a monumental sculptor who had helped decorate the Houses of Parliament. He was apprenticed to an engraver in Swansea at the age of 14, designing brass doorplates, and selling music-hall cartoons to *Swansea Daily Leader, Daily Post, News* and *Echo.* On the recommendation of Albert Chevalier, a popular music-hall comedian of the time who had seen his work, he joined a London advertising agency in 1902. After freelancing for *Pick-Me-Up* and *Ally Sloper's Half Holiday* he began a long association with *Punch* (1905–48) and *London Opinion* (1909–54) – contributing political and social cartoons and latterly the popular 'Child's Guide' to celebrities series. He also contributed to *Humorist, Sketch, Passing Show, Radio Times, Bystander, Fun, Graphic,* and the *World.* Thomas served as a private in the Artist's Rifles in World War I (1916–18) and was official artist for the War Bonds campaign,

producing for it Britain's largest poster, which covered the face of the National Gallery (1918). Painted in oils, it was 75 feet long and depicted Drake facing the Spanish Armada (he also did others for the Royal Exchange and in Cardiff and Glasgow). His most famous cartoon was ''Arf a Mo', Kaiser!' featuring a grinning Cockney Tommy lighting a pipe before engaging the enemy. It was drawn (supposedly in ten minutes) for the *Weekly Dispatch* on 11 November 1914 as part of the paper's tobacco-for-troops fund. This and other contributions to the war effort earnt him an MBE (1918). After the war he produced a red-and-black series for the *Sketch* and drew illustrations to the 'Cockney War Stories' letters column in *Evening News* (a collection of which was published in 1930). For his *Punch* work he usually drew in pen and ink but elsewhere used mostly a brush, a favourite technique being to use an old matted brush on Whatman or Clifford Milburn board to get a chalk-like line. He also worked in charcoal and wash, pencil, chalk-grain scraperboard, litho chalk and 'splatter' (tint obtained by splattering a toothbrush dipped in ink). He never used models or made on-the-spot sketches. In World War II he again produced memorable posters, including the 'Is Your Journey Really Necessary' series for the Railway Executive Committee (1942). He was an admirer of KEENE, OSPOVAT, Eduard Thöny and PHIL MAY. Bert Thomas died on 6 September 1966.

PUB: *One Hundred War Cartoons from London Opinion* (1919), *In Red and Black* (1928), *500 of the Best Cockney War Stories* (1930), *Cartoons and Character Drawing* (1936), *Fun at the Seaside* (1944), *Fun on the Farm* (1944), *Podgy the Pup* (1945), *A Mixed Bag* (1945), *Fun in the Country* (1946), *Fun in Town* (1946), *Playtime* (1947), *Toy Land* (1947), *A Trip on a Barge* (1947), *Railways By Day* (1947), *Railways by Night* (1947), *Close-ups Through a Child's Eye* (n.d.)

ILL: Many books including W. W. Jacobs, *Sea Whispers* (1926); T. R. Arkell, *Meet These People* (1928); C. P. R. Graves, *Candid Caddies* (1935); H. Simpson, *Nazty Nursery Rhymes* (1940), P. Bradshaw, *Marching On* (1943); A. Reubens, *Podgy the Pup* (1945)

EXHIB: London Salon; Boston Public Library (1965)

COLL: BM; V&A; IWM; UKCC

LIT: P. V. Bradshaw, *The Art of the Illustrator* (1918)

MB

A DOCTORED VINTAGE

The Indisposed Gourmet. "DAMMIT, JENKINS—THIS MEDICINE'S CORKED !"

BERT THOMAS, *In Red and Black* (1928)

THOMAS, William Fletcher (fl. 1885–1922). Cartoonist. W. F. Thomas was born in the early 1860s in the Manchester area and educated in Halifax. After some part-time study at an art school and a short stay in Paris he started to draw for the comic, *Random Readings*, and later for the Leeds journal, *Toby*. After having some cartoons published in *Judy* he came to London (*c.* 1884) and was engaged by the newly founded *Ally Sloper's Half Holiday*, at first as a general comic illustrator and then as Chief Cartoonist in succession to W. G. BAXTER (1888). Fortunately for the paper, his style and Baxter's were almost identical so that there was no interruption in the characterization of 'Ally Sloper FOM' (Friend of Man). Thomas continued to depict him with much artistry and gusto, reserving his finest efforts for the Christmas Numbers, until the early 1920s. In the 1890s he also worked for HARRY FURNISS's *Lika Joko* and *New Budget* and contributed two joke cartoons to *Punch* (1895). LIT: J. G. Reid, *At the Sign of the Brush and Pen* (1898) SH

THOMPSON, Alfred (*c.* 1833–95). Soldier, cartoonist, author and theatre manager. Alfred Thompson was educated at Trinity College, Cambridge, from which he was commissioned into a cavalry regiment. As a soldier he contributed humorous drawings to *Diogenes* (1854) and to *Punch* (1856–8), when the Editor advised him to pursue art as a career. He therefore studied art in Paris, contributing to the *Journal Amusant*. Returning to London in the early 1860s, his work appeared in *Comic News*, *The Arrow*, *Broadway* and *Tomahawk*. At the end of the decade he became joint editor of and a cartoonist for the *Mask*. A friend of the proprietor, he drew 18 consecutive caricatures for *Vanity Fair* in 1870 and in *Punch* in the 1870s he appeared as both author and artist. Changing direction, Thompson became manager of the Theatre Royal, Manchester, where he wrote plays and designed sets and costumes. He died in New Jersey in September 1895. ILL: R. Mansfield, *The Water Lily on the Danube* (1853) SH

ALLY STARTS FOR THE SEA.

W. F. Thomas, [Ally Sloper], *Ally Sloper's Half Holiday*, 1888

THE HON. REVERDY JOHNSON.

Alfred Thompson, *The Mask's Album* (1868)

THOMPSON, Harold Underwood 'Anton' (b. 1911). Cartoonist, illustrator and writer. Harold Underwood Thompson was born in West Kirby, Cheshire, on 9 April 1911. He studied life drawing at Heatherley's Art School (1931–2), lettering at St Martin's (1934) and printing at Bolt Court. He also took private classes in illustration at Stephen Spurrier's school (1935) and, after applying for a permit, spent two years drawing antique furniture in the V&A from 1936. Self-taught as a cartoonist, he began submitting drawings under the pseudonym 'H. Botterill' to *Bystander* (1935–7) and *Night & Day* (1937). In 1939 he formed a partnership with his sister ANTONIA YEOMAN, producing cartoons for *Punch* as 'Anton' (though the weekly 'Antons' in the *Evening Standard* (1939) were entirely his). Twice mentioned in dispatches in World War II, his service commanding minesweepers and convoy escort vessels in the Royal Navy interrupted his work during this period, though Antonia continued to submit 'Anton' cartoons. After the war they teamed up again and produced numerous Anton cartoons for *Punch*,

Lilliput, *London Opinion*, *Men Only* and others, Antonia eventually taking over the job completely when he became a senior director of Lonsdales international advertising and marketing organization in 1949. A former member of the Artworkers' Guild, Harold Underwood Thompson has also written a number of short stories for London dailies, *Punch* etc. and designed posters and showcards for Orient Shipping Line and others. He has worked mostly in black and white with a very flexible Gillot 290 nib and indian ink, using colour occasionally for Christmas issues and other special numbers.
PUB: [with A. Yeoman] *Anton's Amusement Arcade* (1947), *Low Life & High Life* (1952), [marketing] *Product Strategy* (1962) MB

THOMSON, Harry Ross (b. 1938). Cartoonist, illustrator and designer. Born in Hawick, Roxburghshire, on 5 October 1938, Ross Thomson (who signs his work 'ross') attended George Watson College, Edinburgh, and studied graphic design at Edinburgh College of Art (1957–61). He moved to London in 1962 and began contributing cartoons to *Punch* (including covers from 1968), *Private Eye*, *Daily Express*, *The Times* (a strip 'Hoff'), *Oui*, *Reader's Digest* and *Playboy* (Germany). In addition he has done considerable work in advertising for companies such as BOAC, Midland Bank, London Transport, Dulux and Royal Bank of Scotland, and recently devised and animated a CD Interactive title 'Whizzo Goes on Holiday' for Philips. He has won cartoon awards at the Skopje Exhibition, Yugoslavia (1971, 1972, 1973). His early influences were ANDRÉ FRANÇOIS, QUENTIN BLAKE and Tomi Ungerer. He started drawing using the top of a Pelikan ink bottle but now uses size 0 paintbrushes for black and white and Dr Martin's watercolour, coloured inks, gouache and occasionally coloured felt-tip pens.
PUB: *A Noisy Book* (1973), *Ross's Guide to Motor-Racing* (1975), *Ross's Guide to Airports* (1977), [with B. Hewison] *How to Draw and Sell Cartoons* (1985), *The Blow-up Doll Companion* (1987), *Doggy Tales* (1989), *Moggy Books* (1991), *Are We There Yet?* (1992)
ILL: B. Green, *Swingtime in Tottenham* (1976); E. Holt & M. Perham, *Historic Transport* (1979), *Customs and Ceremonies* (1980); L. & J. Cooper, *Leo & Jilly Cooper on Cricket* (1985)
 MB

THOMSON, J. Gordon (fl. 1861–93). Cartoonist. As a very young man in 1861 some of

Thomson's drawings were published in *Punch* and during the 1860s, while working as a civil servant, his work also appeared in *Beeton's Annual* (1866), *Boy's Own Magazine*, *Broad-* *way, London Society* and *Sunday*. Most notable were his contributions to the *Graphic*, especially illustrations of the Franco-Prussian War. Leaving the Civil Service in 1870 he became political

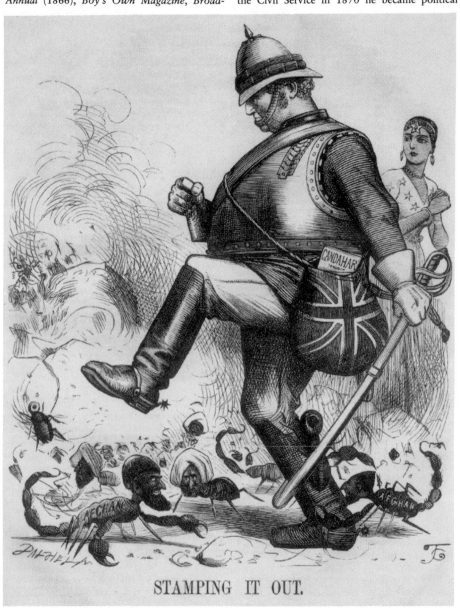

STAMPING IT OUT.

A painful necessity both for John Bull and for the Afghan Scorpion.

J. Gordon Thomson, *Fun*, 11 August 1880

cartoonist for *Fun* (1870–8 and 1890–3) and his well drawn, well composed images in general support of the Liberal cause are in the manner of TENNIEL and show quite as much imagination.
ILL: C. Dickens, *Pictures from Italy* (Household edn *c.* 1870)
EXHIB: RA SH

THORPE, James H. (1876–1949). Cartoonist, illustrator and author. James Thorpe was born in Homerton, London, on 13 March 1876 and was educated at Bancroft's School. He left school aged 17 and trained as a civil servant, later teaching at King's College Civil Service Department, London (1894–1902). He studied art in the evenings at Lambeth School of Art, North London School of Art, Heatherley's (1897) – where he was a contemporary of FRANK REYNOLDS – and with FRANCIS CARRUTHERS GOULD's son, Alec. He won a prize for a cartoon of Sir William Harcourt in *Picture Politics* in July 1894 and his first published drawing was for the *Morning Leader* (September 1898). Thorpe eventually became a full-time cartoonist and illustrator, working at first for music publishers, *The Troubador*, *Table Talk* and the *Windmill* (from its first issue, 1898). He won a silver medal for poster design at the International Advertisers' Exhibition (1900), designed advertisements for the London Press Exchange (1902–22), produced posters for Bell's Three Nuns Tobacco and contributed theatrical drawings to *Bystander*. In addition he worked for *Graphic*, *London Opinion*, *Sketch*, *Nash's*, *Tatler*, *Windsor Magazine*, *Yorkshire Post*, *Printer's Pie* and *Punch* (1909–38), and was a member of the London Sketch Club and Chelsea Arts Club. During World War I he served in the Artists' Rifles and later the RFC (1914–19). He also wrote monographs and a pioneering book on the illustrators of the 1890s. In 1929 he visited the USA and contributed to *Life*. His drawings were admired by RAVEN HILL. He died on 22 February 1949.
PUB: *The Cricket Bag* (1929), *Phil May* (1932), *English Illustration – the Nineties* (1935), *Come for a Walk* (1940), *Edmund J. Sullivan* (1948)
ILL: I. Walton, *The Compleat Angler* (1911); E. E. Foot, *Jane Hollybrand* (1932); H. de Selincourt, *Over!* (1932), *Moreover* (1934), *The Saturday Match* (1937); A.Clitheroe, *Silly Point* (1939)
EXHIB: RI; LG
COLL: V&A

LIT: [autobiography] *Happy Days: Recollections of an Unrepentant Victorian* (1933) MB

TIDY, William Edward (b. 1933). Cartoonist, strip cartoonist, illustrator, writer and broadcaster. Bill Tidy was born in Tranmere, Cheshire, on 9 October 1933, and attended St Margaret's School, Anfield, leaving aged 14 to work in a shipping office in Liverpool. He joined the Royal Engineers as a regular soldier (1952–6), serving in Germany, Korea and Japan where he sold his first cartoon to an English-speaking newspaper in 1955. Returning to Liverpool, he worked in an advertising agency, drew advertisements for *Radio Times* (1956) and became a professional cartoonist in 1957. Perhaps his best-known strips have been 'The Cloggies' for *Private Eye* (1967–81) and the *Listener* (1985–6), and 'The Fosdyke Saga' in the *Daily Mirror* (1971–85) – later broadcast as a 42-part series on BBC Radio 4. He has also produced work for *Punch*, *New Scientist* ('Grimbledon Down'), *Camra* ('Keg Buster'), *Datalink* ('Red Spanner'), *Today*, *Mail on Sunday*, *Sunday Dispatch* ('Nero'), *Yorkshire Post*, *Picturegoer*, *Everybody's*, *John Bull*, *General Practitioner* ('Dr Whittle'), *Tit-Bits* and others. In addition he has contributed single cartoons to a wide variety of publications, has designed board games, ventriloquists' dummies, stage sets and trophies, is a frequent after-dinner speaker, has written and presented BBCTV programmes such as 'Tidy Up Walsall', 'Tidy Up Naples' and 'Three Days Last Summer' and has regularly appeared on Channel 4's 'Countdown' and BBC Radio 4's 'I'm Sorry I Haven't a Clue'. He won Granada TV's 'What the Paper's Say' Cartoonist of the Year Award in 1973 and was CCGB Cartoonist of the Year in 1966. Bill Tidy's style has been influenced by ERIC BURGIN and the early work of RONALD SEARLE. Geipel has described him as having a 'basically vulgar, graffitic yet uproariously funny style ... a graphic counterpart to the comedians ... Morecambe and Wise, spiked with a strong dash of Thurber'. Like JAK, he draws hands in the Disney style, with only three fingers and a thumb. He works on A4 Croxley Script paper and uses a dip pen with a Gillot 303 nib and Pelikan ink.
PUB: More than 30 titles including *Sporting Chance* (1961), *Oh, Cleo!* (1962), *Tidy's World* (1969), *The Cloggies* (1969), *Tidy Again* (1970), 15 volumes of 'The Fosdyke Saga' series (from 1971), *Robbie and the Blobbies* (1982), *A Day at Cringemound School* (1984), *The World's*

Worst Golf Club (1987), *The Incredible Bed* (1990), *Draw me 387 Baked Beans* (1991)
ILL: More than 60 titles including J. Wells, *The Exploding Present* (1971); S. Pile, *The Book of Heroic Failures* (1979); P. Alliss, *Bedside Golf* (1980); C. Freud, *Hangovers* (1981); G. Melly, *This Curious Game of Cricket* (1982); M. Pyke, *Food for All the Family* (1980)
EXHIB: L and UK tour (1986–8); CG
COLL: UKCC
LIT: [with F. Milner] *Bill Tidy – Drawings 1957–86* (1986) MB

TIM – see Timyn, William

TIMYN, William 'Tim' MBE (1902–90). Cartoonist, strip cartoonist, animator and sculptor. William Tymyn was born in Vienna on 5 October 1902 and studied painting, drawing and sculpture at Vienna Academy of Arts. He worked at first as a political cartoonist and animal artist before emigrating to England in 1938. Here he began work as a political cartoonist on *John Bull* and *World's Press News* and contributed to *Punch* and *Lilliput*. During the war years he undertook commissions for the Ministry of Information and other departments, and produced portraits of famous British personalities. He also created a number of strips – 'Wuff, Snuff and Tuff' (*Woman Magazine*), 'Caesar' (*Sunday Graphic*), 'Oh Johnny' (*John Bull*), 'Mimi' (*Weltwoche*, Switzerland) which were syndicated internationally. Perhaps his best-known character was Bengo the Boxer puppy (based on his own dog of that name) for BBCTV, which he first presented on camera himself as a picture sequence narrated by Sylvia Peters. It later became an animated feature on 'Blue Peter' (1962) and led to widespread merchandizing and syndication. He also created for the same children's programme the adventures of Bleep the Spaceboy and his human friend Booster. In addition he was a successful sculptor and produced portrait busts of Sir Malcolm Sargent (Royal Albert Hall), Guy the gorilla (London Zoo), Petra the Blue Peter dog (BBCTV Centre, 1978), Sir Francis Chichester, Sir Bertrand Russell and others. He received the MBE in 1988 and died on 31 May 1990.
EXHIB: Vienna, Cologne (1930s); Moorland Gallery; TRY; Keyser Gallery, Cirencester; Wildlife Art Gallery, Hollywood; RA; Game Coin, San Antonio; World Wildlife Convention, Las Vegas
COLL: [sculptures] RAH; BBCTV Centre;

London Zoo; UM; Riverside Foundation, Calgary, Canada MB

TIMOTHY – see Birdsall, Timothy

TITT, Tom (d. 1956). Caricaturist. Tom Titt came to England to study art in 1907 and published his first caricature in 1910. He worked for *Reynold's News* and in 1930 succeeded NERMAN as theatre caricaturist on *Tatler*, being succeeded in 1948 by EMMWOOD. He also contributed to *Everybody's, Sphere, Evening Standard, Daily Express* ('Talk of London'), produced a series of caricature cards for Brownlee, and had his work animated by Joe Noble for Broda-Jenkins Ltd.
PUB: *Caricatures* (1913)
ILL: A. E. Wilson, *Theatre Guyed* (1935)
COLL: IWM
EXHIB: Doré Galleries (1913) MB

TOPHAM, Captain Edward (1751–1820). Journalist, playwright and amateur caricaturist. The son of an ecclesiastical judge in York, Topham was educated at Eton and Trinity College, Cambridge, where he drew some published caricatures of college servants. He continued to draw personal and social satires, engraved by DARLY and others in the 1770s whilst serving as the Adjutant of the Horse Guards. As a man of fashion (the friend of Wilkes and Sheridan) and caricaturist he features prominently in ROWLANDSON's 'Vauxhall Gardens' (1785). From 1787 to 1792 he edited the *World*, a scandalous daily paper, and was sued for libel; he also wrote a number of plays, mostly farces. After an exciting metropolitan life, he retired to a country cottage to spend the later part of his life farming and hunting. He died in Doncaster on 26 April 1820.
PUB: *Letters from Edinburgh* (1776), *The Life of the Late John Elwes* (1790) SH

TOWNSEND, Frederick Henry Linton Jehne ARE (1868–1920). Cartoonist and illustrator. F. H. Townsend was born in London on 26 February 1868 and studied at the Lambeth School of Art (1885–9) with RAVEN HILL. While still a student he started to contribute to magazines like *Sunlight, Lady's Pictorial* and *Illustrated London News*. Highly prolific, he also contributed during the next decade or so to *Ariel, Black & White, Cassell's, Daily Chronicle, Fun, Gentlewoman, Good Words, Idler, Longbow, New Budget, Pall Mall, Pearson's, Pick-Me-Up,*

Printer's Pie, Queen, Quiver, Royal Magazine, Sketch, Sphere, Tatler, Unicorn and *Windsor Magazine*. He illustrated many books, his work being constantly in demand for its humour, grace, grasp of character and presentation of action. His first cartoon appeared in *Punch* in 1896 and in 1905 he was appointed the magazine's first Art Editor. Mostly employed on *Punch* as a social cartoonist and the illustrator of features like the 'Parliamentary Sketches' – which PARTRIDGE called 'in some ways his most interesting achievement . . . he rollicks among the politicians in the festal spirit of some roguish puppy' – he drew a number of political cartoons and found the need for solemnity 'often irksome'. As Art Editor his attitude to his colleagues was kindly and uncritical and he did not look for innovation. His attitude to his own work was pragmatic, 'sometimes comes funny, sometimes doesn't'. Around 1913 he took up etching and showed much promise, being elected ARE in 1915. He was the brother-in-law of FRANK REYNOLDS. F. H. Townsend died on 11 December 1920. His *Punch* cartoons are remarkable not only for their fine classical draughtsmanship but for a pleasant sense of absurdity and a comparative absence of snobbishness.

PUB: *'Punch' Drawings by F. H. Townsend* (1921)

ILL: More than 30 books including S. J. Duncan, *A Social Departure* (1890), *An American Girl in London* (1891), *The Simple Adventures of a Memsahib* (1893); T. L. Peacock, *Maid Marian* (1895), *Gryll Grange* (1896), *Melincourt* (1896); F. Marryat, *The King's Own* (1896); C. Brontë, *Shirley* (1897), *Jane Eyre* (1897); C. Dickens, *A Tale of Two Cities* (1902); R. Kipling, *The Brushwood Boy* (1907); F. Barclay, *The Following of the Star* (1911)

EXHIB: RA; RE; FAS (Memorial, 1921); NEA; RBA; RSA

COLL: BM; V&A

LIT: P. V. Bradshaw, *The Art of the Illustrator 2: F. H. Townsend* (1918)　　SH

TOWNSHEND, George, 4th Viscount [1st Marquis Townshend] (1724–1807). Amateur caricaturist. After briefly attending St John's College, Cambridge, Townshend entered the Army as a volunteer in 1743, was commissioned in 1745 and fought at the battles of Fontenoy, Dettingen and Culloden. In 1746 he was appointed ADC to the Duke of Cumberland but, quarrelling bitterly with him, resigned his commission temporarily in 1750 so that he could prosecute his attacks by pamphlet, caricature and in Parliament. He was MP for Norfolk (1747–64) and made the Grand Tour in 1749, doubtless absorbing the art of caricature in Italy. He rejoined the Army in 1757 following Cumberland's resignation and held many positions, culminating in his appointment as Field Marshal (1796). He was Lord Lieutenant of Ireland (1767–72), was created marquis (1787) and died at his house, Raynham in Norfolk, on 14 September 1807. Townshend was the first acknowledged amateur caricaturist and the first to introduce personal caricature to political prints. His early drawings, influenced by POND's etchings after Ghezzi, were personal satires, but in the mid-1750s, after his breach with Cumberland, he turned to political caricature in such prints as 'The Recruiting Serjeant' (1757). His collaboration with the printseller DARLY resulted in new forms of caricature prints – small 'cards' which could be sent through the post and 'transparencies' in which certain figures were revealed when the print was held to the light. Although a feeble draughtsman, Townshend's fertility of malicious invention and his power to capture likenesses paved the way for GILLRAY in establishing personal caricature as an essential ingredient of political prints.

COLL: BM; NPG; Yale

LIT: E. Harris, *The Townshend Album* (1974)　　SH

TRIER, Walter (1890–1951). Cartoonist, caricaturist and illustrator. Walter Trier was born in Prague on 25 June 1890, the son of a German-speaking leather-glove manufacturer. He attended the Nikolander Realschule in Prague, the Industrial School of Fine & Applied Arts and the Prague Academy (1905–6) before moving to the Munich Academy (1909). The same year his first drawings were published in *Simplicissimus* and *Jugend*. In 1910 he joined the staff of *Lustiger Blätter* and moved to Berlin, also contributing to *Berliner Illustrierte Zeitung* (1910), *Die Dame* (1923) and *Uhu* (1924). He then designed costumes and stage settings for Max Reinhardt's Das Gross Schauspielhaus (1924), became a member of the Berliner Secession group (1926) and began to illustrate Erich Kästner's children's books (15 titles 1929–51) the first of which – *Emil and the Detectives* – quickly became a classic. In 1929 he was elected vice-chairman of the Association of Illustrators of Germany. After the burning of 'subversive' literature in Berlin, including books illustrated by

Walter Trier, *Lilliput*, October 1947

Trier, he moved to London (1936) drawing title cartoons for Pinewood Film Studios and beginning his long association as cover artist and cartoonist for *Lilliput* (1937–49). He produced more than 150 cover designs for the monthly featuring his familar couple and their black Scottie dog, explaining: 'The couple was the embodiment of something eternally amusing – youth, love … Sometimes they are young, sometimes older, sometimes naturalistic and sometimes stylized, in all possible costumes of all sorts of periods, not even of flesh and blood, but as chopped trees or fruit or often as toys …' During World War II he produced political cartoons for the London-based German weekly *Die Zeitung, Life* and *New York Times*, and in 1944 illustrated John Betjeman's books column in *Daily Herald*. After the war he was commissioned to produce egg-shell caricatures of delegates to the United Nations Organization (1945) and contributed to *Illustrated*. He emigrated to Toronto, Canada, in 1947 and worked in advertising for Maple Leaf Cheese, Domestic Shortening, Quix Soap, York Peanut Butter and others. He also contributed caricatures to *Saturday Night Magazine*, covers for *New Liberty* and designed Christmas cards for William Coutts. He died on 8 July 1951.
PUB: *Toys* (1923), [with F. A. Colman] *Artisten* (1928), *10 Little Negroes* (1944), *8192 Quite Crazy People* (1949), *8192 Crazy Costumes* (1949), *Dandy in the Circus* (1950)
ILL: Numerous books including P. Benndorf, *Till Eulenspiegel* (1920); A. Roda Roda, *Die Verfolgte Unschuld* (1920); E. Kästner, *Emil und die Detektive* (1929) [and 14 others]; E. Mordaunt, *Blitz Kids* (1941); D. Seth-Smith, *Jolly Families* (n.d.)
EXHIB: Berliner Secession, Berlin; Galerie Andre, Prague; Stern House, Brno; Nicholson Gallery; University of Toronto; International Youth Library, Munich; Archivarion Gallery, Berlin
LIT: Art Gallery of Ontario, *Humorist Walter Trier* (catalogue, 1980) MB

TROG – see Fawkes, Walter Ernest

TURNER, Martyn (b. 1948). Political cartoonist, caricaturist and writer. Martyn Turner was born on 24 June 1948 in Wanstead, Essex, and attended Bancroft's School, Woodford Green, and The Queen's University of Belfast (1967–71). A self-taught artist, he was editor of *Fortnight* magazine, Belfast (1972–6), and has been Political Cartoonist of the *Irish Times* since 1976. His work is syndicated by the Cartoonists' and Writers' Syndicate, New York, and he has also contributed to the *Guardian* and various foreign journals. In addition, he writes occasional columns for the *Irish Times* and *Christian Science Monitor*. Winner of the Hibernia Press Award for writing and cartooning in 1975, he works in brush and ink and uses acrylic and gouache for colour cartoons.
PUB: *The Book* (1983), *Illuminations* (1985), *Not Viking Likely* (1986), *A Fistful of Dailers* (1987), [ed.] *Thin Black Lines* (1987), *Heavy Weather* (1989), *The Guy Who Won the Tour de France* (1991), *The Long Goodbye* (1992), *Politics et Al* (1992), [ed.] *Columba!* (1993)
ILL: More than 12 books
EXHIB: More than 20 in Ireland
COLL: National Library of Ireland; Presidential Election Collection, University of Hartford, Connecticut; SAM MB

TWYM – see Boyd, Alexander Stuart

U

ULLYETT, Royden (b. 1914). Sports cartoonist. Roy Ullyett was born in Leytonstone, Essex, on 16 March 1914 and had his first cartoon published in the *Southend Times*. His first job was working for a colour printing firm but at the age of 19 he joined the *Star* as sports cartoonist. After serving as a pilot in the RAF in World War II, he returned to the paper whilst also drawing as 'Berryman' for the *Sunday Pictorial*. Influenced by TOM WEBSTER, he has been sports cartoonist at the *Daily Express* since 1953 and draws with a brush.
PUB: 19 annuals (1956–74), [with JON] *'I'm the Greatest!'* (1975), *Cue for a Laugh* (1984)
ILL: T. H. Cotton, *Henry Cotton Says …* (1962); J. Greaves & N. Giller, *Stop the Game: I Want to Get On!* (1983)
COLL: Royal and Ancient Golf Club, St Andrews MB

V

VERNEY, Sir John Bart MC (1913–93). Author, illustrator and decorator of furniture. John Verney was born in London on 30 September 1913, the son of Sir Ralph Verney, 1st Baronet, who was secretary to the Speaker of the House of Commons. Educated at Eton and Christ Church, Oxford, he entered the film industry and by 1936 was an assistant director. As an officer in the North Somerset Yeomanry he fought in Syria and the Western Desert in World War II, as recorded in his book, *Going to the Wars*. He later served in the SAS (1943–5) in which he won an MC and was awarded the Légion d'Honneur. After the war he wrote and illustrated a number of books for adults and children, contributed to magazines like the *Cornhill*, *Go*, *Illustrated* and *Graphis*, and decorated furniture. He also designed covers for *Collins Magazine* (later *The Young Elizabethan*) in the 1950s and from 1965 produced the *Dodo Pad* illustrated diary. Most of his illustrative work was in black and white in a style strongly reminiscent of EDWARD ARDIZZONE. He died on 4 February 1993.

PUB: *Verney Abroad* (1954), *Going to the Wars* (1955), *Look at Houses* (1959), *Friday's Tunnel* (1959), *February's Road* (1961), *Ismo* (1964), *The Mad King of Chichibo* (1964), *A Dinner of Herbs* (1966)
ILL: G. Kerr (trans.), *The Odyssey* (1947); G. Lincoln, *No Moaning at the Bar* (1957); A. Buckridge, *Our Friend Jennings* (1958), *Jennings Goes to School* (1965); eight titles by G. Avery (1959–67); G. Shepherd, *Where the Lion Trod* (1960); G. Brennand, *Walton's Delight* (1961); R. G. Robinson, *My Uncle's Strange Voyages* (1964); S. Chitty, *My Life and Horses* (1966); C. Bermant, *Diary of an Old Man* (1966); W. Blunt, *Oman* (1966)
EXHIB: RBA; LG; AIA, LON; RG SH

VICTORIA – see Davidson, Lilli Ursula Barbara Victoria

VICKY – see Weisz, Victor

W

WADLOW, Geoffrey Arthur (b. 1912). Cartoonist and illustrator. Geoffrey Wadlow was born in London on 3 November 1912 but spent his youth in Merseyside. He attended Birkenhead Institute Grammar School and studied art at Camberwell School of Art. During World War II he served in the National Fire Service and the RAF (1939–46). For many years he worked as art director of an advertising agency and in 1955 won the National Outdoor Advertising Award for his poster illustrations. As a cartoonist his work first appeared in *Punch* in 1938 and he has also contributed to *London Opinion*, *Night & Day*, *Lilliput*, *Men Only*, *Tatler*, *Everybody's*, *John Bull*, *Tit-Bits*, *Evening Standard* and other publications. Influenced by TOM WEBSTER and *New Yorker* cartoonist Robert Day, he works in pen and ink or pen and wash (monochrome and full colour). FOUGASSE has described his work as 'pleasing confused-thought subjects treated in a pleasingly confused-thought style of drawing' and BRADSHAW saw him as the creator of 'an odd world of pop-eyed, spindle-legged puppets'.

ILL: Unilever, *Marketing* (n.d.), *Market Research* (n.d.) and various staff handbooks etc MB

WAIN, Louis William (1860–1939). Cartoonist and illustrator (mainly of cats). Louis Wain was born in London on 5 August 1860. His father was a textile salesman and his mother designed carpets and church fabrics. A sickly child, he was educated at the Orchard Street Foundation, Hackney, and at St Joseph's Academy, Kennington. He trained at the West London School of Art (1877–80), remaining there as an assistant teacher until 1882. His first drawing – of animals and birds – was published in *Illustrated Sporting & Dramatic News* in 1881 and he joined the staff of the paper the following year. Wain's breakthrough came in 1886 with a double-page drawing, 'The Kitten's Christmas Party' published in *Illustrated London News*, which was an instant success. By 1890 the Louis Wain cat, often dressed in human clothes, wearing human expressions and performing comical acts, was established. He was elected President of the

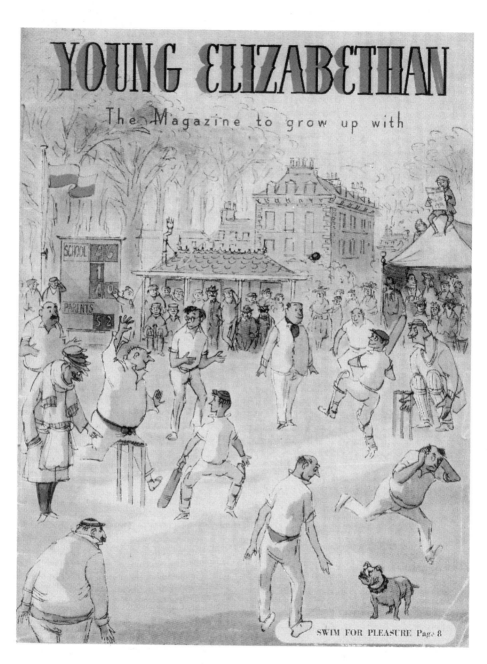

John Verney, *Young Elizabethan*, July 1953

National Cat Club in 1891. His drawings were published in *Boy's Own Paper, Moonshine, Sketch, Little Folks, Pall Mall Budget, Judy* and others, and comical cat postcards were issued by Raphael Tuck. Not a good businessman, Wain was sued for debt in 1907 at the height of his fame and moved to the USA the same year. Here he worked for *New York American* (1907–10). Returned to England, he experimented with animated films in 1917. After the death of his sister his behaviour became increasingly erratic and in 1924 he was declared insane, being confined in a pauper's ward of a mental asylum. A public appeal, backed by the British national press and figures such as Prime Minister Ramsay Macdonald, ensured that his remaining days were comfortable. *Punch* described him as 'the HOGARTH of Cat Life' and H. G. Wells wrote: 'he has made the cat his own, he invented a cat style, a cat society, a whole cat world. English cats that do not look and live like Louis Wain's cats are ashamed of themselves.' He died on 4 July 1939.
PUB: Many books including *Puppy Dog's Tales* (1896), *Pussies and Puppies* (1899), *Louis Wain's Annual* (1901–21), *Nursery Book* (1902), *Baby's Picture Book* (1903), *Big Dogs, Little Dogs, Cats and Kittens* (1903), *Kitten Book* (1903), *In Animal Land* (1904), *Animal Show* (1905), *Cats About Town* (1907–10), *A Cat Alphabet* (1914), *Daddy Cat* (1915), *Pussy Land* (1920), *Animal Book* (1928)
ILL: More than 40 books including *Kari, Madame Tabethy's Establishment* (1886); F. W. Pattenden, *Our Farm* (1888); R. Leander, *Dreams of French Firesides* (1890); C. Morley, *Peter, A Cat o' One Tail* (1892); M. A. Owen, *The Old Rabbit and the Voodoo* (1893); G. C. Bingham, *The Dandy Lion* (1900), *Fun and Frolic* (1902), *Kittenland* (1903), *Claws and Paws* (1908); S. C. Woodhouse, *Cats at Large* (1910); *Cinderella and Other Fairy Tales* (1917)
EXHIB: XXI Gallery (1925); Clarendon House Gallery (1937); V&A (1972–3); Parkin Gallery; CBG; RBA
COLL: BM; V&A; Institute of Psychiatry
LIT: R. Dale, *Louis Wain, the Man Who Drew Cats* (1968); B. Reade, *Louis Wain* (1972); M. Parkin, *Louis Wain's Cats* (1983) SH

WAITE, Keith (b. 1927). Editorial cartoonist and illustrator. Keith Waite was born in New Plymouth, New Zealand, on 19 March 1927 and attended Elam School of Art in Auckland (1948–9). He began as a cartoonist on the *Auckland Star* and then *Otago Daily Times* (1949–51).

Arriving in the UK in 1951, he joined Kemsley Newspapers, working for *Glasgow Daily Record* and *Glasgow Daily News* (1952–3), then free-lanced for *Punch* (from 1953) and others before becoming Editorial Cartoonist on the *Daily Sketch* (1954–64), *Sun* (1964–9), *Sunday Mirror* (1970–80) and *Daily Mirror* (1969–85). He has been business-page cartoonist on *The Times* since 1987. Voted CCGB Cartoonist of the Year (1963), Keith Waite has also won numerous international awards for his work.
PUB: *The Worlds of Waite* (1981)
COLL: UKCC MB

WALE, Samuel RA (*c.* 1721–86). Illustrator, history painter and occasional caricaturist. After being apprenticed to a silver engraver and attending St Martin's Academy, Wale became a pupil of Francis Hayman RA, the portrait painter and illustrator. He exhibited paintings at the RA and elsewhere (1760–78) but illustration became his principal activity and in whole or in part he designed capable but spiritless illustrations for numerous books. He was a founder member of the RA (1768) and its first Professor of Perspective. Between 1769 and 1772 he designed a number of political and personal satires, most engraved by Grignion and published in the *Oxford Magazine*. He died in London on 6 February 1786.
ILL: Around 100 books including A. Pope, *The Works* (1751); I. Walton, *The Compleat Angler* (1760); R. Dodsley, *Select Fables of Esop and other Fabulists* (1761); J. Macpherson, *Fingal* (1762); W. Wilkie, *Fables* (1768); S. Richardson, *Clarissa Harlowe* (1768); Plutarch, *Lives* (1770)
EXHIB: RA; SA
COLL: BM; N SH

WALKER, Anthony (1726–65). Illustrator, engraver and occasional caricaturist. Anthony Walker was born in Thirsk, Yorkshire, the son of an exciseman, and studied engraving under John Tinney. He became a noted book illustrator, inventing a technique that combined etching with engraving. In the 1750s he drew a number of social and political satires and Godfrey included him amongst the caricaturists of the time who were 'consistently interesting'. He died in Kensington, London, on 9 May 1765.
ILL: A. Pope, *The Works* (1751); W. Somervile, *The Chace* (1757); T. Smollett, *Sir Launcelot Greaves* (1760); J. Ogilvie, *Poems on Several Subjects* (1762), *Providence* (1764); J. Philips, *Poems Attempted in the Style of Milton* (1762);

C. Morell, *The Tales of the Genii* (1764)
COLL: BM SH

WALKER, Jack (fl. 1914–21). Political cartoonist. Jack Walker was Political Cartoonist of the *Daily Graphic* and also contributed to *Bystander*.
PUB: *The Daily Graphic Special War Cartoons* (Vols 1–7, 1914–15) MB

WALKER, J. C. (fl. 1920s–40s). Political and sports cartoonist. J. C. Walker was born in Cardiff and was an apprentice in a marine engineering firm before World War I in which he served in the Army on searchlight duty. Whilst a soldier he won competitions for advertisements for Cherry Blossom shoe polish and (in *Blighty*) Swan pens and also contributed to *Royal Magazine*. After the war he returned to marine engineering as a draughtsman and advertisement designer (1919–24) while freelancing sports cartoons for the *South Wales Evening Express*. He joined the paper as Sports and Political Cartoonist in 1926 and began contributing to *News of the World* in 1939. As 'Marksman' (he was a Bisley champion) he drew the front-page political cartoon of the latter paper from 1941 but, though Fleet Street beckoned, he preferred working from Wales and so opted for an exclusive freelance contract with Kemsley Newspapers rather than move to London. At one time he shared an office with a young LESLIE ILLINGWORTH (then working on the *Evening Express*'s sister paper, the *Western Mail*) and he also contributed to *South Wales Echo* in later life. During World War II he was an Instructor of Musketry in the Home Guard. One of Walker's more enduring characters was 'Mr Fullerjoy' – a typical man in the street who wore spectacles in which you couldn't see the eyes. A supporter of the view that 'ridicule is often more deadly than dynamite', he could draw with both hands and would use pencil for roughs and a fine sable brush with ink for the finished artwork, as it helped the ink dry quicker. He drew 18 x 12in. for 6 x 4in. reproduction and indicated tone with blue pencil or transparent blue watercolour paint. He also sometimes signed his work 'JCW'.
PUB: *A Cartoonist at Work* (1949)
 MB

WALTER – see Goetz, Walter

WALTER, John Gardner (b. 1913). Cartoonist. John G. Walter was born in Congresbury,

Bristol, on 6 June 1913. He trained in the drawing-office of an aircraft company and had his first cartoon published in *Punch* on 28 December 1932. He also contributed to *Radio Times*, *Everybody's*, *Illustrated* and various motoring magazines. During World War II he produced pamphlets and illustrated booklets. Since the war his work in local government has taken over from his other activities. He has been influenced by HEATH ROBINSON.
ILL: *ROTOL: The History of an Airscrew Company* (n.d.) MB

WARD, Sir Leslie Matthew 'Spy' RP (1851–1922). Caricaturist and portrait painter. Leslie Ward was born in London on 21 November 1851, the son of E. M. Ward RA and Henrietta Ward, both distinguished painters. He was educated at Eton where he drew caricatures of the masters and his schoolfellows. After a short spell studying architecture under Sydney Smirke RA and at the RA Schools (1871) he became apprenticed to W. P. Frith RA and was soon exhibiting portraits in oil and watercolour. In 1873 John Millais showed some of his caricatures to Thomas Gibson Bowles who promptly engaged him to work for *Vanity Fair* in company with CARLO PELLEGRINI. Using the pseudonym 'Spy' (which he and Bowles chose from the dictionary) many of Ward's early caricatures had considerable psychological insight and bite – his portrait of Anthony Trollope (1873), for instance, infuriated the novelist – but gradually his approach became more bland and flattering, especially in the case of royalty, so that there is some truth in the assertion, 'Spy spent 40 years being a tamed Ape.' Ward drew more than 1000 caricatures for *Vanity Fair* before his retirement in 1909 and also contributed them to the *Graphic*. He continued to paint portraits, exhibiting them and a few other works from 1868 onwards. He was elected RP (1891), published his autobiography (1915) and was knighted in 1918. He died in London on 15 May 1922. Ward's original watercolours, from which the coloured lithographs in *Vanity Fair* were developed, were lively and well drawn if progressively less penetrating. Following in Pellegrini's footsteps, he was the first *English* artist to draw the *portrait-charge*.
EXHIB: RA; RP; DOW; NPG 'Vanity Fair' (1976)
COLL: NPG; V&A; NGI; L
LIT: Sir L. Ward, *Forty Years of 'Spy'* (1915); R. T. Mathews & P. Mellini, *In 'Vanity Fair'* (1982)
 SH

WATT, John Millar (1895–1975). Strip cartoonist, illustrator, commercial artist and painter. Millar Watt was born in Greenock, Scotland, on 14 October 1895. He studied art at the Sir John Cass Institute under Harold Stabler and in 1912 was apprenticed to the Mather & Crowther advertising agency (eventually becoming chief poster artist) while attending evening classes at Westminster School of Art under Walter Bayes. During World War I he served as a Second Lieutenant in the Artists' Rifles (1915–18), later reposted to the Highland Regiment, and produced technical drawings for instructional lectures in the field. After the war he studied sculpture briefly at the Slade School of Art under Harvard Thomas (1919) but left complaining it was 'full of Russian princesses filling in time'. Returning to Mather & Crowther, he found additional work drawing newspaper sports cartoons and illustrations for *Sphere* while attending evening classes at St Martin's School of Art. On 20 May 1921 he created his most enduring character, Pop, star of Britain's first comic strip for adults, which originally appeared in the *Daily Sketch* as 'Reggie Breaks it Gently', intended as a rival to W. K. HASELDEN's box cartoon in the *Daily Mirror*. At first a typical paterfamilias businessman – whose mouth is rarely seen except to emit a cry or shout – the balding Pop worked in the City and wore a top hat, striped trousers, spats, cravat and umbrella (originally he also sported a moustache and pince-nez). Gradually, however, he developed into an Everyman figure and appeared in many guises, from artist to boxer and medieval knight to caveman. FOUGASSE described him as 'a direct descendant of Falstaff and Mr Pickwick, of Jorrocks and Old Bill – like all of them he is a cheerful mixture of opposites and contradictions, of realist and idealist: he is the happy warrior, the hopeful pessimist, the matter-of-fact romantic ... He is, at it were, the average Briton's idea of the average Briton, he is Mr Everyman as seen by himself – he is, in fact, Mr Everypop.' Immensely popular (syndicated worldwide and admired by Sir Alfred Munnings, LOW, FRANK REYNOLDS and STRUBE amongst others), the strip started as four panels, then three and, when Watt left to concentrate on advertising work in 1949 and GORDON HOGG ('Gog') took over, finally appeared as a single frame. The original design of the strip was quite unique, ignoring as it did the confines of the box frame and allowing words (which never appeared in balloons) and the drawing to spill across the panels in the manner of oriental screen paintings. During World War II Watt served in the Home Guard in St Ives, Cornwall. After handing over the strip to Gog, it continued in the *Graphic* and then the *Daily Mail* until its final episode on 23 January 1960. Watt, meanwhile, returned to advertising and freelance illustration for clients such as *Graphic*, *Sphere* (including covers), *Illustrated London News* (including covers), *Everybody's* (in black and orange), *Reader's Digest* (including covers), *Look & Learn*, *Princess*, *Beano*, *Beezer*, and *Robin Hood* annuals. He also created advertising campaigns for Ben Truman ('More Hops in Ben Truman'), Shell, Cherry Blossom and Rowntrees Fruit Gums and designed the first Sunblest Bread trademark. Married to the artist Amy Millar Watt, he died on 13 December 1975.

PUB: Pop annuals (1924–49)
ILL: *Robin Hood*, *Beezer* etc. annuals
EXHIB: RA MB

Dedicated to myself with profound respect and infinite satisfaction.

John Millar Watt, [Pop], *c*. 1937

WATTS, Arthur George DSO and bar ARBA (1883–1935). Cartoonist and illustrator. Arthur Watts was born on 28 April 1883 in Chatham, Kent, the son of a deputy Surgeon-General in the Indian Medical Service. He was educated at Dulwich College and studied art at the Slade School and in Antwerp, Paris, Moscow and Madrid. In World War I he served in the RNVR (1914–19), took part in the Zeebrugge raid and was awarded the DSO and bar. A characteristic of his art was the technique of drawing as if from above the scene. He worked for *Bystander*, *Humorist*, *Life*, *London Magazine*, *London Opinion*, *Nash's*, *Punch*, *Radio Times* (covers and illustrations for 'Both Sides of the Microphone', 1928–35) and the *Sketch* among others. He was elected ARBA in 1923. Father of the book illustrator, Marjorie-Ann Watts, he died in an air crash on 20 July 1935.
PUB: *A Painter's Anthology* (1924)
ILL: A. R. Thorndike and R. Arkell, *The Tragedy of Mr Punch* (1923), *A Little Pilgrim's Peeps at Parnassus* (1927); E. G. V. Knox, *Poems of Impudence* (1926); E. M. Delafield, *Diary of a Provincial Lady* (1930), *The Provincial Lady Goes Further* (1932); H. F. Ellis, *So This is Science!* (1932) and others
EXHIB: FAS; RA; RBA; CAC
COLL: V&A; UKCC; BM MB

WAY, Steve (b. 1959). Cartoonist and editor. Steve Way was born in Plymouth on 1 January 1959 and studied graphic design at Leeds Polytechnic. Cartoon Editor of *Punch* (1989–92) and co-founder (with John Sorrell) and Editor of *The Cartoonist* (1993), his drawings have appeared in *Punch*, *Private Eye*, *Spectator*, *Listener*, *Independent*, *Sunday Correspondent* and the *Observer*. He works with a Gillot 303 dip pen and indian ink – usually Dr Martin's Blackstar waterproof variety. The many artists he cites as having influenced his work include QUENTIN BLAKE, RALPH STEADMAN, FRANK DICKENS, Johnny Hart, George Herriman and Edward Sorel. MB

WEBB, Hector Thomas Maybank 'Thomas Maybank' (fl. 1900–37). Fairy painter, illustrator and cartoonist. Thomas Maybank contributed comic decorations to *Pick-Me-Up* in 1900 and some extraordinary humorous fairy drawings to *Punch* (1902–4) which hark back to RICHARD DOYLE. His cartoons also appeared in the *Bystander*, *Graphic*, *Pearson's*, *Printer's Pie*,

Tatler and the *Windsor Magazine* (c. 1900–30).
PUB: *Mirth for Young and Old Alike* (1937)
ILL: M. Drayton, *Nymphedia* (1906); T. Lodge, *Rosalynde* (1907); R. C. Lehmann, *The Sun-Child* (c. 1907); L. Carroll, *Alice's Adventures in Wonderland* (1910); A. Herbertson, *Teddy and Trots in Wonderland* (1910); W. H. Prescott, *The Conquest of Peru* (1913)
EXHIB: RA; RBA; ROI; RHA
COLL: V&A SH

WEBSTER, Gilbert Tom (1886–1962). Sports cartoonist, journalist and caricaturist. Tom Webster was born in Bilston, Staffordshire, on 17 July 1886, the son of an ironmonger, and educated at Royal Wolverhampton School. His first job (aged 14) was as a booking-office clerk for Great Western Railway in Handsworth, Staffordshire. Self-taught as an artist, he won prizes for humorous drawing offered by *Birmingham Weekly Post* and *Athletic News*. He then got a job as cartoonist on the *Birmingham Sports Argus* and in 1912 joined the *Daily Citizen* in London as Political Cartoonist, whilst also freelancing for *Star* and *Golf Illustrated*. In World War I he served with the Royal Fusiliers but was invalided out with rheumatic fever (1916). He joined the *Evening News* as Sports Cartoonist in 1918, later moving to the *Daily Mail* (1919–40). In 1924 – a year in which was reputed to be the highest paid cartoonist in the world – he helped organize the revue 'Cartoons' at the Criterion Theatre, London, and in the 1929 General Election his cartoons were projected onto a huge screen giving the results in Trafalgar Square. He also produced 14 oil panels of sports figures for the gymnasium of the *Queen Mary* (1936). During World War II he was a war correspondent and participated (with Gracie Fields) in concert parties in France and Belgium as cartoonist/comedian, returning to work first for Kemsley Newspapers (1944–53) and later *News Chronicle* (1953–6). His most famous creation was Tishy the racehorse which was reputed to cross its forelegs when running (Tishy also featured in two animated films – one by Joe Noble had a royal premier at the Hippodrome, London, on 12 December 1922 and another, *Tishy and Steve*, appeared in 1925). Other characters included the Bloated Bookmaker and the Horizontal Heavyweight. His caricatures were also very idiosyncratic, perhaps the most famous being of the billiards champion, Melbourne Inman. Webster sketched in charcoal, chalk or pencil, worked on cardboard with a

MELBOURNE INMAN

Tom Webster, [Melbourne Inman], *Daily Mail*, 23 October 1931

Waverley pen and drew approximately 1½ times published size. Able to draw from life without looking at the paper, he had a Daimler fitted with an easel in the back seat so that he could start his drawings en route to the office after an event. He created a new style of multi-subject sports panel which incorporated a running commentary or storyline within the frame, described by LOW as 'comic pictorial gossip reporting . . . He disdains draughtsmanship and banks on undiluted verve and raciness almost entirely.' Tom Webster died in London on 21 June 1962.
PUB: 20 annuals (1920–39) beginning with *Tom Webster of the 'Daily Mail' Among the Sportsmen* (1920), *The Humours of Sport* (1936)
EXHIB: UKCC
COLL: UKCC MB

WEIRDLY, Awfly – see Robinson, Charles

WEISZ, Victor 'Vicky' FSIA (1913–66). Political cartoonist, caricaturist, pocket cartoonist, strip cartoonist and illustrator. Victor Weisz was born in Berlin of Hungarian Jewish parents on 25 April 1913. At the age of 11 he studied with the painter Tennstedt and on the death by suicide of his father in 1928 began drawing caricatures (his first sale was of a German boxer) freelance until joining the graphics department of the radical anti-Hitler journal *12 Uhr Blatt*, becoming sports

and theatre cartoonist by 1929 and signing his work 'V.Weiß'. In 1933 the paper was taken over by the Nazis and by 1935 Vicky had arrived in the UK. His first work was drawing caricatures and cartoons for various publications including *Evening Standard*, *Daily Telegraph*'s 'Peterborough' column, *World Film News* ('Cockalorum' series), *Sunday Chronicle* (strip 'Vicky by Vicky'), *Sunday Dispatch*, *Daily Mail* ('Funny Figures' series), *Headway*, *Courier*, *Daily Mirror* ('Nazi Nuggets' series), *Sketch*, *Lilliput*, *New Statesman*, *Men Only*, *Tatler*, *Time & Tide* (1936–43) and *Daily Express*. After a trial to replace WILL DYSON on the *Daily Herald*, he joined the staff of the *News Chronicle* (1939) as Political Cartoonist, also drawing strips such as 'Weekend Fantasia' and 'Young Vicky's Almanack' and sharing an office with RICHARD WINNINGTON. He moved to the *Daily Mirror* (1954) and at the *Evening Standard* (1958), later taking over from 'Gabriel' (JAMES FRIELL). He also worked as 'Pierrot' for *L'Express* and as 'Smith' contributed pocket cartoons to the *News Chronicle*. Perhaps his most memorable creation was 'Supermac' (first published in the *Evening Standard* on 6 November 1958), intended to ridicule PM Harold Macmillan but which somehow developed into an endearing image. A passionate Socialist, he was, with DAVID LOW, perhaps the most influential political cartoonist of recent times ('Vicky is a genius' Randolph Churchill; 'the best cartoonist in the world' Michael Foot). His scratchy, brittle pen line has also had considerable impact on the later work of NICHOLAS GARLAND. Himself influenced by Low and Käthe Kollwitz (especially in his bleak 'Oxfam' style), Vicky worked mostly in ink and brush on board, and as a caricaturist once said 'I don't make fun of a face. I make fun of what is behind that face.' He was voted Cartoonist of the Year (1960) by Granada TV's 'What the Papers Say'. Suffering from depression, he took his own life on 23 February 1966.
PUB: *Drawn by Vicky* (1944), *Aftermath* (1946), *The Editor Regrets* (1947), *Stabs in the Back* (1952), *Meet the Russians* (1953), [with 'Sagittarius'] *Up the Poll!* (1950), *New Statesman Profiles* (1957), *Vicky's World* (1959), *Vicky Must Go!* (1960), *Twists* (1962), *Home and Abroad* (1964)
ILL: R. Nurnberg, *Schmeling* (1932); G. W. L. Day, *Outrageous Rhapsodies* (1938), *Sigh No More, Ladies* (1948), *We Are Not Amused* (1940); W. Douglas-Home, *Home Truths* (1939); P. Noble, *Profiles and Personalities*

"I TOLD YOU THIS SORT OF STUFF WILL FETCH 'EM BACK INTO THE OLD CINEMA . . ."

Vicky (Victor Weisz), [R. A. Butler & Harold Macmillan], *Evening Standard*, 17 November 1958

(1946); 'Sagittarius', *Let Cowards Flinch* (1947); M. Shulman, *How to be a Celebrity* (1950); I. Mackay, *The Real Mackay* (1953); E. Hughes, *Pilgrim's Progress in Russia* (1959)
EXHIB: Lefevre Galleries; RFH (Memorial, 1967); CG; NPG and tour
COLL: UKCC; NPG; BFI; CAT
LIT: *Vicky: A Memorial Volume* (1967); R. Davies & L. Ottaway, *Vicky* (1987) MB

WELLER, Sam – see Onwhyn, Thomas

WHEELER, Colin (b. 1938). Pocket cartoonist, editorial cartoonist, journalist and painter. Born in Hindhead, Surrey, on 23 February 1938, Colin Wheeler studied at Farnham School of Art (1954–8), and the painting department of the Royal Academy Schools (1958–61). A teacher for 20 years he had his first cartoon published in the *Times Educational Supplement*. He has also worked freelance for *Private Eye, Guardian, Daily Telegraph, New Statesman, New Scientist,*

Punch and others and has contributed editorial cartoons to the *Independent on Sunday*. In addition he has produced the daily front-page pocket cartoon for the *Independent* since 1986 and has also written a number of articles, reviews etc. for the paper (as well as for the *Daily Telegraph* and others) on architecture, painting and sculpture. He has an 'artfully spare, almost doodled style' (FRANK WHITFORD) and in his pocket cartoons never uses pencil. His larger political drawings use a lot of cross-hatching and graphite pencil rather than mechanical tints.
PUB: *A Thousand Lines* (1979), *Off the Record* (1980)
EXHIB: CG MB

WHISTLER, James Abbott McNeill PRBA (1834–1903). Painter, etcher, lithographer, illustrator and occasional caricaturist. Whistler was born in Lowell, Massachusetts, on 11 July 1834, the son of an engineer. After a boyhood spent partly in Russia and England he entered West

Point Military Academy, USA, from which he was discharged for 'deficiency in chemistry'. He had a brief spell as a cartographer for the US Navy, during which he learned etching, then moved to Paris (1855) where he studied art and acquired a lasting admiration for Velázquez and the Japanese print. He came to London in 1859 bringing, in MAX BEERBOHM's words, 'the tables of the Law from the summit of Fujiyama' and, having great success with his paintings and etchings, made it the centre of his activities from 1863. In his early years in England, especially 1862, his illustrations appeared in *Good Words*, *Once a Week* and the *Portfolio*. In 1877 one of his 'Nocturnes', experiments in tonal harmony, provoked Ruskin's comment, 'I never expected to hear a coxcomb ask 200 guineas for flinging a pot of paint in the public's face', which led to a famous libel action and the award of a farthing's damages to Whistler. By virtue of his talent, his personality and his intelligence he exercised an immense influence on his contemporaries. He was elected PRBA (1886–8), was made Hon LL.D Glasgow University and received many foreign honours. A formidable wit, Whistler made many private sketches of his friends, and the caricature element in these sketches could be savage when a friend, like his patron F. R. Leyland, or Oscar Wilde, fell from grace. He was himself caricatured by APE, BEARDSLEY and BEER-BOHM. He died in London in July 1903.
PUB: *The Gentle Art of Making Enemies* (1890), *The Baronet and the Butterfly* (1899)
EXHIB: RA; RBA; NEAC; RSA; FAS; GG; L (1976)
COLL: T; BM; V&A; A; F; G; M and many foreign galleries
LIT: D. Sutton, *James McNeill Whistler* (1966); S. Weintraub, *Whistler* (1974) SH

WHISTLER, Reginald John (1905–44). Painter of murals, portraits and landscapes, illustrator, stage designer and commercial artist. Rex Whistler was born in Eltham, Kent, on 24 June 1905, the son of a builder and property-developer and the elder brother of Laurence Whistler, the writer and glass-engraver. Educated at Haileybury, where he showed a talent for illustration, he left aged 17 and attended the RA Schools for one term, then the Slade (1922–6). In his last year at the Slade he started to paint the mural decorations for the restaurant at the Tate Gallery – 'The Pursuit of Rare Meats', an Arcadian strip cartoon – that launched his career and led to many other commissions for murals. At the same time

his book illustrations, which evoked the 18th century in a blend of romance and humour, attracted attention. In the early 1930s he painted curtain designs for C. B. Cochran's comic revues and designed stage sets and costumes for a number of productions. His illustrations appeared in *Nash's* and the *London Mercury* and he drew decorative and amusing covers for the *Radio Times* (1931) and the *Tatler* Summer Numbers (1935–7). In the commercial field he designed charming comic advertisements for Fortnum & Mason, Guinness ('Songs of our Grandfathers', 1936), Rothmans and Shell, for whom he invented the 'Reversible Faces' later published in *!OHO!* (1946). He also made a large number of bookplate designs in the rococo style. In World War II he was commissioned into the Welsh Guards (1940) and in 1944 painted the richly comic scene 'HRH the Prince Regent Awakening the Spirit of Brighton', which is now in the Brighton Pavilion. He was killed on active service in Normandy on 18 July 1944.
PUB: *The Königsmark Drawings* (1952)
ILL: Sir F. Swettenham, *Arabella in Africa* (1925); W. de la Mare, *Desert Islands* (1930), *The Lord Fish* (1933); L. Whistler, *Armed October* (1932), *The Emperor Heart* (1936), *!AHA!* (1978); B. Nichols, *Down the Garden Path* (1932), *A Thatched Roof* (1933); *The New Forget-Me-Not* (1934); S. Harcourt-Smith, *The Last of Uptake* (1942); E. Oliver, *Night Thoughts of a Country Landlady* (1943); C. Aberconway, *The Story of Mr Korah* (1954)
EXHIB: V&A (AC Memorial Exhibition, 1960)
COLL: T; V&A; BM; BN
LIT: L. Whistler & R. Fuller, *The Work of Rex Whistler* (1960); L. Whistler, *The Laughter and the Urn* (1985) SH

WHITELAW, George Alexander (1887–1957). Political cartoonist, illustrator and caricaturist. George Whitelaw was born on 22 June 1887 in Kirkintilloch, Dunbartonshire, the son of a doctor. He attended Lenzie Adademy and Glasgow High School and studied under MAURICE GREIFFENHAGEN RA for a year at Glasgow School of Art. He first contributed drawings to *Boy's Own Paper*, *Chums* and *Captain* before beginning work as artist/cartoonist at the *Glasgow Evening News* at the age of 17. In 1915 he came to London as cartoonist for *Passing Show* and after service in World War I (working on camouflage in the Tank Corps) returned there in 1919. He began regularly producing theatre drawings for *Punch c.* 1930 and later succeeded

WILL DYSON as Political Cartoonist on *Daily Herald* (1938–49). He also contributed to *John Bull* (covers), *Punch*, *London Opinion* and *Bystander* (colour caricature series 'George Whitelaw's Who's Zoo' comparing celebrities with animals). He admired TENNIEL, SAMBOURNE, PHIL MAY and TOM BROWNE and used to work exclusively with a pen but later preferred the spontaneity of the brush technique. In addition he also exhibited portrait etchings of celebrities. He died on 19 September 1957.
EXHIB: G; L MB

WHITFORD, Francis Peter 'Rausch' PhD (b. 1941). Pocket cartoonist, illustrator, lecturer and writer. Frank Whitford was born in Bishopstoke, Hampshire, on 11 August 1941 and is a self-taught artist. He was cartoonist and illustrator on the *Sunday Mirror* (1965–6), Pocket Cartoonist on the *Evening Standard* (1966–7), and has been Pocket Cartoonist on the *Sunday Mirror* since 1969. In addition, he has been Lecturer on the History of Art at University College, London (1970–4) and Cambridge University (1974–86), Tutor in the History of Art at the RCA (1986–91), art critic of the *Sunday Times* (since 1991) and gave two series of broadcasts about cartoonists on BBC Radio 4. He draws in pen and ink.
PUB: *Trog: 40 Graphic Years* (1987) and several books about aspects of European art MB

WHITTOCK, Colin John (b. 1940). Editorial cartoonist, illustrator and writer. Colin Whittock was born in Birmingham on 25 February 1940 and is a self-taught artist. Having failed 'O' level Art, he worked as a shopfitter until 1979 before turning full-time freelance. Editorial Cartoonist on the *Birmingham Evening Mail* since 1969, his principal freelance work has been for *Punch*, *Daily Mirror*, *Sun*, *Daily Sketch*, *Tit-Bits* and *Weekend*, and advertising clients have included TNT, British Telecom, Jaguar, Powergen and Tubes Ltd. He has also produced greetings cards for Rainbow Cards and drew 'Champ', 'Lazy Bones' and 'Miss Marple' for *Whizzer & Chips* (1971–89).
PUB: *The Perils of Pushing Forty* (1986), *The Perils of Moving House* (1987), *The Perils of Parenthood* (1987), *The Perils of Getting Married* (1988), *The Perils of Motoring* (1989) ILL: P. Allis, *More Bedside Golf* (1982); R. Reardon, *Bedside Snooker* (1983); S. Waddell, *Bedside Darts* (1984); E. Straiton, *Positively Vetted* (1984), *A Vet on the Set* (1985); T. Blackburn, *The Very Best of Tony Blackburn*

(1989); D. Lloyd, *G'Day Ya Pommie B...!* (1992)
COLL: B MB

WIGSTEAD, Henry (d. 1800). Magistrate, amateur painter and caricaturist. Wigstead was a friend of ROWLANDSON who accompanied him on sketching trips to the Isle of Wight (1784), Brighton (1789) and Wales (1797). He exhibited watercolours at the RA (1785) in a style similar to that of Rowlandson, so similar that the critic of the *St James's Chronicle* wrote 'these humorous and excellent drawings we make no doubt to be the production of Mr Rowlandson'. Because Rowlandson certainly helped him with his drawing, and made prints based on his ideas and sketches, problems of attribution abound. He died in Margate in September 1800.
COLL: BM; V&A SH

WILES, Arnold Frederick (b. 1926). Cartoonist and illustrator. Born in Southampton on 1 June 1926, Arnold Wiles won several newspaper colouring competitions as a child, including a BBC Radio 'Children's Hour' painting competition (1938). He then worked in Cunliffe-Owen's aircraft factory (1942–4), making tools for Spitfires before joining the Royal Signals as a wireless operator (1945–8). Self-taught as an artist, he sold his first cartoon to *Punch* in 1943 and regularly contributed cartoons and cover designs to *Soldier* and joke cartoons to *Blighty*, *Lilliput*, *Men Only*, *John Bull*, *Everybody's* and *London Opinion*. Since the war he has freelanced mostly for *Punch*, *Private Eye*, *Countryman*, *Daily Mirror*, *People*, *Sun*, *Daily Star*, *Chat*, *Angling Times* and numerous other angling journals in the UK and Europe. A specialist in angling cartoons (he has sold more than 1000 drawings on this subject alone), he has also designed humorous greetings cards for Royle, Classic and Raphael Tuck and produced photographic angling calendars for Jarrolds (1978, 1979). Arnold Wiles works in pen and ink, scraperboard and watercolour and cites his influences as CHARLES KEENE, PHIL MAY and DAVID LANGDON. Geipel has described his 'sprightly immediacy of line whose vitality is made all the more telling by a suggestion of the unedited, preliminary drawing cutting through and underscoring the final layers'.
PUB: *Dog in the House* (1961), *A Pretty Kettle of Fish* (1966), [with H. Stoker] *Fishing for Bass with Bill and Bob* (1966), *Everything in the Garden* (1967), *Away from it All* (1968), *Motor-*

ist at Large (1969), Start Fishing – A Guide for Beginners (1983)
ILL: J. Anthony, *Hark! Hark! The Ark!* (1960); M. Boyce Drew, *The Little Dogs Laughed* (1961)
EXHIB: Copperhouse Gallery, Hayle, Cornwall; Cartoon Corner, Butterfly World, Fraddam, Cornwall
COLL: V&A MB

WILFORD-SMITH, Francis 'Smilby' (b. 1927). Cartoonist. Francis Wilford-Smith was born in Rugby on 12 March 1927, the son of a chemist. He enlisted in the Merchant Navy at the age of 16, serving as a radio officer in World War II (1943–6). After the war he attended Camberwell School of Art (1946–50) and did various jobs – including film animator for Halas & Bachelor, assistant display manager for a women's dress chain, assistant to an industrial designer etc. – before being published in *Punch* and *Lilliput* in 1951, since when he was been a full-time cartoonist. His work has also appeared in *London Opinion, Picture Post, Illustrated, John Bull, Courier, Spectator, New Yorker, Playboy* (from 1960), *Esquire, Saturday Evening Post, New York Times, Saturday Review, DAC News, Paris-Match, Lui, Pardon, Diners Club Magazin* (Austria), *Nebelspalter, Vi Menn, Look* and elsewhere. For some years he was relief artist for MICHAEL FFOLKES on the *Daily Telegraph*'s 'Peter Simple' column. In addition, he has illustrated many advertising campaigns from Guinness to ICI and Boots and has been a freelance ideas consultant to top agencies (e.g. KMP). An expert on blues music, he owns the world's most important collection of recorded piano blues, and has written and broadcast on the subject on TV and radio (twice nominated for Sony Award). He was influenced at first by FRANÇOIS, STEINBERG, ILLINGWORTH, ARTHUR WATTS and French Art Deco artists Marty and Barbier. Smilby works in indian ink and Winsor & Newton Artists' Watercolour.
EXHIB: CG; Los Angeles, London, Munich, Switzerland
COLL: SAM MB

WILKINSON, Gilbert (1891–after 1948). Cartoonist, illustrator and watercolourist. Gilbert Wilkinson was born in Liverpool in October 1891 and nearly drowned in the Mersey at the age of five. He attended Liverpool Art School then moved to London and studied at Bolt Court Art School and in the evenings at Camberwell

(under A. S. Hartrick). He then won a scholarship which enabled him to be apprenticed to colour printers Nathaniel Lloyd for seven years. At the time greatly influenced by the work of Arthur Moreland, then working at the *Morning Leader*, Wilkinson had his first drawings accepted by the paper when he was still at Lloyd's and later deputized for the artist when he was ill. He also began contributing cartoons to *London Opinion* and others. In World War I he served in the London Scottish Regiment (1915–19), attaining the rank of lance-corporal, and after the war returned to *London Opinion* and drew colour covers for *Passing Show* for more than 25 years (from 1921) until it merged with *Illustrated*. He also contributed to *Strand Magazine* (notably illustrations to P. G. Wodehouse's stories), *Good Housekeeping, Punch, Pan, London Mail, Judge, Life, Cosmopolitan, Nash's, Saturday Evening Post* and *College Humor* (Chicago) and even turned down a staff job on *Life* magazine. Perhaps his most memorable creation was the daily topical sequence 'What a War' which was featured in the *Daily Herald* during World War II, continued in peacetime as 'What a Life' and later transferred to the *Sun* on the *Herald*'s demise. Wilkinson's signature was almost indecipherable and he worked mostly in ink and wash.
PUB: *What a War!* (1942, 1944), *What a Life!* (1946, 1948)
ILL: C. Dickens, *A Christmas Carol* (c. 1930); various titles by P. G. Wodehouse
EXHIB: Arlington Gallery MB

WILLIAMS – see Martin, Sidney William

WILLIAMS, Charles (fl. 1797–1830). Caricaturist, etcher and illustrator. From c. 1799 to 1815, when he was displaced by GEORGE CRUIKSHANK, Charles Williams was chief caricaturist for the publisher Fores. He worked in a style similar to GILLRAY and imitated or copied a number of Gillray's plates. Most of his early political work was unsigned or issued under the pseudonyms 'Ansell' or 'Argus'. As his career progressed, the element of caricature in his work diminished in favour of realism. Like ROWLANDSON he turned increasingly to book illustration. In 1819 he was paid by the Prince Regent to suppress some drawings; around the same time he made some excellent caricatures of dandies. From 1827 the powers of this competent and prolific artist seem to decline.

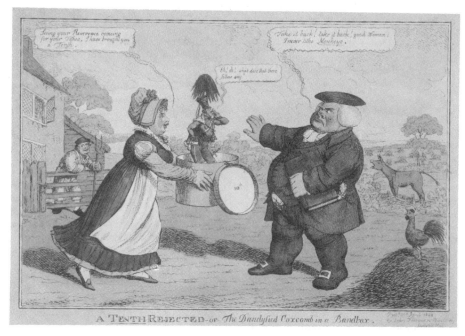

Charles Williams, [satire on 10th Hussars], 1824

ILL: A. Thornton, *Post Captain or Adventures of a True British Tar by a Naval Officer* (1817); J. Mitford, *The Adventures of Johnny Newcome in the Navy* (2nd edn 1819), *My Cousin in the Army* (1822); W. Combe, *Dr Syntax in Paris* (1820); *The Tour of Dr Prosody* (1821)
COLL: BM SH

WILLIAMS, Christopher Charles 'Kipper' (b. 1951). Cartoonist and strip cartoonist. Kipper Williams was born on 30 December 1951 in the Wirral, Cheshire, and attended Ellesmere Port Grammar School. He studied fine art at Leeds University (1970–4), where he drew cartoons for *Leeds Student* magazine, publishing his first collection of cartoons in 1973 and winning a *New Statesman*/NUS Student Journalist Competition (1974). He then went to the Royal College of Art (1974–6) and became a full-time cartoonist immediately afterwards. He has contributed to *New Society, New Statesman, Private Eye, Punch, Euromoney, Spectator, Smash Hits* and *Nursing Times*. In addition he created the strips 'The Lady and the Wimp' for *Time Out* (1983), 'Pile 'em High' for *Sunday Times* (1992), 'Eurocats' for the *Guardian* (1992) and since

1991 has drawn a daily cartoon for the *Guardian*'s finance pages. He prefers to work with a Goode steel-nib pen and black Rotring ink, using Dr Martin's inks for colour work.
PUB: *Warning! This Computer Bytes!* (1986), *The Lady and the Wimp* (1986), [with D. Austin & N. Newman] *Far From the Madding Cow!* (1990)
ILL: Many books
EXHIB: CG
COLL: BM MB

WILLIAMS, Michael Charles (b. 1940). Cartoonist. Mike Williams was born on 27 February 1940 in Liverpool, the younger brother of PETE WILLIAMS, and attended Quarry Bank High School. He started work in Henry Pybus and Littlewoods commercial art studios in the city (1957–66) before turning freelance cartoonist, selling his first drawing to *Punch* in 1967. His cartoons have also appeared in *Private Eye, Spectator, Playboy* and *The Times*. Advertising work has played an important part in his career and his clients have ranged from BMW and Guinness to the Julius Baer Bank for which he created the polar bear image. In addition, he has

produced greetings cards for Valentine's of Edinburgh. He is an admirer of Mankoff, Grosz, and Michael Maslin. In recent years Mike Williams' 'rough-cut, splintery angularity [has become] less brittle and more rollicking' (Geipel), frequently burlesquing biblical and literary themes.

PUB: *Oh No! Not the '23* (1987), *You Can't Still Be Hungry* (1988), [with A. Rusling] *The Very, Very Last Book Ever* (1986)
EXHIB: Albert Dock Gallery, Liverpool; Chester Town Hall; Chester Library; BC
COLL: BM MB

WILLIAMS, Peter George (b. 1937). Cartoonist. Pete Williams was born in Liverpool on 27 January 1937, the elder brother of MIKE WILLIAMS. Self-taught, he is a part-time art teacher at the Alice Elliott and Watergate Schools in Liverpool. His cartoons have appeared in *Punch*, *Private Eye*, *Daily Mail*, *Spectator*, *Daily Mirror*, *Daily Express*, *Daily Star*, *People*, *Men Only* and *Mayfair*. Voted Berol Cartoonist of the Year (1987) and a prizewinner in the Waddingtons International Cartoon Awards (1988), he has also won international awards in Belgium and Japan.
EXHIB: BAG; Colchester Gallery, Essex; Bury St Edmunds, Suffolk; Library Theatre, Manchester
 MB

WILLSON, Richard David (b. 1939). Caricaturist, cartoonist and illustrator. Richard Willson was born in London on 15 May 1939 and studied architecture at Kingston School of Art and graphic design at Epsom School of Art. Caricaturist on the *Observer* (1968–71) and *The Times* (since 1971), he has also worked freelance for the *Spectator*, *New Statesman*, *New Scientist*, *Business Traveller*, *Euromoney*, *Investors Chronicle*, *Punch*, *Financial Weekly*, *Accountancy Age*, *Computing*, *Lloyds Log*, *Ecologist*, *New Internationalist*, *United Nations* and *Racing Post*. In addition, he has produced a considerable amount of advertising work. Richard Willson has a fine, cross-hatched style with big heads on small bodies that show the influence of DAVID LEVINE.
PUB: *The Doomsday Fun-book* (1977), *As Lambs to the Slaughter* (1981) *The Green Alternative* (1985)

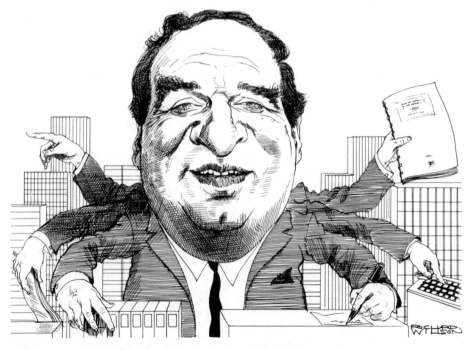

Richard Willson, [Leon Brittan], *The Times*, *c.* March 1993

ILL: M. Ivens, *Born Early* (1975); R. Stilgoe, *The Richard Stilgoe Letters* (1981); J. Tarbuck, *Tarbuck on Golf* (1983), *Tarbuck on Showbiz* (1984) MB

WILSON, David RI, RBA (1873–1935). Painter, caricaturist, cartoonist and illustrator. David Wilson was born on 4 July 1873 at Minterburn Manse, Co. Tyrone, the son of a clergyman. He was educated at the National School and at Royal Belfast Academical Institution and began work for North Bank, Belfast, while attending the local art school in the evenings. He later came to London, working for *Daily Chronicle* (from 1895) and other publications before becoming chief cartoonist on the *Graphic* (1910–16). He also contributed to *Punch* (1900–14), *Fun*, *Sketch*, *Temple Magazine*, *Tatler*, and *Passing Show*.
PUB: *Through a Peer Glass* (1908), *Wilhelm the Ruthless* (1917)
EXHIB: RA; Paris Salon; FAS (1935); BN; BEL
COLL: IWM; V&A MB

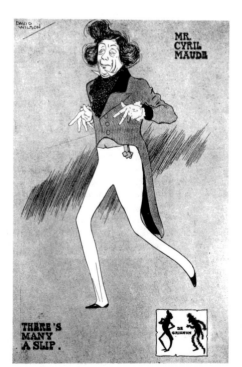

David Wilson, *Tatler*, 5 November 1902

WILSON, Mervyn (1905–59). Cartoonist, strip cartoonist and illustrator. Mervyn Wilson was educated at Hassall's Correspondence School, St John's Wood Art School and the Royal Academy Schools and contributed to *Radio Times* (from 1929), *Punch* (from 1935), *Night & Day*, *London Opinion*, *Lilliput*, *Tatler*, *New Yorker*, *Daily Express* (strip cartoons) and other publications. In his *Radio Times* drawings he often included a portrait of the magazine's Art Editor (later Editor) Douglas Graeme Williams. During World War II he served in the Home Guard and ARP and later worked for the Department of Ancient Monuments. He rarely used pencil and preferred to draw directly on to paper in pen and ink. He died in July 1959. R. D. Usherwood described him as 'One of the most distinguished comic artists in the country. His highly individual style was admired by artists for its expert control of line and texture, and his humour, based on a kindly observation of life around him, was easily acceptable to the layman.'
EXHIB: AG; RBA MB

WILSON, Oscar RMS ARBA (1867–1930). Painter of portraits and genre in oil and watercolour, illustrator and cartoonist. Oscar Wilson was born in London and studied art at the South Kensington Schools and in Antwerp. He contributed illustrations, some with humorous captions, to *Black & White*, *Cassell's*, *London Opinion*, *Madame*, *New Budget* and the *Sketch*. His most typical work was published in *Pick-Me-Up*, starting in the late 1890s – wash drawings of pretty women with comic or sentimental connotations. He was elected RMS (1896) and ARBA (1926). Wilson died on 13 July 1930.
ILL: G. I. Witham, *The Last of the Whitecoats* (1906), *The Adventures of a Cavalier* (1914); E. Grierson, *Bishop Patteson of the Cannibal Islands* (1927)
EXHIB: RA; RBA; RI; RMS; L
COLL: LE SH

WINNINGTON, Richard (1905–53). Film critic, caricaturist, strip cartoonist, illustrator and writer. Richard Winnington was born in Edmonton, London, on 10 September 1935, the son of an accountant. He attended Bancroft's School but received no formal art training. Working first as a salesman, then as a clerk for Thomas Cook Ltd, he was employed by Heinz canned foods when he sold his first comic strip, about two pigeons called Bib and Bob, to the *Daily Express* in 1936. The same year he joined the *News*

241

Chronicle as an illustrator and later became the paper's celebrated film critic, illustrating his own column (1943–53) and sharing an office with VICKY. In addition he wrote film criticism for *Daily Worker* under the pseudonym 'John Ross' (1943–8). Described by Augustus John as 'a brilliant draughtsman and true critic', NICOLAS BENTLEY said of him: 'No other artist of his *genre* could bite out the character of his victims with a more shrewd or more economical wit.' Winnington always drew his illustrations *after* he had written the film review and seldom produced a caricature for a film he liked. 'His skill lay not just in his devastating caricatures of the main players in a film but in an exposure of their roles. He could sum up the whole *sense* of a film in a single drawing without text. The scenic background to his characters was often as important as they were' (Rotha). An admirer of GILLRAY and HOGARTH, his fine, slightly Baroque style was strengthened by a bold use of indian ink applied with a brush. He worked on layout paper and often pasted on new heads if he wasn't happy with a caricature. In his own words: 'The only way of making a caricature is from the inward exposure of the eye and mind. Else it is a mere exaggeration distorting physical peculiarities, or representational romantic likeness. The comment that bites home is between the two and cannot be defined.' Richard Winnington was married to PEARL FALCONER (1938–47). He died on 17 September 1953.

PUB: *Drawn and Quartered* (1948); [with N. Davenport] *The Future of British Films* (1951); P. Rotha (ed.) *Richard Winnington* (1975)
EXHIB: NFT (1975)
COLL: BM; V&A; CAT; BFI MB

WOOD, Clarence Lawson RI FZS (1878–1957). Painter, illustrator and cartoonist. Lawson Wood was born on 23 August 1878 in Highgate, London, the grandson of the architectural artist L. J. Wood RI and son of landscape painter Pinhorn Wood. He studied art at the Slade and Heatherley's and also took evening classes at Frank Calderon's School of Animal Painting. He joined the staff of magazine publisher C. Arthur Pearson at the age of 18 and quickly became its chief artist, leaving after six years to turn freelance. In World War I he served as an officer in the Kite Balloon Wing of the RFC. An accomplished poster designer, Lawson Wood also drew cartoons for *Graphic* (1907–11), *Punch* (notably a Stone Age series), *Bystander*, *Strand Magazine*, *Nash's* (including covers),

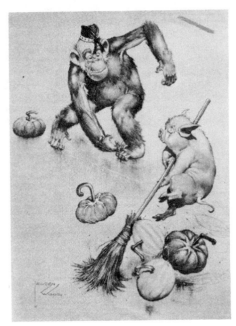

GRANDPOP GOES CURLING

Clarence Lawson Wood, *Christmas Pie*, 1935

Sketch, Boy's Own Paper, Fry's Magazine (including covers), *Illustrated London News, Puck, Royal Magazine, Collier's* (covers), *Printers' Pie* and *London Opinion*, and as 'Hustlebuck' with his son-in-law Keith Sholto Douglas. In addition, he produced work for advertising (e.g. Alwetha Raincoats, Segment Motor Rims), designed three-colour decorative household prints for Lawrence & Jellicoe, and designed and made wooden toys, 'The Lawson Woodies', featuring animals, birds and human figures. He is perhaps best remembered for his humorous animal subjects, especially Gran'pop the artful ginger ape which first appeared in the *Sketch* in the 1930s and led to considerable merchandizing, featured on Kensitas cigarette cards (1935) and, but for the outbreak of World War II would have been turned into an animated film by Ub Iwerks' studio. Lawson Wood had a specially-made enamel palette over a foot square and worked on Milburn Drawing Board. He was elected a Fellow of the Zoological Society and died on 26 October 1957.

PUB: Many books including *The Book of Lawson Wood* (1907), [with J. B. Kernahan] *The*

Bow Wow Book (1912), *Splinters* (1916) and Gran'pop annuals (from 1935)
ILL: J. Finnemore, *The Redmen of the Dusk* (1899); H. Caine, *The White Prophet* (1909)
EXHIB: D; L; RA; RI; Sunderland; BSG; DG; London Salon; WG
COLL: V&A
LIT: A. E. Johnson, *Lawson Wood* (1910); P. V. Bradshaw, *The Art of the Illustrator* (1918)
MB

WOOD, Starr 'The Snark' (1870–1944). Cartoonist. Starr Wood was born in London on 1 February 1870, the son of a customs officer. He worked as a chartered accountant (1887–90) before turning freelance artist, his first drawing being published in *Ariel* in 1892. He also contributed to *Chums, Fun, Sketch, Judy, Pick-Me-Up, Idler, Chips, Parade, English Illustrated Magazine, Bystander, Humorist, Passing Show, Tatler, Moonshine, London Opinion, Printer's Pie* and *Punch* (from August 1898). He was one of the founders and first Art Editor of *The Windmill* quarterly and later ran *Starr Wood's* magazine (1910–*c.* 1935).
PUB: *Rhymes of the Regiments* (1896), *Cocktail Time* (1896), *The Snark's Annual* (1910), *Dances You Have Never Seen* (1921), *PTO: A Collection of 94 Humorous Drawings* (1934), [with H. Simpson] *Woman en Casserole* (1936)
ILL: L. Hillier, *The Potterers' Club* (1900); A. Armstrong, *The After-Breakfast Book* (1937); H. I. MacCourt, *Women as Pets* (1938)
EXHIB: L
COLL: V&A MB

WOODCOCK, Kevin Robert (b. 1942). Cartoonist. Born in Leicester on 2 September 1942, Kevin Woodcock attended Leicester College of Art (1961–4) and has contributed cartoons to *Private Eye, Spectator, Knave, Fiesta, Punch* and *Brain Damage*. Influenced by ROWLAND EMETT, ANDRÉ FRANÇOIS and RONALD SEARLE, he works in pen and ink straight onto A4 or thick typing paper and for colour uses watercolour and gouache (15 x 20cm). He also uses collage.
PUB: *Kevin Woodcock* (1978), *City Rules OK* (1983), *You Are Here* (1987)
EXHIB: CG MB

WOODWARD, George Moutard (1760–1809). Amateur caricaturist and humorous writer. George Woodward, sometimes known as 'Mustard George', was the son of William Woodward of Stanton Hall, Derbyshire, and in his youth

made a name for himself caricaturing local personalities. He came to London (*c.* 1785) and in 1790 drew a set of six caricatures under the title 'Symptoms of Drunkenness', which could have been a conspectus of his own life since he was an exceedingly convivial character who died with a glass of brandy in his hand. From the start his caricatures owed much of their appeal to the inscriptions, often in doggerel verse. Untrained as an artist, all his drawings were etched by professionals like CHARLES WILLIAMS, ISAAC CRUIKSHANK and, most frequently and notably, ROWLANDSON of whom he was a friend and drinking companion. He designed a number of political prints but most of his work is on social themes, disrespectful jokes about parsons, lawyers, doctors, dons, rich citizens of London ('cits'), the militia and, a favourite subject of Woodward's, sailors ashore. Some of these he treated in strip form, of which he was a pioneer. His work was extremely popular in his day – on a par with Rowlandson's – and a good deal of it was published after his death from drawings he left behind him. Dorothy George called Woodward 'a very considerable figure in caricature; he was original, prolific and varied'. His drawings were vigorous but coarse, and he owed a lot to his etchers. He has a strong claim to be considered Britain's first 'gag cartoonist' and his contribution is recalled in Desmond MacCarthy's words: 'when the horse-laugh dies out of English caricature something vital and important dies with it'. He died at the Brown Bear Hotel, London, in November 1809.
PUB: *School for Lovers* (1792), *Eccentric Excursions in England and South Wales* (1796), *Cupids Magick Lantern* (1797–8), *Horse Accomplishments* (1799), *Le Brun Travestied or Caricatures of the Passions* (1800), *Pigmy Revels* (1800–1), *An Olio of Good Breeding* (1801), *Attempts at Humour* (1803), *The Bettyad* (1805), *The Caricature Magazine or Hudibrastic Mirror* (1806–7), *An Essay on the Art of Ingeniously Tormenting* (1808), *Chesterfield Travestie, or School for Modern Manners* (1808)
ILL: 'C. Quizzem', *Annals of Sporting* (1809)
COLL: BM; V&A; F; LE; CAT SH

WREN, Ernest Alfred 'Chris' (1908–82). Cartoonist, illustrator, writer and editor. Chris Wren ('Chris' was a nickname that stuck) was born in Hampstead, London, on 5 July 1908. He studied at St Martin's School of Art and was for some years a commercial artist with G. S. Royds advertising agency. He joined 604 Squadron

Royal Auxiliary Air Force in 1934 as an Aircraft Recognition Instructor, which led to the creation of his famous 'Oddentifications' series of aeroplane caricatures with accompanying verses published in *Aeroplane* magazine during World War II. Wren later worked as a public relations officer and was Editor of *Esso Air World*. He was also a prolific designer of Christmas and anniversary cards in ink, wash and watercolour for aviation bodies, including the Red Arrows aerial display team. He died on 9 December 1982.

PUB: *Oddentifications* (1942); [with S. E. Veale] *How Planes Fly* (1953) MB

WYSARD, Anthony (1907–84). Caricaturist. Tony Wysard was born in Pangbourne, Berkshire, and educated at Harrow School. Finding a life in the City uncongenial he went into advertising, becoming in due course PR Manager for Alexander Korda's film studios at Denham. At the same time, starting with the *Tatler* in 1928, he contributed caricatures to the smart magazines – *Bystander*, *Sphere* and *Harper's Bazaar*. Most of his contributions to the *Tatler* (1929–39) were reproduced in full colour and the early ones are remarkable for bright harmonies and a 'modern' expressionist style. His line-drawn caricatures appeared in the *Daily* and *Sunday Express* and the *Daily Dispatch*. During the war Wysard served in the Greenjackets. Afterwards he founded his own advertising consultancy,

LIKE FATHER, LIKE SON

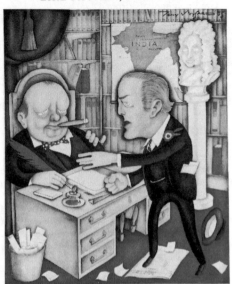

MR. WINSTON CHURCHILL AND MR. RANDOLPH CHURCHILL

Tony Wysard, *Tatler*, 18 December 1935

specializing in print design, and edited *Wheeler's Review* over a long period.

EXHIB: WG (1936)

COLL: NPG SH

PLEASURES OF THE COUNTRY

A Visit from the Vicar !

George Woodward, 1799

YEATS, Jack Butler 'W. Bird' RHA (1871–1957). Painter, illustrator, writer and cartoonist. Jack B. Yeats was born in London on 29 August 1871 the son of the Irish painter John Butler Yeats and the younger brother of W. B. Yeats the poet. He spent his childhood in Sligo, Ireland, then came with his family to London in 1887 and studied at the South Kensington Schools, Chiswick Art School and the Westminster School of Art. While still a student he started to contribute illustrations and cartoons to magazines, his first drawings being published in the *Vegetarian* (1888–94), *Ariel* (1891–2) and *Paddock Life* (1891–4). In the 1890s his humorous work also appeared in *Chums*, *Fun* (1901), *Illustrated Bits*, *Judy*, *Lika Joko*, *New Budget*, *Quartier Latin* and *Sketch* and in many children's comics like *Big Budget*, *Comic Cuts*, *Funny Wonder*, *Jester* and *Puck*. In his work for the comics he was far more original, literate and amusing than the other artists. For *Funny Wonder* he drew the first

parody of Sherlock Holmes called 'The Adventures of Chubblock Homes' and for *Big Budget* he invented the first funny animal hero, Signor McCoy the Wonderful Circus Hoss. His first *Punch* cartoon appeared in 1896 and from 1910 to 1941 he was a regular contributor under the pseudonym 'W. Bird'. Price wrote of his *Punch* work: 'his humour was irrational, wild and precise, his drawing much criticised as incompetent. He broke all the rules and his genius still draws readers back to volumes in which nothing much else appeals to them.' He returned permanently to Ireland in 1902, issued *A Broadsheet* (1902–3) and *A Broadside* (1908–15) – ancient and modern ballads largely illustrated and hand-coloured by himself – and made many designs for Cuala Press cards, prints etc. until 1925. Thereafter he devoted himself exclusively to painting (and writing), becoming the most highly regarded Irish painter of this century. He was elected RHA (1915), made a governor of the

National Gallery of Ireland (1939), D. Litt. Dublin University (1946) and invested as an Officer of the French Legion of Honour (1950). Yeats's zany brand of humour, first apparent in the magazines and comics of the 1890s, looks forward to the work of men like BLAMPIED and PAUL CRUM in the 1930s, whilst the cartooning style of his later work in *Punch* anticipates the loose doodles of LARRY and BILL TIDY in the 1960s. In both senses he was a pioneer and a very significant figure in cartoon art.

PUB: *James Flaunty* (1901), *The Scourge of the Gulph* (1903), *The Bosun and the Bob-Tailed Comet* (1904), *A Little Fleet* (1909), *Life in the West of Ireland* (1912), *Sligo* (1930)
ILL: E. Rhys, *The Great Cockney Tragedy* (1891); W. B. Yeats, *Irish Fairy Tales* (1892), *Reveries over Childhood and Youth* (1911); J. H. Reynolds, *The Fancy* (1905); J. M. Synge, *The Aran Islands* (1907), *In Wicklow, West Kerry and Connemara* (1911); P. Colum, *A Boy in Erinn* (1913), *The Big Tree of Bunlahy* (1933); G. Birmingham, *Irishmen All* (1913)
EXHIB: NG (1942); NGI (1945, 1971); T (1948); Boston, USA (1951); AR and W (1991)
COLL: T; NGI; E; BR; LE; Y and galleries abroad
LIT: H. Pyle, *Jack B. Yeats: A Biography* (1970), *A Catalogue Raisonné of the Work of Jack B. Yeats* (1991); R. Skelton (ed.), *The Selected Writings of Jack B. Yeats* (1991) SH

YEOMAN, Beryl Antonia Botterill [née Thompson] 'Anton' FSIA (1907–70). Cartoonist and illustrator. Antonia Thompson was born on 24 July 1907 in Australia, the daughter of an English rancher and came to England in the 1920s. Confined to bed with TB of the spine as a child, she lost two fingers on her right hand in her teens and learnt to write and draw with her left. She attended the Royal Academy Schools (1928) and studied art under Stephen Spurrier for a year before becoming a freelance commercial artist. She also produced advertising posters and showcards with her brother HAROLD UNDERWOOD THOMPSON (the cartoonist 'H. Botterill') and in 1937 they formed a partnership producing cartoons as 'Anton'. When after the war Harold's work as director of an advertising agency left him less time for drawing, Antonia took over the name herself. The drawings of spivs, forgers, dukes and duchesses were very popular and appeared in *Tatler, Lilliput, Men Only, Evening Standard, Private Eye* and *Punch* (Antonia was the only female member of *Punch*'s Toby Club).

"... and 20 years ago, when we was kids, we made a tryst to meet here tonight ..."

Anton (Antonia Yeoman & Harold Underwood Thompson), *Anton's Amusement Arcade* (1957)

Antonia also drew a series of popular advertisements for Moss Bros and was the first woman elected to the Chelsea Arts Club. She died on 30 June 1970. Price wrote of the *Punch* cartoons 'the jokes stayed good volume after volume. The drawing was decorative and the massed blacks showed up well on the page ... the world ... was calmly, courteously mad.'
PUB: [with H. Underwood Thompson] *Anton's Amusement Arcade* (1947), *Low Life and High Life* (1952)
ILL: 17 books including V. Mollo, *Streamlined Bridge* (1947); V. Grahame, *Here's How* (1951); D. Parsons, *Can it be True?* (1953), *Many a True Word* (1958); M. Laski, *Apologies* (1955); S. Mead, *How to Live Like a Lord Without Really Trying* (1964); D. Briggs, *Entertaining Single-Handed* (1968)
EXHIB: RSA, SGA; Upper Grosvenor Galleries; CG
COLL: V&A; UKCC; CAT
LIT: J. Yeoman (ed.), *Anton* (1971) MB

Z

ZEC, Philip (1909–83). Political cartoonist and editor. Philip Zec was born on 25 December 1909 in London, the son of a Russian Jewish emigré tailor and brother of Donald Zec (later to become film journalist on the *Daily Mirror*). He attended Stanhope Elementary School and St Martin's School of Art and at 19 had his own commercial and photographic studio, working for J. Walter Thompson and other agencies. He joined the *Daily Mirror* as Political Cartoonist in 1937. Zec's most notorious cartoon 'The Price of Petrol Has Been Increased by One Penny – Official' (5 March 1942), depicted a shipwrecked sailor clinging to a raft and led to a storm of controversy. His original caption (changed by 'Cassandra', who often wrote his captions) had been 'Petrol is Dearer Now' and the drawing was one of a series attacking profiteers. However, to the Government it appeared as subversive, unpatriotic and 'Worthy of Goebbels at his best' (Herbert Morrison, then Home Secretary). Questions were raised in the House of Commons and for a time the *Mirror* was under threat of closure. After the war Zec became head of the strip-cartoon department and a director of the paper, succeeding Hugh Cudlipp as editor of *Sunday Pictorial* (1950–2). He later moved to the *Daily Herald* as Political Cartoonist (1958–61). In addition he was a director of the *Jewish Chronicle* for 25 years and editor of *New Europe*. He died on 14 July 1983.
ILL: E. F. Herbert, *Wimpy the Wellington* (1942)
COLL: UKCC MB

ZINKEISEN, Anna Katrina ROI (1906–76). Portrait, mural and flower painter and humorous illustrator. Anna Zinkeisen was born in Kilcreggan, Dumbartonshire, the daughter of a research chemist and the sister of Doris Zinkeisen the theatre designer. Aged seven she came to London and aged 15 won a scholarship to the RA Schools. In 1924 her first picture was exhibited at the RA and the next year she won a silver medal in Paris for decorating Wedgwood plaques. By 1927 she was contributing decorative-humorous illustrations to the *Sketch* and in the same light-hearted manner went on to illustrate books, design advertisements (notably for De Reszke cigarettes) and contribute to other magazines like *Nash's* and the *Tatler*. However, she became most celebrated as a society portrait painter, being elected ROI in 1928.
ILL: A. P. Herbert, *She-Shanties* (1926), *Plain Jane* (1927); C. Brahms, *The Moon on my Left* (1930); M. Sharp, *The Nymph and the Nobleman* (1932); R. H. Buergel, *Oola-Boola's Wonder Book* (1932); C. Graves, *The Complete Hostess* (1935); H. Farjeon, *Nine Sharp and Earlier* (1938); N. Streatfield, *Party Frock* (1946); J. Phoenice, *A Rainbow of Paths* (1965)
EXHIB: RA; ROI; RP; L SH

ZOKE – see Attwell, Michael

Bibliography

General works relating to artists listed in this dictionary. Works relating to individual artists appear under the appropriate entries (LIT).

All books were published in London unless indicated otherwise. The dates are those of first publication.

Books

Abbey, J.R., *Life in England in Aquatint and Lithography 1770–1860 from the Library of J.R. Abbey* (Curwen Press, 1953)

Amstutz, W., *Who's Who in Graphic Art* (Amstutz a Herdeg/De Clivo Press, Zürich/Dübendorf, 1962/1982)

Ashbee, C.R., *Caricature* (Chapman & Hall, 1928)

Ashton, J., *English Caricature and Satire on Napoleon I* (Chatto & Windus, 1884)

Atherton, H.M., *Political Prints in the Age of Hogarth* (Clarendon Press, Oxford, 1974)

Bateman, M., *Funny Way to Earn a Living* (Leslie Frewin, 1966)

Benezit, E., *Dictionnaire des Peintres, Sculpteurs, Dessinateurs et Graveurs* (Librairie Gründ, Paris, 1976)

Bradshaw, P.V., *The Art of the Illustrator* (Press Art School, 1918)

————*They Make Us Smile* (Chapman & Hall, 1942)

————*Lines of Laughter* (Chapman & Hall, 1946)

————*Brother Savages and Guests: A History of the Savage Club 1857–1957* (W.H. Allen, 1958)

Brewer, J., *The Common People and Politics 1750–1790s* (Chadwyck-Healey, Cambridge, 1986)

Briggs, S. & A. (eds), *Cap and Bell* (Macdonald, 1972)

Brinton, S., *The Eighteenth Century in English Caricature* (Siegle, 1904)

Broadley, A.M., *Napoleon in Caricature 1795–1821* (John Lane, 1911)

Bryant, M., *World War II in Cartoons* (W. H. Smith, 1989)

Buss, R.W., *English Graphic Satire* (privately printed, 1874)

Dalby, R., *The Golden Age of Children's Book Illustration* (O'Mara Books, 1991)

Darracott, J., *A Cartoon War* (Leo Cooper, 1989)

Davies, R., *Caricature of To-Day* (Studio, 1928)

Dickinson, H.T., *Caricatures and the Constitution 1760–1832* (Chadwyck-Healey, Cambridge, 1986)

Driver, D., *The Art of Radio Times* (BBC, 1981)

Duffy, M., *The Englishman and the Foreigner* (Chadwyck-Healey, 1986)

Du Maurier, G., *Social Pictorial Satire* (Harper, 1898)

Everitt, G., *English Caricaturists and Graphic Humorists of the Nineteenth Century* (Swan Sonnenschein, 1886)

Feaver, W., *Masters of Caricature from Hogarth and Gillray to Scarfe and Levine* (Weidenfeld & Nicolson, 1981)

Fougasse [K. Bird], *The Good-tempered Pencil* (Max Reinhardt, 1956)

Geipel, J., *The Cartoon: A Short History of Graphic Comedy and Satire* (David & Charles, 1972)

George, M.D., *English Political Caricature: A Study of Opinion and Propaganda* (Clarendon Press, Oxford, 1959)

————*Hogarth to Cruikshank: Social Change in Graphic Satire* (Allen Lane, 1967)

Gifford, D., *Victorian Comics* (Allen & Unwin, 1976)

————*The British Comic Catalogue 1874–1974* (Mansell, 1975)

————*The International Book of Comics* (Hamlyn, 1990)

Gombrich, E.H., *Art and Illusion* (Phaidon, 1960)

————*Meditations on a Hobby Horse* (Phaidon, 1963)

Gombrich, E.H., & Kris, E., *Caricature* (Penguin, 1940)

Griffiths, D., *Encyclopedia of the British Press* (Macmillan, Basingstoke, 1993)

Grose, F., *Rules for Drawing Caricatures with an Essay on Comic Painting* (1788)

Grosvenor, P. (ed.), *We Are Amused: The Cartoonists' View of Royalty* (Bodley Head, 1978)

Hammelmann, H. & Boase, T.S.R., *Book Illustrators in Eighteenth-century England* (Yale University Press, 1975)

Hammerton, J.R., *Humorists of the Pencil* (Hurst & Blackett, 1905)

Hardie, M., *Water-colour Painting in Britain* (Batsford, 1966–8)

Harper, C.G., *English Pen Artists of To-Day* (Macmillan, 1892)

Harvey, J., *Victorian Novelists and Their Illustrators* (Sidgwick & Jackson, 1970)

Heller, S., *Man Bites Man: Two Decades of Satiric Art* (Hutchinson, 1981)

Herbert, W.A.S., *Caricatures and How to Draw Them* (Pitman, 1951)

Hewison, W., *The Cartoon Connection* (Elm Tree Books, 1977)

Hillier, B., *Posters* (Weidenfeld & Nicolson, 1969)

————*Cartoons and Caricatures* (Studio Vista/Dutton, 1970)

Hofmann, W., *Caricature from Leonardo to Picasso* (John Calder, 1957)

Horn, M. (ed.), *The World Encyclopedia of Comics* (Chelsea House, New York, 1976)
————*The World Encyclopedia of Cartoons* (Chelsea House, New York, 1980)
Houfe, S., *The Dictionary of British Book Illustrators and Caricaturists 1800–1914* (Antique Collectors' Club, Woodbridge, 1978)
————*Fin de Siècle: The Illustrators of the Nineties* (Barrie & Jenkins, 1992)
James, L., *Print and the People 1819–1851* (Allen Lane, 1976)
Johnson, J. & Greutzner, A., *The Dictionary of British Artists 1880–1940* (Antique Collectors' Club, Woodbridge, 1976)
Klingender, F.D., *Hogarth and English Caricature* (Transatlantic Arts, 1944)
Kunzle, D. *The Early Comic Strip* (University of California Press, Los Angeles, 1973)
————*The History of the Comic Strip: The Nineteenth Century* (University of California Press, Los Angeles, 1990)
Lambourne, L., *An Introduction to Caricature* (HMSO, 1983)
Lambourne, L. & Hamilton, J., *British Watercolours in the Victoria and Albert Museum* (Sotheby Parke Bernet, 1980)
Low, D., *British Cartoonists, Caricaturists and Comic Artists* (Collins, 1942)
Lucie-Smith, E., *The Art of Caricature* (Orbis, 1981)
Lynch, B., *A History of Caricature* (Faber & Gwyer, 1926)
Lynx, J. (ed.), *The Pen is Mightier: the Story of the War in Cartoons* (Lindsay Drummond, 1946)
Maddocks, P. *How to be a Cartoonist/How to Be a Super Cartoonist* (Elm Tree Books, 1986)
————*Caricature and the Cartoonist* (Elm Tree Books, 1989)
Malcolm, J.P., *Historical Sketch of the Art of Caricaturing* (1813)
Mallalieu, H., *Dictionary of British Watercolour Artists* (Antique Collectors' Club, Woodbridge, 1976/1990)
Mathews, R.T. & Mellini, P., *In 'Vanity Fair'* (Scolar Press, 1982)
Maurice, A.B. & Cooper, F.T., *The History of the Nineteenth Century in Caricature* (Grant Richards, 1904)
Meglin, N., *The Art of Humorous Illustration* (Watson-Guptill, New York, 1973)
Miller, J., *Religion in the Popular Prints* (Chadwyck-Healey, Cambridge, 1986)
Muir, P., *English Children's Books 1600–1900* (Batsford, 1954)
————*Victorian Illustrated Books* (Batsford, 1971)
Norgate, M. & Wykes, A., *Not So Savage* (Jupiter Books, 1976)
Parton, J., *Caricature and Other Comic Art* (Harper, New York, 1878)
Paston, G., *Social Caricature in the Eighteenth Century* (Methuen, 1905)
Pennell, J., *Pen Drawing and Pen Draughtsmanship* (Macmillan, 1889)
————*Modern Illustration* (Bell, 1895)
Peppin, B., *Fantasy Book Illustration 1860–1920* (Studio Vista, 1975)
Peppin, B. & Micklethwaite, L., *Dictionary of British Book Illustrators: The Twentieth Century* (John Murray, 1983)

Perry, G. & Aldridge, A., *The Penguin Book of Comics* (Penguin, 1967)

Pound, R., *The Strand Magazine 1891–1950* (Heinemann, 1966)

Price, R.G.G., *A History of Punch* (Collins, 1957)

Reid, J.G., *At the Sign of the Brush and Pen* (Simpkin Marshall, 1898)

Reitlinger, H., *From Hogarth to Keene* (Methuen, 1938)

Ruskin, J., *The Art of England* (George Allen, 1884)

Russell, L. & Bentley, N., *The English Comic Album* (Michael Joseph, 1948)

Savory, J.J., *The Vanity Fair Gallery: A Collector's Guide to the Caricatures* (Barnes, New York, 1979)

Sharpe, J.A., *Crime and the Law in English Satirical Prints 1600–1832* (Chadwyck-Healey, Cambridge, 1986)

Shikes, R.E. & Heller, S., *The Art of Satire: Painters as Caricaturists and Cartoonists from Delacroix to Picasso* (Pratt Graphics Center/Horizon Press, New York, 1984)

Sketchley, R.E.D., *English Book Illustration of To-Day* (Kegan Paul, Trench, Trubner, 1903)

Spielmann, M.H., *The History of Punch* (Cassell, 1895)

Stephens, F.G. & George, M.D., *Catalogue of Political and Personal Satires in the British Museum* (British Museum, 1870–1954)

Thomas, P.D.G. *The American Revolution* (Chadwyck-Healey, Cambridge, 1986)

Thomson, R. & Hewison, W., *How to Draw and Sell Cartoons* (Quarto, 1985)

Thorpe, J., *English Illustration: The Nineties* (Faber & Faber, 1935)

Tooley, R.V., *English Books with Coloured Plates 1790 to 1860* (Batsford, 1954)

Usherwood, R.D., *Drawing for Radio Times* (Bodley Head, 1961)

Veth, C., *Comic Art in England* (Hertzberger, 1929)

Walker, M., *Daily Sketches: A Cartoon History of Twentieth-century Britain* (Muller, 1978)

Waters, G.M., *Dictionary of British Artists Working 1900–1950* (Eastbourne Fine Art, Eastbourne, 1975)

Westwood, H.R., *Modern Caricaturists* (Lovat Dickson, 1932)

Whalley, J.L. & Chester, T.R., *A History of Children's Book Illustration* (John Murray/V&A, 1988)

Who's Who in Art (Art Trade Press, 1927–date)

Windsor, A. (ed.), *Handbook of Modern British Painting 1900–1980* (Scolar Press, Aldershot, 1992)

Wood, C., *Dictionary of Victorian Painters* (Antique Collectors' Club, Woodbridge, 1971)

Wright, T., *A History of Caricature & Grotesque in Literature and Art* (Virtue, 1865)

————*Caricature History of the Georges or Annals of the House of Hanover* (Virtue, 1867)

Wynn Jones, M., *The Cartoon History of Britain* (Tom Stacey, 1971)

————*A Cartoon History of the Monarchy* (Macmillan, 1978)

Catalogues

'The Art of Laughter' (CAT/A, 1992)
'Beaverbrook's England 1940–1965' (UKCC, 1981)
'British Comic Art' [S. Heneage] (Sotheby's Sussex, 1986)
'Caricature and its Role in Graphic Satire' (Museum of Art/Rhode Island School of Design, 1971)
'Cartoon and Caricature from Hogarth to Hoffnung' (AC/Royal Exchange, 1962)
'Charterhouse, the Cartoon Tradition' (CS, 1977)
'A Child of Six Could Do It! Cartoons about Modern Art' (T, 1973)
'Drawn and Quartered: The World of the British Newspaper Cartoon' (NPG, 1970)
'English Caricature 1620 to the Present' (V&A, 1984)
'English Humorists in Art' (RI, 1889)
'The English in Line' (UKCC, 1983)
'Europeans in Caricature 1770–1830' (BM, 1992)
'Fantastic Illustration and Design in Britain 1850–1930' [D. L. Johnson] (Museum of Art/Rhode Island School of Design, 1979)
'Folly and Vice: The Art of Satire and Social Criticism' (SBC, 1989)
'Frontiers' (UKCC, 1992)
'Getting Them in Line' (UKCC, 1975)
'Half in Jest' (CAC, 1982)
'Humorous Art' (RSA, 1950)
'Mr Punch's Pageant, 1841 to 1948' (LG, 1909)
'Not by Appointment: An Exhibition of Royal Cartoons' (Press Club, 1977)
'Penny Dreadfuls and Comics' (BGM, 1983)
'Punch 150' (RFH, 1991)
'The Shadow of the Guillotine: Britain and the French Revolution' [D. Bindman] (BM, 1989)
'Society of Humorous Artists, First Exhibition' (Goupil, 1912)